AMERICAN VISIONS

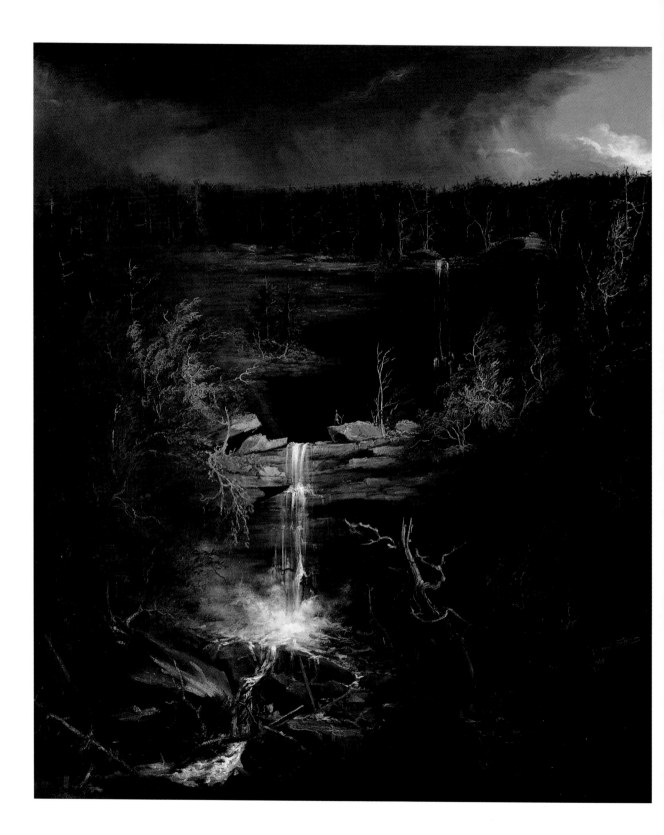

AMERICAN VISIONS

The Epic History of Art in America

ROBERT HUGHES

ALFRED A. KNOPF
NEW YORK
1997

For Victoria, with love

**THIS IS A BORZOI BOOK
PUBLISHED BY ALFRED A. KNOPF, INC.**

Copyright © 1997 by Robert Hughes
All rights reserved under International and Pan-American Copyright
Conventions. Published in the United States by Alfred A. Knopf,
Inc., New York, and simultaneously in Canada by Random House
of Canada Limited, Toronto. Distributed by Random House, Inc.,
New York.

http://www.randomhouse.com/

Owing to limitations of space, all permissions to reprint previously
published material may be found immediately following the index.

Library of Congress Cataloging-in-Publication Data

Hughes, Robert.
 American visions : the epic history of art in America / by Robert
Hughes.
 p. cm.
 Includes index.
 ISBN 0-679-42627-2
 1. Art, American—Themes, motives. I. Title.
N6505.H84 1997
709'.73—dc21 96-45111
 CIP
Manufactured in Singapore
First Edition

Frontispiece: Thomas Cole, *Falls of Kaaterskill,* 1826. Oil on
canvas, 43 × 36 " (109.2 × 91.4 cm). The Warner Collection
of Gulf States Paper Corporation, Tuscaloosa, Alabama.

CONTENTS

INTRODUCTION

Like its predecessor, *The Shock of the New,* published fifteen years ago, *American Visions* grew out of a television series co-produced by BBC-2 and Time Warner. I emphasize "grew"; whereas the script for each of the eight films of *American Visions* was, at the most, three thousand words long, each of the corresponding chapters of the book turned out to be over twenty thousand words, and there are nine chapters, not eight. Nevertheless, its televisual origins are stamped all over it, beginning with its structure.

The Shock of the New took eight themes and pursued them across a relatively short historical span, the century of Modernism, roughly from 1880 to 1980. In *American Visions* we had to deal with a much larger time-frame. Our object was not to do an "art series" as such, but rather to sketch some answers to an over-riding question: "What can we say about Americans from the things and images they have made?" Essentially, we wanted to look at America through the lens of its art. A more (but not rigidly) chronological way of approaching this, beginning in the seventeenth century and working through to the present day, seemed right. But it also doomed all efforts at inclusiveness at the outset. The reason is the sheer richness and variety of the material, which resisted all efforts to compress it into an eight-hour format.

America is conventionally spoken of as a young country, but—apart from the antiquity of its indigenous cultures—the European settlement of New Mexico and Massachusetts took place in the early seventeenth century, when St. Petersburg was still a marsh; people of European (including English) descent have been painting pictures and building structures in North America for the best part of 350 years. It follows that any effort to describe what they made, and to relate this growing flood of images to the society from which it came, is bound to be extremely partial, selective, and incomplete if you have only eight hours—or even a quite long book—in which to do it. The list of significant artists left out of the

TV version of *American Visions*, including some of my own favorites, would be almost as long as the roster of those who appeared on the screen. And these omissions were ineluctably forced by the nature of TV, which favors simple narrative lines, prefers figurative images to abstract ones, and cannot pretend to be either "encyclopedic" or "definitive." Besides, there are no footnotes on television.

There are none in this book either. Nor is there a bibliography. In this, *American Visions* follows its prototypes, Kenneth Clark's *Civilization* and Jacob Bronowski's *The Ascent of Man*. It is not intended as a scholarly text, still less an exhaustive one. It is meant for that creature who, American academics often profess to believe, no longer exists: the general intelligent reader. It should not be seen as a primer, but it is definitely meant as an introduction to its subject for those who feel the same curiosity about it as I did when, knowing very little of American art earlier than Abstract Expressionism, I moved to New York in 1970. Nevertheless, the longer format of the book has enabled me to put back into the account many of the artists who had, perforce, to be omitted from the screen version, and to discuss some of the issues raised by their work at greater length. What results is, in the words of Clark's subtitle, "a personal view"—always opinionated, verging at times on bias. For this, I cannot offer an apology. The critic is by definition a subjective being, and this critic in particular, though he has lived half his life in the United States working for *Time* magazine since 1970, has always found a degree of freedom in not being American himself. Perhaps an American should have done the original series, but none did (it still seems barely credible to me that such a subject should have been lying around untouched by American television, but it was). In talking about the series to journalists, I found myself using the phrase "a love-letter to America," but different stages of an affair produce different letters, and some are not free of reproach to their brazen, abundant, horizon-filling subject. So it is with both the televised and the published forms of *American Visions*.

Since the book could not have been done without the series at its back, my first debt of gratitude is to the BBC and to Time Warner, who jointly financed it, and to Michael Jackson, then the programming head of BBC-2, who gave the project the green light. Nick Rossiter, its executive producer, labored mightily to bring it from some synopses on yellow paper to its completed form as film, over a taxing production span of nearly three years, and I cannot sufficiently thank him for the unwavering faith he had in the project during its vicissitudes. Five directors made the programs: James Kent, Chris Spencer, David Willcock, Julia Cave, and John Bush. No writer/narrator could hope to work with more alert, intelligent, and sympathetic colleagues; and looking back on the results, I sometimes find it hard to distinguish their ideas from mine, the surest sign of true collaboration. Most sincere thanks also to The Principal Financial Group, which, among others, provided underwriting support for the *American Visions* project.

Neither the series nor this book could have been completed without the generosity of my successive managing editors at *Time* magazine, Jim Gaines and Walter Isaacson, in giving me free time to shoot on location—a total of six months on the road, by my count, literally from Maine to Albuquerque—and to write the book. My editors at Knopf, Charles Elliott and Susan Ralston, were unfailing in their patience and perceptiveness, working against a very short deadline together with designer Peter Andersen, head of production Andy Hughes, production assistant Larry Flusser, and production editor Kevin Bourke. Moreover, since 1996 (during which most of the book was written) was not a year of grace for me, and brought unusual stress and turmoil in its wake, I must record my debt to friends who helped me get through it all—in particular, to David Feuer, to Peter Duchin and Brooke Hayward (*amici del cuore*), to David Rieff, Michael Kimmelman, Catharine Lumby, and Malcolm and Lucy Turnbull. And lastly to my dear wife, Victoria Hughes, whose book this is, as all the others for the last fifteen years have been.

AMERICAN VISIONS

I

O MY AMERICA,
MY NEW FOUNDE LAND

I have lived and worked in the United States of America for a little more than a quarter of a century now, without becoming an American citizen. For reasons that have nothing (and everything) to do with this book, I remain an Australian citizen, and thus have the status of a resident alien, a green-card holder. We resident aliens—the very term suggests a small Martian colony—have therefore missed out on one of the core American experiences, that of officially becoming someone else: becoming American, starting over, leaving behind what you once were. Nearly everyone in America bears the marks of this in his or her conscious life, and carries traces of it deep in ancestral lore and recollection. For everyone in America except American Indians, the common condition is being, at one's near or far origins, from somewhere else: England or Ireland or Africa, Germany, Russia, China, Italy, Mexico, or any one of a hundred other places that have contributed to the vast American mix. (And the anthropological evidence suggests that even the American Indians were immigrants too, having made their way across the Bering Strait from eastern Asia some 10,000 to 14,000 years ago— though this is vehemently disputed by the Indians themselves.)

It is this background which gives a particular cast to the encyclopedic museums of America, of which the greatest is the Metropolitan Museum of Art in New York, a place I have visited perhaps thirty times a year for twenty-five years and still not come to the end of. One thinks of its nearest English equivalent, the British Museum, as being (at its origins) a vast repository of imperial plunder, brought from the four corners of the earth to confirm and expand the sense of Englishness. The conventional left-wing view of the Met, in the 1970s, was similar: it was seen as the imperial treasure-house into which the sacred and secular images of other cultures—European, African, South American, Oceanian, Japanese, Chinese, Middle Eastern—had been hoovered by the prodigious suction of

1. Edward Hicks, *Peaceable Kingdom,* c. 1834. Oil on canvas, 30 × 35½″ (76.2 × 90.2 cm). National Gallery of Art, Washington, D.C.; gift of Edgar William and Bernice Chrysler Garbisch.

American capital, to confirm American greatness. There is some truth in this, but not the whole truth. In its seventeen acres of exhibition space, let alone its storage, the Met keeps millions of objects, from New Guinean wooden totems to five-ton black basalt Egyptian sarcophagi, from Mantegna prints to carved human femurs, from an entire Spanish Renaissance courtyard to Yoruba helmet-masks and George Stubbs horses. Anything made with esthetic intentions by anyone, anywhere, at any time, falls within its purview. As a result, it is an extraordinary crystallization of the variety of *American* origins: there can be few Americans who can't find some example of the art of their ancestors in it. Somewhere inside the American museum there is always a small buried image of the immigrant getting off the boat with his luggage, a bit of the Old World entering the New: boots, a Bible—or twenty-seven Rembrandts. The fact of immigration lies behind America's intense piety about the past (which coexists, on other levels, with a dreadful and puzzling indifference to its lessons); in America the past becomes totemic, and is always in a difficult relationship to America's central myth of progress and renovation, unless it can be marshaled—as in the museum—as proof of progress.

Along with this, because the New World really *was* new (at least to its European conquerors and settlers), goes a passionate belief in reinvention and in the American power to make things up as you go along. Both are strong urges, and they seem to grow out of a common root: the inextricably twined feelings of freedom and nostalgia which lie at the heart of the immigrant experience and are epitomized in America, to this day, as in no other country. A culture raised on immigration cannot escape feelings of alienness, and must transcend them in two possible ways: by concentration on "identity," origins, and the past, or by faith in newness as a value in itself. No Europeans felt about the Old in quite the same way Americans came to, and none believed as intensely in the New. Both are massively present in the story of American art, a story that begins weakly and derivatively in the sixteenth and seventeenth centuries, and acquires such seemingly irrefutable power by the end of the twentieth. In this way, the visual culture of America, oscillating between dependence and invention, tells a part of the American story; it is a lens through which one can see in part some (not all) of the answers to Hector St. John de Crèvecoeur's well-known question, posed in the eighteenth century: "What, then, is the American, this new man?"

Until quite recently, most Americans believed that the colonial culture of North America began when the Pilgrim Fathers landed on Plymouth Rock in Massachusetts, in 1620. Others know that there was an earlier settlement attempted in 1607 at Jamestown, near the mouth of the Chesapeake Bay—the so-called Virginia Colony. But the emphasis on these events stems from an English Protestant prejudice. As Walt Whitman wrote in 1883, "Impress'd by New England writers

and schoolmasters, we tacitly abandon ourselves to the notion that our United States have been fashion'd from the British Islands only . . . which is a very great mistake."

The Spanish were in North America long before the English, and the United States of America was a multiethnic society right from the start. (At the zenith of its American influence, the Spanish Empire claimed or actually governed about half the total area of what is now the United States.) Christopher Columbus never saw the American mainland, but it is possible that the coast of southern Florida was glimpsed by Spanish mariners as early as 1499, and the first recorded arrival there was made in 1513 by Juan Ponce de León (who had led the conquest of Puerto Rico five years earlier). Like all other Spaniards who followed the track of Columbus into the Caribbean and later to Mexico, he was looking for slaves and gold, not (as legend persistently has it) the mythical Fountain of Youth. The wooden forts and settlements that sixteenth-century Spanish colonists left all over Florida and Louisiana have long since vanished, and the names they gave to places have often been Anglicized—Key West, for instance, was once Cayo Hueso, "Bone Key." The oldest continuously occupied European settlement in the United States is not in Massachusetts but in Florida: St. Augustine, where the frowning, symmetrically planned stone walls of the Castillo de San Marcos were erected by Spaniards in 1565.

The Spanish did not bring artists with them on these military *entradas*. As far as is known, the earliest surviving painting done by a European artist in North America is a watercolor (Figure 2) by Jacques Le Moyne, a cartographer from Dieppe who went with an expedition of French Huguenots (Protestant followers

2. Jacques Le Moyne, *Laudonnierus et Rex Athore ante Columnam a Praefecto Prima Navigatione Locatam Quamque Venerantur Floridenses*, June 27, 1564. Gouache and metallic pigments on vellum, with traces of black chalk outlines. New York Public Library, New York; Miriam and Ira D. Wallach Division of Art, Prints, and Photographs; bequest of James Hazen Hyde.

The flyer.

of John Calvin) in 1564 to form a settlement about forty miles to the north of St. Augustine. Done in a delectably stylized manner that reminds one of a Mannerist court masque, it shows René de Laudonnière, the leader of the expedition, being welcomed to Florida by a group of lily-white Indians and their lord, Chief Athore; a votive plinth bearing the three heraldic lilies of France is surrounded by the products of native husbandry: gourds, fruit, and the all-important but (to a Frenchman) completely novel Indian corn. The settlement hardly lasted a year; in 1565 the Spaniards from St. Augustine attacked this tiny outpost of Protestant heresy in the New World and slaughtered nearly all its colonists, though Le Moyne himself narrowly escaped with his life and his watercolors; these, along with the more anthropologically accurate watercolors made by John White in Virginia c. 1587–88 (Figure 3), became the basis of the Frankfurt publisher Theodore de Bry's numerous and equally fanciful engravings in his ten-part *America*, 1591–95. De Bry, a Protestant, had a vested interest in portraying the Spaniards in America as monsters of cruelty—although, knowing that readers liked to have their blood curdled, he also harped on the supposed cannibalistic habits of Indians. Consequently his engravings of conquistadorial frightfulness (Figure 4) did much to implant *la leyenda negra*, the "Black Legend" of Spanish atrocities in the New World.

Long before de Bry's work was published, the Spaniards had created a frontier in the southern part of North America. They did so by pushing west from Florida and north from Mexico, which had been subjugated by Hernán Cortés in 1521. The extraordinary moment when the two linked up came in 1536, when a party of Spaniards hunting for Indians to enslave in the north of Mexico saw a strange foursome stumbling toward them, a black man and three whites, clad in ragged garments, with six hundred Indians following behind. The black was an African slave called Esteban and the leading white was an Andalusian named Alvar Núñez Cabeza de Vaca, survivor of a disastrous *entrada* into Florida whose members were routed by Indians near Tallahassee. Cabeza de Vaca and the remaining Spaniards then made a voyage westward on improvised rafts, along the whole southern coast of America to present-day Galveston, Texas, where they were captured and enslaved by Indians. Cabeza de Vaca, a man of incredible resourcefulness, managed to convince his captors that he was a medicine man, won a degree of freedom, and in 1534 set out with his companions—by now the sole survivors

3. John White, *The Flyer*, c. 1587–88. Watercolor and black lead on paper, 9¾ × 6″ (24.6 × 15.1 cm). British Museum, London.

of an original force of three hundred—to reach Mexico City. On the way they accumulated a retinue of Indians by posing as holy men, *curanderos*. Over two years' walking west they became a traveling cult, and entered history as the first Europeans to cross the North American continent from the Atlantic to the Pacific, almost 250 years before Lewis and Clark.

Unfortunately for the future of the Indians of Southwestern America, Esteban took to boasting, and Cabeza de Vaca to hinting, that they had found signs of a great wealthy civilization along their track, a new Teotihuacán.

That was enough for Hernán Cortés and the Mexican viceroy, Antonio de Mendoza. In 1538 they sent Esteban back north with a readily deluded Franciscan friar, Fray Marcos de Niza, to find out if such a golden civilization existed. After a year Fray Marcos reappeared with alluring stories about a city named Cibola, "bigger than the city of Mexico" but only one of seven such cities in the northern lands. Their walls were of gold, and their temples studded with precious stones. One cannot say or even guess why Fray Marcos cooked up this preposterous tale, or why none of the members of his expedition denied it. One guess is

4. Theodor de Bry, sixteenth-century engraving showing Spanish invaders hanging native captives from the mast of their ship.

that since he did not actually enter the city he called Cibola but only saw it from afar, the bright sunset light on Zuni mud walls looked like gold to his hopeful eyes. Not everyone believed him—Hernán Cortés called him a liar—but the viceroy had to be certain. So, in 1540, he sent out a full-scale expedition under the command of Francisco Vásquez de Coronado.

It was a fiasco. Reaching the pueblo that the friar had designated as Cibola, Coronado and his men found no gold, only walls and pots made of mud, and resentful Indians who astutely got rid of them by assuring them that, yes, there was a golden city farther north. Wandering in pursuit of its fool's gold for two years, the expedition reached what is now the southwestern corner of Kansas before turning to straggle back to Mexico City, empty-handed. After that, the Spanish viceroys lost interest in northern expansion for forty years.

It was revived by two things: silver mining and missionary work. But first, the Spanish Crown had to take formal possession of the "wilderness" of New Mexico. This task fell to a Mexican-born aristocrat named Juan de Oñate, who in April 1598, at the head of a small army and ten Franciscan priests, crossed the Rio Grande at a spot where El Paso—"the crossing"—stands today and trekked north to the present site of Albuquerque. Here, the new governor assembled the leaders of various Pueblo communities and told them, in effect, that they were now the vassals of the Spanish king Felipe II, that if they obeyed his commands and embraced the Catholic Church, they would not only grow rich through trade and agriculture but also enjoy the benefits of eternal life with Jesus. The Indian chiefs indicated—at least to Oñate's satisfaction—that they agreed, and thus the first tiny Spanish foothold in New Mexico was established nearby at San Gabriel, complete with a mission church. Around 1608 Oñate moved most of his colonists to the present site of Santa Fe.

This occupation—the Spanish were extremely careful not to call it a *conquista,* for they needed to colonize New Mexico without stirring the ire of its inhabitants to the point where they might become reluctant to work for them—was bloodless at first. But the wary peace between Spaniards and Pueblo Indians did not last long. In 1598, the first year of the occupation, Oñate led a survey expedition to the west, where he and his men arrived at the foot of the immense vertical massif on whose flat top the pueblo of Acoma was perched (Figure 5).

Today, Acoma is the oldest continuously inhabited town in the United States. Acoma Indians have dwelt there since about 1150. It seems to have been built in utter defiance of environmental reality. Its rock rises some four hundred feet from the floor of a vast, flat canyon, twenty miles wide. The cliffs are bare and vertical; in places they bulge out into overhangs. No springs exist, and the only water supply comes from rain collected in cisterns. There is no earth on the mesa top, and hence nowhere to grow crops. Whatever the Acoma ate, and in time of drought whatever they drank as well, had to be dragged laboriously from the val-

ley floor to the summit in baskets and earthenware jars. But the place had two advantages. It was secure from attacks by other Indian tribes, had they been foolhardy enough to try. And for the Acoma, it was suffused with spiritual meaning. Even a modern Anglo, perched on some boss of rock at the edge and watching a raven sail through the indescribable clarity of light, distance, and silence, can sense this—despite the array of ramshackle plywood and tin outhouse privies which modern Acomas have seen fit to erect along the very rim of their sacred mountain.

Oñate thought the Acomas would submit, but he was wrong. The Acoma warriors lured a party of Spanish soldiers up the trail to the top of the mesa and slaughtered eleven of them without warning. Oñate soon struck back. He dispatched a force to Acoma early in 1599. The soldiers managed to scale what one of them later called "the greatest stronghold ever seen in the world"; later they would say they were led by a vision of Santiago Matamoros (Saint James the Moor-Killer) on a white horse, brandishing a sword of fire. They killed some eight hundred Acomas, men, women, and children, and enslaved most of the rest. This fearful reprisal broke the back of Acoma resistance for two generations, and by 1640 the Franciscans had persuaded the Acomas to build a church atop the mesa.

By then New Mexico was thinly sprinkled with other missions. Their work was vital to the imperialist designs of the Spanish Crown. The missionaries needed royal authority and backing; the Crown needed the zeal of the missionaries to "bring in" the natives. Each got what it wanted. Franciscan methods had

5. The Acoma Pueblo (photographed by Edward S. Curtis in 1904). New Mexico.

already proven so successful in Mexico that in the "Royal Orders for New Discoveries," issued in 1573, the Crown specified that they should be used in all new territories—and they were, right up to the mid-nineteenth century. In essence, there were three stages. First came the *entrada,* the entry into native society. Applying the principles of the Counter-Reformation—that emotion and vivid display were vital in impressing religious truth on people's minds—the newly arrived *frailes* would make a great show, bringing gifts of food, colored beads, mirrors, and trade goods. They played music on strange instruments the Pueblos had never seen before. They produced gaudy holy pictures of Christ and the Virgin, the apostles and saints. Before long, curiosity would pass to trust and the Indians would let the Franciscans move in. Then *entrada* shifted to *conversión,* as village leaders and then commoners were won over to the Catholic faith. A friary would be built, and then a church. Finally you had a *misión,* which the Franciscans also called a *doctrina*—a congregation functioning as a parish, where priests pulled the strings of political power behind converted native leaders, and communal life revolved around the mission church and its Masses, not the kiva and its rituals. The Crown supplied the friars with shipments of food, tools, and church paraphernalia—iron hinges, latches, chalices and vestments, altar wine and the all-important bells.

These techniques needed settled Indian villages to work in, and they were particularly effective with the Pueblo Indians. The Crown wanted the friars to insulate the Indians from secular Spanish colonists, so that rape, murder, and theft would not breed the horror and recalcitrance among natives that they had in Old Mexico. Certainly the friars would whip Indians from time to time, to punish them for sin. But it was observed that they also whipped themselves, fiercely enough to draw blood—an ecstatic penitential habit that came out of Spain and developed long roots in New Mexico.

The imposition of Spanish rule on the Pueblo Indians through its "conquistadores of the spirit," the Franciscan friars, was far more successful than military rule could have been. Still, it did not always go smoothly, and it often met with covert resistance, which sometimes flared into open rebellion. Indian risings occurred at Zuni in 1632, at Taos in 1639–40, and elsewhere through the 1650s. But not until 1680 was there a unified, planned revolt of the Pueblos. Two decades of drought and heat waves had all but ruined the fragile desert-farming economy of the Indians. The starving Pueblos were constantly harried by raiding parties of Navajos and Apaches. Clearly, the god of the Spaniards was no better at fending off disaster than their own sky and earth deities. Perhaps if the Spaniards were driven out, the old gods would be appeased and the order of the world restored. This brought a revival of Pueblo religion and ferocious reprisals from the Spaniards, who took to hanging Pueblo priests and flogging their followers for "sorcery" and "treason."

Out of such misery and hope came the Pueblo Revolt, fomented by a charismatic leader named Popé, who made his secret headquarters in a kiva, or sacred room, in Taos. On August 10, 1680, some sixteen thousand Pueblos scattered through dozens of settlements across several hundred miles of the Southwest rose all at once, and annihilated Spanish rule in New Mexico. They killed a sixth of the thin Spanish population outright, about four hundred out of twenty-five hundred; they burned the farms, houses, and churches of the foreigners, along with all their contents—crosses, paintings, vestments, sculpture.

The Spaniards would not regain control over New Mexico for another thirteen years. So complete was the destruction of colonial artifacts that, as far as is known, only one New Mexican sculpture verifiably made before 1680 still exists—a figure of the Virgin Mary (Figure 6) the fleeing Spaniards took with them on their panicky retreat across the Rio Grande. It came back to Santa Fe with the implacable Diego de Vargas, who had been dispatched in 1692 to retake New Mexico. Known as "Our Lady of the Reconquest," or popularly as *La Conquistadora*, it has a place of honor in the parish church of Santa Fe.

None of the early churches survive. If Popé's followers had not wrecked them, the weather would have demolished them long ago, because they were made of mud, which melts. Though the stone circular rooms and kivas of Anasazi villages from the tenth century have survived, there is not one seventeenth- (or even eighteenth-) century Spanish farmhouse standing in its original form anywhere in New Mexico.

Mud architecture was known to the Pueblos, who nevertheless preferred, before the Spanish occupation, to make their walls of stone. The great monument of ancient Pueblo culture, far surpassing in sophistication and size anything built by the Spaniards in New Mexico, is Pueblo Bonito, in Chaco Canyon, where human farming settlement had been ongoing since about 600 A.D. It is not a single building but an entire town of four- and five-story "apartments," with circular underground kivas as much as fifty feet in diameter, spreading over three acres and, at its height of settlement, containing at least a thousand people. One continuous structure, Pueblo Bonito was the largest housing complex erected in North America until the twentieth century: but it was begun in the ninth century A.D. and abandoned around 1200 A.D. It is constructed of finely dressed masonry, the main walls having two stone "skins" filled with random rubble—a building technique common in ancient Rome.

6. *La Conquistadora,* St. Francis Cathedral. Santa Fe, New Mexico.

But stone is laborious to build with, and in any case the masonry skills of the Pueblo Indians had degenerated since those ancient times. Mud is an extremely cheap and fast way of building, compared to the communal stonework that went into Pueblo Bonito, or devoured the labor of whole Mayan and Aztec societies below the Rio Grande. Mud is also very ancient, reaching back to Ur of the Chaldees. The Spaniards gave it a North African name, *adobe,* and introduced technical innovations, such as the use of iron hoes to mix the mud (a compound of wet clay, sand, and straw) and wooden molds to shape the mud bricks. The adobe mix, packed into the forms, was left to drain until it was firm, and then sun-dried. The resulting bricks, about 50 by 25 by 10 cm, were laid in courses and then rendered with more mud. Spanish New Mexican walls had to be thick at the base to sustain their own weight in so friable a material, and this gave them an immense visual solidity, enhanced by their tiny windows in deep, dark openings. (On this distant frontier, there was no glass.) New Mexican roofs were always flat, since adobe was too weak to make a vault or a dome with. They consisted of roof beams, laid athwart the space, with smaller poles of aspen or juniper fixed diagonally across these in a herringbone pattern. Then a layer of earth, grass, and twigs was packed on top to keep the rain out. It did not do

7. Georgia O'Keeffe, *Ranchos Church*, 1930. Oil on canvas, 24 × 36″ (60.8 × 91 cm). The Metropolitan Museum of Art, New York; The Alfred Stieglitz Collection, 1961.

so very well, and more earth had to be piled on from time to time until, eventually, its weight caused the aging wooden structure to cave in. Nothing illustrates the impoverished, sluggish character of New Mexico mission life better than the fact that the Spaniards there never produced a kiln-fired tile, though terracotta was commonly used in the mission churches of Texas and California. Time and labor had no value; one simply had the Indians make a new roof, when needed.

Yet the constant repair, the replastering of eroded mud and the buttressing of sagging walls, has lent a singular majesty of organic form to the New Mexican mission churches that rose after the suppression of the Pueblo Revolt. The finest examples have turned into sculptural "sights," the most famous of which is undoubtedly the apse end of the Mission Church of St. Francis of Assisi in Ranchos de Taos (c. 1813). Painted by Georgia O'Keeffe (Figure 7) and photographed by Paul Strand (Figure 8), Ansel Adams, and innumerable visitors before and since, its heavy, roughly wedge-shaped buttress and the smaller corner buttresses like beehive ovens give it an earth-gripping density. They are solid lumps of mud brick which neutralize the outward thrust of the walls like massive poultices. At the other end, the main door to the nave is recessed between two downsloping but-

8. Paul Strand, *Church, Rancho de Taos, New Mexico, 1931.*

tresses from which the twin bell towers grow, giving the church the air of a mud sphinx with its paws rooted to the ground.

The nave of St. Francis of Assisi is 108 feet long. Its walls are 6 feet thick at the base. By contrast, the largest mission church in New Mexico is fully 150 feet in length and 33 feet wide, with walls 10 feet thick. This is the church of San Esteban, on top of Acoma (Figure 9). A prismatic block with a tapered apse, two stubby bell towers, and no transept, it was completed by 1725. All the materials for its walls, the stone fill no less than the clay and even the water for mixing the adobe, estimated as totaling some twenty thousand tons, had to be brought up the cliffs of Acoma by the Pueblo women—a task which Acoma men considered beneath their dignity. The *vigas* for the flat roof, pine trunks 40 feet long and adzed down to 14 inches square, had to be cut from the forests of the San Mateo Mountains twenty miles away, carried to Acoma, and hoisted up the cliff on the backs of the devout; they were never allowed to touch the ground, in case they lost their magical efficacy. What this pharaonic enterprise cost in time and lives is unrecorded.

Yet the effort spent on the church was as nothing compared to the toil of creating its graveyard. Burial could not be denied the Christian dead. But Acoma had no burial place: it was bare rock. The Indian congregation of San Esteban therefore set out to create a *campo santo*, or cemetery. First they built a stone-and-adobe "box" in front of the church, a precinct whose tallest wall, on the cliff side, rises to a height of 45 feet. Then they proceeded to fill it with an incalculable tonnage of soil, every pound of which had, as before, to be dragged up to the

9. Mission San Esteban. Acoma Pueblo, New Mexico.

site by women. This took forty years, four times as long as the construction of the church itself. If faith is proven by works, the Acoma must have been believers indeed.

Hardly less important than the churches, to Franciscan evangelism, was the art they contained: the *bultos* (devotional paintings), the *santos* (effigies of saints carved in the round), the crucifixes, and, in some churches, the painted and elaborately framed altarpieces. Colonial New Mexico was too poor and provincial to support professional painters, as this trade had begun to be understood in Mexico City—though by the late eighteenth and early nineteenth centuries some journeymen artists traveled around working for different missions; a painter named Molleno, for instance, did altarpieces in both Ranchos de Taos and the remote sanctuary church of Chimayo.

Most icons had to be made by the friars and the Indians. Since the Pueblos supported a vigorous tradition of ritual painting, done on the walls of kivas, on pots or (in the case of the Hopis' way of painting, with poured colored sands which, in the twentieth century, would so influence Jackson Pollock) on the ground, it was not hard for the friars to find artists. For sources, they turned to woodblock prints and engravings, derived from Flemish, Spanish, and Mexican baroque religious painting, which were easily brought in. Some (perhaps most) of them were pious kitsch, but not all. Thus designs by Peter Paul Rubens in praise of the Franciscan order were copied, through the medium of prints, into *bultos* in remote Santa Fe.

The results were unsophisticated, but so were the faithful. The Franciscans encouraged images that were simple, direct, and gory. The streaming wounds of Christ promoted more empathy than his halo. Among the most complete and impressive religious paintings were the multipanel *retablos,* or altarpieces, created for the sanctuary at Chimayo, the Mission Church of Laguna Pueblo, and San José de Gracia in Las Trampas. The Laguna Pueblo church was finished in 1706, and the altarpiece—now considerably restored—was added by an unknown artist in the early 1800s (Figure 10). It is a splendidly florid affair, with carved spiral columns supporting a frieze of exuberant scrolls and shells; every inch of its framework is laden with painted ribbons, flowers, zigzags, and swags. In the center panel Saint Joseph carries the infant Jesus. On the left is Saint John Nepomuk, a Franciscan favorite, whose cult had gone from Prague to Mexico and thence to New Mexico; he was associated with the absolute secrecy of the seal of confession, and hence the bond of trust between Indian and priest. On the right is Saint Barbara, patron saint of gunners and of those under threat from violent death—a useful saint for an Indian community on the Southwestern frontier. On top are the Father, Son, and Holy Ghost, each with a triangular halo indicating his membership in the Holy Trinity; and above them, a design on a projecting ceiling panel represents the firmament, with a rainbow arch, sun, moon, and

stars. The sun and moon are painted in a purely Indian manner, serving to reconcile Pueblo sky religion with Christian heaven myths.

Perhaps the most affecting church decor in New Mexico is in the remote village of Las Trampas, eight thousand feet up in a fold of the Sangre de Cristo Mountains. The reredos of its church, San José de Gracia (built c. 1760–76), lacks the somewhat congested pomp of Laguna, and the images of saints and angels, framed in daisy-like painted flowers and washed by light from the clerestory window above the apse, have a springtime freshness (Figure 11). The artist, aiming at baroque splendor in the scrolls on either side of the lunette at the top in which Jesus is painted, produced something altogether more charming—a pair of exuberantly modeled biomorphic shapes that jump out at your eye.

No doubt most Franciscan friars would have liked to use gold leaf, but because New Mexico had no gold they had to be content with tempera paint, naïvely imitating marble paneling, brocade swags, and other fine material.

The only New Mexican church whose altar uses real gold is the sanctuary chapel of Chimayo, but that is a special case—it being a (relatively) rich rural church. Its original Indian name, Tsimmayo, suggested a healing spring, and by one of those overlays of Indian and Hispanic culture which were frequent in New Mexico, the place came to be associated with a miracle-working image of Christ. An effigy of the Savior, legend had it, had been found buried there, and the earth in which it lay had curative powers. By 1816 the Santuario de Chimayo was built to accommodate the streams of pilgrims who were beginning to arrive, often with great difficulty and hardship, from all over New Mexico. The core of the cult was geophagy—the ritual eating of small lumps of the *tierra bendita*, sacred earth, from a pit next to the sanctuary. Chimayo is the Lourdes of New Mexico, and to go there at Easter, the time of the annual pilgrimage, is to witness a spectacle of mass faith without any parallel elsewhere in American Catholicism. The walls of the low, dim chapel from which the earth is scooped are encrusted with a

10. Altar, Mission San José. Laguna Pueblo, New Mexico.
11. Altar, San José de Gracia. Las Trampas, New Mexico.

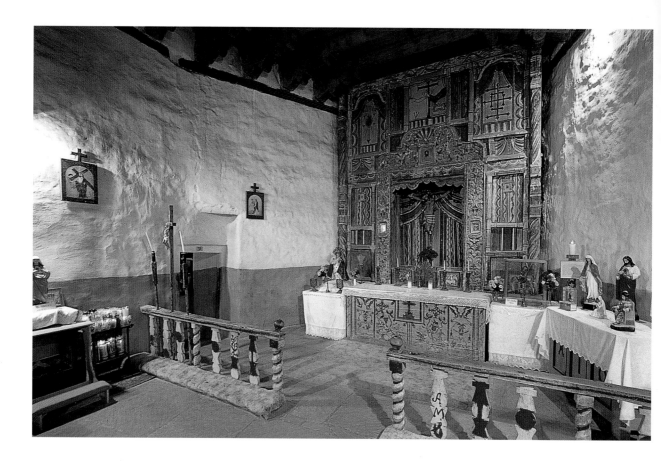

bizarre collage of ex-votos, crutches, artificial legs, and other prostheses. The supply of miraculous clay never runs out, despite the tons of it that must by now have vanished down the gullets of pilgrims. Father Roca, an ancient Catalan priest now in charge of the sanctuary, hints that it is sometimes replenished by a local backhoe.

The focus of Chimayo's altarpiece is an impressive, rough-hewn figure of the crucified Christ (Figure 12), with paintings symbolizing the Franciscan role in the church militant above—in particular, a cross with two human arms, the Savior's and that of Saint Francis in its brown sleeve, conjoined in front of it. Because the *santuario* had money to spare from the gifts of its visitors even in the early nineteenth century, the framing of the niche around the cross is lavishly carved with motifs from some baroque print or pattern book, and then gilded.

The Chimayo crucifixion radiates pain and pathos. But other New Mexican Catholic art from the later nineteenth century carries this to an extreme. These are the devotional images of the so-called Penitente cult, an extremist lay society descended from the *cofradías*, or penitential fraternities, of medieval Spain, whose processions remain such a striking aspect of Holy Week in Seville. The New Mexican Penitentes, or "Third Order of the Franciscans," date back to the first half of the nineteenth century; the group was formed after the Mexican gov-

12. Altar and retable, Santuario de Chimayo. Chimayo, New Mexico.

ernment expelled the Franciscans, in order to loosen their influence on civil life. (The "First Order" of Franciscans was founded by Saint Francis in Assisi; the "Second Order" in the New World.) After the loss of the priests, the Penitentes hoped to keep devotion alive, and the symbolic focus of their cult was a communal reenactment of the events of Holy Week: the trial and flogging of Christ, his heroic journey to Golgotha, his crucifixion, and *las Tinieblas,* the earthquake of Good Friday night that signaled cosmic disturbance at the death of the son of God.

In procession, the Penitentes fervidly reenacted this story, dragging heavy crosses on their shoulders, whipping themselves and one another with iron-tipped cords until blood ran freely, and even simulating Christ's crucifixion. The center of Penitente devotion was the *morada,* or chapter house, which contained their paraphernalia and cult images. (Some early *moradas* were partly sunken in the earth, which suggests a distant affinity with the Pueblo kiva.) The main Penitente image was the life-size figure of the suffering Christ, the Man of Sorrows, its limbs jointed with leather hinges, its wounded back and knees copiously slathered with blood-red paint. Some Penitente Christs had a hollowed-out rib cage in which a heart could be seen hanging, and a cloth wick dripping red oil protruded from the spear wound in the chest. Such figures reflected an obsessive devotion to the Blood of Christ, which found voice in lugubrious *alabados,* or processional hymns:

> *Adora la cruz*
> *Que lleva arrastrando*
> *Pinta con su sangre*
> *Que va derrarmando.*
>
> *Adora el rofrage*
> *Que lleva vestido,*
> *Con su misma sangre*
> *Yo lo vi teñido.*
>
> *¡O preciosa sangre!*
> *Alivia mis males*
> *Y dadme a beber*
> *De tu precioso caliz.*
>
> Adore the cross
> That he drags along
> Painted with his blood
> That he goes shedding.

Adore the garments
That he wears
With his very blood
I saw them dyed.

O precious blood!
Relieve my suffering
And let me drink it
From your precious chalice.

The most memorable form of Penitente sculpture, however, was undoubtedly the figure of the angel of death, known as "La Muerte" or "Doña Sebastiana." She is a skull-headed crone wielding a bow and arrow and riding in a cart with wooden wheels. The cart was laden with stones to make it harder to pull. Doña Sebastiana seems to have reached New Mexico from Europe. She first appears in recognizable form in Renaissance illustrations of Petrarch's *Trionfi,* from which the figure of Death in a processional cart soon found its way into popular culture and became one of the figures in the fortune-teller's tarot cards. The tarot brought it to New Mexico, where Death's scythe was replaced by a bow and arrow. Crudely made and hideous to contemplate, the death angel is Eros reversed, and her nickname associates her with the cult of Saint Sebastian, the young martyr who was tied to a tree and shot with arrows. Be that as it may, these death carts are among the most powerful and unnerving sculptures ever produced in European America.

Despite the prior claims of the Spaniards in Florida and the Southwest, despite the justifiable animus of American minorities against a history that raised English colonists above all others, the truly mythic event in the European colonization of America was the arrival of the Puritans in the early seventeenth century.

Mythic, because the Puritans themselves made it so. They started writing themselves into a heroic world history almost as soon as they arrived. They saw themselves as the latest stage in a story which had begun with the expulsion from Eden, continued with the Israelites' exodus from Egyptian bondage into the wilderness, and was fulfilled by their entry into the promised land of Canaan. Thus Puritan writers had no hesitation in comparing John Winthrop, leader and elder of the Massachusetts colony, to old Moses. And to the trunk of Old Testament comparison they grafted classical scions, narratives that offered the same mythic scheme of loss or oppression followed by wandering and resolved by a new foundation. Chief among these was Virgil's epic of Aeneas' voyage from burning Troy to found Rome on the other side of the Mediterranean, and thus

begin a new phase of secular history. On the back of every American dollar bill are the words *Novus ordo seclorum:* a new order of the ages. If Thomas Jefferson, no Puritan, had had his way, the great seal of the United States would have portrayed the children of Israel led by a pillar of light.

There are several ways in which the Puritan legacy has formed all modern Americans, no matter what the color of their skin or their ancestors' place of origin. They implanted the American work ethic, and the tenacious primacy of religion in American life. They also invented American newness—the idea of newness as the prime creator of culture. *Que no haya novedades,* seventeenth-century Spaniards would hopefully say: let nothing new arise. But the Puritans lived in expectation of something new arising, something very big: the restoration of Christ's reign on earth, a millennium brought about, in part, by the action of his living saints, as they imagined themselves to be. And this newness would bring about a new phase of world history. New, but with ancient precedents that lay in the Old Testament.

In this they were different from all other Europeans who had tried to colonize America. The Spaniards took the Southwest in the name of Spain: they made an outpost of an existing reality. Nobody expected Santa Fe to change Mexico City, still less Madrid.

The same was true of the French in Canada and the Portuguese in Brazil. It also applied to the Pilgrim Fathers, arriving at Plymouth in 1620, who merely wanted to be where they could worship in peace, a place which had no strong culture into which their children would assimilate, thus diluting the faith. They were worried that this had already begun to happen to them in Holland, and they wanted a tabula rasa. Their motive—to be left alone—was no different from that of later Utopian religious groups who came to America: Quakers, Mennonites, Lutherans, Amish, Reformed Church, Shakers, and the rest.

But the Puritans who started their "Great Migration" in 1630 with the backing of the Massachusetts Bay Company had a different end in mind. They were going to create what their leader John Winthrop, in a sermon given on their flagship the *Arbella* in mid-Atlantic, called "a city on a hill," where "the eyes of all people are upon us."

What people? Not the American Indians, certainly. The people of the Old World. The Puritan colony in Massachusetts was to be a beacon whose light would shine back across the Atlantic and show its societies, corrupted by formalism and popery, how to reform themselves. It was thus the exact opposite of other colonial efforts in the New World, for it opposed the existing social models of the Old. Its newness was not mere novelty—they railed against that—but the deep newness of spiritual renovation.

Thanks to the Puritans, no other civilization in history has been as obsessed with the idea of radical newness as America's. Newness became to Americans

what Antiquity was to Europeans—a sign of integrity, the mark of a special relationship to history. It became mythic. It could do so only because the Puritans launched it with such force and conviction, so that it underwrote the American Revolution and continued to resonate in America down to the present. It is the root of American "exceptionalism"—the belief (or simply, assumption) that America is a special case, unlike any other society anywhere, now or in the past.

The newness of America mattered because it meant that America was the place God had chosen to fulfill His designs. The Puritans came there to bring earth and heaven together: to make progress toward the Kingdom of God. Under the scheme of sacred history, "New England" was actually the new Israel.

The confidence to make this apocalyptic claim came out of Lutheran theology. The Catholic Church had never made much of the New Testament's Book of Revelation, which promised a climactic battle between good (Christ and his elect) and evil (the Antichrist or Satan), whose outcome would be the defeat of Satan and the establishment of a "thousand-year reign" of the just on earth.

Apocalypse was at the core of Luther's historical thought. He imagined that a new world history had begun with Protestant secession from the Church of Rome, whose pope he identified with the Antichrist. Frightful tribulations would ensue, as predicted in the Book of Revelation, but in the end the elect of God, the living Protestant saints, would utterly vanquish Rome and "come marching in" to the millennium—the thousand-year reign. In seventeenth-century England this belief was basic to the radical form of Protestantism embraced by the Puritans.

They felt England was too corrupt to be reformed from the inside. Jerusalem, the *new* Jerusalem of the apocalyptic imagination, would instead be built on virgin territory, in America. It would be based on unity. The Puritans discovered their unity not in their language (for the evil, too, spoke English) or in their ancestry (for the evil were also born English) but in their belief in a binding covenant and a mission into the wilderness.

The covenant bound them together and to God. "We must delight in each other," urged Winthrop in his sermon on the *Arbella,*

> make others' conditions our own, rejoice together, mourn together, labor and suffer together: always having before our eyes our commission and community in the work, our community as members of the same body . . . [so] that men shall say of succeeding plantations, "The Lord make it like that of New England."

New England, and all its place names prefaced by "New"—New Canaan, New Bedford, New Salem, New London—represented not mimicry but transfiguration. The Indian names were erased: Agawam became Ipswich, Acushena became Dartmouth. To rename was to take, and Moses' words in Deuteronomy provided

abundant texts to justify wiping out the Indian names, along with the Indians themselves:

> Ye shall utterly destroy all the places, wherein the nations which ye shall possess served their gods, upon the high mountains, and upon the hills, and under every green tree: And ye shall overthrow their altars . . . and destroy the names of them out of that place. (Deut. 12:2–3)

The idea that these "nations," such as the Algonkians, had any prior right to the land would have seemed as absurd to the Puritans as it would to any other seventeenth-century Englishmen, and was hardly even raised by them. Seventeenth-century New England was *terra nullius,* no-man's-land; it was *vacuum domicilium,* empty of settlement; in one expressive phrase, it was "the Lord's Waste," not full of imaginary gold like Spanish New Mexico but ready to be made fruitful by English farming. (Moses in Deuteronomy never promised the Israelites gold mines, only milk and honey.) The men of the Great Migration did not hesitate to praise a smallpox epidemic that more than decimated the Massachusetts Indian tribes before they arrived as part of God's design, a "miraculous plague . . . whereby a great part of [New England] is left void without inhabitants." Converting the Pueblo Indians was central to the Spanish mission in New Mexico. Not to the Puritans, whose missionary work among the Algonkian Indians was sporadic and halfhearted. They were ruthless in their seizure of Indian lands, dishonest in their pious subterfuges of "purchase," and genocidal in their aggression against the "savages." These men of God were killers on a biblical scale: before 1615 about seventy-two thousand Native Americans lived between southern Maine and the Hudson River, and by 1690 most of them had been wiped out and the rest beaten down. It was "culture"—enclosure, tilling, building—that certified ownership; in the words of Edward Johnson, writing c. 1650 in his *Wonder-Working Providence of Sions Saviour in New-England:*

> [T]his remote, rocky, barren, bushy, wild-woody wilderness, a receptacle for lions, wolves, bears, foxes, rockoons, bags, beavers, otters, and all kind of wild creatures . . . now through the mercy of Christ become a second England for fertileness in so short a space, that it is indeed the wonder of the world. . . .

The wilderness the Puritans faced in America was the biblical wilderness, renewed. They marveled at their own ability to overcome Nature. Merely to survive argued a miracle of grace. Thus the collision of Nature and Culture acquired sacred overtones almost as soon as it began in Massachusetts. And though the Puritans had no landscape art, these overtones permeated their writings and

would deeply, subliminally affect painters of landscape who emerged in the nineteenth century: for whom landscape was a theophany, a showing of God through His designs. Just as the wandering Jews were Canaanites before they got to Canaan—since the Lord had reserved the place for them before they knew it—so the Puritans, in their own accounts, were Americans before the fact. America was darkly present for them in the Bible before Massachusetts, in the Psalms, in Jeremiah, in the Book of Revelation. Their task was to insert themselves into it and then write themselves into a prophetic history that made America explicit.

Because they owned America before they got there, they were the first to call themselves Americans and it would never have occurred to them to apply the word to the indigenous Indians. They had reconstituted themselves as a new people—an astonishing act of arrogance, or of faith: in fact, of both. No other colonists in the New World made any such claim. It is the root of a belief that has wound through American history ever since: that by coming to America, whoever you are, you re-create yourself and can become whatever you declare yourself to be.

In short order the Puritans' own identity would be wound into the landscape on which they had collaborated, as it were, with God. Within a generation the New England landscape could be perceived, not as wilderness, but as a sacramental space. So it was by Samuel Sewall, in a pamphlet that appeared in 1697 under the title *Some few lines towards a description of the New Heaven as it makes to those who stand upon the New Earth.*

> As long as *Plum Island* shall faithfully keep the commanded Post; Notwithstanding all the hectoring Words, and hard Blows of the proud and boisterous Ocean; As long as any Salmon, or Sturgeon, shall swim in the streams of *Merrimack;* or any Perch, or Pickeril, in *Crane-Pond;* As long as the Sea-Fowl shall know the Time of their coming, and not neglect seasonably to visit the Places of their Acquaintance; As long as any Cattel shall be fed with the Grass growing in the Medows, which do humbly bow down themselves before *Turkie-Hill* . . . As long as any free and harmless Doves shall find a White Oak, or other Tree within the Township, to perch, or feed, or build a careless Nest upon; and shall voluntarily present themselves to perform the Office of Gleaners after Barley-Harvest; As long as Nature shall not grow Old and dote, but shall constantly remember to give the rows of Indian Corn their education, by Pairs; So long shall Christians be born there; and being first made meet, shall from thence be Translated, to be made partakers of the Inheritance of the Saints in Light.

More than 150 years would pass before American painting began to show a vision of landscape comparable in scope, beauty, and depth to this. One could say that Sewall's rhapsody on the Newbury marshlands, embedded like some

marvelous crystal in a calcified mass of abstruse theological reflections, marks a true turning point in American culture. What appeared to William Bradford and his ocean-battered pilgrims in 1610 as a "hideous and desolate wilderness, full of wild beasts and wild men," has become the natural frame of the New Jerusalem. Sewall was forty-five when he published it, and he was looking back on his childhood at Newbury. It is the first expression of nostalgia in America, the first epiphany of one of the continuous American themes: longing for a better past which, if preserved, can sanctify the present, but if lost will degrade the future. But Sewall is in no doubt that it will go on. This, as Perry Miller pointed out, marks "a point at which the English Puritan had, hardly with conscious knowledge, become an American, rooted in the American soil."

They were people of the Word, not the Image. Truth lived in the Word, but the Image could deceive. They feared what they called "Criollian degeneration"—entropy of language in the American wilderness, the decay of literacy. And the home of language, other than books, was the meetinghouse where sermons bound the village together and to God.

The only Puritan meetinghouse that now survives stands in the village of Hingham in Massachusetts. It is the oldest wooden church in the United States, and the longest in continuous use. Its frame was raised in three days in July 1681, and it opened for worship six months later. It is called the Old Ship Meeting House. From the outside, the reason is not obvious. A large, foursquare clapboard box with a hipped shingle roof, surmounted by an open bell lantern and a thin spike of a steeple (Figure 13). But once inside, you see at once why it got its name. The roof frame is a Gothic trio of knee-braced king-post trusses, each spanning fifty-five feet, hewn by hand from massive oak trunks. With the rafters and planking above them, they do indeed resemble the inside of the hull of a ship, clapped upside down over the walls: an Ark, big enough to hold the entire population of seventeenth-century Hingham, some seven hundred people, singly or two by two (Figure 14).

Its plan, as befits a Congregationalist Puritan assembly hall, rejects the form of Catholic churches and their Anglican derivatives. It is not a cross formed by nave and transepts. It has no apse. It has no decoration of any kind, and the light coming through its diamond-paned windows is clear and explicit: *lux veritatis, lux Dei.* Originally, there were no pews. The seventeenth-century congregation sat on bare benches without backs, connoting equality before the Lord.

Originally, there was no altar, and even the elegant pulpit is a later addition. The preacher addressed his people from a square speaking box whose sole decoration, the only body image in the church, could have been an enormous eye: the all-seeing eye of God. (Such pulpit eyes were used in other churches; it is probable, but not certain, that Hingham had one.) This terrible and hypnotic emblem would fix the congregation during morning and afternoon sermons that could

add up to four or five hours. It must have been purgatory in winter, since the un-heated building was not much warmer than the open air: some infants were bap-tized with lumps of ice.

Though the Old Ship is unique, quite a few seventeenth-century Puritan houses still exist in something like their original form in New England, though none of the very earliest ones (which were hardly more than bark-and-stick huts) have survived. The settlers were English; they called themselves Englishmen; and in all the details of ordinary life, from the arrangement of fields to the walling of gardens to the food they ate and the tools they used, they kept to English ways. When they began to make more permanent houses, the New Englanders built what they were used to seeing and building back in Old England—the timber-framed, two-story cottages with a steep-pitched roof carried down to a single-story lean-to at the back to make a kitchen, that were common in seventeenth-century Kent and East Anglia and became the classic New England "saltbox." Their cladding of horizontal clapboards is English weatherboarding, made mandatory by the harsher climate of Massachusetts. A builder could no longer leave the clay coating over the "wattles" between the studs of an exterior wall exposed to the weather, as he might have in Kent; instead he sheathed it in wood, treating it as internal insulation. Basic construction methods crossed the sea in the hands and minds of English craftsmen, and did not change in America. Often a house would begin small, as a gabled single-room box with the fireplace and chimney at one end, and then would have a second box added to it, produc-ing a larger house with the fireplace in the middle and the entrance door off-center.

13. The Old Ship Meeting House. Hingham, Massachusetts.

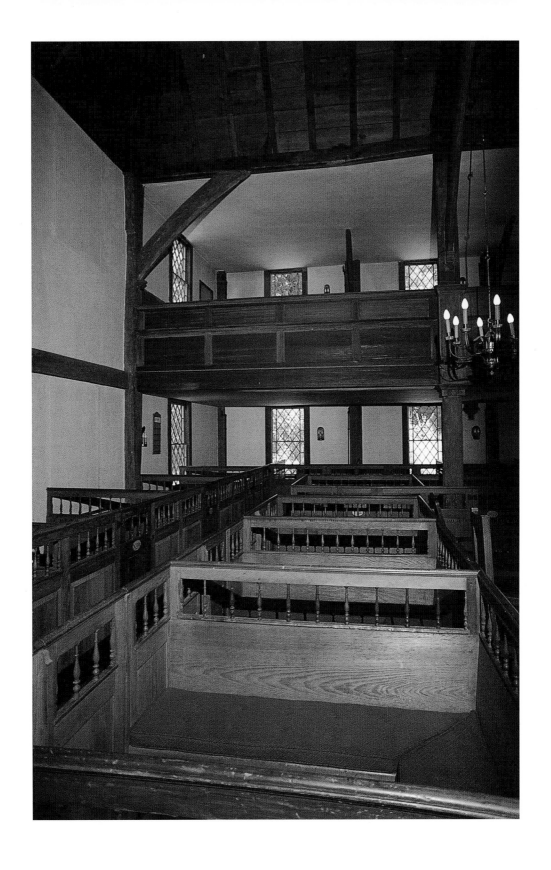

14. Interior of the Old Ship Meeting House. Hingham, Massachusetts.

The spareness and simplicity of these buildings had nothing to do with the ideology of Puritanism. In the villages of Kent and East Anglia, thousands of people lived in such places—carpenters, small traders, yeomen of all sorts—whether they were zealous Puritans or not, and most were not. It was simply an English vernacular, plain and reasonably comfortable, repeated by Englishmen in America. A good example, at the higher end of the social scale, is the Parson Capen House, 1683, in Topsfield, Massachusetts (Figure 15).

Joseph Capen was a moderately well-off divine of reasonable views: he argued for acquittal in the infamous witchcraft trials in nearby Salem in 1692, though without success—nineteen women were hanged. His house is large by the standards of the day, and some of his public duties were carried out in it: the ground floor consists of two rooms warmed by a common chimney, a parlor on the left where he would receive his parishioners, and on the right a kitchen/dining room. The bedrooms above were reached by a narrow, steep stair. All the ceilings are low, the beams heavy, the windows small, the exterior doors clinched with nails to protect against Indian attack: there is something troglodytic about the dark coziness of Capen's house, built to keep the family in and the wilderness out.

The overhang of its second story—a small cantilever known as a "jet"—is a good example of how building forms could sometimes carry across the Atlantic without regard for their original purpose. One sees it in other Puritan buildings, such as the Stanley-Whitman House (c. 1660) in Farmington, Connecticut. In medieval England houses were taxed on their "footprint," the area of the ground floor; a larger second story was a way of getting more space and beating the tax collector, and although there were no property taxes of this kind in early New

15. The Parson Capen House, 1683. Topsfield, Massachusetts.

England (and no shortage of sites anyway), the reflex persisted. The Capen house is plain to our eyes, but would not have seemed altogether so to the parson's parishioners. The detail and solidity of its paneled Tudor chimney betokens prosperity, especially since the bricks would have been shipped from England; and there are brackets and decorative pendants below the overhang, which were probably once picked out in red paint.

Modest though such details are, they introduce a vital fact about Puritan culture: it was not at all "puritan" in today's sense of the word, narrowly art-hating and repressively pleasure-denying. (This image of the fanatic American Puritan is a blend of hostile stereotypes derived from eighteenth-century rationalism and nineteenth-century Romanticism; one should not mistake *The Scarlet Letter* for history.) The New Englanders were, without doubt, suspicious of luxury. But they also believed that being well-off through honest work was a sign of God's approval, an indication (if not a cast-iron proof) of virtue—another of their traits which has come down to a later America. So what could be wrong with signs of wealth and status, as long as they were not exorbitant and the pleasure they gave their owners was not profane or licentious?

By the 1680s New England was no longer the poor hardscrabble colony of the 1630s. Its agriculture had boomed; it had a substantial and ever-growing trade port in Boston. Industrial growth had begun, in profitable projects like the Saugus Ironworks. It was an economy of plenty, not (as in England) of scarcity—illimitable forests, seas thick with fish, fertile soil and unenclosed pasture, seams of metal ore. The New Englanders were trying out new things that hardly existed where they, and their parents, had come from. One of these, of vital importance to their way of life, was the water-powered sawmill. Sawmills were rare in England, because the country lacked rivers near large stands of publicly owned forest. In any case, the labor surplus in England kept hand-sawing cheap. But in Massachusetts labor was scarce, whereas trees and nearby streams were hugely abundant. The waterwheel sawmill—which any reasonably skilled carpenter could make—caught on, and fostered the industrial mind-set of New Englanders. It put sawn pine boards within reach of anyone who wanted to make a chest or a table.

The archetypal New England storage unit was the so-called six-board chest, a dumb and useful box with a hinged lid (Figure 16). Any farmer could nail together plain things like that, but they are plainer today than

16. (Probably) Henry Treat, Puritan chest, Wethersfield or East Hartford, Connecticut, n.d. Pine and poplar, h. 21¾ × w. 48¼ × d. 18¾″ (55.2 × 122.5 × 47.6 cm). Wadsworth Atheneum, Hartford, Connecticut; William B. and Mary Arabella Goodwin Collection, bequest of William B. Goodwin.

17. Attributed to Ephraim Tinkham II, *Turned Armchair*, n.d. Maple, rush, and ash. Wadsworth Atheneum, Hartford, Connecticut; Wallace Nutting Collection, gift of J. Pierpont Morgan.

18. Anonymous, *Turned Great Chair*, c. 1550–1600, England or Wales. European ash with later American oak handgrips, 46½ × 32¾ × 21″ (118.1 × 83.9 × 53.3 cm). Harvard University, Cambridge, Massachusetts; loan from The President and Fellows of Harvard College.

they were then: the evidence of residual paint in rural seventeenth-century furniture shows that ordinary folk liked bright colors and (necessarily crude) decorative patterns, painted, stamped, scribed, or carved, sparks of culture amid the wilderness. "Puritan severity" is often nothing more than paint loss.

People of the higher sort loved authoritative display, much as they did in England. Witness the "great chairs" produced in the early colony: one, it is believed, for William Bradford, c. 1630–55—an imposing Jacobean cage of turned black ash, rigidly architectural, a formal throne (Figure 17). Its style is only slightly plainer than its imported counterpart, a three-square Welsh "great chair," c. 1550–1600, with a riot of turned detail—very uncomfortable, one surmises— that has served as the president's chair of Harvard for the last 250 years (Figure 18), and must have been chosen especially for its ancient and weird appearance.

By the 1660s the preferred style for grand Puritan furniture was more elaborate still, and the distance between town and country craftsmen was large and widening. William Searle's "great chair" made in Ipswich, a deeply carved throne with flowers, scrolls, architectural details, and grotesque human figures, carries the Dutch Mannerist style that had already been absorbed by England into America (Figure 19). Meanwhile, cabinets were turning into veritable architecture, loaded with Anglo-Dutch Mannerist moldings, raised panels, cartouches, and applied decoration. Two Boston shops, one run by a pair of immigrant joiners from London named Ralph Mason and Henry Messinger, the other by a highly skilled turner named Thomas Edsall, created an imposing two-case chest of drawers with doors in this high style around 1670. It is a severe and yet exuberant piece (Figure 20), with its turned spindles and half-egg bosses, and its inlay of exotic hardwoods; and one should imagine its top displaying a row of the heavy, glittering silverware that was in fashion among wealthy Puritans.

Their painting was more limited than their furniture. The Puritans did

19. Attributed to William Searle, *Joined Great Chair*, 1663–67. White and red oak. Bowdoin College Museum of Art, Brunswick, Maine; gift of Mr. Ephraim Wilder Farley, 1836.
20. Anonymous, *Two-case Chest of Drawers*, 1670–1710, New England. Wood, 48⅞ × 45⅜ × 23⅝" (124.1 × 115.2 × 60 cm). Yale University Art Gallery; The Mabel Grady Garvan Collection.

not, of course, approve of religious art: it fell under the ban imposed on graven images in Deuteronomy, and in their nostrils it stank of papism. Nor did they want pictures of landscape for its own sake, although peeps of it are occasionally seen in the background of commissioned portraits. Seventeenth-century New England was not an environment to which an English artist would immigrate in the hope of making a living from his art. As far as they were concerned, painters were useful for two things. They could do crests and shields for the well-off; and they could paint portraits. The New England portrait was a functional thing. It had no "expressive" purpose. Its job was to pass on the features of the notable person to his or her descendants. Not all of them were painted in America: John Winthrop's austere features were recorded by an English artist, who had at least some nodding acquaintance with the work of Van Dyck, before he sailed on the *Arbella* (Figure 21). The likeness of one noted Puritan divine, Dr. William Ames, was done by a Dutch artist, and his followers brought it to America as an icon in 1637—though Ames himself did not come.

Because the sitters are long dead and gone, there is no way of judging how realistic the likenesses were. This may have mattered somewhat less to Puritans than to later Americans, because they seem to have thought of portraiture less as a speaking likeness than as what they called a "shade," an effigy of the spirit—a moral emblem. In Jonathan Fairbanks's words, "The reality of representation did not always seem to matter as much as the fact that a record was made, for Puritans were intensely aware of the evanescent nature of the physical world." The gesture of the sitter, even the props and costume, might matter somewhat more.

The sources for the Puritan portrait lie further back, in Elizabethan miniatures and Tudor portraiture. The only group of family likenesses by the same hand to have survived from early New England is in a Tudor idiom, by the unidentified painter of the Freake-Gibbs portraits. His image of Robert Gibbs (1665–1702), first son of a rich Boston merchant, painted in 1670 when its subject was five, is

21. Anonymous, *Portrait of John Winthrop,* 1629. Oil on canvas, 35 × 25¹³⁄₁₆″ (88.9 × 73.2 cm). American Antiquarian Society, Worcester, Massachusetts.

somewhat naïve and very formal (Figure 22). Its checkerboard floor rises unnaturally high in perspective, and the artist has strained for effects he could not quite carry off because he had seen them in portraits by more skilled men—the hand insouciantly turned back on the hip, for instance, is a sign of the sitter's poise and authority in Van Dyck, but here the painter's struggles with foreshortening turn it into an awkward flipper. Master Robert, like all seventeenth-century children in colonial New England, wears a girl's dress for his portrait; his gender is made

22. Anonymous, *Robert Gibbs,* 1670. Oil on canvas, 40 × 33" (101.6 × 83.8 cm). Museum of Fine Arts, Boston; M. and M. Karolik Collection of American Paintings, 1815–65.

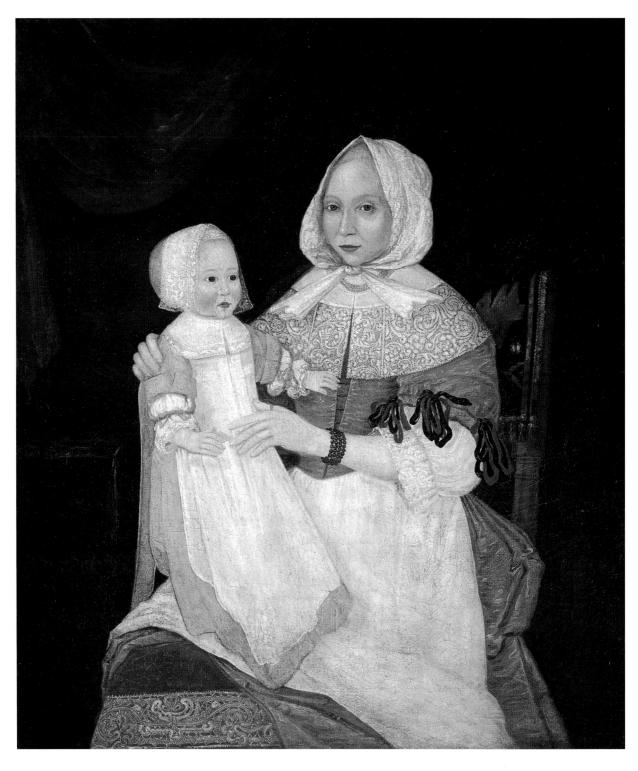

23. Anonymous, *Mrs. Elizabeth Freake and Baby Mary,*
c. 1671–74. Oil on canvas, 42½ × 36¾″ (108 × 93.4 cm).
Worcester Art Museum, Worcester, Massachusetts;
gift of Mr. and Mrs. Albert W. Rice.

clear by the pair of gloves he holds, a masculine attribute.

The best-known and most likable of all Puritan portraits is by the same artist: *Mrs. Elizabeth Freake and Baby Mary,* 1671–74 (Figure 23). Elizabeth Clarke Freake was the wife of John Freake, a well-off young Boston merchant and lawyer, and she posed for the artist on a chair upholstered in red-and-green "Turkey-work"—a rich knotted pile fabric that had to be imported to the colonies. All her attributes are Sunday best: the elaborate Dutch lace collar, the pearl necklace and jet bead bracelet, the gold embroidery on her red underskirt; her pretty, weak-chinned face looks at the painter

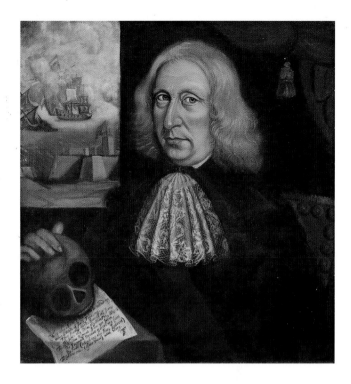

with composure. Sometime after the first version of the portrait was done she bore a daughter, and the artist then painted the child in. Part of the charm of the picture lies in its stiffness, its careful arrangement of profile; but this was part of a general, old-fashioned, middle-class style—the aristocratic style of the day was that of baroque portraiture, too flashy and redolent of royal taste to appeal to New Englanders.

The only Puritan self-portrait that has come to light was painted sometime between 1670 and 1690 by a Boston mariner, Captain Thomas Smith (Figure 24). The image says quite a lot about him: the fine bunch of French lace at his throat suggests that he was well-off, the naval skirmish near a coastal fort in the background must refer to some action in which he took part, and to signify moral plainness he is wearing his own hair in the Puritan way, not a wig. It also says, quite plainly, that he accepts his impending death. He is holding a skull, which rests on a poem he wrote himself and signed T.S.:

> Why Why should I the World be minding
> therein a World of Evils Finding
> > Then Farwell World : Farwell thy Jarres
> > thy Joies thy Toies thy Wiles thy Warrs
> Truth Sounds Retreat: I am not sorye.
> > The Eternall Drawes to him my heart
> > By Faith (which can thy Force Subvert)
> To Crowne me (after Grace) with Glory.

24. Thomas Smith, *Self Portrait,* c. 1680. Oil on canvas, 24³⁄₄ × 23³⁄₄″ (62.9 × 60.4 cm). Worcester Art Museum, Worcester, Massachusetts; museum purchase.

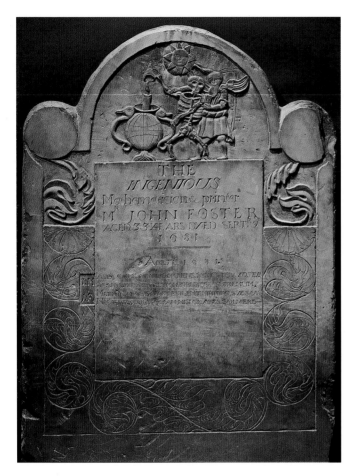

This memento mori is more than an echo of Mannerist convention. It is part of the general Puritan fixation on death. Death had a density, an omnipresence in Puritan culture which it has altogether lost in modern America. They saw no reason to sublimate it, soften its impact, or deny it in any way. Death was the antechamber to eternal life, and the awareness of it was a continuous spur to morality. Preachers dwelled on it, writers constantly returned to it. "In the midst of life we are in death." At burials, small children would be dragged kicking and screaming to the edge of open graves and be made to look down at what awaited them; sometimes, when a whole burial party had got drunk—not uncommon, especially in the country—a child would fall into the grave and have to be fished out.

The only form of sculpture the Puritans accepted was meant to serve death and memory: the tomb-stone. Excessive pomp in death was discouraged—there are no sepulchres of the kind that would be common in later American cemeteries, only vertical head-stones and, sometimes, footstones. They range from a simple slab with the name of the dead on it to stones with crisply carved emblems of a winged death's-head, sometimes framed in a pediment or Mannerist scrolls. The stone thus turns into an architectural emblem—death as the gateway to the next world. Occasionally a craftsman would be asked to do something more handsome. Such a stone was made by the so-called Charlestown Stonecutter, whose name is lost, for "the in-genious mathematician and printer" of Boston, John Foster, who had set up the first printing press in New England and was an amateur astronomer (Figure 25). When he died in 1681 at the early age of thirty-three, his friend Increase Mather wrote the Latin inscription, which translates: "When alive you studied the stars; I pray that in dying, Foster, you may mount above the skies and learn to measure the highest heaven." A candle, representing human life and fame, rests on a globe, the earth. Skeletal Death is about to snuff out its flame, but he is restrained

25. Attributed to the Charlestown Stonecutter, *John Foster Headstone*, 1681. Slate, carved area 28¼ × 23⅛" (72.7 × 59.3 cm); depth 2³/₁₆" (5.6 cm). Boston Parks and Recreation Commission, on loan to Museum of Fine Arts, Boston.

by Father Time, with his scythe and hourglass. The sun, image of Apollo and of Christ, looks on from the firmament.

One virtue the Puritans conspicuously lacked was tolerance in religious matters. They thought it a weakness, not a virtue. They felt they had a perfect right to persecute other religions in the name of the Lord; some, no doubt, regretted that just as there were no icons to smash in virgin America, there were no other Christian sects either. However, this changed with the arrival of the Quakers.

The Puritans' hostility toward the Quakers was boundless. They persecuted them at home in England, as harshly as the Royalists had ever harassed the Puritans. In this they were joined by the established Anglican Church. Some English Quaker communities in the seventeenth century kept "Books of Sufferings" to memorialize what they had been through, from vilification to jail and loss of property. Both Puritans and Anglicans felt threatened by the ideology of Quakerism—its rejection of church hierarchy, tithes, sacraments, and so forth. The Puritan universe was clamped between Heaven and Hell; it was filled with images of patriarchal wrath and eternal retribution. Not so the Quakers'; their God was a God of love, who had died for all humanity, not just for the predestined elect. In coming to America, the Quakers hoped to be free from state and church oppression. They also hoped America would afford a blank slate on which their Utopia could be written into life without interference.

The first Quakers to arrive in the 1650s were itinerant missionaries. They got a harsh reception in Puritan Massachusetts, where four were hanged for heresy on Boston Common. But with the Restoration of Charles II in 1660 and the collapse of the Puritan revolution in England, the American Puritans realized that however much they might loathe the Friends, they could not keep them out of the New World. The Quakers bypassed Massachusetts. They headed mainly for the Delaware Valley and for West Jersey. In 1670 America had only 600 Quakers, a weak presence compared to the Puritan ascendancy in New England. But eighty years later there were about 170,000 of them, the third largest religious group in the colonies.

Their chief territory was Pennsylvania. The state's name, as everyone knows, commemorates its Quaker founder—"the woods of Penn." William Penn (1644–1718) was one of the most singular Englishmen ever to land in America: pacifist, radical Whig, and great spiritual leader. Twice imprisoned in the Tower of London for his writings against the formalism and property interests of the Anglican Church, he led his band of Quakers to the Delaware in 1681, intent on setting up an ideal community of like-minded Christians, a "holy experiment" to reconstitute the primitive Church for the Quakers and to encourage other Protestant settlers to live in harmony alongside them.

The Quakers despised most arts. Music was a distraction, poetry a snare. As for drama, William Penn bade the Friends ask themselves "How many plays did Jesus Christ and his apostles recreate themselves at?" John Woolman, a New Jersey Quaker who made a trip back across the Atlantic in the mid-eighteenth century, was so horrified to see "Sundry sorts of Carved work and Imagery" outside his cabin that he changed his quarters to steerage. So the lack of eighteenth-century Quaker painting is no surprise. Benjamin West was raised as a Quaker and had to leave the faith before he could start a serious career as an artist. There was a Quaker sculptor—or, at least, a sculptor of Quaker origins—named Patience Wright, who had to go to England to find a market for her wax figures; but she was so little noted for her piety that a letter from Abigail Adams, wife of the second President of the United States, refers to her as the "Queen of Sluts." The only artist who lived and died a Quaker was the Philadelphian "primitive" Edward Hicks (1780–1849) who, as a minister, was distressed by the moral conflicts of his métier. "If the Christian world were in the real spirit of Christ," he wrote in a typical diary entry,

> I do not believe there would be such a thing as a fine painter in Christendom. It appears clearly to me to be one of those trifling, insignificant arts, which has never been of any substantial advantage to mankind.

Hicks contented himself with turning out many versions of the same theme, which are prized by folk-art collectors today for their artless charm: the image of the Peaceable Kingdom (Figure 1, page 2). It is based on Isaiah 11:6, a vision of harmony on earth, with the Garden of Eden restored: "The wolf also shall dwell with the lamb, and the leopard shall lie down with the kid; and the calf and the young lion and the fatling together; and a little child shall lead them." Behind the cooperative animals is a landscape of the Delaware River, in which William Penn and his fellow Quakers are seen in their broad-brimmed hats, concluding their peace treaty with the Indians: as in the animal kingdom, so in the human. This background group is based on a design by Benjamin West.

The only areas in which one can speak of a "Quaker esthetic," based on plainness and simplicity, are architecture, furniture, and the prose style of sermons. Like the Puritans, the Quakers reacted sharply against the ornate, euphuistic pulpit oratory of an earlier generation. It was associated with Roman Catholicism, the baroque sensibility of the Counter-Reformation—in short, with the Devil. "Ye that dwell in the light and walk in the light," wrote George Fox (1624–1691), the founder of the English Society of Friends, "use plainness of speech and plain words." Plain talk and writing implied equality before God; it rejected social hierarchy, as in the Quakers' use of "thee" and "thou," rather than "Sir," "Madam," or "Your Lordship."

Quaker meetinghouses were as simple as boxes, every space precisely defined and nothing ornamented. The Quakers' doctrinal aversion to worldly show carried over into their dwellings and furniture. This presented problems, because by the mid-eighteenth century Philadelphia was by no means short of rich Quakers with a fondness for consumption, however screened by the walls of their town houses. But the community could purge itself. Inspectors were appointed to visit the homes of the faithful and edit their contents. Philadelphia saw many enactments of a scene described by an Irish Quaker named Joseph Pike:

> Our fine veneered and garnished cases of drawers, tables, stands, cabinets, scrutoires, &c., we put away, or exchanged for decent plain ones of solid wood without superfluous garnishing or ornamental work; our wainscots or wood-work we had painted of one plain colour . . . our swelling chimney-pieces, curiously twisted banisters, we took down and replaced by useful plain wood-work &c.; our curtains, with valances, drapery and fringes that we thought too fine, we put away or cut off.

However much "great fringes" might darken the Holy Spirit, one could not expect Quakers to give up all signs of social standing. High Quaker and low Quaker were alike in wearing plain gray, but one gray would be homespun and the other velvet. "Of the best sort, but Plain": the sentiment conveyed by this phrase pervaded Philadelphian Quaker attitudes toward material culture. One could virtuously shun the Chinese fripperies of Chippendale; but one could equally reserve an appreciative eye for care and excellence in craftsmanship, for Saint Joseph, after all, had been a carpenter.

Quakers tended to shun the heavy moldings and bulbous details of Anglo-Dutch Mannerism, the William and Mary style. But the middle years of the eighteenth century, roughly from 1725 to the year of revolution, 1776, corresponding to the reigns of the three Georges, brought a newer mode of building to prosperous Philadelphia—a restrained Georgian Palladianism superimposed on pattern-book Wren. One sees this in the Pennsylvania State House, Independence Hall, begun in 1731 to the designs of an attorney, Andrew Hamilton. He must have had the two most used pattern books of the time, James Gibbs's *Book of Architecture* and Colin Campbell's *Vitruvius Britannicus,* within reach, since the façade of Independence Hall follows Wren while its tower is pure Gibbs.

The most striking early example of Gibbs's influence in Philadelphia, however, is Pennsylvania's founding Episcopal church, Christ Church (1727–44; the spire finished in 1754), designed by the physician and amateur architect Dr. John Kearsley. In the mid-eighteenth century one building of Gibbs's spawned a host of American variants: his splendid London church of St. Martin's-in-the-Fields (1721–26). Church builders up and down the Atlantic coast of America copied it (generally in timber rather than stone), from St. Michael's Church in Charleston

(1752–61) to St. Paul's Chapel in New York (1764–66, by Thomas McBean, reportedly a student of Gibbs) to Joseph Brown's tower and spire for the First Baptist Meeting House in Providence, Rhode Island (1774–75). Christ Church belongs to this family. Its projecting chancel in the eastern end contains an enormous Palladian window, the first in America. The Tuscan columns that carry the nave are also pure Gibbs—one of the very earliest American uses of a classical order inside a church. So are the exterior roof parapet, with its strong balustrade and urns, and the 209-foot steeple. This magnificent building expresses the growing confidence of the Protestant merchant ascendancy in Philadelphia, who made it into the young city's best-endowed and most fashionable church. In it, in 1789, the Episcopal Church in America was founded.

William Penn opened the Delaware Valley to other like-minded Protestants, not necessarily Quakers, who wanted to practice their religion peaceably. The larger part of these came to be known as the Pennsylvania Dutch. The first wave of them came between 1683 and 1715. They were not Dutch, but mostly German (*deutsch*), though they came from all over what was still called the Holy Roman Empire, and especially from the Rhenish Palatinate, the rich farm country along the Neckar and the Rhine that had been devastated by Louis XIV in 1688–89. The Thirty Years' War (1618–48) and another forty years of bloody factionalism between Catholic and Protestant had pried two generations of pious farmers off their land and turned them into refugees; immigration to America might be a desperate gamble, but to remain in Europe was ruinous. Traveling down the Rhine, Penn recruited his migrants from among these families, picking them for their skills and character. Moravians, Hutterites, Mennonites, Lutherans, Reformed Church—the denomination hardly mattered, so long as its members were sober, industrious, and able to rub along with one another. He offered them free land use, and above all an atmosphere of tolerance based on a broad acceptance of Protestant theology, whatever the doctrinal differences between sects might be. The Germans, settled on farms, would be primary producers; the English Quakers, in Philadelphia, would be the middlemen and entrepreneurs. And Penn was famously successful in dealing with the Indians; their treaties lasted, and Pennsylvania's history was not dishonored by Indian wars. Which is not to say that he was able to create a frictionless Utopia in Pennsylvania. Families of English descent were apt to dislike the way Germans stuck together, preserving their own language and customs.

The contents of the American melting pot did not melt, or not well enough to suit those Anglo-Americans who felt all others should be like them. It would become an exceedingly familiar motif in a nation composed of immigrants, from eighteenth-century Pennsylvania to California in the 1990s. The prior immigrant group, once settled, regards the newcomer as an intruder. Benjamin Franklin's words in *Observations Concerning the Increase of Mankind,* 1755, were an

opening shot in the interminable debate that has gone on, ever since, over American multiculturalism. Why, he demanded, should the "Palatine *Boors*" be allowed

> to swarm into our Settlements and, by herding together, establish their Language and Manners to the Exclusion of ours? Why should *Pennsylvania,* founded by the *English,* become a colony of *Aliens,* who will shortly be so numerous as to Germanize us instead of our Anglifying them, and will never adopt our Language or Customs any more than they can adopt our Complexion?

He need not have worried. German dialects coexisted easily with English in Pennsylvania down to the present day, and the Pennsylvania Dutch were as much imbued with a passion for their liberty as the English-descended settlers. "Liberty of conscience is certainly allowed here," wrote one of them, David Seibt, to his brother in Silesia in 1734. "Each may do or leave undone as he pleases. It is the chief virtue of this land and on this score I do not repent my immigration." Like the Quakers, they detested slavery. Unlike them, they were not necessarily pacifists. In fact, the weapon that contributed largely to American victory in the Revolution was a kind of flintlock developed by German gunsmiths in Pennsylvania, an often superbly crafted hybrid between the light barreled English fowling piece

and the accurate rifled bore used by Tyrolean mountain hunters. They were also known as Kentucky rifles—"the cursed twisted guns," wrote an English soldier fighting in Pennsylvania in 1775, "the most fatal widow-orphan-makers in the world."

The *Deutsch* brought their crafts with them. These did not include painting or sculpture, except on a decorative level. Some German immigrants shunned decorative art altogether; those whose religion allowed them to make it, who sought a little handmade brightness in their lives, were known to stricter sectarians as the "Gay Dutch." At its best, Pennsylvania German craftwork has a phlegmatic and deliberate grace (Figure 26). The *Schrank*s, or big wardrobes, with their architectural-scale cornices, the energetic linear inlay work, the chests

26. Attributed to Peter Holl II and Christian Huber, *Wardrobe (Schrank)*, 1779, Manheim and Warwick Township, Lancaster County, Pennsylvania. Black walnut, sulphur inlay, and poplar, h. 88 × w. 78 × d. 27½" (223.5 × 198.1 × 69.8 cm). Philadelphia Museum of Art; purchased.

painted with formalized tulips, fruit trees, horsemen, and even unicorns (for the Germans were happy to use those emblematic animals off the British coat of arms), are the expression of an ideal of rooted domesticity, the immigrant's reward. They did what they already knew: German folk art. Motifs are continually recycled between linen embroidery, sgraffito pottery, chest decoration, and *Fraktur,* that vivid form of calligraphy the Pennsylvanian Germans used to give ceremonial importance to baptismal certificates, marriage licenses, and the like (Figure 27).

Such things are eagerly sought today; they remind Americans of what is conventionally called "a simpler age," though farming is not simple. Folk art was made in and for the communities that used it. Like vernacular speech, it was sometimes whimsical, but never inflated. Concise and practical, it was full of the marks of real social life—clues to hopes, values, and aspirations that you feel you can read with trust because they have not been given rhetorical form. The idea of the "anonymous" folk artist, like the Noble Savage, is a figment of the sophisticated. One sees why as soon as one asks, "Anonymous to whom?" Things become "anonymous" when they leave home and drift into the market, because they lose their domestic history and cease to be triggers of memory. Young Franz knew quite well that the weather vane on the barn was made by Uncle Johann twenty years ago, but Uncle Johann did not bother to sign it, since it was not expected to have an audience outside his family. To call things "anonymous" merely because they are unsigned is implicitly to collapse the social space around them.

27. H. Seiler, *Fraktur: Birth and Baptismal Certificate,* c. 1795–1815. Watercolor and ink on paper, 13 × 15¾" (33 × 40 cm). The Henry Francis Du Pont Winterthur Museum, Winterthur, Delaware.

The folk tradition in America only came to be valued when it was almost gone. Today, America has 260 million people but almost no folk. The forms of folk art were diluted or destroyed—and then "revived" as tourist goods or nostalgic images—by the inexorable pressures of the late nineteenth and twentieth centuries: store-buying, industrial production, the impaction of cities, historical self-awareness. Today, the "high art" view of folk art is tinged with benign condescension: here it is, the innocent social birdsong of early America. But some kinds of art made in Utopian immigrant communities were not like that at all. A remarkable example is the Amish quilt.

The first Amish arrived in Pennsylvania in 1737. They were a religious offshoot of the Swiss Anabaptists, and took their name from their inspired leader, Jacob Amman. They believed in a complete separation of church and state, in the Second Coming of Jesus Christ, and in the pacifist communism sketched in the Sermon on the Mount. They were "primitive," literal-minded in their approach to Scripture, and fiercely conservative. "The old is the best," an Amish saying went, "and the new is of the Devil." Their *Ordnung,* or codex of rules, covered an enormous range of detail and behavior, including the avoidance of graven images, in accordance with Scripture. But although they shunned representation, they did have a practical art form, which they did not bring with them from Europe; it grew in America, produced its finest results in the late nineteenth and early twentieth centuries, and was entirely made by Amish women. This was the quilt.

To make a quilt you take three pieces of cloth—top, bottom, and filling in between—and sew them together to make a kind of padded blanket. This is a particularly, if not uniquely, American form, an art based on modular arrangements, intricate geometry, luscious colors—and salvage, not-wasting, "making do." This frugality grew out of religious belief, and the early conditions of American life, in which most cloth had to be imported and so was expensive. Every household worthy of the name had its scrap bag: in 1651 a Boston shopkeeper listed in his inventory "black Turky tamet, linsie woolsie, broadcloth, tamy cheny, adretto, herico Italiano, sad hair coloured Italiano, say, red satinesco tufted Holland," and offcuts of these imports would end up under many a sewing table, the scrap stuff of quilts to come. But the finest American quilts, the designs done by the Lancaster Amish, belong to the time of plain American manufactured cloth. The Amish used no patterns or scraps with any preexisting design: they assembled blocks of store-bought, uniformly colored wool, bought by the yard, and from them created America's first major abstract art. They seem to prophesy the explicit geometry of some American art in the 1960s and 1970s—Sol Lewitt's grids, Frank Stella's concentric squares, and the blocks of muted, saturated color deployed by Brice Marden. A soft, swaddling Minimalism, in which one recognizes a spareness of design just pulled back from dogmatic rigor by its inventive

quirks, a magnificent sobriety of color, and a truly human sense of scale. The austerity of the Amish center-square and diamond-in-the-square designs (Figure 28) is intensely conservative, but it also evokes the words of the patron saint of later American Minimalism, Ad Reinhardt:

> The creative process is always an academic routine and sacred procedure. Everything is prescribed and proscribed. Only in this way is there no grasping or clinging to anything. Only a standard form can be imageless, only a stereotyped image can be formless, only a formulaized art can be formulaless.

In 1774 another group of religious Utopians arrived in New York. It was tiny, consisting of a determined and charismatic leader, "Mother" Ann Lee, and eight followers. They would receive the nickname of "Shakers," from their shivering community dances that looked so odd to outside observers. They, however, called

28. Rebecca Fisher Stoltzfus, *Diamond in the Square,*
c. 1903, Groffdale area of Lancaster County, Pennsylvania.
Wool, 77 × 77″ (195.6 × 195.6 cm). Museum of American
Folk Art, New York; gift of Mr. and Mrs. William B. Wigton.

themselves the "United Society of Believers in Christ's Second Appearing." This miniature sect would ramify and increase over the next seventy-five years, only to go into a sharp decline by the end of the nineteenth century; but at the high tide of the movement, around 1850, there were probably 150,000 practicing Shakers in America.

By the end of the 1780s, their first community near Albany had created missions, or "families," in Connecticut and Massachusetts. Though Mother Ann died in 1784, the Shaker faith rode a wave of religious revivalism that followed the American Revolution. The northernmost Shaker community was founded in 1794, at Sabbathday Lake in Maine. Today, it is a museum unto itself—its meetinghouse and associated buildings still stand, but the community is down to eight people. Unlike the Quakers, they took no part in public life. They wished only to be left alone. They were self-sufficient. Most communities bought nothing from "the world" except sugar, salt, molasses, and raw metal.

Some Shakers were excellent craftsmen, and through the medium of their handwork—mostly furniture—they came to influence American culture more strongly than any group of Utopian religious "seekers" since the Puritans. Their effect, however, was delayed. Shaker esthetic principles did not have much resonance outside the circle of the "enlightened" until the twentieth century, when the purity and strict functional thought entailed in Shaker design was adopted, as ancestors often are in America, as a precursor of modernist rationality. Why was it, over a long period during which "mainstream" American design looked to Chippendale and Sheraton and moved gradually into the florid and often congested exuberance of the 1850s, that Shaker furniture kept its bareness to the eye, its foursquare beauty? The answer has to be sought in the Shakers' difference from other Americans—their religious beliefs.

Mother Ann Lee, the daughter of a Lancashire blacksmith, had been caught up in the great movement of working-class religious "enthusiasm" of mid-eighteenth-century England. Like hundreds of thousands of others, she believed in direct revelation, not the rites and formality of the Anglican Church. Inspired by a vision, she believed the Kingdom of God was not to be found in the official Church. It dwelled in each individual soul. The *parousia,* or Second Coming of Christ, would not happen with public grandeur and clouds of glory; it was immanent within each believing man, woman, and child. When the millennium came, which Ann Lee's followers expected it to do at any moment, it would be an internal event. But it required the right conditions: humility, community, and remoteness from the "worldly."

The rules of Shakerism included a strictly observed equality of the sexes, and an equally strict celibacy. The sect could only expand by conversion. In the New Jerusalem there could be no mine and thine, no masters or servants. Every detail of life in the communities was enlaced by rules, the so-called Millennial Laws,

which governed an infinity of matters from how to finish a workbench top to the correct way of climbing stairs in segregated order.

Once these conditions were met, the most ordinary life of work could fill with spiritual meaning, as the indwelling of Christ took hold. Hence the Shaker emphasis on the twin ideas of "unity and simplicity." One fostered the other: unity, because the cohesion of the sect discouraged vanity and attachment to the world, fostered simplicity, the willing detachment from egotism and appetite that left the soul clear to be occupied by Christ. This applied to all aspects of Shaker life, and is implicit in their craftwork. "Hands to work," said a Shaker motto, "and hearts to God."

The Shakers did not reject innovation—which made them very different from more conservative groups, like the Amish. They were remarkably ingenious, inventing a number of things so common by now that we tend to assume they have always been around: the clothespin, for instance, the flat broom (which swept better than the traditional round besom), and the washing machine. Laborsaving devices freed the soul; they left more time for prayer. The Shakers were the first Americans to express a link between piety and technology. They would not be the last. They were a bridge between early rural America, the America of the eighteenth century, and the future America of industry, process, and analysis. But industrialization doomed the movement: by pulling so many Americans off the farms and into the city, it dried up the Shakers' main source of future converts; and their feminist God, unlike the divine patriarch of the Amish and Hutterites, had forbidden them to beget new ones.

The nuances of Shaker behavior were not, of course, self-evident to those outside their faith, who often viewed them as cranks. Charles Dickens, visiting the community at Mount Lebanon in New York in 1842, saw only "such very wooden men," no more sympathetic than "figure-heads of ships." Their shaking dance he judged (without seeing it) to be "a preposterous sort of trot . . . unspeakably absurd." The bare interiors they lived in reminded him of the soul-killing nineteenth-century workhouses he loathed:

> We walked into a grim room, where several grim hats were hanging on grim pegs, and the time was grimly told by a grim clock, which uttered every tick with a kind of struggle, as if it broke the grim silence reluctantly, and under protest. Ranged against the wall were six or eight stiff, high-backed chairs, and they partook so strongly of the general grimness, that one would much rather have sat on the floor than incurred the smallest obligation to any of them.

What would Dickens's reaction have been if the future auction price of those grim chairs had been revealed to him? Disbelief, no doubt. But he had arrived in Mount Lebanon at the apex of the Shaker style's development, a period which

lasted roughly from 1820 to 1850. Earlier Shaker work tends to be painted (with milk-based paint) and the colors were brighter than we think—mustard yellow, leaf green, sky blue (which has darkened over time, robbing the woodwork of the Sabbathday Lake meeting hall of its heavenly symbolism) and a dense earthen red. But "high" Shaker furniture preferred the natural grain of the wood, and sometimes sought highly decorative contrasts just on the edge of worldliness: some makers were particularly fond of tiger maple, with its flamboyant striped grain contrasting with clear chestnut, birch, or fruitwoods. Decoration is kept to the minimum: a discreet ogee molding or perhaps a cove to finish the top of a chest, an elegant taper to a turned leg. Turning, within limits, was much used; the slender sticks of a chair-back may terminate in pointed finials, and the tapered mushroom-cap peg for hanging hats or chairs on is so much a hallmark of the style that mail-order suppliers sell them to American do-it-yourselfers by the cartload. But in principle, there is no decoration in Shaker work

that does not arise from the integral nature of its planing and jointing. Everything depends on profile, proportion, and lightness, the latter quality reinforced in some chairs by openwork caning, which lets so much "air" into the frame that the piece seems almost volatile. A "classic" Shaker chair of this type (Figure 29), capable of supporting a two-hundred-pound man, may weigh no more than three or four pounds. The craftsmen and -women (for there was no gender division in Shaker carpentry) shunned all carved decoration and all painted figures. They abhorred the kind of faux finishes (imitation wood grain and the like) that figured so prominently among the Pennsylvania Dutch. Only movable furniture could be varnished. Only the oval boxes known as "nice boxes" could be stained red or yellow. All elements—except curved rockers and sometimes the back rails of chairs—were rectilinear, "on the square," as a sign of probity. Furniture, a Quaker edict had declared, ought to be "plain and of one color, without swelling works" (such as cabriole legs, curved splats, or bombé fronts); and no craftsmen carried this out more strictly than the Shakers.

The Puritans had fled a royalist England, where they felt persecuted. By 1650 it would be the turn of the other side to come looking for refuge and Utopia in America: the Puritan victory in England was so complete that "distressed

29. Anonymous, *Rocking Chair with Arms*, c. 1850–60.
Hancock Shaker Village, Pittsfield, Massachusetts.

cavaliers"—many of them younger sons who had no fortune to expect and no sure social footing in Cromwell's England—came looking to change their lives in Virginia.

The colony they came to after 1655 had been a failure for most of its existence. The English colonization of Virginia was devised in 1606 by a group of merchants who formed the Virginia Company of London. James I had given them title to a vast territory that neither he nor they knew anything about; it stretched from New York to what is now North Carolina, and it was expected to produce immense wealth without a hand's turn of work. A poem written in 1611 by Michael Drayton, "To the Virginian Voyage," was a classic of deceptive advertising. Addressed to the cavalier in everyone—"You brave heroic minds . . . That honour still pursue"—it dilated on how

> . . . cheerfully at sea
> Success you still entice,
> To get the pearl and gold,
> And ours to hold,
> Virginia,
> Earth's only paradise,
>
> Where nature hath in store
> Fowl, venison and fish,
> And the fruitfull'st soil
> Without your toil
> Three harvests more,
> All greater than your wish.

Virginia was to be the Garden of Eden, the Land of Cockayne, and small investors flocked to the Virginia Company. They lost everything. Almost from the moment that Jamestown was founded in 1607, on the tidal edge of the Chesapeake River, it was a disaster—as any colony pitched in the expectation of immediate leisure and wealth was bound to be. Three hundred Englishmen crossed the Atlantic to Virginia between 1607 and 1609, and one in five of them was a cavalier buck who refused to work at all. They must have cut ludicrous figures, trudging through the salt marsh of the Chesapeake in their embroidered doublets and silken hose; Sir Walter Raleigh is said to have taken jewels worth 30,000 pounds with him, several million dollars' worth in modern currency. Most of the laborers who could be recruited were unskilled, and most of the few craftsmen were of a sort useless in a new colony: clockmakers, perfumers, and even jewelers, who, doubtless to their annoyance, found none of the gold—or, despite the abundance of Chesapeake oysters, the pearls—that everyone expected. Since they

could not work and had no farming experience, the colonists stole what they could from the Indians, which put paid to any hopes of peaceful coexistence. The Powhatans and the English thus lived in a state of more or less continuous warfare. In 1622 Chief Powhatan's successor Opechancanough killed a third of the English colony—some 350 people. The "gentlemen"—those who did not die of scurvy, malaria, or the bloody flux, and had not succumbed to despair—abandoned Jamestown as fast as they could.

By 1625 only 1,200 whites remained alive in Virginia, out of the 8,500 whom the Virginia Company had shipped there since 1607. To hold Jamestown together, the Virginia Company imposed laws and punishments of a severity unimagined by the Puritans who were now settling Massachusetts. These included forced labor under military discipline—a foretaste of the draconian system that would be installed with slavery. The only thing that saved the wretched settlement was the "Sot-weed," tobacco, whose use had caught on in England, and which required little skill to grow. Before long most of the arable land within reach of the Chesapeake had been gobbled up by a small elite of wealthy planters, driving less successful colonists into a condition not far above serfdom. But the tobacco market did galvanize the colony, which in 1619 set up an independent government, the elected House of Burgesses, to replace martial law. In 1624 James I abolished the Virginia Company and declared the place a royal colony.

What really saved Virginia, however, was the arrival of an astute, hardfisted governor in 1642. He was Sir William Berkeley, and he was determined once and for all to give this squalid and brutally competitive place a social structure that the English could recognize: to make it a cavalier Utopia that worked. Berkeley would rule Virginia for thirty-four years, and more than any other single person, he shaped its emergent culture.

The popular American idea that English migration to America promoted democracy, equality, and freedom is roundly contradicted by the facts of life in Virginia under Berkeley. His aim was to transfer to the New World the social order of the Old, meaning the aristocratic order of cavalier England, of unquestioned vertical chains of power and patronage. When the apex of the social pyramid migrated to Virginia, it found no base to lord it over. The Indians could not be enslaved or "persuaded" to come into the system as wage workers. So the top colonists had to import labor: indentured servants at first, the English poor, some of them convicted felons and others who signed their lives away for the chance of a new start in America; and then, somewhat later, black slaves from Africa. African-American slave labor would predominate by the end of the eighteenth century, but there was never a time when the Virginia elite did not depend on coerced work of one kind or another. By the mid-seventeenth century more than three-quarters of the white people of Virginia were English indentured servants, ruled by a small but powerful group of families, sprung from the "distressed cav-

aliers" whom Berkeley had recruited. These First Families, none of whom traced their line back to the original Jamestown settlement—Byrds, Carters and Lees, Washingtons, Diggeses and Throgmortons—owed their presence in Virginia to Berkeley. They stuck close together, and one Virginian, speaking to a newly arrived immigrant, "very freely cautioned us against disobliging or offending any person of note in the Colony . . . for, says he, either by blood or marriage, we are almost all related, and so connected in our interests, that whoever of a Stranger presumes to offend any one of us will infallibly find an enemy of the whole, nor, right or wrong, do we ever forsake him, till by one means or other his ruin is accomplished."

For most of its existence, more than a century until the Revolution swept it away in 1776, the Royal Council that governed Virginia was completely controlled by half a dozen interlocking families. Back "home," the English scoffed at their pretensions to gentility. Colonial prestige meant a plantation in the West Indies, not in Virginia, a place regarded as distinctly second-rate. But nothing could deflect Berkeley's vision of a patrician order. One way of keeping the lower 75 percent in its place, for instance, was education—and the lack of it. The Puritans, fearing "Criolian degeneracy," had encouraged printing, founded Harvard (the first American university, in 1636), and vigorously created a network of town-supported schools throughout Massachusetts. Not so the cavaliers, who kept tutors for their own children, viewed schools for the common people as a waste of money (what did they need to read and write *for*?), and thought of political argument as treason. They were interested in higher education—for their own children only. As for the rest, including the slaves, who were punished by amputation of a finger if a book was seen in their hands, "I thank G-d," remarked Governor Berkeley with satisfaction,

> there are no free schools nor printing, and I hope we shall not have these [for a] hundred years; for learning has brought disobedience . . . and printing has divulged [it] and libels against the best government. G-d keep us from both.

The result of all this was a lopsided society, its genteel surface of hierarchy stretched over a fabric of brutality supported by slave labor, and of intellectual dullness guaranteed by colonial snobbism. These cavalier bloods might preen themselves on restoring monarchical values in America, but they had neither the largesse nor the self-questioning ironies that showed in the art and writing of the English Restoration. The early Virginia noblesse had Lord Rochester's sexual predacity but none of his wit; it had every social absurdity that Congreve and Vanbrugh had anatomized in their plays, without the least sense of self-satire. Its obsessive anxiety—a parallel, in its way, to the Puritan fear of "Criolian degeneracy," the loss of literacy—was that the aristocracy might go to seed in the

American wilderness and revert to its inglorious origins. So the sense of status could never be allowed to relax; the Other, black slave or poor white, was right behind you. This habit was long-lasting. "If we observe the Behaviour of the Polite Part of this Country," wrote an essayist in the *South Carolina Gazette and Country Journal* in 1773,

> we shall see that their whole lives are one continued Race; in which every one is endeavouring to distance all behind him, and to overtake or pass by all before him; everyone is flying from his Inferiors in pursuit of his Superiors. . . . Every Tradesman is a Merchant, every Merchant is a Gentleman, and every Gentleman one of the Noblesse. We are a country of gentry; we have no such thing as a common People among us.

What sort of paintings did these people have? The short answer is: few and poor. Berkeley himself had been painted by Van Dyck before he left England, but there was nobody in late-seventeenth-century or even early Georgian Virginia who could do a plausible imitation of Van Dyck's grand manner, which the new cavaliers would presumably have liked. As in Puritan Massachusetts, the only demand was for portraits. A German émigré painter who worked in Annapolis until his death in 1717, Justus Engelhardt Kühn, painted one of the sons of the oligarchy, Henry Darnall III (Figure 30). The boy is eight or ten years old, armed with a bow and arrow, kitted out in lace, a heavily embroidered jacket, and a green cloak: a baroque doll. A young slave gazes at him with submissive adoration, holding a dead quail. The African-American boy wears a polished silver collar, like a favorite dog. This is the first appearance of a black in colonial painting. Behind them stretches an improbably idealized garden landscape with parterres and a statue on a plinth, which must have been copied from some European print. The bulbous balusters, the base of the column, and the cartouche with a cherub's head in it are all, likewise, fictions. No properties in America looked like this. The image records the defiant, illusory desire of the colonial gentry to imagine themselves as an extension of European culture—which

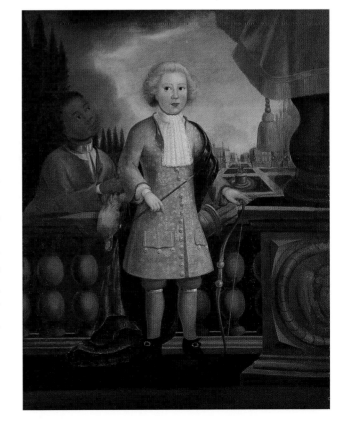

30. Justus Engelhardt Kühn, *Henry Darnall III*, c. 1715. Oil on canvas, 29⅞ × 25" (76 × 63.5 cm). Maryland Historical Society, Baltimore.

indeed they were, but not in the grand sense that they envisioned for themselves. One can see how dependent the limners were on imported prototypes by comparing a portrait (c. 1722–23) of another Virginia son, Edward Jaquelin, Jr. (Figure 31), with the English mezzotint from which it is obviously derived, a portrait of young William Cecil by John Smith after William Wissing. The pose, the drapery, the dog, even the parrot are essentially the same. The artist ran into difficulty when he tried to repeat the baroque flutter of Master Cecil's cloak, but his attempt has a startling linear vitality missing from the print.

Why could so wealthy a group as the Virginia planters not support local painters by the 1720s? Probably because they sometimes went to England and could have their portraits done at the source in London by pupils of Peter Lely or Sir Godfrey Kneller. It was an arid time for English portraiture, which had sunk into an enfeebled formalism with Kneller, and these were second-rate paintings; still, better second- than fourth-rate. When the London portraitist Thomas Hudson painted Virginia's Robert Carter, who was over there on a visit in 1753, he turned him into the very image of the cavalier, complete with flowing Van Dyck collar (Figure 32). One English émigré artist who had some success in Virginia was Charles Bridges, who fled his creditors in England and arrived in Williamsburg in 1735, armed with a slight talent and letters of introduction to, among others, the lieutenant governor William Gooch, who thought him pushy. "Mr Bridges I have already loaded with my civilities," Gooch would harrumph in a letter, "tho' it looks a little odd for a Governor to show so much favour to a Painter, as to . . . entertain him at Dinner and Supper several times since his arrival, and to promise him as soon as he's settled that he shall begin to show the country his Art, by drawing my Picture."

They also depended on English pattern books for their architectural ideas, and it was really in building that the planters expressed themselves: their notions of luxury, their dreams of status. Virginia architecture—as distinct from mere vernacular "building" of timber shacks and brick or weatherboard cottages—did not take off until the end of the seventeenth century. There had been earlier manors, of which the sole survivor is Bacon's Castle, built before 1676 in the Jacobean manner, with twin curvilinear gable

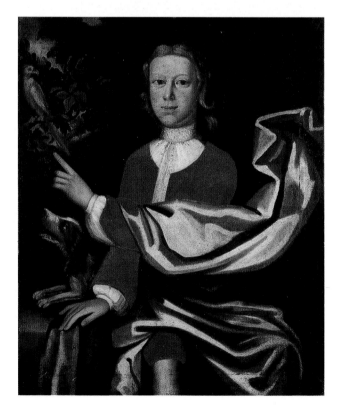

31. Nehemiah Partridge, *Portrait of Edward Jaquelin, Jr.,* 1722–23. Oil on canvas, 31½ × 26″ (80 × 66 cm). Virginia Museum of Fine Arts, Richmond; lent by the Ambler Family.

ends recalling Flemish housefronts and a handsome trio of diagonally set brick chimneys in the Tudor taste. Its actual builder was Arthur Allen, a planter; but for a time it quartered a "Rabble of the basest sort of People," a rebel militia of indentured servants, poor whites, and black slaves led by another planter, Nathaniel Bacon, against Berkeley's rule. Bacon's rising briefly turned the Chesapeake upside down, horrifying Berkeley and his backers with the prospect of solidarity between blacks and whites against their rule; but its leader died of dysentery, not before burning most of Jamestown to the ground. Berkeley's suppression of the rebels was draconian. "That old fool," remarked Charles II when news of it reached him, "has killed more people in that naked country than I have done for the murder of my father."

After these ructions, at the end of the short, troubled reign of James II (1685–88) the Virginians shifted their capital from Jamestown to Williamsburg, which bore its Dutch name to celebrate the accession of the new monarch, William of Orange. Williamsburg represented a new start, on a virgin site, shucking off the discreditable history of failures built into the memory of Jamestown. What it needed, and rapidly found, was a new and suitably grand architectural style—grand, that is, by the hitherto impoverished standards of the colony. Up to the end of the seventeenth century, the American colonies had no purpose-built "public buildings" that displayed the prestige of government and, through that, of the Crown. Law and government were administered through private houses, which served as meetinghouse, court, and residence all rolled into one.

With Williamsburg, this changed. A new architectural language was implanted on American soil: formal but flexible, adapted to the limited skills and materials that were to be had in this remote part of the earth. It was a simplified form of English baroque, as defined by Sir Christopher Wren. Since the Great Fire of London in 1666, Wren had transformed the appearance of the mother city with his designs for Chelsea Hospital, Hampton Court Palace, and some forty-five city churches, including St. Paul's Cathedral. Now the message of his style crossed the Atlantic.

It is a pious legend, no more, that Wren actually designed the so-called Wren Building, c. 1695, in Williamsburg's College of William and Mary

32. Thomas Hudson, *Robert Carter*, 1753. Oil on canvas, 50 × 40″ (127 × 101.6 cm). Virginia Historical Society, Richmond.

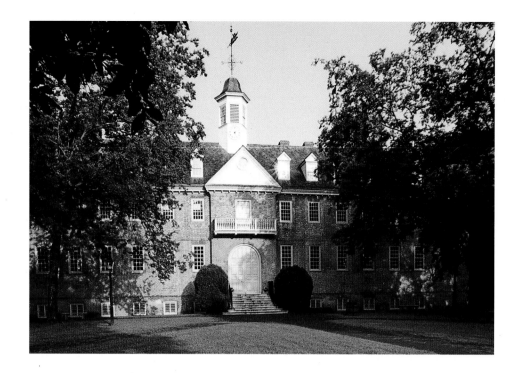

(Figure 33). Its architect's name is unknown, but he clearly understood something of Wren's idiom through pattern books and engravings. Edmund Burke, visiting the colony in 1761, commented on its resemblance to Wren's Chelsea Hospital; but the similarity is only skin-deep, and a thin skin at that. It was, of course, impossible to find craftsmen who could emulate the grand plasticity of Wren's detail, and so the building is more like a schematic sketch of Wren effects. The window reveals are shallower than an English builder would have made them, giving a flatter appearance to the walls. The plan is basic, almost rudimentary. The proportion of the central pedimented bay to the rest of the façade is too narrow, and the arched entranceway too wide. Nevertheless, it was by far the most ambitious building yet raised in European America. A rectangular block with a hipped roof and an elegant hexagonal lantern, the three bays united by a stringcourse and a cornice and built of red brick, which probably had to be imported as ship's ballast from England; sash windows in place of the older casement type; and, luxury of luxuries, rectangular sheet glass to let in plenty of light, rather than the old "bulles-eye" diamond panes set in lead.

The building in Williamsburg that set the standard for domestic architecture was also an official one: the Governor's Palace (1706–20). As a symbol of British rule, it was burned in 1781 during the Revolution, after the battle of Yorktown, and the present building is entirely a reconstruction—based, however, on a trustworthy engraving found in the Bodleian Library, on measured drawings by Thomas Jefferson (who lived in it for a time), and on careful excavation of the old foundations (Figure 34).

33. The Sir Christopher Wren Building, modern reconstruction of original c. 1695. The College of William and Mary, Williamsburg, Virginia.

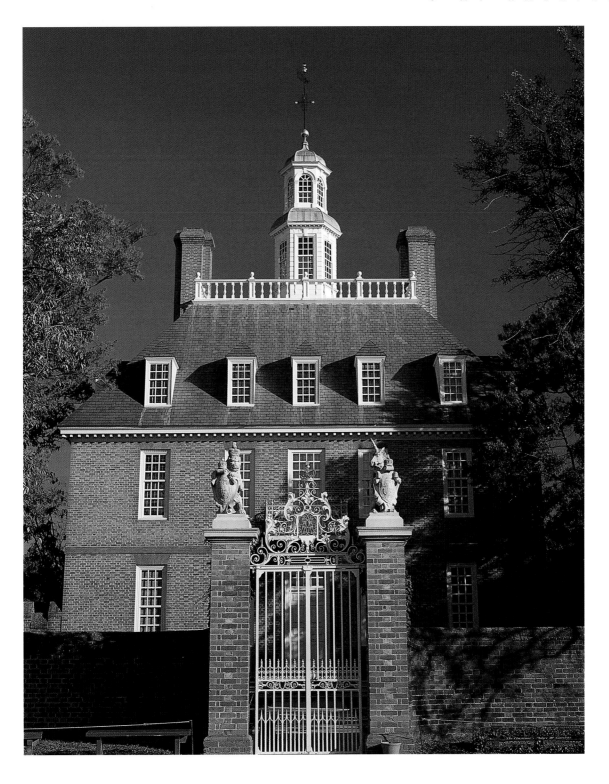

34. The Governor's Palace, modern reconstruction of
original c. 1706–20. Williamsburg, Virginia.

It may not have been a grand palace by English or French standards, but a clear symbolism of power was designed into it nonetheless. Its focus is the second-floor balcony, which was more than a place from which the governor could enjoy the view down the village green. The balcony signified government by proclamation, from on high; and the military might at the governor's disposal was expressed in the decoration of the palace's entrance hall, with its gleaming arrays and ceiling sunburst of steel, brass, and mahogany muskets. Nobody in early-eighteenth-century Williamsburg would have interpreted this as oppressive—though of course the American republicans would do so. The Virginian upper crust saw in the palace an image of benign continuity with the England whose way of life they were preserving in the New World, and the muskets as an extravagant display of protection. Lesser people, if they were ever let inside, would simply have been overawed. The imitation of all things English in Williamsburg was so close that one of its eighteenth-century colonial governors, Norborne Berkeley, Baron de Botetourt, chose to address the multitude from the balcony in a curiously affected voice which aped not only the cadences but the actual speech defects of King George III. People remembered this, but nobody seems to have laughed at it.

Robert "King" Carter was one of the Virginia oligarchs. His father, John, came out from England in 1649, and died in 1669 worth 2,250 pounds. But when Robert Carter died at the height of his power in 1732, he was the owner of

35. Shirley, c. 1720–40. Virginia.

10,000 pounds in cash, a thousand black slaves, and some fifty plantations totaling a third of a million acres. It all came from the sot-weed. His house "Shirley" (c. 1720–40), built on the bank of the James River, where his crop could be loaded directly into freighters bound for England, illustrates very well how dependent the patron was on the inherited culture of individual builders. It is, in effect, a French château with a mansard roof and heavily projecting dormers, with symmetrically disposed "dependency" buildings on the landward side, thought to have been designed by one of the noticeable colony of French Huguenot settlers who, fleeing to England and thence to America from the persecutions of Louis XIV, had ended up near Richmond (Figure 35). The two-story Palladian porticoes, front and back, were added much later, in the 1830s.

"King" Carter's main mansion, Corotoman, was razed long ago. His most interesting surviving building is not a house but a place of worship: Old Christ Church (c. 1732), near Kilmarnock in Lancaster County, Virginia (Figure 36). The name of its architect is unknown, but whoever it was gave Carter the finest piece of Anglo-Palladian church design in America. Old Christ Church is compact and dense-looking. In plan, it is a short-armed cross. Its brick walls are three feet thick, laid in Flemish bond with subtly differing colors that give relief to the surface; these bricks were made on the site. The look of weight and permanence is increased by the steep hipped roof, which flares slightly at the eaves, pressing

36. Old Christ Church, c. 1732. Lancaster County, Virginia.

down on the generous cornice, which in turn bulges as though responding to the thrust. The logic of this unusual detailing is strong, and it reads vividly against the otherwise plain wall treatment, pierced by an elliptical window above each doorway—each with a "cross" motif given by its four keystones—and by tall arched windows that light the arms. The main doorway is taken from a plate in another English builder's guide, William Salmon's *Palladio Londinensis*. Inside, the church is lyrically severe, with a Palladian effect of light washing across the simple white-plastered vaults—a distant echo of San Giorgio Maggiore. Its calm is emphasized by a thin, dark stringcourse molding that connects the springing of the window arches. Old Christ Church has the highest-sided pews of any church in America: this served a double purpose, enabling "King" Carter and his family to concentrate without distraction on the word of God coming from the pulpit, but also preventing the lower orders from looking in on their squire. "The wretched, the widowed and the orphans, bereaved of their comforter, protector and father, alike lament his loss," his tombstone declares; but an ungrateful wit chalked on it, soon after Carter's burial,

> *Here lies Robin, but not Robin Hood,*
> *Here lies Robin that never was good,*
> *Here lies Robin that God has forsaken,*
> *Here lies Robin the Devil has taken.*

As the gentry of England based their houses on the designs of Andrea Palladio, so did the equestrian class of the South. (Some would take it to an extreme;

37. Drayton Hall, 1738. Charleston, South Carolina.

Thomas Jefferson wanted the President's house in Washington to be a copy of Palladio's Villa Rotonda.) The "Southern portico," familiar from a score of film sets as an emblem of gracious living in the slave days, comes from Palladio: a temple-form structure of two stories, with Doric or Tuscan columns on the ground floor and Ionic ones above, surmounted by a triangular pediment and standing proud of the façade. The earliest one in the American colonies is on the front of Drayton Hall, 1738 (Figure 37), near Charleston, South Carolina, and it was copied almost line for line from Palladio's Villa Pisani in Montagnana (1555). A magnificent building, its ceremonial air is announced by the twin stairways and continued in the central hall, the largest room in the house, used for balls and musicales.

Propelled by English design books, the fashion for Palladio spread in Virginia as well, altering the preponderant influence of Wren. Mount Airy, seat of the Tayloe family in Richmond County, Virginia, is a fine example of this New World Anglo-Palladian style (Figure 38). In a provincial culture whose distance denied access to the original forms, a single book could have great influence. For some eighteenth-century Virginians that manual was written by the English architect James Gibbs. Gibbs's *Book of Architecture containing designs of buildings and ornaments,* 1728, was aimed (its preface declared) at "such Gentlemen as might be concerned in building, especially in the remote parts of the Country, where little or no assistance for Design can be procured." Such a gentleman was John Tayloe II (1721–1779). He owned an ironworks on the Rappahannock River and had inherited one of the largest slave gangs in the colony, 384 men and women. When Tayloe decided to build himself a mansion worthy of his place in life, he turned to a local Virginia builder named John Ariss (c. 1725–1799), who owned a copy of Gibbs's pattern book. Ariss took one of its designs for a country house,

a two-story central block with an entrance porch of strongly rusticated stone arches and side wings (stables on one side, a service building on the other) connected to it. He copied the porch and its pediment almost exactly, shrank the façade from six bays to four, and enlarged the connecting arms to the side buildings into sweeping quadrants. The walls were built of a mottled, dark local sandstone, against which the honey-colored stone columns, pediment, and quoins "read" crisply. The layout expresses ownership, having and holding: the curved links are like a man's arms, and the dependent blocks like his hands, embracing property. It speaks for Tayloe: *Here I am, you can't take this away from me.* Begun in 1748 and ten years in the building, Mount Airy was finished with all the appurtenances of an English stately home: orangerie, terraced garden, bowling green, and even its own private racecourse, the only one in the colony. Such early slave plantations call to mind W. B. Yeats's elegiac lines on Irish colonial mansions, built at the same time:

> *Some violent bitter man, some powerful man,*
> *Brought architect and artist in, that they,*
> *Bitter and violent men, might rear in stone*
> *The sweetness that all longed for night and day,*
> *The gentleness none there had ever known. . . .*

39. Street façade, Isaac Royall House, 1732–37. Medford, Massachusetts.

Meanwhile, in the North, a similar transition had been going on: from the simple forms of Puritan meetinghouse and dwelling, toward classical domestic detail and an ampler ceremonial public architecture based first on Wren and then on Palladio's English disciples. An emblem of this shift was the Isaac Royall House, 1732–37 (Figure 39), in Medford, Massachusetts. It had begun as a country farmhouse, two and a half stories in the Puritan style, originally built by John Winthrop in 1637. Isaac Royall, a merchant grown rich on the slave, rum, and sugar trade in Antigua, bought this simple building in 1732 and remodeled it in the early Georgian taste. Each side of the house is handled differently, and the most interesting and spirited of them is the east façade (1733–37), on which the sash windows and their deep spandrels are framed into continuous vertical white bands, running from the ground to the roof cornice and contrasting with the gray clapboards of the wall. By Massachusetts standards it was grand and imposing: a new Anglo-America, showy and hierarchical, had begun to peer through the big twenty-four-pane windows and the Georgian moldings.

If this confidence was visible in buildings, in furniture it was even more so.

By the mid-eighteenth century American furniture, especially in Philadelphia and Newport, Rhode Island, had reached a high level of exuberance and finesse. A common inspiration was Thomas Chippendale (1718–1779), whose design manual, *The Gentleman and Cabinet-Maker's Director,* 1754, was a useful source book for colonial cabinetmakers, since it set forth all that was new and desirable in English style. American painters like John Smibert might be hampered by their lack of access to English and European art, and their efforts might look somewhat stilted and naïve compared to the diction of the Grand Manner. But the best American cabinetmakers were the equal of the best English ones in skill, design quality, and inventive variation. Adapting Chippendale's designs to the immense abundance of American hardwoods, they produced in the eighteenth century the delayed baroque that seventeenth-century America did not have. Part of the clue to their "look" was the willingness to waste wood. With so much of it so cheap, a joiner could hog out a cabriole chair leg from an eight- or ten-inch-square blank, giving it voluptuously swelling S curves—Hogarth's "Line of Beauty"—and leaving plenty to spare for relief carving. This gave the best chairs of the period (Figure 40) their space-grabbing emphasis, planted as securely and indeed aggressively on their four legs as one imagines their merchant owners were on two.

40. Anonymous, side chair in the Chippendale style; one from a set of six believed to have been made for Sarah Logan at the time of her marriage to Thomas Fisher in 1772. Mahogany with poplar and yellow pine, 39¼ × 24¼ × 22¼″ (99.7 × 61.6 × 56.5 cm). The Metropolitan Museum of Art, New York; purchase, anonymous gift, in memory of Elizabeth Snow Bryce, 1983.

41. Anonymous, *Highchest*, c. 1770, made in Philadel-
phia. Mahogany, h. 94¹⁵⁄₁₆ × w. 45⁹⁄₁₆ × d. 23¹³⁄₁₆″
(241.1 × 115.7 × 60.5 cm). Milwaukee Art Museum;
purchase, Virginia Booth Vogel Acquisition Fund.

42. Townsend-Goddard, *Chest-on-chest*, 1780–95, made in
Providence, Rhode Island. Mahogany, chestnut, h. 96 ×
w. 40 × d. 22½″ (243.8 × 101.6 × 57.2 cm). The Henry Fran-
cis Du Pont Winterthur Museum, Winterthur, Delaware.

Why does one find a Philadelphia Chippendale piece like the so-called Logan
high chest, c. 1770 (Figure 41), so satisfying? It is not just the fine craftsmanship;
some lesser chests, in fact, are equally well made. Rather, it is how the maker
(whose name is lost) integrated form and decoration. Its shape is architectonic;
not only is it big—at nearly eight feet high, it had to have an appropriately scaled
room—but it liberally quotes from architecture, in its broken scrolled pediment,
in its moldings and especially its quarter-round pilasters framing the upper and
lower cases. The drawer fronts are straight and plain. But its top and bottom sec-
tors are full of organic metaphors, the antithesis of architectural order. The mas-

sive cabriole legs bend, acknowledging the visual weight of the piece. The skirt bears a scallop shell, and on the drawer front above it is a larger one, concave side out, exquisitely carved and surrounded by flowing vines. Then your gaze travels up the plain body of the cabinet, to be caught again at the top by the carved-shell motif and vines on the scroll board, by the scrolls breaking like waves over it, and by the rococo finial.

Eighteenth-century America produced many such masterpieces of case furniture. Another idiom was that of the Townsend and Goddard shop in Newport, Rhode Island. This was the "block-front" style, so called because the drawers of the chest were band-sawn and then carved from thick blocks, usually of mahogany, giving an effect of assertive relief. This was an American invention for which no exact parallel can be found in the English pattern books. One example will do for all: an imposing chest-on-chest, c. 1780–95 (Figure 42), with nine shells carved from the solid drawer fronts. It is furniture verging on architecture, occupying space with massive, refined confidence—the delayed baroque that Puritan America never had, arriving late. Furniture was the first American art to lift into real originality. There had been good furniture in early-eighteenth-century America: "good" in terms of craftsmanship, proportion, the harmonious relationship of part to whole. But from the 1740s on, and rising to a crescendo by the 1780s, a more ambitious spirit pervaded the shops of the best craftsmen. It was willful and headstrong in its energies. It suggested, not just a straightforward way of doing things (as in Puritan America, or with the Shakers), but the belief that the public expression of style could mirror and perhaps even inflect social organization. This was new. It was also quite different from the situation in which the painting of portraits or landscapes found itself.

At the beginning of the eighteenth century, no town in America, not even Boston or Philadelphia, could support a full-time portrait painter. Trade of every kind was flourishing and the bases of great fortunes were laid, but most of the Europeans in America were "persons of the middling sort," who did not think of patronizing the arts. Consequently the portrait painter had to be a jack-of-all-trades. Some were dancing masters, others taught French or embroidery, but most were gilders or stainers who turned to portraiture to make an extra few shillings; and their clients thought of them as tradesmen who made effigies, not "great artists" like Kneller or Van Dyck. "Painting done in the best manner, by GUSTAVUS HESSELIUS, from Stockholm . . . viz, Coats of Arms drawn on Coaches, Chaises, &c., or any other kind of Ornaments, Landskips, Signs, Shewboards, Ship and House Painting, Gilding of all Sorts, Writing in Gold or Colour, old Pictures clean'd and mended, &c."—but significantly, Gustav Hessel's advertisement in the *Pennsylvania Gazette* in 1740 does not even mention that he

did portraits. In fact, he was the first European in America to record the likeness of an individual Indian; his portraits of two Delaware Indian landowners, Tishcohan (Figure 43) and Lapowinsa, were commissioned by the Quaker leader John Penn in 1735 as a prelude to the Walking Purchase Treaty of 1737, whereby Penn and his brother got the right to buy from them all the land that a walking man could mark out in thirty-six hours. (Penn cheated by hiring a runner, not a walker.)

The artist who was to make a decisive break with the limner past and thus change the face of portraiture in Massachusetts arrived in Boston in 1729, not meaning to stay. His name was John Smibert (1688–1751), a Scot from Edinburgh. Smibert was the first academically trained artist to come to the American colonies. He had studied in a London school run by Kneller, and visited Italy, where he copied paintings. In Florence he had met the formidable Irish bishop and philosopher George Berkeley; the two men struck up a friendship, and Berkeley must have talked to Smibert about America, which he saw in glowingly idealistic terms as the future hope of civilization. Indeed, the Dean wrote a poem on this theme:

> *There shall be sung another golden Age,*
> *The rise of Empire and of Arts,*
> *The Good and Great, inspiring epic Rage,*
> *The wisest Heads and noblest Hearts.*
>
> *Not such as Europe breeds in her decay;*
> *Such as she bred when fresh and young,*
> *When heavenly Flame did animate her Clay,*
> *By future Poets shall be sung.*
>
> *Westward the Course of Empire takes its Way;*
> *The four first Acts already past,*
> *A fifth shall close the Drama with the Day;*
> *Time's noblest Offspring is the last.*

"Westward the Course of Empire takes its Way"—this phrase, as we shall see, was to settle on the lips of every explorer, land-grabber, imperialist, and cultural jingo in nineteenth-century America. In 1728 Berkeley asked Smibert to join him in a visionary scheme. He wanted to lead a group to the island of Bermuda and set up a university college. There, they would train cadres of Protestant missionaries, to fight what Berkeley feared was the spread of Roman Catholicism and of depraved European values in America. In this seagirt, semitropical boarding school, the sons of American colonists would be educated; and American Indians

too, who would go among their main-land brethren and inoculate them with Protestant doctrine before the wily Jesuits got to them.

This plan was widely (and deservedly) ridiculed, but Smibert—who was not doing well as a portraitist in London—jumped at the chance to be an art teacher in fabled Bermuda. He set off for Boston with Berkeley and his friends. In 1728, just before they sailed, one of the disciples, a future baron of the Irish Exchequer named John Wainewright, commissioned their group portrait from Smibert with a down payment of 10 pounds. This painting, known as *The Bermuda Group* (Figure 44) was to prove remarkably influential in the colonies. Once in Boston, Smibert did not hurry to finish it, since he was flooded with portrait commissions from notables who were delighted to have a "real"

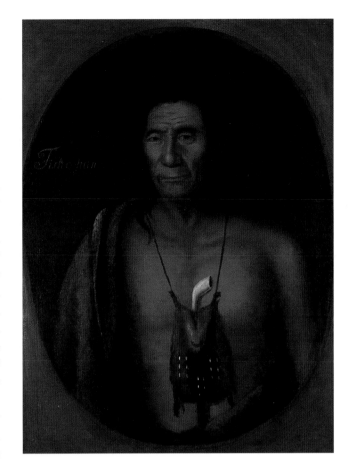

artist in their midst. But by 1730 it was plain to all that the Bermuda College was a pipe dream, and Smibert, seeing his fee evaporating with it, scurried to complete his large canvas—at nearly six by eight feet, the biggest group portrait yet done in America—before the group went back to England. Then he backdated it to 1729, probably to give Wainewright (who had stayed in England) the impression that it was finished before the plan was abandoned. To no avail. Wainewright did not want to be encumbered with so large a souvenir of the Bermudan embarrassment, and the picture stayed, unsold and unsalable, in Smibert's studio in Boston, where local artists had easy access to it. It became the prototype of American group portraits for the next half century.

Its scheme is a familiar, classic one: the sage expounding ideas to his disciples. We see a pause in the flow of words. Plump Dean Berkeley gazes over their heads, eyes raised in thought, and earnest John Wainewright—the next most prominent figure in Smibert's composition—writes his words of wisdom down in a ledger. Berkeley's wife, her baby son, and their traveling companion are at the table, which is draped in a Turkey carpet; the men in wigs behind them are Berkeley's rich young disciples Richard Dalton and John James; and Smibert, in his own brown hair, stands back on the far left, holding a rolled drawing. The back-

43. Gustavus Hesselius, *Tishcohan*, 1735. Oil on canvas, 33 × 25″ (83.8 × 63.5 cm). Historical Society of Pennsylvania.

ground colonnade is generic, and the landscape too. Smibert's skills at modeling, shading, and the realistic drawing of the human face were obviously far beyond those of earlier colonial artists. It is a recognizably professional picture, not least in the massing of the group, its distribution of narrative emphasis, and the way the figures are bathed in light and air.

You can see its immediate influence on a younger, American-born artist working in Boston, Robert Feke (c. 1705–c. 1750). In 1741 Isaac Royall, Jr., the son of Isaac Royall, got Feke to paint him with his sister, sister-in-law, wife, and child (Figure 45), all exactly rendered in their finery, the twenty-two-year-old patron with one hand on his hip (a sign of noble bearing) and the other with its index finger marking the place in a book (a sign of education). Feke's picture follows Smibert's, down to the books and the Turkey table carpet, but it lacks the trained English artist's suaveness. Its poses are wooden, effigy-like, and instead of tonal transitions, Feke relied on what he knew: the hard and relatively "primitive" outline drawing of the New England limner tradition. One can even see this in the carpet design, which is thrust forward and sharply enumerated. Feke is painting

44. John Smibert, *Dean Berkeley and His Entourage (The Bermuda Group)*, d. 1729. Oil on canvas, 61½ × 93″ (176.5 × 236.2 cm) unframed. Yale University Art Gallery; gift of Isaac Lathrop.

things in a row, A-B-C-D, and not trying for the interweaving of forms that Smibert had learned from baroque composition. Other painters saw *The Bermuda Group* too: its influence would extend to John Singleton Copley, and to Charles Willson Peale, both of whom apparently saw it in his studio after he died. The big picture, and other portraits by Smibert as well, would remain something of a talisman for such artists of the next generation, proving that they had to reach beyond the narrow repertoire, cramped ambitions, and lowly status of colonial portraiture and connect themselves—with much difficulty and not a little Yankee self-promotion—to the Anglo-European mainstream. To accomplish this, they had to cross the Atlantic and become expatriates. But they would not manage to do so until well after 1750.

45. Robert Feke, *Isaac Royall and Family,* 1741. Oil on canvas, 56¼ × 77¾″ (142.9 × 197.5 cm). Art Collection, Harvard Law School, Cambridge, Massachusetts; gift of Dr. George Stevens Jones, March 31, 1879.

2

THE REPUBLIC OF VIRTUE

The chief project of American culture before, during, and for years after the Revolution of 1776 was to graft pagan antiquity onto Puritan newness: to use what was old in a new way. Out of this came the state style of the American Revolution: neo-classicism. "We can no longer say there is nothing new under the sun," Thomas Jefferson wrote to Dr. Joseph Priestley in 1801. "For this whole chapter in the history of man is new. The great extent of our republic is new. Its sparse habitation is new. The mighty wave of public opinion which has rolled over it is new." But the matrix in which the New was to be embedded was that of classical Rome and Greece. "I should as soon think of closing all my window shutters, to enable me to see," declared Samuel Adams, the guiding spirit of the Boston Tea Party and organizer of the Sons of Liberty, "as of banishing the Classicks." Greek democracy and the Roman republic—emphatically not the later Rome of the Caesars—were the twin founts from which American political theory sprang. The term "neo-classical" was unknown to American artists and architects in the late eighteenth century: the term they used was the "true" or "correct" style, eternal in its validity and deriving from the ancients. The newness of the old lay in its power to abolish whatever was frivolous, luxurious, trivial—rococo, in a word. Early American republicans did not think in terms of *copying* antiquity, any more than Winckelmann or Canova did in Europe. Rather, one sought and understood its principles, grasped its essence, and brought that forward into the present. And the essence of antiquity was understood to entail a "noble simplicity and calm grandeur," in Winckelmann's phrase. Art, design, architecture, and literature should be didactic, stoic, and radiant with the values of restraint, self-sacrifice, and patriotism. "I think it of very great importance," wrote Gouverneur Morris to George Washington in 1790, advising him on how to furnish his presidential mansion,

46. John Singleton Copley, *Paul Revere*, c. 1768–70. Oil on canvas, 35 × 28½" (88.9 × 72.3 cm). **Museum of Fine Arts, Boston; gift of Joseph W., William B., and Edward H. R. Revere.**

to fix the taste of our country properly, and I think your example will go very far in that respect. It is therefore my wish that everything about you should be substantially *good and majestically plain,* made to endure.

Thus there was no real conflict between the values of American neo-classicism and those of the Puritan tradition; one flowed into the other, sharing a common radicalism. Creating a stoic, didactic style was not a problem in the already highly developed realm of American furniture. It was not so easy, but still entirely possible, for architects, on the basis of overseas experience and the ever-useful pattern books; indeed, it was in the Federal period that the time lag between Anglo-European and American architecture shrank from two generations to a matter of ten years. But painters had the worst problem of all. They were hampered by an unreceptive audience, and by an almost total lack of instructive models; they had to pull themselves up by their bootstraps from the limner tradition, making the past up as they went along. John Trumbull, America's first history painter, had to teach himself to paint in Boston in the 1780s by copying John Smibert's copies of Raphael and Van Dyck. The difficulties of self-education in the colonies can be gauged from the careers of the two men who brought American painting into its early maturity, and in a real sense founded an American school: Benjamin West and John Singleton Copley.

Benjamin West was the tenth child of a Pennsylvania innkeeper. He had little education and, even when president of the Royal Academy, could scarcely spell. He did, however, have an ego the size of a house, and his biographer John Galt, who knew West and allowed him to check his manuscript, records early portents and near miracles which West believed had marked him out for fame. A Quaker minister, seeing the terminally pregnant Mrs. West go into contractions, solemnly assured her that this could only mean the child was marked out for some special mission in life. Indians in the wild showed him how to collect and grind yellow and red pigment. At twelve, he announced that his talent would make him the "companion of kings and emperors." It did.

West really was talented, more so than any teacher he could have found in provincial America. By eighteen, entirely self-taught, with no serious works of art to look at except limner portraits, inn signs, and a few random engravings, he was getting work as a portraitist. He even essayed a history painting, a clumsily drawn, friezelike composition of *The Death of Socrates,* 1756. It caught the eye of the provost of the College of Philadelphia, Dr. William Smith. This divine saw that the young painter of Socrates had no Latin or Greek, and offered him instruction in the classics; this consisted mainly of pointing out to him stories in Livy, Plutarch, and Pliny that could serve as the source for history paintings. Thus Benjamin West moved to Philadelphia—his mother had died, and he had no more family responsibilities—and entered what was then the most progressive college

in America as the protégé of its head. He also, for the first time, met a well-regarded professional painter, John Wollaston, who had emigrated to New York from London in 1749 and left portraits from Virginia to Massachusetts. West copied Wollaston's skills—mainly in rendering the shimmer of silk and satin—and his mannerisms, the most prominent of which was to give all his subjects large almond-shaped eyes, which clients thought very chic. Dr. Smith's friends at the college believed they had a prodigy on their hands, and one of them, Francis Hopkinson (who would later design the American flag) addressed him in verse:

> *Hail, sacred Genius! may'st thou ever tread*
> *The pleasing path your Wollaston had led.*
> *Let his just precepts all your works refine,*
> *Copy each grace, and learn like him to shine.*

But it was clear to West that Wollaston's path, however pleasing, was a dead end. He had no chance of growth without studying the Old Masters, and in America there were none to be seen. The only European painting he had ever clapped eyes on was an image of Saint Ignatius by some follower of Murillo, which had turned up on a ship captured in American waters. He resolved to get to Europe, worked diligently to save the money, and embarked on the ship *Betty Sally* in 1760. He was twenty-two, and heading for Rome.

Any American in Rome was a novelty, and the idea of an American painter, fresh from the wilderness, must have seemed an oxymoron, a cultural chimera. Benjamin West was the first one to go there. Though he spoke hardly a word of Italian, he was quickly taken up by the cognoscenti and showed considerable shrewdness—for a Quaker boy in the capital of immoral plots and popery—in threading the social reefs. One story has become famous. West was introduced to the ancient Cardinal Alessandro Albani, the arbiter of artistic taste in the capital. The blind cardinal, who was expecting to meet a Red Indian, felt the contours of West's head and pronounced him to have *una vera testa da pittore*. It was then decided that he should be taken to see the Apollo Belvedere in the Vatican. Albani and West went there the next day, accompanied by a cloud of connoisseurs, eager to see what the American *naïf* would make of the figure which all agreed, in those days, to be the greatest surviving antique marble. It was kept in a sort of sentry box, and when the door was opened the lucky viewer would not uncommonly dissolve into tears: the sight was one of the climaxes of the Grand Tour. *Du musst dein Leben ändern,* "You must change your life"—the last line of Rilke's poem "An Archaic Torso of Apollo"—fits eighteenth-century reactions to the Apollo Belvedere. West did not weep, but he did not disappoint the Romans either. "How like a young Mohawk warrior!" he exclaimed, and launched into a disquisition on how the "strength, agility and grace" of the Native American,

the Noble Savage, recalled the ideal perfection of classical statuary; how Apollo, loosing his shaft at the dragon Python, reminded him of Indian archers following the flight of their arrows with their sharp gaze. Albani and the connoisseurs, West later recalled, were at first disconcerted and then thrilled by this insight.

Perhaps. Or perhaps not. West was not the first to compare the Apollo Belvedere to an Indian. That person was Johann Winckelmann, one of the founders of modern art history, who worked as Cardinal Albani's librarian and through him enjoyed unique access to the antiquities of Rome. In *Thoughts on the Imitation of Greek Art in Painting and Sculpture*, published in 1755, Winckelmann urged his readers to

> look at the swift Indian, as he hunts the stag on foot: how easily the blood courses through his veins, how supple and quick will be his nerves and muscles, how lithe his whole body! . . . [T]he bodies, free from superfluous fat, acquired the noble and manly contours the Greek masters gave to their statues.

Certainly West could not read German, but he knew Winckelmann; indeed, they became close friends. So it is not unlikely that in old age, he edited the conversation in front of the Apollo to make Winckelmann's sentiments his. What else

47. Benjamin West, *Agrippina Landing at Brundisium with the Ashes of Germanicus*, 1768. Oil on canvas, 64½ × 94½″ (163.8 × 240 cm). Yale University Art Gallery; gift of Louis M. Rabinowitz.

did he get from Winckelmann? Confirmation, certainly, of his moralizing cast of mind. As one of the founders of neo-classical art theory, Winckelmann hated rococo frills and fal-lals. Frankness and elevation were what he admired in classical art: "a noble simplicity and calm grandeur." He was puritan at heart (though homosexual), just as West was at root a Quaker. They were natural esthetic allies, and the older man (Winckelmann was forty-three when they met) greatly influenced the younger's thinking. So did the most admired artist of the emerging neo-classical school in Rome, another German expatriate, Anton Raphael Mengs. Mengs was only ten years older than West and, though an insipid artist to modern eyes, was considered the prodigy of new German painting. He mapped out West's Italian movements for him. First, he should stay in Rome and see the best things he could, drawing from the Antique. Then he must visit Florence, Bologna, Parma, and Venice, and come back to Rome to paint a major historical subject; for history painting, not portraiture, was the real test of an artist. West copied Mengs's paintings, along with works by Titian, Correggio, Domenichino, and Guido Reni. The Roman cognoscenti observed that he painted well but drew poorly. His limited draftsmanship inclined him toward simplified contour, lack of fluid uniting rhythms in the composition, and a general absence of *pittura graziosa*. But these were also the hallmarks of neo-classical style, and West's development under Mengs's influence is a striking example of how he could make virtues out of his limitations. One sees this in the history painting that capped his Roman experience and launched his English career, *Agrippina Landing at Brundisium with the Ashes of Germanicus*, 1768 (Figure 47).

West had left Italy and settled in London five years earlier, in 1763. His timing was perfect. The Royal Academy was about to be formed: an institution which, under the patronage of George III, was designed to give professional status to the visual arts, hitherto regarded by the English as the province of craft and trade. The man in charge of this ennoblement of his metier was Sir Joshua Reynolds, the first president of the Royal Academy, who took West under his wing. West exhibited three paintings at the 1763 exhibition of the Society of Artists, the precursor of the Royal Academy. They were praised—to the point where he was dubbed "the American Raphael." From this success came the commission from the Archbishop of York to paint *Agrippina*.

Agrippina fairly creaks with antiquarian correctness. Its story is from Tacitus: Germanicus, a great Roman general, was poisoned in Syria by agents of the emperor Tiberius, who feared him as a rival. His widow is seen arriving with the urn at the port of Brindisi, with her children (the future emperor Caligula, and a little daughter also named Agrippina, who was to be the mother of Nero) and her retinue, all dressed in mourning white. This group is based on an Augustan processional relief on the Ara Pacis, which West had sketched. The background ar-

chitecture is from Robert Adam's reconstruction engraving of the ruins of Dio-cletian's palace at Spalato. The temple which projects in from the left, establish-ing a minor chord of the Golden Section, is taken from Raphael; Poussin had used it earlier. Indeed, West may have thought of his painting as a pendant to Poussin's *Death of Germanicus;* later, while explaining it to King George III, he said he was surprised that Poussin, "who was so well qualified to have done it justice," had never tackled this subject.

The picture that cemented West's reputation was *The Death of General Wolfe* (Figure 48), which he completed in 1770 and exhibited, to a storm of applause, at the Royal Academy the following year. It was a history painting, but of a kind not seen before. Its story had unfolded only a decade earlier. It told of recent im-perial glory: the British army defeating the French at the battle for Quebec, in September 1759. At the height of the battle, the British commander, Major Gen-eral James Wolfe, was shot in the belly and slowly died. He lived long enough to learn that the French were on the run; his last words were, "Now, God be praised, I will die in peace."

West divided his painting into three groups. At the center Wolfe lies on the ground in the classical posture of the dying hero, his eyes turned upward, his con-cerned and grieving officers forming an arch above him which culminates in a bil-lowing standard whose skyward thrust indicates the impending trajectory of his soul. It also reminds one of the empty cross in a Deposition, linking Wolfe's body to the image of the sacrificed Christ.

The main figure in the left group is his second-in-command, Brigadier General Robert Monckton, his arm in a sling from a wound received in combat; with him are three officers, an American ranger scout (in the green coat and ornaments of Indian beadwork) who points dramatically backward and is bringing the news of the French retreat, and a pensive Indian squatting on the ground. On the right are two more figures, an English grenadier officer and his servant, wringing their hands at Wolfe's death. The grenadier's abandonment to grief is stressed by his embroidered hat, which has fallen unremarked to the ground while his long hair blows distractedly in the wind.

West went to great trouble with the details of uniform and weaponry, and he may have interviewed some of the identifiable figures, most of whom (including Monckton, whose portrait he painted in 1764) were still alive in 1770. Why, then, was *The Death of General Wolfe* so controversial and, in the end, so influ-ential? Why did it change the English sense of decorum in heroic commemora-tion, the idea of what history painting could do?

Because it was in "modern," late-eighteenth-century dress. Heroes required togas and other accoutrements of Antiquity; swords and javelins, not muskets and bayonets. Word of West's departure from this norm reached George III even as he was working on the painting, and the King warned him that "it was thought

48. Benjamin West, *The Death of General Wolfe,* 1770. Oil on canvas, 60 × 84½" (152.6 × 214.5 cm). National Gallery of Canada, Ottawa; transfer from the Canadian War Memorials, 1921 (gift of the Second Duke of Westminster, Eaton Hall, Cheshire, 1918).

very ridiculous to exhibit heroes in coats, breeches and cock'd hats." Reynolds came to the studio and tried to convince West that "the classic costume of antiquity" was to be preferred to "the modern garb of war," even when the subject *was* modern war. The American's retort was to become famous. "The event to be commemorated," he replied,

> took place on the thirteenth of September 1759, in a region of the world unknown to the Greeks and Romans, and at a period of time when no such nations, nor heroes in their costumes, any longer existed. . . . The same truth that guides the pen of

the historian should govern the pencil of the artist . . . but, if instead of the facts of the transaction, I represent classical fictions, how shall I be understood by posterity! I want to mark the date, the place, and the parties engaged in the event.

There spoke the Natural Man from the New World, pragmatic, realistic. Yet *The Death of General Wolfe* is very far from "the facts of the transaction" ten years before. If not a "classical fiction," it is certainly a modern one. Thus none of the officers who can be recognized in the painting, not even Monckton (West supplied a key list to their identities), were with Wolfe when he died—they were all busy, or lying wounded, on other parts of the confused battlefield. No American Indian was there, because none served with the British at Quebec: West's Indian is probably best understood as representing "natural nobility" pondering the nobility of Anglo-Christian, civilized sacrifice. Interestingly, West would later drop his documentary-truth defense of *The Death of General Wolfe,* which had become an icon by then anyway. "Wolfe must not die like a common soldier under a Bush," he declared. The painting should be "proportioned to the highest idea conceived of the Hero. . . . A mere matter of fact will never produce this effect."

There was no stopping West now. "I have undertaken to whele [wield] the club of Herculus," he wrote to a friend in 1771, in his execrable spelling. "In plain English I have imbarked in Historical painting. . . . I can say I have been so fare successfull in it that I find my pictures sell for a prise that no living artist ever received before."

West's English success, in contrast to his old life in America, is tellingly implied in a small conversation piece he began in 1772, *The Artist's Family* (Figure 49). It shows his father, John West, and his elder brother Thomas, over from America, wearing their sober Quaker garb. Their hands are clasped in their laps, to show they are meditating; soon they will doff their flat hats and resume family conversation. Compared to Benjamin West, his wife and children, they are like visitors from another planet. His wife wears an elegant turban; his older son, Raphael Lamar, is dressed in fine style, with a spreading collar and shiny buttons; and West himself, leaning over his father's back in a powdered wig and a dressing gown, is the complete Londoner, at the top of his professional tree.

West's friendship with George III determined his career. It began in 1768 when the monarch, liking *Agrippina,* commissioned from him a similar "history" of Regulus leaving Rome, impelled by duty to face torture and death at the hands of the Carthaginians. (There is a distinct irony in the fact that such scenes of Roman republican virtue were exactly what the American revolutionaries of 1776, and the French of 1789, would extol as an antidote to monarchy.) Over the next thirty years, West did more than sixty paintings for his king, and his career went badly downhill after 1801, when George lost interest in him and his work. So far was West from any sympathy with the American patriots that in

1776, the very year the Revolution began, he painted a full-length portrait of George with redcoat soldiers fighting an action in the background. (Still, he was nothing if not flexible: in 1783, with the Treaty of Paris that ended hostilities between England and America, West started planning a set of paintings commemorating the glories of the American Revolution.) No English painter, and few European ones, had ever been on such intimate terms with his sovereign as Benjamin West, and none would be again. George III would spend whole mornings in West's studio, discussing art and unburdening himself of the cares of state. The King, said the painter, was "the best friend I ever had in my life." It was West, as much as Reynolds, who got the monarch to give a royal charter to the new Academy, thus turning it into the most powerful association of artists in Great Britain and endowing it with an authority that it would not begin to lose until the end of the nineteenth century. The letters R.A. after an artist's name meant much for his career, and P.R.A. (president of the Royal Academy) much more; the first man to bear them was Sir Joshua Reynolds, and in 1792 Benjamin West became the second. He was immediately offered a knighthood, which he declined. Not because of some residual streak of Quaker humility—far from it. He thought knighthood was beneath him. His friendship with the King should make him a

49. Benjamin West, *The Artist's Family*, 1772. Oil on canvas,
20½ × 26¼″ (52 × 66.5 cm). Yale Center for British Art,
New Haven; Paul Mellon Collection.

peer. But he never got the expected ermine, and died a commoner. This did nothing to ruffle West's self-esteem.

Established as England's chief history painter, he produced all kinds of histories. He looked back to his Quaker origins and painted *Penn's Treaty with the Indians*, 1771 (Figure 50), the most Poussin-like of all his compositions; his father's face is visible, third from the left in the group of Quakers. He did sea pieces full of Rubenesque billow and rhythm, like *The Battle of La Hogue*, c. 1775–80, and fifteen-foot-wide scenes of medieval battle and chivalry—part of a lucrative commission for Windsor Castle—such as *Edward III Crossing the Somme*, 1788.

As if the production of grandiose historical "machines" were not enough, West also aspired to religious painting on a Michelangelesque scale, and the King encouraged him in this by giving West the largest royal painting commission since Rubens had decorated Inigo Jones's Banqueting House in Whitehall: some thirty-six pictures of religious subjects, for the royal chapel in Windsor Castle. Earlier, West had audaciously proposed decorating St. Paul's Cathedral, but this plan was rejected by the Bishop of London, on the grounds that it smacked of popery. But Windsor was a private chapel, and West labored from 1779 to 1801 on a series whose theme was nothing less than, as he put it, "the progress of Revealed Reli-

50. Benjamin West, *Penn's Treaty with the Indians,* 1771.
Oil on canvas, 75½ × 107¾" (192 × 273 cm). Pennsylvania
Academy of the Fine Arts, Philadelphia; gift of Mrs. Sarah
Harrison (The Joseph Harrison, Jr.,Collection).

gion from its commencement to its completion," starting with Genesis and ending with the Apocalypse of Saint John.

Few of the paintings were actually finished, and none were installed, though some of the larger ones have since gone to their long home in the memorial chapel of Bob Jones University, a fundamentalist college in South Carolina—not at all what West had in mind. The tone of the project can be gauged from one of the finished sketches, *Death on the Pale Horse*, 1796 (Figure 51), illustrating Revelation 6:8: "And behold a pale horse: and his name that sat on him was Death, and Hell followed with him. And power was given unto them over the fourth part of the earth, to kill with sword, and with hunger, and with death, and with the beasts of the earth." With liberal quotations from Rubens, West turned this into a phantasmagoria that joins the wildest scenes of English Romanticism, from Henry Fuseli to "Mad" John Martin; it is kitsch, but sublime kitsch, and its emotional fortissimo (is there another eighteenth-century painting with so many flaring nostrils and flashing eyeballs?) would appeal to French Romantics as well. Working on *The Death of Sardanapalus* thirty years later, Delacroix jotted on one of his preparatory drawings a reminder to "study the sketches of West." The Pennsylvania Yankee at King George's court had come a long way from the neoclassical style that first lodged him there. West's embrace of Rubens was a remarkable act of self-reinvention. Once again, he was at the forefront of a new style. His timing, culturally speaking, was perfect. Politically, it was not. This upsurge of the irrational and demonic in West's work did not please Queen Char-

51. Benjamin West, *Death on the Pale Horse,* 1796. Oil on canvas, 23³/₈ × 50⁵/₈" (59.5 × 128.5 cm). The Detroit Institute of Arts; Founders Society Purchase, Robert H. Tannahill Foundation Fund.

lotte, who feared that it would worsen the encroaching madness of her husband. The commission for the chapel was canceled in 1801. Nor did West please George III by showing *Death on the Pale Horse* in Paris, where Napoleon himself wanted to buy it—thus fulfilling the second half of West's childhood prophecy about himself, since, having consorted so long with a king, he had now attracted the attention of an emperor. But emperor and king had just emerged from a draining and terrible war with each another, and when West returned to London singing the praises of Napoleon as art patron, they fell on cold ears at court. West was so blinded by the effulgence of his own self-esteem that he did not quite grasp how people, in the real world, bore grudges against one another for wars and revolutions. In 1800, having served George III for thirty years, he sent a design to Thomas Jefferson in America with the suggestion that he, only he, could create a suitable memorial to George Washington. The second Vice President of the United States did not respond. Perhaps, for once in his life, Jefferson was at a loss for words.

West continued to work almost until his death in 1820. Large historical and religious commissions were no longer coming to him, but he painted them for private exhibition and both his prices and his popularity stayed high. In 1811 he sold a *Christ Healing the Sick* for 3,000 guineas—this at a time when Velázquez's *Rokeby Venus* was acquired for about a thousand!—and he is said to have refused 10,000 guineas for the enormous *Christ Rejected* in 1814. When this painting, his last elephant, twenty-one feet across, went on exhibition in London, nearly a quarter of a million people paid a shilling apiece to see it. This must have gratified West: it was proof that he had achieved a genuinely public art which no longer needed royal patronage. No matter that his stock had slipped badly with the intelligentsia. William Hazlitt witheringly observed that he was great, "but only great by the acre"; and Lord Byron, furious that West had campaigned for the British Museum to buy the Parthenon Marbles from Lord Elgin, guyed him as "the flattering, feeble dotard West / Europe's worst dauber, and poor England's best."

But he could not be written off as a mere *pompier*. Part of West's strength was that he had always stayed open to the times, to new art: he was simply too convinced of his own standing as "the English Raphael" to oppose the up-and-coming. He admired William Blake, for instance, and was one of the first to recognize the genius of Turner (though he later repented of this). John Constable never forgot West's advice: "Always remember, sir, that light and shadow *never stand still.*" Especially, he never failed to give a helping hand to American artists in London. England had no painting school (the Royal Academy taught only drawing), and Benjamin West's studio did duty for one. Young Americans flocked to it, and one of them, Matthew Pratt, recorded their presence in *The American School*, 1765 (Figure 52), diligently absorbed in their work, with West himself

supervising them on the left. West advised and trained three generations of American artists: Matthew Pratt (1734–1805), John Singleton Copley (1738–1815), Charles Willson Peale (1741–1827) and his son Rembrandt Peale 1778–1860), Ralph Earl (1751–1801), Gilbert Stuart (1755–1828), John Trumbull (1756–1843), Washington Allston (1779–1843), Thomas Sully (1783–1872), Samuel F. B. Morse (1791–1872), and a dozen others. If anyone deserves to be called the father of American painting, that man is surely Benjamin West.

Of the artists who owed their career in part to West, John Singleton Copley was the most important. He was also the same age as West, and, like him, entirely self-taught. However, Copley had little of West's serene belief in his own genius; he was rather a timid man, and poor at self-promotion. His time in America lasted much longer than West's, and his finest achievements as a portraitist belong to it. He left for England on the eve of the American Revolution in 1774, when he was in his mid-thirties. He never came back.

Copley's parents were poor Irish immigrants from County Clare, who came to Boston in 1736. His father died a few years later, leaving his son and his widow Mary; she had a tobacco shop on the Boston waterfront, and in 1748 married an engraver named Peter Pelham, who died after only three years, when the boy was twelve. Pelham's own son, Henry Pelham, became an engraver too, and the Pelham shop was the only place where young John Singleton Copley had any exposure to the craft of image-making. There were no art schools in Boston, of course, no public collections, and very little to see in the way of accomplished painting.

52. Matthew Pratt, *The American School,* 1765. Oil on canvas, 36 × 50¼" (91.4 × 127.6 cm). The Metropolitan Museum of Art, New York; gift of Samuel P. Avery, 1897.

As a result, Copley had to pull himself up by the bootstraps, in an environment whose esthetic provinciality is unimaginable anywhere today. Decades later, his own son, Lord Lyndhurst, would recall that his father "was entirely self-taught, and never saw a decent picture, with the exception of his own, until he was nearly thirty years of age." In 1767 Copley would touchingly observe that "painters cannot Live on Art only, tho I could hardly Live without it." "In this Country as You rightly observe," he had written to West in London the year before, "there is no examples of Art, except what is to [be] met with in a few prints indiferently exicuted, from which it is not possable to learn much." In Boston, he complained, people only judged portraits as effigies; the sole criterion was likeness to the sitter. Their qualities as painting went unremarked. America had no public institutions, like the Royal Academy in London, to dignify an artist's work as professional. "The people generally regard it as no more than any other useful trade, as they sometimes term it, like that of a Carpenter, tailor or shew [shoe] maker, not as one of the most Noble arts in the world. Which is more than a little Mortifying to me." Lacking informed criticism, how could an artist grow? A portraitist could be the wonder of Boston, but nothing in the larger world. Such was Copley's dilemma, and he set out to resolve it by painting a demonstration piece and sending it to experts abroad.

This was *Boy with Squirrel*, 1765 (Figure 53). Its model was his sixteen-year-old stepbrother, Henry Pelham, whose image he idealized—lost in reverie in front of a red curtain, his eyes slightly raised like a Guido Reni saint as he toys absently with a gold chain. The other end of the chain is attached to a tame squirrel, nibbling on a nut—not an ordinary European one but an American exotic, a flying squirrel. Everything in the painting is a show of skill. The mahogany tabletop with its white thread of highlight projects toward your eye at an angle, inviting you in. Each link of the gold chain gets its weight of scrutiny. There is a glass of water, to show how well he could paint transparency. The pink collar picks up its deeper tones from the red curtain and reflects them up into the fresh skin of the face. The young American knows his business. He also may have known Chardin, through prints: there is a similarity between the sitter's absorption in

53. John Singleton Copley, *Boy with Squirrel (Henry Pelham)*, 1765. Oil on canvas, 30¼ × 25" (76.8 × 63.5 cm). Museum of Fine Arts, Boston; anonymous gift.

thought and the entranced inwardness of Chardin's boy looking at a spinning top on a table. Intelligent youth, alert but not yet imprinted by the callused thumb of the world: a discreet Enlightenment message.

Who could give him professional judgment? Copley, emboldened by Benjamin West's success, went right to the top. He sent *Boy with Squirrel* to the Society of Artists' annual jury in London, through a seagoing friend, Captain Bruce, who reported Sir Joshua Reynolds's reaction to it back to the anxious young artist in Boston. Reynolds could hardly have been more encouraging. He urged Copley to cross the Atlantic at once. In America his "genius" would not flower, but "with the advantages of the Example and Instruction which you could have in Europe,"

> you would be a valuable Acquisition to the Art, and one of the first Painters in the World, provided you could receive these Aids before it was too late in Life, and before your Manner and Taste were corrupted or fixed by working in your little way in Boston.

The main criticism from the London connoisseurs who saw it, as Benjamin West pointed out to him in a letter, was that the painting seemed too "liny," harsh and emphatic in outline, without enough of the full modeling of form that the high manner of painting required: it was "impossible that nature, when seen in a light and shade, can ever appear liny." But West also urged him to come. "Nothing is wanted to perfect you now but a sight of what has been done by the great masters, and if you would make a visit to Europe for this purpose for three or four years, you would find yourself then in possession of what would be highly valuable. . . . You may depend on my friendship in any way."

This, one might have thought, would have been enough to make any ambitious young artist grab a berth on the next ship out of Boston Harbor. Not Copley. Nervous and indecisive by nature, he was doing well in Boston, making 300 guineas a year from portraiture, "as much money as if I were a Raphael or a Correggio," the equivalent in spending power of a thousand a year in costly London. In Boston he had no real competition. He was already, at twenty-eight, the one big fish in a tiny pond. In London he would be a sprat in an ocean of talent and, he candidly wrote to his friend Captain Bruce, "I cannot think of purchasing fame at so dear a rate." And, he hemmed and hawed, what would he do with his newfound skills when he got back to America—"bury my improvements among people entirely destitute of all just ideas of the arts"? So he hung back. Copley stayed in the colonies another nine years, until the summer of 1774, almost the eve of the American Revolution. In 1769 he gave himself an even stronger reason to stay by marrying Susannah Clarke, daughter of Richard Clarke, a rich Tory merchant and an agent for the East India Company. Soon Copley was able to invest 3,000 pounds in a twenty-acre farm astride Beacon Hill and start building a

mansion on it. Entering this Boston nabob's family clinched his career; now the Irish tobacconist's boy was at the same social and financial level as his sitters, and he was deluged with commissions. He became the first American painter to really prosper on his home ground.

To West and Reynolds, Copley's decision to shy away from London's open door must have seemed a failure of nerve. So in a sense it was. But artists, like sleepwalkers, sometimes take the right turn for inexplicable reasons, and so it was with Copley. The "liny" style of his "little way in Boston" turned out, in the end, to be the very basis of his best achievement as a painter: the hard, unfussed, uningratiating realism of his portraits, which make up a unique record of the men and women who formed America from the top in the third quarter of the eighteenth century. Copley took the linear, enumerative style of American effigy painting and made it grand—not through rhetoric, as in the "Grand Manner," but in the candor of its empirical curiosity. We can now see Copley's work as the origin of one of the main lines of American art—that empirical realism which, disdaining frills of style and "spiritual" grace notes, tried in all its sharpness and bluntness to engage the material world as an end in itself. Later figures in this line would be James Audubon and Thomas Eakins.

Copley, particularly when young, was a slow and earnest worker. He wanted to get everything right, from the shading on an eyeball to the sluggish flow of light over a woman's broad silk skirt. In his candor and curiosity, he did not edit out the warts and wens, the pinched New England lips, the sallow skin, or even (as several portraits show) the pockmarks which were the common disfigurement of an age before vaccination. Eighteenth-century America did not have today's obsession with the cosmetic.

His clients complained, in a chaffing way, about the tedium of sitting for a painter with so little facility. Sarah Mifflin remembered how Copley needed twenty sittings for her hands alone. But this patient and scrupulous address to visual fact cut out all generalizations, and gave his portraits of Americans a density seldom seen in America before. He thought in terms of fully comprehensible shapes and broad areas, each separate and distinct. His way of painting was geared to the particular structure of things. To oblige his clients, however, he learned the tricks of the "swagger portrait" early: in 1764 he painted Nicholas Sparhawk, a robust merchant from Kittery, Maine, in a pose copied from Allan Ramsay's portrait of George III (widely known in the colony through engravings), in front of an entirely fictional staircase and arcade whose Italianate splendors resembled nothing ever built in Maine. His portraits of the business grandee Jeremiah Lee and his wife are almost absurdly opulent, in their contrast between the mundane portly flesh and the imagined gilt and marble around them. The closest he came to the rococo sparkle of English portraiture was in his 1767 portraits of Nicholas Boylston (Figure 54), Boston's biggest luxury-goods importer—

54. John Singleton Copley, *Nicholas Boylston,* 1767. Oil on canvas, 49¼ × 39⅛" (125 × 99.5 cm). Harvard University, Cambridge, Massachusetts; bequest of Ward Nicholas Boylston, 1828.

blue-chinned, sharp-eyed, and relaxed in his morning panoply of damask dressing gown, unbuttoned waistcoat (showing the careless ease of the gentleman), and velvet turban. His ships ply the sea behind him, and his arm rests on an account ledger. Indeed, Copley's portraits *were* a form of visual accountancy, an enumeration of material things, from nailheads in a chair to the highlights on a silver teapot; his clients, the leading figures in Boston's mercantile ascendancy, liked his style because it was embedded in the world of substance, lists, and inventories that had made them what they were.

Copley's portraits of Boston's Tory ascendancy were not the whole of his work, though they were the most lucrative part of it. He also painted some of the men who, in the 1760s and early 1770s, were preparing the coming Revolution. One of these was the silversmith Paul Revere, whose portrait by Copley, done c. 1768–70, is one of the icons of American identity (Figure 46, page 69).

In point of fact, Copley painted it well before Revere's night ride from Boston (in 1775, to warn the patriot troops at Lexington and Concord that the British were coming) carried him into history and thence into legend. But Revere was already a well-known political figure in Boston. Active in the group that called itself the Sons of Liberty, he was a vital link between the intellectual leaders of what would become the American Revolution and the working-class people—artisans, small shopkeepers—whose dissatisfactions they spoke for. Revere also etched the most famous broadsheet in American history—the scene of that much-exaggerated event the Boston Massacre of 1770, a minor, botched police action by English troops who panicked under a rain of cobblestones from a hostile crowd near the Old State House and fired their muskets, killing five citizens, including a free black named Crispus Attucks.

Copley's portrait of Revere is a manifesto of democratic American pride in work. The radical as craftsman. No finery here. He sits in his shirtsleeves, holding his chin in thought, fixing the viewer with a bland stare. He is holding one of his own products, a silver teapot, which is poised above the work rest (a brown cushion which would have been filled with sand) on the mahogany table. Three engraving tools lie on the table. Copley's design edits out workbench clutter to emphasize two virtuoso passages of painting: the reflections of Revere's fingers and the glaring window in the teapot's polished silver, and the structure of folds in his white shirt, which reads as vividly against the dark background as a passage in Zurbarán. Compared to this, the treatment of Revere's head is rather wooden, although the assonance between its big smooth mass and that of the teapot (Hamlet holding the skull of Yorick, one thinks for a moment) is surely meant to remind us of the identity between the craftsman and his work.

Another of Copley's Revolutionary sitters was Samuel Adams (1722–1803), the populist stirrer whose writings, from 1765 onward, pointed the way to the Declaration of Independence. Adams would rise to become Governor of Massa-

chusetts in the 1790s, but Copley painted him in his firebrand days c. 1772, seen in the act of confronting Thomas Hutchinson, the Royal Governor of Massachusetts, over the Boston Massacre (Figure 55). (The portrait was commissioned, not by Adams, but by his friend the Whig merchant John Hancock—he of the signature.) This portrait is much more expressive than the Revere. We see him, as it were, through Hutchinson's eyes: a tight-lipped "Jacobin," all Calvinist fervor and republican principle, pointing with one rigid finger at the charter given the Massachusetts colony by William and Mary while gripping a screed of protest from Boston citizens in the other hand. The Caravaggesque drama of the image (not that Copley had ever seen a Caravaggio) comes from the extreme con-

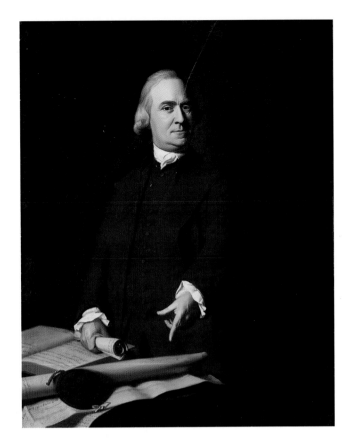

trast between Adams's highlit hands and head and the darkness of his clothes and background. *Samuel Adams* is Copley's only painting to show a political figure engaged in conflict. Even so, it is impossible to tell from it where Copley's own political sympathies lay: with the common citizenry that he came from and Adams spoke for, or with the Tories (including Copley's own father-in-law), who detested Adams as a tribune of the "mob."

Perhaps the finest of Copley's family portraits is that of Mr. and Mrs. Thomas Mifflin, done in 1773 (Figure 56). Thomas Mifflin (1744–1800) was a well-off young radical Whig of Quaker origins, a merchant who would become George Washington's aide-de-camp and, after the Revolution, the Governor of Pennsylvania. His wife, Sarah Morris, came from a distinguished Boston family. Their double portrait is very sober in color—browns, grays, and silver, the only bright note being a tiny red flower pinned to Mrs. Mifflin's bodice. Neither of these young people is done up to the nines: Mifflin is at home, "in his own hair," quite unlike the conspicuous self-display of the Boylstons. What interests a modern eye is the relationship between man and wife that Copley recorded. Conventional eighteenth-century portraiture had the wife looking admiringly at the husband, who looks at the viewer; the inferior deferring to the superior being. Not here: it is Sarah Mifflin who occupies the foreground and fixes us with a composed, level,

55. John Singleton Copley, *Samuel Adams,* 1772. Oil on canvas, 50 × 40¼" (127 × 102.2 cm). Museum of Fine Arts, Boston; deposited by the City of Boston.

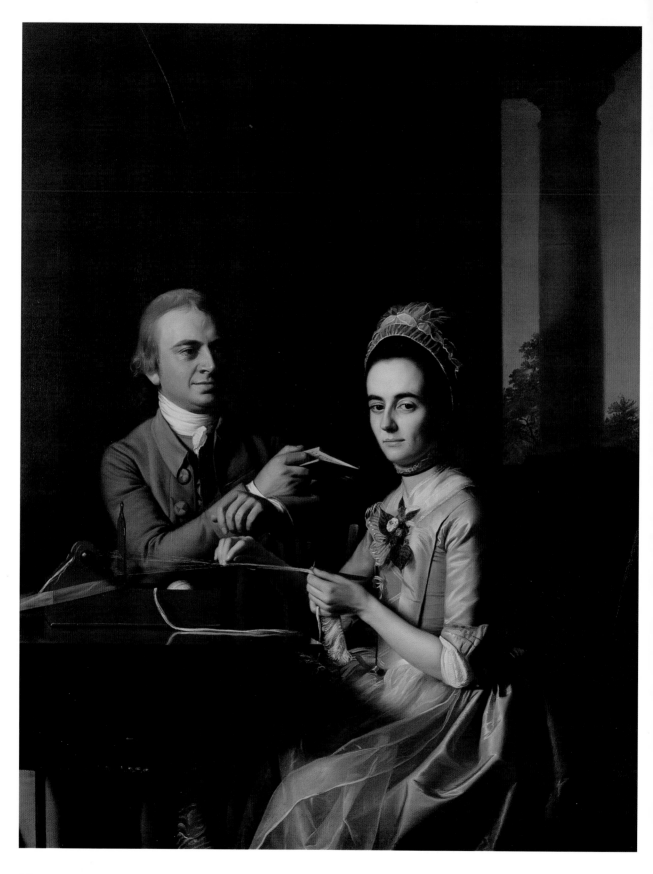

and perhaps slightly interrogatory gaze, while Thomas Mifflin looks at her with a manifest pride and love that are, however, very far from proprietary complacency. It is a beautiful reflection of Enlightenment ideas about the necessary equality of man and wife in a voluntary contract. This feeling is underlined by a subtle device of Copley's. Thomas Mifflin has been reading and he holds the book closed, with a finger in it to mark the place. This creates a small wedge of white, where the pages show. Sarah Mifflin is weaving a fringe on a small mahogany handloom. Its threads produce a similar triangle, a visual rhyme which subliminally equates her occupation, and her self-improvement, with his. One realizes that Copley, out of the supposed poverty of means available to a painter in America then, had created a counterpart to the plain didactic neo-classical style which was just coming into focus on the Continent: his Mifflin portrait is to American art what Jacques-Louis David's portrait of the Lavoisiers was to French painting, and it radiates very similar values: earnestness, probity, equality, set forth within the microcosm of marriage, an Ideal Republic of two.

Shortly after finishing it, in 1774, Copley made his long-delayed voyage to England and thence to Italy. The Mifflin portrait mattered so much to him that when in Rome he actually found its virtues in Raphael's *Transfiguration:*

> He has painted [it] with the same attention that I painted Mr. Mifflins portrait and his Ladys, in that determined manner he has painted all the heads, hands, feet, Draperys, and background, with a plain simple body of Colours and a great precision in his outline, and all parts of it from nature.

By this Copley did not, of course, mean to place himself on a par with Raphael; he intended only to record his pleasure in finding an approach which could be compared to his own: that his "liny" style was sanctioned by the past.

There is no mystery about why Copley left. His position as a social portraitist in Boston was threatened by the political climate. The Revolution was beginning to boil up. The Boston Tea Party of 1775 had shown how fierce popular sentiment was against the Tories—including his in-laws, the Clarkes. (Much of the tea that the rebels, disguised as Mohawk Indians, threw into Boston Harbor had been imported by Richard Clarke, and Copley himself played a small but ineffectual role in negotiating with the "violent Sons of Liberty" over British tea duties.) In the past he had been able to paint both Whigs and Tories, but no longer; and there would be no living for a painter in a colony convulsed by civil war. Already the more extreme Whig patriots held him suspect because he was a pacifist who did not believe in revolution by violence: a Tory hanger-on. In his more timid moments, Copley feared that his family would be murdered, his house put to the torch; but he cannot have been too certain of that, because he sailed to England on his own, leaving his invalid mother, his wife, and their children in Boston.

56. John Singleton Copley, *Mr. and Mrs. Thomas Mifflin (Sarah Morris),* 1773. Oil on ticking, 61 × 48″ (154.9 × 121.9 cm). The Historical Society of Pennsylvania, Philadelphia.

Much has been made of Copley's cowardice in running from the Revolution: how un-American of him! True, no doubt, but like many colonials Copley saw the affair as a civil war, the outcome of pigheadedness and botched policy on both sides, and not the "marvellous event" it later became.

He went to Italy and succumbed to esthetic indigestion, caused by stylistic overeating. He saw the work of Pompeo Batoni, that fluent (and often vacuous) recorder of the costume and features of *gli signori inglesi* on the Grand Tour, with the Colosseum or the Arch of Titus in the background and a drawing in hand. Naturally, when a rich young American couple called Izard engaged him to do their double portrait, Copley went all out for Batoni's effects. If *Architectural Digest* had existed in those days, the Izards would have been its dream pair (Figure 57), ensconced among the trophies procured from this and that antiquarian. On the ledge above Ralph Izard's head, an Athenian red-figure krater; between them, a gilded table with swags, masks, and a highly polished porphyry top, which gave Copley ample scope for his signature reflections; in the distance, the inevitable Colosseum. Izard is passing to his wife a drawing after the antique sculpture group in the background, depicting Orestes and Electra; perhaps this drawing will be the *donnée* for a copy, to be installed in their garden back in Virginia. It is a skillful painting, but compared to the inspired straightforwardness of his earlier American work it is stilted. Copley did not have the temperament for the Grand Manner rococo portrait, and although he produced many of them in England throughout the rest of his life, and some are not without esthetic interest, the core of his vision remained in New England, to which he was never to return. He also nourished a desire to create large historical paintings rivaling those of Benjamin West, and he enjoyed a spectacular public success with *The Death*

of Chatham, commemorating the moment when Pitt the Elder, Earl of Chatham, was felled by a stroke while speaking in the House of Lords. He exhibited it privately, in a hired gallery; twenty thousand people paid to see it, and it outdrew the annual Royal Academy exhibition, much to the rage and jealousy of English artists. He went on to paint other huge historical subjects, including a *Repulse of the Floating Batteries at Gibraltar*, finished in 1791, which measured fully twenty by twenty-five feet: one might say that the American fondness for painting excessively large

57. John Singleton Copley, *Mr. and Mrs. Ralph Izard (Alice de Lancey)*, 1775. Oil on canvas, 69 × 88½" (175.3 × 224.8 cm) unframed. Museum of Fine Arts, Boston; Edward Ingersoll Browne Fund.

canvases, which was to become so irksome in the 1960s and later, was born with Copley. And yet the only one of his "histories" which still commands one's attention today was finished much earlier, in 1778. This was *Watson and the Shark* (Figure 58).

It is a peculiar sort of history painting, because unlike West's *Death of General Wolfe*, or Copley's own later historical essays, its subject had no public import at all—though it meant a lot to the man who commissioned it, a London merchant named Brooke Watson. In 1778 Watson was a man of consequence—an MP and a director of the Bank of England, who would later become Lord Mayor of London, chairman of Lloyds, and a baronet. But he was wholly self-made and regarded his life, with some justice, as a triumph over adversity.

Watson was an orphan. Born in 1735, he had been sent to Boston as a child, under the wing of a relative named Levens who had, as the phrase went, "inter-

58. John Singleton Copley, *Watson and the Shark,* 1778. Oil on canvas, 72 × 90¼″ (182.9 × 229.2 cm). Museum of Fine Arts, Boston; gift of Mrs. George von Lengerke Meyer.

ests" in the Caribbean—chiefly, trading in tea and slaves. He was fourteen, and in the crew of one of Levens's ships in Cuba, when the incident occurred.

As the craft rode at anchor in Havana Harbor, Watson went swimming over the side. He was about two hundred yards from the ship when a shark attacked him and dragged him under. The crew of the ship's launch, which was waiting to take the captain to shore, cast off and rowed frantically toward the spot where the boy had disappeared. They saw him surface, disappear again, and bob up for a second time. The shark was making its third run at Watson when the crew drove it off with a boathook and pulled the mauled boy over the gunwale. Miraculously—Watson's right leg was first stripped to the bone from the calf down, and then bitten off near the ankle—the lad survived, though the ship's surgeon had to amputate below the knee.

Watson, in later life, thought of this as providential. He had been snatched, literally, from the jaws of death, thus enacting one of the commonest tropes in the literature of religious salvation. He was the errant soul saved from the Devil; he was Jonah, delivered from the whale. His life turned. Crippled, he could no longer go to sea. He became a merchant, and a very successful one, making a fortune from the usual goods of the Triangle Trade: slaves and slaving supplies, rum, sugar. When Watson died, he left Copley's painting to Christ's Hospital in London, a charity school for orphans and poor children; his will desired its governors to "allow it to be hung up in the Hall of their Hospital as holding out a most usefull lesson to Youth." One should thus think of *Watson and the Shark* as a moral allegory, with overtones of a traditional ex-voto.

Copley had never seen a shark; the one he painted has the wrong shape of pectoral fins, no gills, an incorrectly formed mouth, and ears. In all likelihood he was working from the preserved jaws of a shark, a commonly seen object then as now: this would account for the "lips," which sharks do not have. The rest of the creature he made up. It is influenced by the kind of generic representations of Leviathan, the biblical monster of the deep, that Copley would have seen in baroque engravings. It is also—a pedantic fisherman might object—much too large for a Caribbean shark, at least twenty feet long, a size only reached (and that, rarely) by *Carcharodon carcharias,* the Great White: but Copley wanted to make a monster, and he did.

Some of the human actors in the drama are taken from art-historical sources. The figure of Watson, pale in the turbid water, is a Roman sculpture whose form was widely circulated in prints, the Borghese *Gladiator,* turned on its back. The men in white shirts, lunging over the gunwale, are adapted from a print by Philippe Tassaert after Rubens's *Jonah Flung Into the Sea.* Copley also borrowed from Raphael's *Miraculous Draft of Fishes,* which he may have seen in the British royal collection (through the good offices of George III's favorite, Benjamin West) and which was, in any case, widely circulated in engravings.

But the originality of *Watson and the Shark* rises above its quotations, which were the common coin of an eighteenth-century artist's practice anyway. Its composition is a triangle, the base formed by the shark and Watson, the apex supplied by the head of the black crewman who stands in the launch, one hand extended in a gesture of amazement, the other holding a line which trails over Watson's arm. The black sailor's outstretched arm parallels Watson's white arm, rising from the water. For the first time an American artist depicted a black man on equal terms of will and action with whites, without the slightest tone of demeaning caricature. This would not happen again for nearly a century—in the paintings of Winslow Homer. He is as striking, full, and dignified a presence as the black castaway who acts as a similarly climactic figure in Géricault's image of maritime terror, *The Raft of the Medusa*. Who was the model? Nobody knows; it may have been a "servant"—for which read slave—in Copley's own household, though no record of such a person exists. One of Copley's studies for the figures in the boat shows this climactic figure as a white, but shortly after that Copley painted a portrait head of an African who, though smiling rather than registering horror, is probably the same man. Presumably, then, both Copley and Watson agreed on the change.

Why? Art historians, seeking a political meaning for the image, have claimed that *Watson and the Shark* is a polemic against slavery. But this is unprovable, since we know nothing of Copley's views on slavery (which was still legal in England, as in America) and Watson himself was not only pro-slavery but profited greatly from the slave trade—he brokered shipments of "refuse-fish" (low-grade, reject salt cod) to Caribbean planters as slave-food in exchange for rum. It has also been suggested that Watson's severed leg symbolized the loss of trade that would follow American independence from Britain. This seems strained. None of the reactions to Copley's painting when it attracted admiring notice at the Royal Academy in 1778 indicate that its viewers interpreted it that way—even though such images of dismemberment were common in political cartoons. Sometimes, to paraphrase Dr. Freud, a leg is only a leg, not a colony. The black sailor does not "symbolize" anything. Most likely, he is in the picture because Watson remembered a black sailor throwing him a line. Both Watson and Copley meant the big painting to be a moral spectacle based on personal salvation, not a political allegory. "I avoid engaging in politics," Copley once wrote to his wife, "as I wish to preserve an undisturbed Mind and a Tranquillity inconsistent with political disputes."

With Copley gone, painting in eighteenth-century Boston returned to mediocrity. The city's prosperity declined badly after the Revolution, as did its political importance once the new Republic was proclaimed. The center of that republic,

where its first Congresses sat and the Constitution was written, was Philadelphia; and Philadelphia's ascendancy in the arts was largely due to one man, who founded a cultural dynasty: Charles Willson Peale (1741–1827).

Peale was the son of a crook—a Cambridge-educated London dandy who embezzled the impressive sum of 1,900 pounds and, reprieved from the gallows by the influence of friends, was transported to Maryland and found work as a schoolmaster. He died when his son was eight, and young Charles Willson Peale had to fend for himself with homemade schooling, learning the rudiments of one trade after another: saddlery, metalwork, watch repair. Then he happened on the trade of painting, in which he got a little instruction in Annapolis from John Hesselius, the son of the Swedish portraitist Gustavus. This was the blind leading the blind, but young Peale, with the pragmatic optimism that always sustained him, went right on—painting a face could be learned like any other craft skill. He did not see the work of a real portraitist until, after he got north to Boston in 1765— leaving behind a mountain of debts and writs and a pregnant wife in Maryland, and protesting his sobriety and innocence all the way—he fetched up in a colorist's shop that was owned by the nephew of the late John Smibert. Upstairs was a room full of Smibert's paintings, including *The Bermuda Group*. Peale was both dazzled and frustrated. It was his first glimpse of professional painting; but the man who might have inducted him into its mysteries was dead. Instead, he got an introduction to Copley. Through Copley, presumably, he heard of Benjamin West. And by 1766 he had talked the governor of Maryland and a group of merchants on his council to form a syndicate to send him to London, where he arrived at the year's end, marveling at the shipping in the Thames: "Their masts appeared to me like a forest in America." At last he had exchanged Nature for Culture. He made a beeline for West's studio.

West received him kindly, saw quite a lot of him over the next two years, and pushed a little work in his direction, but Peale's main effort during his stay in London was a commission from a group of Virginia planters, led by Richard Lee. They wanted a portrait of William Pitt, Earl of Chatham.

Why Pitt? Because he had led the House of Commons to repeal the Stamp Act, the chief English thorn in the side of American business. Every transaction requiring printed paper was taxed and the proceeds (collected in hard currency, of which the colony was short) went straight back to England. Americans naturally saw this as exploitation, and viewed Pitt as a hero for putting an end to it.

Peale's image of Pitt was conceived in the abstract, allegorized, classical mold of West's work at the time. Pitt did not pose for it, of course, and Peale made it up from engravings, loading it with a plethora of symbolic attributes (Figure 59). Here is Pitt dressed as a consul of the early Roman republic. His left hand holds the Magna Carta and his right gestures to a statue symbolizing British liberty, with her liberty cap on a pole. On a pedestal below is an American Indian next

to a dog, showing, Peale explained, "the natural *Faithfulness* and *Firmness* of America," and thus reflecting the Anglophilia of his Virginian patrons. A sacred fire burns on the altar in front of Pitt, and on this altar, linked by a swag of laurel, are the carved heads of two British liberals who defended common rights in the seventeenth century, Algernon Sidney (who, having fought against Charles I and then refused to give pledges to Charles II at the Restoration, died in exile) and John Hampden (whose refusal to pay ship money to Charles I helped to set off the Civil War). Behind all this is Inigo Jones's Banqueting House, a reminder of Charles I's autocracy. Even the sky, Peale explained, was operative—"the dark lowering Clouds, and disturbed Air, representing the alarming Times; and yet at a Distance, you observe a calmer Sky, tho' not altogether clear—Hope of better Times."

Peale's Virginian clients were delighted with the painting, which illustrates both his naïveté as an artist—it is a wooden effigy—

and his literal cast of mind. In the years to come, Americans would make a great point of representing themselves as ancient Romans (republican, not imperial), and Peale treats Pitt as a sort of American *avant la lettre*. Nevertheless, it was clear to Peale that he had no future in London. He disliked the place and felt like a fish out of water. He got to know most of its small American colony. With his usual brashness, he managed to get to Benjamin Franklin and secretly sketched him necking with a young woman on his lap. But his growing republican views could not fit London society, and in any case he doubted that he would ever acquire West's pictorial erudition. Peale knew his limitations and was frank about them. "How far short I am," he wrote to an American friend in 1772,

> of the excellence of some painters, infinitely below that perfection, that even Portrait painting I have seen may be carried to in a Vandyke. My enthusiastic mind forms some Idea of it but I have not the execution, have not the ability, [n]or am I a master of Drawing. . . . A good painter of either portrait or History, must be well acquainted with the Greesian and Roman statues . . . must know the original cause of beauty—in all he sees.

59. Charles Willson Peale, *Portrait of William Pitt,* 1768. Oil on canvas, 95³⁄₄ × 61¹⁄₄″ (243.2 × 155.6 cm). Westmoreland County Museum, Montross, Virginia.

So he went home, to a public that knew even less than he did. It welcomed him, effusively. Being self-taught was no disgrace in do-it-yourself America. His admirers were not blasé. No English connoisseur would have written about him in the terms chosen by some anonymous bard in Annapolis in 1771:

> In thee O Peale both Excellences join,
> Venetian Colours, and the Greeks design
> Thy Stile has match'd what ev'n th' Antients knew,
> Grand the Design, and as the Colouring true.

In Maryland, Philadelphia beckoned: the richest city in America by now, and with seventy thousand inhabitants the largest. Peale's best client there was John Cadwalader, whom he painted in 1771–72 with his wife, Elizabeth, and their young daughter Anne (Figure 60). Cadwalader was rich but he was no Quaker; he has a worldly paunch, and the fine clothes that he and his wife wear proclaim a taste for display. Peale's rendering of their silks, gold embroidery, and lace is one of his few successful attempts at a rococo portrait in the English manner. He has Cadwalader giving his child a ripe peach because the fruit is to the tree what the child is to the family.

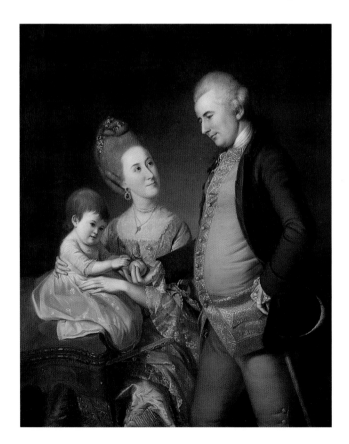

The portrait is one of five that Cadwalader commissioned from Peale for his new mansion in Philadelphia. But Peale's role as a civilian portraitist was soon to be interrupted. When the Revolutionary War broke out in 1776, Charles Willson Peale joined the citizen militia and was rapidly promoted to first lieutenant. He served at Valley Forge, where he even found time to paint a likeness of George Washington on a sheet of blue-and-white bed ticking. His wartime journal is one of the most vivid accounts of the war that has survived. The Revolution was the making of Charles Willson Peale's career in America. Without it, he would have continued to do well as a portraitist; but because of it, he turned into something else—the young country's first resident history painter. Peale

60. Charles Willson Peale, *Portrait of John and Elizabeth Lloyd Cadwalader and Their Daughter Anne,* 1772. Oil on canvas, 51½ × 41¼" (130.8 × 104.4 cm). Philadelphia Museum of Art; purchased for the Cadwalader Collection with funds contributed by the Mabel Pew Myrin Trust and the gift of an anonymous donor.

was an ardent patriot, without a Tory streak in his makeup: a populist on the ex-
treme left of the Revolution. He realized that the young Republic, whatever po-
litical shape it would eventually take (and nobody in the early days of the
Revolution had the smallest certainty as to what form of national government
would take over from English colonial rule, assuming that the patriots won), was
going to need icons of its newfound heroes and stories of its struggles: the clock
of history had been reset. This is perhaps only a highfalutin way of saying that
Peale saw an opening for cultural propaganda, but either way the Revolution cer-
tainly inspired him. He was there, and no other painter of comparable gifts had
been. In the course of the war he painted scores of miniatures of American offi-
cers and leaders; he knew George Washington, and indeed everyone of impor-
tance on the American side. When he painted Washington, Lafayette, and their
aides on the beach after their victory over Cornwallis's troops at the battle of
Yorktown, for instance, he left no doubt that he had witnessed the aftermath of
the battle (Figure 61): a more generalizing artist would not have put in the for-
lorn carcasses of dead horses lying at the tide line, and might not have included
the masts of sunken ships sticking every which way out of the broken water. In a
later war he might have been a documentary photographer like Robert Capa, but
in this one he conceived of his work as commemorative and, in a real sense, de-
votional. He painted Washington as the first American hero, but he was not al-
together in command of the formal language of deification.

When Princeton College—then a small and struggling institution—commis-
sioned Peale in 1783 to do a full-length portrait of his commander (Figure 62),

61. Charles Willson Peale, *Washington and His Generals at
Yorktown*, c.1781. Oil on canvas, 21⅛ × 29½" (54.3 × 75
cm). Maryland Historical Society, Baltimore.

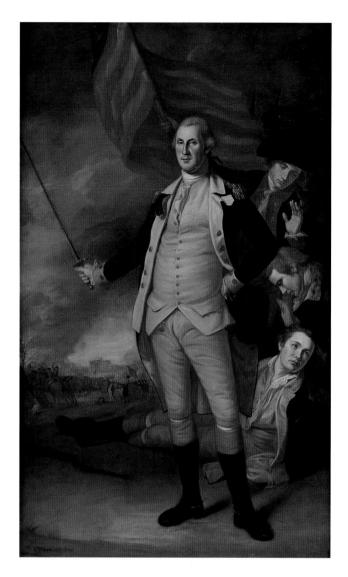

Peale went to great trouble over it, visiting and making studies of the scene of his victory there. We know where we are—near the university, with Nassau Hall on the horizon. The general holds a conventional heroic pose, sword drawn, hand on hip. He is Cincinnatus, the big-boned farmer drawn from his acres. Behind him, on the ground, is the dying General Mercer, looking fairly unaffected by his mortal wound, while a surgeon bends over him and a standard-bearer, holding the Stars and Stripes, looks down with a gesture of pity. Wooden though this group is, it would have impressed American taste as ambitious and skilled. It was hung in the college hall to replace, fittingly, a portrait of George III that had been destroyed by an American cannonball. After an earlier Washington by Peale was installed in the Philadelphia State House in 1779, indignant Tories got in one night and defaced it. Doubtless such "atrocious proceedings," as a patriot journal called the act, were tit for tat; by that time there was scarcely a portrait of a British sovereign left intact in America, and by the end of the Revolution there would be none whatever except for a chipped and defaced marble head of George III, all that was left of a public statue overthrown by patriots. The monarch's lead body was melted down and cast into bullets. The head was found, much later, in a well.

Peale wanted to fill America with his Washingtons, and painted many of them—standing, sitting, half-length, head only.

He also worked for the patriotic cause by doing public shows. Not much is known of these, but everyone in Philadelphia found them spectacular. He designed "transparencies" and made floats for processions—one of them featuring the two-faced traitor Benedict Arnold taking money from the Devil. He made a statue of Washington on whose head a laurel wreath descended by machinery, when Peale pulled a lever. He was hired to make a triumphal arch for the victory

62. Charles Willson Peale, *Washington at the Battle of Princeton, January 3, 1777,* 1784. Oil on canvas, 93¼ × 56⅞" (237 × 144.5 cm). Princeton University, commissioned by the Trustees.

celebrations in 1783. It included a representation of *Peace in the Clouds* lit by more than a thousand candles, but on the great night the whole structure caught fire and seven hundred rockets attached to it ignited, severely burning Peale. Undeterred, he threw himself into another project: illuminated "moving pictures" of events from the war, such as John Paul Jones's capture of the English warship *Serapis* at sea, complete with waves, moonlight, and cannon fire. Exhibited in his studio in 1785, these too caused a sensation; but he took a loss on them.

This precursor of Disney next set out to invent the American museum. Its seed lay in Peale's desire to create a public gallery of his portraits of Great Men, the Revolution's heroes. This did not attract the public Peale had hoped for, and by 1787 he had started adding stuffed American birds and animals to the display. As the project turned and expanded in Peale's mind, his purpose became nothing less than "to bring into one view a world in miniature"—a synoptic representation of that world, applying Enlightenment principles of sorting, classification, and naming to its fascinating chaos and abundance. He was, in short, creating America's first encyclopedic museum.

Into it went everything from pre-Cambrian fossils to stuffed hummingbirds and wolves. Peale had to shoot his own specimens and teach himself taxidermy, with stinking and nearly fatal results, since he used arsenic dust to preserve the creatures from moths and mold. He displayed them in lifelike poses in dioramas he made and painted himself: gophers peered from mounds of real earth, snakes coiled around real branches. He read Linnaeus, and used his new system of classification. He read Buffon and other naturalists, and kept up a correspondence with them all.

Thus, in the New World, exotic creatures that had once filled the ducal *Wunderkammers* of old Europe were brought under the sway of republican reason. There were other "museums"—featuring automata, waxworks, and oddities—in Boston and New York. But they were mere sideshows. They had no intellectual or moral content. Peale's did: public virtue was its aim, Nature its means. One exemplified and reinforced the other. "As this is an age of discovery," he wrote,

> every experiment that brings to light the properties of natural substances helps to expand the mind and make men better, more virtuous and liberal; and, what is of infinite importance in our country, creates a fondness for finding the treasure contained in the bowels of the earth that might otherwise be lost.

The most extraordinary of these buried treasures was found in 1801, when some farmworkers digging in a marl pit near Newburgh, New York, unearthed some enormous bones. The locals hauled out as many as they could, and displayed them in a barn; before long the news of this prodigy reached Peale in Philadelphia, and he rushed to the site with his son Rembrandt. He found the pit

flooded by heavy rain and underground seepage, but "the pleasure . . . almost tempted me to strip off my clothes and dive to the bottom to feel for bones." (Peale was then sixty.) He bought the excavation rights from the farmer. He borrowed $500 to hire diggers. He got his friend Thomas Jefferson, now the third President of the United States, to lend him a wheel-driven bucket-chain pump from Navy stores to bail out the pit. Bone by fossil bone, against every imaginable difficulty, the giant creature was extracted. It proved to be a mastodon—the first complete skeleton of such a creature to be found in America. Before long the Peales unearthed a second mastodon skeleton on another farm nearby.

Today, every child knows about fossils. But two hundred years ago, the idea of an extinct species had scarcely even been formulated. People were apt to assume that the world's creatures had remained fixed in form since God created them, and that their catalog had remained essentially the same since the time of Noah. Peale's mastodon, therefore, presented thinkers with a considerable challenge. It implied a new conception of geological time, pushing back the limits of paleohistory. Europeans might deride America for having nothing old in it. But this loxodont was older than the Parthenon, more ancient than the Pyramids, and as enduring. When its bones were carted back to Philadelphia and assembled standing up in Peale's museum, Rembrandt Peale gave a dinner party under the towering rib cage. The guests drank a toast to all Americans: "May they be as preeminent among the nations of the earth as the canopy we sit beneath surpasses the fabric of the mouse."

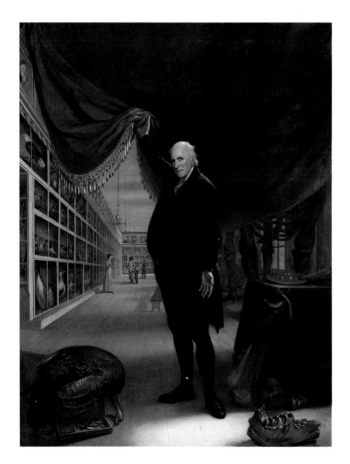

The mastodon became Peale's emblem. In a self-portrait, *The Artist in His Museum*, 1822 (Figure 63), we see him—white-haired, hale, and eighty-one years old—lifting a curtain to induct us into the marvels of his museum, a long gallery lined with vitrines containing stuffed birds. In the foreground, on the left, is the noblest of American birds, the wild turkey, which his friend Benjamin Franklin thought should replace the bald eagle

63. Charles Willson Peale, *The Artist in His Museum*, 1822. Oil on canvas, 103³/₄ × 79⁷/₈" (263.5 × 202.9 cm). Pennsylvania Academy of Fine Arts, Philadelphia; gift of Mrs. Sarah Harrison (The Joseph Harrison, Jr., Collection).

as the national emblem. But on the right are a femur and a mandible from the mastodon, sharing equal prominence with Peale's palette and brushes. The rest of the giant can be glimpsed beyond.

Five years after he dug up the mastodon, he commemorated its resurrection. *The Exhumation of the Mastodon*, 1806 (Figure 64), is a painting in praise of science and technology. It depicts a moment of crisis in the pit, when sudden rainstorms threatened to bury the creature again in water and mud. Its dominant image is the water-bailing engine and the pyramid of poles that supports its machinery. We see the men in the treadmill, turning the great wheel and its drive belt; the endless chain of buckets; the wooden flume that carries off the water; the young men with poles holding down the lower, freewheeling axle of the bucket chain; and in the pit, a buzz of wet activity and a half-naked worker triumphantly holding up a mastodon bone, showing it to Peale. The very new (technology) collides with the immeasurably old (fossils), down in the muck. On the

64. Charles Willson Peale, *The Exhumation of the Mastodon*, 1806. Oil on canvas, 50 × 62½″ (127 × 158.7 cm). The Peale Museum, Baltimore.

101

right, we see Peale and his children unfurling an enormous drawing—like a cartoon for some future fresco of paleobiology—of the mastodon's leg. The message, we gather, is being entrusted to future generations of Peales, who will carry on the saga of American self-discovery. And to make explicit the theme of progress, there is the figure to their extreme right: the Man with the Ax, cutting wood. Through the nineteenth century, the Man with the Ax will become a standard trope of American progress and expansion. Thomas Cole will paint him looking back on the forests he has cut down. He will appear in marble on the pediment of the main façade of the Capitol, felling a tree on a doomed Indian. Winslow Homer will paint him, and Walt Whitman apotheosize him in *Song of the Broad-Axe,* as producing "Shapes of Democracy total, result of centuries, / Shapes ever projecting other shapes"—the agent of protean America. Not until the late twentieth century will he become an outright American villain, the foe of Nature itself. For Charles Peale, who introduces him to American art as a member of his mastodon team, he is a foot soldier in the campaign of knowledge.

A provincial Leonardo, a homegrown Cecil B. De Mille, Peale was the very archetype of all those American inventors and cultural entrepreneurs who have struggled since to bring their ideas of progress into the world. He was the great do-it-yourselfer, the frontiersman inspired by the need to make his culture up as he went along, in the unquenchable belief that if his work interested him, it had to interest others. His work in "making up" American culture and its institutions, in shifting nimbly between artistic and scientific projects, was a spectacle of affirmation, his rambunctious curiosity all the more moving for his occasional naïveté. It ran parallel to the effort of other

65. Charles Willson Peale, *The Staircase Group (Portrait of Raphaelle Peale and Titian Ramsay Peale)*, 1795. Oil on canvas, 89½ × 39⅛" (227.3 × 100 cm). Philadelphia Museum of Art; The George W. Elkins Collection.

Americans in inventing a new state, flying into democracy by the seat of their collective breeches. A "sophisticated" man might not have had Peale's deep wells of hope. He was not the best American artist of the eighteenth century; that honor belongs to Copley. But he was the most *American* of them all.

He also had strong dynastic urges. Peale didn't only want to create museums; he would engender artists to fill them. Eight of his ten children, along with his brother, a nephew, four nieces, and three grandchildren, became practicing artists, a record probably unmatched by any family in or out of America. To stamp them with his hope, he named most of his children after famous European painters: Rembrandt, Rubens, Titian, Raphaelle, Angelica Kaufman, Sophonisba Anguissola, and Titian II. Since young America had no Old Masters, he would give it new ones. *The Staircase Group,* 1795 (Figure 65), which Peale painted for his own pleasure, portrays Raphaelle (with palette and maulstick, emblems of his profession) turning to gaze at the viewer from a stairway, with his younger brother Titian peeping from the corner above him. It was to be the centerpiece of the first and only exhibition of the American Academy of Fine Arts, founded by Peale in Philadelphia. (Otherwise known as the Columbianum, it dissolved amid political squabbles after only one show.) The picture had a professional purpose: Peale wanted to retire from painting to concentrate on natural science, and *The Staircase Group* announced that he was turning over the family business to his sons. This painting starts the American tradition of ultra-illusionistic painting, which was to become so popular in the nineteenth century; you are meant to see the boys and the stair as "real"—they are life-size—and their reality is increased by a simple, domestic setting, as though you had just walked in on them. Originally, Peale enclosed the canvas in a doorframe and nailed on a projecting wooden step. Ever since Pliny's ancient fable of Zeuxis deceiving birds with his painted grapes, no feat of eye-fooling painting has been complete without its stories of how people were taken in by it: the story goes, unverifiably alas, that George Washington greeted Peale's sons when he caught sight of the picture.

Such illusionism would have seemed rather passé in England, a conjuring trick for the groundlings—but not in Philadelphia. This was not lost on Raphaelle Peale (1774–1825), who became America's first professional painter of still-life. His work was much closer to seventeenth-century Dutch still-life than to the more modern images of Chardin, which he could hardly, in any case, have seen (Figure 66). His technique was meticulous: finely brushed, almost enameled surfaces, enumerating every pore and wart on the skin of an orange, every last highlight on a glass decanter. He never attempted the cascading abundance of Dutch baroque still-life, preferring simple groupings of sparse objects on plain tabletops with a neutral-colored though presumably domestic space behind them. But the results have real integrity of design, and a certain modest charm. Raphaelle Peale was not a practicing Quaker, but the quiet austerity of his work reminds one that

it was made for an audience permeated with traditions of Quaker plainness-as-morality; this is the context of his famous joke-picture, *Venus Rising from the Sea—A Deception [After the Bath]* (Figure 67), done c. 1822, shortly before he died in poverty and drink. All we see of Venus is the tip of her enticing toe and her right forearm, raised as her hand pulls up her hair. (Nevertheless, Peale's source for her absent body has been identified as a print done fifty years earlier, after a nude Venus by the English artist James Barry.) The rest of her is hidden by a masterfully painted white cloth. Though this is often identified as a "towel," it is actually a rendering of a handkerchief: Venus is not hidden by her own towel on a clothesline—rather, Peale has painted a picture of a handkerchief pinned to a ribbon and draped across a *picture* of Venus. (If this handkerchief were a towel, the pins in it would be the size of meat skewers.) It is an image, not of Venus's own comic modesty, but of Quaker censorship. For though the ability to draw and paint the female nude was essential to artistic practice in Europe, in Federal America images of naked women were rare, never encouraged, and always controversial. Probably Raphaelle Peale, like many another artist, found this an unhappy restriction; but at least he could joke about it.

66. Raphaelle Peale, *Still Life: Strawberries, Nuts, &c.,* 1822. Oil on wood panel, 16³/₈ × 22³/₄″ (41.6 × 57.8 cm). The Art Institute of Chicago; gift of Jamee J. and Marshall Field, 1991.

In contrast to tippling Raphaelle, his younger brother Rembrandt Peale (1778–1860) had a long and productive career, shuttling between America, England, and Europe. He took the mastodon to England in 1802; he studied, like his father before him, under the now venerable Benjamin West; once across the Channel, he met with a succession of distinguished European neo-classical artists (among them, Jacques-Louis David and the sculptors Bertel Thorwaldsen and Jean-Antoine Houdon) and painted their portraits for Peale's Museum. Later Rembrandt would found his own museum in Baltimore, where a cast of the

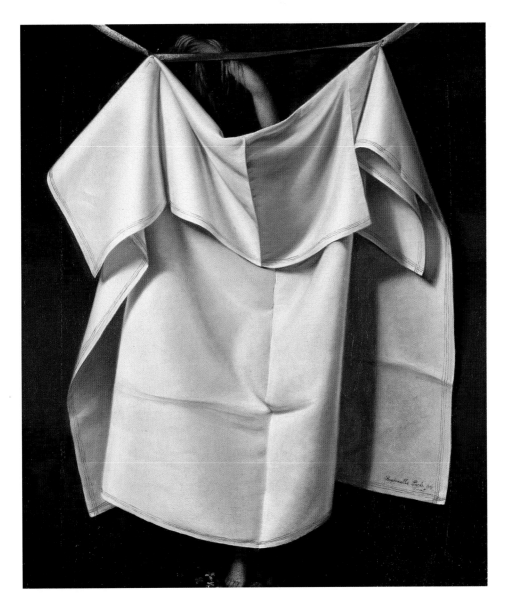

67. Raphaelle Peale, *Venus Rising from the Sea—A Deception [After the Bath]*, c. 1822. Oil on canvas, 29¼ × 24⅛" (74.3 × 61.3 cm). The Nelson-Atkins Museum of Art, Kansas City, Missouri; purchase: Nelson Trust.

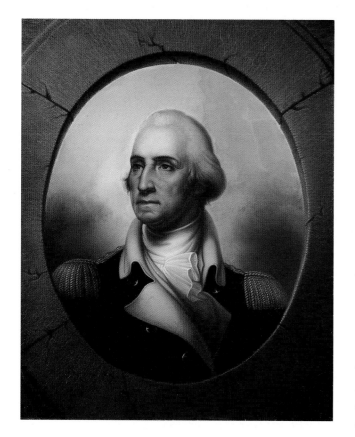

mastodon still stands today, pointing its tusks at his father's picture of its exhumation. He met George Washington and painted his portrait some sixty-five times, though (luckily for the *pater patriae*'s patience) only once from life. His contribution to the growth area of Washington iconography was the so-called Porthole portrait (Figure 68), in which the great man is seen framed in a ponderous stone oculus, gazing resolutely out like a classical bust, only colored. The stone frame was meant to translate Washington onto the plane of the Ideal; the figure within was available facing left or right, in civilian or in military costume, as a half-length or on horseback, and with or without the words *Patriae pater* and a head of Zeus. In various permutations, Peale cranked out (by his own reckoning) seventy-nine "Porthole" replicas, and the actual total may have been higher. Washington in uniform was always more popular than Washington in mufti.

To Peale's disappointment, his Washington was never to displace Gilbert Stuart's (Figure 79, page 126) as the canonical image of the first President. And though he hoped for success as a history painter on the large scale, Rembrandt Peale's most memorable painting was a portrait of his younger brother Rubens with a geranium (Figure 69). Rembrandt's image of Rubens is an enchanting rendition of the meaning of their city's name—Philadelphia, "brotherly love." For despite his name, Rubens was half-blind. He sits for his brother, looking sweet, mild, and myopic, gazing over the metal frame of his spectacles and holding another pair of glasses in his hand on the table. (Bifocal lenses were unknown then; one needed two pairs of spectacles, one for close and the other for distant looking.) He is the young scholar sharing the painting on equal terms with the object of his study. The geranium is as big as he is, and receives as much scrutiny; it is not treated as a mere emblem of Rubens Peale's botanical interests. Thus it goes against the usual grain of American portraiture in its time, as indeed the work of Charles did when he was painting for himself. This is the most genuinely neoclassical painting produced by any of the Peales, and in its sober palette (russet,

68. Rembrandt Peale, *George Washington*, 1795–1823. Oil on canvas, 36 × 29″ (91.4 × 73.7 cm). The Metropolitan Museum of Art, New York; bequest of Charles Allen Munn, 1924.

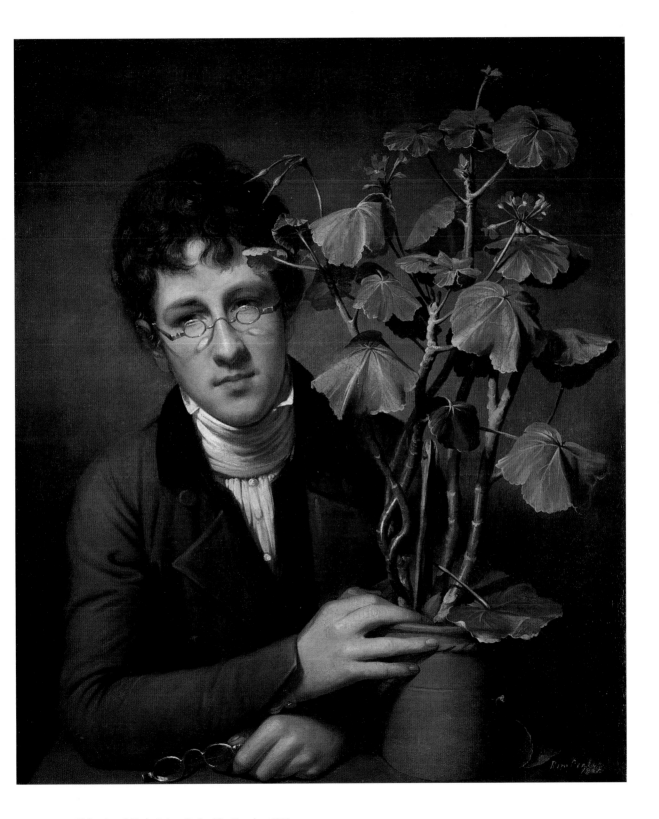

69. Rembrandt Peale, *Rubens Peale with a Geranium,* 1801.
Oil on canvas, 28¼ × 24″ (71.7 × 61 cm). National Gallery
of Art, Washington, D. C.; Patrons' Permanent Fund.

dark brown, warm terra-cotta, and green, with a spark or two of red from the flowers that are just beginning to bloom) it surely reflects Rembrandt Peale's contacts in Europe, particularly with the work of Jacques-Louis David.

"Better, more virtuous, and liberal." Charles Willson Peale's hope for his fellow Americans was shared by all literate citizens of the new Republic, in the wake of the Revolution. "Virtue, virtue alone . . . is the basis of a republic," said another Philadelphian patriot, Dr. Benjamin Rush, in 1778. There was much dissension about what form the Republic should take, what its political institutions should be.

Broadly speaking, three ideas competed for supremacy, though in practice they all overlapped.

The first was held by an educated elite represented by such men as Thomas Jefferson and the Adamses of Massachusetts. Basing their ideas of democracy on the republics of ancient Rome and Greece, they envisaged rule by those whom the Romans had called "optimates"—"the best men," or, in Jefferson's phrase, a "natural aristocracy" based not on wealth and inherited title (as in corrupt old Europe) but on talent. The state, through education and guaranteed freedom of speech, would enable such people to rise from humble birth to power. It would require of them a degree of self-sacrifice, a willingness to put common interests before private ones. Such an idea of democracy could and did accommodate slavery, and felt no obligation to give women the vote.

The second was more mercantile, less abstract; it came from the ideas of Adam Smith. The strength of a republic lay in its creation of wealth; "enlightened self-interest," in Smith's famous phrase, rationally sought, would expand democracy without the need to sacrifice excessively to ideas of the common good. The appeal of this reached craftsmen and small businessmen, as Jefferson's loftier conceptions did not. It spoke to Americans imbued with the Puritan work ethic, and with Puritan beliefs in self-made wealth as a sign of God's recognition of one's virtues.

The third was frankly populist and became the seed of modern American democracy, although at first it gathered very little headway, because so many of the ordinary people to whom it appealed were illiterate and could not argue their case. Basing itself on the ideas of Thomas Paine, and on the worker's natural distrust of the boss, it urged that the gentry and the new rich could not and, when the chips were down, would not speak for the masses. It called for the widest vote, for general engagement in politics—through referendums, town meetings, and the like.

But whichever republican line you preferred, one issue was not in debate. America was to be a republic of virtue. American republicanism did not toss out

the Puritan heritage. On the contrary; it enlarged it, though with transfusions from the secular Enlightenment. Just as the Puritans had imagined themselves transcending the corruptions of old Europe in creating their "city on a hill," so the patriots of the Revolution would create a society where tyranny, blood aristocracy, and monarchy would be no more, and their cultural results—effeteness and luxury—would be unknown. This was a tall order. What role could the arts play in such a republic? Americans sharply disagreed on the answer, and their disagreements continue more than two hundred years later. Some thought that the arts, being signs of luxury, were intrinsically corrupting and that there was no place for them in America—even, or perhaps especially, if they served the state. For how could a good message be delivered by a bad messenger? But the more common view was that art could be useful as long as it embodied virtue, held up examples of worthy behavior, and armed republicans with zeal. But were they not too costly for a young republic? Thomas Jefferson thought so. "Painting. Statuary. Too expensive for the state of wealth among us," he wrote in a note to some friends who were about to go to Europe, in 1788. "It would be useless, therefore, and preposterous, for us to make ourselves connoisseurs in those arts. They are worth seeing, but not studying." The art he wished to foster, as we shall see, was architecture. Benjamin Franklin saw no point in importing art from Italy, but wished America could get hold of the recipe for Parmesan cheese.

It is Jefferson, of course, who presides over the esthetic of Federal America, as he does over its political and social identity. This can be frustrating, because everyone has his or her own Jefferson. There is Jefferson the radical populist, disdaining the ceremonies of rank and placement at the President's table and receiving diplomats in his slippers. Equally, there is Jefferson the laird of Monticello, his self-designed Palladian villa on a Virginia mountaintop, accumulating works of art that he had no chance of paying for and burying himself under another mountain, this time of debt, with the recklessness of a spendthrift aristocrat. There is Jefferson the apostle of human equality, and Jefferson the hypocritical slave owner. There is Jefferson the deist—which he was—and Jefferson the fierce anticlerical, which he also was. Modern atheists may have trouble with his unswerving belief that the universe reflected an organizing Intelligence, but not as much as the modern fundamentalist zealot who sees the Founding Father banning the meddling hand of organized religion from American politics, inveighing to Joseph Priestley against "the times of Vandalism, when ignorance put everything into the hands of power & priestcraft" and describing Christianity as "the most sublime & benevolent, but the most perverted system that ever shone on man." Everyone, it seems, wants to claim him as an ally or a precedent, and there can be few people who have dipped into his voluminous writings—the correspondence alone runs to fifty thousand letters—and not been captivated by the amazing openness, flexibility, and spirited elegance of his mind. The third Presi-

dent of the United States of America would, of course, be unelectable today. He did not suffer fools gladly, speak in sound bites, or trim his ideas and his sometimes contradictory desires to suit those of fools or fanatics. Besides, he spent too much of his time on architecture. It is risky, with Jefferson, to say which of his multifarious interests (lawyer, farmer, revolutionary, diplomat, statesman, architect) was his chief passion. But thinking about buildings, and creating them as expressions of the individual and of society, was certainly high on the list. "Architecture *shows* so much," he wrote, and his own buildings do—about him, and his vision of America. Jefferson's known output includes at least seven houses, two courthouses, a state capitol, a church, and a university. He was the greatest American-born architect of his time, and the first level on which his work embodied the idea of American independence was that it rejected English models.

A Virginian, Jefferson studied law at the College of William and Mary in Williamsburg. His opinions on the capital and architectural showpiece of the state appear much later in his *Notes on the State of Virginia*. In general, he remarked, "the genius of architecture seems to have shed its maledictions over this land." Houses were burdened with "barbarous ornaments" done by uncomprehending workmen, "scarcely . . . capable of drawing an order [a correct classical column]. The first principles of the art are unknown, and there exists scarcely a model among us sufficiently chaste to give an idea of them." The only public buildings worth mentioning in Virginia were all in Williamsburg, and they were not very good; Jefferson reserved special scorn for his old alma mater, the College of William and Mary, and for the Hospital—"rude, mis-shapen piles, which, but that they had roofs, would be taken for brick-kilns."

What Jefferson disliked about the architecture of Williamsburg was not just its relative crudity and provinciality but its Englishness. How could the author of the Bill of Rights not be an Anglophobe? "That nation hates us, their ministers hate us, and their King more than all other men," he wrote to his friend John Page from Paris in 1786 after a two-month trip to England. He ascribed the cultural inferiority of the English to a sluggishness of mind caused by eating too much beef—a French idea, if ever there was one. He found the architecture of London inferior to Philadelphia's. It was "in the most wretched stile I ever saw, not meaning to except America where it is bad, nor even Virginia where it is worse than in any other part of America." Consequently he missed out on the great influence which permeated the work of his more professional successors Benjamin Latrobe and Charles Bulfinch—that of Sir John Soane. Though he delighted in the style and techniques of English gardening, his architectural taste would be formed by France.

It was Jefferson's (and American architecture's) good luck that he succeeded Benjamin Franklin as American Minister to Paris, the year after America won its

Revolution. This was in 1784, at the height of the architectural ferment during which the sweet ebullience of rococo was being thrust aside in favor of the more severe and idealized forms of neo-classicism, the mature architectural speech of the Enlightenment. The house he rented as an embassy, the Hôtel de Langeac on the Champs-Élysées, was by the neo-classical architect Jean François Chalgrin; and Jefferson missed no chance to see and study the new work by Claude Nicolas Ledoux and Étienne-Louis Boullée that was rising in and around Paris. The plain surfaces and massive primary forms (sphere, cube, pyramid) favored by both these architects were to sink deep into his own architectural vocabulary, as was the message behind them: that Virtue could be encouraged by the spectacle of such shapes, leading men toward the "primitive" nobility possessed by the early Roman republic and lost in the decadence of Empire. He visited the Halle aux Blés (wheat market) with its lightweight wooden dome designed by Jacques Molinos and Étienne Le Grand: "Oh! It was the most superb thing on earth!" He loved the Désert de Retz, a folly built on the outskirts of Paris in the form of a ruined tower, with trees sprouting from its roof; later he would adopt the oval rooms inscribed within its cylindrical plan for the lower floor of the Rotunda of the University of Virginia. He was "violently smitten" by Pierre Rousseau's Hôtel de Salm, then under construction beside the Seine, and folded its domed single-story central hall into his ideas for the construction of Monticello. A letter to his friend Maria Cosway recalls the ecstatic and sentimental delight with which the two of them had explored the architectural sights of Paris. "How beautiful was every object!" Jefferson cries,

> the Port de Reuilly, the hills along the Seine, the rainbows of the machine of Marly, the terrace of St. Germains, the chateaux, the gardens, the statues of Marly, the pavillon of Lucienne. Recollect too Madrid, Bagatelle, the King's garden, the Dessert. How grand the idea excited by the remains of such a column! The spiral staircase too was beautiful. Every moment was filled with something agreeable. The wheels of time moved on with a rapidity of which those of our carriage gave but a faint idea.

But the building that influenced Jefferson most was neither modern nor in Paris. It was in Nîmes, in the south of France: a Roman temple dating from the time of Augustus, known as the Maison Carrée, or "Square House." It had been admired since the seventeenth century as an unusually pure and perfect relic of classical style—the painter Nicolas Poussin, among others, studied it—and Jefferson, seeing it on a tour in the spring of 1787, "nourished with the remains of Roman grandeur," fell in architectural love again. "Here I am, Madam," he wrote to his friend Madame de Tessé, "gazing whole hours at the Maison quarrée, like a lover at his mistress." He had Jacques-Louis Clérisseau, archaeologist

and architect, make drawings and a stucco model of the temple and shipped them back to Richmond, where they became the basis of Jefferson's design for the new capitol for Virginia, the "State House." Even today, when we imagine public architecture we tend to think in terms of classical pillars and pediments. But Jefferson's design for the capitol was new: it was, in fact, the first temple-form public building erected anywhere in fifteen hundred years, a realization of his hope to improve American public taste by "introducing into the State an example of architecture in the classic style of antiquity" (Figure 70). The capitol, begun in 1785, was finished in 1799. It was larger than the Maison Carrée, and lacked the engaged pilasters of the original; its columns are Ionic, not Corinthian, because Jefferson suspected that local craftsmen were not up to the task of carving all those acanthus leaves. But the political message of its design was clear. This was the prototype of the American Roman Revival, the Federal style: it was to be the model of future public architecture in the new democracy. It was not "colonial," and did not speak of royal tyranny. It claimed to go back to the republican sources of reason and virtue. In fact, of course, the Maison Carrée belonged not to a republican Rome, but to the imperial Rome of the Caesars—and being in France, it was certainly a colonial building. But no matter: transferring it to Richmond meant, in Jefferson's ringing words, that "we wish to exhibit a grandeur of conception, a Republican simplicity, and that true elegance of Proportion, which correspond to a tempered freedom excluding Frivolity, the food of little minds."

Before the Virginia capitol was finished, plans for a national capital were under way. To choose such a site is a radical act for any state. The Founding Fathers of the American Republic didn't want to take an existing city, like New York or Philadelphia, and call it the capital of the United States of America. They wanted a clean slate. And with reason: to redesignate a city would have given too much prominence to the state it was in, over the others. Besides, on an empty site the republican vision would not be blurred by earlier royalist and colonial meanings.

The place they chose in 1791 was empty because, until then, nobody in his right mind would have wanted to live there. It was a tract of hot, humid land beside the Potomac River, with a few tobacco farms and an abundance of animal life, mostly mosquitoes. But it was to be the site of the new Rome, and they named it Washington: a mere hypothesis at first, some planners' lines on paper that, within two hundred years, would grow into the most powerful city on earth.

The design was entrusted to Pierre Charles L'Enfant (1754–1825), a French military engineer who had volunteered to fight for the young American Republic, where he arrived in 1777. L'Enfant was the son of an artist who, for six years, had worked at Versailles as "Painter in Ordinary" to the King. Living at Versailles as a child would seem to have marked the future city planner deeply, since his plan for Washington, with its grid and diagonal boulevards, takes its form

from the greatest baroque metaphor of royal autocracy in France: the gardens of Versailles, with their corridors of power radiating from the palace, designed by Le Nôtre for Louis XIV. Jefferson, trusting L'Enfant's taste because he was French (and had a common passion for the massive classicism of Ledoux), appointed him in 1791. By then Jefferson was secretary of state, in which position he tried to ensure that the main buildings of the nation's new capital should be classical in style, and when "modern," French rather than English. The two most important ones would be the Capitol and the President's house (which L'Enfant had sited on the only hills on an otherwise flat site, one north and the other east of a stream optimistically called Tiber Creek). In 1791 he advised L'Enfant that

> whenever it is proposed to prepare plans for the Capitol [in Washington], I should prefer the adoption of some one of the models of antiquity, which have had the approbation of thousands of years; and for the President's house, I should prefer the celebrated fronts of modern buildings, which have already received the approbation of all good judges. Such are the Galerie du Louvre, the Gardes-meubles, and two fronts of the Hôtel de Salm.

But meanwhile he continued to work on his house in the Virginia countryside, near Charlottesville, where his father had left him thousands of acres of rural

70. Thomas Jefferson, Virginia State Capitol, 1791.
Richmond, Virginia.

property and a gang of slaves. Because it was sited on a hill, he called it Monticello (Figure 71). He began planning it in 1767, and he was to work on it, tinker with it, for the better part of forty years. "Building up and pulling down are the delights of my life," Jefferson would say. And a visiting Frenchman, the Marquis de Chastellux, remarked in 1782 that his host was the first man in America to use the fine arts to shelter himself. Monticello is pervaded with esthetic ambition. It was also his spiritual center, his hearth, and his refuge from the painful stress of political life.

Palladio had described the setting for his Villa Rotunda as *sopra un monticello* (up on a small hill). Jefferson's hill was very large, but he decided to place on it a French Palladian pavilion of the most elegant sort. "In Paris particularly," he had noted,

all the new and good houses are of a single story. That is of the height of 16 or 18 f. generally, and the whole of it given to rooms of entertainment, but in the parts where there are bedrooms they have two tiers of them from 8 to 10 f. high, with a small private staircase. By these means great stairways are avoided, which are expensive. . . .

71. Thomas Jefferson, Monticello, begun in 1770; façade, 1793–1809. Charlottesville, Virginia.

Monticello followed this planning system, and looks like a single-story house even when it is not. His general prototype was Pierre Rousseau's Hôtel de Salm, with its domed room centered on the middle block, and arms extending back to enclose a courtyard, but Monticello came out looking more like one of the English Palladian suburban villas of the 1770s. Its utility wings are dropped below grade so that their roofs form terraces, across which the house has uninterrupted views of the Virginia country on all sides. On top, roofed by a shallow dome, is Jefferson's "sky room," an octagon. In the entrance hall, he placed his "museum," a collection of maps, souvenirs, and relics that included a Mandan buffalo robe collected by Lewis and Clark on the 1804–6 transcontinental exploration he had sponsored, along with busts, the tusks of a mammoth, and the fossil bones of *Megalonyx jeffersonii*, a giant prehistoric sloth—a most unfitting animal, one would think, to bear his name. There was also a hall clock of his own design, which recorded the days of the week as well as the time of day. Cannonball weights moved down the wall past the day markers. Unfortunately, the hall was not high enough to contain more than Monday through Thursday, so he had to cut a hole in the floor and put Friday, Saturday, and Sunday in the cellar.

All this splendor and luxury was raised on black slave labor. Jefferson denounced slavery as an "abominable crime," but by 1796 he owned about 170 slaves; they underwrote his leisure and wealth, and though he had the deepest qualms about slavery, he would not abandon the system. Aristotle had written that "slaves allow time for good citizens to follow virtue," but Jefferson was not so sure. His hypocrisy on the subject ran deep, but he was realistic about it; slaveholders, he warned, had "a wolf by the ears."

To brush against his work is to want to know him, because of the overwhelmingly attractive cast of Jefferson's mind. He was one of those rare people who want to build everything up from first principles, and are completely free of fanaticism, self-pity, and cant; and in the variety of his interests he was the living proof of William Blake's remark that energy is eternal delight. He was diplomat, constitutionalist, president, educator, farmer, botanist, architect. Reading him, you feel his enthusiasm and curiosity on your face like sunburn. He lived far beyond his means and was constantly in debt from the huge sums he spent on Monticello—eighty-six cases of antiquities, furniture, and books came back from Paris with him. He spent like a duke, but without a ducal income. Under the surface of eighteenth-century Whig reasonableness there is something immoderate and crazy about Jefferson. And he was the patron saint of all American do-it-yourselfers, a fact to which Monticello bears witness in its profusion of gadgets: from automatic doors and ventilation ports for his winter wardrobe to a machine to make copies of his letters.

Jefferson's greatest architectural achievement was his "academical village," the University of Virginia (1822–26), in Charlottesville. Here, he hoped that the elite necessary to Virginian democracy would be trained. We are apt to be hypocritical about elites today. We pretend mediocrity is democratic. Jefferson knew better. He was against the idea of an artificial aristocracy of birth, but passionately for the fostering of a "natural aristocracy" of talent and virtue, without which democracy could not survive. Hence his concern with education. But he wanted that education to be secular, not religious—as the earlier Puritan foundations and schools in Massachusetts had been. His university would be dedicated, he said, to "the illimitable freedom of the human mind," without any input from religion. A pure expression of the Enlightenment. Jefferson was a deist; but he was also a secular humanist through and through. How today's religious right would have hated him, for all their pious invocations of the Founding Fathers! And how he would have disliked them; modern evangelical Christianity would have struck him and his contemporaries as a form of mob rule, and its intrusion into politics as dangerous.

He therefore eschewed the available models of university design, such as Oxford or Cambridge, which still carried the marks of their origin as Church foundations. Instead, he adapted his plan from Marly-le-Roi, the retreat of Louis XIV in France. Marly had a rotunda at one end for the King's quarters, and twelve

72. Thomas Jefferson, Rotunda and pavilions of the University of Virginia, 1822–26. Charlottesville, Virginia.

pavilions, six on a side, enclosing a lawn which was open at the opposite end to the view. Jefferson—with advice from his architect friend Benjamin Latrobe— planned his campus along similar lines, with a central rotunda facing an open view at the opposite end, and ten pavilions, five on each side (Figure 72). Each pavilion had classrooms at ground level, with quarters for unmarried professors above, and the students' dormitories in between the pavilions. The spacing of the pavilions was thus determined by the width of the dormitories, which increased the farther they were from the Rotunda. This manipulation of space, like a Palladian stage set, was a brilliant touch, prolonging the perspective of the lawn and suggesting that—in a symbolic sense—knowledge and wisdom were radiating from the open university into the Virginia countryside. All the pavilions were made of red brick, but were differently detailed to make them a museum of classical orders, based on those of Roman buildings: Doric (from the Baths of Diocletian), Ionic (from the Temple of Fortuna Virilis), Corinthian, and so on.

The climax of the design is the Rotunda (Figure 73). It is a half-size adaptation of the Pantheon in Rome; a sphere inscribed in a cylinder, forming the dome with its top and with its imagined bottom touching the ground floor. The whole is raised on a stepped base, so that its form can be appreciated in all its purity and distinction. The top half of the sphere forms the library, the round cranium of the university—literally, its brain. Light floods it from the round skylight above, representing the power of Nature. The books (long since removed) radiated the power of Reason. Originally Jefferson wanted to take his metaphor further, by

73. Thomas Jefferson, Rotunda of the University of Virginia, 1822–26. Charlottesville, Virginia.

painting the dome sky blue and having gilt planets and stars moved across it by a sky clock. It is hard to suppose that the domed room would have benefited from such a gadget. It is a pristine space, a precinct of intellectual light, clarity, and harmony: the most beautiful room in America. Standing in it, one realizes why Jefferson wanted his tombstone to record only three achievements, without even mentioning his presidency:

Here was buried
Thomas Jefferson
Author of the Declaration of Independence
Of the Statute of Virginia for Religious Freedom
And Father of the University of Virginia.
Born April 2, 1743 O.S. Died July 4, 1826.

Political freedom, religious freedom, intellectual freedom: such guarantees, embodied in the Declaration, the statute, and the university, were Jefferson's gifts to America.

For all his talents, Jefferson was not a professional architect and would never have claimed to be. The first trained professional, in the strict sense of the term, to work in the new democracy was an English emigrant, Benjamin Henry Latrobe (1764–1820), who arrived in America in 1796. Latrobe had been raised in Germany (he was the son of a Moravian clergyman and a Philadelphia Quaker mother) and had traveled in France and Italy. His taste was radical, more so than Jefferson's; he admired the abstract, cubic, bold severity of Ledoux, Boullée, and the Prussian neo-classicist Carl Gotthard Langhans, designer of the Brandenburg Gate in Berlin. He was especially influenced by Sir John Soane, whose abstract massing of large primary forms in strong contrasts of light and shadow he would always seek to emulate.

Latrobe first made his American reputation in Philadelphia, with his design for the Bank of Pennsylvania (1798–1800). "I have changed the taste of a whole city," he claimed later, which was true: single-handedly, he directed Philadelphian taste away from provincial variants on decorative Adam-style classicism toward the Greek Revival, and the bank started this shift. In context, it was a startlingly explicit and severe building, with its Ionic porticoes front and back of a massive cube, inside which was inscribed the circular banking room lit from above by a glazed oculus inside a low dome (Figure 74). The model for this was Soane's great Stock Office in the Bank of England, finished only six years before—which illustrates how the arrival of professional architects narrowed the time lag between English and American style. The bank, alas, was demolished, but one can still admire Latrobe's Soanian sense of grand massing and spatial interpenetration in the Roman Catholic Cathedral of Baltimore (1804–18), with its colossal tem-

ple portico and its sixty-five-foot-diameter dome, the largest yet built in the United States.

Latrobe's biggest (and most troublesome) commission came in 1803, after Jefferson appointed him Surveyor of the Public Buildings for the United States. As such, he worked on Washington's two chief buildings. To the White House, which had been designed by the Irish emigrant architect James Hoban (1762–1831) along the lines of Leinster House in Dublin, Latrobe added the Oval Office. And then there was the Capitol, a source of endless worry and frustration to Latrobe. He took over from its first architect, William Thornton, an amateur chosen by Jefferson; by 1811, when he resigned, Latrobe had remodeled the interior of the Senate wing and changed the House chamber from an ellipse to a room with two semicircular ends connected by colonnades. The climactic central block, the domed rotunda, remained to be done. But in 1814 the British attacked Washington and burned the Capitol. Latrobe was rehired to bring it back from ruin, and between 1815 and 1817 he finished the Hall of Representatives (now the half-domed Statuary Hall) and designed the Senate chamber.

Latrobe was the most inventive detailer America had yet seen, and his flair showed itself in the Capitol. He wanted to invent Greek orders in terms of American nature; thus the famous corncob capitals, and the slightly less well known

74. Benjamin Henry Latrobe, *View of the Bank of Pennsylvania, Philadelphia*, 1798–1800. Watercolor on paper, 10½ × 18″ (26.7 × 45.7 cm). Museum and Library of Maryland History, Maryland Historical Society, Baltimore.

capitals of the vestibule and rotunda of the Senate wing, in which he took a Corinthian form with acanthus leaves and substituted the leaves and flowers of the tobacco plant (Figure 75) in a design of unmatched elegance.

His successor as architect of the Capitol was Charles Bulfinch (1763–1844). Bulfinch was America's first native-born professional architect, and in his blood the two opposed strains of America mingled: his mother was an Apthorp, from a fiercely royalist Boston family, while the Bulfinches had fought for the Republic in the War of Independence. Both families were builders (Apthorp House, 1765, now part of Harvard, was a radically "modern" English Palladian structure in its day), and it seems almost preordained that Charles Bulfinch should have become an architect. At twenty-two, he took the Grand Tour of Europe, a venture planned for him, in part, by Jefferson. And at the early age of thirty-two, in 1795, with only a few houses to his credit, he was commissioned to draw up plans for a new capitol in Boston: the Massachusetts State House.

Boston already had a State House, but its symbolism was all wrong. Built in 1712, it was the largest building in the city, the prime architectural image of British rule, set plumb on the main intersection of the town on the axis to the Long Wharf, where all trade was generated and all imports had to pay the hated British taxes. Thus the site proclaimed the State House as the focus of English power over American economic life; and its ceremonial upper balcony, like that of the Governor's Palace in Williamsburg, signified government by proclamation and not consensus—the citizens being told what to do from on high. On the square below this balcony, the much-exaggerated Boston Massacre took place in 1770. This tainted the site, so Charles Bulfinch was engaged to design a new State House on Beacon Hill for the Commonwealth of Massachusetts (Figure 76).

Then as now, American cities were competitive; they wanted signature buildings. The originality of Bulfinch's design was that it did *not* follow the lines set by Jefferson's Virginia capitol. It did not copy an ancient Roman building to reject England. Instead, it took its cues from an English one, less than ten years old:

75. Benjamin Henry Latrobe, *Tobacco-leaf Capital*.
In the Senate Wing of the United States Capitol,
Washington, D.C.

Somerset House in London (1776–86), by William Chambers. It had been designed expressly as government offices, and Bulfinch took from it the central block of his design, with its seven-arched arcaded entrance porch and its open pillared loggia above. This not only expressed the close cultural connection that Bostonians still felt to England, it affirmed a belief that the New was better than the Antique, and that Boston was different from Virginia. An exuberant gilded dome tops the design. Bulfinch, frugally, had it shingled; then Paul Revere sheathed it in copper in 1802; finally it was gold-leafed in 1874. The dome and the pedimented structure it rises from may not marry perfectly with the rest of the building, but no one in Boston cared: this was the grandest public building in the United States, and remained so for many years, providing a model for all other state houses that were rising across the country—Bulfinch's severe cubic forms, the very essence of the Federal style, were echoed even in faraway California. He went on to design other state houses, as well as churches, schools, halls, private homes, a hospital, and a prison; but it was the Boston State House

76. Charles Bulfinch, Massachusetts State House, 1795–98.
Boston.

that remained the key to his career, for on a visit to Boston President James Monroe was so impressed by it that, in 1818, he appointed Bulfinch to succeed Latrobe as architect of the Capitol in Washington. He served in that post until 1829, mainly carrying out and harmonizing Latrobe's designs, but working on the rotunda as well (Figure 77). Latrobe had wanted a near-flat dome over its rotunda; Bulfinch pushed the dome a little higher, but not high enough to satisfy political opinion: the dome, as the crowning element of America's seat of government, should be as high and wide as possible, and in 1853, nine years after Bulfinch's death, a monumental, coffered, iron-ribbed structure to rival the domes of St. Paul's and St. Peter's rose over the rotunda.

More even than Jefferson, Bulfinch had given America the architectural forms that expressed democracy. His idea of grand simplicity was part of a general movement in design toward whatever was simple, masculine, direct—the Federal style. It extended from architecture to furniture. Cabinetmakers used large, explicit, and abstract shapes: circle, ellipse, square, and their various permutations. Deep carving and intricate swag-work flatten out. They are replaced by abstrac-

77. Interior of the rotunda of the United States Capitol
Building, designed by Charles Bulfinch, c. 1818–29;
redesigned by Thomas U. Walter and others, 1851–65.
Washington, D.C.

tions of depth, like alternating bands of dark and light veneer that are actually flat and in the same plane. This taste for clarity and severity, this interpretation of the Greek legacy which was so fundamentally different from the frills of rococo or the Pompeiian charms of Robert Adam, was part of the same impulse which, between 1776 and 1840, would sprinkle America with Hellenic place names: Troy, Ithaca, Sparta, Athens.

Meanwhile, the work of memory went on. How was the new Republic to commemorate its glorious, if recent, past?

In popular art—prints, ceramics, and the like—certain motifs appeared almost at once and were endlessly recycled, such as the goddess of liberty, the "cap of Liberty"—the Phrygian cap on a pole, often with the Stars and Stripes flying beneath it—and of course the American eagle. The diffusion of these symbols was not without its irony, since most of them were turned out by English firms and exported to the American market.

Nor were the makers of Birmingham knickknacks and Chelsea pottery the only ones to see a market in the American Revolution. "Higher" artists did too. America had no native-born sculptors—or none that were any good—and this left the field to the Italians and the French, eager to find commissions in America.

The first monument to be erected on the orders of the Continental Congress was commissioned in 1776 from a French sculptor, Jean-Jacques Caffieri, who hoped it would open the door to a monopoly on American official sculpture. It did not. He was displaced by an ambitious Italian named Giuseppe Ceracchi, who enterprisingly sailed to America in 1791 with a view to cornering the market in heroes. He carved a marble Washington, did several other Revolutionary heroes "on spec," and then, in the 1790s, presented plans for a project of truly paranoid grandeur: a monument to American liberty, 100 feet high and 300 in circumference, complete with a swarm of allegorical figures, Washington on horseback, and a marble rainbow. No one seemed to want it—it was budgeted at $30,000—and shortly afterward poor Ceracchi, back in France, was guillotined for allegedly plotting Napoleon's assassination.

The first American political statue of serious esthetic quality was a life-size portrait of Washington by Jean-Antoine Houdon. Jefferson commissioned it, on behalf of the Virginia legislature. To make sure it was lifelike, Houdon made the voyage to America in 1785, accompanied by Benjamin Franklin; he met Washington, drew him, and measured his august head. The "pedestrian statue," as Jefferson called it (meaning a standing figure, on its own feet), was the by-product of a larger deal, for in 1783 Congress had authorized the commissioning of an equestrian statue of the *pater patriae*, and Houdon was to do that too: his studio

was already set up with the expensive gear and furnaces needed to cast a bronze figure of Louis XV on horseback. Jefferson was horrified by its prospective cost ("In truth it is immense. . . . [I]t will be much greater than Congress is aware of") and he decided to get two figures from Houdon, if not for the price of one, then at least at a discount.

In the end, the bronze Washington on horseback was never done, but the marble one was delivered and installed in the rotunda of the Virginia State House in 1792 (Figure 78). It is a superb display of neo-classical style and intelligence. Insofar as a single figure can, it expresses democracy. Jefferson had insisted that "the size should be precisely that of a man." Anything bigger would have been pretentious. It shows the statesman as citizen, *primus inter pares* in the Latin phrase that meant so much to the Founding Fathers—not a king, not a god, but first among equals. Divine presence, however, is implied by its placement in the State House; Houdon's Washington stands where the effigy of the god would have stood in a real Roman temple. The plinth, and the obstructive and ugly iron railing around the figure, was not part of Houdon's design, but added much later, in the nineteenth century.

We do not see Washington as victorious general. He is presented as a new Cincinnatus. Washington was a Virginia planter, summoned to lead the patriot armies. Cincinnatus, a legendary Roman hero, was called from farming life to become dictator of the Republic in 458 B.C. and save the Roman army. He defeated the enemy, resigned his powers after only sixteen days, and returned to his farm, thus becoming the very archetype of Roman-Yankee civic integrity.

Houdon's Washington leans on a bundle of rods, the Roman fasces—each rod a state, their union connoting strength. His sword is sheathed. His

78. Jean-Antoine Houdon, *George Washington*, 1786–95(?), signed 1788. Marble. Virginia State Capitol, Richmond.

plough is the symbol of agrarian virtue, and implies the planting of a new political order. The final, almost subliminal touch is a missing button on the right lapel of Washington's coat, which lets you know that the great man is capable of a certain negligence in *tenue* and is not a stickler for protocol—democracy in dress, as it were.

Washington died in 1799. As the essence of American history, the leader of the Revolution, and the father of his country, he required a monument. Yet the problems of representing him seemed almost insoluble. A colossus? Undemocratic: anything that suggested the *pater patriae* was a king or a god was going to offend some Americans, even though popular art was full of images of Washington being taken up to heaven by angels, and there was a considerable flurry of posthumous hagiology, if not actual deification.

The eventual solution—the gigantic obelisk that stands on a green mound in the center of the city and is, at 555 feet, the tallest stone structure on earth—is so much a part of America's mental landscape by now that it seems hard to believe that there was ever any controversy about it. But people objected to it, and the designs that preceded it, vehemently. The very idea of an obelisk was not accepted until 1848, or finished until 1885, nearly a century after Washington's death. It was kicked around by opposing factions and parties. Politicans accused more modest designs of lacking respect for the national father, and more elaborate ones of deifying him as a Caesar with the suspicious trappings of autocracy. The most original idea for a Washington monument, one which would incarnate the principles of one-man-one-vote democracy while serving the memory of the politician as hero, was proposed to the sixth Congress by a Virginian, John Nicholas: "A plain tablet, on which every man could write what his heart dictated. This, and this only, [is] the basis of [Washington's] fame." If Nicholas's scheme—never adopted—seems oddly modern, a conceptual monument, the proposal of Washington's own adopted son, George Washington Parke Custis, was hardly less so: an earth mound or national anthill raised by thousands of citizens from all over America, not necessarily old veterans of the Revolution but people "of revolutionary stock," who would converge on the capital and each add a few shovelsful of earth to its bulk, symbolizing the soilbound and agrarian virtues of America's primal revolutionary act. But this was ridiculed by those who wanted a grander monument—pillar, temple, or statue.

In 1836 the leader of the Washington National Monument Society, George Watterston, sought designs for a monument 500 feet high, composed of a temple surmounted by an obelisk. It should be the tallest building in the world, or in history: "the most stupendous and magnificent monument ever erected to man." Clearly, there was a great difference between the values of old Cincinnatus (who had wanted to be buried on his farm, Mount Vernon, anyway) and those of a newer, more booming and boosterish America: Watterston specified that the

monument should cost no *less* than a million dollars, a far cry from Jefferson's frugal hope of getting two Houdon Washingtons, equestrian and pedestrian, for the price of one. This project, a counterpart to the fantasy-patisserie visions of ancient Rome that Thomas Cole was painting at about the same time, was, of course, not realized—not least because the American economy was so badly shaken by a flight of foreign capital caused by a failure of its 1820–36 canal boom that its "Hard Time Depression" of 1837–41 put an end to all notions of public monuments, especially million-dollar-minimum ones.

The idea languished, only to be revived in 1845 in the form of an immense circular Doric colonnade designed by Robert Mills, its columns some 100 feet high, from whose core the 500-foot obelisk would rise. This imperial fantasy got falteringly under way; ten years later, the shaft of the obelisk had risen a mere 150 feet. Money was piteously short—a fund-raising campaign by the xenophobic party called the Know-Nothings, who seized and occupied the site in 1855, produced only $51.66 in contributions over three years. In the aftermath of the Civil War, the unfinished stump on its mound was an embarrassment, a phallic joke on

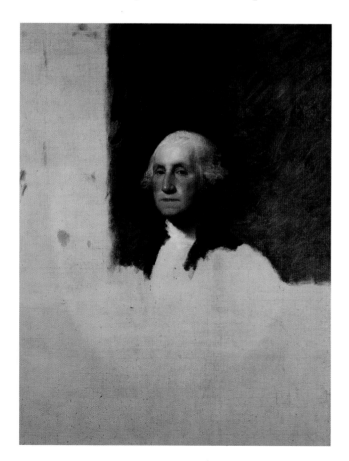

lost American potency. Then, in 1876, Congress decided it had to be rid of this embarrassment; a hundred years had flown since the Revolution, and the monument must be finished. Almost by stealth, the design was taken over in 1878 by Lieutenant Colonel Thomas Casey, an army corps engineer who had been charged with the responsibility of constructing Mills's obelisk. He abolished the Doric colonnade and excised all trimmings, basreliefs, inscriptions—everything that looked like "Art." He left a pure, perfect shaft, which today continues to look like the middle term between the first heroic style of America, neoclassicism, and the last, late-twentieth-century Minimalism. Some did not like it; it was compared to "a stalk of asparagus . . . the refuge of incompetence in architecture," and Mark Twain thought it looked like a damaged factory chimney. Today, its noble impersonality takes your breath

79. Gilbert Stuart, *George Washington,* 1796. Oil on canvas, 48 × 37″ (121.9 × 94 cm). Museum of Fine Arts, Boston; jointly owned by the Museum of Fine Arts, Boston, and The National Portrait Gallery.

away—it is the largest and most perfectly sublimated hero-figure in the world. It is also, more discreetly, a Masonic symbol, for George Washington—along with many other of the Founding Fathers, and some thirty presidents since—was a Mason, and on the dedication of the memorial in 1885 its keys were handed over for safekeeping to the master of the Washington Masonic lodge.

In the absence of American sculptors, painters met the demand for effigies of Washington and other heroes of the Revolution in the first twenty-five years of the young Republic. We have already seen something of the Peales' Washingtons. Another artist, Gilbert Stuart (1755–1828), depended almost entirely on Washington's face for his living, after the President first sat for him in Philadelphia in 1795–96. He is known to have painted 114 portraits of Washington, 111 of them replicas of three originals that he made from the life, of which the so-called Athenaeum head is by far the best known and has become the canonical image of the man (Figure 79). Stuart made sixty versions of it, and other artists copied it as well; it is the source for the head of Washington on the American dollar bill. (Stuart, in his turn, unblushingly referred to these icons as his "hundred-dollar bills.") Curiously, he never finished either this original or its companion piece, a head of Martha Washington (Figure 80); both retain the immediacy of *alla prima* oil sketches, which they were. Nor did he deliver them to Martha Washington, who had commissioned them in the first place, for he realized that he would make far more money by copying them than he ever could from a onetime sale.

Stuart was canny, and poverty had made him so. The penniless and uneducated son of a Rhode Island tobacconist, he had taken off for Edinburgh in 1772 as the pupil of a Scots painter named Cosmo Alexander. But Alexander died suddenly, leaving his protégé stranded. After three years of misery,

80. Gilbert Stuart, *Martha Washington*, 1796. Oil on canvas, 48 × 37″ (121.9 × 93.9 cm). Museum of Fine Arts, Boston; jointly owned by the Museum of Fine Arts, Boston, and The National Portrait Gallery.

which included a failed voyage back to America to find work, Stuart was rescued in 1775 by Benjamin West, who took him into his London studio and made him his chief assistant. He had a degree of success when he set up on his own as a portraitist in London in the early 1780s, though it was not easy to compete in a market dominated by George Romney and Sir Joshua Reynolds. Stuart's real problem, however, was his profligacy. He drank like a fish, had an uncontrollable temper, and believed he belonged to an aristocracy of talent, taking the word "aristocrat" to mean a rake. His debts wildly outran his commissions, and he had to flit from London to Dublin to evade the duns; the debts he left behind are said to have included 80 pounds for snuff, for this tobacconist's son had a mighty addiction to nicotine. (One of his friends recalled that Stuart's snuffbox was the size of a small hat.) Before long, a line of Irish creditors had formed at his door, and he was forced in 1792 to go back, this time for good, to America.

He brought with him his stylistic signature, an elegant and suave version of the painterly English portrait: no hard outlines or abrupt transitions, a silvery softness of tone given by patches of pigment left to mix on the eye. All Stuart's pictorial interest tended to focus on the human face. There is rarely, in the bodies or clothing or background of his sitters, a passage of painting that carries the charge that went into his rendition of noses, cheeks, lips, hair, and especially the gaze of his clients. It was not altogether true that, as one of his detractors said, Stuart "could not get below the fifth button"—do a creditable full-length portrait; indeed, his portrait of William Grant, known as *The Skater*, 1782, shows a vivacity of line and an alertness to the movement of the human body that quite refute this (Figure 81). The remarkable thing was that he could fake the sense of direct confrontation between painter and sitter so well that not a few of his Washington replicas, some done years after Washington's death, seem to preserve it. But by the time Stuart got to him, Washington was an old man of sixty-three, and bored to death by the pestering of artists who kept flocking to do the likeness of the greatest celebrity America had thus far produced.

The undeniable stiffness of Stuart's full-length "Lansdowne" portrait of Washington (Figure 82), his most formal exercise in the Grand Manner, was due not so much to the pain the great man was suffering from his wooden false teeth (relieved, allegedly, by marijuana grown at Mount Vernon), or even to the cares of office, as to a combination of other factors. Washington did not sit (or, rather, stand) for this portrait; since it was a present from a senator's wife to an English lord, the Marquis of Lansdowne, Stuart wanted to convey that Washington as head of the American state must now be accorded the grandeur with which his mentor, Benjamin West, had invested George III; and to do this, he adapted Washington's pose from prints of English nobility portraits by Reynolds and others, which reached back, ultimately, to the pose of the Apollo Belvedere. As a result, it is all gravitas and no personality: a pure icon of statesmanship. But even

81. Gilbert Stuart, *The Skater (Portrait of William Grant)*, 1782. Oil on canvas, 96⅝ × 58⅛″ (245.5 × 147.6 cm) unframed. National Gallery of Art, Washington, D.C.; Andrew W. Mellon Collection.

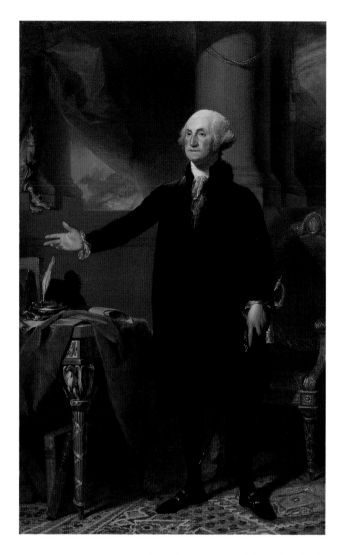

in life, Washington was no fun to paint: his conversation, in the studio, was minimal.

Gilbert Stuart's American career was a long success. Since neither West nor Copley ever returned to his native soil, it was Stuart who filled the American need for a virtuoso painter: a portraitist who had flown above the limitations and pedestrian effort of the limners, who could imbue any likeness with dash and style, registering character without apparent effort, as though he were not a constructor of fictions but a conduit for "nature." His style conferred style on his clients, who by the early 1800s included practically everyone with a claim to wealth, power, or social prominence in Federal America. It was also a mass-production device: the image rose from a few strokes and scribbles of a loaded brush, without underdrawing, and could be finished in a sitting or two. Sometimes one thinks of him as a sort of Warhol without the camera, but this gives too much credit to Warhol as portraitist and not enough to Stuart's realism, which no amount of self-repetition could altogether dispel.

Stuart was the best American portraitist of the Federal style, and he had no rivals—only a few successors, and none with his flair. The best of them was Thomas Sully (1783–1872), who became the top social portraitist of Philadelphia after the federal government moved from that city to Washington in 1803 and Stuart moved with it. Sully's work had, at best, a certain Romantic dash and broodiness, though his women were almost uniformly insipid, idealized, and pretty. His son-in-law John Neagle (1796–1865) also worked in Philadelphia, where he produced one remarkable social document: *Pat Lyon at the Forge,* 1826–27 (Figure 83). Lyon was a rich, self-made Irishman with a particular chip on his shoulder about the social elite of Philadelphia, some of whose members

83. John Neagle, *Pat Lyon at the Forge,* 1826–27. Oil on
canvas, 93 × 68″ (236.1 × 172.6 cm). Museum of Fine Arts,
Boston; Henry M. and Zoë Oliver Sherman Fund.

had had him flung in jail on a trumped-up charge of bank robbery. In the background of the portrait is the grim cupola of the old Walnut Street prison, and in the foreground is Pat Lyon in florid middle age, wearing the blacksmith's working clothes of his youth, staring with defiance and self-satisfaction at the viewer: the patron as proletarian, risen through American equal opportunity beyond the reach of the snobs.

So by the 1820s America had a plethora of portraitists. But history painting—which correct taste considered a higher field—was in short supply. Through it, the Revolution and the virtues of its heroes in action could be formally commemorated. Who could do it? The chief candidate, who believed he had been singled out by Providence for the task, was John Trumbull (1756–1843). "The greatest motives I had . . . for continuing my pursuit of painting," he wrote to Thomas Jefferson in 1789,

> has [sic] been the wish of commemorating the great events of our country's revolution. I am fully sensible that the profession, as it is generally practiced, is frivolous, little useful to society, and unworthy of a man who has talents for more serious pursuits. But, to preserve and diffuse the memory of the noblest series of actions which have e'er presented themselves to the history of man; . . . [and to preserve] the personal resemblance of those who have been the great actors in those illustrious scenes, were objects which gave a dignity to the profession, peculiar to my situation.

There was a wound beneath this pomposity. Unlike Copley, West, Stuart, and Peale, Trumbull was not of humble birth. His father, Jonathan Trumbull, was well-to-do, a Connecticut assemblyman who presently became governor of the state. He was determined that his son should go to Harvard, as he had, and then pass into the church or the law. He opposed John Trumbull's desire to become an artist; he thought a painter's life was low, beneath the dignity of the family. Hence the sentence in Trumbull's letter to Jefferson decrying painting as "frivolous, little useful to society, and unworthy." It is the father's voice speaking, with the son defying Jefferson to echo it.

Trumbull had served in the war against the British, though he only saw action at a distance as one of Washington's aides-de-camp. In 1778 he started painting in Smibert's old studio in Boston, and in 1780 he went to France, and thence to England, seeking instruction from Benjamin West. While in London he was arrested as an American spy, and it took all West's influence with George III to save him from the gallows; Trumbull was thereupon deported, but after the peace between England and America in 1784 he went back to London to take up his studies again.

He never doubted his mission as a history painter, and from 1785 on he launched into his project of thirteen canvases depicting scenes from the American Revolution. Over the years, he completed eight, mainly battle scenes. The best-known of the series is certainly *The Declaration of Independence, 4 July, 1776,* 1787–1820 (Figure 84). He based it on a description and a rough floor plan that Jefferson, who supported his plan for a record of Revolutionary history, gave him of the Assembly Room in the Pennsylvania State House in Philadelphia, where the first Congress had sat. Some of the portraits—those of Jefferson, John Adams, and Benjamin Franklin—were painted directly from life, in London and Paris; after his return to America in 1790 he spent years seeking out and painting other surviving members of the first Congress, bagging, in all, thirty-six of the original forty-seven "from the life." The last head was finished in 1819, after more than two decades of intermittent work. During this time Trumbull had to support himself as a portraitist, though he chafed at "the mere copying of faces." With Copley and West both in England, he still had rivals in Stuart, Sully, and

84. John Trumbull, *The Declaration of Independence, 4 July, 1776,* 1787–1820. Oil on canvas, 21⅛ × 31⅛" (53.7 × 79.1 cm). Yale University Art Gallery, New Haven; Trumbull Collection.

Vanderlyn, and every portrait meant time stolen from history painting. "I rail at Vanity, yet I live by flattering it." In 1808 his eyesight began to deteriorate and he sought treatment in London, where he stayed for another eight years. There was little market for his portraiture there, but when the War of 1812 broke out he could not return to America; he was stuck. "I am tired of this place," he wrote from Bath in 1814. "I hope to God our mad Government will soon conclude some arrangement which will admit of our finding our way to America—I am heartily weary of this waste of Life."

Trumbull and his family at last found their way back to America in 1815, and he immediately started lobbying Jefferson and Adams to commission large scenes of American history from him for the Capitol. Adams, who if anything disapproved of the arts, was not encouraging. He thought (or, at any rate, fobbed Trumbull off by saying) that Americans were no longer interested in the Revolution, now forty years in the past. "I see no disposition to celebrate or remember, or even Curiosity to enquire into the Characters Actions or Events of the Revolution. I am therefore more inclined to despair, than to hope for your success in Congress."

But the Capitol commission came through. In 1817 Congress authorized Trumbull to do four scenes of Revolutionary history, scaled up from his earlier and smaller paintings. The architect of the rotunda, Charles Bulfinch, designed appropriate niches in its walls to await them. Two were military: not battle pieces, but scenes of peacemaking after the fight—the surrenders of British armies at Yorktown and Saratoga. Two were political: George Washington resigning his military commission and, most famous of all, the signing of the Declaration of Independence, which a skeptical congressman—irked by Trumbull's huge fee of $32,000—called "The Shin Piece" because of its forest of eighteenth-century calves.

They are very big, and what inspiration they have is spread thin. "Competent" and "worthy" are the words that come to mind. But they have the inertness of the large-scale rehash: in the original version of *The Declaration of Independence* there are at least a few bravura passages and felicities of brushwork, but in the rotunda there are none whatever. Congress had recognized that American history should be commemorated in the Capitol, but Trumbull was devastated to find that when his agent approached its individual members to subscribe to a proposed engraving of *The Declaration*, not one of them signed up.

All four paintings were finished in 1826, the year Thomas Jefferson died, and installed without public enthusiasm. By then Trumbull was seventy years old and completely embittered; to make things worse, his beloved wife had died two years earlier. He was made president of the American Academy, only to earn a reputation for eccentricity, pomposity, and hostility toward younger artists. (This was not altogether deserved; he helped foster the career of Thomas Cole, among

others.) America's appetite for history painting, never strong, had now almost completely vanished. There was no market for the work which he considered his special claim on posterity. Trumbull made a deal with Yale University to create what was in effect America's first university museum, filled with his work. He wanted a tomb below the gallery. The pictures, he wrote in a touching access of despair in 1831,

> are my children—those whom they represent have all gone before me, let me be buried with my family. I have long lived among the dead.

He was to live longer among them; Trumbull did not die until 1843, at the age of eighty-seven. By then he seemed a relic of a vanished age, and his ambitions to reconstruct the American past through history painting futile. Not so many people wanted the past. What chance did history painting have in a country whose social imagination was fixed on the urgency of the New? The Revolution was no longer new. But the landscapes Americans were discovering within their own immense spaces: *they* were new, and already being raised into myth by painters.

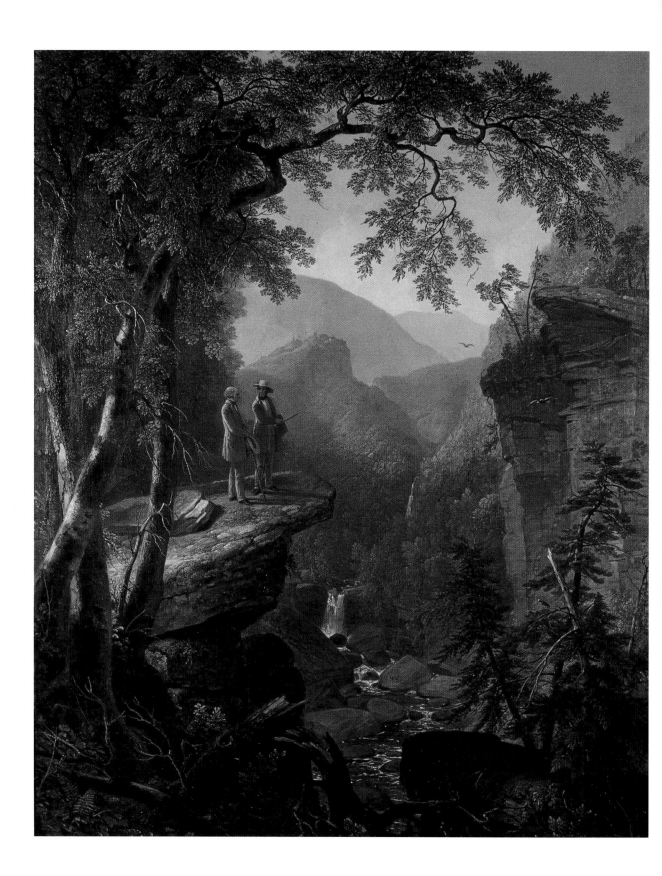

3

THE WILDERNESS AND THE WEST

In 1825 the men and women who had been born with the Revolution were well into middle age. The Republic was no longer new. Its foundation had receded into history. Its human icons were all dead or very old. George Washington had died in 1799, James Madison was seventy-four, and Thomas Jefferson, at eighty-two, had only a year to live. A painter could no longer make a living by commemorating them, as Peale and Trumbull once had. And not much to inspire a history painter, it seemed, had taken place in America since.

Without history painting or new great men, where was a national image to be found? What would symbolize America in art? Only the landscape itself, unique, vast, marvelous, the container of all possibility. Americans were busy discovering it, and hailing their own triumphs over nature. Floods of self-congratulation poured forth in 1825 when the Erie Canal opened barge traffic from the Great Lakes to New York Harbor. The same year, work began on the Pennsylvania canal system, and another canal was authorized to link Cleveland to the Ohio River and thence to the Mississippi, thus connecting the heart of the Midwest to the southern port of New Orleans.

The West, too, was gradually opening up, and the homesteading movement began. Settlers could travel up the Missouri by steamboat to the town of Independence, and then set off in covered wagons for the long, arduous, and often fatal trek west. The Santa Fe Trail, from Missouri to the Southwest, opened in 1821. The first convoy of covered wagons set out along the Oregon Trail, which led west across the Sierras to California, in 1839.

All along the way, through the dangers and mishaps, the battles with Indians and the frequent disasters caused by poor planning and bad leadership, the hopeful settlers found themselves moving through landscapes of unimagined grandeur: plains teeming with buffalo and antelope, wide rivers, conifer forests, stupendous mountain ranges. Had all this not been put there by special dispen-

85. Asher Brown Durand, *Kindred Spirits,* 1849. Oil on canvas, 44 × 36" (111.8 × 91.4 cm). New York Public Library.

sation? Certainly it was too good to be left to the Indians. Back east, by the 1830s, the landscape was already compromised by industry, polluted, approaching overuse. But Eden lay "across the wide Missouri," in God's Western wilderness. Here, Nature was incorrupt. No other part of the world that was being colonized by whites in the first half of the nineteenth century was so rich with promise. No wonder, then, that in the nineteenth century Nature became America's national myth, and the act of painting it an assertion of national identity.

This process was not, of course, confined to America. The great cultural project of the nineteenth century was to explore the relations between man and nature, to learn to see nature as the fingerprint of God's creation and thus as a direct clue to His intentions. Nature, without the "awful presence of an unseen Power" that William Wordsworth sensed in it, would be just a heap of matter—complicated stuff certainly, but shorn of real meaning. But seen as an intermediate term between the muffled consciousness of humankind and the supreme mind of the Creator, it became a medium of endless wonder, edification, and joy. And of muddle, too: for extreme nature lovers passed from trying to find God in Nature to conflating Nature with God. No previous age had brought such passionate scrutiny to nature, from the highest Alp to the smallest pollen grain; none had spent so much moral energy interpreting it, or projected so many of human aspirations onto it, as the age of Romanticism.

One of these was the desire for national identity. Romanticism and nationalism, in the Europe of 1790–1900—roughly, from the emergence of Friedrich von Schelling to the death of John Ruskin, from Turner to the end of the Pre-Raphaelite movement—were deeply intertwined, for each nation claimed for itself a distinctive landscape that embodied its own "spiritual" traits. In England there were the Lake District and the Fells, in Germany the Black Forest and the Baltic coast, in Italy the stern Apennines and the soft valley of the Tiber, and in Catalunya the "sacred mountains" of Montseny and Montjuic. And in America there was . . . most of America. "In the beginning, all the world was America," John Locke had written in the seventeenth century. Americans saw in their wilderness the very prototype of Nature, the place where the designs of God survived in their virgin and unedited state.

This compensated them for the lack of other signs of the Romantic sublime: old castles, crumbling Gothic chapels, the ruins of Roman aqueduct and Greek temple. By contrast, places like the Catskill Mountains and the prodigious canyon of the Colorado seemed to answer the murmur of skeptical old Europe, that Americans had nothing ancient and man-made to speak for them—because God spoke for them, through his deep architecture of the ancient earth.

The ability to experience, in solitude, what the novelist James Fenimore Cooper called "the holy calm of Nature" was a duty that became a right. Exercise of that right created a vast tourist industry and a chain of museums and

archives of Nature—the national parks, each a preservation of wildness, a quotation of God's original text.

Every year five million people, mostly Americans, go to the Grand Canyon to experience the very overcrowded sublime. At dawn, as the sun appears over the rimrock, it is saluted by the clicking and chirring of thousands of shutters and motor drives. Wilderness is replaced by a social construct, the "wilderness experience." Visitors talk about that experience in unabashedly religious terms: how the Grand Canyon attests to a Creator who saw fit to put it in America, and then created Americans to look at it and be reminded, uniquely among the peoples of the earth, of Him.

It would be excessive to claim that the images made by American artists in the nineteenth century created this atmosphere of pious identification with American nature, but they certainly helped to define and promote it—as did the writings of the novelist Fenimore Cooper, the poets Longfellow and William Cullen Bryant, and of course Thoreau and Emerson. If American nature was one vast church, then landscape artists were its clergy. This changed the status of American artists themselves. At first they were regarded with suspicion by Puritans and Quakers as mere limners at best and, at worst, conspirators toward idolatry. They achieved a tradesman's respectability by the end of the eighteenth century, but not that of a professional artist as understood in Europe—hence, as we have seen, the departures of Benjamin West and John Singleton Copley to more rewarding shores. But with landscape the artist came into what he felt was his birthright. If the presiding metaphor of the landscape experience was that of God as supreme artist, it need only be a short step to the idea that artists were seers or priests—if they fulfilled their mission as teachers, and behaved properly. They had privileged information. They were trained to read the Book of Nature, in which God's will was inscribed, as surely as in the Bible.

But these high responsibilities gave art a certain fragility. If it slipped, it fell a long way, like Lucifer. Between the first presidency of Monroe and the death of Lincoln, most writing about art in America tended to be rapturously pietistic, evangelical, and full of a breathless conviction that the visual arts could change the moral dimension of life. One sees it in full early bloom in the weekly editorials in *The Crayon,* New York's main art magazine of the 1850s, which was the voice of the American artist's profession and, as such, held strong and stern views on what the character of artists should be. "The enjoyment of beauty," *The Crayon* declared in 1855, "is dependent on, and in ratio with, the moral excellence of the individual. We have assumed that Art is an elevating power, that it has *in itself* a spirit of morality." And so,

> if the reverence of men is to be given to Art, especial care must be taken that it does
> not belie its pretensions, and receive contempt instead of respect, from being offered

in foul and unseemly vessels. We judge religion from the character of its priesthood, and we would do well to judge art by the character of those who represent and embody it.

Thus Puritan suspicion of the icon was assuaged. American public opinion on art was haunted by the specter of vanity, mere worldliness, gratuitousness—and by what, after the appearance of Murger's *Scènes de la vie de bohème* in 1848, was called "bohemianism."

A nude might well be a "foul and unseemly vessel." It might look un-American too, for the art audience of the day had not grown much more sophisticated about naked women as a subject since 1814, when the American neo-classical artist John Vanderlyn's masterpiece *Ariadne Asleep on the Island of Naxos* (Figure 86), one of the very few nudes painted by an American artist before the late nineteenth century, met with rejection in America after being acclaimed at the Salon in Paris.

But there was nothing foul or unseemly about landscape. It was pure, and pointed to its Creator. The wilderness, for nineteenth-century American artists, is mostly stress-free. Its God is an American God whose gospel is Manifest Des-

86. John Vanderlyn, *Ariadne Asleep on the Island of Naxos,*
1809–14. Oil on canvas, 68½ × 87" (174 × 221 cm).
Pennsylvania Academy of the Fine Arts, Philadelphia; gift of
Mrs. Sarah Harrison (The Joseph Harrison, Jr., Collection).

tiny. It is pious and full of uplift. No wonder it was so quickly absorbed as a metaphor of religious experience by the first mass audience American art was to reach. It dovetailed so well with the pieties of its time.

The artist who set this cultural machinery going was, in fact, born in England. If he had stayed there, he would have been a very small footnote in the history of English landscape painting. His name was Thomas Cole (1801–1848). He was the son of a small textile manufacturer in Bolton, Lancashire, and his childhood among the "dark satanic mills" of the industrial Midlands stamped him for life with a sense of the deep opposition between virgin, Edenic nature and the ravages of industry and development. Certainly this was to become a major theme of his work in America. Cole immigrated with his parents and family to Philadelphia in 1818. He worked as an engraver. He saw, in Philadelphia, works by the portraitists Gilbert Stuart and Thomas Sully, whose names "came to my ears like the titles of great conquerors." He decided to be a painter. Without formal training, he learned the rudiments of oil painting from a traveling portrait limner. But they were only rudiments. Without access to life classes or any intensive advice, he never learned to draw the human face or body competently. (Neither could his hero, Claude Lorrain.) His attempts at figure painting were inane; wisely, he learned to keep his Indians, woodsmen, and hermits in the distance.

Cole was only twenty-four when, in 1825, he moved to New York City from Philadelphia and found a dealer for his landscapes and sketches. The influential John Trumbull, president of the American Academy, saw his work and introduced him to patrons. These rich Federalist families, landowners, merchants, and lawyer-politicians with long roots, had aristocratic pretensions and formed a kind of American squirearchy: men like Stephen Van Rensselaer III, America's biggest landlord in the 1820s, and the merchant Philip Hone. Unsettled by the rising currents of democratic populism, deeply mistrustful of Andrew Jackson, such people tended, consciously or not, to idealize a passing era which they represented; to feel nostalgic for a more pristine America, unsullied by the powerful crowd.

In Cole they found an artist who completely shared their values: not because he was an "aristocrat," but because he aspired to be one. Nostalgia was intrinsic to Cole's imagination. He believed that American grandeur and American purity were vanishing in slow motion, before his very eyes.

In Cole's work, landscape is the vehicle of elevated feelings about transience and change. These belong to a particular class. To see why, one must remember that few late-eighteenth-century Americans were even faintly interested in visiting mountains or gorges for pleasure's sake, let alone enclosing them in the sort of mental frame that turned them into "scenery." The taste for landscape as an

object of esthetic satisfaction was narrow. Among farmers—those who actually had to work the land—it hardly existed, as far as anyone can now tell. Landscape wasn't landscape to the average American eye: it was territory, property, raw material. Its qualities were practical—the fertility of the soil and the ores it might contain, the availability of water, the kind of trees it bore, the hundred questions that all converged toward one: "How can I exploit this?" The idea that wild terrain might be, in and of itself, a "spiritual" resource occurred to very few white Americans—in fact their main spiritual tradition, that of Puritanism, had argued vehemently against it, treating uncultivated land as "wilderness," a place of biblical trial and the abode of demons. The idea of landscape, as distinct from mere territory, was imported from England and it appeared quite late in America; Thomas Cole, an English import himself, was its first bearer in painting. Through him, Edmund Burke's theory of the Sublime, along with the ideas of the English school of picturesque landscape (William Gilpin, Richard Payne Knight), passed into America. Cole was also the first artist of any consequence to try and adapt to America Claude Lorrain's idyllic scheme of the pastoral and the antique acting on one another through the medium of human culture. To the English gentry admired by Cole's patrons, the Claudean temple in the woods suggested a long continuity between nature and culture. In America, there was none: the place was *all* nature, with new, raw intrusions of commerce and development. But Cole argued that this could be turned to a painter's advantage. Nobody had painted America before. Its landscapes were not encumbered with other painters' visions. "The painter of American scenery," he wrote in 1835,

> has indeed privileges superior to any other; all nature here is new to Art. No Tivoli's, Terni's, Mont Blanc's, Plinlimmon's, hackneyed & worn by the daily pencils of hundreds, but virgin forests, lakes & waterfalls feast his eye with new delights, fill his portfolio with their features of beauty . . . because they had been preserved untouched from the time of creation for his heaven-favoured pencil.

A grain of salt is needed. Though he was to become the spiritual father of a number of "wilderness painters," most notably Frederick Church, Cole himself never painted unexplored wilderness; his subjects were newly opened tourist areas. Mainly, he painted the Hudson River and the Catskill Mountains.

By the early 1820s these were familiar territory to those New Yorkers whose taste for picturesque and beautiful scenery created a tourist business. Its center was the Mountain House, a hotel perched on an escarpment of the Catskills looking down on the valley of the Hudson, not far from the Kaaterskill Falls. Built in 1824, it was an instant success. The Mountain House gave its guests a stirringly religious sense of primal landscape: there, early in the morning, you seemed to float above the world, looking down on banks of cloud in the valley below.

Being literally "above the clouds" is a commonplace today, thanks to air travel; in 1824, for most Americans, it was unique and promoted feelings of sublimity and awe. The morning mist reminded them of the chaos which preceded God's creation. Fenimore Cooper has Natty Bumppo, the frontier scout of the Leather-Stocking Tales, speak of the most beautiful place he had seen in all his fifty-three years of roving the American forests. It is the top of the Kaaterskill Falls,

"... next to the river, where one of the ridges juts out a little from the rest, and where the rocks fall for the best part of a thousand feet, so much up and down, so that a man standing on their edges is fool enough to think he can jump from top to bottom."

"What do you see when you get there?" asked Edwards.

"Creation!" said Natty.

Young Thomas Cole went to the Mountain House the year it opened, and saw Creation from the Kaaterskill Falls. He painted several versions of them, the best-known being a view back from the floor of the valley, the Kaaterskill Clove, gazing up at the double pitch of the Falls (Figure 87). The season is autumn; the woods are turning russet, crimson, and yellow. Above the mountain rim, a storm cloud passes. Cole, intent on reimagining the primal American scene, left out all the appurtenances of tourism—handrails, steps, a viewing tower—that had been added to the place. And he put something back. On the remote rock ledge, a solitary Indian is hallooing into space. He is, presumably, the last of the Mohicans. By the time (1826) Cole returned him to the landscape, the native peoples of the Hudson Valley and Long Island were all but wiped out, but as an emblem of vanishing wildness Cole thought him indispensable.

Cole recrossed the Atlantic in 1829, visiting London, where he met John Constable and J. M. W. Turner and exhibited some pictures. By 1831 he had reached Italy. He would work there for almost two years. Essentially, Cole's Italian paintings are Italian Turners, more crudely and literally done: the same panoramic views with umbrella pines and limpid evening skies, the same picturesque peasant figures among ruins. Occasionally an American strain of pre-Twainish humor will break through Cole's earnest versions of the Arcadian mode. In *Italian Scene, Composition, 1833*, the artist is sketching in the foreground, his back propped against the stump of a pillar. He has draped his red jacket over the column, and a sneaky goat is up on its hind legs, chewing it.

Before Cole left for Europe, his friend the writer William Cullen Bryant addressed him in a sonnet. It shows how the sense of unique value in American landscape was perfusing American imaginative life by the late 1820s. In Europe, the "trace of men" was everywhere; in America, not. And the painter must remember the primordial scene while contemplating the humanized one.

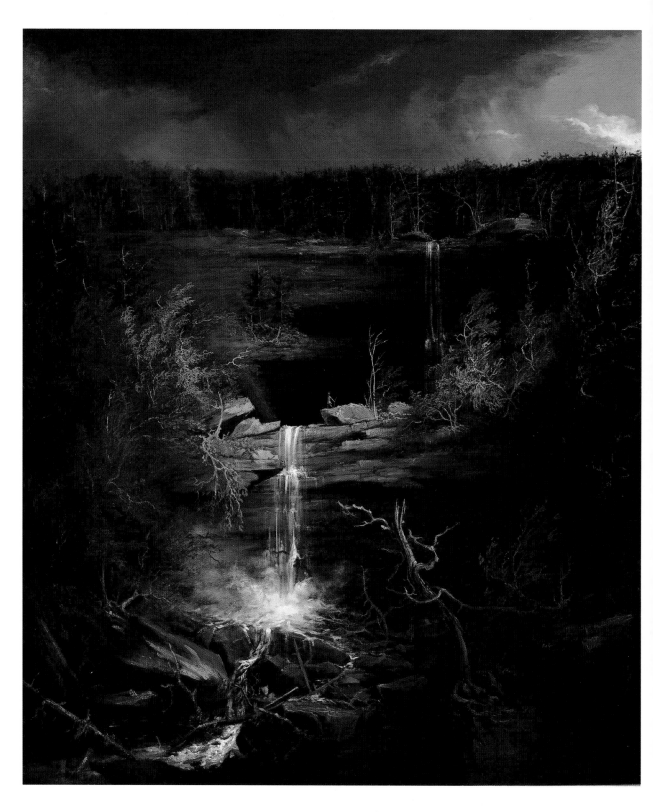

87. Thomas Cole, *Falls of Kaaterskill,* 1826. Oil on canvas,
43 × 36 ″ (109.2 × 91.4 cm). The Warner Collection of Gulf
States Paper Corporation, Tuscaloosa, Alabama.

Thine eyes shall see the light of distant skies;
> Yet, Cole! Thy heart shall bear to Europe's strand
> A living image of our own bright land,

Such as upon thy glorious canvas lies;
Lone lakes—savannas where the bison roves—
> Rocks rich with summer garlands—solemn streams—
> Skies, where the desert eagle wheels and screams—

Spring bloom and autumn blaze of boundless groves.
Fair scenes shall greet thee where thou goest—fair,
> But different—everywhere the trace of men,
> Paths, homes, graves, ruins, from the lowest glen

To where life shrinks from the fierce Alpine air.
> Gaze on them, till the tears shall dim thy sight,
> But keep that earlier, wilder image bright.

Back in America, Cole was able to pour the lessons of Italian landscape into less history-laden scenes. The outstanding example is his large landscape known as *The Oxbow,* whose full title was *View from Mount Holyoke, Northampton, Massachusetts, after a Thunderstorm,* 1836 (Figure 88).

It is a "prospect"—a view from high up, commanding a vast fan of territory. One of Cole's favorite themes was pastoral, Arcadian America beset by storms.

88. Thomas Cole, *View from Mount Holyoke, Northampton, Massachusetts, after a Thunderstorm—The Oxbow,* 1836. Oil on canvas, 51½ × 76" (130.8 × 193 cm). The Metropolitan Museum of Art, New York; gift of Mrs. Russell Sage, 1908.

They pass, but their presence suggests impending change in the world. So here. On the right, the serene curve of the river (and an "oxbow," one should not forget, was a yoke, a symbol of control over raw nature). The river valley is dotted with farms, peaceful in the golden light. On the left, we see the uncontrollable— a storm blotting out the distant view, and in the foreground reminders of other storms, in the form of blasted trees straight out of Salvator Rosa. On the extreme right of the canvas we see Cole's parasol, planted like a brave flag above his gear. He has retreated into a gully, where we can just make him out, with his easel. He has left the possession of the scene—and the decoding of its moral message—to us. Now that the storm has passed, our eyes can move out to the horizon, into infinite light: the American promise.

Cole was skeptical about progress. For him, the image of America as Arcadia served to spiritualize the past in a country without antique monuments. America's columns were trees, its forums were groves, and its invasive barbarian was the wrong sort of American, the builder of railroads and the man leaning on his ax, who is seen in several of Cole's paintings surveying the cleared hills, contemplating the destruction he and his fellows have wrought. The Man with the Ax would recur in American painting through the nineteenth century, as a symbol of progress—the last painter to depict him in the spirit of Cole was Winslow Homer. Cole saw that the rhetoric of American nationhood was fatally entangled with greed, for, as he wrote in one of his attempts at didactic poetry,

> Each hill and every valley is become
> An altar unto Mammon, and the gods
> Of man's idolatry—its victims we.

Thus it was Cole who introduced in painting the terms of the great debate over natural resources which has preoccupied Americans ever since. On the one hand, the landscape is an immense cornucopia, created by a providential God for men to use just as they please. The sanction for this was given to Adam and Eve in Genesis 1:28: "Be fruitful, and multiply, and replenish the earth, and subdue it: and have dominion over the fish of the sea, and over the fowl of the air, and over every living thing that moveth upon the earth." In the opposite view—that of Cole, the American Transcendentalists, and every conservationist that followed them down to the present day—God had inscribed his being in the wilderness and to destroy it was sacrilege. A justly famous passage in Ralph Waldo Emerson's *Nature,* 1836, sums up the American ideal of theophantic, healing nature:

> In the woods, is perpetual youth. Within these plantations of God, a decorum and sanctity reign, a perennial festival is dressed. . . . In the woods, we return to reason and faith. There I feel that nothing can befall me in life,—no disgrace, no calamity, (leaving me my eyes,) which nature cannot repair. Standing on the bare ground,—

my head bathed by the blithe air, and uplifted into infinite space,—all mean egotism vanishes. I become a transparent eye-ball; I am nothing; I see all; the currents of the Universal Being circulate through me; I am part or particle of God.

To grasp the meaning of Cole's Arcadian scenes of the Hudson River, one must imagine them, as he did, in contrast to the go-getting populist energies of American development. They are deeply conservative, deeply nostalgic—and sometimes openly allegorical. They are a visual counterpart to the prescient remark made by the French visitor Alexis de Tocqueville, in the late 1830s: "It is the consciousness of destruction, of quick and inevitable change, that gives such a touching beauty to the solitudes of America. One sees them with a sort of melancholy pleasure; one is in some sort of a hurry to admire them."

Cole also worried about the fate of American society. In 1831–32 he began a series of allegorical paintings, collectively titled *The Course of Empire*. They were meant as a reflection on the rise and fall of civilizations, and as a warning to America about the dangers of democracy, which (he thought) could so easily degenerate into mob rule at the hands of a demagogue who, in deifying the will of the people without curbing its fickle passions, will become a dictator, an American Caesar.

The man Cole feared was Andrew Jackson, "Old Hickory," the President who, upon entering the White House in 1829, horrified the conservative Whigs by his promotion of populist democracy. Jackson declared for "the humble members of society—the farmers, mechanics and laborers." He was for commerce but against the concentration of wealth in the hands of big merchants and bankers. He represented, in fact, the worst nightmares of the very class of people on whose support Cole's career depended, the Federalist Whigs with their landlord values, whose vision of an American republic sprang from Jefferson's ideal of a nation of yeomen farmers presided over by good leaders with a "natural" suspicion of unrestrained commerce.

The Course of Empire offers a cyclical view of history. If America was a new Rome, as the Federalists had hoped, then Cole's series was meant to be a visual analogue to Edward Gibbon's *Decline and Fall of the Roman Empire*. He wanted to present Gibbon's pessimism through the visual language of Claude Lorrain, with special effects from the English artist John Martin. By the 1820s "Pandemonium" Martin (1789–1854) was famous for his scenes of colossal architecture, apocalyptic turmoil, and divine vengeance, from the Deluge to the destruction of Pompeii. His work embodied the Hysterical Sublime.

Cole's series was commissioned, for the then huge price of $5,000, by the New York grocery millionaire Luman Reed, a self-made man who, like so many Americans since, collected partly out of moral idealism and partly for purposes of social climbing. Reed's collection was semipublic, housed in a gallery in Greenwich Village, and it consisted mostly of American art. *The Course of Empire* would

be its centerpiece. It would represent, Cole wrote, "the History of a Natural Scene, as well as an Epitome of Man; showing the *natural* changes of Landscape and those effected by Man in his progress from Barbarism to Civilization—to the state of Luxury—to the vicious state or state of Destruction etc." The word "luxury" has changed its meaning since the 1830s. For Americans today, it is a goal, a fantasy. Then, it meant a cancer of vice at the heart of politics and morals.

The core of Cole's series is landscape. In the five paintings, the setting is always the same: a natural harbor with a Gibraltar-shaped headland, topped by a round rock. The landscape endures, outlasting the cycle of human history that turns within it. The first painting, *The Savage State*, 1834, is the primitive scene. Scarves of mist blow back from the dark shore and stream up to join the clouds, which in turn part to reveal a coming dawn; in the distance we see canoes, an Indian encampment with tepee-like huts, and in the foreground a Claudean hunter with skin garments and a bow. It is a culture without monuments or records.

Things have improved in *The Arcadian or Pastoral State*, c. 1836 (Figure 89). Permanent architecture appears, in the form of a circular, Stonehenge-like temple, with smoke fuming upward from its altar. (Cole did not put his story specifically in America, since he wanted it to be universal; in the 1830s the oldest known human structures were the megaliths of England.) Technology is symbolized by a longship being built on the beach. The arts have begun, for girls are dancing to a flute in a grove. Hunting and gathering have given way to the rais-

89. Thomas Cole, *The Arcadian or Pastoral State,* c. 1836, second in the *Course of Empire* series. Oil on canvas, 39¼ × 63¼" (99.7 × 160.6 cm). The New-York Historical Society; gift of New York Gallery of Fine Arts.

ing of flocks. Memory, learning, and speculation appear. This, Cole implies, is the idyllic pastoral state of the early Republic, when all human affairs are in tune with nature, and Horace's *prisca gens mortalium,* the uncorrupted race of mortals, lives without want but also without greed.

This Eden cannot last. The lesson of what can go wrong with the State unfolds in the third painting, which Cole called *Consummation,* 1836 (Figure 90). No more, the agrarian simplicity of the early Republic. Populism has led to mob rule, the fickle mob begets dictatorship, a culture of spectacle and patronage reigns. Here comes Caesar across the bridge, in triumph, holding the palm of victory and the trumpet of fame, with his slaves, lictors, and presumably corrupt senators. Cole didn't go so far as to give him Andrew Jackson's face, but he didn't need to, since both he and Luman Reed felt the moral would be plain enough.

There is something rather prissy about Cole's version of the awful delights of imperial Rome. No orgies—but he clearly had a great time doing the architecture of this marzipan city, column by column. In its nutty grandiosity and bathroom-like newness, it looks forward to the film fantasies of D. W. Griffith and Cecil B. De Mille, and to Hearst's San Simeon. And Cole hints at what is coming: on the

90. Thomas Cole, *Consummation,* 1836, third in the
Course of Empire series. Oil on canvas, 51¼ × 76" (130.2 ×
193 cm). The New-York Historical Society; gift of New York
Gallery of Fine Arts.

right, the little children playing by the marble pool have learned about aggression. They are staging a naval battle, and a toy trireme is sinking.

As the child is, so will the man be. In *Destruction,* 1836, these bellicose little beasts have grown up. Enfeebled by luxury and excess, the imperial city has fallen. It is being sacked and pillaged by hordes of unspecified origin—vandals? other Romans/Americans?—while its colonnades burn. The imperial bridge, which once bore Caesar in triumph, collapses under the weight of struggling armies.

And now, in *Desolation,* 1836 (Figure 91), the cycle of history returns to its beginning: a wilderness, this time with ruins, and only a single column left to mark the vanity of man. Cole set a faint hint of regeneration on its battered capital—a stork's nest, the stork being a symbol of (re)birth. But the anxiety he expressed in *The Course of Empire,* for all its universal aims, is a very American one, and it would raise its head at intervals right down to the Cold War: the fear that this culture, so new, so full of shine and strength, could be swept away in one catastrophic eye-blink. Except that for Cole the threat wasn't nuclear, it was moral, and its seed of apocalypse was planted right in the heart of the American democratic experience. Hindsight, of course, alters one's experience of paintings. Within thirty years of the completion of *The Course of Empire,* Americans had turned on one another in the Civil War, and photographs of the ruins of the South—the charred relics of classical porches raised on the labor of so many slaves—now seem to complete Cole's prophecy.

Yet though it was extravagantly praised by Fenimore Cooper and other conservatives—it struck the author of the Leather-Stocking Tales as "one of the noblest works of art that has ever been wrought"—*The Course of Empire* was by no means the most popular series Cole produced. That distinction belongs to a suite of religious paintings called *The Voyage of Life,* done in 1842. To a modern eye, they are unalloyed Victorian kitsch: four stages in the progress of the soul, from childhood through youth to manhood and thence to old age. Under the watchful eye of his guardian angel, the soul rides in a sort of canoe, heavily ornamented with other, gilded angels, down the river of life. As the soul enters the dangerous rapids of manhood, one of the angels on the prow seems to be squawking with alarm; and once the canoe is into the peaceful waters of old age, the angelic heads have broken off altogether, leaving gilded stumps behind. But what seems corny to us was deeply moving to Cole's audience in the 1840s and 1850s; nearly half a million Americans flocked to see *The Voyage of Life* in a memorial exhibition of Cole's work in 1848, and engravings made after the four paintings were once as much a fixture of American parlors as Landseer's *Stag at Bay* was of British ones. Cole's piety fitted the religious temper of his audience, and at the time of his death in 1848 he was the best-known artist in America, mourned by everyone who had the slightest affiliation with the arts.

The other major artist who concentrated on America's natural scene in the
1820s and 1830s was not, however, a landscapist. His study was birds. We tend
to think of "ornithological art" as a branch of illustration; but the work of John
James Audubon (1785–1851) went far beyond that. He was a great *formal* artist,
which could never be claimed for Cole; and one reason why his climactic work,
The Birds of America, remains a touchstone of American sensibility—and has in-
fluenced artists well into the twentieth century, such as Ellsworth Kelly—is its ab-
stract quality: its sense of profile, placement, rhythm, and graphic energy. He set
out to give the hard facts about birds, as John Singleton Copley had about the
human face; indeed, it was Audubon who took up the strand of direct empirical
realism where Copley left it when he departed for England. But the facts were of-
fered by a stylist who was, unlike most stylists, untaught.

Born in Les Cayes in Haiti, Audubon was the illegitimate son of a French mer-
chant and slaver, Captain Jean Audubon, and a Haitian chambermaid. His
mother died soon after his birth and he was raised by his father's family at Nantes
in Brittany. When he was eighteen, his father sent him to America to manage one
of his estates, "Mill Grove" near Philadelphia. In 1805 the young man went to
France for a little more than a year, only to return to the United States in 1806.
Where did he get his art training, if in fact he was trained? Nobody knows.
Audubon, a man given to role-playing and grandiose boasts—they soothed the
shame of illegitimate birth—would later claim that he had studied under Jacques-
Louis David in Paris, but no record confirms this. (In dealing with Aububon one

91. Thomas Cole, *Desolation*, c. 1836, fifth in the *Course of
Empire* series. Oil on canvas, 39¼ × 63¼" (99.7 × 160.6
cm). The New-York Historical Society; gift of New York
Gallery of Fine Arts.

must realize, right off, that he was not a nice guy. He was self-inflated, paranoid, and a bit of a thug. He jeered bitterly at the good work of rivals, or, worse, claimed it as his own.)

There is no doubt, however, that he drew constantly from childhood onward, and that the obsessive subject of his drawings was birds. "My whole mind," he noted, "was ever filled with my passion for rambling and admiring those objects of nature from which alone I received the purest gratification." The birds left him little time for business, for which he had no talent anyway; and his luck was terrible. His father's land interests collapsed under him and were sold in 1807. He married in 1808, and opened a general store in Louisville, Kentucky, in 1809. It went broke. A further string of failures culminated in 1819, when he was clapped in debtor's prison and forced to sell all his belongings. At this point, aged thirty-four, Audubon decided to be an artist full-time. He and his long-suffering wife, Lucy Bakewell, moved to Cincinnati, where he taught drawing, did some taxidermy, and painted portraits. He also began to plan his great work, *The Birds of America,* four volumes showing 435 species, life-size, based on his own watercolor and pastel drawings, and engraved in full color on the biggest sheets of paper then commercially available—double-elephant, measuring approximately forty by thirty inches.

92. John James Audubon, *American Swallow-Tailed Kite (Elanoides forficatus),* 1821. Watercolor, graphite, pastel, and selective glazing with brown ink inscriptions on paper, 20⅝ × 28⅞" (52.5 × 73.6 cm). The New-York Historical Society, New York.

There had been illustrated studies of American birds before, notably the 109 plates in Mark Catesby's *Natural History of Carolina, Florida and the Bahama Islands* (1731–43). But Catesby was nowhere near the artist Audubon was, and in scope and detail, Audubon's project was unprecedented. Nobody had ever embarked on such a description of any aspect of American nature before. None would again.

In order to describe the birds, Audubon killed them, and in great numbers. America had no endangered species of birds in the 1820s. They lived in enormous profusion. There being no cameras, the only way to study a bird close-up—beyond gazing at it through the imperfect telescopes of the day—was to shoot it. Aububon represented, in a particularly acute way, the paradox of early-nineteenth-century Americans in the face of nature. He was a hunter, in love with hunting. The artist's and the hunter's eye were the same. The hunter assumes the pitilessness of nature, but this does not diminish his respect, even his love, for his prey. Audubon wrote of shooting a spruce grouse, seen moving through the woods with her brood of chicks behind her: "Her very looks claimed forbearance and clemency, but the enthusiastic desire to study nature prompted us to destroy her, and she was shot."

Having shot his bird, Aububon would wire its corpse to a board in an attitude that seemed both esthetically pleasing and full of information. In death, it became the sculpture of its own life:

> I pierced the body of [a kingfisher], and fixed it on the board; another wire passed through his upper mandible held the head in a pretty fair attitude, smaller ones fixed the feet according to my notions, and even common pins came to my assistance. The last wire proved a delightful elevation to the bird's tail, and at last—there stood before me the *real* Kingfisher. . . . [E]ven the eye . . . was as if full of life whenever I pressed the lids aside with my finger.

The result was often a bird ballet worked out in advance before Audubon's pencil touched the paper, solo or pas de deux: two owls spreading and twisting their wings, cock and hen snakebirds darting their sinuous necks, a whooping crane balanced on one mighty black leg as its beak stabs at a baby alligator. Audubon made a special point of representing his birds life-size, and it was a challenge to fit very large ones (such as the whooping crane, tallest of American birds) into their page confines. Wiring up his models enabled Audubon to use the actual bird as a sketch for its own representation, thus freeing him to display his formal virtuosity. A superb example is his watercolor (engraved as plate number 72 of *The Birds of America*) of *Elanoides forficatus*, the American swallow-tailed kite, 1821, drawn during his stay in New Orleans (Figure 92). Its silhouette is rigorous and graceful, catching the spread wings and their flared tips, the deep V of

the tail, and the fierce flexure of the hawk's neck as it bends to tear into the garter snake it has snatched from the ground. The negative (white) space on the page is as operative as the black shape of the bird, and the snake is no mere limp reptile but a creature knotted in agony whose body spins out in a string of diminishing curves that suggest the departure of life.

Audubon was enraptured by the drama of nature, its indifferent battle for sustenance and survival. Even his small birds, blue jays or wrens, are voracious, with bright eyes and stabbing beaks. The large raptors have the same ferocity as Géricault's wild horses or Delacroix's tigers, and equal symbolic power. Two peregrine falcons tear at a duck's breast; blood drips from one bird's beak while the other bird glares at you. An osprey lugs its prey, a five-pound weakfish, through the sky, and Audubon notes the rhyme between the fish's open mouth and the bird's gaping beak. Yet despite their "otherness," Audubon identified with these birds—or rather, it was precisely their otherness that he identified with. The most vivid example is his watercolor of a golden eagle, *Aquila chrysaëtos*, done in 1833–34 (Figure 93). Its mighty shape fills the foreground, rising up with a white rabbit clutched in its talons, one of which is driven into the rabbit's eye—a hideous thought for an artist to have. In the background, on a fallen tree bridging two crags, is Audubon himself, inching his way along with a freshly killed eagle tied to his back. The eagle is prey to him, as the rabbit to the eagle. Which makes the artist a kind of eagle too, the all-observing monarch of the wilderness.

The Audubons moved to Philadelphia in 1824. John James hoped he would be generously received by Philadelphia's scientific establishment. He was not. Though some naturalists admired and befriended him, he soon made an enemy in George Ord, a member of the Academy of Natural Sciences who was republishing the first illustrated study of American birds, Alexander Wilson's *American Ornithology*. Ord did not want this bumptious unknown cutting into his market, and he attacked Audubon so remorselessly, in print and by word of mouth, that the artist could not find a publisher for his work. (And yet again, Audubon was no innocent victim here; his arrogance worked against him.) In the end, this may have been just as well: no American engraver of the day could have rivaled the English ones Audubon later found. But Audubon had a vulnerable and sore point. He was not a scientist. He had no formal training in natural history, no degrees, "little Latin and less Greek." He could not compete on academic ground. What he could do, however, was claim supremacy in the area of practical experience, backed up by that ever-growing portfolio of ambitious, exquisitely rendered watercolors. Other naturalists worked from skins, skeletons, corpses. Audubon had ranged the wilds, closely studying live birds in all their habitats. He had observed their social behavior, their mating rituals, their nesting habits, and their prey. He knew them—as we would now say—as parts of a biosystem, not just as isolated specimens in an abstract taxonomic context. "I

know I am not as a scholar," he wrote in 1830 at the start of his *Ornithological Biography*, "but meantime I am aware that no man living knows better than I do the habits of our birds; no man living has studied them as much as I have done. . . . I can at least put down plain truths." Which was not altogether the

93. John James Audubon, *Golden Eagle*, 1833–34.
Watercolor, graphite, pastel, and selective glazing on
paper, 38 × 25½″ (96.6 × 64.7 cm). The New-York
Historical Society, New York.

plain truth; Audubon was an excellent field naturalist, but not as supreme in his time as he thought. Others could observe, but not draw, as well as he. Nevertheless, the lack of American support for his project obliged him to seek funds and publication in England, and in 1826 he went there.

Audubon's gamble on England paid off. Whereas Philadelphians thought him a pushy, gauche hick, the English saw in him their idea of an American, a man of the woods. Audubon, with his mania for image-creation, wore his hair long and slicked it with bear grease, not macassar oil. His trousers were rough wool, and sometimes he would sport a fringed buckskin jacket or a wolfskin greatcoat. He claimed to have gone hunting in Kentucky with Daniel Boone himself—an unlikely story, but one which Audubon may have come to believe. The English believed it.

Armed with letters of introduction, Audubon soon found exhibition space, supporters, patrons, and acceptance in scientific societies; by 1828 he had become a member of both the Zoological Society of London and the Linnaean Society. Most important of all, he assembled a band of assistants, headed by the engravers Robert Havell Sr. and Jr., to turn his watercolors of birds into hand-colored printing plates in a composite technique of direct engraving, etching, and aquatint. Fifty assistants were needed for the coloring alone. *The Birds of America* was published serially, in eighty-seven parts of five prints each. Audubon's struggle to round up subscribers seemed never-ending: to make even a modest profit, he had to sell two hundred sets at roughly $1,000 each. And he had to make more trips to America—to Pennsylvania and New Jersey in 1829–30, to Florida and the South in 1831–32—to sketch and paint more birds. By 1831 the first bound examples of volume 1 were ready, and with these in hand—the most impressive books on American natural history ever produced, up to then or since—he was able to find more subscriptions in America, to which he finally returned to live in 1839. Neither *The Birds of America* nor Audubon's later projects (a small edition of the *Birds,* and a three-volume study of North American mammals) made him rich, but they did make the Audubons fairly comfortable—until, at the early age of sixty-two, he began to show signs of what would be diagnosed today as Alzheimer's disease. Audubon died in 1851, aged sixty-six, leaving a graphic monument which has not been equaled by any American artist.

Audubon had no real successors, although there would be many American bird artists. Thomas Cole's legacy, however, was continuous. After he died in 1848, younger painters, and some not so young, began competing for his mantle. Asher Durand, five years Cole's senior, painted *Kindred Spirits,* 1849 (Figure 85, page 136), as a memorial. It shows Cole, with his sketch portfolio under his arm, standing on a rock ledge in the Kaaterskill Clove with his friend William Cullen Bryant, the "American Wordsworth," poet and editor, who had pronounced the exequies at Cole's funeral. The artist discloses the meaning of Nature to the

writer, who is fraternally silent. This trope of the artist as the appointed voice of Nature was shared by Bryant himself: in his funeral oration, he imagined the wild places mourning their painter—"We might dream that the conscious valleys miss his accustomed visits, and that the autumnal glories of the woods are paler because of his departure."

But Durand didn't get to fill Cole's place. And neither did other artists who had been strongly influenced by Cole, and who painted melancholy landscapes of the Catskills emblematic of his loss—Jasper Cropsey, Sanford Gifford, and John F. Kensett. A much younger painter did. He was Frederick Edwin Church (1826–1900), who was only twenty-two at Cole's death and had studied with him for the last four years of his life. Church believed he was Cole's real heir, and the ever-growing American art public took him at his word. He promptly staked his claim to succession with *To the Memory of Cole*, 1848, conceived as a pendant to Cole's own *Cross in the Wilderness*. It is a "moralized" landscape, with symbolic overtones—not only the cross draped in a garland, signifying the honors due to the late artist, but also the cut-off stump of a tree to the left, Nature's equivalent of the broken funereal column, from which new growth has sprouted. Thus, Church says, the tradition founded by Cole will go on. The red sunset clouds on the horizon suggest the close of life, but above them the high white banks of distant cumulus clouds indicate sublimity and eternity. Church found it natural to think in these terms: he inherited Cole's belief in "a higher style of landscape," not merely descriptive but suffused with "a language strong, moral and imaginative." The essential text of his work would be John Ruskin's definition of landscape painting: "The thoughtful and passionate representation of the physical conditions appointed for human existence." *Appointed:* God's will looms behind the word, as it would behind Church's landscapes. Church's instinct for the main current of American belief showed itself early, in a work painted when he was only twenty: *Hooker and Company Journeying Through the Wilderness from Plymouth to Hartford, in 1636*, 1846. In a Claudean landscape, a small party of Puritans is journeying through wild New England territory to form a new colony. A man holding a gun—emblem of conquest and civilization—points out the way ahead. The serene light, still waters, and cloudless dawn sky make it clear that their enterprise enjoys God's favor. It is the first appearance in American art of that recurrent theme of the nineteenth century, Manifest Destiny: the belief that westward colonization of America was not only a right but a sacred duty.

Hooker and Company showed Church to be a promising artist. His big landscapes of the later 1840s and early 1850s, particularly *New England Scenery*, 1851, established him in the critics' eyes as a developing master; the year after it

was painted, it sold for $1,300, then the largest price ever paid for an American painting. By then the crucial intellectual influence on his work had come to him: his reading of the German naturalist Alexander von Humboldt (1769–1859). The first two volumes of Humboldt's *Cosmos: Sketch of a Physical Description of the Universe* had appeared in English translation in the late 1840s. In 1799 this friend of Goethe's and future acquaintance of Jefferson's had embarked on a long, hazardous, and profusely rewarding scientific journey to South America, and its results were to become a *summa* of optimistic, rational thought about the world's unity under its Creator's eye. Humboldt's five-year excursion was, in terms of its effects on both professional and popular scientific thought, the most momentous undertaking until Darwin's voyage in the *Beagle* thirty-five years later. When thinking Victorians were moved to anguish by Darwin's vision of a world governed by conflict and random events leading to opportunistic "natural selection," it was Humboldt's idea of all-reconciling unity that they mourned. "Nature," Humboldt had written at the start of his book-about-everything,

> is a unity in diversity of phenomena: a harmony, blending together all created things, however dissimilar in form and attributes; one great whole animated by the breath of life.

Inspired by Humboldt, Church joined an expedition to South America in 1853. He traveled through Colombia, crossed the Andes into Ecuador, and returned to America from Panama, sketching all the way: this was the terrain of

94. Frederick E. Church, *Niagara*, 1857. Oil on canvas, 42¼ × 90½" (107.3 × 229.9 cm). The Corcoran Gallery of Art, Washington, D. C.; museum purchase.

Humboldtian diversity, and Church recorded everything from leaves to volcanoes, even making the dangerous ascent of Chimborazo—in homage to his German hero, who had reached 19,000 feet on its cone. Later, in his New York studio, he combined his observations into a sequence of South American views, whose climactic effort was *The Andes of Ecuador*, 1855. This panoramic landscape, suffused with burning light, struck his growing audience as a near-religious experience. "Let me stand," one viewer wrote,

> with bare head and expanding chest upon one of Church's mountain-peaks, gazing over a billowy flood of hills . . . while from the rifted heavens the southern sunshine pours, like God's benediction upon my temples.

The success of *The Andes of Ecuador*, however, was soon to be outdone by a painting of the most famous view in North America: *Niagara*, 1857 (Figure 94). It was one thing to amaze the public with scenes they had not seen before. But to take the most celebrated subject in American landscape painting, to eclipse all earlier images of it—that was quite another feat, and Church brought it off.

Nothing in America had been painted and described more often than Niagara Falls. The first engraving of it had been made more than a century and a half before, in 1697. The Falls had been drawn and described by a dozen eighteenth-century topographers before John Vanderlyn, in 1801, became the first professionally trained American artist to draw them. And then, so to speak, the floodgates opened. John Trumbull, Edward Hicks, Thomas Cole, Karl Bodmer, Jasper Cropsey, and John F. Kensett were only a few of the better-known artists to paint the Falls before Church got to them; in popular art, from miniatures to panoramas, from wallpapers to cheap colored engravings, the Falls had become the most widely circulated and best-known image of sublime nature in America. So Church was not stepping on virgin territory when he undertook to paint the view from the Canadian side of that foaming horseshoe. And yet in a sense the Falls were esthetically virginal, since it was generally agreed that their size, their grandeur, their overwhelming sublimity made them unpaintable. But then, they had been thought indescribable as well until Charles Dickens visited them in 1842:

> I think in every quiet season now, still do those waters roll and leap, and roar and tumble, all day long; still are the rainbows spanning them, a hundred feet below. Still, when the sun is on them, do they shine and glow like molten gold. Still, when the day is gloomy, do they fall like snow, or seem to crumble away like the front of a great chalk cliff, or roll down the rock like dense white smoke. But always does the mighty stream appear to die as it comes down, and always from its unfathomable grave arises that tremendous ghost of spray and mist, which is never laid:

which has haunted this place with the same dread solemnity since Darkness brooded on the deep, and that first flood before the Deluge—Light—came rushing on Creation at the word of God.

Just as Dickens's mastery of prose combined precise description with intense feeling and moral reflection, so did Church's painting. It is, to begin with, an extraordinary feat of *seeing*. The motion of water had always been one of the most generalized-about subjects in Western art, because it is ever-changing and notoriously difficult to "freeze." Not a wavelet or an eddy in Church's water fails to play its part in a narrative of factual cause and effect; you aren't aware of any imposition of style over observation, and no mark is arbitrary. Small wonder that John Ruskin himself was amazed by *Niagara* when Church showed it in London later in 1857. In effect, Church had combined Turner's light with Pre-Raphaelite detail.

Niagara is a picture about power—the relentless kinetic energy of the green liquid sliding toward the brink, breaking into foam, pausing in some places to show its transparency on a rock ledge, and then plunging. It is horizontally stretched: for panoramic effect, the canvas is twice as wide as it is high. It is also heavily edited. In the late 1850s more than sixty thousand tourists a year came to Niagara and both its banks were crowded with factories and hotels. The painting has

95. Frederick E. Church, *Heart of the Andes,* 1859. Oil on canvas, 66⅛ × 119¼" (168 × 302.9 cm). The Metropolitan Museum of Art, New York; bequest of Mrs. David Dows, 1909.

no people in it, and the works of man seem quite insignificant. People would be an impertinence in the vastness of the scene, falsely humanizing it. Indeed, Church left out any suggestion of a foreground on which a person *could* stand: your gaze is suspended, as it were, above the lip of the Horseshoe Falls. At Niagara, the painting insists, you do not communicate with other tourists; you are confronted by God's creation, and through that with His mind. The rainbow suggests a pristine America rising from the cataract, a promise of ongoing American renewal. Niagara's equivalence with the Deluge indicated a wiping-out of failure, a sort of cosmic baptism—strong and resonant themes for Americans in the mid-nineteenth century.

Niagara was a smash hit with critics, journalists, and the American public, "incontestably," as one newspaper declared, "the finest oil picture ever painted on this side of the Atlantic." Crowds flocked to see it; then it toured England, to more praise and audiences just as large. For Church, it raised the question of what to do next. Fired by the need to surpass himself, he left again for South America, by ship to Panama; crossing the isthmus, he took a boat south to Guayaquil in Ecuador, and spent two months sketching the volcanoes of Chimborazo, Cotopaxi, Pichincha, Cayambe, and Sangay. Back in New York, he started assembling his impressions into a painting, which was exhibited in New York and London in 1859 under the title *Heart of the Andes* (Figure 95).

It was bigger than *Niagara,* fully ten feet by five—the largest canvas of Church's career. It was also a composite, not a view from an actual spot of a real landscape. This followed Humboldt's precepts on the construction of "heroic" and didactic landscape painting. "Colored sketches," Humboldt had written, "are the only means whereby the artist, on his return, may reproduce the character of distant regions in more elaborately finished pictures." As soon as he finished it, Church put it on view in the gallery of the Tenth Street Studio Building, a block of studios that had been designed by the architect Richard Morris Hunt for well-off artists, including Church himself.

Never had the debut of a single American painting been so carefully staged. Church had it framed in a big niche with raised panels in false perspective, a bracketed cornice, and heavy draperies on a curtain rod drawn back to disclose the painting—literally, as a "picture window," so that, as a reporter from Boston put it, "you seem to be looking from a palatial window or castle terrace upon an actual scene of picturesque mountains, tropical vegetation, light and loveliness." It was the Colonial Sublime, suggesting that the North American viewer owned the South American view as his back garden. All around stood palms and aspidistras, and dried specimens of plants he had gathered in Ecuador. The public sat on a semicircle of benches, and some twelve thousand people over the next few weeks paid a quarter each to do so. Church had it lit by gas, so that visitors could come at night. All comers were invited to view it through opera glasses or,

lacking those, through metal tubes which, by isolating a small circle of the painting while one's gaze roved around erratically, made the "scene" look even realer. Thus one could concentrate on detail after detail—a quetzal bird on a branch, a peasant at a solitary shrine, the clustered epiphytes on a tree—without distraction, and this was part of Church's purpose. He had set out to give a detailed account of plants, geology, and atmosphere, scientifically true and symbolizing Humboldt's and his own belief in the unity and harmony of the cosmos. Church wanted to send the big picture to Germany after its triumphant New York showing so that Humboldt could see it. Alas, the old man died before the painting could go, and Church never got to meet his idol.

By 1860, then, Frederick Church stood at the peak of his career. He had become America's "national artist," the unchallenged leader not only of its landscape school but of its art as such. In his work, he reconciled science with religion, fusing myriads of observable facts with an overarching sense of the presence of God in His creation. Like Dickens, indeed like any artist who becomes both great and popular, he hadn't reached this position by figuring out what the public wanted and then giving it to them. He *wanted* what the public wanted, and was rewarded by its unstinting gratitude. There was no angle between Church and his audience. He was a model citizen, devoutly Christian, descended from six generations of Yankee ministers and merchants, untouched by the taint of bohemianism, and

96. Frederick Edwin Church, *Twilight in the Wilderness*, 1860s. Oil on canvas, 40 × 64″ (101.6 × 162.6 cm). The Cleveland Museum of Art; Mr. and Mrs. William H. Marlatt Fund.

extremely patriotic. Following Thomas Cole, he advised younger artists not to study in Europe, in case they lost their American essence.

Shortly after the Civil War broke out in 1861, he painted *Our Banner in the Sky,* a small oil which, reproduced as a chromolithograph, was circulated in thousands of copies to Union soldiers and their families. At first glance it looks like a standard Church sunset: streaks of cloud, twinkling stars in the deep blue of evening, a bare tree trunk. Then you notice that the clouds form the stripes of Old Glory, and the tree becomes a flagpole. Nature and God's design have combined to bless the Union. To us this double image is corny, but to Yankees in 1861 it was uplifting and moving.

It is possible, though unprovable, that Church's feelings about the Civil War underlie three spectacular landscapes he produced just before, during and just after it: *Twilight in the Wilderness,* 1860s (Figure 96); *Cotopaxi,* 1862 (Figure 97); and *Rainy Season in the Tropics,* 1866 (Figure 98). *Twilight in the Wilderness* is the most baroque of all his sunsets. Its elements, such as the primrose-

97. Frederick Edwin Church, *Cotopaxi,* 1862. Oil on canvas, 48 × 85″ (121.9 × 215.9 cm). The Detroit Institute of Arts; Founders Society purchase with funds from Mr. and Mrs. Richard A. Manoogian, Robert H. Tannahill Foundation Fund, Gibbs-Williams Fund, Dexter M. Ferry, Jr., Fund, Merrill Fund, and Beatrice W. Rogers Fund.

yellow horizon sky, the purple mountains under it, the contorted bare trees, and the cadmium-red afterglow on the fretted, phantasmagoric clouds whose reflection turns the lake to blood, are "natural" and, as it were, verifiable. But their conjunction is foreboding in its intensity. It shows, not evening for its own sake, but the eve *of* something—landscape as portent.

In *Cotopaxi* the boil of nature has burst. Church had witnessed the Andean volcano in eruption, and here, with the Civil War raging, he paints a moralized landscape, a panorama of airborne ash and lurid red light on primordial rocks. It would not have been hard for Americans, used as they were by 1862 to Civil War news that regularly compared the smoke, fire, and roar of artillery to volcanic eruptions, to find in this landscape a metaphor for the conflict that was tearing their country apart. The rising sun burns through the darkness, predicting the victory of the Union. The calm lake and the ethereal blue of the sky beyond suggest eventual peace.

This comes in *Rainy Season in the Tropics*, painted the year after the Civil War ended. It is a landscape of crags and circulating moisture—water descending as rain and rising as mist. A rainstorm has passed and the sun is trying to break through; in the left foreground, a hillside and a path, lit by a shaft of sun, picks out two Andean peasants and their pack animals; all the rest gleams indistinctly

98. Frederick Edwin Church, *Rainy Season in the Tropics,* 1866. Oil on canvas, 56¼ × 84¼" (142.9 × 214 cm). The Fine Arts Museums of San Francisco; Mildred Anna Williams Collection.

through the fogs and vapors. The dominant form is a rainbow that arches clear across the canvas, linking the barren crags on the right to the lush vegetation on the left. Pious Church probably meant it to recall the rainbow at the end of the flood in Genesis 9:11–13, through which God promised Noah that "neither shall all flesh be cut off any more by the waters of a flood; neither shall there any more be a flood to destroy the earth. . . . I do set my bow in the cloud, and it shall be for a token of a covenant between me and the earth."

From the late 1860s on, Church had troubles with his health—severe rheumatism of the hands, almost the worst affliction short of blindness that a high-detail painter could have. He was poisoned by the heavy-metal colors he preferred, cadmiums and arsenic-based greens. His powers as an artist began to flag and his reputation began its long decline. But in 1860, in the middle of painting *Twilight in the Wilderness*, Church bought a large parcel of land above the Hudson River, north of New York. On its hill, which commanded grand views down the river valley, he built a house which he called Olana. This house would be his last major work of art; Church painted few works of significance after 1870, certainly nothing that equaled his efforts of the 1850s and 1860s, and the main reason apart from his health was his obsessive concentration on Olana. Though he had an architect (Calvert Vaux, a fluent but minor figure who also worked on the first designs for the Metropolitan Museum of Art in New York), the man was hardly more than an executive consultant who did the construction drawings and supervised the work. Church himself designed almost everything, from the initial layout to the profuse decorative stenciling on and around its doors, arches, and windows. His "Feudal Castle," as he half humorously called it, monopolized his time. "I am obliged to watch it closely," he wrote to a friend,

> for having undertaken to get my architecture from Persia where I have never been—nor any of my friends either—I am obliged to imagine Persian architecture—then embody it on paper and explain it to a lot of mechanics whose idea of architecture is . . . a successful brick schoolhouse or meeting house or jail. Still—I enjoy this being afloat on a vast ocean paddling along in the dreamy belief that I shall reach the desired port in due time.

Though he had never been to Persia, Church and his family had gone to the Middle East in 1867, and the trip made a strong impression on him: the big houses of Beirut and Jerusalem, planned around a central court and filled with ornamental detail, became his model. He took care to orient each of the main rooms toward a view, framed in a large arched picture window, so that the entire house worked as a viewing platform toward the American Sublime. Its exterior was adored with patterns of ornamental tile and glazed brick, Mudejar pointed arches, and striped awnings. He liked Arabic motifs for their own sake, as luxu-

riant decor; moreover, though he felt no attraction to the Islamic religion, he had
seen them in the Holy Land and associated them with the life of Jesus Christ. The
Churches brought back fifteen crates of bric-a-brac and curios from their trip—
Moorish tiles, Roman and Greek fragments, Arab weapons and textiles, stones
from Petra. These shared the rooms of Olana (Figure 99) with Japanese armor,
the straw hats of Colombian peons and the terra-cotta figures representing their
Mayan ancestors, a fragment of marble from the Parthenon, and even a stuffed
quetzal bird, perhaps the original of the green flash in the foliage of *Heart of the
Andes,* now badly moth-eaten. Today, visiting Olana is like perambulating
through Church's brain. It is a memory-palace, set in a landscape which Church
also designed and planted over a span of thirty years. It is also highly symbolic,
a mishmash of souvenirs from all manner of ancient cultures—a sketch for a mu-
seum hoarded up in the belief that would be fully realized in the big encyclope-
dic American museums, like the Metropolitan in New York, which were rising in
Church's last years: that America was the ground on which the evidence of old
culture could be thrown together, acquiring a refreshed intensity from its pres-
ence in the New World.

Church's example pervades American landscape art in the mid-nineteenth cen-
tury. Nobody could outdo him at spectacle, but one could presume to pay his pic-
tures homage—as Worthington Whittredge, for instance, did in 1865 with

99. Frederick Edwin Church, Court Hall, Olana State Historic
Site, c. 1870. Hudson, New York. Church also designed the
elaborate stencil decoration, and the colors for the room
were mixed on his palette.

Twilight on the Shawungunk, a mountaintop panorama whose subject recalls Church's *Twilight in the Wilderness*, though without the sublime theatrics and keyed-up color. And the less theatrical side of Church—his sense of stillness, calm, and pervasive light—had its effect on another aspect of nineteenth-century American painting, known as Luminism.

Luminism was more a description than a school. It denoted a group of similarities among rather different painters: a polished realism in which all brushwork is suppressed, gestures of the hand played down, the atmospheric effects achieved by superfine gradations of tone and exact study of the "luminous envelope" around near and far objects.

The origins of Luminism lie in English-style, provincial marine painting, mainly in Boston. The Boston merchants who had got rich from sea trade may have been religious, but they were all materialists too. In their portraits, they wanted exactly painted details of their status—silks, satins, embroidery, the gleam of silver. They also wanted "portraits" of their ships, full of precise and quite unemotional detail. How was the vessel rigged? What color was her hull? How much overhang to the counter? How many crew did she carry? They liked transcriptive painting, plain drawing, and calm water.

Marine artists like Robert Salmon (c. 1775–c. 1844) supplied all that. Salmon was a somewhat eccentric character, who worked in a shack near the Boston wharves. His more ambitious works, such as *Boston Harbor from Constitution Wharf*, 1833 (Figure 100), show the influence of Claude's harbor scenes—flat, glowing water, ships against the light, a buzz of silhouetted activity in the foreground. There was nothing original or particularly American about Salmon: he

100. Robert Salmon, *Boston Harbor from Constitution Wharf,* 1833. Oil on canvas, 26³⁄₄ × 40³⁄₄" (67.9 × 103.5 cm). U.S. Naval Academy Museum, Annapolis, Maryland.

had emigrated from England at the age of fifty, with his derivative style fully formed. One of his protégés in Boston was a young painter from Gloucester, Massachusetts, named Fitz Hugh Lane (1804–1865), whose early works, like *Boston Harbor,* 1855–58 (Figure 101), are done under Salmon's spell but exceed them in clarity and formal strictness. The genre elements—sailors and dock workers in the foreground, for instance—are edited out; a wherry is moving away in the middle distance, into the path of golden sunset on the water, but that is the only sign of motion in the picture. The elliptical glow of yellow light in the sky leads one's eye out into space, beyond the harbor. The courses of sail on the two big ships, left and right, hang down limply, backlit gray trapezoids hung on the grid of masts and yards. Not a puff of wind stirs them. All animation is suspended. This trait would pervade all Fitz Hugh Lane's work. Each image offers a small moment in time, but infinitely stretched out. *Ships and an Approaching Storm off Owl's Head, Maine,* 1860, depicts the calm before the storm; a white squall is on the horizon, and in the enveloping darkness out there one can just pick out a schooner heeling before its blast, its mainmast pennant streaming; but the foreground is windless, and though the crews of the small fishing sloop and the bigger ship are hurrying to furl sail, the sails themselves—marble white against the darkness—are fixed in their eerie calm.

Fitz Hugh Lane was a modest artist, incapable of the sort of rhetoric one associates with Cole and Church; he did not moralize or construct allegories, he painted nothing but ships and coastlines. But just as one must not relegate

101. Fitz Hugh Lane, *Boston Harbor,* 1855–58. Oil on canvas, 26¼ × 32″ (66.8 × 106.7 cm). Museum of Fine Arts, Boston; M. and M. Karolik Collection of American Paintings, by exchange.

Audubon to the box marked "ornithological artist," so one should beware of condescending to the ship painter. Ships had an American spirit in them—a keen pragmatism, an inventive splendor of form that arose from need, not Europe-envy. This inspired Lane, and he was not the only one. The neo-classical sculptor Horatio Greenough (1805–1852), whose colossal figure of George Washington as Zeus was installed in the Capitol Rotunda in 1841, waxed eloquent on the subject. "Observe a ship at sea!" he wrote in 1843:

> Mark the majestic form of her hull as she rushes through the water, observe the graceful bend of her body, the gentle transition from round to flat, the grasp of her keel, the leap of her bows, the symmetry and rich tracery of her spars and rigging. . . . What Academy of Design, what research of connoisseurship, what imitation of the Greeks produced this marvel of construction? Here is the result of the study of man upon the great deep, where Nature spake of the laws of building. . . . Could we carry into our civil architecture the responsibilities that weigh upon our ship-building, we should ere long have edifices as superior to the Parthenon . . . as the *Constitution* or the *Pennsylvania* is to the galley of the Argonauts.

Lane took scrupulous care with the detail and design of boats, whether he was painting a coastal sharpie, a brig, or one of the new steam-propelled vessels that plied the Atlantic waters in the 1850s. Empirical realism was just as important to him as the evocation of mood, and today's interest in the "spiritual" aspect of his work might well have surprised him.

Nevertheless, there was a difference between Fitz Hugh Lane's marines and the more routine productions of other ship painters. It is in their stillness, and the peculiar self-effacing beauty of his paint as well: an even, stippled skin, whose brushmarks are blended and suppressed. His stillness, with its exquisite nuances of light and atmosphere, became one of the essential marks of American Luminism, and one sees it in the work of two younger and in some ways more eloquent artists: Martin Johnson Heade (1819–1904) and John Frederick Kensett (1816–1872).

Heade was born in Pennsylvania and received some basic art training from the Quaker "primitive" Edward Hicks. Though he never imitated the moralizing text-pictures of his teacher, and was certainly a more sophisticated artist, his work had retained links to the limner tradition: he liked clear ABC compositions with simple elements, always stressing the picture plane in a series of quiet, orderly steps from foreground to distance. At first Heade worked mainly as a hack portraitist, when he was not traveling in Europe (1837–40) or roaming America, speculating in land. He produced little of merit until the late 1850s. In 1859 he moved to New York, where he struck up a friendship with Frederic Church. This relationship was decisive for his work: Church showed Heade how expressive

light on landscape could be. Instead of seeking out grandiose panoramas, Heade
made a number of sketching trips to the coastal salt marshes of Massachusetts,
New Jersey, and Rhode Island: a flat landscape of boggy ground and tidal chan-
nels, where salt hay was gathered in round stacks. Heade's paintings of this un-
promising scene could be hauntingly beautiful. He chose a low horizon line to
stress the pure plane of the sky, usually in a calm sunset; and under its benign
light, the haystacks act as spatial markers. The result is a very minimal landscape,
wide and low, in which space and interval are used with the utmost deliberation,
and each element—the loaves of hay, a wedge of reflective water, the sky's dom-
inant rectangle—acquires a perfect clarity. They are the images in American art
closest to those of European Romantics like Caspar David Friedrich, with the
same sense of quiet awe at boundless space; light turns matter into spirit. Hori-
zontality equals sublimity. It was characteristic of Heade that, as so often in Lu-
minist painting, the clarity he pursued could tremble between the meditative and
the ominous. In *Approaching Thunder Storm*, 1859 (Figure 102), the ring of
dark water is as still as black marble under the sky, but it is bracketed by light on
both sides. Each element in the space seems unnaturally distinct—the white sail
of the catboat, the rower's shirt, the man and his dog in the foreground, and the
odd limp form, drooping over a rock like one of Dalí's soft watches, which on

102. Martin Johnson Heade, *Approaching Thunder Storm*,
1859. Oil on canvas, 28 × 44″ (71.1 × 111.8 cm). The Met-
ropolitan Museum of Art, New York; gift of Erving Wolf
Foundation and Mr. and Mrs. Erving Wolf, 1975.

closer inspection turns out to be a sail. Few American paintings convey such a strong sense of arrested time as this.

The sea induces thought. "Yes, as every one knows, meditation and water are wedded for ever," wrote Herman Melville at the start of *Moby-Dick*, having set up his extraordinary vision of New York's foreshores: "Posted like silent sentinels all around the town . . . thousands and thousands of mortal men fixed in ocean reveries . . . How then is this? Are the green fields gone? What do they here?" The sea's immense inviolability makes up for the loss of wilderness on land. We see one of these watchers (Melville himself, he could almost be) in the enchanting image of *Meditation by the Sea* done by an anonymous artist (Figure 103)—a solemn little figure among stones as carefully arrayed as Heade's haystacks, arms folded, staring at the tresses and lace of breaking waves. We know what's going through his head: Byron. "Man marks the earth with ruin; his control/Stops with the shore."

The purest images of sea-meditation were painted by John Frederick Kensett through the 1860s. Of the Luminists, Kensett was the best trained and the best connected within the circle of New York painters that included Church and Durand. He was sociable, clubbable, and, in the best sense of the word, professional, caring seriously about the well-being of other artists rather than just looking after his own career; he was a founder of the Metropolitan Museum of Art and a mem-

103. Anonymous, *Meditation by the Sea,* n.d. Oil on canvas, 13½ × 19½" (34.3 × 49.5 cm). Museum of Fine Arts, Boston; M. and M. Karolik Collection of American Paintings, 1815–1865.

ber of the National Academy of Design, which since its beginnings in the 1820s had grown into the most important art institution in mid-century America. The son of an English immigrant engraver, he worked in his father's shop and then for other firms as an engraver through the 1830s. The sight of Thomas Cole's work gave him the ambition to take up landscape painting. In 1840 he and two other New York artists, Asher Durand and Thomas Rossiter, raised the money to go to Europe. Kensett was to stay abroad seven years. He and Rossiter settled in Paris, in the Latin Quarter near the École des Beaux-Arts, and their education began. "The advantages held out here to the artist are incalculably great," the raw newcomer wrote to his uncle. "We discover the necessity of the most constant and indefatigable exertions in order to arrive even to mediocrity."

Kensett was an assiduous worker, not much interested in the arguments that swept the Parisian art world in the 1840s—such as the battle of the Rubensians, under Delacroix, and the Poussinists, whose paragon was Ingres. These, in any case, mattered mainly to figure painters, which Kensett had no ambition to be. His god (inevitably, since Cole worshipped him too) was Claude Lorrain, whose work he copied in the Louvre and would return to, with adulation, in the idealized views of the *campagna* with monuments and peasants he would paint in Italy after 1845. He was also taken with the fine, smooth surfaces of seventeenth-century Dutch and Flemish painting—David Teniers, Willem van de Velde, and Meindert Hobbema; this kind of treatment, with its near-suppression of texture, would come into play in his later work, in which every crack, shadow, and incrustation of mold and moss on a rock would be set forth but balanced against the broader luminosity of sky and water. Meanwhile, there was John Constable, too. Kensett got to know his work in London during a two-year stay there in 1843–45. For a time he emulated Constable's methods and "look"—the on-the-spot straightforwardness, the (relatively) thick wet-into-wet paint with sparkling, fresh highlights. But mainly he learned confidence from Constable and other English landscapists: that any subject, however humble or apparently trivial, could become the vehicle of an artist's intention and thus be transformed. After one of his sketching trips in the English countryside, he wrote that "*things* are nothing but what the *mind* constitutes them. Nothing, but by an infusion into them of the intellectual principle of our nature 'tis thus the humble habitation becomes a shrine . . . and thus the most indifferent, and of itself most undervalued thing— be it but a fragment of a rock . . . a decayed branch, or a simple log." Or, as it would turn out, an empty beach. Fullness of being was all.

Kensett had left New York as a naïve young enthusiast; he returned a cosmopolitan, having passed (a hope he set down in his journal in 1841) "from the simplicity of indigence and ignorance to the simplicity of strength and knowledge." His technical range was formidable, and through the late 1850s and 1860s he combined it with an increasing abstraction. There is nothing spectacu-

lar—not, at least, in the way Church painted landscape spectacles—about *Lake George*, 1869. No rainbows, bursts of foam, lavish cloud-architecture. It is static and silent, low-toned, with the subtlest transitions of light. Kensett puts enough detail in the foreground rocks and reeds to satisfy any Pre-Raphaelite, but the sum effect is conceptual rather than tactile, the wholeness and peace of large forms bathed in transparency. And this discovery of abstraction within the landscape undergirds the marine paintings of Kensett's last years, especially those done on the Connecticut shore of Long Island Sound and around Newport in 1872, of which *Eaton's Neck, Long Island* (Figure 104), is perhaps the masterpiece. It is as bare as could be. A plane of sea; another of sky; scarcely a ripple in the membrane of water. The scimitar curve of white beach, topped by a low rampart of grass and dark scrub, cuts into the right half of the canvas, and that's it— no figures, not even a seagull. The sky is gray and the water a darker gray, and yet by some alchemy of tonal precision Kensett conveys the bleaching intensity of summer light on the Sound. It is as mysterious and almost as abstract as a Rothko, and yet no one who has sailed or fished those waters can fail to recognize its perceptual truth.

There were Luminist elements in the work of painters who were never classed among the Luminists themselves. One of these was George Caleb Bingham (1811–1879), the first significant American painter to come out of the Midwest and make its life his main subject. Born in Virginia, he was taken by his family to Missouri at the age of eight; in his early twenties he became a portrait painter in Missouri and then in Washington, turning out stiff, rather primitive effigies. Finally, in 1844, he returned to Missouri. All of Bingham's best work belongs to

104. John Frederick Kensett, *Eaton's Neck, Long Island,* 1872.
Oil on canvas, 18 × 36″ (45.7 × 91.4 cm). The Metropolitan
Museum of Art, New York; gift of Thomas Kensett, 1874.

the next decade of his life, as he set out to record the manners and social behavior of men by and on the great river. In the process, he drastically edited reality. Bingham had an idyllic imagination; he sought carefully contrived, highly formal compositions, which gave his river boatmen the air of refugees from a Poussin in American shirts and plug hats. They are not the dirty, ring-tailed roarers, "half horse, half alligator," of the actual rafts and steamboats. In the 1840s Bingham was painting with unabashed nostalgia the river traffic of an earlier day, the 1820s.

His best-known work in this vein is *Fur Traders Descending the Missouri,* 1845 (Figure 105). It is one of the strangest pictures ever painted in America, an image both strongly formal and hauntingly weird. Bingham's original title was *French Trapper and His Half-Breed Son,* but the American Art-Union, which bought the painting after showing it, renamed it, partly to head off the possible moral objections of a public which preferred not to think about miscegenation,

105. George Caleb Bingham, *Fur Traders Descending the Missouri,* c. 1845. Oil on canvas, 29 × 36½″ (73.7 × 92.7 cm). The Metropolitan Museum of Art, New York; Morris K. Jesup Fund, 1933.

and partly to bring in a frontier reference to the Missouri River. It is dawn; pale light floods the glassy water, whose steady flow is indicated by long streaks on its mirrorlike surface. The eyeline is low, perhaps from another boat. The canoe floats doubled in the water. The grizzled father in the stern wears a voyageur's knitted cap, reminiscent of the Phrygian cap of French Liberty—an allusion, perhaps, to the untrammeled life of a trapper on the very margins of settlement. His gaze fixes you. So does his son's, but more amiably. The smiling half-Indian boy in his blue shirt and buckskin pants leans forward on the bale of furs. He has a rifle. The bale carries a small still-life: a fringed bag, a red sash, and a dead duck. The duck's breast has one neat hole in it which, one realizes—though it is hard to be sure, given the lack of orthogonals—is probably the vanishing point of the *Fur Traders'* perspective. This red dot is the key to the bewitched formality of the painting, so meticulously constructed, so hushed. The emblem of its strangeness is the black silhouette tied to the prow of the canoe: an animal of some sort. It has been variously identified, always in vain, as a cat, a dog, a bear cub, a fox. None of these fit. With its pointy ears, reflected in the glassy water, it is more like a spirit of the wild, a tamed imp.

Bingham's genre scenes of river boatmen, stump orators, squatters, political meetings, and men playing checkers in taverns record a distinct shift in American taste. For until the 1840s, the carrier of American identity had been Nature; Bingham, like the Long Island genre painter William Sidney Mount (1807–1868), brought in a much more specific, documentary interest in distinctively American social life. Who are we? How do we amuse ourselves? How do we work, relax, argue? By locking his observations into a formal architecture so curiously reminiscent of Poussin, with its highly determined poses and theatrical range of expression, Bingham sought to *name* America—but in a naïvely elevated way. The irony was that when, in 1856–59, he went to Germany and entered the Düsseldorf Academy, his work began to lose its "local" qualities and thus its interest. The gradual paralysis of Bingham's talent was hastened, after the Civil War, by his entry into politics.

There was one kind of American whose depiction had always raised problems: the American Indian. Whites had been praising, deriding, or trying to be objective about the first Americans ever since they crossed the Atlantic. The image of Indians projected by writers and artists was a faithful index of the way white society at large thought about them. If, at first, some Puritans felt they should be converted, they imagined them as innocent and childlike, waiting for God's word. When the Indians rebelled against Christianity and its bearers, they became imps of Satan. When white Americans wanted to show their own native identity—their difference from the English—they dressed up as "Mohawks" to

throw the tea chests into Boston Harbor. On the other hand, when the British used Indians as auxiliaries, the Declaration of Independence complained that George III had sent "savages" against the settlers. In America the Enlightenment view of Indians as Noble Savages was always unstable: behind it lurked the other stereotype of the Indian as treacherous, cunning, violent, and animal, which instantly emerged in periods of conflict as a justification for killing them.

The classic image of the Indian as Noble Savage was made by Charles Bird King (1785–1862), a former student of Benjamin West's in London who had returned to the United States in 1812 and settled permanently in Washington in 1818. His specialty was painting Native Americans for the recently formed Bureau of Indian Affairs, and between 1821 and 1842 he turned out some 140 portraits of Indians who had come, on various delegations, to negotiate with the white authorities in Washington. Among them were two Pawnee chiefs, Petalesharo and Peskelechaco, whose multiple portrait he made in 1821. Rather confusingly, it bears the title *Young Omahaw, War Eagle, Little Missouri, and Pawnees* (Figure 106). These faces have the directness and intelligence of portrait busts from the Roman republic: their muscular frames, aquiline noses, sparkling eyes, and level gaze (directed slightly above your eyeline, thus suggesting thought about higher things) could hardly be more noble, and the message is that, un-

106. Charles Bird King, *Young Omahaw, War Eagle, Little Missouri, and Pawnees,* 1821. Oil on canvas, 36⅛ × 28" (91.7 × 71.1 cm). National Museum of American Art, Smithsonian Institution, Washington, D. C.; gift of Miss Helen Barlow.

der the skin garments and ceremonial face paint, red men and white are indeed brothers.

At about this time, a young artist in Philadelphia saw just such a group of Plains Indian chiefs passing through on their way to Washington. He was George Catlin (1796–1872). He had originally trained as a lawyer, and then, self-taught, become a not very successful portrait painter and miniaturist. He lamented being confined to "the limited and slavish branch of the arts in which I am wasting my life and substance for a bare living." Catlin would hardly be remembered today if the sight of those Indians had not changed his life. Their "silent and stoic dignity," he wrote, impressed him. It made real and urgent what had, up to then, been an abstract issue for him. Catlin was quite well read, and he was fascinated by the philosophical questions raised by Enlightenment writers about the "savage" state. Was it, as Jean-Jacques Rousseau had argued fifty years before in *Émile,* the natural state of man in which the root of human goodness showed itself, free from the deformities of property and despotism, the incrustations of manners? Or was it closer to the dyspeptic view of Thomas Hobbes, a century before that—"solitary, poor, nasty, brutish and short"? Or something in between? Only in the American West, Catlin decided, could one find out. And even there, one had better hurry: for the eventual fate of the Indians at the hands of advancing whites was not in doubt. Whiskey, disease, and the gun were harrying them to extinction. Their rights, he wrote, had been "invaded, their morals corrupted, their lands wrested from them, their customs changed, and therefore lost to the world; and they at last sunk into the earth, and the ploughshare turn[s] the sod over their graves."

Catlin thus became the first painter (for Lewis and Clark had taken no artist on their crossing of the continent) to travel west with the sole purpose of finding out about Indians, as distinct from converting the "savage" to Christianity, annexing territory, or surveying land. With a crazy and optimistic courage, he decided, as he later put it, to go out alone, "unaided and unadvised, resolved (if my life should be spared), by the aid of my brush and my pen, to rescue from oblivion so much of their primitive looks and customs as the industry and ardent enthusiasm of one lifetime could accomplish."

Unaided he was, but not unadvised. Catlin first went to St. Louis, Missouri, to call on the aged doyen of American explorers, General William Clark, who with Meriwether Lewis had led the first east-west expedition across America to the Pacific at Thomas Jefferson's behest in 1803–4. Clark was now the superintendent of Indian Affairs for the Missouri Territory. He let Catlin pick his brains, and took the artist on a journey with him to Wisconsin in 1830.

In March 1832 Catlin set off on the first of his own journeys. John Jacob Astor's American Fur Company, which since its foundation in 1808 had acquired a virtual monopoly on the Western sources of beaver, otter, wolverine, and other

prized pelts, had a steamboat, the *Yellowstone*, built to ply the forts and trading posts along the Missouri River. Its route covered more than a thousand miles, much of it following the track of Lewis and Clark's journey into the heartland along the Missouri—a northwestern diagonal from St. Louis, along the edge of Nebraska, through South and North Dakota to the junction of the Yellowstone River near the border of Montana. This vast stretch of territory was the home of the Plains Indians, the Sioux, Chippewas, Assiniboine, and Mandans. Catlin wangled a berth on the *Yellowstone*'s maiden voyage. The voyage took three months, and during it Catlin worked as though possessed, painting the Indian warriors, chiefs, and women, observing their rituals, riding with them on buffalo hunts, entering their tents and sweat lodges, and keeping voluminous notes in his journal about their appearance, customs, diet, and ceremonies. The Plains Indians had art traditions of their own, but none of depictive portraiture, and so the sight of this white man painting illusionist renderings of tribal leaders fascinated them—if one can judge by Catlin's own rendering of himself painting a portrait

107. George Catlin, *Catlin Painting the Portrait of Mah-to-toh-pa–Mandan,* 1857–69. Oil on cardboard, 15³/₈ × 21⁷/₈″ (39.1 × 55.6 cm). National Gallery of Art, Washington, D. C.; Paul Mellon Collection.

of the Mandan chief Mato-Tope, "Four Bears," 1857–69. (Figure 107). Some objected that by painting them in profile, Catlin had made them out to be mere half-men.

The most sensational images he brought back from this trip were of the Okeepa, the Mandans' most important religious ceremony, never before witnessed by a white man. Lasting several days, it culminated in a terrifying rite of endurance: young initiates were hung from the roof of the lodge on rawhide cords attached to skewers driven through their breasts and shoulders; when they lost consciousness, they were let down, their little fingers were cut off, and—with buffalo skulls and other totemic objects tied to the skewers in their flesh—they were made to run in a circle until these weights tore out. Catlin's hasty sketches of this ceremony would fascinate white audiences back east, as would his studies of the buffalo hunt—which, reworked by a succession of artists from Currier and Ives to Albert Bierstadt, became a standard Western iconographic form for the next seventy years and more. White images of the Noble Indian were also shaped by Catlin's more considered and better-finished portraits of tribal elders, chiefs, and warriors, such as White Cloud, chief of the Iowas in 1844. He also painted chiefs who had led their people in resistance against the federal government's drive to evict them from their lands, and were now prisoners, such as the Sauk leader Black Hawk and Osceola, chief of the Seminoles. Osceola was dying in jail, and Black Hawk holds the corpse of his totemic bird, a black hawk; he, too, would soon be dead.

In 1837 Catlin started showing his "Indian Gallery" to viewers in Boston, New York, Philadelphia, and Washington. By then it comprised nearly five hundred paintings, along with thousands of sketches and Indian artifacts. By 1840 he had visited forty-eight tribes. What drove him? De Tocqueville's "consciousness of swift and inevitable change." He knew at the outset, and every passing year confirmed, that his subject matter was dying, not just "slipping away" but being ground into extinction by his own people. America consumed painted Indians as fast as it could wipe out real ones.

Catlin paid his own way on these trips, but he hoped to sell his "Indian Gallery" to the U.S. government. But in the 1840s there was no mechanism for federal patronage, and although Catlin lobbied incessantly for a special bill in Congress authorizing the purchase of "the most perfect monument of an extinguished race that the world has ever seen," he failed. Some congressmen felt that Indians were not worth sympathetic commemoration, especially not in the halls of Congress itself, and most found Catlin's asking price ($65,000 to begin with, eventually dropping to $25,000) far too high.

Hoping that European acclaim would help his cause, Catlin took his "Indian Gallery" to London in 1839, where it excited a good deal of interest—though not from potential buyers. In 1844 he showed it in Paris, where it was visited by

Louis Philippe; Catlin became the first man to install *le Wild West* in Gallic consciousness. The great Alexander von Humboldt, prince of natural scientists, singled him out for praise—an honor comparable to being lauded by Goethe, had Goethe been alive. But none of this cut much ice back in Washington. Neither did his larger dream, a museum of nature in what was still referred to as "the great American desert." Catlin spoke of forming "a *Nation's Park*, containing man and beast, in all the wild and freshness of their nature's beauty." It would preserve the Indians by exempting them from history. The tidal wave of white settlement would flow past them, leaving them in peace. In effect, Catlin invented the idea of the national park—but too early for the whites, and too late for the Indians. Meanwhile, his failure to dispose of the "Indian Museum" brought financial ruin, and he was imprisoned for debt in London in 1852. He managed to sell his life's work to Joseph Harrison, an American locomotive manufacturer—an exquisite irony, since the steam train was already so powerful an element in the machinery of Indian suppression. From Harrison, luckily, Catlin's paintings passed to the Smithsonian Institution, whose staff Catlin joined as an adviser in his last years.

Besides Catlin, the artist who did most to record the still robust society of the Plains Indians in the 1830s was the Swiss painter Karl Bodmer (1809–1893). Bodmer was hired by Prince Maximilian zu Wied, a German naturalist and a devotee of Humboldt, who had already traveled in the wilds of Brazil in 1815, to come as his recording artist on an expedition up the Missouri—Catlin's territory—in 1833–34. Not only was Bodmer a far more skilled draftsman than Catlin, he had the help of Prince Maximilian's ethnologically trained eye when it came to picking which details of dress, ornament, facial painting, and weaponry to include as significant. There is a world of difference—in observation, in intensity—between Catlin's portrait of the Mandan chief Mato-Tope, "Four Bears," with his generic "Indian" face, and Bodmer's watercolor of the same man, his

108. Karl Bodmer, *Mató-Tópe (Four Bears), Mandan Chief,* 1833–34. Watercolor on paper, 13¾ × 11¼″ (34.9 × 28.6 cm). Joslyn Art Museum, Omaha, Nebraska; gift of the Enron Art Foundation.

profile like a hatchet, with a tense dignity that fairly springs off the paper at you (Figure 108). Catlin painted an impression, but Bodmer gives a biography, to those who can read the codes of Mandan Indian ornament. The red wooden knife in Mato-Tope's hair testifies that he has killed a Cheyenne chief hand to hand. The yellow hand on his chest shows that he took prisoners. Each dyed yellow feather from a great owl represents an arrow wound he has received in battle; and so on. Likewise, in his portrait of "Flying War Eagle," the young Mandan warrior Mahchsi Karehde (Figure 109), superb in his red buffalo robe and standing more than six feet tall, Bodmer was careful to enumerate each talon in his bear-claw necklace and to include his eagle-wing fan and the wolves'-tails which, strung to his moccasins, signified that he had already killed two enemies in combat.

Bodmer also paid close attention to landscape, setting down with a fascinated eye the details of terrain in the Missouri River valley, such as the "White Castles," eroded landforms shaped by wind and water from soft stone. Such sights, you cannot help but feel, stirred Bodmer—and his patron too—as a heroic and primeval landscape, a fitting backdrop to men who represented a human antiquity that reached back beyond the Doric or even the Homeric Greeks. German Romanticism entailed a worship of origins, and here part of the origin of mankind seemed to disclose itself to them. Perhaps the earliest Germans were men like these?

What Catlin, Bodmer, and Maximilian recorded of the Mandans, in their sketches and notes, is now virtually the sum of what is known about them. For they were not the only whites to meet the Mandans. Regular contacts had been taking place since 1804, the year Lewis and Clark's expedition passed through their territory. Visits from traders and trappers had brought the germs of smallpox. In 1837 an epidemic devastated the tribe, leaving fewer than 150 of its members alive. Mato-Tope, who had always made a point of welcoming the whites,

109. Karl Bodmer, *Máhchsi-Karéhde (Flying War Eagle),* *Mandan Man,* 1833–34. Watercolor and pencil on paper, 16⅞ × 12″ (42.9 × 30.5 cm). Joslyn Art Museum, Omaha, Nebraska; gift of the Enron Art Foundation.

uttered a dying curse whose words were taken down by a trader named Francis Chardon. "I have never called a White Man a Dog," he said,

> but today, I do pronounce them to be a set of Black harted Dogs, they have deceived Me, them that I always considered as Brothers, has turned Out to be My Worst enemies. I have been in Many Battles, and often Wounded, but the Wounds of My enemies I exalt in, but today I am Wounded, and by whom? By those same White Dogs that I have always Considered, and treated as Brothers. I do not fear Death my friends, You Know it, but to die with my face rotten, that even the Wolves will shrink with horror at seeing me, and say to themselves, That is the Four Bears the Friend of the Whites. . . . [T]hink of all that My friends, and rise all together and Not leave one of them alive. . . .

But it was too late for such a rising to be much more than a dying warrior's dream. What happened to the Mandans befell many other tribes, and those that did not perish were uprooted or reduced to a marginal, begging existence on the fringe of white settlements. The terrible years of "Indian Removal" were now under way. In his second address to Congress in 1830, President Andrew Jackson, a famed Indian-killer who habitually referred to his foes as "savage bloodhounds," had called for a policy of apartheid. Indians and whites could no longer mingle behind the frontier; the Indians must be driven out of their ancient lands and relocated to new ones west of the Mississippi. Jackson dilated on how this segregation would be for the Indians' good. It would free them from "the power of the states." It would "enable them to pursue happiness in their own way and under their own rude institutions," and "retard the progress of decay, which is lessening their numbers." It would also free huge tracts of territory for unimpeded white development. The Indian Removal Act of 1830 proved to be an unmitigated disaster for the Cherokees, Choctaws, Creeks, Seminoles, and other tribes, some seventy thousand of whom were harried from their lands east of the Mississippi, while hundreds of thousands of black slaves were moved in to grow cotton on the territory they had vacated. Of the Cherokees alone, four thousand died on the Trail of Tears from Tennessee to Oklahoma.

The genocidal brutality of Jackson's removal policy found no reflection in American painting of Indians, except in a skewed and distorted way: when Indians fought back, their hostility toward the white invaders was translated into atrocity stories for the palpitant Eastern viewer.

Thus the Noble Savage mutated quite rapidly through the late 1830s and 1840s into the Demonic Indian, in whose fierce and phallocratic presence all talk about the brotherhood of man was wasted effort.

The Demonic Indian had already appeared in American painting: a vivid example was John Vanderlyn's *Murder of Jane McCrea,* 1804 (Figure 110). It was

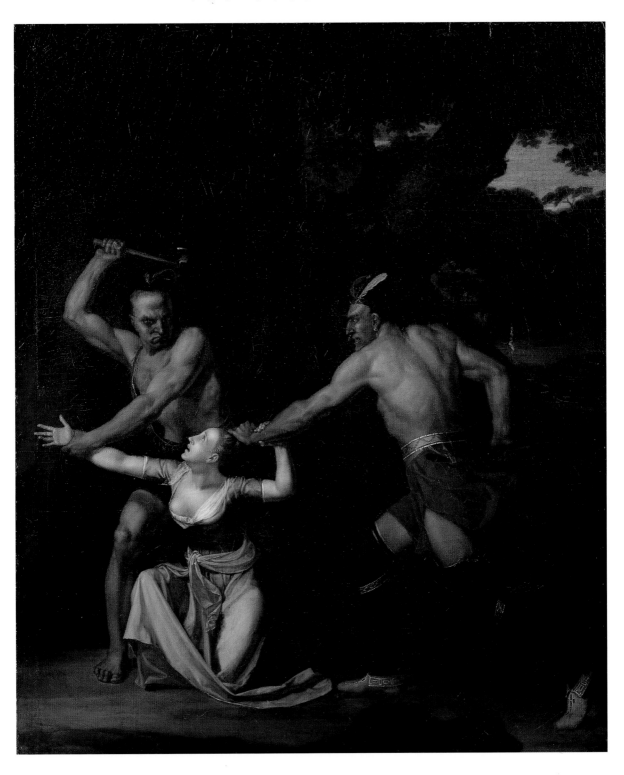

110. John Vanderlyn, *Murder of Jane McCrea,* 1804. Oil on
canvas, 32 × 26½″ (81.3 × 67.3 cm). Wadsworth
Atheneum, Hartford, Connecticut.

meant as an illustration to *The Vision of Columbus,* a historical epic of America which Vanderlyn's fellow expatriate Joel Barlow, diplomat and sometime Connecticut preacher, thought his finest work—a turgid swathe of heroic couplets. At one point it describes the murder of a rebel's fair wife by Mohawks in the pay of the British during the Revolutionary War:

> The scalps by British gold are paid:
> A long-hair'd scalp adorns that heavenly head;
> And comes the sacred spoil from friend or foe,
> No marks distinguish and no man can know.
> With calculating pause and demon grin,
> They seize her hands and thro' her face divine
> Drive the descending axe. . . .

Vanderlyn's painting is far better than the sub-Miltonic fustian of the poem. It is a pastiche *all'antica,* featuring the white victim as a grief-stricken Niobid and her red murderers in the poses of two Hellenistic sculptures Vanderlyn had studied and drawn in the Louvre. But its energy and concision are extraordinary, almost worthy of Vanderlyn's hero Jacques-Louis David. And Vanderlyn may not have wished to imply that these bloodthirsty braves were typical of all Indians—only that they were Noble Savages gone wrong, corrupted by the perfidious British.

The Demonic Indian, as a symbol of *all* Indians, entered the official visual language of the U.S. government in 1827, when the Italian sculptor Enrico Causici was commissioned to carve a bas-relief for the rotunda of the Capitol in Washington. It shows Daniel Boone locked in mortal combat with an enormous Indian, while a smaller one—his proportions dictated by the narrowness of the panel—lies dead on the ground between them (Figure 111). The scene illustrates an episode in October 1773 (the year is carved on the lower branch of the tree) when Boone led a party of settlers across the Kentucky frontier; they were attacked by Indians, but Boone's bravery encouraged the whites to drive them off. An emblematic moment, therefore, in the penetration of the early frontier. This Indian warrior is depicted as an ogre, savagery incarnate, with bulging eyes and a bloodcurdling snarl on his face; Boone is cool and calm. In the early 1830s Causici's relief was shown to a group of Winnebago Indians from Wisconsin who, having sold their land to the federal government and accepted tribal relocation to Iowa, were visiting Washington. Reportedly, they examined the carving and then "raised their dreadful war-cry and ran hurriedly from the hall." This, the whites who were present felt, showed that Causici's sculpture had impressed them with the futility of resistance. But perhaps the Indians were just insulted by it, as well they might have been.

111. Enrico Causici, *Daniel Boone Struggling with the Indian,* 1826–27. Sandstone sculptural relief in the rotunda of the United States Capitol, Washington, D.C.

Painters, following on from Vanderlyn's *Murder of Jane McCrea*, revived one of the literary forms of earlier American colonization: the captivity narrative. These described the bizarre fate of white women and their children abducted by Indians. Some were killed, but others became "white squaws," losing (so the stories insisted) their language, their memories, and their shame: they were living proof of how Europeans, weak women in particular, could still go to seed and revert to primitivism when the props of higher civilization were kicked away. This "Criolian degeneration"—in effect, cultural entropy through racial mixture—had been one of the worst fears of the Puritans, and it was to become an obsession with nineteenth-century white Americans as its anxieties took in black slaves as well as red savages.

Horror inspired by miscegenation is certainly at the heart of a painting like John Mix Stanley's *Osage Scalp Dance*, 1845 (Figure 112). Stanley (1814–1872) made a specialty of painting "Indian" subjects all over the West. Here, muscular Indian warriors encircle a white woman and her child. She kneels on the ground, her arm raised in a plea for their lives. Her dress is unsuited to the frontier, being long, white, and gauzy; she is meant to be both pure bride and virgin sacrifice.

112. John Mix Stanley, *Osage Scalp Dance,* 1845. Oil on canvas, 40³/₄ × 60¹/₂″ (103.5 × 153.6 cm). National Museum of American Art, Smithsonian Institution, Washington, D.C.; gift of the Misses Henry, 1908.

The bare bottom of her clinging little boy emphasizes their helplessness and (perhaps) desirability to the savage brute. Stanley, one presumes, had seen engravings of Poussin's *Rape of the Sabine Women* and *Massacre of the Innocents*. By contrast, the Indians are dark and dreadful: all id. One of them raises a war club to bash out the woman's brains, but he is restrained by a chief who interposes his spear. This figure wears a medallion, a silver disk of the sort that the federal government issued to tribal leaders, bearing the effigy of the President. He has had contact with whites and learned a little mercy. But what will the white angel's fate be, now that her life has been spared? Worse than death, no doubt.

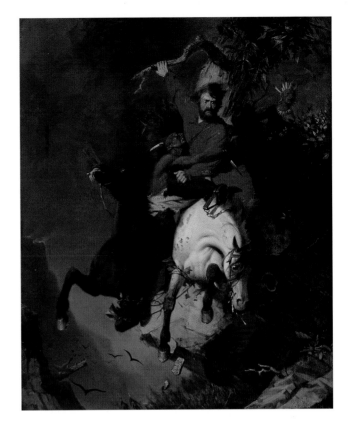

By the 1840s it seemed to most American whites that, whatever the tolerant might say or think, on the frontier itself there could be no truce between the white man and the red: they were locked in a territorial fight to the finish. This was given lurid expression by the painter Charles Deas (1818–1867), who, inspired by Catlin's example, had gone west to paint the Sioux and Winnebago Indians in 1840. In *The Death Struggle*, 1845 (Figure 113), a white trapper on a white horse has been ambushed by an Indian on a black one. Teeth glitter, eyeballs bulge, the Indian's horse snorts red fire from its nostrils (a sign of its satanic nature)—and, bound together in a frenzy of hatred while brandishing their knives, they plunge over the edge of an abyss. Given the manic character of this image, it is not altogether surprising to learn that Deas was committed to a lunatic asylum in 1848, a few years after painting it, and died there twenty years later.

But by the 1840s it was also apparent to many white Americans that the Indians were bound to lose the battle for land and, probably, for survival—that they were a "dying race," one more image for the loss of America's original nature. Once the whites had won, they could view their defeated enemy through the lens of their art with magnanimous regret—though never with guilt. Were they not self-condemned by (as one congressional document phrased it) "their suicidal repugnance to the light of civilization"? The laws of Progress had condemned the Indian, and so the children of Progress could mourn him, up to a point. His liq-

113. Charles Deas, *The Death Struggle,* 1845. Oil on canvas, 30 × 25″ (76.2 × 63.5 cm). The Shelburne Museum, Shelburne, Vermont.

uidation was merely the fulfillment of the natural order, in which the strong displaced the weak. Nothing personal. Thus a new stereotype rose to replace the Demonic Indian: the Doomed Indian. Tompkins Matteson (1813–1884), a painter who seems never to have gone west—he spent his whole professional life in New York—painted *The Last of the Race* (Figure 114) in 1847. From a cliff, the remnants of an Indian tribe—an old chief in a red cloak, a younger man, and two women—contemplate the ocean, over which the sun is setting. That the sunset is over the sea identifies the place as the Pacific coast. This is the end of the line. Even the dog knows that. The image accurately follows the sentiments expressed by William Cullen Bryant in 1824, through the mouth of an imagined Indian:

> They waste us—aye—like April snow
> In the warm noon, we shrink away
> And fast they follow, as we go
> Towards the setting day,—
> Till they shall fill the land, and we
> Are driven into the western sea.

Probably the most vivid image of the Doomed Indian is the most official one, placed where few visitors notice it today—on the Senate pediment of the U.S. Capitol in Washington. It is the work of Thomas Crawford (c. 1813–1857), an American sculptor who, until his life was cut short by a brain tumor in his early forties, was one of three gifted American "Florentines" working in Italy—the others being Hiram Powers and Horatio Greenough. Crawford had begun his studies with Bertel Thorwaldsen in Rome in 1835; by 1853, when the U.S. government offered him the commission for the Senate pediment, he was in complete command of a neo-classical vocabulary derived from Thorwaldsen and Canova—lucid, highly abstract, politically eloquent, and based on Greco-Roman models. The theme of the pediment was "The Progress of Civilization." It should provide an allegory of "our history of the struggle between civilized man and the savage, between the cultivated and the wild nature," wrote Captain Montgomery Meigs, the supervisor of the Capitol's extension, in his instructions to Crawford.

Crawford designed the pediment after the model of Phidias' sculptures for the east pediment of the Parthenon. At the center is America; to her right—our left—are various figures of white security, progress, and prosperity: a vigilant soldier, a merchant, a schoolteacher, two eager students, and a "mechanic" or artisan. Such are the agents of civilization. On the other side of the pediment is the earlier stage of American development. A pioneer is felling a tree, necessary prelude to the taming of the wilderness. And the marble trunk is about to fall on some Indians. Beside it, a young Indian boy, a hunter, gazes with alarm at the pioneer;

next to him, his father, a chief with feathered headdress, sits in the familiar posture of melancholy, head on his hand, frozen with despair. And beyond him, his wife and her child sit by an open grave. If this was the official view of the fate of the American Indian in the mid-1850s, what chance of succor from the federal government did they have? Other derogatory images of Indians have been removed from the Capitol in years past, but Crawford's figures, like Causici's Daniel Boone, are built into the very fabric of America's seat of government, and likely to remain there.

The catchphrase of American expansionism from the mid-nineteenth century on was "Manifest Destiny," always declaimed and usually written with capitals. Manifest Destiny was a rhetorical figure that became an ideology, and transfused itself through all policies. It was invoked as a raison d'être for the annexation of Texas in 1845 and the consequent Mexican-American War of 1846–48, the occupation of Oregon in 1846 and of California in 1848. Its quintessential utterance was written in 1846, and soon afterward read to the U.S. Senate, by a journalist named William Gilpin, who had traversed the Oregon Trail two years before.

114. Tompkins Harrison Matteson, *The Last of the Race*, 1847. Oil on canvas, 39¾ × 50″ (101 × 127 cm). The New-York Historical Society, New York.

The *untransacted* destiny of the American people is to subdue the continent—to rush over this vast field to the Pacific Ocean—to animate the many hundred millions of its people, and to cheer them upward . . . to teach old nations a new civilization—to confirm the destiny of the human race. . . .

Divine task! Immortal mission! Let us tread fast and joyfully the open trail before us! Let every American heart open wide for patriotism to glow undimmed, and confide with religious faith in the sublime and prodigious destiny of his well-loved country.

Clearly, the destiny Gilpin and the jingo senators who cheered his words had in mind was not confined to North America. The "empire" he spoke of, embracing "many hundred millions" in "old nations," was that of Latin America, the Pacific, and Asia—not just the American Indian tribes. The Indians that expansionists would run into on the way to the Pacific were merely dust beneath the hooves and wagon wheels of Progress. Manifest Destiny meant what it said. It *was* manifest, obvious beyond all argument, that empire must expand beyond the Mississippi and not stop rolling till it reached the Pacific, where it could rest awhile and gather strength for the next American leap into history. Whatever you found was yours by absolute right. To see was to discover; to discover was to conquer. If the Indians fought back, they weren't just resisting invaders—they were up against History itself; and to see yourself as a force of History is to be freed from pity and from guilt. Manifest Destiny was America's myth of redemptive violence. It created its own heroes; and art had a large role in promoting it.

The emblematic hero of Manifest Destiny was long dead by then. He was Daniel Boone (1734–1820), frontier scout, real estate speculator, and supposed "discoverer" of Kentucky. In the early 1770s Boone had blazed a trail from western Virginia through the Cumberland Gap into eastern Tennessee near the Kentucky border, and this path—known as Boone's Trace or the Wilderness Road—was used by many frontier settlers in America's first great westward migration. He made money in Kentucky and Virginia land deals, some of them crooked; he was captured by the Shawnees (in 1778) but escaped; he had a formidable reputation as a pioneer and Indian-killer; and he was turned into a celebrity by John Filson, a writer to whom he dictated a wildly embellished autobiography, which became the model for all future tall tales of frontier heroes, such as Davy Crockett. Boone was the man who mediated between savagery and civilized authority—a midpoint between the "savage" Indian, the man of the woods who knows the woods, and the "civilized" colonizer who is innately a stranger to the wilderness. Boone was imagined as totally American—but in a white way. He goes into the wilderness and is redeemed; but his redemption becomes the means of further conquests by civilization. He thus represented the

best of both worlds. In the last twenty years of his life, the real Daniel Boone became a tourist sight. Awestruck visitors would approach the house where the old man sat in his fringed buckskin coat, shake his hand, and pay a dollar for a copy of John Filson's hagiographic book, which he would sign with a chuckle: "Every word of it true, by God!" Only six years after Boone died, Thomas Cole (who never met him) painted him as a figure out of classical antiquity, part Cincinnatus and part lake god, sitting gun in hand on a sarcophagus-like rock slab outside a rude cabin by the Great Osage Lake in Kentucky (Figure 115). Such men, it is clear, will no more return than the Romans themselves.

By the 1850s the chief metaphor of Western movement was biblical, not classical: the narrative of Exodus was taken up where the Puritans had left it, and Daniel Boone became Moses, leading his people to the Promised Land. George Caleb Bingham painted *Daniel Boone Escorting Settlers Through the Cumber-*

115. Thomas Cole, *Daniel Boone and His Cabin on the Great Osage Lake,* c. 1826. Oil on canvas, 38 × 42½" (96.5 × 123.2 cm). Mead Art Museum, Amherst College, Amherst, Massachusetts.

land Gap (Figure 116) in 1851–52. Clean-shaven and rather elegantly dressed, Boone marches toward you with his rifle at the slope-arms position, fairly radiating determination; just behind him is a settler's wife on a white horse, suggesting (since Bingham's image draws both on Exodus and the flight into Egypt) the Virgin Mary protected by Saint Joseph. Stricken trees on either side record the dangers of nature, through which Boone will shepherd his followers.

The image of Boone as an American Moses was widespread. Its most spectacular use was in a later painting, *Westward the Course of Empire Takes Its Way (Westward Ho!)*, 1861, by Emanuel Leutze (Figure 117).

Leutze (1816–1868) had been born in Germany. His parents brought him to Philadelphia when he was a baby, and he grew up to study painting there, but in 1841 he returned to study history painting in Düsseldorf and remained there—with sojourns in Rome, Venice, and Munich—for twenty years. He painted American subjects, however, the most famous of which, then and ever since, was his large academic composition of 1851, showing George Washington and his men forging in a wherry across the ice-clogged Delaware. If there was anyone who could be relied on to produce a large, efficient, patriotic machine whose meaning would be over no one's head, that person was Leutze. In 1861 the federal government invited him to paint a mural at the head of the west stairway in

116. George Caleb Bingham, *Daniel Boone Escorting Settlers Through the Cumberland Gap*, 1851–52. Oil on canvas, 36½ × 50¼″ (92.7 × 127.6 cm). Washington University Gallery of Art, St. Louis, Missouri; gift of Nathaniel Phillips, Boston, 1890.

the House wing of the Capitol. It was, on the face of it, a strange time to issue such a commission. Government spending on the arts had been stopped by the outbreak of the Civil War. But this particular project was meant to show Northern confidence; the very act of embellishing the Capitol with a mural showed that the Union no longer feared that Washington would be taken by the Confederate army; and the apex of Leutze's design, the Stars and Stripes being passed into a young pioneer's hands at the peak of the ridge, conveyed the message that only the Union could carry Americans into the golden future of westward expansion. Leutze accepted eagerly, returned to America, made a trip west to the Rockies to research the scenery, and began his magnum opus.

It was a big wall, twenty by thirty feet, and Leutze divided it into three zones. At the top, in a foliated border that frames the whole wall, is the motto from Bishop Berkeley's prophetic verse of 1752, "Westward the course of Empire takes its way." Below that, we see the main scene: the conquest of the Pacific slope.

It is a huge landscape populated with dozens of emblematic figures, toiling up the Rockies to the view of the Promised Land beyond. The trail behind them is littered with broken wagon wheels and bullock skulls from earlier expeditions. A young man rises in his stirrups to glimpse the view; a large Boone-figure, that of the now stereotypical frontier scout, complete with buckskin jacket and coonskin

117. Emanuel Leutze, *Westward the Course of Empire Takes Its Way (Westward Ho!)*, 1861. Fresco, 20 × 30′ (6.09 × 9.14 m). Mural in the United States Capitol Building, Washington, D.C.

cap, displays the prospect to two women. There is also—for the first and almost the only time in American pictures of pioneering—an African-American, a young man leading a donkey on which an Irishwoman rides. He is there because of the Civil War. Leutze, like most American artists, was pro-emancipationist, and wanted to suggest that the rewards of Manifest Destiny should go to freed slaves as well. This image also suggests that the Irish immigrants, among whom anti-black racism was particularly virulent, should settle their differences with American blacks.

The pioneers are flooded with ruddy light from the Pacific sunset; and below them, in the third zone, is the goal of their journey—a view of San Francisco Bay, seen from the ocean, flanked by two medallion portraits of the tutelary gods of Manifest Destiny: William Clark in his greatcoat, Daniel Boone in his buckskins.

And what of the Indians? They do appear, as ghosts of the past—mere emblems, literally in the margin of the mural, "creeping" (in Leutze's words) and "sneeking [sic] away from the light of knowledge," like the little grotesques in the borders of Renaissance manuscripts. They do not belong in the Big Picture. In his sketch, Leutze showed the plains below the mountains as completely empty. In the final mural, there are plumes of smoke rising into the sky. These have been interpreted as Indian campfires, but Leutze probably meant the smoke to be volcanic, not human, in origin.

The paintings that did most to promote the image of Manifest Destiny, however, were made by a younger contemporary of Leutze's, Albert Bierstadt (1830–1902). Born in Germany, Bierstadt came to America with his emigrant parents when he was only two; he grew up in the coastal town of New Bedford, Massachusetts, where his father made casks for the whaling trade. At twenty-three, Bierstadt returned to Germany to study at the Düsseldorf Academy, acquiring a high academic polish and a meticulous eye for detail; afterward he spent a winter in Rome, with the landscape painter Worthington Whittredge.

It soon became plain to Bierstadt, when he returned to America, that the image of the West was there to be exploited. The West made America unique among nations, and nobody was painting big panoramas of it. Other artists with Luminist affiliations, such as Sanford Gifford, Worthington Whittredge, and John Kensett himself, had all been on painting expeditions west of the Missouri, but their paintings tended to be fairly small, without the heroics of Church—and Church's territory was the Hudson Valley and South America. They did not express the idea of a providential mission into the wilderness that was at the heart of Manifest Destiny. Bierstadt set out to do so.

In 1858 he joined a Western surveying expedition commanded by Colonel Frederick Lander. Its aim was to plot an overland wagon route from Fort Laramie, Wyoming, to the Pacific, and Bierstadt went as far as the Rockies, making copious drawings and watercolor studies along the way. He then peeled off

on his own to make sketches on the Wind River and in Shoshone country, and returned to New York in 1859, taking a studio in the same Tenth Street Studio Building as Church. Here, fired up by the success of *Heart of the Andes*, he worked his studies up into huge landscapes, which he promoted as showing the West "as it really is," but were actually composite views, just as Church's Andean scenes had been. There is no actual view which corresponds to Bierstadt's six-by-ten-foot *Rocky Mountains, Lander's Peak*, 1863 (Figure 118), but this hardly mattered. What counted for its audience was the grandeur of representation of the mountains, the far misty crags rising behind the glassy lake and its waterfall, brilliantly lit by a shaft of sun in the middle distance; and the apparent care with which he rendered the details of Indian tribal life in the Shoshone encampment in the foreground. This was, as the art critic James Jarves pointed out at the time, an unstable mix—idealization in the large view, materialism in the details. Bierstadt was propagating a dream of conquest, and he had no illusions about what would happen to these Shoshones, Claudean figures in his idyll of primitive immensity. One day, he said, in the very foreground of the painting, "a city, populated by our descendants, may rise and in its art galleries this picture may eventually find its resting place."

Bierstadt's first Western superviews were an instant success, and in 1863 he set off west again, this time in the company of a writer, Fitz Hugh Ludlow. Ludlow was a young New York journalist-bohemian who had caused a sensation a few

118. Albert Bierstadt, *The Rocky Mountains, Lander's Peak,*
1863. Oil on canvas, 73½ × 120¾″ (186.7 × 306.7 cm).
The Metropolitan Museum of Art, New York; Rogers Fund,
1907.

years before with *The Hasheesh Eater,* a lurid account of his drug experiences modeled on Thomas de Quincey's *Confessions of an English Opium-Eater.* (Soon afterward he died of the combined effects of dope and booze, leaving a notably pretty widow named Rosalie, whom Bierstadt married.) However, the two young men were seeking the natural Rocky Mountain High, not the *paradis artificiel* of cannabis, and they found it in abundance on a trip that included the Yosemite Valley and the western slope of the Sierra Nevada down to California. Ludlow's bombast—his dispatches from the frontier were commissioned by the *Atlantic Monthly* and collected in 1870, the year he died, as *The Heart of the Continent*—admirably matched the sublime histrionics of Bierstadt's paintings. He described the Yosemite Valley at sunset as opening "into a field of perfect light, misty by its own excess,—into an unspeakable suffusion of glory created from the phoenix-pile of the dying sun." On their way through Nebraska, they had encountered a convoy of German emigrants, fifty wagons or more, driving their cattle toward Oregon; and Bierstadt, identifying with them, turned the sight into one of his most extravagant paeans to Manifest Destiny, *Emigrants Crossing the Plains,* 1867 (Figure 119). Scattered in its foreground are cattle bones, the emblems of earlier death on the trail, but the live cattle next to them are fat, and for these settlers everything sets fair: their wagons roll forward into a beckoning sunset of such excessive splendor that it's obvious that God himself is calling them on, flooding their enterprise with metaphorical gold. "Progress," as one orator of the day put it, "is God!" There are signs of Indian presence—a few distant tepees—

119. Albert Bierstadt, *Emigrants Crossing the Plains,* 1867. Oil on canvas, 67 × 102″ (170.2 × 259.1 cm). National Cowboy Hall of Fame and Western Heritage Center, Oklahoma City, Oklahoma.

but they are all but invisible in the radiance, and the farthest wagons are already past them.

The peak of Bierstadt's career coincided with, and was supported by, the boom in Western business—logging, mining, and, above all, railroads. Financiers who were making fortunes in the West by destroying wilderness naturally wanted trophies of the same wilderness in its Edenic state, and paid Bierstadt the kind of prices that only Frederick Church, up to then, had been able to ask. One such magnate, Legrand Lockwood, bought Bierstadt's *Domes of the Yosemite* for $15,000 (perhaps $1.5 million in modern dollars), fresh off the easel, for the octagonal hall of his New York mansion. When the transcontinental railroad was at last completed in 1869, the vice president of the Central Pacific Railroad, Collis Huntington, commissioned Bierstadt to do one of his six-by-ten-foot specials commemorating the landscape where its greatest difficulties had been overcome: the Donner Pass, in the Sierra Nevada. The two men rode up there together, to pick the right spot. The name of the Pass was synonymous with death and disaster: in 1846 a snowed-in expedition had perished there, amid gruesome scenes of cannibalism. Constructing a track across it had been an immense feat of engineering and labor, and once the track was laid, much of it had to be covered with "snow-sheds," timber-framed tunnels that kept the snowdrifts off the tracks so that the trains would not stall. They can be seen on the right of Bierstadt's vista, *Donner Lake from the Summit*, 1873 (Figure 120): a small straight line among

120. Albert Bierstadt, *Donner Lake from the Summit*, 1867.
Oil on canvas, 72 × 120″ (182.9 × 304.8 cm). The New-York
Historical Society, New York.

the granite peaks. Bierstadt poured all his rhetoric, inherited and invented, into this canvas: the God's-eye view from the summit, reminiscent of Church but with an ancestry that stretched back to Pieter Breughel and Joachim Patinir in the sixteenth century; the early morning sun burning through the vapors above the lake; the grim ramparts of rock, the stand of sequoias (the biggest trees in the world, and already famous as such, but dwarfed by the scale of the landscape) and the brilliant blue eye of the lake. The crowds that assembled to view this tour de force when the Central Pacific Railroad exhibited around America learned three things: first, that the Donner Pass held no more terrors for the traveler; second, that the railroad didn't damage Nature; and third, that the deep cushions of a Pullman Palace car on the CPR were the right throne from which to view its splendors. *Donner Lake from the Summit* was the patriarch of all American travel posters. It was not for nothing that a journalist remarked that "Alfred Bierstadt has copyrighted all the principal mountains."

But not, as it turned out, the principal gorges. That was left to a painter of Irish ancestry, born (like Thomas Cole) in Lancashire and raised in Philadelphia: Thomas Moran (1837–1926). Unlike Bierstadt, this son of poor immigrant handweavers was entirely self-taught. He got some training as an engraver and opened an engraving business with his two brothers. But his heart was in painting, and his predilections intensely, youthfully Romantic. One of his earliest canvases, *Among the Ruins—There He Lingered,* 1856, took its title from Shelley's *Alastor; or, The Spirit of Solitude* (1815), in which the pure young poet is imagined pursuing "Nature's most secret steps,"

> where'er
> The red volcano overcanopies
> Its fields of snow and pinnacles of ice
> With burning smoke, or where bitumen lakes
> On black bare pointed islets ever beat
> With sluggish surge. . . .

Shelley's imaginary landscape predicts the real one of Yellowstone that Moran would eventually paint. Indeed, one dealer was later able to sell a very early Moran entitled *Childe Roland* under a new and topographical title, *The Lava Beds of Idaho.* And Moran would always be on the lookout for the sublime, the exceptional, and the picturesque—landscapes that satisfied the Romantic prototype. Only the great scene, he viscerally believed, could produce the great picture. He would find such scenes in the West, and nowhere else.

Moran rationalized his lack of formal training, as the self-taught are apt to do, with the belief that art was not "teachable." "You can't teach an artist much how to paint," he would declare in his later years. "I used to think it was teachable,

but I have come to feel that there is an ability to see nature, and unless it is within the man, it is useless to try and impart it." Nevertheless, the example of two painters obsessed him: Claude Lorrain and Turner. He was able to spend a year in England in 1861 studying Turner and copying his works in oil and watercolor: in particular, *Ulysses Deriding Polyphemus*, 1829, which Ruskin had called "the *central picture* in Turner's career." Moran kept his full-size copy of *Ulysses* in his studio thereafter, and it is not difficult to see why the painting had such a deep effect on him. Its high-keyed, unusually saturated color—yellows, ochers, crimsons, and roiling tracts of impasted white cloud—is just what Moran would reach for in his landscapes of the Green River and of Yellowstone. Turner's vision of Polyphemus' island, the crags on which the giant mistily reclines, is remembered in Moran's later visions—or, as he insisted, accurate transcriptions—of Western scenery.

The turning point in Moran's career came in 1871, when Dr. Ferdinand Hayden (1829–1887), director of the United States Geological Survey, invited him to join an expedition into the Yellowstone area of Wyoming. At that time Yellowstone was terra incognita to the white man. It was known, for its hot mud lakes, geysers, and constant geothermal activity, as "the place where Hell bubbled up," but apart from a few mountain men and trappers, the only white man to describe it had been John Coulter, a member of Lewis and Clark's expedition, who strayed into it in 1807. The expedition was backed by the U.S. government, and Moran's role was funded partly by the directors of the Northern Pacific Railroad—who reasoned, shrewdly, that the circulation of Moran's images of Yellowstone, and the publicity they got, might help create a new tourist destination and thus a profitable new railroad line.

Besides Moran, Hayden brought along a former stagecoach driver turned photographer, William Henry Jackson. The two had worked together before: Jackson had accompanied the painter Sanford Gifford on Hayden's 1869 survey of Wyoming, and the two had made parallel images of the same scenes. With his cumbersome cameras, tripods, developing equipment, and fragile glass plates (some of them twenty by twenty-four inches, yielding the largest outdoor photographs ever attempted) all loaded onto pack mules, Jackson now worked alongside Moran. He provided the objective record of Yellowstone's world of wonders, for a public which believed the camera couldn't lie. Moran's watercolors, more interpretative, supplied the color. The photographs confirmed the reality of Moran's strange sketches of fumaroles, sulfur pinnacles, and Dantesque hot lakes. To those back east who saw them on his return to New York, Moran's watercolors of Yellowstone looked as thrillingly alien as the first photos from the moon would a century later. Yet there were some scenes whose scale and grandeur neither a plate negative nor a watercolor could adequately convey, and one of these was the direct view down the chasm of Yellowstone, toward the falls.

Hayden remembered Moran saying "with a sort of regretful enthusiasm, that these beautiful tints were beyond the reach of human art." What the sketchbook could not encompass, however, memory and imagination perhaps could, and as soon as he got back to New York, Moran ordered an eight-by-fourteen-foot canvas and flung himself into work on the climactic panorama of America's years of Western expansion: *The Grand Canyon of the Yellowstone*, 1893–1901 (Figure 121).

Meanwhile, Hayden had been busy lobbying Congress, with the enthusiastic backing of the Northern Pacific Railroad's directors, to set aside Yellowstone as a national park—a museum of American sublimity. To prove its uniqueness, he displayed Moran's sketches and Jackson's photographs; and in March 1872 President Grant signed into law an act of Congress protecting the whole Yellowstone area, thirty-five hundred square miles of it, in perpetuity. This was to do wonders for the Northern Pacific Railroad's cash flow—and, not incidentally, for Moran's. *The Grand Canyon of the Yellowstone* became the first American landscape by an American artist ever bought by the American government. It cost $10,000, or about 80 cents per square inch, and it went straight on view in the Capitol, where the effigies of so many flesh-and-blood heroes were to be seen. This, too, was a painting of a hero: the landscape as hero, limbs of rock, belly of water, hair of trees, all done with absorbing virtuosity. It rivaled Church and outdid Bierstadt in offering the panoramic thrill that no watercolor can give, and the density of substance that no photograph could rival. It became a prime symbol of wilderness tourism. Two years later, Moran tried to repeat its success with an even larger canvas, *The Chasm of the Colorado*, the result of an expedition down the Grand Canyon led by Colonel John Wesley Powell, another surveyor who needed, as he put it, an artist of Moran's stature to paint scenes that were "too

vast, too complex, and too grand for verbal description." Moran certainly did his best, but the Canyon defeated him—as it has defeated all landscape painters since; not even he could solve the principal problem of painting it, the lack of any scale that related to the human body and so might allow the viewer to imagine himself on the edge of the scene.

In 1911 the "Western" artist Charles Schreyvogel found himself among the Sangre de Cristo Mountains of Colorado, trying to sketch Pikes Peak. "I started [a drawing]," he wrote to his wife, "and it looked fine. I was there at 7.30 a.m. Then the smelters started in and the black smoke just covered the whole valley so that I couldn't see a thing and I had to stop."

The idea that any part of the West could be blotted out by industry would have seemed barely conceivable to its admirers forty years before, but it had come to pass. Except in the national parks, the Western landscape by 1890 was so disfigured by mining, clear-cutting, damming, railroad construction, and pollution that it was only a shadow of its former self. The great cattle drives out of Texas, along the Chisholm Trail to the railhead in Kansas, had created the cowboy as a figure of American popular imagination after the Civil War—the hard-living, instinctively noble, straight-shooting, resourceful centaur of the West. But after 1890 most cattle ranching ceased to be open-range; feed was farmed, and pastures fenced, and it was cheaper to ship stock all the way to market by rail. The cowboy was rapidly joining the Indian in the vivid shadowland of American myth; both still existed, but not in the way they once had, the cowboys no longer "home, home on the range," the Indians shunted into a deracinated life on reservations. Americans had begun to experience the West through reenactment. The Battle of the Little Bighorn, in which George Custer and his cavalrymen were wiped out by Sioux warriors in 1876, was restaged by the showman Buffalo Bill Cody just a year later in 1877, using Indians who had actually fought there; and it is still reenacted every year in Hardin, Montana. The last major Indian revolt, that of the Oglala Sioux, was crushed in 1890 at the massacre (called by whites the Battle) of Wounded Knee. The U.S. government's policy of slaughtering the buffalo herds of the plains—commemorated in remarkable photographs of whole pyramids of buffalo skulls, like Toltec monuments—had destroyed the Plains Indians' food base.

Their near extinction prompted Albert Bierstadt to paint, c. 1889, *The Last of the Buffalo* (Figure 122). It shows no white hunters with Sharps rifles. The blame for the ecocide is put on the Indians themselves. The picture is a lie, but by then Bierstadt's own reputation was going the way of the buffalo. A committee of American artists, choosing works to be sent to the Universal Exposition in Paris in 1889, voted to reject it—not because it was false propaganda, but because the

121. Thomas Moran, *The Grand Canyon of the Yellowstone*, 1893–1901. Oil on canvas, 96½ × 168⅜" (245.1 × 427.8 cm). National Museum of American Art, Smithsonian Institution, Washington, D.C.; gift of George D. Pratt.

subject (and Bierstadt) seemed hopelessly out-of-date. Church's reputation, too, had declined. On his death in 1900, obituarists had to remind their readers who he had been. The taste for nationalist blockbuster landscape was gone: it was replaced by a preference for Barbizon-style scenes, moodier, smaller, gentler, and without pretension to sublimity.

In 1890 the U.S. government declared the frontier closed. This began the slow ebb of an American state of mind: the idea that natural resources were infinite, that always, somewhere Out There, the bold and the brave could find more land or another big lode, just for the taking. By the end of the 1870s, it was abundantly clear that the key to American social reality was no longer the frontier but the cities, whose culture was based on fast change, harsh inequality, the friction of crowds competing in narrow social space, industry, and the impersonal power of the machine.

But people rarely want social reality. They want dreams. As the wilderness and the West declined into objects of nostalgia, emblems of imperiled freedom, they drained out of high art and into popular culture. They became a powerhouse of stereotyped fantasy, whose messages were replicated through Wild West shows, memoirs, illustrations, and novels. Zane Grey wrote more than sixty and sold thirteen million copies during his lifetime; Owen Wister's tales of the frontier were also hugely popular. In a photograph from 1903, one sees Charles Schreyvogel painting a cowboy on the roof of his studio building in Hoboken, New Jersey (Figure 125, page 205). Finally, recycling everything, came the movies.

In the visual arts, the man whose work most clearly stood for this nostalgic packaging of a bygone "real" West for an urban public was Frederic Remington (1861–1909). All his life Remington was tormented by the thought that he was seen as an "illustrator," not a "fine artist." He was right to worry; his work was entirely illustrative, but as the historian Richard Slotkin and others have pointed out, it has much to say (subliminally, as it were) about the expectations and anxieties of its turn-of-the-century American audience. Its narrative punch, its vividness of composition and cropping also exerted a large influence on the movies, not only in stereotypes—the good cowboy versus the traitorous and savage Indian—but in its details: there are passages in John Ford's Westerns, such as *She Wore a Yellow Ribbon,* based entirely on Remington's pictures, which in turn (since one hand washes the other) have come to look like action-movie stills.

Educated at Yale, Remington had tried his hand at ranching (briefly and unsuccessfully) in Kansas before settling down in New York. Thereafter, he made frequent trips to the West, looking for material. The image he cultivated, that of a hardy denizen of the prairies who had fought in the "Indian wars" with the U.S. Cavalry, was entirely a myth. (Remington could ride, though at forty he was so fat that he could hardly clamber aboard a horse.) He was a facile and prolific draftsman, whose output ran to some twenty-seven hundred paintings and countless sketches. His career took off in the mid-1880s, as a result of his friendship with America's future president, Theodore Roosevelt. Roosevelt, like Remington (and his writer friend the novelist Owen Wister), believed wholeheartedly in the vanished West as the ground of American virtue. He hired Remington to illustrate one of his early books, *Ranch Life and the Hunting Trail,* and introduced him to magazine editors. The public's appetite for Wild West stories was insatiable by the 1890s, and Remington swiftly became their top illustrator.

He fitted the *Zeitgeist* like a Colt sliding into a well-worn holster. "Manliness" is as much a talisman in Remington's work as it was in Roosevelt's politico-moral vision of "the strenuous life." Rather defensively, he enjoined art students to remember that "to be a successful illustrator is to be fully as much of a *man* as to be a successful painter." He saw the Old West as populated by "men with the bark on"; now (he wrote to his wife in 1900) "I shall never come to the West again.—It is all brick buildings—derby hats and blue overhauls—it spoils my earlier illusions." His entire imagination revolved, in a naïve way, around the vision of an Arcadia of noble violence, a black-and-white (or rather, red-and-white) world of frontier conflict, of displacement, and, in the end, of loss.

Hence, one of his favorite themes was the Last Stand, the back-to-the-wall defense of the white man's values against all the odds. Hard-bitten cowpokes down in a waterhole, their Winchesters pointed at the Indians galloping around them (Figure 123); Custer and his men huddled together on their hillock, holding out to the last cartridge. Such images had a very clear metaphorical life. Their core

122. Albert Bierstadt, *The Last of the Buffalo,* c. 1889.
Oil on canvas, 71¼ × 119¼″ (180.9 × 302.9 cm).
The Corcoran Gallery of Art, Washington, D.C.; gift of
Mrs. Albert Bierstadt.

123. (above) Frederic Remington, *Fight for the Waterhole,*
1903. Oil on canvas, 27¼ × 40⅛″ (69 × 102 cm). The Mu-
seum of Fine Arts, Houston; The Hogg Brothers Collection,
gift of Miss Ima Hogg.

124. (below) Charles Schreyvogel, *Defending the Stockade,*
c. 1905. Oil on canvas, 28 × 36″ (71.1 × 91.4 cm). Okla-
homa Publishing Company, Oklahoma City, Oklahoma.

was an obsessive sense of doom. Turn-of-the-century America was filled with anxiety about immigration: many of Anglo-Saxon stock felt imperiled by a rising tide of racial "impurity." The idea of a beleaguered white society holding out against invasion was close to Remington's own hotly xenophobic heart. "Jews, Injuns, Chinamen, Italians, Huns!" he declared in a letter, "rubbish of the earth. . . . I've got some Winchesters and when the massacring begins I can get my share of them, and what's more, I will." The Last Stand, in Remington and others, entailed a reversal. The Indian became the cruel invader; the white became the native, the true owner of the West and of America. And there is no hope in sight: Charles Schreyvogel in *Defending the Stockade*, c. 1905 (Figure 124), leaves little doubt that the troopers will soon be overwhelmed by the hordes clambering over the wooden border of their enclosed world. Such images had a political dimension as well. In 1876 the American press made close connections between the defeat of Custer and the agitation by labor radicals in the cities. In the eyes of many conservatives, universal suffrage was a menace to civilization: it endowed "alien hordes" with more power. The Last Stand symbolized the closing of the frontier, but also served as a warning of what could happen if the lower orders—freed blacks in the South, immigrant workers in the North—began to claim their rights and take over government and industry. Custer could never have become such a powerful symbol if his doom did not represent such powerful anxieties. They were not to be assuaged until Theodore Roosevelt led the charge of his Rough Riders up San Juan Hill, thus redeeming the memory of Custer's defeat and symbolically baptizing Americans as what Roosevelt called "one of the great fighting races." In this way Manifest Destiny was adapted to an age of immigration, and the West underwent one more mutation as it receded from the experience of most Americans. It is hard to imagine what Remington, had he lived into the golden years of the Hollywood Western, would have thought of the continuing influence that his paintings exerted on the form. For everything his work transmitted was taken up and expanded by an industry owned and run by the "rubbish of the earth" he hated and feared: Samuel Goldwyn, Carl Laemmle, and other studio heads, the Jews who re-created the West. Nobody, in the end, was more faithful to the primal vision of America, or did more to promote it, than its European immigrants and their children.

125. Anonymous, *Charles Schreyvogel Painting on the Roof of His Apartment Building in Hoboken, New Jersey,* 1903. National Cowboy Hall of Fame and Western Heritage Center, Oklahoma City, Oklahoma.

4

AMERICAN RENAISSANCE

Gold horse, gold rider, gold goddess. High on a plinth, they stand at the southeast edge of Central Park in New York, just in from the creeping traffic of Fifth Avenue and Fifty-ninth Street. Together, they commemorate the crushing of the Confederacy by the Union, in the Civil War. Americans are slow to put up monuments—the Washington Monument, as we have seen, wasn't dedicated until Washington himself had been dead for more than eighty years. This one follows the pattern. Created by the sculptor Augustus Saint-Gaudens, it was not installed until 1903, nearly forty years after the surrender at Appomattox.

It represents General William Tecumseh Sherman on his horse, leading the Northern troops through Georgia (Figure 126). This man created the greatest systematic atrocity, next only to Jackson's Indian wars, ever committed by American troops on American soil: the march of sixty thousand Union troops from Atlanta to the sea, burning and destroying every town, farm, railroad, factory, and plantation across a front sixty miles wide and three hundred miles long, utterly smashing the defeated world of King Cotton. Its memory never left him, and fifteen years later he would exclaim, in an upsurge of anguish, to a startled class of graduates at the Michigan Military Academy: "I am tired and sick of war. Its glory is all moonshine. It is only those who have neither fired a shot nor heard the shrieks and groans of the wounded who cry aloud for blood, more vengeance, more desolation. War is hell." It was a Greek moment, an utterance torn from the throat of an American Atreus. And so it was fitting that another quarter century later Saint-Gaudens should have chosen to cover the statue with gold, so that Sherman's face, with its deep lines and stubble, now gazes sightlessly at the Plaza Hotel like the gold mask of Atreus' son, King Agamemnon. Over the years, the original gold leaf was worn and corroded away, so that the Sherman Monument reverted (more or less) to bronze; when it was regilded in the 1980s, an operation paid for by one of America's chief vulgarians, the property speculator Don-

126. Augustus Saint-Gaudens, Sherman Memorial, installed 1903. New York.

207

ald Trump, there were choruses of disapproval at the "glitz" and "desecration," the "Trumpery." The dissenters were wrong. The new gold restores the tragic meaning of the Sherman Monument, and its original intent—which was to ram home the lesson of Southern defeat, and to show that the North had all the money and power now. A little tardily, perhaps, but the men who paid for it, through the New York Chamber of Commerce, the big businessmen and "gold bugs" of McKinley's presidency, were never averse to saying the same thing over and over, in different ways, as they continued to crush the defeated South by peaceful economic means more effective than Sherman's cannon.

The horse is trampling on pine fronds and cones, symbols of Georgia. Superbly modeled, it advances with the remorseless animal power of Saint-Gaudens's fifteenth-century Renaissance prototypes—the warhorses of Verrocchio, in his Venetian monument to Bartolommeo Colleoni, and of Donatello's statue of Gattamelata in Padua. Ahead of it walks Nike, the goddess of victory, holding up a palm. The spikes of its fronds echo the bronze points of the horse's streaming tail, giving closure to the group. Her mouth is open (you imagine the wind that distends Sherman's cloak blowing into it). Not in a smile, or even an expression of triumph: a grimace, almost. She might be getting ready to howl some syllables. Her face, bare as a hand, is as strange and ambiguous as the closed warrior face of Sherman above. Her eyes stare like a maenad's, wide open. She is an implacable and angry Victory, a terror to the losers, not a congratulation to the winners.

127. Augustus Saint-Gaudens, Robert Gould Shaw and the Fifty-fourth Regiment Memorial, unveiled 1897, completed 1900. Boston.

Six years earlier, in 1897, another Civil War memorial by Saint-Gaudens was unveiled in another city, on the edge of Boston Common, where (in the words of the poet Robert Lowell) it still "sticks like a fishbone in the city's throat" (Figure 127). It commemorates Robert Shaw, colonel of the Union's Fifty-fourth Massachusetts Regiment, whose men were all black volunteers, some of them former slaves. In the summer of 1863, two months after leaving Boston and moving south, Shaw and most of his men were killed in a frontal attack, against overwhelming odds, on the ramparts of Fort Wagner in South Carolina. They were buried in a mass grave.

The Irish-born Saint-Gaudens (1848–1907) was only just coming into young manhood at the end of the Civil War, and when he received the Shaw commission in 1884 he was thirty-six. It was an unusual project, fit for a young and idealistic man, and unprecedented in several ways. First and most obviously, no American sculptor had ever been called on to represent blacks as heroes, level in nobility and resolution with a white leader. Second, this was the first American monument to a group rather than a single figure—although Saint-Gaudens's first sketches show that he began with Shaw alone on horseback. There were other, minor differences. How did he resolve them? By combining two Renaissance elements: the hero on horseback, and the sarcophagus frieze of other heroes on foot.

The bronze face of Shaw is finely modeled, an image of sensitivity and command. He and his mount stand out in very deep relief, the better to give depth to the column of men marching by his side, who might otherwise have been reduced to less substantial forms like the genius of Victory flying over them.

Saint-Gaudens took great pains with these soldiers. In the 1880s nearly all images of African-Americans by white American artists were either crude racist stereotypes—Sambos, black mammies, lazy niggers, watermelon-eating pickaninnies—or else merely generic. Saint-Gaudens, however, worked assiduously from the life, doing studies in clay of some forty different heads for the black soldiers. Only a fraction of these were used in the final monument. These studies (Figure 128) rank with Copley's black crewman in *Watson and the Shark* among the very few American treatments of blacks, up to that time, that neither mock nor condescend, but set before you a fellow human being in his own vitality and presence. In the monument, this feeling is preserved, even amplified. Stoic and resolute, the

128. Augustus Saint-Gaudens, *Black Soldier's Head, Study for the Shaw Memorial*, 1884–96, this cast made in 1964. Bronze cast, h. 7½″ (19.1 cm). Saint-Gaudens National Historic Site, Cornish, New Hampshire.

men march forward to the beat of a drummer boy in front. Their uniforms do not have the emblematic neatness a lesser sculptor might have given them. They are rumpled and creased, each in a different way, which goes with the individuation of the men's faces. They are not cogs in a machine but citizen soldiers, volunteers with free will—an essential part of the sculpture's message, reflecting the inscription on the Shaw Memorial that "they gave proof that Americans of African descent possess the pride, devotion and courage of the patriot soldier." The visual rhythm of the column is given by the barrels of rifles carried at the slope, which divide the space vertically; and by the six spiral ends of the blanket rolls and the disks of the water bottles, which meter it horizontally. Every small form plays its part. This is the most intensely felt image of military commemoration made by an American.

Saint-Gaudens was highly prolific. He designed and carried out every kind of commission, from the weather vane atop the tower of Madison Square Garden (a delectable bronze nude of Stanford White's mistress Evelyn Nesbit) to the most beautiful coin ever minted in America, the 1907 twenty-dollar gold eagle. But there is little doubt that his images of commemoration were his most resonant work.

No previous American sculptor had ever created a work as dense and profound as the Sherman and Shaw monuments. There was American sculpture, most of it mediocre, before Saint-Gaudens; there would be even more of it, again mediocre for the most part, after him, until in the 1940s the culture threw up another artist of comparable greatness, David Smith. But for range, expressiveness, subtlety, and the ability to create original images from a deep study of earlier art, no nineteenth-century American sculptor comes within a mile of Saint-Gaudens—especially in the domain of public art, where he displayed a medium's intuition for how the formal and conceptual energies of the Italian Renaissance could be channeled into the present.

Between 1870 and 1910 some Americans, patrons, architects, and artists alike, didn't just want to imitate the Renaissance: it was their obsession, their model, their goal, and their idea (if possible) of the historical event to outdo. They equated their own robber barons with the Medici and Sforza. In his first book, *The Venetian Painters,* 1894, Bernard Berenson, the twenty-nine-year-old Boston Jew who would rise to become the feared and waspish pontifex of I Tatti, the world's ultimate authority on Italian Renaissance painting and sculpture, declared that

we [Americans], because of our faith in science and the power of work, are instinctively in sympathy with the Renaissance. . . . The spirit which animates us was anticipated by the spirit of the Renaissance, and more than anticipated. That spirit seems like the small rough model after which ours is being fashioned.

129. John La Farge, **Rhinelander Altarpiece,** Church of the Ascension, 1884–87. New York.

A small model indeed; it is doubtful whether the total wealth of the Medici in Florence and their fellow bankers and city bosses in Padua, Siena, and Milan would have equaled a year of J. P. Morgan's income four hundred years later.

Americans spoke of their artists as living Old Masters; the architect Charles McKim was familiarly known as "Bramante," and his partner Stanford White as "Benvenuto Cellini."

As never before in America, artists, architects, and decorators worked together on joint projects, in emulation of the famous conjunctures of talent that produced masterworks of the Renaissance. Thus the Rhinelander Altarpiece in New York's Church of the Ascension, 1884–87 (Figure 129), had a mural by John La

Farge (1835–1910) depicting the ascension of Christ in terms translated from Raphael into smoky, warm Titianesque color; the architectural surround was by Stanford White, the paired gilt bronze angels holding up a chalice over the altar by Louis Saint-Gaudens, Augustus's brother, and the mosaics by D. Maitland Armstrong.

Of the team assembled partly under his direction for one enormous project, Augustus Saint-Gaudens wondered, "Do you realize that this is the greatest gathering of artists since the fifteenth century?" This boast was, of course, delusive but wholly typical of the time. The work in question was the temporary "White City" created in Chicago for the World's Columbian Exposition of 1893. The Exposition was both trade fair and political extravaganza. It marked the four hundredth anniversary of Columbus's landing in the Caribbean, which signified, to white Americans, the planting of the first outpost of civilization in the New World. (Today, poor Columbus has taken such a beating that merely to suggest that he did something worthwhile, or at least memorable, is to invite the wrath of the virtuous. But that was not, to put it mildly, how Americans saw him in 1893. To them, the *Almirante del Mar Océano* was a hero, almost a god, the emblematic founder of their culture.) It represented an American imperial fantasy, the idea that the "march of civilization" across the Atlantic, started by Columbus, had paused on the shores of Lake Erie before moving on to the Pacific. The year 1893 marked the annexation of Hawaii by the United States. Within five years it would have grabbed Cuba and the Philippines as well, thus completing the destruction of the Spanish empire founded, in the Americas, by Columbus. The American economy was still wracked by the depression of the early 1890s, so that the splendors of the Exposition were mostly plaster and pasteboard. But the possibility of Empire suggested a way out, to which much of their imagery was dedicated. In the past, America had only exploited its own continent. But now it had no wild frontier left. In 1893 the frontier was officially declared closed. America, emulating the carve-up of Africa and Asia into colonies by Britain, France, and Germany, now wanted its own passive foreign markets: colonies, declared as such or not.

The chief architects and artists of the American Renaissance, and dozens more now forgotten except by hopeful art dealers, worked in concert to raise the Exposition's halls and monuments. What the "greatest gathering" produced is perhaps summed up in Frederick MacMonnies's Columbian Fountain (Figure 130), a most unseaworthy-looking barge, sixty feet long, sired by Bernini upon Radcliffe and Wellesley, with Columbia enthroned amidships, Feminine Fame with a trumpet in the bow, Father Time astern, and its eight ridiculous oars worked by plaster girls representing the Arts and Sciences, the whole shebang firmly fixed to the bottom of a shallow pond in front of the main exhibition building.

And yet the White City did have important consequences. Real American cities

had always grown higgledy-piggledly, without any conception of a master plan—
two obvious exceptions being L'Enfant's design for Washington, D.C., and the
grid layout of Manhattan. The example of White City, with its elitist, didactic
palaces and monuments set down in strictly organized space, sparked the City
Beautiful movement in the 1890s, whose aim was to reform urban chaos by the
radical surgery Haussmann had used on Paris, and fill the newly cleared boule-
vards with resplendent new buildings. Funded by the rich and by business asso-
ciations, these would be architectural texts, reminding the citizen whose labor
had created the wealth of the great that now they were getting it back from the
wise hand of power. This, it was claimed, showed "Democracy in action." It was
an American rendition of the Beaux Arts tenet that public architecture should
show the citizen that he, or she, is the reason for the state; and yet the fulsome
terms in which the City Beautiful movement preened itself were not untinged by
hypocrisy.

For the period of the Gilded Age—roughly from the mid-1870s to the early
1900s—brought the deepest and fiercest class conflict America had ever experi-
enced. The North's victory in the Civil War unified America politically, but not
socially. The explosion of the great railway strikes of 1877, which spread from
West Virginia to Pittsburgh, erupted into near class war in Chicago, and para-
lyzed freight and communications in the Midwest, left a scar of death and de-
struction; this was only the prelude to thirty years of unrest, in which American

workers forged the links of class solidarity against the boss, the Pinkerton, the scab, the hired militias, the corrupt judges, and the bought police force. Never had the gulf between rich and poor been wider or more bitterly felt. But if in these years American labor was creating an unprecedented mutual strength, so was American capital: for the Gilded Age earned its name by becoming a time of unassailable and mutually interlocking trusts, combines, and cartels, of rampant money acting under laws it wrote for itself in an orgiastic monopolization of American resources. The new financial barons took over the Republican party, turning it into the instrument of big business and high tariffs. When labor organized and resisted them, they struck back with fury. More and more power lay in fewer and fewer hands. Nowhere was the adage that "behind every great fortune lies a great crime" truer than in the United States. "Get rich," wrote Mark Twain sardonically, "dishonestly if we can, honestly if we must." From this culture of Promethean greed arose the primal names of American business: Rockefeller (oil), Carnegie and Frick (steel), Vanderbilt (railroads), the Goulds, Astors, Fisks, and, towering over them all, J. Pierpont Morgan, the real power behind the Vanderbilt lines, who by 1900 controlled forty-nine thousand miles of track directly and another fifty thousand indirectly, and thus dominated the entire communications and long-range transport system of the continent on the eve of the automobile age.

Through such men, Americans lost all vestiges of their Puritan inhibitions about the display of wealth. Their cultural ideology was consistent with their principles, such as they were: it revolved around a belief in trusteeship and patronage. God had made the rich man rich so that he could discharge His will on earth. He would not fail them. Greed was public service: how could the poor or the middling classes be expected to manage money with equal responsibility? In the words of Samuel Tilden to a room of magnates at a dinner for Junius Morgan, J. P. Morgan's father:

> While you are scheming for your own selfish ends, here is an over-ruling and wise Providence directing that the most of all you do should inure to the benefit of the people. Men of colossal fortunes are in effect, if not in fact, trustees for the public.

How to bridge the chasm between their business doings and this delusive piety? Some felt no need to: they remained social Darwinists, red like Nature itself in tooth and claw—vile brutes with coffers full of bonds. But for other and more reflective money barons, the Protestant ethic enjoined a sense of obligation, released in philanthropy and public works: the creation of libraries, schools, university colleges, concert halls, parks, museums, and other amenities, which would inspire gratitude in the laboring masses and defuse their resentments, while creating around their donors the aura of Maecenas.

The intellectual frame for this project came out of Pater, Hegel, and Ruskin, among others; but its core proposals had been supplied by Matthew Arnold, in *Culture and Anarchy* (1869). Up till then, Arnold argued, Englishmen (and their American relatives) had been too much crimped by a moralizing "Hebraism"— the Puritan tradition. This had deprived the world's natural rulers, the Anglo-Saxon race, of part of its cultural birthright: the past achievements of humanity wherever they might be found. Now, more "sweetness and light" was needed: Moses must be retired to the background, and Pericles brought forward. "Hellenism" became the watchword of the cultivated, who advised the American rich. It did not mean a slavish imitation of Greek, and only Greek, models. It meant an idealized eclecticism, gathering together "the best that has been thought and said in the world." Its objects could be secular: there was no imperative superiority built into religious art. But from such a basis, art—or, in the wide sense, "high culture"—could approach being a religion in itself, improving the people and the nation by example, as moral proscriptions once did by threat. "Do not tell me only of the magnitude of your industry and commerce," Arnold told his American readers,

> of the beneficence of your institutions, your freedom, your equality; of the great and growing number of your churches and schools, libraries and newspapers; tell me also if your civilization—which is the grand name you give to all this development— tell me if your civilization is *interesting*.

The superrich of the Gilded Age, and the artists who served them, wanted to make it so by any means possible. They were tired of being cultural appendages to Europe. They wished to lead the world. They would express this desire in the magnificence of their buildings and the comprehensiveness of their collections. This is why Henry Adams hailed the White City in Chicago as "the first expression of American thought as a unity; one must start there."

One must look to the Gilded Age as the point where the Museum began to supplant the Church as the emblematic focus of great American cities. You could not fit Donatello, Bernini, or Rubens into the simple clapboard meetinghouse of Puritan tradition. But that ethic was over; a new age of the spectacular and the therapeutic had begun, and favored a cult of taste, of the rarefied and exquisite.

From this sprang America's Aesthetic Movement, its museum age, and its academic art of the late nineteenth century. From it also came the vision of the Renaissance and the Middle Ages that Bernard Berenson and Joseph Duveen unloaded on the American rich, whose lives had epitomized the raw, booming, ruthless character of American capitalism, the war of all against all. In the "American Renaissance" both were locked together, since one promised relief from the intolerable anxieties of the other. Enfolded in this, waiting to burst out,

was a sense of freedom, which Henry James unerringly identified. "We young Americans are (without cant) men of the future," he wrote.

> I look on it as a great blessing; and I think that to be an American is an excellent preparation for culture. We have exquisite properties as a race, and it seems to me that we are ahead of the European races in the fact that . . . we can deal freely with forms of civilization not only our own, can pick and choose and assimilate and in short (aesthetically and culturally) claim our property wherever we find it.

At the core of the American Renaissance was a conflicted idea which tried to come out as serene idealism. Essentially, it was that nationalism and cosmopolitanism had to be fused. Americans were boasters and boosters. They boasted of their limitless potential, and in order to make the potential actual they boosted their artists and architects. To call yourself a "young nation" is to excuse crudity and naïveté while claiming a superior vitality. But while you are trumpeting your role in the future, you find yourself casting nervous glances over your shoulder at the certifying past, which has never heard of you; and the way to own the future thus becomes conflated with the desire to take over that past as well, so that it too will become the voice of your will. The nineteenth century, in almost all Western countries, was a period of intense cultural nationalism, in which traditions were discovered (as with the Catalans, or the French discovery of the Gallic, rather than Roman, roots of their culture) or, in other cases, invented. But Americans were a little embarrassed about their newness, the insecurity of their cultural roots. They therefore made a big point of claiming the roots of others, as a right conferred, ultimately, by might.

The result of this has sometimes been called the "genteel tradition" in America. All great art borrowed from the past, and no art that did not could be great. It assumed that certain forms had already been perfected, and that the duty of artist and architect was to adapt them to American conditions. Nobody, it was agreed, would ever cast a better bronze horse than Verrocchio's in Venice, or Marcus Aurelius' mount on the Campidoglio, but Saint-Gaudens won every laurel for having gone to Italy, studied them, and produced a horse in the full spirit of its prototypes with an American general on top. "Authority: the influence of the best," wrote John La Farge. "That, I suppose, is what we mean by civilization." Only under the sign of authority could American artists find what they were, and the way to Truth lay through the Ideal.

To see the origins of this, one must go back a few decades. The search for the Ideal in Europe had always been a little confounding to Americans. It was so hard to winnow out from the undreamt-of overload of art. This had been especially so before the Civil War, when transatlantic travel was more arduous and expecta-

131. Hiram Powers, *The Greek Slave*, c. 1843. Marble 65½″ (166.4 cm) including integral base; 90″ (228.6 cm) including pedestal. Yale University Art Gallery; Olive Louise Dann Fund.

tions of cultural transformation in Europe more fevered: six weeks of vomiting at sea, and then—Chartres. Harriet Beecher Stowe, visiting the Louvre for the first time in the 1850s, described how she flew up its staircase in search of revelation, art's equivalent of religious conversion, to find the work which would "seize and control my whole being, and answer, at once, the cravings of the poetic and artistic element"—but alas!

> For any such I looked in vain. . . . [M]ost of the men there had painted with dry eyes and cool hearts . . . thinking little of heroism, faith, hope, love and immortality.

Presently she discovered Claude Lorrain, and her doubts began to recede.

It was quite possible for an American artist to approach the Ideal if he lived in Italy, and between 1830 and 1875 about two hundred of them did. Notable among them were the "American Florentines," led by a former machinist from Cincinnati, the sculptor Hiram Powers (1805–1873). By the 1840s Powers was incontestably the most famous sculptor America had yet produced, and he became so (inside America) with one marble, *The Greek Slave*, c. 1843 (Figure 131), an adapted copy of the Uffizi's Medici Venus, with some chains on her wrists as a *cache-sexe*. This, Americans thought, was the first truly *moral* nude they had ever seen—very different from John Vanderlyn's languorous and vaguely available-looking Ariadne, twenty-five years before. Powers astutely explained, in the pamphlet that accompanied his statue on its American tour in 1847, that his slave's nudity was not her

fault: she had been divested of her clothes by the lustful and impious Turks who put her on the auction block; thus her unwilling nakedness signified the purest form of the Ideal, the triumph of Christian virtue over sin. This sales pitch, aimed point-blank at Puritan sensibilities, worked so well that American clergymen urged their congregations to go and see *The Greek Slave:* "Brocade, cloth of gold," one of them preached, "could not be a more complete protection than the vesture of holiness in which she stands." This notion of the Holy Nude became an American tradition, and it accounts for the proliferation of dewy, spiritualized American virgins, whether demurely naked or clad in filmy muslins or shining cuirasses (depending on allegorical needs) in the work of the leading American painters of the Gilded Age—Edwin Blashfield, Thomas Dewing, Abbott Thayer, and Kenyon Cox. The Greek slave led through them, as we shall see, to the Gibson girl.

These men were the mainstays of the American academy—the National Academy of Design, the most powerful taste-forming body of the American Renaissance. It had been cofounded by Thomas Cole, the architect Ithiel Town, and the painter Samuel Morse in 1826, in reaction against America's first professional guild of artists, the American Academy of the Fine Arts (1801–40), which by then had fallen into dim staidness. Morse's main gift to America, and the world, was his invention of the electromagnetic telegraph and the Morse code. But his larger ambition was to change the status of American artists, himself included; and he knew that this could only be done by better teaching, more informed and less condescending patronage, exacting standards, professional conduct, and, above all, fine things to look at in what was still an esthetic desert where few could be found. "All we wish is a taste in this country and a little more wealth. . . . In order to create a taste, however, pictures, first-rate pictures, must be introduced into the country, for taste is only acquired by a close study of the merits of the old masters."

It was an old complaint, going back to the days of Copley and West. Rembrandt Peale had lamented that "the painter, and the lover of the painter's art, have to lament the non-existence of public galleries where specimens of European artists . . . might serve as examples of instruction. . . . We have no Libraries of Art!"

Morse saw no hope of this changing from the top down, in Andrew Jackson's philistine America dedicated to "commerce, commerce, commerce," "boorishness and ill manners," and "low and vulgar pleasures and pursuits" where "the arts are but incidentally talked of." Nevertheless, he decided to strike his blow for knowledge—with a painting of a museum.

In 1831 Samuel Morse was in France, a country he adored for esthetic reasons and despised, from the depths of his prickly Calvinist soul, for political and moral ones—though not as much as Italy, from which he had just come. Paris

was still reeling from the aftershocks of the 1830 Revolution, and republican sentiment (which Morse shared) was in the air. In Italy and now in Paris, this extreme American patriot kept turning over and over what had become the central question of his life: how could you bring to America a sense of the fine arts without importing with it the contagion of the patronage for which they had been made—the sinister forces of the papacy, royalty, absolutism, and aristocratic decadence? He had the idea of painting an enormous picture full of replicas of noble past works which met his moral and political criteria and would instruct Americans back home. It would show how to use such art as well. And it would have to be convincing—not an imaginary scene.

Thus *Gallery of the Louvre,* 1831–33 (Figure 132). Morse ordered up a six-by-nine-foot canvas. He had chosen as his architectural setting the *salon carré,* but was irked to find that it had been entirely rehung with relatively recent French paintings, by Géricault, Prud'hon, and others, not the mix of past masterpieces from Italy, Holland, and elsewhere it had contained before: "bloody and voluptuous" stuff, wrong for American eyes. So, in order to copy the pictures he wanted "from the life," Morse the inventor had his giant canvas mounted on a special trolley, which he trundled around in the corridors of the Louvre, stopping

132. Samuel F. B. Morse, *Gallery of the Louvre,* 1831–33. Oil on canvas, 73¾ × 108" (187.3 × 274.3 cm). Terra Museum of American Art, Chicago; Terra Foundation for the Arts, Daniel J. Terra Collection.

where he wished. He filled the canvas with more than forty replicas of works in the museum: Leonardo's Mona Lisa and Raphael's *Belle Jardinière*, three Rubenses, four Titians, two Rembrandts, and so on through Claude, Poussin, Caravaggio, Veronese, and others. He must have cut a very strange figure, obsessively laboring at his copies while a cholera epidemic raged outside the museum and coffins stacked up in the Paris streets.

The lineage of *Gallery of the Louvre* is obvious. It descends from a kind of painting that became popular in the seventeenth century: the *Kunstkammer* scene, an opulent room crowded with works of art and natural curiosities being admired by their aristocratic or royal owners. Certainly Morse had seen one famous painting of this kind, Johann Zoffany's *Tribune of the Uffizi*. But the intent of *Gallery of the Louvre* is quite different from these—their opposite, in a sense. It does not celebrate ownership, but middle-class education. The central figure is, naturally, Morse himself in a black frock coat, leaning over the shoulder of a young woman who is making a copy and giving her instruction. All the other figures in the room are also earnest students. The *salon carré* is a classroom, full of Americans. It has transcended its purpose as a display of royal acquisition and plunder. But it is also a kind of sieve, in which Morse, the arbiter of art history and teacher of his country, winnows out the pure gold grain of European art from the lesser chaff. An act, therefore, both of homage and of arrogance—and as much a starting point for the American museum as Charles Willson Peale's museum had been. In a curiously literal sense, Morse's painting was a museum without walls. When it was shown in America in 1833, critics praised *Gallery of the Louvre* but the public ignored it; Morse's high plans came to nothing and, greatly embittered, he gave up painting in 1837, to devote himself to electromagnetics.

The National Academy of Design, as it developed through the 1890s, continued to fill the role that Morse had imagined for himself. It was artist-run, and its artists would decide what was best for America. The Academy would prevent taste from descending into a democratic babel. It would uphold standards derived from Europe, but in the interest of a higher "Americanism." It would discourage lewdness in art and testify to the healthiness—that national obsession—of the artist's calling, punishing backsliders and bohemians. It would show that the artist, no less than the businessman, had his place in the American work ethic, and even in religious life: clergymen, to a degree unimaginable today, claimed association with artists, and insisted on being arbiters of the moral effect—which for many pious Americans was the whole effect—of their work. And then there was the connection with business and civics: "Faith, and heroism, and literature, and art, are all worth money," boomed a preacher named Henry Bellows in a panegyric on the moral worth of American materialism, "and therefore there is no peril in resting their support on their practical value."

This was in 1853. Thirty or forty years later, the expectations placed on the public American artist, whose address to the world the Academy largely controlled, were a little more sophisticated but they still kept their moralized basis. But the abstract authority of God had become the cultural authority of an ideal, Renaissance-based Europe by now, and virtue depended on how fully you internalized it before speaking up as an American.

One did this by going to Italy, and by studying in Paris. There was no longer any question of an American artist "making it" on the basis of a purely local art education, in New York or Philadelphia. For Thomas Cole and a succession of other American landscapists, Italy had been a fount of romantic motifs, a generalized and dreaming past. Now, an artist went there with more specific ends in mind: to study this Michelangelo and that Donatello, to know the sequence of moldings in the cornice of the Palazzo della Cancelleria, to grapple with the compositional forms of a Giovanni Bellini or a Titian, and to learn the techniques of *buon fresco*. His or her practical education would be implanted in Paris, to which Americans repaired in the hundreds to work in the leading artists' ateliers—Carolus-Duran, Cormon, Léon Bonnat—or at the École des Beaux-Arts, at least a quarter of whose students, at one point, were Americans.

The dean of the genteel Renaissance men was Kenyon Cox (1856–1919), who came originally from Ohio and, in 1877, went to study in Paris, first in Carolus-Duran's studio and later at the École des Beaux-Arts under Gérôme. To him, everything was new at first: "I have taken a very great fancy," he wrote in a letter home, "to an odd old painter named Sandro Botticelli. Have you ever heard of him? To me his pictures are altogether charming in their quaint sweet feeling." Gradually, as he got to know European art better, Cox's ideas coalesced into the form they took in his later lectures, published in 1911 as *The Classic Point of View*. Central to them was the belief that the art of painting was about sublimation: unruly nature must be tamed and re-formed in a kind of idealized ornament, whose chief part was the human figure, naked or clothed. Transcendence through generality and typifying led to the Ideal. The "classic spirit," Cox stressed, had nothing to do with the historical style of neo-classicism: it was more general, being

the disinterested search for perfection; it is the love of clearness and reasonableness and self-control; it is, above all, the love of permanence and of continuity. It asks of a work of art, not that it shall be novel or effective, but that it shall be fine and noble. It seeks not merely to express individuality or emotion. . . . It does not consider tradition as immutable or set rigid bounds to invention. But it desires that each new presentation of truth and beauty shall show us the old truth and the old beauty, seen only from a different angle.

What this meant in terms of Cox's own art first came to national attention with Chicago's "White City" exposition in 1893, where his murals were much admired. Praised in its day for the excellence of its draftsmanship and the suave formality of its design—"without design there may be representation, but there can be no art" was one of Cox's maxims—it now seems controlled to the point of insipidity. A late work, *Tradition,* 1916 (Figure 133), painted three years after the explosively controversial Armory Show against which Cox himself had led the more intelligent wing of the conservative attack, illustrates the problem. It is faultlessly composed and as dead as mutton, with its allegorical figures (Past Art on the left with her torch, Tradition in the middle passing on the sacred lamp of Knowledge, and Future Art and Literature on the right about to receive it) enacting a symbolic narrative that already had whiskers on it a century before. Aiming to be a lesser Titian, Cox became a lesser Mengs.

A nuisance for such artists, of course, was the decorum problem. They wanted to implant the nude in American art as the sign of the Ideal. The audience, however, persisted in seeing it as flesh and sin. Americans did not respond well to public displays of the nude: Cox's *Hunting Nymph,* 1896, a well-fleshed chorine twanging her bow in imitation of Artemis, her pudenda barely concealed by a wisp of chiffon borrowed from Titian's *Diana and Actaeon,* offended a public which did not consider it in the least "Ideal." On the other hand, what clothes could one put on the figures? The late-nineteenth-century military uniform or business suit, or the cumbersome ladies' skirt, didn't go well with designs based on the High Renaissance, and were too mundane to allow the bodies inside them to express abstract ideas. All the artists, Saint-Gaudens included, complained about this, but muralists like Cox and Edwin Blashfield (1848–1936), another

133. Kenyon Cox, *Tradition,* 1916. Oil on canvas, 41¾ × 65⅛" (106 × 165.5 cm). The Cleveland Museum of Art; gift of J. D. Cox.

ex-student of Gérôme's, solved it with the adroit use of togas, peplums, chitons, and other articles of the Greek and Roman wardrobe, worn by robust-looking or, on occasion, poutingly fierce American girls personifying Literature, Plenty, Concord, Justice, or the Apotheosis of Kansas. Abbott Thayer (1849–1921) specialized in ideal portraits of American innocence, usually based on his daughter Mary, as in *A Virgin*, 1892–93 (Figure 134). Or else—as with *The Trials of the Holy Grail*, an exceptionally popular set of murals by Edwin Austin Abbey (1852–1911) for the Boston Public Library—one could use medieval costumes. Abbey's unrealized ambition was to do a cycle of paintings based on Boccaccio's *Decameron*. In 1896 he set forth his plan in language that sums up the kind of Pateresque *rinascimento* dreamworld that haunted the genteel American imagination of the time, artists no less than critics and collectors:

> It is the condition of things—the thoughtless life of cultivated people within beautiful surroundings—which seemed to me to adapt itself particularly to decorative purposes. [I wished] to give an impression of a number of handsome personages, before a background of calm dignified landscape, low and rich in tone as . . . in the pictures of Giorgione.

Thus the body, as carrier of the Ideal, tended to regress into etiolation—Puritanism denied it expression. An extreme case of this was the sensitive and gifted artist Thomas Wilmer Dewing (1851–1938), who had fallen equally under the spell of Whistler and the Pre-Raphaelites, and sought to combine them in gauzy, languid groups of virginal young women, as in *The Days*, 1887 (Figure 135), displaying their spirituality in Greek dress while holding archaic musical instruments. There was bound to be some reaction against these white-corpuscle damsels, however, and it came at the turn of the century with an immensely popular female stereotype invented by the illustrator Charles Dana Gibson—the Gibson girl (Figure 136). This was the American Virgin *en fleur*—healthy, strong,

134. Abbott Handerson Thayer, *A Virgin,* 1892–93. Oil on canvas, 90 3/8 × 70 7/8" (229.7 × 182.5 cm). Freer Gallery of Art, Smithsonian Institution, Washington, D.C.

135. Thomas Wilmer Dewing, *The Days,* 1887. Oil on canvas, 64³⁄₄ × 94″ (163.2 × 238.8 cm) framed. Wadsworth Atheneum, Hartford, Connecticut; gift from the Estates of Louise Cheney and Anne W. Cheney.

136. Charles Dana Gibson, "A Gibson Girl."

innocent, white of teeth and skin, and pure as the yet unborn Doris Day. She had her own sexual attraction, but the viewer would never dream of transgressing it. She was Hiram Powers's *Greek Slave*, but clothed, and with a bicycle or a tennis racket instead of the chains; her entourage no longer consisted of imagined Turks but of clean-cut young American men in straw boaters, lightly enslaved by her freedom.

Murals need walls, and walls were rising in abundance. The "American Renaissance" expressed itself most directly in its buildings, and there the man one thinks of first is Stanford White (1853–1906). If the Renaissance valued *sprezzatura*, the knack of making hard things look easy and natural, White had more of it than any American then or since. He was the kind of gorgeous millipede whose dance is hated and resented by every toad on the forest floor—and indeed he paid for it with his life, when a crazed millionaire named Harry Thaw, who had married White's mistress Evelyn Nesbit, shot him to death in Madison Square Garden out of retrospective jealousy.

White was a social turbine, the best-known and most popular man in New York, blessed with singular powers of social empathy and a genius for friendship. His early gift for drawing made him want to be an artist, but his friend John La Farge, who was one, advised him against it. Architecture was a stabler career. In 1872 he apprenticed himself to Henry Hobson Richardson, who in that year was designing Trinity Church in Boston (Figure 137). Its wonderfully inventive re-working of Romanesque space into soaring, auditorium-like openness, with a splendor of detail and color—painted throughout with figural scenes and abstract designs by La Farge—unrivaled in American church architecture, would bring Richardson to national fame. Thus, though White had never taken an architecture course, he was able to imbibe the principles of Beaux Arts design through its best American practitioner.

In 1879 he teamed up with Charles McKim (1847–1909) and William Mead (1846–1928) to create the firm of McKim, Mead & White, the most prolific and influential partnership in the history of American architecture. Between them, McKim and White (Mead was usually content to look after the business side of the firm) executed about a thousand commissions; and the cachet attached to White's name remains such that in the early 1970s a real estate ad in *The New York Times* hopefully listed an 1840 Manhattan town house as being by Stanford White, which, if true, would have made him the first architect on record to design a building thirteen years before he was born.

Not only was their work voluminous, but it covered an extraordinary range. They first became known in the 1880s for their country houses in the Shingle Style—an elegant and often poetic adaptation of the rural American idiom of

cedar shingles over stud framing, mingled with references to the forms of French slate-covered farmhouses (hence the swelling "eyebrow" windows) and with acknowledgments to Japanese rural building. Their most daring essay in the Shingle Style was the William Low House, 1886–87 (Figure 138), on Rhode Island, a building that seems to be all pediment, intimately hugging the ground despite its long frontage, under the spreading wing of its immense roof—"organic architecture," twenty years before Frank Lloyd Wright. At the other extreme there were the late official works, of which the grandest by far was their design for Pennsylvania Station, the huge complex which (until its tragic demolition in the 1950s) served as the ceremonial gateway to New York: its waiting room was based on the Baths of Caracalla in Rome, but was enlarged some 25 percent in each direction, and the soaring glass vaults that covered the passenger concourse were a crystalline spectacle that surpassed anything else of the kind built in America.

Though their plans always worked superbly well in terms of function and human use, they were not hobbled by mere functionalism. Their major buildings always had a celebratory character that went far beyond the minimum standard. They could not and would not build cheaply. They built exactingly well, in the finest possible materials, in pursuit of "firmness, commodity and delight." They brought the lessons of the past into the present, with its superior technology, to rival the past.

An early design that unequivocally stated this was the Boston Public Library,

137. H. H. Richardson, interior of Trinity Church, photographed in 1996. Boston.

1887–98 (Figure 139). This palazzo-form building was based on the model of many late-nineteenth-century libraries: Henri Labrouste's Bibliothèque Sainte-Geneviève in Paris (1843–50), with its masonry shell and iron roof structure. But whereas Labrouste's façades look like a stone membrane, McKim and White stressed the solidity of the light pink granite walls with deeper relief and wider piers between the arched main windows, a richer cornice, and grand treble-bay entrances, giving a more authoritatively Italian effect. (It derives, ultimately, from Alberti's Tempio Malatestiano in Rimini.) Inside, the theme of Renaissance col-

138. McKim, Mead & White, William G. Low House, 1886.
Bristol, Rhode Island.
139. McKim, Mead & White, Boston Public Library,
1887–98.

227

laboration was carried out with gusto—bronze doors by Daniel Chester French, murals by Puvis de Chavannes, John Singer Sargent, and Edwin Austin Abbey, sculpture by Louis Saint-Gaudens and Frederick MacMonnies. The object was to give Boston not just a library but an exemplary theater of civilization, symbolizing America's right to draw on all the world's resources, past and present, local and foreign, in the interest of its own enlightenment.

This was the spirit that informed collecting, too. Over and above the commissioning of works by American artists, the great obsession of the Gilded Age was acquiring the trophies of other and earlier cultures—especially those of a grander and more aristocratic Europe, the Middle Ages, and the Renaissance. If your family tree was stubby and plebeian, try that of the Medici. To buy the art object, whether it was a suit of armor, a Giorgione, or a whole library, was also to appropriate its history, its magic, and its aura. Thus, with a huge sucking noise, old Europe began to vanish into America. Stanford White saw nothing wrong with this imperial process, and indeed there was nothing wrong with it. It wasn't looting; it was love and fair trading, my cash for your past. "In the past," he said, "dominant nations had always plundered works of art from their predecessors. . . . America was taking a leading place among nations and had, therefore, the right to obtain art wherever she could." And she did. Today, you cannot study the Italian Renaissance without going to America.

The man whose very name stood for this process, and for whom McKim, Mead & White built a magnificent library on Madison Avenue in Manhattan, was J. P. Morgan, the man with the ogre's nose and the bottomless pocket, who divided his time between his railroad trusts, his royal progresses through Europe, and his four huge black yachts, each of them called, appropriately enough, the *Corsair*. No American before, and none since, has collected on Morgan's scale. He did not begin until he was past fifty: the death of his father seems to have set him free to fulfill his fantasies, which ramified and became insatiable. The holdings of the Morgan Library began with a small acquisition: a manuscript by Thackeray. Before long it would swallow whole libraries, like the Earl of Gosford's, at a gulp, and include everything from Byron and Keats manuscripts to eighth-century missals, from the complete output of the Aldine Press to original scores by Mozart. As with manuscripts and incunabula, so with drawings, watercolors, Renaissance paintings, jewelry, bronzes, enamels. Morgan rarely bargained and never disclosed what he paid. "If the truth came out," he remarked in 1901 of his purchase of Gainsborough's *Duchess of Devonshire* through Agnew's in London (reportedly for 150,000 pounds), "I might be considered a candidate for the lunatic asylum." When in 1882 Queen Victoria's daughter, the Crown Princess of Prussia, wrote to her mother in a prophetic burst of anxiety about the loss of England's cultural patrimony, it was Morgan, above all, whom she had in mind:

If our *great* English families are obliged to sell their unique collections, at least I think if possible the nation *ought* to *secure* them. The day will come when these things *can* no longer be had—and all is readily snapped up by the *new* collections of America.

The paragon of collectors in Boston was Isabella Stewart Gardner (1840–1924), who married into the top of Boston's caste-obsessed society but had (in its eyes) the defect of having come from New York, albeit from a perfectly respectable family. "Mrs. Jack," as she was known, was seen as an outsider at first; but she laid siege to the walls of Proper Bostonianism with the delicate battering rams of high culture, both old and new. The accepted routines of social life were not enough for her restless intelligence, and she gathered a salon whose membership stretched from Charles Eliot Norton, for twenty-five years the professor of fine art history at Harvard, to visiting figures like Nellie Melba and the very young Pablo Casals. From the 1870s, when she burst on the Boston scene, until her death, there was scarcely a leading light in the transatlantic world where society and the arts intersected whom she did not know. Short and plain as a bun, with a moonface and a slight harelip, she made up for her lack of beauty with an imperious flamboyance of character. Her motto came from the Versailles of Louis XIV: *C'est mon plaisir* (Such is my pleasure). She drank beer, smoked cigarettes, danced all night with 25-carat diamonds in her hair, and once invited a prize-fighter in boxing shorts to tea so that her lady friends could admire his physique. At regular intervals she would decamp to Europe on shopping sprees, renting the gilded splendors of the Palazzo Barbaro in Venice or some equivalent *hôtel particulier* in Paris; she also traveled to Egypt, Indonesia, China, India, and Japan, collecting as she went.

Inspired by Jacob Burckhardt's *Civilization of the Renaissance in Italy* and by Charles Eliot Norton's Harvard lectures on Italian art and literature, which she started attending in 1878, Isabella Stewart Gardner set out to cast herself in the mold of Renaissance patroness. She identified, in a big way, with Isabella d'Este, Marchioness of Mantua, who had presided over a sparkling court, received the homages of Pietro Bembo, Ludovico Ariosto, Bernardo Tasso, and a dozen other poets, and filled her *studiolo* in the Ducal Palace with the works of Mantegna, Giovanni Bellini, Perugino, Costa, and Correggio—as Burckhardt had written, "the catalogue of her small but choice collection can be read by no lover of art without emotion." Mrs. Jack wanted a choice but large collection. She admired Isabella for winning intellectual respect in her own right as the equal—albeit the titled equal—of men.

To some Europeans, such emancipated American women seemed quite new, and scary. John Singer Sargent painted Mrs. Jack's portrait in 1888, frontal, in a near-hieratic pose possibly derived from Khmer sculpture, wearing a plain black

sheath and a girdle of pearls (Figure 140). She stands in front of a Renaissance brocade, a rich cloth of honor whose abstract design seems almost Eastern. One's sense of confronting, not an ordinary social portrait, but a quasi-religious figure is completed by the design of the brocade behind her head, which forms a halo like a saint's or a Buddha's. Significantly, Sargent first showed it under the title *Woman, an Enigma,* not identifying Mrs. Gardner as the subject. In 1895 it stirred a friend of Henry James's, the French writer Paul Bourget, to emulate Walter Pater's famous purple passage on the Mona Lisa, published twenty years before and still one of the touchstones of "decadent" prose. Bourget saw Mrs. Jack's effigy as "an idol, for whose service man labors . . . in the ardent battles of Wall Street":

> Frenzy of speculations in land, cities undertaken and built by sheer force of millions, trains launched at full speed over bridges built on a Babel-like sweep of arch, the creaking of cable cars, the quivering of electric cars, sliding along their wires with a crackle and a spark, the dizzy ascent of elevators in buildings twenty stories high, immense wheat-fields of the West, its ranches, mines, colossal slaughter-houses . . . these are what have made possible this woman, this living orchid, unexpected masterpiece of this civilization.

Shades of Pater's "She is older than the rocks among which she sits"! In effect, Bourget assimilated the image of Mrs. Jack to the widely diffused late Romantic fantasy, beloved by the Decadents, of the Fatal Woman—a dehumanized, sphinx-like object of ill-concealed dread, at whose indifferent feet propitiatory sacrifices are laid (in this case, the whole American industrial and agricultural economy). Isabella Stewart Gardner was not unused to encomiums, though this was certainly more florid than most. She surrounded herself with a court of protégés, young men in whom she discerned talent. The best-remembered of them, today, was Bernard Berenson (1865–1959), a young Jew of shtetl family, deeply conflicted by his origins, fresh out of Harvard, and filled with a consuming ambition to escape into the great world of Boston Brahmin sensibility, with its worship of the Renaissance as an art-historical Camelot swarming with geniuses in silk doublets, its narcissistic refinement, its cult of exquisite sensation, and its endemic anti-Semitism. Once established in Europe, Berenson became Mrs. Jack's scout, adviser, and dealer, and supplied her with extraordinary coups, with the backing of the dealer Joseph Duveen. He played her like a salmon, coaxing her into ambition, sacrifice, and acquisition. In 1896 he persuaded her to buy a painting for the unheard-of price of $100,000. It was a Titian belonging to the Earl of Darnley: not just any Titian but *The Rape of Europa,* done in 1561 as one of a cycle of eight *poesie*—interpretations of the theme of love in classical literature—for Philip II of Spain. It is still arguably the greatest Italian Renaissance painting in

140. John Singer Sargent, *Isabella Stewart Gardner,* 1888. Oil on canvas, 74³/₄ × 31¹/₂″ (189.9 × 80 cm). Isabella Stewart Gardner Museum, Boston.

231

America. Mrs. Jack needed a lot of cajoling, but in the end she sent a coded telegram to Berenson: a single acronym, YEUP, "Yes to Europa." *Yeup!* Sweet surrender! And from now on it wouldn't be rape but consent for Europa, as the mass migration of Renaissance paintings across the Atlantic got under way: those gorgeous trophy wives whose names finished in *-ini* and *-ano* and *-elli,* heading for the eager arms of meatpackers, grocers, and railroad kings.

Not all of them collected, however; some were content to build, leaving behind paintings of no great worth but enormous piles of personal masonry.

The opulence, the frenzied eclecticism of these buildings was not lost on satirists, whose pens were nonetheless powerless against the crushing confidence that the marble and gold proclaimed. Wallace Irwin, a popular writer of the day, wrote some doggerel to them:

> Senator Copper of Tonapah Ditch
> Made a clear million in minin' and sich,
> Hiked fer Noo Yawk, where his money he blew,
> Buildin' a palace on Fifth Avenue.
> "How," sez the Senator, "can I look proudest?
> Build me a house that'll holler the loudest."
> Forty-eight architects came to consult,
> Drawin' up plans for a splendid result:
> If that old Senator wanted to pay,
> They'd give him Art with a capital A.
>> Pillars Ionic,
>> Eaves Babylonic,
> Doors cut in scallops, resemblin' a shell,
>> Roof was Egyptian,
>> Gables conniption,
> Whole grand effect, when completed, wuz—Hell.

The red-hot site of Gilded Age extravagance was not Fifth Avenue, though, but Newport in Rhode Island. Here, the very rich went to spend their summers; here, the rituals of consumption and display became so extreme, so competitive and self-referential, that they eclipsed anything done in private American building before or since.

The rich in Newport built what they called, with wincingly false modesty, their "cottages," their fronts opening to the ocean and their drives with gates on Belle-vue Avenue. Since the 1850s, tycoons of various stripes had been putting up large Gothic Revival houses in Newport. It was no longer fashionable to estivate in a hotel; one had to have one's own Newport house. But not until the taste for Italian-French Renaissance architecture fell into the ocean of monopoly-money that

lapped Newport in the 1880s did opulence as an end in itself really take off, without the slightest deference to any sort of social reality beyond its rocky shores. Newport confirms the piercing insight of Henry Adams, lamenting the crassness of his time: "The American wasted more money more recklessly than anyone ever did before; he spent more to less purpose than any extravagant court-aristocracy; he had no sense of relative values, and knew not what to do with his money when he got it, except to make more or throw it away."

Various architects served the needs of Newport, but the paragon was Richard Morris Hunt (1828–1895), the Bernini of the swells and the most important American architect—at least in terms of his effect on the professional standing and practice of architects—of the nineteenth century. He was the first American to complete training at the École des Beaux-Arts in Paris, and by the 1880s his prestige

and authority were unrivaled in New York, where he kept his offices. Any visitor to New York's Metropolitan Museum of Art can feel gratitude to Hunt for supplying it with the most august and noble entrance hall of any museum in America—that soaring, limestone-cool space with its arches, vaults, and domes, based on the Baths of Caracalla (Figure 141); its relative emptiness enables you to take a deep and much-needed breath and clear your mind before entering the collections beyond.

In Newport, Hunt was not making public spaces. He was housing, with the utmost extravagance, a tiny group of people: a job with very different requirements. At all times in America, the poor have wondered how the rich live. But more to the point, the rich have always wondered too. Suppose that your name is Vanderbilt and you own half the country. It's easy to say to someone, "My good man, see me now: I own half America." But the real test is whether you can live like someone who does. For this, a rich man needs help. Wealth on the scale of the 1880s was still uncharted territory, like the Rocky Mountains in the 1780s.

141. Richard Morris Hunt, entrance hall of the Metropolitan Museum of Art, looking north, photographed in 1993. New York.

"Marble Palace" (Residence of Mrs O. H. Belmont), Newport, R.I.

Even if you wake up one morning and say to yourself, "I see it: I shall have a dining room in my cottage by the sea, and it shall be three or four stories high and entirely paneled in marble the color of raw steak," you may still get it wrong, because the Astors, say, next door, who own the other half of America, may just have sheathed their dining room in marble the color of poached fish. So you must get an architect to fantasize on your behalf, so that you may be secure in the knowledge that because he is working for practically everyone else in your class he will not get his symbols crossed.

That was what Hunt did for the rich of Newport. He created a seamless etiquette of shared ostentation, with variants. His four "cottages" there set the scale for all the rest. They were Ochre Court (1888–92), for Ogden Goelet; Marble House (1888–92), for William and Alva Vanderbilt; Belcourt Castle (1891–94), for Oliver Belmont, in whose stables the horses slept on hand-embroidered linen; and The Breakers (1892–95), for Cornelius Vanderbilt II.

Of these, the most lavish were Marble House and The Breakers. Marble House (Figure 142) was the first great architectural fantasy of that iron-willed Southern belle and women's suffragist Alva Vanderbilt, *née* Smith. The daughter of an Alabama cotton planter, she boasted that she was the first member of her set to marry a Vanderbilt. Soon after, she became the first to divorce one. William Vanderbilt only got to spend two summers in Marble House; after their divorce in 1895, Alva married August Belmont, moved across the road to Belcourt, and went on to commission so many more buildings that the American Institute of

142. Richard Morris Hunt, Marble House, 1888-92.
Newport, Rhode Island.

Architects offered her an honorary membership—a proposal which, surprisingly, she turned down.

The construction of Marble House lasted four years, and was treated as a secret prodigy from the very beginning. Even the workmen, imported in gangs from France and Italy, were quartered on the site so as to minimize the spread of rumors about the extravagance of the project. An essay in French-inspired late Renaissance Revival, it was modeled after the Petit Trianon at Versailles, with additional references to the White House in Washington and the Temple of Apollo at Heliopolis. (Its four huge Corinthian orders supporting the entrance porch were copied from the Temple of Apollo, but were much bigger.) It ate up more than half a million cubic feet of white Carrara, and the interiors were paneled and paved with yellow Sienese and pink Numidian marble, which, topped off by the congested riot of gilding and bronze in its Gold Ballroom, contributed to a final construction cost of about $11 million in gold dollars, perhaps a quarter of a billion in today's money. On the staircase, the grateful owner placed two bas-relief portraits, one of Jules Mansart, Louis XIV's chief architect at Versailles, the other of Hunt. This still seems right.

As Hunt was finishing Marble House, he began work on the pile that remains the archetype of Gilded Age excess: The Breakers. Its owner, the railroad king Cornelius Vanderbilt II, was a somewhat reclusive man, pious and even moderately philanthropic (he gave about a million a year to charities), and quite without Alva Vanderbilt's passion for entertaining. Nevertheless, he felt impelled to leave a permanent monument to himself in the form of a four-story, seventy-room house, some 250 by 150 feet, designed by Hunt in the manner of a late-sixteenth-century Genoese palace. (It was, however, not the largest house Hunt did for a Vanderbilt: that honor belongs to Biltmore House, in Asheville, North Carolina, with its 255 rooms and 125,000-acre park, commissioned by George W. Vanderbilt in 1888. There, Hunt delved back into late French Gothic and early Renaissance castle architecture to produce the only château that does indeed make The Breakers look like a cottage.)

To relieve the risk of fire, of which Cornelius Vanderbilt was terrified, no timber was used in The Breakers' construction; it is all stone and steel. Incredibly, the whole affair was built in only two years (this when builders had none of today's machine tools); the paneling, marquetry, and other decor of the major rooms was all prefabricated in Paris by the decorating firm of Allard and brought in kit form, by steamer, to Newport. Adjectives tend to fail under the opulence of the result, and yet it is a desolating opulence, heavily rhetorical and without much brio. Hunt was one of the great detailers of the age, and The Breakers contains some extraordinary elements, such as the cornice and staircase of its main hall. And yet to stand in its famous dining room (Figure 143), more ornate than almost any European state apartments of the period it mimics, with its 45-foot-

high ceiling groaning with bulbous stuccowork and its twelve massive rose alabaster columns topped by gilt bronze capitals, is to sense the futility of building huge pedestals for small figures: somehow, you come away with an impression not of Vanderbilt's magnificence but of his ordinariness, and you think how Richard Morris Hunt conned him while serving him. In any event, Vanderbilt did not enjoy The Breakers for long. He succumbed to a stroke in 1896, one year after his cottage was finished, and died three years later at the early age of fifty-six. By then, Hunt too was dead, and no American architect better deserved the epitaph written for Sir John Vanbrugh:

> Under this stone, reader, survey
> Dead Sir John Vanbrugh's house of clay.
> Lie heavy on him, Earth! for he
> Laid many heavy loads on thee.

143. Richard Morris Hunt, dining room of The Breakers. Newport, Rhode Island.

. . .

When Commodore Matthew Perry sailed into Yokohama Bay in 1854 on his black ship with his spindle-nosed, round-eyed sailors, he unwittingly set in train two cultural convulsions—one in Japan itself, the other in Europe and America. Disoriented and amazed by American technology and military power, the Japanese of the Meiji period began to imitate Western values wholesale as best they could, which led many of them to depreciate their own inherited culture. As they modernized, they threw out the old in a mounting frenzy of self-purgation. Meanwhile, cultivated Europeans and Americans gobbled it up, with grateful enthusiasm, as an antidote to just those industrial, realist, and materialist values of the West that so enraptured the Japanese.

The spread of the craze for *japonaiserie* is too vast a subject to be treated here. Very few major artists of the later nineteenth century were immune to it. Through its influence on Manet, Degas, Lautrec, van Gogh, Gauguin, Bonnard, and Vuillard, it utterly transformed painting and the decorative arts in the West. The Art Nouveau style is unimaginable without it. Its more general cultural effects were propelled by writers like the Goncourts, by a strong and ever-increasing Japanese presence at the international expositions (London in 1862, Paris in 1876, 1878, and 1889), by entrepreneurs like the arts-and-crafts dealer Samuel Bing in Paris (whose influence soon spread to every department store on both sides of the Atlantic)—by all the media, in fact, of an increasingly media-saturated West. One artist in particular stood out as a key figure in this process: James Abbott McNeill Whistler (1834–1903), the first American painter since Benjamin West in the eighteenth century to become famous and influential on the far side of the Atlantic.

Whistler was the son of a railway engineer, born in Lowell, Massachusetts, but throughout his life he pretended to be a Southern gentleman. He was, in most imaginable ways, self-invented. Like West, he was irked by the low status America accorded its artists. His solution was not to attach himself to a court, as West did, but to depart for Paris and London and pretend to be a native aristocrat from an America he would never revisit. Perhaps his fixation on rank was impressed early: he was partly raised in Russia, where his father was designing the St. Petersburg–Moscow railway for Czar Nicholas I. It may have been reinforced at the military academy at West Point, from which he flunked out in 1854 for his cluelessness about chemistry. "Had silicon been a gas," he would say later, "I would have been a major general." He left for Paris the next year, aged twenty-one. Thus, although he liked to pose as a dashing Tidewater cavalier, Whistler never became an officer, still less saw action in the Civil War. This insufficiency troubled him, and it accounts for a peculiar adventure he undertook in 1866, when he sailed from France to Chile—a long and grueling trip across the Atlantic and around Cape Horn—to be present at a Spanish naval blockade of the port of Valparaiso. Whether Whistler thought his being there would make an ounce of dif-

ference in the outcome of Chile's small colonial rebellion, one cannot tell; in the event, the Spanish warships bombarded Valparaiso and reduced most of its waterfront to rubble, while Whistler, along with most of the Chilean officials, fled for the hills. By the end of 1866 he was back in Paris with a few misty, blue, crepuscular seascapes of Valparaiso to show for his trip, but no honorable scars.

Whistler was accepted by Paris as no American painter before him had been. As a young man, he worked with Gustave Courbet. He enjoyed the respect of Édouard Manet and Edgar Degas, though the latter sometimes gave him the sharp edge of his tongue—"Visslair, you behave as though you had no talent." He appears (with Baudelaire, Manet, and other luminaries) in Fantin-Latour's group portrait of the rising art stars of 1864, *Homage to Delacroix*. "This American is a great artist," said Camille Pissarro, "and the only one of whom America can be justly proud." And Marcel Proust would turn part of his name, unpronounceable by the French, into an anagram: he became the painter Elstir in *À la recherche du temps perdu*. Posterity, of course, has not set him alongside those who saw him as a colleague. Whistler was one of those artists whose legend as wit, dandy, and esthetic kamikaze—for what was his libel suit against John Ruskin but a suicide mission, compelled by his own pose of "Southern honor"?—continued after his death and became a barrier to proper appraisal of his work. One would like to think that Whistler the artist flies clear of Whistler the celebrity, the "character." Not so. On the one hand, his self-construction, his sense of the self as a work of art, remains as fiercely impressive as Oscar Wilde's. "Float like a butterfly, sting like a bee"—he did that long before Muhammad Ali was born. But though a fine painter, he was never a great one, and it is absurd to class him with Degas or Manet. He didn't have the range, the formal toughness, or the breadth of human curiosity for that.

Valparaiso was as close as Whistler ever got to the Orient, but he was seen in France and England as a cultural bridge to Japan. He was obsessed by the formal

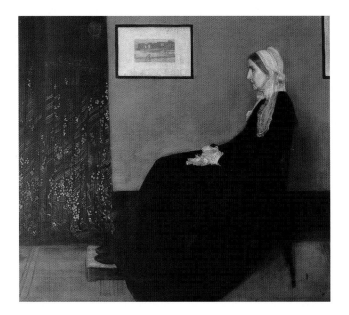

beauty of Oriental art, especially Japanese prints (which were available by the ream in Paris and London) and Chinese blue-and-white porcelain, of which he amassed a choice collection. Through the study of Japanese concision, he brought an esthetic of hints and nuances into late-nineteenth-century painting. His abhorrence of narrative, his refusal to moralize through art, his preference for the exquisitely designed moment over the slice of life: these were new, and they

144. James A. M. Whistler, *Arrangement in Grey and Black, No. 1* (*The Artist's Mother*), 1871. Oil on canvas, 56¼ × 63¾" (144 × 162 cm). Musée du Louvre, Paris.

epitomized the ideal of Art for Art's Sake. It was provocative, in 1871, to call a portrait of his mother *Arrangement in Grey and Black, No. 1*. To reduce one's dear mama to an "arrangement," however devotedly the arrangement was painted, implied an aversion to the banalities about motherhood that filled the Victorian air. It contradicted the ostentatious cult of what Americans today call "family values," which Whistler viewed as mere cultural baggage. It proposed that the esthetic life of shapes mattered at least as much as social piety (Figure 144).

"Whistler's Mother" remains his most famous painting—up there in the grab bag of images which, for one reason or another, usually unconnected with their quality as art, everyone knows, like the Mona Lisa and Grant Wood's *American Gothic*. The painting that made his reputation was earlier, and better. Painted in 1862, it is a portrait of his Irish model and lover, Jo Hiffernan: *The White Girl (Symphony in White, No. 1)* (Figure 145). Shown in London first and then in Paris, it provoked a buzz of irrelevant interpretation. The expressionless young woman in virginal white, standing on a wolfskin with a lily in her hand (that floral emblem of the Aesthetic Movement), was declared to

be a bride on the morning after her wedding night; or a fallen ex-virgin; or a victim of mesmerism—anything except what she actually was: a model posing in Whistler's studio to give him a pretext to paint shades of white with extreme virtuosity and subtlety. The story was that there was no story. It was Whistler's first sally against the narrative insistence in French and (especially) British art, though by no means the last.

145. James A. M. Whistler, *The White Girl (Symphony in White, No. 1)*, 1862. Oil on canvas, 84½ × 42½" (214.7 × 108 cm) unframed. National Gallery of Art, Washington, D.C.; Harris Whittemore Collection.

In his later, more Japanese-influenced work, Whistler changed the way people saw the world. His taste for the indefinite, the twilit, set in a matrix of extremely conscious formality, invented a new landscape, as Oscar Wilde acknowledged in 1889:

> Where, if not from the Impressionists, do we get those wonderful brown fogs that come creeping down our streets, blurring the gas-lamps. . . . To whom, if not to [Whistler], do we owe the lovely silver mists that brood over our river, and turn to faint forms of fading grace curved bridge and swaying barge? The extraordinary change that has taken place in the climate of London during the last ten years is entirely due to a particular school of Art.

Wilde was thinking of Whistler's Thames nocturnes of the 1870s, such as *Nocturne in Blue and Gold, Old Battersea Bridge,* c. 1872–75 (Figure 146). It is a perfect example of Whistler's translations from the Japanese. Its point of origin was probably a woodblock print by Hiroshige, which features a large curving bridge with fireworks behind it, on a river at night. Whistler's version brings the big T of the pier and roadway of the bridge so high that it no longer resembles Hiroshige's, or bears the least physical resemblance to any structure over the Thames, let alone Battersea Bridge. The dim figure in the foreground, balanced

on the stern of a barge, could equally well be a Japanese boatman. But the essence of the painting is its haunting, intense, twilight blue—a blue so ethereal and pervasive that it appears to supersede nature in artifice, while the falling rocket fire spangles it like the gold flakes embedded in Japanese *maki-e* enamel.

At about the time he painted it, Whistler was working on another and bigger blue-and-gold project, his greatest sustained essay in the decorative: the Peacock Room, now in the Freer Gallery in Washington (Figure 147). Originally it was painted for the London house of an English millionaire, Frederick Leyland, who had asked his architect Thomas Jeckyll to adapt a dining room to display his collection of blue-and-white Chinese and

146. James A. M. Whistler, *Nocturne in Blue and Gold, Old Battersea Bridge,* c. 1872–75. Oil on canvas, 26⅞ × 20⅛″ (68.3 × 51.2 cm). Tate Gallery, London; presented by the National Art Collections Fund, 1905.

Japanese porcelain. Its walls were covered with panels of antique Cordovan leather, which Whistler proceeded to cover with thick layers of glossy blue-green paint, meant to imitate the surface of Japanese enamel, decorated with designs of peacocks in gold leaf. Leyland's pique at losing his expensive leather, which the antique dealer who sold it to him had claimed, no doubt falsely, was salvaged from the wreck of the Spanish Armada in 1588, set off a train of quarrels and recriminations between the annoyed patron and the touchy artist. Determined to finish his masterpiece, Whistler agreed to halve the agreed fee of 2,000 pounds. Then Leyland was "much perturbed" to find that Whistler, with his mania for publicity, had been inviting not only artist friends and prospective patrons but the press and the public into his house to view the work in progress. In revenge, he insulted Whistler by paying him in pounds, not guineas. One paid tradesmen in pounds, professionals in guineas—and Whistler was extremely sensitive on the

147. James A. M. Whistler, end-wall panel from *Harmony in Blue and Gold: The Peacock Room,* 1876–77. Oil paint and metal leaf on canvas, leather, and wood, dimensions of the room 167⅞ × 398 × 239″ (425.8 × 1010.9 × 608.3 cm). Freer Gallery of Art, Smithsonian Institution, Washington, D.C.

matter of his professional standing. Whistler's own revenge was to decorate the south wall with a design of two squabbling peacocks, one rich and the other poor, somewhat in the manner of an Edo period Japanese screen. Its immediate source was an 1804 woodblock print by Utamaro, *Utamaro Painting a Ho-o Bird in One of the Green Houses.* The bird on the right is Leyland, drawn up in a haughty attitude with disks of gold and silver—his money—scattered on the ground before him. The other is Whistler, rejecting the filthy lucre with equal hauteur.

From then on Whistler was constantly in difficulties with money, and he went to his grave blaming Leyland for his misfortunes. But the worst blow to his career—an entirely self-inflicted wound—came in 1878. The year before, the Great Cham of English art criticism, John Ruskin, now in his sixties and beginning to show signs of the madness and melancholy that disfigured his last years, wrote a vehement attack on *Nocturne in Black and Gold: The Falling Rocket,* which Whistler had exhibited at the Grosvenor Gallery in London. Whistler's impressionistic and evocative style was, of course, the very thing that Ruskin hated most, and he pulled out all the stops: "The ill-educated conceit of the artist . . . approached the aspect of wilful imposture," and "I have seen, and heard, much of Cockney impudence before now; but never expected to hear a coxcomb ask two hundred guineas for flinging a pot of paint in the public's face." The national press quoted and requoted this at once, and there was no way around the fact that such a widely circulated opinion from a critic regarded as the supreme English authority on art would do grave damage to an artist's career.

Whistler sued for libel. It is rarely wise to sue a critic. He won the case, but it was a Pyrrhic victory: the judge awarded him one farthing in damages, and the costs of the trial bankrupted him. Whistler lost his house, his collection of blue-and-white porcelain—everything. The falling rocket took him down with it; that disputed firework might have been Whistler's own career.

Though he never once returned to America, and feared not being honored as a prophet in his own country, Whistler was greatly admired there: collectors were proud of their expatriate and competed for his work, some to the point of obsession. The Detroit railroad millionaire Charles Freer not only bought the Peacock Room but amassed some forty of Whistler's paintings and hundreds of his drawings, along with the magnificent collection of Japanese screens, scrolls, calligraphy, and ceramics that now fills the Freer Gallery in Washington. What did Japan and *japonisme* promise self-made Americans like Freer, whose inherited culture was so utterly different from those of the Orient? To sketch an answer, one must consult the peculiar phenomenon of the "Boston Bonzes," and the uses of Japanese art as a religion-surrogate for such Americans.

Apart from Whistler, the main conduit of Japanese style into America up to 1880 had been furniture, especially the luxurious and highly crafted work of the

Herter Brothers. A piece like their ebonized cherry cabinet of c. 1880 (Figure 148) is in a peculiar yet confident bastard style, with Western griffin-head finials but curved saber legs that imitate the form of Japanese katanas (swords) with their hilts and mountings. The grid frame acknowledges Japanese furniture, and so does the rich door panel, with its symmetrical cranes and gold-and-red lacquerwork with a bamboo-leaf motif.

But already the attraction to Japanese art was beginning to acquire a literary and theoretical cast, through the work of three Bostonians: first, Edward Morse, who went there in the 1870s and then returned with friends; the writer Ernest Fenollosa in 1878, and William Sturgis Bigelow, a physician, in 1882. These men—and others of like mind, such as the Harvard design professor Denman Ross—were to be nicknamed, for their devotion to all things Japanese, the "Boston Bonzes"

(a bonze being a Buddhist priest). They were by no means amateurs. Their cast of mind reflected the increasing professionalism of esthetic activity at the dawn of America's museum age. Bigelow, for instance, spent seven years in Japan, and from the mass of old Japanese art that new Japanese were getting rid of he put together the core of the collection of the Boston Museum of Fine Arts—the finest of its kind in America, and arguably the best collection of Japanese art outside Japan itself. He became a Buddhist, studied under a sensei, and was received into the esoteric Mikkyo sect. Fenollosa wrote copiously and methodically on Japanese culture, and proposed ideas of art education based on it. On Morse's recommendation he became professor of philosophy at Tokyo University from 1878 to 1886, teaching a wide range of subjects—logic, philosophy, political economy— to the future leaders of modern Japan. And as the treasures of Japanese art came tumbling onto an uncertain market, he caught them at their source for his collection, which would later enter the Boston Museum of Fine Arts.

What were they seeking? In a word, relief. Relief from the ostentatious materialism of American life, and its incessant harping on "progress"; relief from the

148. Herter Brothers, New York City, *Cabinet,* c. 1880. Ebonized cherry, marquetry of lighter woods, gilt decoration, 60 × 33 × 16¼″ (152.4 × 83.8 × 41.3 cm). High Museum of Art, Atlanta, Georgia; Virginia Carroll Crawford Collection, 1981.1000.51.

conflicts and contradictions of their own Puritan heritage. In Japan the Bonzes believed they had discovered a way of spiritual and esthetic life which paralleled the severity of the old Massachusetts Puritan promise while rejecting the pious money-worship into which it later fell. Here was a technologically backward society, intriguing in its promise of simplicity and severity. It was wholly itself, self-contained, permeated with martial values, and exquisitely, astringently, estheticized. Its hierarchic organization from the Emperor and the daimyo clans down—and the Bonzes weren't dealing with rice growers—appealed to the snob within the Boston connoisseur. It was, in short, a wholly plausible "other" to American Puritanism, to which one could surrender while rejecting one's own ancestral values.

Immersion in such a culture was a kind of therapy, in which latently good elements in their Western experience were refined and confirmed. Thus Buddhism agreed with their reading of Emerson, while fitting the emergent cult of art as therapeutic self-realization. In this way the shift from 1860s "religious uplift" to a different kind of transcendence was prepared. This rang especially true for Bigelow, a depressive upper-class dandy in search of "Nirvana" or "enlightenment," a way to drop out of the relentless demands of the Puritan work ethic. Japan promised psychic sustenance to Charles Freer, too, a deeply neurotic man afflicted by paralyzing bouts of depression, whose entrepreneurial success had failed him (he retired at forty-four) and who now found relief in the "timelessness" of Japanese art.

One of the *loci classici* of the Japanese impact on the dissatisfied American mind stands in a small grove in Rock Creek Cemetery, in Washington.

In 1872 Henry Adams (1838–1918), writer, Boston mandarin, and descendant of presidents, had married Marion "Clover" Hooper. Thirteen years of what appeared to be a blissfully happy marital life ensued until, in 1885, Clover Adams committed suicide by drinking poison.

Soon after, her grieving widower embarked on a trip to Japan with his friend the artist John La Farge. One might have supposed he was ripe for Japanese conversion: a man sick of the milky prescriptions of liberal Protestantism and in revolt against his cold and detached father, one who had (to some degree) mastered his neurasthenia through an intellectual cult of vitalist energy. But in truth, despite the grand tour Fenollosa and Bigelow mapped for him, he did not like Japan. He thought it miniaturized, a "child's country." The Buddhist loss of ego, eagerly sought by Bigelow, was not his goal. In Japan, however, Adams began to think of a monument for his wife's grave (and his own) in Rock Creek Cemetery. Its inspiration, for Adams, seems to have been a sixth-century wooden figure sheathed in bronze which he saw in the convent of Chugu-ji; it had, he wrote, "the face of a sweet loving spirit, pathetic and tender, with the eyes closed in inner contemplation. It dominates the room like an actual presence." Could this be

translated into Western terms? Back in America, he gave the commission to his friend Saint-Gaudens, with Stanford White as architect and La Farge as supervisor. The two had worked together many times before, but this was perhaps the most successful of their mutual projects, a monument to unassuaged private grief, rather than civic mourning, secluded and rather hard to find: a shrouded bronze figure seated on a rock, with a bench for contemplation facing it—"my Buddha grave," Adams called it. Adams plied Saint-Gaudens with books on Buddhism, although it is uncertain how much of it the sculptor actually took in—not much, Adams thought: "St. Gaudens is not in the least oriental, and is not even familiar with oriental conceptions. Stanford White is still less so. Between them, the risk of going wrong was great."

It did not go "wrong." Saint-Gaudens conceived the monument not as a portrait of Clover Adams but as a life-size figure with a strong, serene, and almost mannish face immersed in thought, an American cousin of Michelangelo's Sistine sibyls (Figure 149). Only the face and the hand barely touching its cheek are visible; all the rest is covered by a shroud of coarse cloth rendered in bronze—originally a length of sacking that one of Saint-Gaudens's assistants had thrown over his head and shoulders. This figure, an enigma beyond rational decoding, reminds one of the desert apparitions in T. S. Eliot's *Waste Land*:

> when I look ahead up the white road
> There is always another one walking beside you
> Gliding wrapt in a brown mantle, hooded
> I do not know whether a man or a woman
> —But who is that on the other side of you?

Its ineloquence, coupled with the massively articulate forms of face and robe, is the source of its power. Adams himself "never once thought of questioning what it meant." He believed it represented "the oldest idea known to human thought," but, rather frustratingly, did not say what that old idea was:

149. Augustus Saint-Gaudens, Adams Memorial, 1886–91.
Rock Creek Church Cemetery, Washington, D. C.

He knew that if he asked an Asiatic its meaning, not a man, woman or child from Cairo to Kamchatka would have needed more than a glance to reply. From the Egyptian Sphinx to the Kamakura Daibuts . . . art had wrought on this eternal figure almost as though it had nothing else to say. The interest of the figure was not in its meaning, but in the response of the observer. . . . Like all great artists, St. Gaudens had held up the mirror and no more.

The last two sentences are a strikingly modern insight. What earlier American patron would have claimed such autonomy for a work he commissioned? For Adams, the memorial to Clover performed the essential job that later writers would claim for modernism: it divided its viewers into those who "got" it and those who did not; it created an elite of understanding from which the vulgar were excluded. Among the latter, true to his anti-Puritan rebellion, Adams placed the clergy who visited the statue and "broke out passionately against the expression they felt in the figure of despair, of atheism, of denial."

The 1880s, in fact, mark the beginnings of a great change in American upper-class expectations of art—what it could do for you, what it could do for society. Once early Puritan suspicions about the immorality of images were allayed, art (as we have seen, especially landscape) came to be viewed by American Victorians as a moral instrument, putting man in touch with the works of God or, in the case of historical or narrative images, stirring him to the emulation of noble deeds. Now, art was turning into a therapeutic refuge from the stress of American modernity. The whole museum (to paraphrase Eliot) was our hospital, endowed by the ruined millionaire. And this applied not only to Japanese or Chinese art, but to the early Renaissance as well, to the "eternal and simple" character of gold-ground primitives, to Gothic enamels—anything that suggested a surrender of the stressed-out modern will to the benign absolutism of tradition and faith. Naturally, this spilled over into the creation of works of art, in which it was often brought to a very high level of luxury and elegance. A striking example is the revival of stained glass, a Gothic medium which the Puritan tradition abhorred for its associations with Rome, in the work of Louis Comfort Tiffany (1848–1933) and John La Farge.

One could see Tiffany as the antitype of another great designer, his English contemporary William Morris. Unlike Morris, Tiffany had no social vision and his interests were purely esthetic and commercial. Tiffany always made a point of treating his employees considerately and well—and he ran a very big outfit indeed—but he had no trace of Morris's socialist idealism and took no part in politics or public debate. He was, however, obsessed with excellence. There are stories of him as an old man walking through the factory in Corona, New York,

smashing with his cane objects that did not seem, after a few seconds' scrutiny, to meet his standards. The true descendants of Morris in America were men like Gustav Stickley, founder of the Arts and Crafts movement in furniture. Nevertheless, Tiffany was an extraordinary figure, whose products came to define the ideals of luxury and refinement for wealthy Americans in the 1890s. He made objects and whole interiors for every kind of public and private place: churches, clubs, hotels, libraries, and the homes of the very rich. Furniture, lamps, altar crosses, screens, stained-glass windows, commemorative silver, vases, jewelry—there was nothing that "he" (meaning the designers on his ever-growing staff, under his supervision) did not take on, and no material from pottery and glass to gold and precious stones that he would not use. His tenderest thoughts of art were, at the same time, prehensile and go-getting; you can hear the estheticized form of America's newly imperial self-image as he says he wants to put into everyday objects "the endless wealth of precept and suggestion . . . in air and water and earth, in all the vast, teeming bosom of nature." But this also lent his work, at best, an inordinate richness of design: there was no motif he would not draw on, no natural form he could not adapt, and, above all, no fear of failure.

In particular this was true of stained glass. At the beginning of the 1870s, he and John La Farge started work together in a glassworks in Brooklyn, developing an opalescent type of glass that could be used both for ornamental trim and for large windows. America, at the time, had no glassmaking industry that could give them what they wanted—glass came in clear sheets, or single-color, and even the imported European glass that designers of stained-glass windows used was flat and uniform in color, without texture or depth. It was mechanically perfect and so could not rival the luminosity of medieval glass, with its flaws and modulations of tone. Tiffany and La Farge wanted pictorial effects. These needed variety of tone and many blending colors within the glass itself. They shunned as fake the common practice of painting washes of color on the glass; the hues had to be part of the substance. They layered one piece of glass on top of another, to provide extra richness in the darks, and stressed the lead joints as part of the whole design. Their experiments in making opalescent glass would lead, eventually, to the Tiffany Favrile glassware that was a hallmark of the firm—the amazingly sensuous, opulent, brittle substance of the Tiffany lamps and vases, which could be used on an architectural scale for church and domestic windows all over America, such as the six-foot-high, lushly romantic scene of an ideal garden with a peacock, now in a museum in Florida (Figure 150). Presently Tiffany and La Farge would part company, and remain low-key enemies, over the issue of who was really responsible for the invention of opalescent stained glass. But each continued to produce a large body of stained-glass work, and the elaborate beauty of their windows could never have been tolerated in the churches of an earlier America. It signaled that religion could be voluptuous; that ritual could provide

relief from the austerities of doctrine, an idea in which the Puritans would have found the repellent whiff of Rome. But nothing could now restrain the American appetite for worldly luxury in the arts, and in painting the best proof of this was the work of John Singer Sargent.

With Henry James and James McNeill Whistler, John Singer Sargent was the most vivid American presence on the Anglo-European cultural stage in the late nineteenth century. Highly successful in his own day, then disparaged by American modernist taste to the point where his social felicity and flashing bravura seemed an embarrassment, he has come back in the last twenty years; it's okay to

150. Tiffany Studios, *Landscape with Peacock and Peonies*, 1900–10. Leaded Favrile glass, 75 × 60″ (190.5 × 152.4 cm). The Charles Hosmer Morse Museum of American Art, Winter Park, Florida.

like him again, and claim him as American—which he was, though not very. Only his passport and his accent were. He was born in Florence to expatriate parents—his father an introverted doctor from Philadelphia, his mother a clinging neurasthenic who used a succession of imaginary illnesses and real pregnancies to avoid having to recross the Atlantic to the crude continent of her birth. He grew up at home everywhere and belonging nowhere: Paris, Munich, London, Rome, spring in the Tyrol, summer on the Rhine, winters in Nice, years of hotel rooms and rented villas. It bred in him a case-hardened adaptability, a compliance with wherever he happened to be, and a precocious sophistication. He was a stylist without a "natural" subject, unlike those American realists Thomas Eakins and Winslow Homer, whose work was deeply rooted in American experience and values and asks to be "read" in their terms.

He was trained as a tonal painter in Paris, in the studio-school of Carolus-Duran. Charles Auguste Émile Durand, to give him his actual if more prosaic name, ran an outfit that largely catered to Americans (he had started it in 1872, at the suggestion of an American friend named Robert Hinckley), and this showy *maître*'s appearance impressed them all, including, one may surmise, young Sargent: tight pantaloons, pointed boots, elaborately curled and pomaded hair, black velvet coat, ruffled orange silk shirt, green tie, and gold jewelry. More important, however, was what he taught. He drilled his students in direct drawing on the canvas with a brush, not the underdrawing and linear construction favored at the École des Beaux-Arts, with emphasis on surface texture, color, and movement of masses. This was the lingo of virtuosity, and Sargent took to it like a duck to water. Throughout his career, he would paint directly, stroke for stroke, wet into wet, with a loaded brush, which (in turn) required a minute and careful analysis of the way light fell on the subject before that brush touched the canvas. Look hard, and then paint *au premier coup,* retouching as little as possible. This was the habit that gave Sargent's best work its apparent spontaneity and directness. It had nothing to do with Impressionism, the legacy of Monet and Pissarro.

Secondly, Carolus-Duran's studio god was Velázquez, and this, too, formed Sargent's artistic character—his belief in the discretion of the virtuoso performance. Velázquez was the grandee of modernity, as modernity was imagined by painters like Manet, Fantin-Latour, and Whistler in the late nineteenth century. His restriction of color, his brilliant control of tonal range, gave the image an aristocratic force through its difficult and exacting simplicity. A white, a black, a gray, a buff: who needed all that whorish color? Velázquez was a supremely ineloquent painter in the sense that he never disclosed his feelings about anything but the pictorial possibilities of a subject: a strict etiquette of vision prevents the paint from declaring what he "felt" about a dwarf, or a king. So it was, in a lesser way, with Sargent. He was a painter of surfaces, one passage at a time, all united by the constancy of distance, by his accuracy of judgment and elegance of rejec-

tion. The last quality counted for much with Sargent. He recoiled, instinctively, from the precepts of John Ruskin, whose idea of entire and detailed truth had dominated English and American art for so long. For Sargent, pictorial truth arose from editing reality, perfecting fictions. Moreover, just as he had no interest in politics—a useful blind eye for a society portraitist to have—so, too, he was quite unaffected by Ruskin's passionate social moralizing, which was looking obsolete by the 1880s anyway. He was inclined, as real virtuosos are, to decouple art from morality, whereas for Ruskinians art *was* morality. He never believed that art could place one mind, one character, directly in contact with another. Rather, it provided the viewer with a performance to reflect on, admire, enjoy for its own sake. This was the core of the doctrine of *l'art pour l'art* (art for art's sake) that Sargent had in common with his closest literary friend and most intelligent supporter, Henry James. Except that in James the autonomous meaning of the work arose from the fascinating, sometimes excruciating slowness with which the whole rises to view, through those winding sentences and hedged qualifications of perception, "like," as one Edwardian wit memorably remarked, "an elephant trying to pick up a pea"; whereas in Sargent, the distance of meaning is conveyed in the opposite way, by speed and ease. Bend toward a Sargent, try to enter it, and your forehead bumps against the cool glass of mastery. It is not all art that can give, but neither is it a disagreeable feeling.

French Romantic writers (think of Victor Hugo's *Hernani*, 1830, and Théophile Gautier's *Voyage aux Pyrénées*, 1840, as two of a myriad of examples) were obsessed by Spanish themes. Velázquez, Goya, and all things Spanish were equally the rage among in Paris—Delacroix copied freely from Goya's *Caprichos*, for instance, and easily half of Manet's paintings in the 1860s were of Spanish subjects: bullfighters, dancers, and spectators (after Goya's majas) on a balcony. So it is not surprising that the ambitious young Sargent should have taken a Spanish subject for his first masterpiece, which went to the Paris Salon of 1882. This was *El Jaleo*, 1880 (Figure 151). Sargent had crossed the Pyrenees in 1879 and spent nine months in Spain, with a side trip to Morocco. His goal was to study and copy the Velázquezes in the Prado. But *El Jaleo* contains no figures quoted from Velázquez or any other Spanish artist. It is a tavern scene, more than eleven feet wide: a bare stage (in a cellar, one thinks, from its darkness and sudden highlights) with a single flamenco dancer up front and a frieze of figures, her guitar accompanists and other waiting dancers, seated along the back wall. In "working up" this big picture from memories three years old, Sargent used thumbnail sketches he had made of Gypsy dancers, but there is no full study for its composition, and there probably never was one—he followed Carolus-Duran's injunction to draw directly on the canvas, and with stunning results.

El Jaleo is about ecstasy. It celebrates the Dionysiac urge, a visceral joy in movement and music. And it may very well be the first painting by an American

to do so—at least, no others suggest themselves. For once, Puritan decorum is overcome: if you added up all the nudes painted by American artists before this, they wouldn't amount to a tenth of *El Jaleo*'s erotic charge, even though all you see of the women is their arms and faces. The title word means, in Spanish, the rush of spontaneous clapping, finger-snapping, and *olés* that flamenceros break into to encourage the single dancer. Her figure dominates the painting: leaning back in abandon, the chaotic silver mass of her skirt disciplined, above, by the precise right angle of her left and right arms, the left hand stabbing out in air like a snake's head, the foot stamping imperiously.

Then, along the back wall, her fellow Gypsies. On the left, a group of three men in black, two hunched over their guitars, the third rasping out the syllables of the *cante jondo* with his eyes closed and head thrown back, his open mouth a brilliantly Goyesque sight. They are all inwardness, whereas the women on the right are all outwardness—twisting and clapping in their seats, their arms waving like sea plants in the tide of low light that moves across the wall, with snapping eyes and a flash of red shawl right at the edge of the frame—the only touch of red in the whole picture. Spontaneous as it looks (as though any picture so big could be spontaneous), *El Jaleo* is highly calculated—witness such details as the

151. John Singer Sargent, *El Jaleo,* 1880. Oil on canvas, 94½ × 137″ (240 × 348 cm). Isabella Stewart Gardner Museum, Boston.

orange, symbol of Andalusia, on the empty chair between the figures on the left, or the twin guitars hanging on pegs to animate the Caravaggesque emptiness of wall above it. Thanks to the inspired dash with which it's painted, the last thing you think of is models in a studio, but in fact the flamenco dancer was a French professional. A curious detail of *El Jaleo* is that the drawings on the wall behind the figures bear more than a passing resemblance to the handprints and bull silhouettes that were, in Sargent's time, being discovered in prehistoric caves; and that his use of excited graffiti (*Olé* is scribbled three times above the group of girls, like speech in a comic strip) is probably the first by any American artist.

El Jaleo was admiringly received by the critics, and it was an extraordinary performance for a thirty-four-year-old artist; but the painting that created his reputation as a portraitist appeared two years later at the Salon of 1884. It was a portrait of a social-climbing Southern belle, Madame Virginie Gautreau, *née* Virginie Avegno, the daughter of a Southern planter—it was thought; in Paris all Southerners were planters unless proven otherwise—who had died for the Confederacy in the Civil War. Mademoiselle Avegno and her mother had moved to Paris, where, in due course, she married a rich banker and began her social career. It is sometimes thought that French high society in the 1880s was open in its moral laxity. In fact, the surface of adultery and intrigue was held together by rules of extreme strictness, and Madame Gautreau managed to flout almost all of them. She was not discreet about her affairs. At the same time she was a most conspicuous beauty, though of an eccentric and artificial-looking kind. Such women had the kind of public fascination that supermodels had for Americans in the early 1990s, and Sargent confessed to "a great desire to paint her portrait." He had already painted one of her lovers, a renowned society gynecologist named Dr. Samuel Pozzi, who was said to have performed abortions on many ladies of the sixteenth arrondissement, including Madame Gautreau. He found her a restless, distracted sitter, but the resulting portrait was a pact between two pushy Americans anxious to make their mark in Paris with a succès de scandale. They got more than they bargained for.

In mid-work, Sargent wrote to a friend, the writer Vernon Lee:

> Do you object to people who are *fardées* [made up] to the extent of being a uniform lavender or blotting-paper colour all over? If so you would not care for my sitter. But she has the most beautiful lines and if the lavender or chlorate-of-potash-lozenge colour be pretty in itself I shall be more than pleased.

It wasn't exactly "pretty" in itself, but it was striking (Figure 152). Virginie Gautreau is seen in profile, looking disdainfully away from the viewer's gaze—already a slight infringement of decorum. Her lavender powder, in life, gave her the air of a femme fatale, and Sargent played this up: woman as part self-made work

of art, part indifferent sexual predator, both converging in the image of an idol. Her tiara bears a crescent moon, symbol of the cold huntress Diana. Her air is that of an affected, strained, slightly poisonous lily, conveyed by Sargent's mannerisms of profile (her face is as heraldic as any Renaissance medallion-style portrait), by the pallor of the skin rising above the deep décolletage, and by the elegant darks of gown and table. And a suggestion that she was no better than she had to be lay in one shoulder strap, which Sargent painted as having slipped from her shoulder to her arm. (Later he repainted it back to her shoulder.)

Scandal and horror. *Madame X,* as the painting was titled, was the talk of the Salon; so was Madame Gautreau herself, her morals and habits, and her relationship, both amatory and medical, with the elegant Dr. Pozzi, whose portrait in a flaming red dressing gown (also by Sargent) unfortunately hung next to hers. There were salvos from the critics, branding *Madame X* as detestable, monstrous, boring, curious. This was more than a sexual scandal. It had an undercurrent of French anti-Americanism too. And what most shocked the art and social worlds of Paris was Sargent's extreme estheticization of this woman, a post-

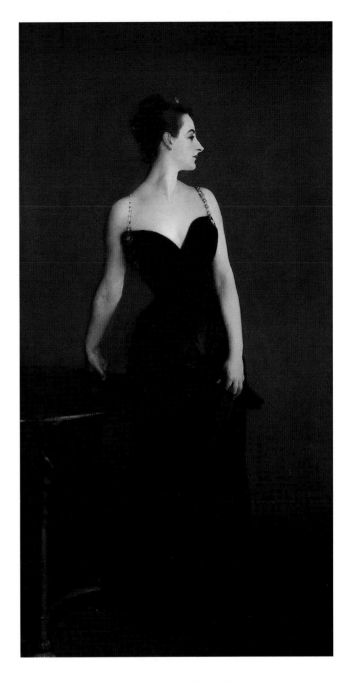

ing of the art-for-art's-sake doctrine that art had claims beyond morality. No wonder that *Madame X*'s biggest fan was the style-obsessed dandy Robert de Montesquiou, Proust's inspiration for the Baron de Charlus and patron of French estheticism. Ever after, Montesquiou declared it to be Sargent's best portrait, and saw the painter's departure for England and colossal success as a cop-out.

Which, to some degree, it may have been. Sargent was unnerved by the brouhaha, and soon left Paris. He kept *Madame X* but refused to show it for

152. John Singer Sargent, *Madame X (Mme. Gautreau)*, 1884. Oil on canvas, 82½ × 43¼" (209.5 × 109.8 cm). The Metropolitan Museum of Art, New York; Arthur Hoppock Hearn Fund, 1916.

more than twenty years. He concentrated on entering English society, strictly on its own terms, and becoming its top social portraitist. The English ruling class had not had a great portraitist since Gainsborough, or a first-rate one since the deaths of George Romney and Sir Joshua Reynolds nearly a century before. Sargent moved into this gap with tremendous *élan*. He would become the Van Dyck of late Victorian and Edwardian England, its unrivaled topographer of male power and female beauty. His full-length portrait of Lord Ribblesdale in hunting gear, exhibited at the Paris Salon, became for the French the very prototype of *le grand diable du milord anglais*. His celebrity portraits remain an indispensable record of their time and class: from Henry James, who seems on the very point of uttering one of his long and convoluted sentences ("I . . . am all large and luscious rotundity," the master remarked on viewing his image after ten sittings), to the actress Eleonora Duse, who favored Sargent with her somberly direct gaze for fifty-five minutes and then abruptly left. He excelled at women. "Women don't ask me to make them beautiful," said Sargent, "but you can feel them wanting me to do so all the time." He would have been a cad to refuse any lady his rhetoric of fine bones, porcelain skin, gracefully tapering fingers, and cascades of embroidery and silk. But sometimes they were beautiful, and some of his greatest images were of people whose notability was merely social. At best, as in *Lady Agnew of Lochnaw*, c. 1892–93 (Figure 153), he could be in every way as good as Van Dyck. He brought such excitement to his scrutiny of light and shade on a knotted lilac sash, of delicate flesh so strongly modeled as to convince you that nothing could be more worth looking at. There is a perfect match between the decorous luxuriance of Lady Agnew's pose, the creaminess of the paint, and the shadow of tension on her face. For that, one can forgive a lot of the routine rich-and-famous work that Sargent himself would later disparage as his "paughtraits."

Some of Sargent's English work verged on Impressionism, without being, in the true coloristic sense of the word, Impressionist. In France he had known Claude Monet since at least 1876, two years after the first Impressionist show; he visited him at his country estate in Giverny, and painted his portrait several times. They also painted together out-of-doors. On one such occasion, Sargent asked Monet for some black pigment. Monet had none; he never used it. "Then I can't paint," said Sargent. This, in a nutshell, was the difference; Sargent could not do without neutral tones and shadows, whereas for Monet color was in everything. Impressionism certainly had its impact on Sargent, when he was not working in his grand portrait manner; he used pure landscape studies as a way of loosening up, the strokes becoming freer, more fluid, and atmospheric, the color scintillating and higher-keyed. The results looked like Impressionism to the Americans and English; his delightful painting of two of the young Vickers children with Chinese lanterns at dusk in a garden, *Carnation, Lily, Lily, Rose*, 1885–86, was credited

153. John Singer Sargent, *Lady Agnew of Lochnaw*, c. 1892–93. Oil on canvas, 49 × 39¼" (124.5 × 99.7 cm). National Galleries of Scotland, Edinburgh.

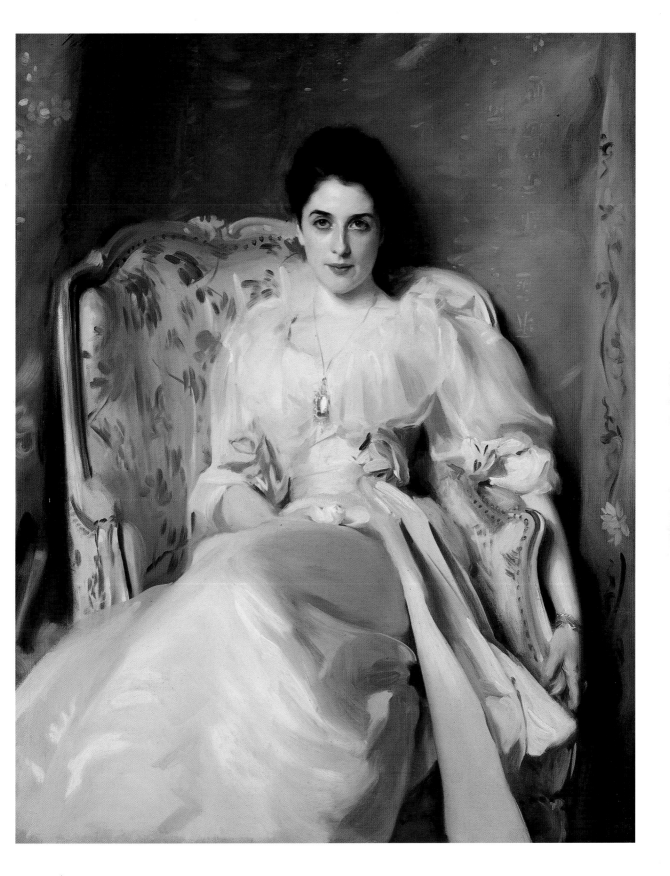

with bringing Impressionism to England, but it was at least as Pre-Raphaelite as Impressionist in spirit. One may doubt whether a French artist would have seen it as "Impressionist" at all.

One American painter, in particular, regarded Sargent as a fuddy-duddy and a "buffoon," full of empty virtuosity and far removed from Impressionist candor. She was the only American artist who got Impressionism straight from the horse's mouth, and who played a part in the later phase of the movement as an equal and colleague of its French exponents rather than as an imitator. This was Mary Cassatt (1845–1926).

Cassatt was not only the best of the American Impressionists but the outstanding woman painter of the nineteenth century. Her insights as an artist, her originality of mind and temperament, her active and critical relation to her sources, and the steely rigor of design that undergirded her scenes of domesticity and pleasure, all make her so: women painters who were much more famous in the Paris of her day, like Rosa Bonheur, do not compare with her. It is worth remembering, however, that she was no more (and of course no less) "American" than Whistler or Sargent were: she spent less of her youth in America than Whistler did, revisited it in her maturity less often than Sargent, and lived almost all her long life in Paris. Her first sale to a national museum was to the Luxembourg in Paris in 1894, fully twelve years before the Metropolitan Museum in New York bought one of her works. Nevertheless, there are good reasons for seeing her in the American context. First, because she was raised and first trained in Philadelphia, and never dropped her American citizenship. Second, because her work had more impact in America than in France: it was eagerly bought by American collectors, and (through friends like the Havemeyers) she was crucially influential in directing their taste away from a single-minded concentration on Old Masters and toward Impressionism. (Without Cassatt, American collections of Impressionism would have started much later, and been much poorer, than they are.) And thirdly, because she was known as *une Américaine* by the painters in Paris: she never tried to redefine herself as French, and it was in the context of American expatriation that she was appreciated by other artists, both French and American, in her lifetime.

Mary Cassatt was born to wealth, the daughter of one of the more prosperous families in Philadelphia. She studied first at the Pennsylvania Academy in the mid-1860s, and then for several years in Italy and France, mainly copying Old Masters. Her career as an artist really began, however, after a visit to Seville in 1873. She had seen the figure paintings *à l'espagnole* Manet had done, under the spell of Goya and Velázquez, in the 1860s—toreadors, majas, musicians, and dancers. Now she launched into a series of her own Spanish subjects. Spain, at the time, was as little-known and exotic to Americans as Morocco, and Cassatt's dark-toned pictures with their strongly modeled figures were among the first by

an American to deal with it. She now began to exhibit at the annual Paris Salons, her palette growing steadily lighter and the brushwork more fluid. She never adopted the divisionist color of Monet and Renoir, but she was moving toward Impressionism, and in 1877 she met Edgar Degas, who became her friend, mentor, and confidant and invited her to join the Impressionist group. Thus Cassatt ceased to be a woman painter quietly showing her work in a conservative, official milieu, and joined the most ridiculed band of artists in all Europe. It did not worry her in the least. Beneath the ladylike surface—and she was a lady: her breeding was one of the reasons why the famously sardonic and misogynistic Degas liked her so—was an exceedingly independent woman, and her "conversion" to Impressionism was the natural outgrowth of ideas about art that she had held for a long time: the need for a certain immediacy and directness in the reflection of life, which preserved its joie de vivre and projected it in fresh pictorial design.

The two great influences that enabled her to do so were Degas's work and Japanese prints. Degas was ten years her senior, but (beyond her admiration for him, and his unstinted respect for her, as artists) the nature of their relationship remains unknowable, since she took care to destroy all their letters before their deaths. Perhaps some romantic element was there, or else why destroy them? In any case, Cassatt was no mere epigone of Degas. To begin with, her subject matter was different: she was not interested in washerwomen or the *petits rats* of the ballet, her work had no erotic component whatsoever, and there is nothing in it remotely resembling Degas's extraordinary pastels of women bathing and drying themselves. She depicted a somewhat different world, drawn from her own strong family allegiances: sociable encounters over tea, fashionable women in theaters (but as spectators, not performers) or in drawing rooms, mothers with babies. What sexuality was for Degas, family intimacy was for Cassatt, but both liked the beau monde and its rituals of association; Cassatt viewed it with a less ironic eye than Degas, but there is a wonderfully concise quality of social observation in some of her scenes: the cocked finger of the lady drinking tea on the right of *Five O'Clock Tea* (Figure 154) is as well turned and informative as a sentence by Henry James. Cassatt catches the sense of a pause in conversation, framed by the pink-and-gray decor and weighed down, as it were, by the mass of silverware gleaming on the tea table: the tea drinker with eyes averted, abstractedly looking at something beyond our view; her friend waiting for her to speak. There is truth in this perfectly registered moment.

Though she did some park and garden scenes, Cassatt had no interest in landscape for its own sake: this was what caused the critics who reviewed the 1878 Impressionist exhibition to associate her with Degas, rather than with, say, Monet or Pissarro. Degas and Cassatt, wrote one,

are perhaps the only artists who distinguish themselves in this group of "dependent" Independents. . . . Both have a lively sense of the fragmented lighting in Paris apartments; both find unique nuances of color to render the flesh tints of women fatigued by late nights and the rustling lightness of worldly fashions.

From Degas she learned a great deal about cropping and framing. She used his strong diagonal thrusts across the picture plane, and adopted his way of suppressing the middle distance of her spaces. And his influence enabled her to get rid of the vestiges of formal, academic pose in her figures: they sit and stand as people do in moments of unawareness, seen but not responding to others' sight. Moreover, the example of Degas prevented her from moving at all in the Impressionist direction of dissolving form into colored blurs and vague nuances: everything in her work, as in his, aims at palpable structure, experienced as compression, tension, and weight.

It was also Degas who set Cassatt on the path to printmaking. The late nineteenth century brought a blossoming of the artist's print in Paris, in the traditional media of lithography and etching—it was, apart from anything else, an excellent way of spreading one's work around and increasing one's income—but Cassatt, who was much fonder of painting than of drawing for its own sake, was slow to catch up with it. Degas, however, was pushing the technical limits of traditional printmaking in ways that yielded far more "painterly" effects, especially in aquatint and monotype. This stimulated Cassatt to produce a stream of elegant and inventive prints, using the rhythmic profiles and asymmetrical design

154. Mary Cassatt, *Five O'Clock Tea,* 1880. Oil on canvas, 25½ × 36½" (64.8 × 92.7 cm). Museum of Fine Arts, Boston; M. Theresa B. Hopkins Fund.

of Japanese prints in a unique way, as in *The Letter*, c. 1891 (Figure 155)— Franco-American *ukiyo-e*. The Japanese influence also flowed strongly into her painting, as one can readily see in *The Bath*, 1891–92, one of the mother-and-child images which Degas called "Little Jesus with his English nurse." It is a daring impaction of different patterns: the woman's boldly striped gown, the wallpaper, the painted chest, the carpet, and the Oriental design on the water pitcher in the foreground. And yet the effect is of fullness and clarity, not congestion.

In 1893–94, during a stay in the south of France near Juan-les-Pins, she painted *The Boating Party* (Figure 156) one of the strongest of all her canvases. In one respect, it harks back to her earliest, Spanish-influenced European work: then, she was interested in local costume and large dark masses à la Manet's Spanish subjects, and *The Boating Party* is dominated by the strong black silhouette of the oarsman pressed up against the foreground plane, with his black shirt and pants, black beret, and ultramarine sash—the Catalan-derived garb of local fishermen. The color is as structural as in any Matisse, and delivered at high Provençal intensity: blue-green sea, the acid yellow of the boat's thwarts and oars, the frame of the white coaming, and the beautiful lighter blue of the woman's dress, hatched with its spontaneous red lines. All the subsidiary shapes are strong. The sprawl of the baby's legs may not be gracefully bambino-like, but it's the way small children do lie in the lap, and its left leg, stiff as a stick, perfectly counterpoints the larger structural elements of oars and arms.

In the early 1880s, when Mary Cassatt's talent was at its height—later she would go partly blind—it was all but impossible for an American, even a New Yorker,

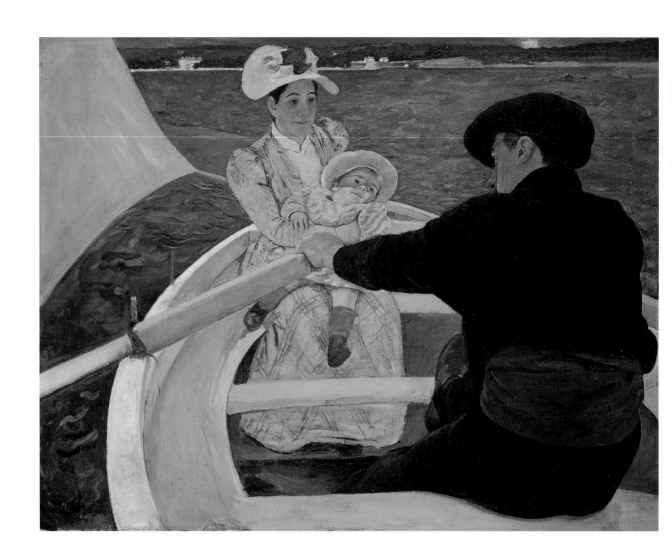

156. Mary Cassatt, *The Boating Party,* 1893–94. Oil on canvas, 35½ × 46⅛″ (90.2 × 117.1 cm). National Gallery of Art, Washington, D. C.; Chester Dale Collection.

to see an Impressionist painting without going to Europe. By a bizarre circumstance, the very first Impressionist work (other than Cassatt's own) to be shown in America was Manet's *Execution of the Emperor Maximilian:* banned by the Paris censors as politically inflammatory, it was brought to New York and Boston in 1879 by an opportunistic singer named Madame Ambré, who put it on show to generate publicity for her recitals. Not until 1886 was there a professionally done show of Impressionism in America. Mounted by the French dealer Durand-Ruel at the American Art Association's galleries, it contained forty-two Pissarros, thirty-eight Renoirs, forty-eight Monets, twenty-three Degas, seventeen Manets, and three Seurats—a staggeringly good representation, which brought down none of the catcalls and insults the French critics routinely decanted on such work. The American press and public loved it, in fact, and the collectors already trusted Durand-Ruel because he had been the main conduit for the Barbizon paintings they had been buying in quantity. Durand-Ruel's missionary work on behalf of Impressionism began a pattern which was to last, with some glitches and stalls, through the entire period of modernism: great new European work, despised and willfully ignored by *le bon goût français,* ended up not in France but in America. It is, on the face of it, barely credible that (among hundreds of other things) masterpieces of the order of Manet's *Boy with a Sword,* two of Cézanne's monumental *Bathers,* Seurat's *Grande Jatte,* and Matisse's *Red Studio* were lost by the complacent French. Yet it was so, and remained so until at least the late 1950s.

The steady and time-consuming efforts Mary Cassatt had made to get American collectors, chiefly her friends the Havemeyers, to buy Impressionist work were joined by other artists. One of them was William Merritt Chase (1849–1916), a remarkable figure whom a later modernism sought to punish for his opposition, in his later years, to New York's Post-Impressionist and colonial-Cubist avant-garde. (He taught some of them, though: Joseph Stella, Georgia O'Keeffe, Charles Demuth, Alfred Maurer, Charles Sheeler, and Edward Hopper were all his students.) Coming out of Indiana, where his father had a prosperous business in women's shoes, Chase studied art in New York and then, in 1872, went to the Royal Academy in Munich—a city which, at the time, was attracting as many American art students as Paris. The Academy's star teacher was Karl von Piloty, who specialized in painting history scenes done with a self-conscious, broad-brush bravura—and a penchant for that kind of dash would stay with Chase all his life. But the presiding spirit for the more gifted students, including Chase, was Wilhelm Liebl, most esteemed of German realists, a sort of northern Courbet, with his dense surfaces and dark palette and reluctance to embellish "ordinary" subjects; Liebl's belief in painting directly and spontaneously, and then retouching as little as possible, became an article of faith with Chase as well, though the American turned it to showier ends, with some input from the paintings of the Belgian artist Alfred Stevens, whom he greatly admired.

Chase was—if the term is not an oxymoron—a natural dandy, and when he returned to New York in 1878 after six years' study in Europe he was determined to impress. This wasn't a mask: the man *was* impressive, a brilliant teacher (as soon became evident after he took up a post at the Art Students League) and a born communicator. As a character, he had much in common with Stanford White—gregarious, clubbable, and a virtuoso. He set out to create an image for himself. He wore spats and a topper, a cutaway coat and a neck scarf drawn through a jeweled ring; he sauntered down Fifth Avenue with Russian wolfhounds on a leash; he had a spectacular studio, where he entertained often, with the help of a black manservant dressed as a Nubian prince. He was, in short, enacting in New York the lion's role that leading French and German painter-teachers had shaped for themselves, and it was good for business: soon Chase became one of the most fashionable portraitists in New York. As *boulevardier* and wit, he was also doing a Whistler in reverse—in America, not Paris. Chase extravagantly admired Whistler, whose influence is written all over the younger artist's portraits, with their tendency to isolate the single figure against a bare ground, and their highly conscious placement of props—a fan, a Japanese vase, a curious rattan chair. The two men did not meet until 1885, when Chase was on a trip to London, and they took to each another at once—though, perhaps inevitably given the short span of Whistler's friendships, they fell out later. Chase believed Whistler was a modern Velázquez, and he painted the canonical image of his much-portrayed and often-caricatured friend: full length, the head rakishly cocked, the long index finger on top of

157. William Merritt Chase, *James Abbott McNeill Whistler*, 1885. Oil on canvas, 74¹⁄₈ × 36¹⁄₄″ (188.3 × 92.1 cm). The Metropolitan Museum of Art, New York; bequest of William H. Walker, 1918.

the cane, all in Velázquez's Escorial-black with the famous tuft of white hair among the disordered dark curls (Figure 157). Alas, Whistler's reciprocal portrait of Chase is lost.

Chase had argued for French Impressionism early on. In 1883 he co-organized an exhibition of French art at the National Academy of Design, and made sure it was built around Manet and Degas, not the *pompiers* like Cabanel, Gérôme, or Bouguereau—a prelude to the Durand-Ruel show three years later. But his own full conversion to Impressionism *as a painter* did not begin until the 1890s, when he moved to eastern Long Island, setting up his studio—and, with his usual boundless zest, a new art school as well—by the sea at Shinnecock, some seventy-five miles out of New York. Here, on the south fork of Long Island, Whitman's "fish-tailed Paumanok" narrows; the sea is all around, blueness abounding, the Atlantic on one side, the Sound on the other. The glittering, crystalline light of the place, with its blond beaches and scrubby dunes, enraptured Chase, as it would a succession of American painters from then on. He had McKim, Mead & White design him a house and studio there. Shinnecock became his equivalent of Monet's Étretat, and in a succession of canvases he painted it very directly, without the stylistic grace notes of his previous portraits and studio interiors, keying his palette up high to match the reality of the light. The effect of a painting like *Shinnecock Hills,* c. 1895 (Figure 158), is more akin to Alfred Sisley than to Monet, however; it relies, not on conspicuously divisionist color, but on the truth

158. William Merritt Chase, *Shinnecock Hills,* c. 1895. Oil on canvas, 40 × 50″ (101.5 × 127 cm). The Cleveland Museum of Art; gift of Mrs. Henry White Cannon.

with which the flat, sunstruck scene with its high sky and thin stripe of distant sea is translated by sensitive flickers of the brush, lifting it into euphoria.

Chase epitomized the pattern of American responses to Impressionism, whose one exception had been Cassatt. That is to say, he did it well, but late. Other artists who contributed to the movement in America, like Julian Alden Weir (1852–1919) and John Twachtman (1853–1902), were in a like position: Weir's *Red Bridge,* 1895 (Figure 159), with its invigorating Monet-like contrast between the red-painted iron structure and the bright green of nature, is a highly enjoyable painting but by no means an inventive one. The fact was that "Impressionism," as understood in America by the century's end, could mean almost anything. It could mean the Sargent-derived portraits of Cecilia Beaux (1863–1942); or the innumerable variants on Whistler's silvery tonal impressionism; or fuzzed-up versions of American Luminism, with parasols; or work that based itself on the mellow, elegiac, late Hudson River School landscapes of George Innes. It also meant many routine and insipid canvases of nice American virgins posed against the light in crispy white voile, holding cups of tea or baskets of freshly picked flowers. However, two Americans made something different out of Impressionism. Their work was genuinely inventive and even, on occasion, forward-looking. They were Childe Hassam and Maurice Prendergast.

Childe Hassam (1859–1935) had become, by the turn of the century, America's foremost Impressionist painter, working in a style—the "Glare" esthetic, it was sometimes called—whose high-keyed, flickering light and fondness for *contre-jour* effects stemmed directly from Monet. He had made a trip to Paris in

159. Julian Alden Weir, *The Red Bridge,* 1895. Oil on canvas, 24¼ × 33¾" (61.6 × 85.7 cm). The Metropolitan Museum of Art, New York; gift of Mrs. John A. Rutherford, 1914.

160. Childe Hassam, *In the Garden (Celia Thaxter in Her Garden)*, 1892. Oil on canvas, 22⅛ × 18⅛" (56.2 × 45.8 cm). National Museum of American Art, Washington, D.C.; Gift of John Gellatly.

1883, but his paintings of the early 1880s showed no sign of Impressionist influence. This changed after he returned to France in 1886, and in 1887 his *Grand Prix Day,* with its empty foreground, plunging street perspectives, and asymmetry of design, bore the marks of Pissarro and Gustave Caillebotte. However, his complete conversion to Impressionism came a little later, and its fullest expression came in the late 1880s and early 1890s with a sequence of oils and watercolors he made in and around the garden of a close friend, the writer Celia Thaxter, on Appledore Island off the coast of New Hampshire (Figure 160). They account for a tenth of Hassam's enormous output of more than four thousand works. Perhaps the example of Monet's garden at Giverny lay behind these often brilliantly spontaneous glimpses of an American *hortus conclusus,* hemmed by rocks and sparkling with red Iceland poppies and blue delphiniums under the summer sky. However, Thaxter's garden was a much less formal affair than Monet's, and the very antithesis of the harsh, stiffly patterned "bedding-out" with annuals then popular in America. It recalled the simple, rambling cottage gardens of an earlier colonial time, with their soft tints and overlapping drifts of perennials. Americans in the 1890s were rediscovering their colonial past, and this wave of nostalgia for a simpler America added to the popularity of Hassam's garden views.

His most memorable subject, however, which he did not broach until he was going on sixty, was the American flag. Early in 1917, America entered the First World War. This had been preceded by a long run-up of anti-German and patriotic propaganda: speeches, parades, rallies, displays. In times of agitation, all societies wave the flag, and America more than most. In New York, Old Glory was everywhere—cascades and curtains of the red, white, and blue, drifting from poles, hanging in masses from the façades of Fifth Avenue, interspersed with the flags of other allied nations such as the *tricolore* and the Union Jack. Hassam, a

more patriotic man than artists often are, was ravished by the sight. More important than his general feelings for God and Country, however, was his delight in the new visual texture that this massing of banners gave the canyons of Manhattan.

Flags in city streets had been a favorite subject of French Impressionism as early as forty years before: Monet, Pissarro, and Manet had all painted Parisian streets decked with banners, breaking up their colors and their snap in the wind into a texture of swift, ebullient brushstrokes. You can hardly read them, except in a very general way, as patriotic emblems. They are more like festive signs. Hassam's purpose was different. He wanted his flags to be entirely legible as flags, because he was constructing images of American patriotism and of Allied cooperation: he wanted to symbolize the good guys' power to win. Propaganda banners that a French artist would have blurred are, in Hassam, messages: BUY LIBERTY BONDS. Generally the flags are densely painted, with a creamy impasto that stresses their "presence," and in particular the long, sinuous red stripes of the American flag, hanging vertically down a building, supply much of the pictorial structure of the image. Compared to the iconic force of the flags, the buildings behind are usually vague and the people and traffic more so. The angularity and flatness of the flags, and their movement to the foreground, all contribute to the flatness of the painting. Indeed, there are moments when Hassam's flag paintings seem almost on the point of turning abstract: one is *Celebration Day*, 1918 (Figure 161). The tall buildings are completely covered with flags, like twin cliffs of signs. Below them, the crowd on Fifth Avenue pullulates, but is scarcely recognizable as being made up of people. What dominates the painting is the silvery sky, in which three enormous Red Cross banners—the Greek cross on the white ground—are floating, as though caught in a religious moment of ascension. It is a strange image, at the same time a revival of the American transcendental urge and, perhaps, a premonition of the factuality of Stuart Davis. But the transcendental predominates. For a moment one thinks of the Russian artist Kazimir Malevich and his Suprematist crosses in the sky. In any case, though Impressionist in handling, *Celebration Day* has moved into the world of Post-Impressionism.

So did the work of Maurice Prendergast (1859–1924), but somewhat earlier. Prendergast was never a true Impressionist, but he had distant affinities with the movement—he was considerably influenced by Whistler, and by a lesser-known figure named Charles Conder, who when very young was one of the "Heidelberg School" painters of tonal impressionist landscape in Australia, but by the early 1890s was painting decorative pictures in Paris.

Prendergast was born in St. John's, Newfoundland, but grew up in Boston. He first visited Paris in 1886, and returned there in the winter of 1890–91, staying three years and studying at the Colarossi Academy and the Académie Julien.

161. Childe Hassam, *Celebration Day*, 1918. Oil on canvas, 35½ × 23½" (90.2 × 59.7 cm). May Trust for Christopher May, Sterling May, Meredith May Smith, and Laura May.

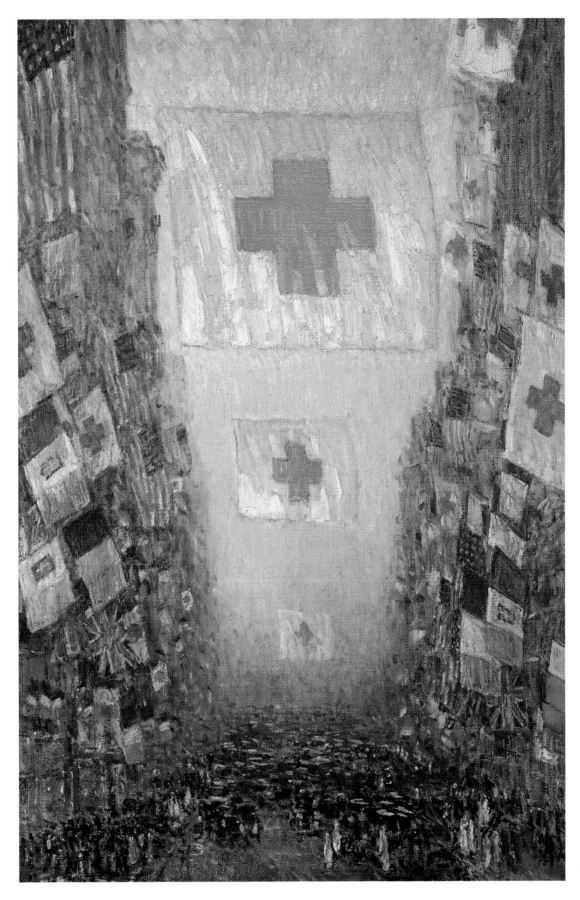

By then, of course, Impressionism was a completely established and accepted style in Paris, and the new tendencies with which alert art students had to contend were Symbolism, Neo-Impressionism—Seurat, Signac, and their followers—and the work of Gauguin, Bonnard, Vuillard, and the circle of the Nabis or "Prophets," such as Sérusier and Maurice Denis. Prendergast enthusiastically absorbed their basic doctrine—that a painting, before representing anything, should be perceived as a flat surface covered with ordered patches of color. He wasn't much interested in Impressionist "atmosphere"; he evolved a brilliant, sparkling watercolor technique in which the surface became a mosaic of rotund, swirling forms, laid close side by side, with deep perspectives that nevertheless had an air of frontality.

The results, as in one of his Venetian watercolors, *Ponte della Paglia,* 1898–99 (Figure 162), were effervescent. Prendergast's color, clear, direct, and laid on very wet, coalesces in the bubble forms of open parasols—red, Prussian blue, beige, white—which echo the hues of the buildings, the Grand Canal, and the sky. The sense of luminosity that Venice confirmed in Prendergast's work stayed with him in later years, as his compositions became more friezelike and abstract, with their rag-doll people enacting scenes from modern pleasure spots which are at the same time rendered archetypal in all but the modern dress of the figures: beach, park, promenade. The color is opalescent and subtle, the paint surface like that of a thickly piled tapestry. *On the Beach, No. 3.,* c. 1915 (Figure 163), is typical.

Prendergast, a man steeped in art history and thus in the repertoire of figure poses, was able to give the people on their summer outing a variety of posture and gesture that humanizes their otherwise faceless and schematic bodies: it sets up a gently flowing movement through the frieze, in which memories of Seurat's *Grande Jatte* mingle with others of Cézanne, Matisse, and, perhaps, of Piero della Francesca. Such a painting, obviously, has nothing to do with Impressionism. It is an intelligent and sensitive response to the Post-Impressionism that Prendergast encountered in Paris on his later trips, but without the jar and dissonance of Fauve color. It thus seems curious—an accident of mutual sympathy—that the ultrarefined Pren-

162. Maurice Prendergast, *Ponte della Paglia,* 1898–99. Oil on canvas, c. 25½ × 29½″ (64.8 × 74.9 cm) framed. Private collection.

dergast, in 1908, should have joined the group of painters known as "The Eight," which in opposition to the National Academy of Design held a much-reviled show in New York. A "revolutionary black gang," one hostile critic dubbed them. For the leading figures in "the Eight" were all realists, and realists of a fairly confrontational kind at that, attracted to the life of the streets, the worker ghettos of New York, the bawdry of music halls, and the vitality of cheap popular entertainment: Robert Henri, George Luks, Everett Shinn, and John Sloan. They carried on a tradition of empirical realism which had entered American art during the Gilded Age, and yet shared absolutely none of its values. To this current we must now turn.

163. Maurice Prendergast, *On the Beach, No. 3*, c. 1915.
Oil on canvas, 26 × 33¾" (66 × 84.7 cm). The Cleveland
Museum of Art, Hinman B. Hurlbut Collection.

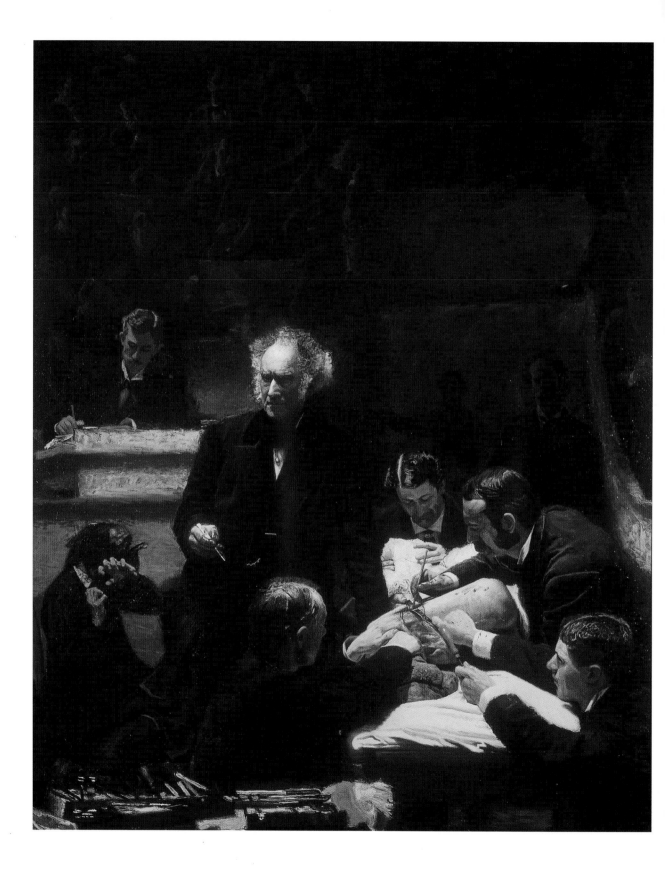

5

THE GRITTY CITIES

American culture after 1860 was dominated by two vast images, as well as that of Nature. One was the Civil War. The other was the Machine. They were strongly linked.

The Civil War was the world's first great modern war, total war, fought at the limits of an expanding technology of railroads, breechloaders, repeating guns, and ironclads. It was America's Iliad, and its Holocaust as well.

It seemed to run on its own, a thing with its own will, swallowing the men in blue and gray as a furnace swallows coal. By 1865, when General Lee surrendered to General Grant at Appomattox Courthouse, it had killed 630,000 young men. This was more death than Americans suffered in all the wars of the twentieth century put together. The war's autonomy fascinated and horrified Americans: there seemed to be no way that mere human beings could bring it to an end—a feeling that would recur on both sides of the European trenches in 1914–18. In his novel *The Red Badge of Courage*, 1895, Stephen Crane—who was born in 1871, too late to know the war at first hand, but immersed in its letters and journals—has his protagonist see it in industrial terms:

> The battle was like the grinding of an immense and terrible machine to him. Its complexities and powers, its grim processes fascinated him. He must go close to see it produce corpses.

If the war resembled a machine, it was recorded by other machines. It was the first American conflict to be described by the modern art of photography. The technique had made strides since Louis Daguerre, in 1839, found a way to make chemically treated metal plates capture images in sunlight. By the 1860s the camera was relatively mobile and could be carried to the field. The entrepreneur who turned war photography into a business was Mathew Brady (1823?–1896), who

164. Thomas Eakins, *The Gross Clinic,* 1875. Oil on canvas, 96 × 78" (243.8 × 198.1 cm). Jefferson Medical College, Thomas Jefferson University, Philadelphia.

271

employed dozens of assistants to go to the lines and photograph what they found there; the results, adding up to some seven thousand images, were displayed in Brady's studio-galleries in New York and Washington. No drawing or painting, still less a sculpture, could claim the documentary impact of the camera. Some things could not be photographed: the equipment of the day was too slow and cumbersome to record the movement of actual fighting. But it could catch the silent aftermath. Here it was, the raw unvarnished truth, the killing fields of Gettysburg and Chancellorsville carpeted with Union and Confederate dead (Figure 165). A fascinated public was given everything, or so it thought, except the groans of the wounded and the stink of putrefaction. Americans then believed that the camera could not lie. In this they were wrong; Brady's assistants, such as Timothy O'Sullivan and Alexander Gardner, were apt to drag the corpses around to concentrate their pathos and improve their visual composition. But the factual superiority of the camera over traditional ways of image-making could not be denied, and it helps account for the scarcity of worthwhile paintings or drawings of the Civil War; Winslow Homer, as we will see, was virtually the only artist to give some sense of its reality, and a muted, behind-the-lines one at that.

The war encouraged, in some artists and writers and in much of their audience, a desire to face unpleasant facts: not so much out of morbidity (though there was a strain of that) as from a sense of obligation not to flinch from atrocious realities. It is reflected, for instance, in Walt Whitman's collection of wartime poems, *Drum-Taps*, 1865, whose descriptive tone—leaner, far less lyrical than the earlier *Leaves of Grass*—emerged from his service in a Washington hospital tending wounded soldiers, both Union and Confederate:

From the stump of the arm, the amputated hand,
I undo the clotted lint, remove the slough, wash off the matter and blood,
Back on his pillow the soldier bends with curv'd neck and side-falling head,
His eyes are closed, his face is pale, he dares not look on the bloody stump,
And has not yet look'd on it.

Over time, there would develop a tendency to not look at the "bloody stump" of America's catastrophic self-amputation. The imagery of the Civil War, especially in the South, would soften and become hazy, dissolving in a mist of sentiment about chivalry, noble enterprises, and romantic courtships on the edge of the Ultimate Sacrifice. But during and immediately after it, there was no escaping its reality, which transmitted itself through a vastly expanded press to a public eager for the latest victory or in dread of the newest disaster: the journalistic eye replaced that of the novelist or the poet, as the camera replaced that of the painter, as the conduit of unbearable reality. This in itself was new, and it intersected with an appetite for the real, the scientifically verifiable, and the pragmatic that had long been resident in nineteenth-century America. American public culture was driven by technique: the skills that built bridges and docks and railroads, the scientific laws that underwrote American man's ongoing conquest of his environment. There was no ghost in the machine, only the machine itself. These positivist beliefs in "the stupendous power of Science" had long roots in an America where men (and women too) had had to fend for themselves, make do, cut down their own trees to make their own cabins, fix their own tools, and in general deal with the resistant and difficult world without guarantee of intermediaries. Not even the ideas of the Transcendentalists—Emerson, Thoreau, and their brethren in Boston, whose idealistic way of thought based on Kant and Plato sought the "essences" of reality beyond mere "appearances"—were entirely immune to this realist impulse. In 1837, in an influential speech at Harvard entitled "The American Scholar," Emerson declared to the general enthusiasm of the students that "I ask not for the great, the remote, the romantic. . . . I embrace the common, I explore and sit at the feet of the familiar, the low." It could have been Walt Whitman talking.

Of course, a distinct visual esthetic was bound to rise from American utilitarianism and materialism. It showed itself, earliest and most dramatically, in the area where science, material, and common social needs most visibly came together: architecture.

Its great expression was the iron grid, which begat the skyscraper, which in turn gave New York and Chicago their basic shape by the end of the nineteenth century. The invention of this grid didn't happen in a flash, and it needed a cultural context. That context, strangely enough, was not metal technology. It was timber.

165. Mathew Brady, aftermath of the battle of
Chancellorsville, 1863.

Despite the warnings of artists and poets about the Man with the Ax, the surface of nineteenth-century America was still covered in oceans of forests, billions of trees, an apparently limitless resource. They grew beside rivers—the water roads down which they could be transported. The flow of the same rivers could readily be harnessed to turn sawmills, even before the arrival of the steam mill, which wholly industrialized the production of lumber.

Take a tree and run it through a mill, and you have the first element in American prefabrication, the dimensionally accurate stick of lumber. Standard lumber sizes—two by four, two by six, and so on—enabled builders to plan and cost out structures with an accuracy that had not been available before, in the days when wooden frames were made of thick baulks of timber, hand-sawn, adzed, mortised, and tenoned on the site, and joined with wooden pegs. Dimensioned mill-sawn lumber, fixed with the wire nails that the Eastern factories were turning out, enabled anyone of ordinary practical skills with hammer, saw, and rule to knock together a house anywhere in America. The type of structure was known as a "balloon frame," for its (relative) lightness.

The stick and the connector. Relatively few places had the right kind of clay for making bricks, and fewer still had working stone quarries within range. Transporting these heavy materials put them beyond the purse of most Americans. But sawn sticks of predimensioned wood could go anywhere, cheap, by cart, river, canal, and eventually by rail. The huge expansion of America's chief cities in the 1840s and 1850s, from San Francisco to Chicago and thence to New York, was the result of balloon framing—and the cause of many a disastrous fire.

The wooden balloon frame got Americans thinking naturally in terms of the structural grid, as distinct from the solid bearing wall. Then they transferred their thought from the sawn stick to cast-iron joists and columns.

That technology had come from Europe. Its spectacular example was the Crystal Palace, erected by Joseph Paxton in 1851. Iron framing was widely used in vast one-story market buildings in England and Europe: Covent Garden, Les Halles, the Boqueria in Barcelona. But it remained for America to adapt cast iron for multistory construction. This was first done in New York from the 1850s on—in the industrial area now known as SoHo. In those days it was not downtown but uptown: the city had not yet expanded far north. Called Hell's Hundred Acres—not so much for its reputation as a dive and brothel area as for its numerous fires—it was ripe for development into manufacturing. Its new iron buildings were, essentially, kits like Meccano or Lego sets. Their building boom followed the Civil War, when the great iron mills at Troy up the Hudson River at its confluence with the Mohawk went over to peacetime production. Such places are all but ghost towns today—Pompeiis of the early industrial age. There in Troy, the Burden works turned out all the horseshoes for the Union armies in the Civil War, fifty-one million a year; the rolled armor plate and rivets for the iron-

clad *Monitor* were made in the Albany and Rensselaer Steel Company; and the uniforms of the North came from Harmony Mills, whose mastodon bulk still stands abandoned, the largest of fifty textile mills drawing power from the falls of the Mohawk. This was where the figure of Uncle Sam first made an appearance: he began life during the Civil War as an illustrator's propaganda figure of a sharp, tough old Union overseer, his goatee based on a real employee's, directing the flow of war material to the boys in blue.

Seeking new markets, the ironmasters went over to the peacetime production of wrought- and cast-iron building units: structural columns, pediments, façade elements of every kind. The great advantage of iron, from their point of view, was its adaptability to ornament. You could cast every kind of rosette, molding, florid capital or recessed panel, no matter how intricate, and repeat them over and over. This was far cheaper than carving them in stone. And since the wall was now a grid, it could have larger glazed-window openings and let in more light than ever before. Such was the ancestry of modular construction, and the first important iron-frame building in New York to use it was a printing plant, the Harper & Brothers Building, designed by the architect James Bogardus (1800–1874) in 1854 (Figure 166). Its floors were supported by the first seven-inch I beams to be rolled in the United States, carried on arched cast-iron girders and columns. Bogardus also designed, made, and shipped to Cuba the immense kit for an iron warehouse measuring 400 by 600 feet. A self-taught Yankee from Catskill, New

166. James Bogardus, Harper & Brothers Building, New York, 1854. Museum of the City of New York.

York, Bogardus even fantasized—as a succession of architects, including Frank Lloyd Wright, would from then on—about unimaginably tall towers: he dreamed of building one ten miles high.

The man who did most to popularize the prefabricated iron-front building was, however, Daniel Badger (1806–1884), who employed a prolific English designer to turn out whole catalogsful of iron modular detail—panels, cornices, balustrades, and complete façades that could be ordered up and combined from

167. Poster for the Architectural Iron Works, Daniel D. Badger and Others, Proprietors. The New-York Historical Society, New York.

kits. Badger and his competitors created the urban "look" of what is now SoHo, and the sumptuous illustrations produced by his firm, the Architectural Iron Works of the City of New York, are to the iron vernacular of America what Audubon's great folios were to wildlife (Figure 167). He shipped his buildings and façades as far afield as Chicago, but most of his major buildings are in New York, and of these the best survivor—sometimes, with pardonable exaggeration, called the Parthenon of American iron—is the five-story Old Haughwout Building at 490 Broadway (Figure 168). Badger took as his model Jacopo Sansovino's design for the library in Piazza San Marco in Venice (1536), with its window arches held between pairs of columns, framed between larger orders that define the intervals

of the bay. Adapting this to iron, he changed the details and proportions but preserved the rhythmical beat of the façade and the exquisite relations between the major rhythms of the bays and the internal detail. In the 1970s, before it was revamped by the present owner, the Old Haughwout Building—dilapidated, painted black, and featuring a central clock which had lost its hands long before—looked like an image from De Chirico planted on lower Broadway. But in 1856, when it opened, it was the newest of the new, not least because it contained the first working example of the invention that would make the modern city possible: Elisha Otis's safety elevator.

The genius of the multistory building was to extrude the site, like toothpaste out of a tube—to multiply your patch of land into a stack, giving value to what had once been empty air. It was no problem to build a high iron building. But for the corpulent businessman of New York or Chicago, the problem was to get up to his office. Nobody wanted to climb six floors, let alone twenty.

Hence the elevator: a cage on a cable, raised and lowered by an engine. But what if the cable broke? The nearer you rose to Heaven, the worse the prospect of an unscheduled appointment with the Lord. In 1851 another Yankee inventor, Elisha Otis, solved this problem with a ratchet device, which clamped the cage in its shaft if the cable went. Thus the elevator was born, the most crucial busi-

168. Daniel Badger, Old Haughwout Building, New York, 1857. Museum of the City of New York.

ness invention until the computer. It changed everything, not least the American skyline.

As the vast and tragic split between the industrial, forward-looking North and the tradition-obsessed, slave-owning South widened toward the Civil War, such buildings and the technology behind them gathered power as symbols. They were images of the wonders of science and skill, which sustained a culture of mass production and interchangeability, founded on process. Manufacture from interchangeable elements was named "the American System" in Europe. You saw it in the Colt revolver, assembled from identical machined and stamped parts, not built individually and by hand like a Manton dueling pistol or a Kentucky rifle. You experienced it in the shipyards and forging mills. Out of the immense industrial expansion of America in the 1850s and 1860s, through the smoke and glare of the foundries, the clamor and all-transforming speed of the railroads and the pandemonium of the factories, there emerged the dominant image of the American nineteenth century, an image monopolized by the North after the ruin of the South: the myth of the Machine itself. The Machine was imagined as a vast, omnipotent, stupid, and obedient genie, released from the bottle by the hand of Yankee ingenuity. It was, in effect, a superslave, to whose ownership no moral criticism attached. From this arose the perception of the Technological Sublime, America's counter to the visible and God-given sublimity of its own landscape. The works of man are seen to rival those of God, and limitless power can be released by the merest gesture of a hand. All this was dramatized in the Hall of Machinery in the Centennial Exposition held in Philadelphia in 1876. Reporters covering it wrote in anthropomorphic terms about the vast hall and its contents: it was "a concourse of genii" whose "mechanical forms crouched low along the nave, resting on huge iron paws, their hoppers yawning for vittles." The effect, in their eyes, was that of some Egyptian temple hall full of near-animate deities, and its presiding monster was the huge Corliss double walking-beam steam engine, with its thirty-foot diameter and fifty-six-ton flywheel that supplied power to all the other slave machines in the show (Figure 169). People flocked in the thousands, reported the *Scientific American,* "to see sublimity in the magnificent totality of the great Corliss Engine."

169. Giant Corliss Engine, Philadelphia Centennial Exposition, 1876.

The opening ceremony was performed by President Grant, destroyer of the South. Accompanied by the Emperor of Brazil, he ascended a platform by the Corliss engine and touched a handle—nothing more than that. Whereupon the flywheel, and everything else in the long, wide hall, began to move.

This rite acknowledged the position of the engineer as American hero—a practical moralist, showing the application of God's laws to the physical world, repeating God's work in the transformation of substance. Admiration for his work gets ecstatic voice in Walt Whitman's paean to the 1876 Exposition, where the poet invites the Muse to

> migrate from Greece and Ionia,
> Cross out please those immensely overpaid accounts,
> That matter of Troy and Achilles' wrath, and Aeneas', Odysseus' wanderings,
> Placard "Removed" and "To Let" on the rocks of your snowy Parnassus, . . .
> The same on the walls of your German, French and Spanish castles, and Italian
> collections,
> For know a better, fresher, busier sphere, a wide, untried domain awaits, demands
> you.

The fresher sphere is America, the center of a world made new by invention.

The reign of the engineer was identified with peace. Technology would heal America, Whitman believed; it would abolish the memory of those rotting and ruined bodies that he had seen in his service as an army nurse: "the dead, the dead, the dead—*our* dead—or North or South, ours all (all, all, all finally dear to me. . . . the infinite dead—the entire land saturated, perfumed with their impalpable ashes' exhalation in Nature's chemistry distill'd. . . ." At the Exposition, he turned his "shuddering sight" from the memory: "Away with themes of war! away with war itself! / . . . And in its stead speed industry's campaigns, / With thy undaunted armies, engineering."

Within the New World, the Grand Canyon and Peale's mastodon had testified to an unimaginably old one, ruled by geological—or, better, theological—time. But its counterpart was an even newer world, created from day to day by *Homo artifex*. Europeans might sneer at the sight of rampant American positivism, the belief in ordained progress that filled every corner of American rhetoric and was eventually to decay into mere advertising slogans and styling. But to Americans, by the 1880s it was an extremely serious affair: the factory, the bridge, the dam, the dry dock were all parts of the Cathedral of Making, as the Grand Canyon was the Temple of Nature. Hence their creation and unveiling could be described in terms appropriate to religion. When the greatest of them was opened in 1883, one reporter in the crowd wrote as though God were endorsing it in the visual language of Frederic Church:

The blaze of the dying sun bathed everything gold. The great building looked like burnished brass. In the west the sun sent its last tribute to the bridge in a series of great bars of golden light that shot up fanlike into the blue sky. Gradually the gold melted away, leaving the heavens cloudless. . . .

This was the Brooklyn Bridge (Figure 170). Designed by John Roebling and his son Washington Roebling, built by thousands of American workers laboring under perilous and sacrificial conditions (men fell off the high cables or died in anguish from the "bends" inflicted by work in the underwater caissons), it was the greatest engineering feat of nineteenth-century America and, with a central span of 1,595 feet, by far the longest suspension bridge in the world. It established an entirely new sense of urban scale for New York, and it would be hard to exaggerate the reaction of awe and pride with which Americans (not only Manhattanites and Brooklynites) responded to it. You might compare it to the 1969 *Apollo* moon landing. It was probably deeper, since many people even thirty years ago regarded the NASA projects as a political cosmetic and a waste

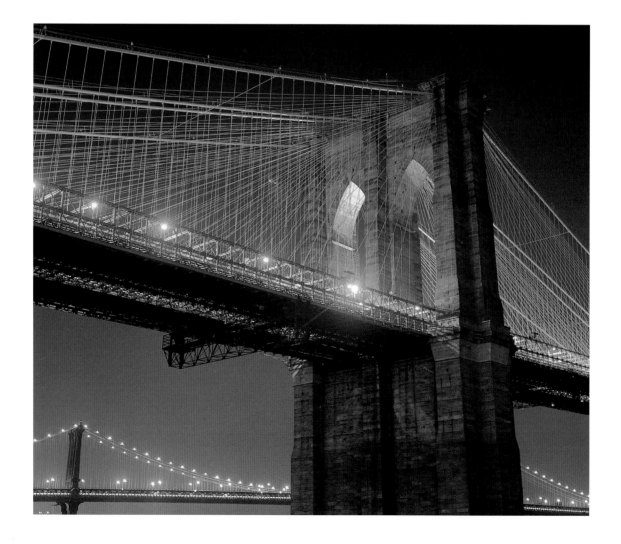

of money, whereas no such suspicions attached to the Brooklyn Bridge. It was to America what the Eiffel Tower, built six years later, would become to France— but horizontal, not vertical, and useful, not ornamental. The bridge summed up the whole burgeoning imagery of benign industrial capitalism shedding its benefits on society. The Roeblings wanted to make the most beautiful bridge in the world, and they succeeded: there was no inconsistency or conflict, in their minds, between great engineering and great art. The Brooklyn Bridge demonstrated the nature of its materials: the solid compression-resistance of the old stuff of building, stone, in its buttresses; the fine spidery tensile strength of the newer stuff, steel, in its prodigious catenary cables. It was a national symbol, not only a local one, for—as the historian David McCullough put it—you had the feeling that if you could pick it up and turn it over you would see "Made in America" stamped on it. It was a powerful metaphor for unity and linkage, suggesting the binding-together of America after the terrible division of the 1860s. Its Gothic arches— the Roebling family came originally from Mulhouse in Alsace, a cathedral city remembered in the design of their bridge—implied a transcendental purpose. It served as a double triumphal gateway, from Brooklyn to Manhattan and from Manhattan to Brooklyn: it framed the passage either way, by carriage or on foot, with expectation and ceremony. It was one of the first things immigrants arriving by sea glimpsed as they approached New York, and it told them they were coming to a land of infinite possibility.

The Brooklyn Bridge predicted the vertical city, whose chief element—the high, steel-framed palazzo block—reached its first maturity outside New York in the 1890s, in the skyscrapers of Louis Sullivan and others. It is by now futile to claim who designed the "first skyscraper" in America, partly because so much depends on what you mean by "skyscraper"—the Haughwout Building, for instance, looked very tall on Broadway in the 1850s—but mainly because if the skyscraper form is to be defined, as it ought, in terms of a wind-braced skeleton metal frame that carries all the structural load of the building, then one can only speak of a gradual evolution, not a sudden invention. William Jenney's eleven-story Home Insurance Building in Chicago, 1889 (Figure 171), had a struc-

170. John and Washington Roebling, Brooklyn Bridge, 1883.
171. William Jenney, Home Insurance Building, Chicago, 1889.
Engraving from a photograph by an unknown photographer.
Chicago Historical Society.

tural system of wrought- and cast-iron columns and wrought-iron floor beams as far as the sixth floor; above that, the girders were steel, the first time it had been used in any building other than a bridge. Some of the load, however, was also carried by granite piers.

But if there is room for debate about the origins of the high, steel-framed American building, there is no question as to the name of the first genius of its design, who was also America's first great modern architect. He had worked (briefly) for Jenney in 1873 before departing for Paris to study at the École des Beaux-Arts, and his name was Louis Henri Sullivan (1856–1924).

It is a curious twist of posthumous fate that Sullivan, who wrote hundreds of thousands of words of theory, speculation, and exposition about architecture, should be known to the general public today by only one phrase: "Form follows function." It became the motto of all twentieth-century Functionalist architects, especially of those in the Bauhaus, and yet it does not adequately represent Sullivan's ideas at all, not even his conceptions of function and form. Actually, Sullivan's writings didn't dwell very much on the functions of buildings—circulation, heating, division of work space, and so forth. He assumed that the objective function was determined by the client's needs and wishes, though the architect had to rationalize it; but it wasn't the generating force of design. What interested him was a subjective approach that would reveal a "higher" functionalism, the purposive disclosure of a "creative spirit" that would link the architect's work with universal, organic processes of Nature. (Hence his enormous influence on his pupil Frank Lloyd Wright; all Wright's ideas about "organic architecture" go back, in the end, to Sullivan.) In fact, the true function of the architect, Sullivan believed, was to bring into being a transitional unity between spirit, matter, and society:

> To vitalize building materials, to animate them with a thought, a state of feeling, to charge them with a social significance and value, to make them a visible part of the social fabric, to infuse into them the true life of the people, *to impart to them the best that is in the people,* as the eye of the poet, looking beneath the surface of life, sees the best that is in the people—such is the true function of the architect;—for understood in these terms, the architect is one kind of poet, and his work one form of poetry.

There was, unquestionably, something messianic about Sullivan, but it was a democratic messianism and not the rather grim, autocratic kind practiced later at the Bauhaus. Sullivan passionately admired Walt Whitman—he was, one might almost say, the Whitman of architecture—and like him was very much a man of the nineteenth century, in his passionate belief in progress. The ideas of Charles Darwin did not fill him with anxiety, as they had Americans of an earlier gener-

ation, brought up to believe in an all-ordering, all-creating, and benign God. Rather, he saw in the vision of autonomous evolution a pressure toward perfect adaptation to environment, ever-improving, becoming always more articulate—if sensitively understood. But he was in no sense a scientific rationalist, and it remains a misunderstanding of his work to claim that the scientific rationalism of the Bauhaus in some way "completed" what Sullivan had started. One might say of him, as one could say of Cézanne, that his work struggled toward a kind of modernism that did not exist and still does not. Nowhere is this truer, as we will see, than in his use of ornament.

Sullivan was almost incapable of compromise, and his one partnership (with Dankmar Adler, as Adler & Sullivan in Chicago) lasted only twelve years, from 1883 to 1895, coming unstuck under the financial stress of the 1893 depression. Thereafter, Sullivan worked alone. Though he joined the roster of architects who worked on the White City extravaganza in Chicago in 1893, he felt rejected by the American cultural establishment. He was not very good at wooing the client, with the result that his list of built buildings was tiny compared, at the other extreme, to Stanford White's. The ones that changed American architectural history almost all belong to the decade 1890–1900, after which Sullivan had no further opportunities to build high big-city steel-frame blocks and had to content himself with a series of small if exquisitely designed banks, low and in load-bearing brick, in small Midwestern towns. In the last twenty years of his life, he finished only fifteen buildings. Sullivan was a tragic figure, but tragedy requires a certain greatness in its protagonist, and to that his buildings testify.

The magnitude of Sullivan's achievement can best be sensed from two of his key multistory buildings (of which, in the end, he designed nineteen but only built nine): the Guaranty Building in Buffalo, New York, 1894–95 (Figure 172), in partnership with Adler, and the Carson Pirie Scott department store, 1898–1904 (Figure 173).

172. Dankmar Adler and Louis Sullivan, Buffalo Guaranty Building, 1894–95. Buffalo, New York.

The Guaranty Building speaks directly of Sullivan's Beaux Arts roots. It is in fact a Renaissance palazzo morphed into verticality but keeping its clear divisions: base, colonnade, entablature. He had learned clarity from his Beaux Arts training—the distinct and logical procession of rooms, the use of axes and clearly articulated rhythms; balance, symmetry, and regularity of all parts. One sees this everywhere in the Guaranty Building, planted to occupy a whole block with majestic confidence: in the plain solidity of its base, the exhilarating rise of the pilasters with their arched links at the top, and finally the light play of the ornament around its string of round windows, like bubbles, under the cornice. The spandrels are set back to give an unimpeded upward rush to the vertically stretched "colonnade."

Purist architects and critics, after Sullivan's death, had difficulty with his love of ornament: it struck them as a hollow, historicist fossil, which he didn't quite have the courage to dispose of. And they took Sullivan's own words as proof, for in 1892, in an essay on "Ornament in Architecture," he had written that

> I take it as self-evident that a building, quite devoid of ornament, may convey a noble and dignified sentiment by virtue of mass and proportion. It is not evident to me that ornament can intrinsically heighten these qualities. . . . I should say that it would be greatly for our esthetic good if we should refrain from the use of ornament for a period of years, in order that our thought might concentrate acutely on the production of buildings well-formed and comely in the nude. . . . If we shall have become well-grounded in pure and simple forms . . . we shall have discerned the limitations as well as the great value of unadorned masses.

But one should note what Sullivan was *not* saying. He was not claiming that ornament was a bad or historicist distraction. In effect, he was calling for a reduced diet of ornamental fulsomeness, irrelevant crusting, and flouncing, so that architects could "look on beauty bare" in the big essential masses—and then, as he said, see the *limitations* of bareness. "If this spiritual and emotional quality is a noble thing when it resides in the mass of the building," he went on,

> it must, when applied to a virile and synthetic scheme of ornamentation, raise this at once from the level of triviality to the heights of dramatic expression.

Ornament in Sullivan's work is not a nostalgic leftover: it is a live thing, integrally part of the building, deduced from earlier ornamental forms (as in the beautiful woven and swirling relief patterns around the top windows and at the upper corners of the Guaranty Building, which assert the plasticity of its terra-cotta cladding over the invisible steel frame) but always reinvented in Sullivan's terms, which were also American terms. It plays a vital role in Sullivan's achieve-

173. Albert Fleury, *Carson-Pirie-Scott Store* (designed by Louis Sullivan), n.d. Oil on canvas. Chicago Historical Society.

CARSON PIRIE &

285

ment, which was not to have "invented" the high, steel-framed building, but to have given it an esthetic unity and clarity it had never possessed before.

And, just as important, there was Sullivan's way of thinking about the street, the larger urban fabric. Sullivan's palazzo blocks define the street, make it into a long "room" or "corridor," its solidity pierced with alleys and minor streets—so different from, so much more urbanistically rich than, the banal plazas superficially "enriched" by corporate sculpture favored by later, modern architects in Chicago and elsewhere—and yet with each building distinguished from its neighbor by façade treatment and ornament. The building, in other words, is thought of as a phrase in a connected urban text. It is not imagined as an isolated monument-to-itself, as would happen—to the degradation of tall American cities like New York and Chicago—with the wholesale spread of the International Style into corporate building after the 1950s.

Verticality itself was not the criterion. Sullivan was as good with horizontal spread as he was with vertical ascent. This is shown by the Carson Pirie Scott store in Chicago, the most minimal of his designs. It is pure skin and bones. The grid of vertical members and horizontal spandrels that faces the street, with its huge three-part "Chicago windows"—the central pane fixed, the double-hung sashes on either side of it opening for ventilation—follows and expresses the structural grid that carries the building. Since the invention of fluorescent lighting, no department store would need or want so much glass; but shopping in Sullivan's day depended, to a great extent, on natural daylight. The long and short street walls rush horizontally toward one another, to meet at the slightly awkward bullnose of its round corner. But the generosity is in Sullivan's details: those exhilarating swirls and cascades of taut floreation, related in their spiky inventiveness to the ironwork of his great Catalan contemporary Luis Domenech Muntaner, that frame the entrance portals and the spandrel friezes of the first two floors. By turns seaweedy and quasi-geometric, bristling with energy, these possess the vitality that comes from a complete understanding of how depth and light interact, how the differences of projection—from the lightest surface pattern to the deep fold-overs of the voluted leaf and tendril motifs, working against the open dark space behind—create a parallel liveliness to what we see in Nature, artificial and stylized though they are.

The art of painting does not go in tandem with that of engineering or architecture: "structure" in a painting is real enough, but it does not have to bear actual loads; its metaphors work differently. And yet when painting aspires to a scientific analysis of things in sight, when the ego of the artist recedes behind that patient examination, one can at least speak of parallels; and Thomas Eakins (1844–1916) might not have objected.

Eakins's work gathers the strands of empirical vision that had been in American art since William Copley. He was not interested in allegory, "poetry," or moral exhortation; nor did he give a fig for metaphysics, the presence of God, or any of the other things that permeated the landscapes of the Hudson River School, the Luminists, or the painters of Western spectacle pictures. No American painter ever worked harder to make the human clay palpable and open to scrutiny. Since art is always a fiction, it may be that moral probity, expressed in the desire for truth, is not a criterion of excellence in painting; but Eakins, at least when you are looking at *The Gross Clinic* or *Max Schmitt in a Single Scull*, convinces you that it is. Creating this belief was his life's work, his mode of poetry. His motto might have been Gustave Courbet's:

> Painting is an essentially concrete art and can only consist of the presentation of real and existing things. It is a completely physical language, the words of which consist of all visible objects; an object which is abstract, not visible, nonexistent, is not within the realm of painting.

He was not, however, a follower of Courbet. He was a peculiarly American painter, and this was noticed by a French reviewer at the Paris Salon of 1875, to which Eakins had sent two hunting pictures: wildfowlers in punts on Delaware Bay. "One asks oneself," he wrote, "whether these are not specimens of a still secret industrial process." Eakins's empirical eye looked strange in Paris, very American.

He realized, quite early, that his field of experience had to be American life, American character, and American ideas. This was not going to be easy. Toward the end of his turbulent career, Eakins advised his students in words that can be taken as a manifesto of his own ambitions: "If America is to produce great painters and if young art students wish to assume a place in the history of the art of their country, their first desire should be to remain in America to peer deeper into the heart of American life." Other artists (Whistler, Sargent, Cassatt) might choose expatriation to Paris, the main center of world painting in the last half of the nineteenth century; not Eakins. He was born and raised in Philadelphia. Beginning in October 1866, he did a three-year training stint in Paris in the teaching atelier of Jean Léon Gérôme (who presently went off to Greece, leaving his students in the hands of the inferior virtuoso academic Gustave Boulanger). He visited Spain, to see the work of Ribera and Velázquez. He never went to England. By the end of 1870 he was back in Philadelphia. There he would remain for the rest of his life, painting and teaching. He disliked most of the successful art he had seen in Paris, academic classicism with its smooth overtones of *banquier* prurience. "The professors as they are called read Greek poetry for inspiration," he scoffed in a letter to his father, "& talk classic & give out classic

subjects & make a fellow draw antique. . . . I love sunlight & children & beautiful women & men their heads & hands & most everything I see & some day I expect to paint them as I see them . . . [but] I could not paint a Greek subject for my head would be full of classics the nasty besmeared wooden hard gloomy tragic figures of the great French school. . . ."

It's typical of Eakins that when he went to the 1867 Paris Exposition, he missed or ignored the shows of paintings by Courbet and Manet that were included in its wandering bulk. What excited him was the machinery, especially the American sewing machines (so much better, he crowed, than the European ones). This, after all, was the young man whose student work in Philadelphia had included an exact perspective drawing of a lathe. This, too, was Whitmanesque, before Whitman's 1876 "Song of the Exposition" set forth its vision of a new American civilization based on process, technology, and skilled transformation:

> Here shall you trace in flowing operation,
> In every state of practical, busy movement, the rills of civilization,
> Materials here under your eye shall change their shape as if by magic, . . .
> The photograph, model, watch, pin, nail, shall be created before you.

Eakins had no contact with the Impressionists when he was in Paris. He was an academic artist. What did this term, which we think disparaging, mean to him? A particular way of doing things: the value of the past, transmitted from teacher to student; close scrutiny of objects, a sense of form fed and disciplined by constantly drawing the naked human body from life, preceded by the usual student work of drawing casts of antique sculptures. Patient and exact construction. Eakins wasn't an academic classicist, and he fretted somewhat at doing the inert, chill, dusty-white casts over and over again; and yet, in his teaching years in Philadelphia, he encouraged his students to draw from these solidified memories of Antiquity, and his own work—not only his paintings but even his photographs—shows an intimate familiarity with standard bodily poses that reached back to ancient Greece and Rome.

To illustrate Eakins's passion for fact, writers like to quote one of his letters home to his father. "In a big picture you can see what o'clock it is, afternoon or morning, if it's hot or cold, winter or summer, and what kind of people are there, and what they are doing and why they are doing it." So far so good: a painting must be a factual and consistent slice of life. But then another, more nuanced thought comes in, as Eakins recognizes that slices of life, too, are imaginatively constructed, that no painting is instantaneous, that all sight enfolds memory as well, and that we make up what we see in the act of transcribing it. This is the other half of Eakins the realist:

The sentiments run beyond words. If a man makes a hot day he makes it like a hot day he once saw or is seeing; if a sweet face, a face he once saw or which he imagines from old memories or parts of memories and his knowledge, and he combines and combines, never creates—but at the very first combination no man, and least of all himself, could ever disentangle the feelings that animated him right then, and refer each one to its right place.

So Eakins rejects the illusion of Impressionist instantaneity. He is for memory and combination. He also rejects the fiction of purely "scientific," dispassionate painting. He is for the tangle of feelings, however far under the surface they may be. His feelings are not, as we will see, as violent as his contemporary Winslow Homer's could be, but they are there to be sorted out, each "to its right place," and they include a deep-running and somewhat bearish melancholy. The means of sorting them was the academic basis of his art, which implied a steady, pragmatic rigor. Real people in real space, nothing fudged or generalized. We see the results in a series of paintings he did after his return from Europe in 1870: scenes of rowing and sailing.

Philadelphia is a river city, divided by the Schuylkill. After the Civil War the sport of rowing caught on among middle-class Philadelphians. Rival rowing clubs proliferated on the banks, and on weekends the river swarmed with light racing craft, graceful toothpicks of varnished cedar: single sculls, pairs, fours, and eights, gliding like waterbugs on the shining surface. Eakins was an oarsman and clearly loved these craft: they were (and are) of an extreme functional elegance, pared down for lightness, with no purpose except speed and exercise. Oarsman and shell formed a perfect unit. To Eakins, the Schuylkill was an American version of a Greek palaestra, with muscular, lightly clad men in strongly disciplined movement. He spent his spare time rowing on it, sailing catboats and "hikers" on the Delaware Bay, and hunting rail from punts in the coastal swamps.

His first large image of rowing was *The Champion Single Sculls* (*Max Schmitt in a Single Scull*), 1871 (Figure 174). Schmitt was a rowing champion and Eakins's friend; Eakins too is in the picture, in the farther boat, pulling away, with his name lettered on the transom. The picture does not pretend to be done "from life," painted on the motif. On the contrary, Eakins made numerous studies of the landscape, water reflections, the boats in perspective, and assembled them in the final composition, thus faithfully carrying out the academic process he had learned in Paris. (In other paintings he would take this further, making tiny cigar-box models "and rag figures, with the red and white shirts, blue ribbons around the head," and setting them up in bright sunlight on his studio roof.) In the deep space filled with the mellow golden light of an autumn afternoon, all is sharp. You can count the members in the far-off trusses of the railroad bridge. The water, a glassy sheet, is windless. In it, things are doubled: a clump of trees,

Schmitt's oars, his head and body. Nothing moves, except Schmitt's scull; the oars leave long tracks on the water. The hush is both intense and, due to its assembled character, slightly artificial.

The construction of these rowing pictures was a matter of endless fascination to Eakins. You can almost hear him muttering the words Vasari put in the mouth of Paolo Uccello, as his wife tried to drag him away from his perspective studies: *O, che dolce cosa è questa prospettiva!* (Oh, what a joy this perspective is!). Édouard Manet could render a couple of warships as black splotches, casually dropped on the blue waves; not Eakins. His perspective setups of rowing shells have the same hard, inquisitive elaboration as Beaux-Arts architectural renderings—or, for that matter, Uccello's fiendishly complicated *mazzocchi,* his perspective drawings of geometrical rings. No spatial relationships are "invented," not even those of ripples on the water. Linear, one-point perspective was a method that produced all the spatial truth a painter could need; get it right, and it would produce reality—reality rising out of the mechanism of process, like a very exalted form of painting-by-numbers, surprising the artist. "I know of no prettier problem in perspective," Eakins told his students,

174. Thomas Eakins, *The Champion Single Sculls (Max Schmitt in a Single Scull),* 1871. Oil on canvas, 32¼ × 46¼" (81.9 × 177.5 cm). The Metropolitan Museum of Art, New York; purchase, The Alfred N. Punnett Endowment Fund and George D. Pratt Gift, 1934.

than to draw a yacht sailing. . . . [A] boat is the hardest thing I know to put into perspective. It is so much like the human figure, there is something alive about it. It requires a heap of thinking and calculating to build a boat.

Or to paint one, the act of painting being a sort of building. *Sailboats Racing on the Delaware,* 1874 (Figure 175), is such a product of calculation. On the one hand, it is full of documentary truth: the brown estuary water, the high, blowing blue sky, the photographic cutoff of the mainsail of the "hiker" disappearing out of frame on the right, the teamwork of the crews. On the other, it is nudged and revised into a strong pictorial structure, with the abstract disposition of the white sails and, a subtle device, the emphasis given to the skipper in the central boat by the rhyme between his red jersey and the thin red stripe of the gunwale.

"There is so much beauty in reflections that it is generally well worth while to try to get them right," he advised his students. This was, as Eakins's utterances normally were, an understatement. One sees the results of this effort in *John Biglin in a Single Scull,* 1874 (Figure 176), where the arrowing interweave of reflections below the boat, containing the colors of the varnished hull, Biglin's white singlet, his skin, and his red sweat-bandanna, seem to have the beauty of undeniable fact—a fact, however, which we cannot test for ourselves, but are induced to take on trust.

As a realist, Eakins identified with physicians and scientists, who also strove to

175. Thomas Eakins, *Sailboats Racing on the Delaware,*
1874. Oil on canvas, 24$\frac{1}{8}$ × 36$\frac{1}{8}$" (61.3 × 91.7 cm).
Philadelphia Museum of Art; given by Mrs. Thomas Eakins
and Miss Mary Adeline Williams.

176. Thomas Eakins, *John Biglin in a Single Scull,* 1874. Oil on canvas (mounted on aluminum), 24$\frac{1}{16}$ × 16″ (61.1 × 40.6 cm). Yale University Art Gallery; Whitney Collections of Sporting Art, given in memory of Harry Payne Whitney, B.A. 1894, and Payne Whitney, B.A. 1898, by Francis P. Garvan, B.A. 1897.

describe the structure and nature of the world in objective terms. His portraits of Philadelphia scientists—several of whom had been his acquaintances since their school days—are both probing and sympathetic. Sometimes, as in the portrait of Professor Howard Rand, 1874, he could infuse them with a flick (no more) of quiet humor. Rand was the first person Eakins chose as the subject of a major portrait outside the circle of his own family and closest friends. He was professor of chemistry at Jefferson Medical College in Philadelphia, and Eakins painted him reading, in a pool of light that brings his face and shirtfront out of the general, indeterminate gloom of his "brown study." He has taken off his tie but is still in formal dress. A pink rose on the desk, and a woman's shawl draped over the chair-back in the foreground, suggest festivity. The professor is catching up on some reading after an evening reception. He is completely absorbed and ignores your gaze. The light also gleams on a massive brass microscope and other scientific instruments to the left, and he is absently stroking his black cat, which has leapt up on the desk: a charming touch, the witch's "familiar" of positivism. (Did Eakins remember the black cat in Manet's *Olympia,* 1863? Maybe, but the scientist actually had one, which mattered more.)

In *Professor Henry A. Rowland,* 1897 (Figure 177), Eakins gave the image of science an almost religious cast. One reads it as a barely secularized icon. Henry Rowland's was one of the outstanding scientific minds of nineteenth-century America. His research was wide-ranging, but his particular field was spectroscopy: the analysis of light. The chief tool for this was a diffraction grating, a metal plate on which lines were closely engraved; white light, reflected from its surface, broke down into the colors of the spectrum, red through violet. Rowland had developed an unprecedentedly accurate "ruling machine" to make such gratings; it permitted spectral measurements correct to within one twenty-thousandth of an inch. In Eakins's portrait, we see Rowland sitting in a chair, in profile, holding one of his diffraction plaques; it glows brilliantly, a jewel of light, a point of focus in the brown gloom of the lab. Beside him is the famous ruling ma-

177. Thomas Eakins, *Professor Henry A. Rowland,* 1897. Oil on canvas, 80¼ × 54" (203.8 × 137.2 cm). Addison Gallery of American Art, Phillips Academy, Andover, Massachusetts; gift of Stephen C. Clark.

chine, and behind it is Rowland's assistant and instrument maker Thomas Schneider. The sorcerer and his apprentice, in the cave of making: for despite Eakins's studious objectivity, you can hardly help seeing this image as hierophantic, and the light that falls on Rowland's straight blade of a nose and high-domed forehead seems akin to *lux veritatis,* a kind of grace. One thinks of Rowland holding his jewel-grating as a nineteenth-century answer to John Singleton Copley's *Paul Revere,* thinking intently while holding the product of his work and ingenuity, a silver teapot. For the Rowland portrait is, above all, a picture of *thought,* and Rowland's ideas (formulae and diagrams from his notebooks) surround his image, scratched by Eakins on the custom-made gilt frame. Thus the frame works like a thought balloon in a comic strip. But the main effect of the gold is to sacralize the portrait by association, to raise your memory of altarpieces and holy images. Rowland becomes a saint of empiricism, Eakins's religion.

Eakins's fullest treatment of the theme of the scientist as hero, however, was painted long before; it is *The Gross Clinic,* 1875 (Figure 164, page 270). Eakins was just back from Paris. He was thirty, and he wanted to make a splash with what French teachers called a *toile maîtresse*—in the old sense, a "masterpiece," a painting which showed that the young artist had reached full possession of his powers. He hoped, as many American painters did, to show the work at the 1876 Centennial Exposition in Philadelphia, where it would be seen in the company of work from Paris and Munich, not only against other Americans. In this he was disappointed: the selection committee accepted five of his paintings but rejected *The Gross Clinic,* though at Gross's insistence it was finally hung in the U.S. Army Post Hospital Building, as part of a display of the treatment of Civil War injuries.

Dr. Samuel David Gross was the leading surgeon at Jefferson Medical College in Philadelphia, a teacher renowned for his skill and technical innovations. Eakins had studied anatomy at Jefferson before going to France; in 1873 he re-enrolled there. He had no commission to paint Gross—Eakins hoped the portrait would lead to commissions to do other doctors. Gross gave his own time to Eakins, and the painter used so much of it that Gross wished, half-jokingly, that Eakins would drop dead.

The scene is the surgical amphitheater of Jefferson Medical College. Its raked seats are crammed with students, concentrating, dimly seen. Dr. Gross presides over an operation for osteomyelitis—the removal of dead bone from the thigh of a young man, a charity case whose feet stick out at us, encased in mundane gray socks. One assistant holds the legs steady. Another keeps the cut open with a retractor. A third probes the incision; a fourth, the anesthetist, holds a wad of chloroform-soaked wool over the patient's face. These are the realists: the men who can carry out the bloody work of healing and not flinch. Their gazes, arms,

hands, even (in a brilliant touch) the white slash of the anesthetist's hair-parting, all converge on the incision, the red wound and hand, so harsh and sudden against the swooning white thigh and the black coats. On the left side is a horror-stricken woman, presumably the patient's mother, covering her eyes. She provides the opposite to realism. She cannot look; she cannot face the facts.

Above them, the apex of the pyramidal composition, rises Gross. He has turned away from the work, not to face the viewer (which Eakins's portraits seldom do) but to reflect and then to explain. His forehead shines with light, and is aureoled with gray hair; the strong planes of his face are broadly painted, to give them the utmost immediacy. There is blood, fresh and enamel red, on his hand that grasps the scalpel. You can see Gross thinking. This is the most Rembrandt-esque of all Eakins's portraits, not only in its massing of shade and its dramatic highlighting but in its desire to make cogitation real. Rembrandt's *Anatomy Lesson of Dr. Tulp,* of course, is one of the precedents for Eakins's picture, but the two are very different, since Rembrandt painted a dissection of a dead cadaver with which one cannot identify, whereas Gross's didactic subject is a live patient with whom we may. And rather than simply painting the master and his disciples, as Rembrandt did, Eakins shows us teamwork, a pooling of shared knowledge and technique. Other sources flow into the picture, too. Eakins adored Velázquez. No artist made a greater impression on him. He had seen *Las Meninas* in Madrid, and an echo of it (the chamberlain seen in the open doorway at the end of the room) remains in the figure silhouetted in the dark entranceway of the operating theater. He had also reacted strongly to Ribera, and without pointing to any specific source, one may guess that the sharp contrast between violence and sobriety in *The Gross Clinic,* the patient's blood and the black doctors' suits, refers back to the sacrificial red and ecclesiastical black in seventeenth-century Spanish art. Such memories were fresh in Eakins then, jostling to be used.

The Gross Clinic was immediately controversial. William Clark, a Philadelphia art critic, wrote that "nothing greater . . . has ever been executed in America," but others hated the subject and its realist treatment. When Eakins showed it three years later in New York, it ran into a barrage of denunciation. "No purpose is gained by this morbid exhibition, no lesson taught—the painter shows his skill—and the spectator's gorge rises at it—that is all." So wrote the critic of the New York *Tribune,* followed by others: "Revolting to the last degree, with the repulsiveness of its almost Hogarthian detail."

Eakins's public often resented having unvarnished truth shoved at it, and he entered his forties regarded as truculent and socially inept—at home with his family and his cabal of students, but otherwise unpleasant to know. He did not run an atelier, he liked to say: he had a workshop. Visiting it, one art critic found

not even a man of tolerably good appearance or breeding. His home and surroundings and family were decidedly of the *lower* middle class. . . . His studio was a garret room without one single object upon which the eye might rest with pleasure—the sole ornaments some skeletons and some models of the frame and muscles which looked, of course, like the contents of a butcher's shop.

The bear in his den, as it were. People's unease at Eakins's blunt empiricism and thorny character was heightened by his attachment to photography. During Eakins's working life, photography became popular in America; it passed from being an alchemical rite done only by professionals, involving mysterious black hoods, chemicals, and rosewood boxes, to become a popular hobby which, thanks to the Kodak, anyone could take up. Eakins bought his first camera in 1880.

Photography, he saw, could be empirical or romantic. It could describe fact or, more deviously, suggest fiction. Eakins was passionate about the factual side of photography: it was a tool which, far from subverting the patient construction of academic art, could improve it. He knew the latest experiments in capturing

178. Thomas Eakins, *Swimming (The Swimming Hole),* 1885. Oil on canvas, 27³⁄₈ × 36³⁄₈″ (69.5 × 92.4 cm). Amon Carter Museum, Fort Worth, Texas; purchased by the Friends of Art, Fort Worth Art Association, 1925; acquired by the Amon Carter Museum, 1990, from the Modern Art Museum of Fort Worth through grants and donations from the Amon G. Carter Foundation, the Sid W. Richardson Foundation, the Anne Burnett and Charles Tandy Foundation, Capital Cities/ABC Foundation, Fort Worth Star-Telegram, the R. D. and Joan Dale Hubbard Foundation, and the people of Fort Worth.

movement through photography—Eadweard Muybridge's sequential photographs of figures and animals in action, for instance—and, with the help of his students at the Pennsylvania Academy of the Fine Arts, made his own. In 1879, preparing to paint the picture of a carriage known by the cumbersome title *A May Morning in the Park* (*The Fairman Rogers Four-in-Hand*), he developed Muybridge's pictures of a trotting horse into wax sculptures and painted from them. He took photos of posed studio nudes for later use. But he also did something odder and, by the moral conventions of his day in Philadelphia, more questionable. He made photos of his naked students, men and women, in the open air. He photographed himself naked with them—in one image, full-frontal and holding a naked girl. Some of these, such as a shot of his wife, Susan, naked, seen from behind, leaning on the neck of a horse, carry a distinct sexual charge today, which must have been more vivid a century ago. Inevitably, these nudes in landscape settings, in leafy groves or by water, suggest Arcadian scenes, an incipient classicism that linked up with Eakins's academic training in the study of plaster casts. (Some of his photos showed nude men playing panpipes in the open air; others were of students wearing Greco-Roman costumes, chitons, peplums, and sandals, self-consciously posing in front of pieces from the Academy's enormous collection of casts from the antique.) But the unideal bodies in his photos were

179. Thomas Eakins, *Students at the Site of the "Swimming Hole,"* 1883. Albumin print on paper, 6¹/₁₆ × 7¹³/₁₆" (15.4 × 19.8 cm) irreg. Hirshhorn Museum and Sculpture Garden, Smithsonian Institution, Washington, D.C.; transferred from the Hirshhorn Museum and Sculpture Garden Archives, 1983.

also very much of the there-and-then, and this is the peculiar tension that infuses a picture like *Swimming (The Swimming Hole),* 1885 (Figure 178).

On one level, it is a wholly "classical" picture. Its scheme is Arcadian and virile—healthy bodies at play, in and out of their element—and its ancestry includes Roman sculpture and the prints of bathing soldiers made after Michelangelo's lost *Battle of Cascina.* The figure lying on the rock is the *Dying Gaul,* reversed; a cast of this sculpture was in the Academy's collection. The broad stability of the triangular composition reminds you of Poussin.

But it is also based on photographs of Eakins's students, whom he posed for the purpose (Figure 179). And while it reminds you of a pediment frieze, it actually tries to outdo photography's grasp of the instant: the arms and head of the youth diving into the water have thrown up a spray that no camera available in 1883 could record. This interweaving of the old and the new had a further purpose. *Swimming* is a discreetly homoerotic image. Eakins took one of the chief themes of classical art—loving companionship between men and boys—and brought it up to date. He wanted to thaw the sexual content of such classical motifs out of the cold, dusty plaster of the Academy. The beautiful figure of the standing youth, buttock thrust out, is as erotically coded as Donatello's *David,* and the whole image is permeated by the feelings Walt Whitman released in his description of young Americans bathing, surrendering themselves to sensation:

> The beards of the young men glistened with wet, it ran from their long hair,
> Little streams pass'd all over their bodies,
>
> An unseen hand also pass'd over their bodies,
> It descended tremblingly from their temples and ribs,
>
> The young men float on their backs, their white bellies bulge to the sun, they do
> not ask who seizes fast to them,
>
> They do not think whom they souse with spray.

No public allegations of homosexuality were made against Eakins in Philadelphia, and there is no evidence that he had an active gay life. But in the early 1880s he was in trouble for the sexual frankness of his teaching methods. Parents worried about exposing their children, especially their daughters, to Eakins's life class. One catches the tone in a furious letter written to the Academy by one such mother, protesting in the name of idealism and prudery:

> Where is the elevating ennobling influence of the beautiful art of painting in these studies? The study of the beautiful in landscape & draped figures, and the exqui-

sitely beautiful in the flowers that the Heavenly Father has decked and beautified the world with, is ignored, sneered at—and that thing only made the grand object of the Ambition of the student of Art, which carries unholy thought with it, that the Heavenly Father himself covers from the sight of his fallen children.

In 1886 Eakins was forced to resign from his teaching post at the Academy, ostensibly because he had pulled the loincloth off a male model in front of a class of students that included women, an act considered shocking. Though fifty-five of his students petitioned the school to reinstate him, the great teacher was now ostracized and more rumors of scandal followed; he found another teaching job at the Drexel Institute but was fired from it in 1895 for exposing another model to a mixed class. His enemies also whispered that he had gone further and exposed *himself* to young women during classes in the privacy of his own studio. "Was ever so much smoke for so little fire?" Eakins complained.

One of the alleged student-victims of this harassment, though she never claimed it had happened and loyally defended Eakins through the 1890s—she said that her teacher had merely been settling a point about the anatomy of the thigh and groin—was Amelia Van Buren. She had taken Eakins's classes at the Pennsylvania Academy right up to his expulsion, and Eakins painted her portrait c. 1891 (Figure 180). She was still in her twenties, but in the painting her pensive, drawn expression and the gray streaks in her hair make her look middle-aged. Eakins excelled at painting thought. He was a patriarchal Victorian and perhaps a bit of a sexual bully as well, but he knew quite well that cogitation was not the act of men only, and he was morally incapable of turning out the kind of female image—drooping or spectacularly *en fleur,* vapid or discreetly vampy, but always passive—that "refeened" American taste in the 1890s preferred. In this image, "Minnie" Van Buren becomes a female equivalent of his more withdrawn male portraits, like the standing figure of his brother-in-law, Louis Kenton: a tired, lanky, rather sallow creature, intelligent and vulnerable, gazing without illusions into the light from the studio window. You know that she, too,

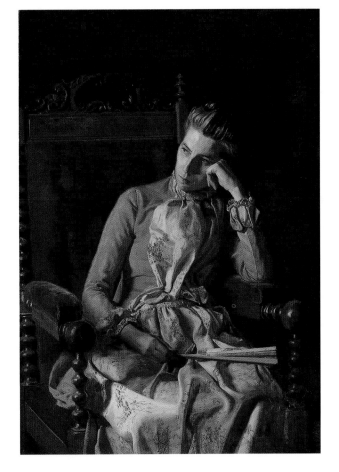

180. Thomas Eakins, *Miss Amelia Van Buren,* c. 1891. Oil on canvas, 45 × 32" (114.3 × 81.2 cm). The Phillips Collection, Washington, D.C.

is a realist, and has her ex-teacher's respect. His disillusionment has gotten into her. "My honors," wrote the embittered Eakins in 1894, "are misunderstanding, persecution and neglect, enhanced because unsought."

Vexed by backbiters, he made one significant new friend in these difficult years: Walt Whitman. The two met in 1887 and were close "comrades" until the poet died five years later. Eakins was twenty-five years Whitman's junior—a mirror reversal of the relationship he had with his own younger students. The fact that both men were controversial figures must have supplied a bond, but Whitman never wrote anything about Eakins: his admiration for the painter survives only in reported conversations, but it was clearly intense. In 1888 Eakins painted Whitman's portrait (Figure 181), a freely brushed study of a ruddy-cheeked old man who might have been one of Frans Hals's topers. "How few like it," commented Whitman. "It is likely to be only the unusual person who can enjoy such a picture—one who can weigh and measure it according to his own philosophy. Eakins would not be appreciated by the artists, so-called. . . . [T]he people who like him best are the ones who have no art prejudices to interpose." What these slightly nebulous words convey is surely Whitman's belief that Eakins was a democratic artist, capable of reaching the heart of a common, nonspecialist audience with his plain visual truths—the kind of artist that Whitman conceived himself to be. In return, Eakins said that when it came to painting Whitman, he "soon found out that technique, rules and traditions would have to be thrown aside; that, before all else, he was to be treated as a *man*."

Eakins's influence on his students can be gauged from a single painting by Thomas Anshutz (1851–1912): *The Ironworkers' Noontime*, 1880 (Figure 182). The Kentucky-born Anshutz attended Eakins's classes at the Pennsylvania Academy and later succeeded him in his teaching post after Eakins's dismissal. His output was not large, and he is known mainly through this one picture of iron puddlers stretching and relaxing at the midday break in the foundry yard. (By one of art's little ironies, *The Ironworkers' Noontime* briefly became the most expensive of all nineteenth-century American paintings; it made $250,000 at auc-

181. Thomas Eakins, *Walt Whitman*, 1888. Oil on canvas, 30⅛ × 24¼" (76.5 × 61.6 cm). The Pennsylvania Academy of the Fine Arts, Philadelphia; General Fund.

tion in 1973 and was later acquired by John D. Rockefeller III, whose grandfather had been a ruthless union breaker, for twice that amount.)

Anshutz believed wholly in the realist idea, as taught by Eakins. And he exaggerated it a bit. In his early twenties, he wrote about wanting to "go out into some woebegotten, turkey chawed, bottle-nosed, henpecked country and set myself down. Get out my materials and make as accurate a painting of what I see in front of me as I can." Maybe this was true of his youthful plein air landscapes, but it wasn't the way he did the tight, crowded little composition of *The Ironworkers' Noontime*. Like Eakins, he assembled it from studio sketches, memories of antique sculpture, and possibly photographs.

Anshutz had spent much of his childhood in the iron town of Wheeling, Virginia, and the daily sight of the factories, the forges, and the ironworkers must have inoculated him against the melodrama which earlier American painters put into such scenes. This was a legacy from English Romanticism and its images of the "industrial sublime": the furnace seen as an Etna belching fumes and lava, the associations with Vulcan's forge or the fires of Hell tended by blackened

182. Thomas Anshutz, *The Ironworkers' Noontime*, 1880. Oil on canvas, 17⅛ × 24″ (43.5 × 61 cm). The Fine Arts Museums of San Francisco; gift of Mr. and Mrs. John D. Rockefeller 3rd.

demons. The demon imagery had further resonance in America, since most iron-workers were either despised African-Americans or immigrant foreigners, Micks, Wops, Polacks, Krauts, Hunkies—brutes and strangers, either way.

Anshutz's little painting carries none of this symbolic traffic. It is a double rarity: first, because it was painted at all—scenes of industrial work were the last things that the respectable American middle class, with its pastoral taste and genteel liking for "uplift," wanted to have on their walls: farmers yes, fishermen maybe, foundry puddlers no; and second, for its straightforward treatment of its subject. A frieze of young men, some bare to the waist, stretching and horsing around against the bare, smoky perspective of a millyard. The color is somber—slag gray, black, rust brown—and against these tones the men's pale skin stands out in sharp relief. Several of the figures come, despite their contemporary appearance, from antique models: the young man in the foreground rubbing his bicep, for instance, derives from a plaster cast of a bas-relief of a standing youth from the Panathenaic frieze on the Parthenon, which hung on the classroom wall of the Pennsylvania Academy when Anshutz was a student. In the coherent mechanism of the group one sees afterimages not only of machinery itself—the limbs like cranks and connecting rods—but also of Poussin's figure groups, and perhaps of Degas's *Young Spartans Exercising* (1860–62), which Anshutz may well have known from reproduction.

It is not a "socialist" picture, in the sense of depicting downtrodden workers at the mercy of a boss or a system. Nonetheless, it is matter-of-fact in its clear modeling and sober color, and its figures have the dignity of fact. They look self-possessed, each one his own man; but they are also a team. It's a piercing image of American youth and strength, feeling its new muscle (literally so, in the case of the foreground figure) in the industrial awakening that followed the Civil War. In their self-sufficiency, young Anshutz's workers are the proletarian cousins of Eakins's middle-class oarsmen. The painting's political content, if that is not too heavy a phrase, probably has less to do with socialism as such—although there were certainly Americans in the 1880s who would have read *any* attempt to paint ironworkers as a socialist gesture—than with a general ideology of manliness and toughness, which would reach its apogee in the oncoming years of Theodore Roosevelt, the Rough Riders, "muscular Christianity," and "strenuous delight." Its tone was set by Roosevelt in a speech entitled "In Praise of the Strenuous Life," delivered in Chicago in April 1899:

> The timid man, the lazy man, the man who distrusts his country, the overcivilized man, who has lost the great fighting, masterful virtues, the ignorant man and the man of dull mind . . . all these, of course, shrink from seeing the nation undertake its new duties. . . . These are the men who fear the strenuous life, who fear the only national life that is really worth leading. . . .

This emphasis on the masculine reacted to what many Americans from the 1880s on saw as a gap, even a crisis, in their culture. America's industrial and business environment was abundant, booming, brutal, and young. But to the realists, its art and literature looked sissified, pious, neurasthenic, and "feminized." The Home—for which we would now read, "family values"—with its attendant imagery of maternal care, little-angel children, and "sensitive" repression of the satyr in the husband, was an oasis of propriety against the dog-eat-dog strife of the world outside. Innumerable novels, paintings, plays, and poems were dedicated to reinforcing these fantasies. Over them ruled the inexorably proper American Madonna, keeper of the hearth and promoter of all refinement. In such a scheme, the chief purpose of "culture" was to promote gentility. "There is no doubt," quipped Oscar Wilde after his American lecture tour, "that within a century from now the whole culture of the New World will be in petticoats."

Inevitably, culture produced a reaction against this threatening feminization of America, which is still, one may surmise, enshrined in the figure of the Statue of Liberty—the biggest stern nanny in the world. It came in the form of hypermasculine fiction which viewed society and the world as a scene of Darwinian struggle for survival and domination—as in the writing of Stephen Crane, Frank Norris, and Jack London. It also affected painting, and one of its signs was the swift rise of Winslow Homer (1836–1910) to the status of an icon. Homer, like Frederic Church, showed that an artist could be both profound and popular; his work caught a national mood and became a model for younger artists. For although Eakins's *Gross Clinic* may have been America's greatest single picture of the late nineteenth century, Winslow Homer was probably its finest all-around painter.

Like John Singleton Copley, Winslow Homer was self-taught and from Boston. His mother was an amateur artist, encouraged (a rare enough thing in its day) by her husband, a hardware importer. In the 1850s Boston had no art school, and although his parents encouraged their son to paint, the only training young Winslow Homer received was purely commercial—a stint in the workshop of a jobbing lithographer, which led to illustration work for magazines. It was as a visual journalist that Homer, aged twenty-five, was sent to cover the Civil War in 1861 by the wide-circulation magazine *Harper's Weekly*. His images of that war launched his career as a painter.

Homer was not a "war artist" in the accepted European sense. That is to say, he did not do set pieces of battles, charges, and parades. (He did draw a few for publication, but they were clearly imaginary and derivative.) The Civil War produced very few such commemorative paintings, and none of real merit. Americans did not appear to want them.

In his Civil War paintings, Homer's natural bent showed early: it was for genre scenes of limited action, usually in camp—realistic, unrhetorical, setting down the truth of a particular moment. In this they succeeded, so that Homer's work remains the most truthful visual record of the Civil War, outside of photography, that has come down to us. In what is probably his earliest oil painting, *Sharpshooter*, 1862–63, he caught the implacable objectivity of a Union sniper perched in a tree, aiming his telescopic-sighted rifle at a target out of view; the sniper's remote death-dealing, he wrote, "struck me as being as near murder as anything I could ever think of in connection with the army & I always had a horror of that branch of the service." He made one painting of a Confederate private standing up to defy the far-off Union troops with a rebel yell; the fact that it is "taken" from behind the Southern lines shows that Homer imagined the scene. Otherwise his images are mostly vignettes of everyday camp life: a soldier on punishment duty, another sticking out his tongue for the suspicious doctor, a third devouring a big slice of pie, and Zouaves pitching quoits or whittling a briar pipe. His finest piece of reportage—and his most popular early painting—was *Prisoners from the Front*, 1866 (Figure 183), which shows a Union officer, General Francis Barlow, receiving three Confederate soldiers captured at the battle of Spotsylvania: a young, tough, defiant Virginia cavalryman, a grizzled old vet, and a lumpish "poor white" boy who gazes stupidly, hands in his pockets, from the left of the group. This image has been praised for its evenhandedness, but it's hard to see how, short of caricature, Homer could have come up with a clearer ideological

183. Winslow Homer, *Prisoners from the Front,* 1866. Oil on canvas, 24 × 38″ (61 × 96.5 cm). The Metropolitan Museum of Art, New York; gift of Mrs. Frank B. Porter, 1922.

image of the difference between the two sides of the Civil War. On the one hand, the frank, articulate intelligence of Barlow, whose face is as sensitively drawn as that of Robert Shaw in Saint-Gaudens's memorial on Boston Common; on the other, the mean-as-hell firebrand look of the Southern cavalier, with behind him the old man who is too old to change, and the cracker kid who is too dumb to develop.

The painting that sums up the meaning, if not the whole story, of Homer's Civil War experience was done in 1865, a few months after Lee's final surrender at Appomattox. It is *The Veteran in a New Field* (Figure 184). Not one of his Civil War paintings shows a dead body, but this one allegorizes death. It has both a narrative and a symbolic level. A man in a white shirt, whose face we don't see, has gone back to his farm and is mowing the wheat, which stretches to the blue band of the horizon. His jacket and water canteen, lying on the ground, identify him as a former Union soldier. The composition is stark: one man, two planes of color—the stalks of wheat rapidly conveyed in ocher with umber streaks of shadow rising through them from the ground—and the crooked diagonal of the scythe, at the end of its swing. We are meant to think of Isaiah 2:4: "And they shall beat their swords into plowshares, and their spears into pruning-hooks: nation shall not lift up sword against nation, neither shall they learn war any

184. Winslow Homer, *The Veteran in a New Field,* 1865. Oil on canvas, 24⅛ × 38⅛" (61.3 × 96.8 cm). The Metropolitan Museum of Art, New York; bequest of Miss Adelaide Milton de Groot, 1967.

more." Those who saw the painting in 1865 would have needed no reminder that the Northern armies were largely volunteers, not professional soldiers; that they went back to a very different life after the South surrendered; that they all had something in common with that earlier ideal of American citizenship, the Roman general Cincinnatus, to whom George Washington was frequently compared.

But why "a *new* field"? The wheat is mature, the land (presumably) belonged to this veteran before the war. Here a darker allegorical level comes in. One of the commonest images in writing and preaching about the Civil War was that of Death the Reaper. It was reinforced with biblical texts, such as Isaiah 40:6–8:

> All flesh is grass, and all the goodliness thereof is as the flower of the field: The grass withereth, the flower fadeth: because the spirit of the Lord bloweth upon it: surely the people is grass. The grass withereth, the flower fadeth: but the word of our God will stand for ever.

The new field of ripe wheat is meant to remind us of the soldier's previous, "old" field: the ghastly battlegrounds where the ripe youth of America was mown down. (And two of the bloodiest battles of the Civil War, Antietam and Gettysburg, were fought in wheat fields.) Homer will not let you forget that this reaper was also Death. To make sure of this, he used a deliberate anachronism: the single-bladed scythe, Death's immemorial symbol but not an implement that farmers, in 1865, were apt to use. They reaped with the "cradle"—a scythe with five or six parallel slats to hold the wheat stalks—or, on larger and more prosperous farms, with the steam-powered harvester. Indeed, the traces of a cradle scythe remain in the paint surface as a pentimento: Homer painted this factual detail out to make his symbolic point. And so an image that ostensibly spoke

of sunlit peace and reconciliation remains a harsh and troubling one, and presages the symbolic notes that will flicker in and out of Homer's art over the next forty years, making it very much more than a celebration of America the beautiful.

But after the war, Homer—like all other American artists—painted as though the trauma was best forgotten. Writers meditated incessantly on the Civil War, but not painters, and especially not Homer. To say that he "regressed" is unfair, but he did construct an ideal-but-real subject matter as far from death and suffering as possible.

This was childhood. He painted the life of American children as a distinct state, a perfect enclosure. Adults do not impinge on their lives much. He did not paint them with their parents, but you know their lives are secure. Outside his New York studio in the 1870s were other parentless children, the abused tykes who, as most social observers agreed, were becoming an insoluble problem, living as thieves and prostitutes in an underclass from which no education or philanthropy could as yet release them. Homer did not paint those. His children were of the farm and the seashore; they were part of the large-scale idealization of childhood which took hold in America in the 1870s, largely in reaction against the war. Popular American painting was glutted with rubicund infants chewing blueberries, and their older brothers, in ragged pants, tapping maple sap or skinning the coon. Homer's children, though sentimental at times, are better than that; they are cognate with such books as Louisa May Alcott's *Little Women* (1868–69) and Mark Twain's *Tom Sawyer* (1876). They are *potential* America, the stock from which renewal will spring in the aftermath of the Civil War—young, strong, quick-witted, practical, and without pretense. They reflect, they are earnest; they embody the inwardness of childhood. Homer shows them learning skills (sailing, fishing, clamming, egg-hunting, boatbuilding, farm work) and getting their education in the schoolhouse. *Breezing Up*, 1876 (Figure 185), his most popular work after *Prisoners from the Front*, is such a picture: three kids learning to sail, skippered by an older youth. From the foam around the rudder to the abstract rigging shadows on the taut mainsail (whose pattern rhymes with the silhouette of the schooner on the horizon), it is full of nautical truth, but it's the sense of generational renewal and physical delight that captivated Homer's audience. Sometimes his childhood images distantly reflect memories of war, but only as a faint tremor on the edge of awareness: the boy protecting his timorous younger brother in *Crossing the Pasture*, 1872 (there is a bull in the background, which might charge them), carries a long switch at the shoulder arms position of a military rifle. Homer's paintings of the active figure also reach for a rough kind of classical energy. The frieze line of kids running parallel to the picture plane in *Snap the Whip*, 1872 (Figure 186), brings to mind the dancing putti on Donatello's Cantoria in Florence.

185. Winslow Homer, *Breezing Up (A Fair Wind)*, 1876. Oil on canvas, 24⅛ × 38⅛" (61.5 × 97 cm). National Gallery of Art, Washington, D.C.; gift of the W. L. and May T. Mellon Foundation.

Henry James recoiled from Homer's "little barefoot urchins and little girls in calico sun-bonnets." They were "almost barbarously simple" and "horribly ugly," but they won you over: "He has chosen the least pictorial features of the least pictorial range of scenery and civilization; he has resolutely treated them as if they *were* pictorial, as if they were every inch as good as Capri or Tangiers; and, to reward his audacity, he has incontestably succeeded."

This was what his American audience liked most. What seemed a barbarous vernacular to James looked quite natural to them. Homer, as another writer put it, "resolutely refuse[d] to imitate in [his] methods any of the fashionable foreign masters whose works are so much sought after by American collectors." This was not quite true—there are certainly echoes, in Homer, of some contemporary French realists—but it indisputably applied to his American social subject matter, into which he went deeper than any other American artist of the day. A case in point is how he painted American blacks, completely avoiding the stereotypes with which their collective image had been flooded during the period of Reconstruction after the Civil War. The 1870s and 1880s produced innumerable images of Negroes at carnival time, mindless, jolly, condescending. But Homer's *The Carnival*, 1877 (Figure 187), is unlike all of them: a deeply nuanced and, in the end, tragic scene of preparation for festivity. A group of people is preparing for the African-American festival known in the South as Jonkonnu and in the North as Pinkster. It entailed the costuming of a Harlequin-like figure or Lord of Misrule, and this Homer depicts: a man caparisoned in bright, tatterdemalion clothes, yellow, red, and blue, with a "liberty cap" on his head. Two women are sewing them on him. The one on the right extends her arm, pulling the long thread right through, in a gesture of compelling and somber gravity; she is a classical Fate, seen below the Mason-Dixon line. Next to her, but apart from her, gaz-

186. Winslow Homer, *Snap the Whip,* 1872. Oil on canvas, 12 × 20″ (30.5 × 50.8 cm). The Metropolitan Museum of Art, New York; gift of Christian A. Zabriskie, 1950.

187. Winslow Homer, *The Carnival,* 1877. Oil on canvas,
20 × 30″ (50.8 × 76.2 cm). The Metropolitan Museum of
Art, New York; Amelia B. Lazarus Fund, 1922.

ing at the vesting ceremony with wonder, are some children, one of whom holds a Stars and Stripes (for by Reconstruction, the rituals of the Fourth of July had been overlaid on those of Jonkonnu). Homer makes us sense how far the hopes of emancipation still are from the realities of black life in the South.

Homer's knack for picking distant echoes of the classical from the forms of everyday life, and then recapturing in paint some trace of their original energies, shows in the paintings that followed his trip to England in 1881. After a brief spell in London, he settled in the village of Cullercoats, near Newcastle, and painted the fisherfolk there—the men, massive in their rain-slicked oilskins, and the women mending nets and waiting onshore. His sense of form was changing. In New England his figures, whether of women or of children, had tended to be "artless," suggesting that Homer's eye had caught them in accidental poses. Not here. His Cullercoats work was consciously monumental. The distended shapes of windblown clothes gave these already robust female figures a strong, sculptural character. You can feel the gale blowing their aprons into spinnakers. Homer must have been looking at the Parthenon marbles in the British Museum, with their fluent drapery, wet or windblown, rippling across limbs and torso. He could not have got this vigor of form from English artists who used *draperie mouillée* as a half-sexy, half-classicizing device to suggest passivity and languor— Alma-Tadema in his scenes of Roman life, for instance. He was improvising from the source. Sometimes these stalwart women in their shawls, silhouetted against the scudding gray sky, have the very air of Greek mourners. When his Cullercoats studies were seen in America, critics noted two things: his mastery of watercolor and the intense gravity Homer had learned to give the figure as a symbol of endurance. The lessons of Cullercoats would never leave him; though he could, on occasion, work in a lighter vein, it was there that he found the basic frame of his later imagery: man (or woman) against the sea, the self in the enormous, indifferent context of nature. The epitome of this was *The Life Line*, 1884 (Figure 188). Homer saw the event on the New Jersey coast: a lifeguard rescuing a woman from a shipwreck by means of a breeches buoy. What strikes you today is less the drama of the sea—though that is magnificently painted, with a climactic burst of white foam silhouetting the woman's head—than the sexual mood of the image. The strong man and the swooning woman are bound together, their limbs interlaced; she lies back in unconditional surrender, her soaked clothes skin-tight across her breasts and thighs. It is a *Liebestraum*, a none-too-constrained American version of the image that Kokoschka would paint, decades later, in his self-portrait with Alma Mahler blown along by the storm winds. How conscious was this? Impossible to know. Perhaps the celibate Homer was painting a memory of his desire for a woman he is said to have courted in Cullercoats. Perhaps a sign of repression is the woman's red scarf, which blows in the wind and hides her rescuer's face: the man with the hidden identity bearing her to

188. Winslow Homer, *The Life Line,* 1884. Oil on canvas, 28⅝ × 44¾″ (72.7 × 113.7 cm). Philadelphia Museum of Art; George W. Elkins Collection.

safety (and intimacy) from the grip of the storm may be, as the art historian Jules Prown observed, Winslow Homer himself.

Homer is rarely as simple as he looks. The idea most people had of him thirty or even twenty years ago, as a one-level narrator of American work, sport, and vigor, was plainly insufficient. To reduce him to that is like calling Herman Melville a writer of whaling yarns—which he was, but only for a start. The sea was Homer's great subject, and no artist since Turner had painted its many moods with such lyric concentration, from the beaming blue transparency of the Caribbean to the sullen, tremendous repetition of gray combers driven by an Atlantic gale on the rocks of the New England coast.

He understood the structure of waves, currents, surges, loops of foam; the sheer power of water, its relentlessness, and its strange, fickle, maternal beauty. Like Melville's Ishmael, he wanted "to go about and see the watery part of the world." In 1875 he had briefly visited Prout's Neck, a narrow spit of rocky coast in Maine. Now, in the spring of 1883, he made a momentous decision. He shut down his New York studio and moved to Prout's Neck, which is remote enough from New York now but in the 1880s—especially in the winter—would have been intolerable for anyone without a marked taste for solitude. It perfectly suited a man whose four favorite words, as one of his friends recalled, were "mind your own business." Homer found himself a cottage overlooking the sea. He turned it into a studio, which he called his "factory," a term meant to suggest regular American work with no frills. There, he scrawled above a sketch of it, "the Women cease from troubling and the Wicked are at rest." In the summer members of his family came to Prout's Neck, as did tourists—in fact, Homer supplemented his income from painting with real estate deals. But in the cold months he had the place to himself. None of his paintings remain there, of course, but it preserves a board which Homer painted and would stick up on the path that led

to wherever he was painting. Meant to repel the inquisitive, it read "Snakes, snakes and mice."

Homer would spend twenty-seven years at Prout's Neck, relieved by occasional excursions to New York and by fishing trips to the Caribbean, Florida, and the Adirondacks. Its steep, sea-gnawed granite ledges would be the emblematic landscape of his finest work. Throughout his life he returned to a simple but potentially heroic compositional device: a diagonal that cuts the painting from corner to corner. (The flat horizon line, he said, was "horrible.") The deep, seaward rock slope of Prout's Neck embodied it, and Homer returned to it in picture after picture. Because this area has not physically changed much (there are a few more houses along the top of the slope, but the rock and water remain exactly the same) you feel you are "in" a Homer when you go to Prout's Neck, especially on a gray October day with a hard onshore wind. *Cannon Rock*, 1895, with its high horizon line and broad V of incoming waves framed by dark rocks, exactly captures the sensation of standing on an exposed promontory with the sea coming straight at you, like a wall. On the other hand, Homer did not simply view the sea as a challenge and a danger. His sea pieces, even when the weather is bad, are seductive: they have an element of allure that hovers just on the fringe of apparition, as when a wave breaks on the rocks in *West Point, Prout's Neck*, 1900 (Figure 189), and flings up an S curve of foam that might, with a little more definition, be a sinuous white torso—the ghost of a female presence, a water-witch.

Just such an image of the sea as impersonal and yet female, a field of masculine effort which also has the traits of enchantress and Mother, was explored by another great artist: Rudyard Kipling. Published in 1897, his novel *Captains Courageous*—a tale of how fifteen-year-old Harvey Cheyne, a millionaire's spoiled brat, is swept overboard from a transatlantic liner in a Grand Banks fog

189. Winslow Homer, *West Point, Prout's Neck,* 1900. Oil on canvas, 30$\frac{1}{16}$ × 48$\frac{1}{8}$" (77.8 × 122.2 cm). Sterling and Francine Clark Art Institute, Williamstown, Massachusetts.

and, after near death, is born into his first manhood by working with the Gloucester cod fishermen who have rescued him—begins with the sea:

> He was fainting from sea-sickness, and a roll of the ship tilted him over the rail. . . . Then a low, grey mother-wave swung out of the fog, tucked Harvey under one arm, so to speak, and pulled him off and away to leeward; the great green closed over him, and he went quietly to sleep.

Harvey's reeducation begins with a whack on the ear from the skipper, and over the coming months he will learn the virtues of guts, stoicism, craft, self-denial, hard work, obedience to authority—all the qualities absent from his pampered life onshore. The rejection of such a life—the artist as tastemonger, making baubles for the cultivated rich—was written all over Homer's removal from New York to Maine; he, too, preferred hardness and self-reliance, and admired those who showed them—"they that go down to the sea in ships, that do business in great waters." Herein lay part of the reason for the popularity of both Kipling and Winslow Homer. In the public eye, the originality of both men was bound up with their virility of feeling and expression. (One American critic dubbed Homer a "virile-Impressionist," to distinguish him from the supposedly effete French kind.) Pessimism was part of it, saving the work from mere jingoism of gender: for Homer no less than for Kipling or Conrad, man is at war with his surroundings in a world that does not care and gives him no natural allies. The moment you step from the social path, whose security is an illusion, all becomes wild and strange, and the sea in Homer's paintings was a metaphor of this perception.

This is explicit in *The Gulf Stream,* 1899 (Figure 190). A black sailor lies on the afterdeck of a dismasted sloop, adrift, rudderless, and wallowing in the deep,

190. Winslow Homer, *The Gulf Stream,* 1899. Oil on canvas, 28⅛ × 49⅛″ (71.4 × 124.8 cm). The Metropolitan Museum of Art, New York; Catharine Lorillard Wolfe Collection, Wolfe Fund, 1906.

turbulent blue. He cannot save himself or control his boat. With one hand he grips a line made fast to a bitt. Enormous sharks circle the boat: the largest of them is clearly a back-reference to Copley's *Watson and the Shark,* with the difference that Homer knew very well what sharks looked like, whereas Copley did not. Their ominousness is subtly reinforced by the zone of black water from which they rise. On the horizon, a square-rigger sails indifferently by. There will be no rescue, and worse is to come: we see the waterspout of a coming tornado, which will overwhelm the boat. Recent Freudian criticism has found in the sharks an image of Homer's sexual anxiety—their mouths, in this version, are the Viennese doctor's far-famed *vagina dentata.* This, one may safely bet, could only occur to someone who has never had an inch of wooden planking between himself and a hungry shark. The immediacy of narrative in *The Gulf Stream* almost convinces you that it is not a fiction—that Homer had witnessed such a scene, which he did not. Instead, he chose to take separate elements of real life that he knew well—shark, boat, black sailor—and conflate them with his memory of images of marine disaster, notably Turner's *Slave Ship* (whose bloody sea is referred to in the flecks of red in the water) and Géricault's tragic but ultimately hopeful *Raft of the Medusa,* producing an image of total pessimism. This, says Homer, is what the Voyage of Life comes down to in the end: hanging on and facing down your death, when all hope is gone and there are no witnesses.

Fox Hunt, 1893 (Figure 191), portrays an animal as existential hero: a starving fox in winter, loping with effort through the snow, harried by sinister crows which, though they cannot kill him, are hastening his death. (To get it right, Homer—who much preferred fishing to hunting—had a friend at Prout's Neck shoot him a fox and a couple of crows. The fox was wired to stakes to make it look lifelike, and he strung the crows on a clothesline above. At night he would

191. Winslow Homer, *Fox Hunt,* 1893. Oil on canvas, 38 × 68½″ (96.5 × 174 cm). Pennsylvania Academy of the Fine Arts, Philadelphia; Joseph E. Temple Fund.

bury the fox in a snowdrift in the position he wanted, so that it froze stiff and gave him a few hours of work the next morning before it went limp again.)

It was not only in such finished and elaborated oils that Homer's best work lay. He was a master of watercolor. Indeed, it was largely due to Homer that watercolor found its place as an important medium in nineteenth-century American art. In structure and intensity, his best watercolors yield nothing to his larger paintings. Watercolor is tricky stuff, reputedly an amateur's but really a virtuoso's medium. It is the most light-filled of all ways of painting, but its luminosity depends on the white of the paper shining through thin washes of pigment. It is hospitable to accident (Homer's seas, skies, and Adirondack hills are full of chance blots and free mergings of color) but disaster-prone as well. One slip and the veil of atmosphere turns into a mud puddle. It demands an exacting precision of the hand—and an eye that can translate solid into fluid in a wink. Homer understood and exploited all these needs of watercolor through long practice, and he applied them where they most belonged—to the recording of immediate experience. He had great powers of visual analysis, and never looked at a scene without resolving it as structure; some of his watercolors of the Adirondack woods, with their complicated shuttle of vertical trunks against a fluid background of deep autumnal shade, are demonstration pieces of sinewy design. His Adirondack paintings, like *The Blue Boat*, 1892 (Figure 192), have the astringent

192. Winslow Homer, *The Blue Boat (Adirondacks)*, 1892.
Watercolor over graphite on very thick, off-white wove
paper, 15⅛ × 21½" (38.4 × 54.6 cm). Museum of Fine
Arts, Boston; bequest of William Sturgis Bigelow.

completeness of the Michigan woods in early Hemingway. The deep ultramarine curve of the boat's hull, the brilliant light and reflections on the water, the alert solidity of the fishermen, the enjoyment of marking and splotting the paper—all come together with perfect unity, as though in a single moment of vision and action.

Though Homer and Eakins were by far the most influential American realist painters of the postwar era, they were not, of course, the only ones. Two artists from Philadelphia, William Michael Harnett (1848–1892) and John Frederick Peto (1854–1907), engaged in a virtual fetishization of the mundane. Their common subject, indeed their obsessive theme, was still-life: Harnett seldom painted the human face or figure, and Peto never did, except when quoting a photograph. Harnett, the more popular of the two—though, in the end, a lesser artist—traded on the relative naïveté that Americans had about illusion at the dawn of the photographic age: less blasé than we are about images, because less drenched in them, his public loved to have its eyes fooled. People associated the trompe-l'oeil painter with the trickster, the con man, the card sharp. *How the hell did he do that?* To be fooled and know you are being fooled (along with others) is a truly democratic joy. "So real is it," wrote a Cincinnati journalist in 1886 about a Harnett called *The Old Violin*, "that [a guard] has been detailed to stand beside the picture and suppress any attempts to take down the fiddle and bow. . . . Mr. Harnett is of the Munich school, and takes a wicked delight in defying the possibilities." To others, Harnett's skills suggested a classical parallel: he was the American Zeuxis, the ancient Greek painter who supposedly could paint grapes so lifelike that birds flew down to peck at them. Little as we know of Harnett, it seems likely that he enjoyed the idea of the artist as forger—the shady implications of the illusionist's tour de force. One of the things he painted, for instance, was money: Treasury bills, as inviting to the American hand as Zeuxis' grapes were to the bird's beak. Desire makes deception, and what is more desirable than money? You may not like a peach, a dead rabbit, or an old visiting card nearly as much. A reproduction, on a flat surface, of a flat (but crinkled) piece of paper— this held unusually rich possibilities of deception, but the trouble was that the U.S. Treasury, not interested in the philosophical questions that surround the shifty point where reproduction ends and forgery begins, took a different view. In 1886 the Feds confiscated a Harnett painting of a five-dollar bill from the wall of a New York saloon and visited Harnett's studio with the intent of arresting him for forgery. He talked his way out of it.

The son of an immigrant Irish shoemaker from Cork, Harnett died of kidney failure at the age of forty-four. His earliest paintings, done in the 1870s, are stiff, naïve, and curiously old-fashioned; you could almost take them for the work that

Raphaelle Peale, America's first still-life artist, had been doing in 1815. (And yet he probably never saw a Peale, whose work had sunk from sight long before.)

By the end of the decade, his style had matured. *The Artist's Letter Rack,* 1879 (Figure 193), is a collation of letters, visiting cards, and a theater ticket, the meager index of an artist's social life, held by a crisscrossed square of pink tape to an unvarnished pine board. Everything is actual size, and the flatness of the board corresponds to the flatness of the painting, so that the illusion is perfect. The marks of pencil and chalk on the board look like chalk and pencil, not oil paint; each grain line in the cheap wood and fuzzy fiber in the torn paper edges is there, and the play of the yellow and blue rectangles against the square of tape has the lovely spareness of a Motherwell collage.

Harnett's work was made in a time when America was flooded, as never before, with brand-new, machine-made, mass-marketed, store-bought goods. And yet these never appear in his paintings. As he put it (in his sole recorded comment on his own work): "The chief difficulty I have found has not been the grouping of my models, but their choice. To find a subject that paints well is not an easy task. As a rule, new things do not paint well. . . . I want my models to have . . . the rich effect that age and usage gives." Preferring the worn and old to the new and shiny, he also avoided the richness of the "antique": almost nothing depicted in Harnett's work is precious, unlike the exquisitely blown glass or the cunning orfevrerie in a seventeenth-century Dutch or Spanish still-life. His paintings, in other words, are not emblems of material glory and bear no relation to the show-offy, accumulative, value-choked spirit of America in the Gilded Age. The objects in them are not antiques, but bric-a-brac: in a word, junk. They are what the new rich consign to the attic as they rise, and eventually throw out. An exception to his refusal of newness was printed media—not only Treasury bills but souvenirs of the enormous mass of handbills, chromos, sheet music, newspapers, pamphlets, and the rest that were pouring from America's mechanical presses. The act of meticulously hand-painting images that were in fact mechanical in origin was perverse.

When Harnett—and Peto, too—painted their pipes, horseshoes, worn boxes, dented candlesticks, and rusty-

193. William Michael Harnett, *The Artist's Letter Rack,* 1879. Oil on canvas, 30 × 25″ (76.2 × 63.5 cm). The Metropolitan Museum of Art, New York; Morris K. Jesup Fund, 1966.

hinged cupboard doors, few of these "models" were more than fifty years old. They all bear the marks of recent social use. But the implication is that the society that used them is vanishing or has gone, and has become an object of nostalgia. Harnett, in 1890, painted an ivory-handled revolver hanging by the trigger guard on a nail. He called it *The Faithful Colt*: it is old (thirty years old, this 1860s model) and belongs to the era of the Civil War and the opening of the West, in which, its title implies, it once did yeoman service. The work of these illusionists suggests a vanished age to us in the 1990s, but the real point is that it also suggested one to *their* audience.

Nostalgia, in the America of the 1880s, was a new kind of emotion. It consisted of a warm but anxious regard for a past which was still notionally within reach, but was perceived—correctly—as slipping away. This was the past of a less complicated and accelerated America, sparsely but sufficiently endowed with handmade objects rather than glutted with machine-made ones. It is largely a masculine domain, the "world of the fathers," with its much-fondled briar pipes, rusty horseshoes, and tattered books: no mothers are commemorated, since there are no objects such as sewing instruments or kitchen utensils that might be identified with the work of women. Thus Harnett, Peto, and their illusionist confreres sought, with some accuracy, a fault line in American history: the way in which America's eager anticipation of the future turned, for some Americans at least, into a more hesitant, qualified, and doubt-ridden view of progress.

The sources of this nostalgia run back to the social wounds and convulsions of the Civil War. For John Frederick Peto, the further emblematic event was the death of Abraham Lincoln. On the night of April 14, 1865, John Wilkes Booth, a Virginia actor aged twenty-six, calmly entered Box 7 of Ford's Theater in Washington and fired one round from a .44-caliber derringer into the back of President Lincoln's head. He thus became the first in a long line of American celebrity assassins.

The murder of John Kennedy in 1963 set off a long wave of mourning for an imagined Camelot, and turned the young President into the god of a mawkish celebrity cult. But the shock of Lincoln's death was worse. He was the very first President to be killed; no such event had been even remotely imagined by Americans before 1865. Moreover, Lincoln was a political hero who had won the Civil War and freed the slaves. Thus his murder diffused a sense of irreparable loss in America, mingled with factional hatred and distrust, which was still felt thirty years later. To Henry Adams, writing in the early 1900s, it seemed to have thrown Americans into a state of mind without connection to the past; no security could be assumed; it was a secular analogy to the death of God. An elegiac tone spread through the arts. Walt Whitman expressed it at its highest level in "When Lilacs Last in the Dooryard Bloom'd," one of whose movements reflects on what visual images could possibly help to console and heal the bereaved nation:

O what shall I hang on the chamber walls?
And what shall the pictures be that I hang on the walls,
To adorn the burial-house of him I love?

Pictures of growing spring and farms and homes,
With the Fourth-month eve at sundown, and the gray smoke lucid and bright,
With floods of the yellow gold of the gorgeous, indolent, sinking sun, burning, ex-
 panding the air,
With the fresh sweet herbage under foot, and the pale green leaves of the trees
 prolific,
In the distance the flowing glaze, the breast of the river . . .

Like a dead pharaoh, Whitman's Lincoln takes art into the grave with him—and the art is Hudson River School landscape. Not the triumphalist visual rhetoric of a Church, still less a Bierstadt, but more contemplative and autumnal images, full of haze and sunset, such as would presently be painted by George Inness.

The image of the martyred Lincoln recurs frequently, even to the point of obsession, in John Frederick Peto's paintings from the 1890s on. It takes the form of a daguerreotype, pinned to the board or pushed under a tape. Peto's own fa-

ther died in 1895, and it has been plausibly suggested that he associated his father's death with Lincoln's, personal with national loss. In *Reminiscences of 1865*, 1897 (Figure 194), the nicked oval photograph of Lincoln shares the board with a couple of rough, emblematic carvings in its wood: the date "65," and the name "ABE." But hanging on a string from a nail above Lincoln's head is an old horn-handled bowie knife. Peto family tradition had it that this weapon was picked up on the field of Gettysburg by the artist's father-in-law, who served as a corps drummer for General Grant. Now it is a rusty Sword of Damocles, suspended by a thread above the President; and its blade obscures, or cuts off, the word "Head" in the card behind it, which originally read "Head of the House." In *Lincoln and*

194. John Frederick Peto, *Reminiscences of 1865,* 1897. Oil on canvas, 30 × 22″ (76.2 × 55.9 cm). Wadsworth Atheneum, Hartford, Connecticut; The Ella Gallup Sumner and Mary Catlin Sumner Collection Fund.

the Star of David, 1904, a connection is implied behind the Lincoln photo, this time tucked behind an opened envelope, and a Star of David scratched in the wood across from it. The two are separated by a fissure in the wood, a small, dark chasm. This, Peto seems to say, is the lost Moses who did not live to see his people led out of Egyptian bondage into the promised land.

Such Petos are darker in spirit and suggest more violence than anything by Harnett. In *Lincoln and the Star of David,* the wooden board is not just worn but riven to the point of disintegration; rusty nails stick out of it, one point-first, and fire is implied by the dead and the live match and the burning cigarette. Compare Peto's *Old Time Letter Rack,* 1894 (Figure 195), to Harnett's *Artist's Letter Rack* and you see an encroaching chaos: the tapes are more torn, things dangle or have been brusquely ripped away, everything except the image of Lincoln bears the trace of small ravages. Later, after Kennedy's death, Robert Rauschenberg would achieve a similar sense of disintegration mixed with iconic intensity in such paintings as *Retroactive,* 1964—the very title implying nostalgia, a looking-back—in which the image of Kennedy shares the space with (among other things) a photograph by Gjon Mili restaging, with strobe flash, Duchamp's *Nude Descending a Staircase*—and ends up looking exactly like Masaccio's figures of Adam and Eve expelled from Paradise in the Brancacci Chapel, thus connecting the dead politician to one of the most powerful symbols of loss in Western art. Rauschenberg and Peto have much in common. Both are storytellers reflecting on history in an oblique way, one through objects and the other through recycled images; both devise rebuses, stopping just short of an annoying literalism.

The deeper side of Peto was not appreciated in his own lifetime. He was praised in terms of what Americans traditionally liked: craftsmanship, skill, and illusionistic power. But his anxiety and the hints of a collapsing social order figured in the entropy of his objects were lost on the viewers, who preferred the more straightforward and narrative-bound works of Harnett.

195. John Frederick Peto, *Old Time Letter Rack,* 1894. Oil on canvas, 30 × 25″ (76.2 × 63.5 cm). Museum of Fine Arts, Boston; bequest of Maxim Karolik.

. . .

The harshest form of realism belonged to the lens of the camera, when turned on the city. A bird's-eye view of Manhattan at the end of the 1880s showed a clean, progressive grid, rational in most of its layout. At street level it was very different. There, in the civic entrails of Five Points and other slum areas, it held a concentration of human misery as bad as modern Calcutta or eighteenth-century London, where three families could live packed in a basement room and many of the streets were still unlit sloughs. The Tenth Ward of lower Manhattan—the Lower East Side, around Orchard Street—had, by the 1890s, the highest concentration of people in the world: 344,000 people packed into one square mile, or nine square yards each, including street and pavement space. There were, it was thought, 11,000 sweatshops turning out clothing, cigars, furniture, and tinware. Swollen by the influx of European and Asian immigrants whose lifeways and labor were to irrevocably change American society after 1880, the Manhattan of the working poor and the destitute was less a city than a collection of villages, ethnic enclaves divided by their different languages and cultures of origin. Thus divided, they were ruled by corrupt Tammany bosses, bad cops, and slumlords. No painter did more than touch the fringe of this Manhattan; there could have been no market for its images. Some journalists wrote about it, generally in terms of prurient sensationalism, as though describing the behavior of remote tribes in the Congo. The person who opened the subject to a wide public was a photographer and writer, Jacob Riis (1849–1914); and his photographs, though not without their ambiguities and condescensions, became to American inequality what those of Brady's team had been to American war.

Born in Denmark, a schoolmaster's son, Riis immigrated to America in 1870. Before leaving, he spent his last forty dollars on a pistol to defend himself against the Indians and bisons he thought he would encounter on Broadway. Like millions of other immigrants, he had to scrape and shift to survive in what he had imagined was a land of plenty, in brickyards and steelworks, as a lumberjack and a trapper, before fetching up with the New York *Tribune* as a police reporter in 1877. The nature of American journalism was already changing. With the explosion of advertising after the Civil War, the scrum of competing newspapers needed to reach the biggest audience they could find, and this meant a boom in human-interest stories—not just about the social elite or the politically powerful but about "the other half" and how it lived. Poverty sold print. As a spectacle, it pricked the conscience of the comfortable and excited pity and terror among the less so, who, living precariously just above the working class, were afraid of falling back into its maw. Hence the growth of muckraking journalism—the very phrase was an invention of the day. Riis became New York's chief reporter of urban blight. It was his moral vocation, his mission. But words alone would not suffice. The camera, paragon of fact, would provide the undeniable evidence. "I

wanted to show," Riis would declare, "as no mere description could, the misery and vice that I have noted in my ten years of experience, and suggest the direction in which good might be done." In 1887 Riis got amateur photographers to go with him on his night safaris into lower Manhattan. Then he learned how to use a camera himself, and published the first results (together with line engravings based on his photos) as a book, *How the Other Half Lives*, in 1890. It was a best-seller and ran through several editions.

Of Riis's passion for social reform there could be no doubt. "When brotherhood is denied on Mulberry Street we shall look vainly for the virtue of good citizenship in America. . . . You cannot let men live like pigs when you need their votes as freemen." But, no doubt because he, as an educated Scandinavian, felt somewhat superior to the "queer conglomerate mass" of migrants, he mirrored the prejudices of the dominant nativist culture: they were foreign, not American, and never likely to be. In the alleys and courts of lower Manhattan,

one may find for the asking an Italian, a German, a French, African, Spanish, Bohemian, Russian, Scandinavian, Jewish colony. . . . The one thing you shall vainly ask for in the chief city of America is a distinctly American community. There is none. [The native-born] are not here.

196. Jacob Riis, *Lodgers in a Crowded Bayard Street Tenement—Five Cents a Spot*, c. 1890. Museum of the City of New York; Jacob A. Riis Collection.

Viewing these folk as specimens, who must be exposed to view for the ultimate good of their own class, Riis could be—by more recent standards of journalistic etiquette—grossly intrusive. He felt no need for agreement between subject and photographer. His forays were like police raids. Late at night Riis and his assistants would burst into the tenements and dives. "Our party carried terror wherever it went," he remarked, as indeed it must have, for people hoicked from sleep, drunkenness, or lust and blinded by the magnesium flash. The results are like images of befuddled animals in their dens (Figure 196).

If Riis created proletarian New York as a visual subject, some painters were not so far behind him. Their leader and main source of inspiration was Robert Henri (1865–1929).

Henri was reborn and renamed in trouble. His father was John Jackson Cozad, descended from French Huguenots named Cazat who had fled to Holland to escape the Catholic massacres in 1572; in fact, Robert Henri and the artist Mary Cassatt were distant cousins, she from the better and he from the worse side of the tracks. Cozad, the father, began as a professional card sharp on the Mississippi riverboats and then made a pile in real estate and land development. Unfortunately, in the course of building a sod bridge over the Platte River near the town he had named for himself—Cozad, Nebraska—he got in a quarrel with a workman and shot him, fatally. Cozad and his family vanished, fled east from the clutches of the Nebraska law, and were reborn in Atlantic City as the Henri family, pronounced "Hen*rye*." Robert Earle Henri, as the son was now known, started his art career by copying caricatures from the illustrated newspapers. In 1886, aged twenty-one, he entered the Pennsylvania Academy of the Fine Arts. Thomas Eakins had been fired from it only a semester before, but his influence still reigned among the students, and Henri's ideas about art were formed by this charismatic, absent father figure, transmitted through Thomas Anshutz, who had taken Eakins's place as instructor in the life class.

Like Eakins, Henri made the pilgrimage to Paris in 1888 and absorbed a fairly academic style of Impressionism during three years of study there. But it was his second trip to Paris, in the mid-1890s, that confirmed his direction as an artist. Dissatisfied with Impressionism as an insubstantial art of surfaces, he immersed himself in dark, tonal painting, based on Manet and drawing on Manet's own enthusiasm for Goya, Velázquez, and Franz Hals. He wanted the image to be a lump in the mind, massive and immediate, given urgency by slashing, liquid brushstrokes and depth by strong tonal contrast, within a narrow range of color: mostly black, white, warm umbers, and Venetian red. In his mature work after 1900, he especially liked the vulgarity of Hals, and reflected it in his portraits—George Luks at full length looking like a jovial Dutch toper in his dressing gown, or the spectacular and raffish strut of the actress Madame Voclezca as Salome, 1909 (Figure 197), in the first New York performance of Strauss's opera.

Back in Philadelphia, Henri's strong talent and worldly, rebellious, effusive nature made him a magnet for younger artists, most of whom worked as illustrators for the Philadelphia press: John Sloan, William Glackens, Everett Shinn, and George Luks. They drank together, had long poker sessions, bellowed poetry at one another, and argued late into the night. Henri was, Sloan recalled fifty years later,

> a catalyst, an enthusiast, a healthy-minded man. A born preacher . . . [with] the pioneer's contempt for cant and aestheticism. His teaching was strong stuff in the Nineties of the Victorian era that put "art for art's sake" on a pedestal. We admired Whistler's savage tongue-lashing and Oscar Wilde's wit. But Henri won us with his robust love for life.

Henri had two qualities that seemed especially charismatic. The first was a real and unfeigned interest in the young. "We want to know the ideas of young men. We do not want to coerce them into accepting ours." Which was, of course, the exact opposite of the message of deference to the Past, the Norm, and the Canon that America's powerful but provincial academics emitted. Henri's enthusiasm and tolerance, backed up by his instinctive anarchism, inspired several generations of students as well as painters closer to his own age. He began to teach at the New York School of Art, then headed by that paragon of style and taste, William Merritt Chase. Within a few years Chase, unable to compete with Henri's popularity among the students, resigned and left the running of the school to his rival. Among the students Henri taught at the school from 1902 to 1912 were George Bellows, Stuart Davis, Patrick Henry Bruce, Edward Hopper, and Rockwell Kent. In 1911–18 he also taught at the politically radical Ferrer Center School in New York, where his students included the future Dadaist Man Ray and, for a short while, Leon Trotsky. Many art students in America have had fantasies about starting a revolution; Henri taught the only one who actually did.

197. Robert Henri, *Salome (No. 2)*, 1909. Oil on canvas, 77½ × 37" (197 × 94 cm). The John and Mable Ringling Museum of Art, Sarasota, Florida.

struggles of the Civil War. But certainly it is one of the most vivid expressions of that culture of machismo, of fundamental struggle at the bottom of the social heap, that was so much to the fore in America at the turn of the century.

Given the vividness of Henri's presence, some younger painters were bound to model their personalities—that word was creeping into American speech by the turn of the century—on his. The most gifted of them was George Bellows (1882–1925), who came to New York from Ohio in 1904 and got into Henri's class at the New York School of Art. Bellows was extremely precocious. He did nearly all his best-known paintings by 1913, when he was thirty-one, and his work declined appreciably in the last decade of his short life. Hungry for success, and more candid about it than his fellow painters, he devised an approach (or perhaps "devised" is unfair; the man was the style) which managed to look modern, and in some respects was modern, without actually offending American conservatives such as the archreactionary critic Royal Cortissoz. "Others paved the way," he remarked in his late twenties, "and I came at the psychological moment." This was indisputably true; for what Bellows's major pictures offered was not radicalism of style or political thought but the charm of ebullience and vulgarity. In 1895 it had been a risk to go up against the potently genteel taste of the American Academy. But fifteen years later, academic taste was seen as moribund even by many of its supporters. And Bellows celebrated what so many people in and out of the art world wanted: Roosevelt's "strenuous life" in a big-boned, muscular America, the struggle to survive, the macho virtues (always with a bow to Winslow Homer, whose popularity by then was unassailable), and an unthreatening vision of the disorganized poor.

Three New York subjects made his name: the excavation of ground for Pennsylvania Station, the overflowing human life of lower Manhattan, and boxing. All had something in common: the celebration of raw energy. The Penn Station railroad terminal, designed by McKim, Mead & White, was one of the biggest urban projects ever started in Manhattan, and by far the largest since the Brooklyn Bridge. To bring the trains of the Pennsylvania Railroad into Manhattan meant boring miles of tunnel under the Hudson and the East River, razing four city blocks (everything between Thirty-first and Thirty-third streets, and Seventh and Ninth avenues), excavating a vast pit, and then constructing the terminal itself. No hole of this size had been dug in America before. It was a homegrown Grand Canyon, and as a feat of engineering it compared, in American eyes, with the famed Culebra Cut in the Panama Canal, recently finished and representing American technology at its peak—heroic engineering to match Roosevelt's call to strenuous life. Constantly celebrated in the press as the digging went on, its dynamiting and its ponderous ballet of steam shovels and spoil-removal trains watched from the rim of the crater by thousands of New Yorkers, the Pennsylvania excavation was a big running news story, and Bellows's decision to paint it

200. George Bellows, *Pennsylvania Station Excavation,* 1909. Oil on canvas, 31¼ × 38¼" (79.4 × 97.1 cm). The Brooklyn Museum; A. Augustus Healy Fund B.

George Luks's temperament was coarser. "Guts! Guts! Life! Life! That's my technique!" he blustered. Luks (1867–1933) was apt to dilate on his childhood in Pennsylvania coal-mine country and his prowess as a fighter quite as much as his art studies in Düsseldorf, Munich, Paris, and London. (The latter may have been an invention, and his fighting powers hardly extended beyond those of the ordinary barroom drunk, but he was certainly born in Pennsylvania—though his father was a doctor, not a miner.) He was also an amateur actor and had hammed it up on the vaudeville stage. But he did enter the Pennsylvania Academy of the Fine Arts in 1884, and like Sloan and the rest of Henri's Philadelphia acolytes, he worked for the papers, drawing some of the now classic early American comic strips of the 1890s: *The Yellow Kid, Hogan's Alley,* and *McFadden's Flats.*

As a painter, under the Henri-inspired influence of Frans Hals and Dutch realism in general, Luks was drawn to crowds and congestion. *Hester Street,* 1905, is a bluntly unrefined picture, scarcely "composed" at all except in terms of a frieze of jostling figures parallel with the backdrop plane of tenements and shops, an awkward slice of overbrimming Jewish life from the Lower East Side. Luks's most memorable image was *The Wrestlers,* 1905 (Figure 199)—two grappling men fused, as it were, into a block of straining flesh. No doubt it is only hindsight that makes one think of it as Cain and Abel, a distant echo from the fratricidal

199. George Luks, *The Wrestlers,* 1905. Oil on canvas, 48¼ × 66¼" (122.5 × 168.3 cm). Museum of Fine Arts, Boston; Charles Henry Hayden Fund.

all of which could be seen from his studio on Twenty-third Street, at the edge of the seedy Tenderloin district. He set them down in a brusquely spontaneous way, as reminiscent of Manet as his etchings and illustrations were of Gavarni. Sometimes a countercurrent of melancholy runs through them, and one thinks of Whistler: especially in the beautifully composed *The Wake of the Ferry II*, 1907 (Figure 198). Black stanchions and a tilted line of roof frame the cold blue evening sea from the stern of the Staten Island Ferry, as the blue in Whistler's Thames was framed by Battersea Bridge (and both have the same root in Hiroshige). Daringly, Sloan counterposed the dark mass of the lone woman gazing astern against an open, swiftly brushed diamond pattern of the safety rail running out to the left, giving both balance and a sense of exposure: you see the wet light on the steel deck and feel the cold.

Though Sloan's vision may seem modest compared to the more flamboyant Henri's, younger painters got what they needed from him. His exuberant girls on the street were developed into regiments of overripe Coney Island cuties by Reginald Marsh, and his moments of voyeuristic detachment—Sloan didn't like feeling detached from his human subjects, but that was part of city life—were amplified in Edward Hopper's glimpses of disconnected people staring out of windows at nothing in particular. Sloan's own feelings extended neither to Marsh's licentiousness nor to Hopper's acute solipsism. This was a matter of temperament, not style.

198. John Sloan, *The Wake of the Ferry II*, 1907. Oil on canvas, 26 × 32″ (66 × 81.3 cm). The Phillips Collection, Washington, D.C.

standing I have for the common people, as they are meanly called, I feel as a spectator of life." There would always be a marked difference between the mordancy of Sloan's political illustration and the benign, life-affirming tone of his *bas genre* paintings of New York life, the "bits of joy," as he called them, that he fixed on "with an innocent poet's eye." Now and then satire creeps into the paintings, as in *Fifth Avenue, New York 1909*, 1911, with its press of upholstered women shoppers, or in the swells riding in their toadlike touring car in *Gray and Brass*, 1909. But Sloan's painted world is generally amiable, a place full of fleshy, rosy girls on swings or in dance halls, Brooklyn Fragonard and Hester Street Renoir, chattering in front of the nickelodeon parlor or parading in Washington Square Park. Prone to the sentimental fallacy of treating the poor as figures in an urban pastorale, he wanted to see happiness everywhere, as in a 1906 diary note on one of his rambles on the Lower East Side:

> Doorways of tenement houses, grimy and greasy door frames looking as though huge hogs covered with filth had worn the paint away and replaced it with matted dirt in going in and out. Healthy-faced children, solid-legged, rich full color to their hair. Happiness rather than misery in the whole life. Fifth Avenue faces are unhappy in comparison.

Harsh, dirty New York, O. Henry's "Baghdad on the Hudson," had its demotic refuges: the new movie houses, the dance halls, and, very important for Sloan, McSorley's Ale House, a dimly lit, sawdust-floored, working-class Irish tavern from which women were banned and whose eccentric annals would be recorded by Joseph Mitchell in his essay "McSorley's Wonderful Saloon." Sloan drank there regularly. It was to him and some of his friends what the more exalted Century Association was to the likes of Augustus Saint-Gaudens. Some of his sketches still hang on its encrusted walls.

To some doctrinaire Marxists of the next generation, Sloan seemed unrealistic; and yet his work has an honest humaneness, a frank sympathy, a refusal to flatten its figures into stereotypes of class misery, that was certainly truer to the life of his subjects than theirs. He saw "his" people as part of a larger totality, the carnal and cozy body of the city itself, where even the searchlight installed on top of Madison Square Garden was "scratching the belly of the sky and tickling the building." Sloan, not incidentally, was the first American to set down that image of urban eroticism which would become identified with Marilyn Monroe—a girl with her skirt flaring in the hot blast of subway air. He was, as Willem de Kooning would say of himself in a rather different context many years later, "a slipping glimpser," with a strong sense of the fleeting moment in which people are caught unawares: a woman pegging out the wash or lovers furtively embracing on a tenement roof, arguments on the fire escape, a girl stretching at a window—

I love the tools made for mechanics. I stop at the windows of hardware stores. If I could only find an excuse to buy many more of them than I have already bought on the mere pretense that I might have use for them! They are so beautiful, so simple and plain and straight in their meaning. There is no "Art" about them, they have not been *made* beautiful, they *are* beautiful.

This, too, was Whitmanesque, reminding you of the poet's ecstatic list-making of "mere" ironmongery in "A Song for Occupations":

Strange and hard that paradox true I give:
Objects gross and the unseen soul are one. . . .

The cotton-bale, the stevedore's hook, the saw and buck of the sawyer, the mould
 of the moulder, the working-knife of the butcher, the ice-saw, and all the
 work with ice,
The work and tools of the rigger, grappler, sail-maker, block-maker . . .

In them realities for you and me, in them poems for you and me . . .

Unlike most of the artists he knew in Philadelphia, John Sloan (1871–1951) began not as an artist-reporter (he worked too slowly for such deadlines) but as an illustrator and cartoonist. He imitated John Tenniel, the *Punch* artist who illustrated, among other books, *Alice's Adventures in Wonderland*. And his decision to stay in America may have been enjoined by early marriage and a small income, but it was certainly confirmed by his early reading of Ruskin, who fulminated against the expatriate's weakness, a rootless style. Illustrating connected him to American life. Some of Sloan's most successful work would always be in black and white, whether etchings done for their own sake or illustrations for *The Masses*, a left-wing magazine of social commentary that numbered Max Eastman and John Reed among its contributors. "I'm not a Democrat, I'm of no party. I'm for change—for the operating knife when a party rots in power," he declared in 1908. Though his sympathies were broadly socialist, he was wary of using his art as propaganda. He told one art critic that "I had no intention of working for any Socialist objects in my etchings and paintings though I do think it is the proper party to cast votes for at this time in America." Significantly, he did not mention drawings for press reproduction, which were his real political vehicle. Sloan deeply admired French lithographers for their ruthless edge— Gavarni, Steinlen, and especially Daumier. He could never honestly pretend to paint as a "man of the people," a routine claim among socialist artists. "I never mingled with the people," he would later say, "and the sympathy and under-

The second quality, linked to the first, was Henri's belief that art must be vernacular or fail. He saw art history as a vital process of organic growth, the record of people testing a changing world around them—"inventing something that is absolutely necessary to the progress of our existence." There was, he wrote in 1910, only one reason why America—especially America, land of the go-getter and the philistine!—could really need art,

and that is that the people of America learn the means of expressing themselves in their own time and in their own land. In this country we have no need of art as a culture; no need of art as refined and elegant performance; no need of art for poetry's sake. . . . What we do need is art that expresses the *spirit* of the people of today. . . . I want to see progress. It should be impossible to have any feeling of jealousy towards those who are young and are to accomplish the future.

An artist must be a realist. He must connect with the harsh facts of his society, especially with those of the city, and most of all the city of New York. His work would draw vitality and survival power from its common subject matter. This was the belief of Henri and his cénacle of young painters, who all moved to New York at the turn of the century and, thirty years later, were dubbed the Ashcan School. "His vest is slightly spotted: he is real," said John Sloan approvingly of the Irish painter Jack Yeats. George Luks boasted that he could paint with a shoestring dipped in lard and pitch. The artist, smearing oily-colored gunk on a cloth with bristles, is immersed in mess: a manual worker of images. This makes him one with the city and its people. He is a flaneur, but not a dandy: he promenades the city not to be seen, but to see. "The sketch hunter has delightful days of drifting among people," said Robert Henri. "He is looking for what he loves, he tries to capture it. It's found anywhere, everywhere. Those who are not hunters do not see these things. The hunter is learning to see and understand—to enjoy." The artist as hunter: this was part of the lesson given them by Winslow Homer, whom the Ashcan painters embraced as a role model—the virile eye, always staring at reality over the pencil. "The big strong thing," said Henri, thinking of Homer's waves at Prout's Neck, "can only be the result of big strong seeing."

Henri wanted his students to learn from Whitman how to embrace the body of the city, to "contain multitudes," dirt and all. Paint should be as real as mud, as real as the clods of horse shit and snow that froze on Broadway in the winter, as real a human product as sweat, carrying the unsuppressed smell of human life itself. Against the idealized, depilated, asexual, virtuous, and upper-class body of the Academy—the nudes of Abbott Thayer or Kenyon Cox, the allegorical maidens of Thomas Wilmer Dewing—he set the chorus girl, "brazen" and competent. Against the prosperous banker as subject for portraiture, the tramp and the urchin. He perceived a necessary beauty rising out of fitness for use, indifferent to taste:

had a distinctly journalistic impulse behind it. This was a more public subject than anything on Orchard Street or in McSorley's Ale House, and Bellows painted several versions of it. *Pennsylvania Station Excavation*, 1909 (Figure 200), is the most dramatic of them: an evening view, probably in March, with late snow still on the floor of the crater, a glare of fire, and steam and smoke billowing up. This and the rocky sides, knocked in with turbid brushstrokes, associate it in one's mind (and probably Bellows's too) with a volcano. The tiny spectators in the foreground fix the scale, and their presence, peering gingerly over the edge, conflates the view with earlier scenes of gorges and mountains in the American West. The dark bulk of a building looms on the far side, silhouetted against a bright turquoise sky with lurid slashes of evening cloud. Culture as nature.

The image of the city as precipitous, dizzying, a place where people swarmed like swallows on a wall, was on Bellows's mind. He used it in the title of his crowded lower Manhattan slum scene of 1913, *Cliff Dwellers*, whose original drawing was published by the socialist paper *The Masses* under the caption

(imagined as spoken by a middle-class onlooker) "Why Don't They Go to the Country for a Vacation?" Whenever he painted the working class, Bellows's natural ebullience always took over from whatever social indignations he may have felt, or felt obliged to feel. *42 Kids*, 1907 (Figure 201), depicts the pale, gawky, knobby bodies of working-class boys horsing around on what was called "Splinter Beach"—one of the broken-down pier platforms that stuck out into the Hudson. "Kid," of course, had a loaded meaning then, as in the hugely popular comic strip *The Yellow Kid*: it implied truancy, mischief, being outside good society—the teenager as trickster. Good boys were "children" or "lads." You could see these mudlarks any warm day on the West Side waterfront, but it's just possible that Bellows was also thinking of Thomas Eakins's painting *Swimming*, and set out to parody it, exchanging Eakins's dignified Arcadian figures in their classic poses for a crowd of squirming, hopping bodies that reminded one hostile critic of maggots. The result shows how far Bellows had gone toward a journalistic way of work: funny-paper reportage, with an undercurrent of sentimentality in presenting the life of the poor as innocent and, in a low way, Arcadian. The 1900s were a time when the adventurous enjoyed a bit of class tourism: they went "slumming" downtown, as their sons and daughters in the 1920s would go to Harlem, for a whiff of strangeness. Bellows's images appealed to this taste.

His most vivid exercises in it were his boxing pictures, which for brutal energy

201. George Bellows, *42 Kids*, 1907. Oil on canvas, 42³/₈ × 60¹/₄″ (107.6 × 153 cm). Corcoran Gallery of Art, Washington, D.C.; museum purchase, William A. Clark Fund.

(in the paint, the emotions, and the depicted action) outstripped anything done in America in the 1900s. Here, literally, was the "world of fists" described by somewhat earlier "hard" realist novelists, Frank Norris and Jack London—the lumpen Darwinism that had grabbed the public's imagination, the sense of life determined by clash and struggle. Though Eakins had painted boxing scenes at the end of the 1890s, and there were plenty of earlier American "sporting prints" and primitive pictures showing fighters squaring off, nothing in earlier American art quite prepares you for the explosive violence of Bellows's two paintings *Stag at Sharkey's*, 1909 (Figure 202), and *Both Members of This Club*, 1909.

The old style of prizefight, in which two pugs hammered away at each other until one collapsed, had given way by 1900 to a more formalized affair, with timed rounds and a referee who could award a decision "on points" in the absence of a knockout. But these encounters were still bloody and brutal, and they were held to be morally degrading. Public boxing was thus illegal in 1900s New York, but this stopped nothing. Fights were held in private clubs; the law made it easy for any bar with a suitable back room to declare itself a club and make the boxers "members" of it for the night along with the audience. One of the toughest and seediest of these saloons was run by an Irish crook named Tom Sharkey. If you wanted to go slumming, Sharkey's was the place: it was a magnet for jour-

202. George Bellows, *Stag at Sharkey's,* 1909. Oil on canvas,
36¼ × 48¼″ (92 × 122.6 cm). The Cleveland Museum of
Art; Hinman B. Hurlbut Collection.

nalists, thrill-seekers, and anyone who wanted machismo-by-association, including Bellows.

Both Members of This Club (Figure 203) was originally titled *A Nigger and a White Man:* so much for the impression given by some writers that Bellows meant it as a disapproving commentary on racial exploitation. Rather, Bellows probably shared the alarm with which many boxing fans viewed the rise of blacks within the sport, as dramatized by the victories of Jack Johnson, who in 1908 had whipped the white world-heavyweight champ Tommy Burns in Sydney, Australia. If the Negro could beat the white, what did this say about the Master Race? No question, Bellows was on to a hot topic here, and *Both Members of This Club* created something of a sensation with the art public.

It is a deliberately sensational painting, given over to extreme stress and strain, light and darkness. The two figures, the furiously charging black boxer and the sagging white one, whose groans of effort you can almost hear, are locked in an arch. The black's rib cage and back muscles shine with sweat, and the white man's face is a speed-blur of blood, its forms smeared around by Bellows's loaded brush: you might, in this detail, almost be looking at a head by Francis Bacon. There is more blood on his rib cage, and under the carbide lamps his body is spectral against the gloom. Here, as in *Stag at Sharkey's*, the strain of muscles is so assimilated into the physical life of the paint strokes that the pigment runs over its contours. Bellows's contemporaries found such images "Hogarthian," but their closer ancestor is Goya. In particular the frieze of spectators' heads, yelling, gaping, sly, stupefied, brings to mind the faces in Goya's *Witches' Sabbath* or the

203. George Bellows, *Both Members of This Club,* 1909.
Oil on canvas, 45¼ × 63⅛″ (115 × 160.5 cm) unframed.
National Gallery of Art, Washington, D.C.; Chester Dale Collection.

pilgrims in his *Romeria de San Isidro*—the "Black Paintings" which Bellows, who had not been to Europe, cannot have seen, though he must have known something of them from reproductions.

Despite his eye for the city as a compressor of violence, some of Bellows's best paintings were set on an island at the farthest possible remove from Manhattan: Monhegan, on the Maine coast, where his idol Winslow Homer had also painted. Though born and raised in Ohio, he had coastal roots—his grandfather had been a whaler at Montauk on the eastern tip of Long Island—and the Atlantic became a fundamental source of nourishment to him. "We two and the great sea," he wrote to his wife in a moment of romantic exaltation from Monhegan, "and the mighty rocks greater than the sea . . . four eternities." There are times, as in *An Island in the Sea*, 1911, when Bellows's vision of the coast as a primal geological scene of humped resistant stone, lapped around by silver water or assailed by beating green rollers, assumes a poetry worthy of Winslow Homer; this sense of unpeopled, epic nature was a cleansing relief from the anthill of Manhattan.

After 1914 his work changed. Probably this was caused by his first sight of modern European painting en masse, at the 1913 Armory Show. In his effort to become a modernist, he became interested in theory, and this did his art no good: he went for the pedantic structure-recipes set out by the American artist Jay Hambridge in his book *Dynamic Symmetry in Composition*. In his effort to produce compositional machines full of golden sections and other formal clockwork, Bellows managed to annul the immediate and visceral character of his best work, nearly all of which falls between 1907 and 1913. His 1924 painting of Jack Dempsey knocking Luis Firpo out of the ring is a marionettes' ballet compared to *Stag at Sharkey's*, and the commissioned portraits and *fêtes galantes* of people at play on the green lawns of Gatsby-land that he produced in the last few years of his life are insipid. But Bellows was not the only American artist to be unsettled, or even unhinged, by the Armory Show. No single exhibition before or since has had such a traumatic, stimulating, and disorienting effect on American art and its public. It shook the bag, reshuffled the deck, and changed the visual culture in ways that its American organizers could not have been expected to predict. We must now see how, and why.

6

EARLY MODERNISM

Ever since there was modernism in America, New York has been the capital of its visual arts. In the eighteenth century New York was a small place, in terms of talent, compared to Philadelphia or Boston. Even by 1870 it was not—or not clearly—the leading American producer of painting, sculpture, and opinion about both. But after 1910 this changed. The twenty years from 1910 to 1930 turned America into the world's most powerful nation, the only combatant state that had not been crippled by World War I, and New York became its most powerful city: a condenser of change, renewal, experiment, and hope. The essence of its culture, like that of its population, was hybridity. On the one hand, pictorial ideas and movements flowing (fitfully, at first) in from Europe—Post-Impressionism, Fauvism, Cubism, the high ornamental style of Art Deco; on the other, the energies released by African-American migration, which implanted the deep roots of blues and jazz in Manhattan and created the Harlem Renaissance, a movement of extraordinary power in music, dance, poetry, fiction, and storytelling, though not in the visual arts. Intense formalism and rampant commercialism; demolition of old cultural standards and an ache to begin new ones; frivolity and fashion raised to fever pitch, coexisting with a dandy's sense of style as morality; celebration of the city, and an intense wariness of it. New York made modernism; modernism made New York. And the city, in modernist eyes, was its own total and challenging work of art.

New York was the only part of America in which this took place on such a scale. It could only happen against the background of an immigrant culture—an island of impaction and conflict, with its continuous and heady vortices of new information. New York, in the eyes of the rest of America, was the valve through which everything that seemed new, disturbing, and alien drained into the United States. Hence the perception, still widespread today and still reflected in American politics, that New York was not really part of America, but rather a theme

204. John Marin, *Brooklyn Bridge,* 1910. Watercolor on paper, 18½ × 15½″ (47 × 39.4 cm). The Metropolitan Museum of Art, New York; Alfred Stieglitz Collection, 1949.

park (not that the phrase had been invented then) of shifts—an Island of Dr. Moreau, dedicated to bizarre mutations.

Some cultural changes that spread from New York were eagerly embraced by America; others were bitterly resisted. And there could be a strange disproportion between the magnitude of the social effect and the degree of the resistance. Unquestionably, the invention that did most to alter the way Americans perceived the world and constructed their narratives of it, between 1900 and 1920, was the silent movie. It became the folk art of the urban crowd, disseminated from New York when Hollywood was orange groves and dust roads. It assimilated all the visual subject matter that had previously been marketed only through static chromos and illustrations: the disasters, the Arcadias, the ideal families battling adversity. It was easy for astute immigrants to get into the new nickelodeon business, at first a matter of rented shopfront "theaters" and a few machines; seeking a mixed, demotic audience, they saw the potential of the flickering toy. As it matured from its ur-state of plotless spectacle—a minute or so of a speeding train or a writhing belly dancer—the silent film began to reflect immigrant hopes, dreams, and fantasies. Its characters and plots portrayed immigrant experience: the misfit, the down-and-outer, the cocky kid with chutzpah. Its bumbling cops enabled the subjects of police discrimination to laugh at those whom they feared. Its comic and racist stereotypes of the black reminded the migrant that there is always someone beneath him on the social scale. The silent movie crossed all barriers of language and spoke to all levels of the American Tower of Babel precisely because it *was* silent. It created the first American cultural form capable of embracing the whole world as well.

Because early film was entertainment, and went down easily, few Americans saw how it was changing the way huge publics would interpret images. Its revolution was so big and far-reaching, and affected so many people so diffusely, like a change in the content of the air they breathed, that no one saw it as anything but benign. Whereas other changes in a difficult language that only affected a very few people were pounced on at once, and bitterly resisted *as an immigrant form*. This was the language of "high" art. It did not go before a mass public. It had no power of social change. And yet it was attacked with vituperative fury.

Modern painting and sculpture came to New York much later than to France or Germany, and its voice was heard against suffocating odds of derision and indifference. It would grow into an institution, a cultural industry. But its first presence there was both frail and, in its determination to transcend that frailty, brave. To be a provincial aspirant to cosmopolitan achievement is never easy. The artist always finds himself looking over his shoulder: to whom can I turn for approval, for certification? Not, in the first decade of the twentieth century, to Paris, whose avant-garde circles were unlikely to regard work by an American follower of Cézanne or Matisse as having much to add to current debate. And not at home

in America, either, where the new art was viewed by all men of sense as the vulgar effusion of five-thumbed lunatics. Moreover, the would-be avant-gardist in the province fears that no matter how many lumps he takes from conservatives at home, his work—due to the time lag of imitation—will still be stuck behind the beat of the big clock in Paris. Meanwhile, the provincial conservative (represented, in New York around 1910, by the successful National Academy artists like Kenyon Cox or Edwin Blashfield) is equally imitative; but he can claim to be continuing a tradition, not imitating a "mere fashion."

Can the innovative provincial change art history? Or must he be content with the freedom that others' inventions open up, discovering in his own exploration of it an authenticity of his own, in some as yet uncertain relation to his experiences as an American? In thinking about them, one should remember that there is, in art, no such thing as absolute originality—that is a vulgar myth. All art builds on other art, and art can be derivative *and* good. Let us first call the roll, name the cast of artists who, with Paris experience, formed the core of the first American avant-garde around 1910: Arthur Dove, John Marin, Max Weber, Marsden Hartley, Alfred Maurer, Patrick Henry Bruce, Morgan Russell, Stanton MacDonald-Wright, and (a little later) Elie Nadelman—and, as the John the Baptist in the American wilderness for most of them, Alfred Stieglitz.

Some paid a high price for their passion for the new. The most painful case was the artist Alfred H. Maurer (1868–1932). Maurer had trained at the National Academy and gone to Paris in 1897. Seven years later, he was introduced to the brilliant salon of Gertrude and Leo Stein at 27 Rue de Fleurus—the main meeting point between Americans and French modernism. In those rooms, their walls hung with Matisses and Picassos, Maurer met Henri Matisse, who was just entering the plenitude of his Fauve period. Matisse's color—its freedom, startling intensity, and expressive range—struck the American with the force of revelation, and one sees its effect in Maurer's *Woman with Blue Background*, c. 1907 (Figure 205): the viridians and ultramarines, the luminous orange-ocher of face and hands with their slashes of pure vermilion, all held together by tough, structural drawing and succinct design. This was no juvenile conver-

205. Alfred H. Maurer, *Woman with Blue Background*, c. 1907. Oil on panel, 21¾ × 18″ (55.2 × 45.7 cm). Sheldon Memorial Art Gallery, Lincoln, Nebraska; University Collection, bequest of Bertha Schaefer, 1971.

sion—Maurer was nearly forty. Over the next ten years, he painted with great vigor and attack in a Fauvist idiom—but the outbreak of war in 1914 forced him to return to America. This proved to be banishment to a hell of Oedipal conflict. For Maurer's father was an artist himself, old, bitter, and conservative. His specialty had been drawing horses for Currier & Ives prints, and he loathed modernism as rabies. The son's poverty forced him to live with the father, and to put up with an unceasing stream of slights and vituperation from this dreadful patriarch, whose death at the age of ninety-nine in 1932 was followed, a few weeks later, by Maurer's own suicide—on the exact anniversary of the event that had deprived him of Paris, August 4, the day the war had begun eighteen years before.

If no other American modernists had to bear such Job-like sufferings as Maurer, still there was always a disagreeable contrast between the liberty and openness of Paris and the hostility of America. Patrick Henry Bruce (1881–1937), a son of decayed Virginian gentlefolk who studied under Chase and then Henri at the New York School of Art, reached Paris in 1904, and entered the Stein circle, attending Matisse's studio classes. (Several other fledgling American modernists did too: Henry Lyman Saÿen, Max Weber, and Arthur B. Carles.) His early work, like *Still Life (With Tapestry)*, 1912, became an ambitious effort to combine the faceted structure of Cézanne with the luminous, space-forming color of Matisse. From 1917 on he produced a remarkable series of geometric, abstracted still-lifes, Utopian arrays of cylinders, disks, trapezoids, rods, and beams, mechanically drafted with compass, scale, and french curve. Elegant, frugal, and less ponderous than their nearest French equivalents, they have the crystal-clear assurance of fine modernist architecture (Figure 206). They were, however, largely ignored. Bruce, once a habitué of the Paris art world, eked out a living dealing in antiques; he withdrew into his shell and gave up painting altogether, destroying much of his own work. In 1936, convinced (rightly, as it happened) that his work would not be understood in his own time, especially by Americans, he killed himself in a New York hotel room.

Some American artists in Paris were influenced, in these formative years, by Cézanne/Picasso rather than Cézanne/Matisse. The best of them was Max Weber (1881–1961), a Russian Jew who had come to America, in dire poverty, with his emigrant parents when he was ten, and made it to Paris in 1905. During his five years there, he studied under Matisse, became the Douanier Rousseau's only American friend (and bought a small but choice collection of his paintings), and got to know Picasso and Apollinaire. He arrived at a powerful style based on (and only just later than) Picasso's sculptural proto-Cubist figures of 1907–8. *Composition with Three Figures*, 1910 (Figure 207), does not attempt the violent fragmentation of *Les Demoiselles d'Avignon;* it is much more in the spirit of Picasso's large *Three Women,* now in the Hermitage—those strange, sleepy pres-

ences, as though roughed out at angles from red sandstone. Using massively simplified planes with knife edges where they meet (sharper than Picasso's) and acute articulation at the joints, Weber achieved a highly sculptural effect in these figures, packed tight against the edges; even the eyelids are as heavy as abalone shells.

The only real sculptor in Paris at this time who was to affect America as a resident had not crossed the Atlantic yet: he was Elie Nadelman (1882–1946). This singularly gifted Polish artist had settled in Paris in 1904 with no thoughts of ever migrating to America—the 1914 war, and the impossibility of recrossing Europe, plus the encouragement of American friends, left him with little choice but to cross the Atlantic. During his ten years in Paris, he evolved a mellifluous sculptural style. Nobody could call Nadelman one of the consistent pioneers of modernist sculpture—although Nadelman's belief that Picasso was influenced by seeing a bronze head in his Paris studio in 1908 was very likely true—and yet what an eye he had, what a sense of quotation and paraphrase, and what integrative powers! A partial list of Nadelman's sources, whose traces appear in direct or disguised ways in his work, would include both Hellenistic and

206. Patrick Henry Bruce, *Still Life,* 1920–21. Oil on canvas, 35 × 45¾″ (88.9 × 116.2 cm). The Metropolitan Museum of Art, New York; George A. Hearn Fund, 1961.

207. Max Weber, *Composition with Three Figures,* 1910. Gouache and watercolor over black crayon on corrugated cardboard, 47 × 23" (119.4 × 58.4 cm). Ackland Art Museum, The University of North Carolina at Chapel Hill; Ackland Fund.

Praxitelean Greek sculpture, Michelangelo's bound *Slaves,* Giambologna's twisting figures, the drawings of Constantin Guys (for their *boulevardier* wit), Seurat, Beardsley, Tanagra figurines, the rococo sculpture of Clodion, the neo-classical portraits of Houdon. The classical heads in marble that largely occupied him through 1908–10 are among the most intelligent pastiches of the antique made in the twentieth century, and beautifully worked, with an exact sense of the play between incised linear rhythm (as in the hair) and the gentle, luminous swells of brow and cheek; and yet they hardly rival the plastic vigor of their Greek prototypes.

Nadelman's finest achievements as a sculptor unfolded in America, and were inspired by its folk art. Elegant and worldly, with the profile of a melancholy hawk, Nadelman was irresistible to women (he and Marcel Duchamp were the male sex symbols of transatlantic culture in the 1920s) and he duly married a very rich wife. Between 1923 and 1928—before they lost everything in the Wall Street crash—the Nadelmans spent more than half a million dollars buying American folk art and were the first collectors to do so systematically. Folk art then was despised as barn-junk by "cultivated" Americans. It was left to Nadelman to appreciate its concision, directness, lack of pretension, and (in the best examples) its blunt grandeur, and to bring these qualities into the enchanted circle of his own wit and sense of form. Thus his wood carv-

208. Elie Nadelman, *Woman at the Piano*, c. 1917. Wood, stained and painted, 35⅛ × 23¼ × 9″ (89.2 × 59.1 × 22.9 cm), including base. The Museum of Modern Art, New York; Philip L. Goodwin Collection.

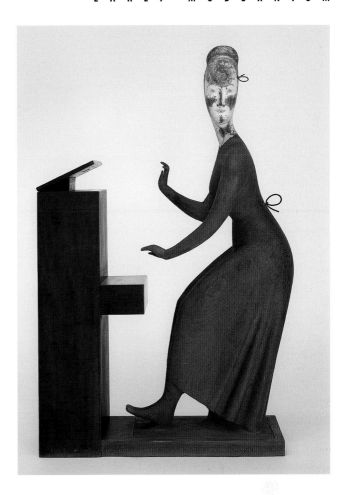

ings, like *Woman at the Piano*, c. 1917 (Figure 208), with her long, slightly prissy egg of a head (Modigliani meets Brancusi meets schoolmarm), her hands briskly poised in an interval of silence, her foot cocked on a nonexistent pedal, and the lovely swell of her skirt finished by a wire loop that echoes the wire ribbon in her hair: one-two, one-two.

At the furthest remove from the urbanity of Nadelman stood the American painter Arthur Dove (1880–1946). "I would like to make something that is real in itself," he once wrote, "that does not remind anyone of any other thing, and that does not have to be explained—like the letter A, for instance." And so, in a sense, he did. For Dove was the first American artist to paint a completely abstract picture, or rather a set of six; he did this in or around 1910, perhaps a little before Wassily Kandinsky's first abstract compositions. The difference, however, was that whereas Kandinsky's abstract work fell at once into a cultural context in Europe, Dove's had none. So his abstract paintings changed nothing. His work was twice orphaned, by the general indifference of American taste and by his own reclusiveness. Thus it never had the chance to be tested against the great arguments of metropolitan modernism; it remained a sequence of lyric meditations on nature, some beautiful, others clumsy and naïve, but always isolated.

Dove's work was all about nature, from beginning to end. The son of a well-off brickmaker in Geneva, New York, he began his art career as an illustrator for the New York press and went, in 1907, on a year-and-a-half trip to Europe, spending most of it in Paris. There he fell in with the circle of American expatriates: Weber, Maurer, Bruce. Inspired by Fauvism, he exhibited at the Salon d'Automne in Paris in 1908 and 1909; typical of his early work was *The Lobster*,

1908, painted in Provence—by then the *locus classicus* of Fauvism—and show-
ing the influence of Cézanne in the heavy construction of the still-life and of Ma-
tisse in its lush color and the twining, exuberant cabbage-rose wallpaper behind.

This was Dove's only time in Paris. As soon as he got back to America he
"went native," as he put it, spending much of his time camping in the wilderness.
"I can claim no background," he once reflected, "except perhaps the woods, run-
ning streams, hunting, fishing, camping, the sky." Thereafter, landscape would
dictate the essential forms of his work, and apart from the small, rather tentative
abstractions of c. 1910 (some of which look like landscape anyway), there is
hardly a painting by Dove that doesn't have some perceptible reference to land-
scape in it, whether in the earthen and green colors or the format ("sky" above,
"land" below, sometimes with suns or just-legible clouds, rocks, and foliage).
Dove was immersed in nature. He wanted to be a farmer, and after his father in
1912 refused to support him with a stipend of one hundred dollars a month—
"No, I won't do it, I won't encourage this madness," he exclaimed—he bought a
farm in Connecticut and tried to make a living off it without much success. Later,
in 1920, when he and his wife split up, he bought a yawl, the *Mona,* on which he
lived for seven years sailing the waters of Long Island Sound along the Con-
necticut shore. These long experiences fed into his work, while isolating him
from New York's small avant-garde circles. At the same time he felt that a rural
or marine life didn't cut him out of the discourse. "What do we call 'America'
outside of painting?" he asked a friend. "Inventiveness, restlessness, speed,
change. Well, a painter may put all these qualities in a still-life or an abstraction,
and be going more native than another who sits quietly copying a skyscraper."

In 1913 Dove explained to a friend his process of abstraction (or, as he some-
times called it, "extraction"): the landscape slowly disappears like the Cheshire
cat in the tree, leaving the "abstract" form behind.

> The first step was to choose from nature a motif in color, and with that motif to
> paint from nature, the form still being objective.
>
> The second step was to apply this same principle to form, the actual dependence
> on the object . . . disappearing, and the means of expression becoming purely sub-
> jective.
>
> After working for some time in this way, I no longer observed in the old way, and
> not only began to think subjectively but also to remember certain sensations purely
> through their form and color, that is, by certain shapes, planes of light, or character
> lines determined by the meeting of such planes.

In this way Dove believed he could arrive at "essences" that would transmit
his sense of the spiritual in nature, the deep concern of his art. Such "essences"
were shapes that symbolized different kinds of force, organic growth, and *élan*

vital, suggesting (he thought) some inner principle of reality. His early abstractions, particularly the large pastel paintings on linen like *Nature Symbolized, No. 2,* 1911 (Figure 209) are part of his effort to realize this. One can recognize its landscape basis—the round hill and high horizon line—but within it dance sail- and comma-like forms that lend the image a joyous vibrancy. It is in the same spirit as Kandinsky and Kupka. Perhaps because Dove's ideas about this were also in the American grain (they had been formed, in part, by his reading of Ralph Waldo Emerson), such early abstractions were tolerated by his American critics, though one journalist twitted him with the couplet "To show the pigeons would not do / And so he simply paints the coo."

Actually, the coo mattered to Dove. He was interested in synesthesia—the possibility that sounds could be experienced and depicted as colors or shapes, an idea current in French Symbolist circles since the 1880s. *Foghorns,* 1929 (Figure 210), represents the moaning of warning sirens in the Long Island mist as concentric rings of paint growing in lightening tones of grayed pink from a dark center: the bell mouths of the horns, their peculiar resonance, and the color of the fog are fused in one image.

Dove had a homespun side too, a folksy kind of buckeye humor that came out in the series of assemblages he did between 1924 and 1930, such as *Portrait of Ralph Dusenberry,* 1924 (Figure 211). It has little in common with Cubist collage—it is less formal and more anecdotal, with a side-of-the-mouth twist, a few notches up from the kind of amateur driftwood-and-shell collages that were once a staple of seaside restaurants. It is unlikely that Dove ever saw a Schwitters, but this is a Yankee *Merzbild,* and the framing device—a folding wooden carpenter's rule—offers a laconic joke: how do you measure the fictional space of a work of art?

In Paris, two other Americans explored synesthesia, earlier and more systematically than Dove. They were Morgan Russell (1886–1953) and Stanton MacDonald-Wright (1890–1973). They were not the only artists there to do so, just the only Americans: color-sound equivalence was one of Kandinsky's themes, and in 1913 František Kupka told an interviewer that "I believe I can find something between sight and hearing and I can produce a fugure in colors as Bach has done in music." Russell and MacDonald-Wright called their work "Synchromism"—a Greek term meaning simply "with color"—and their mutual project, too technical to go into here, was to elaborate a theory on the basis of "laws" which governed the interaction and perception of colors, and the possibility that colors in and of themselves conveyed emotional states. Their ideas were worked up from color theories already in circulation—mainly, Eugène Chevreul's *On the Law of Simultaneous Contrast of Colors* (first published in Paris in 1839) and the

209. (above) Arthur Dove, *Nature Symbolized, No. 2,* c. 1911. Pastel on paper, 18 × 21⅝″ (45.8 × 55 cm). The Art Institute of Chicago; Alfred Stieglitz Collection.

210. (below) Arthur Dove, *Foghorns,* 1929. Oil on canvas, 18 × 26″ (45.7 × 66 cm). Colorado Springs Fine Arts Center; anonymous gift.

211. Arthur Dove, *Portrait of Ralph Dusenberry,* 1924. Oil on canvas with applied ruler, wood, and paper, 22 × 18″ (55.9 × 45.7 cm). The Metropolitan Museum of Art, New York; Alfred Stieglitz Collection, 1949.

optical writings of Hermann von Helmholtz. Both had begun as figurative painters (Stanton MacDonald-Wright basically remained one), but both believed in musical equivalents: Russell, a musician himself, compared color scales with musical scales and voice ranges. "It is from an ensemble of colors poised around a generative color that form will spring," he wrote, adding that harmonic connections between colors would create "color rhythms" and thus unfold "like a piece of music, within a span of time." This hope of bringing linear (musical) time into painting, an art which presents itself all at once to the eye, was not to be fulfilled. Certainly Russell's attempts to develop Synchromism into an abstract art owed something to Robert Delaunay's color disks, but the most ambitious of his paintings, the eleven-foot-high *Synchromy in Orange: To Form*, 1913–14 (Figure 212), is actually based on a submerged figure, lurking hidden among the radiating wedges and quadrants of green, cadmium red, and lemon yellow: a Michelangelo *Captive* that Russell had seen in Florence.

A group of artists, then, that was not a group; that had been loosely jelled in Paris by the Steins; that had a common admiration for the *maîtres d'école* of modernism, chiefly Matisse and Cézanne, but otherwise had little in common beyond a mutual love of modernity, however that was to be worked out. Their emergence before 1913 (and Marin's and Hartley's too, to which we shall come) was announced, orchestrated, and staged by one man, the most influential proselytizer for art America has ever had: Alfred Stieglitz.

The son of wealthy Jewish parents, Stieglitz was born in New Jersey in 1864, the last year of the Civil War, and died in New York in 1946. He first learned photography, of which he was to become a master, in Germany in the 1880s. His career thus spanned two cultural worlds in America: in it all manner of strands, both nineteenth- and twentieth-century, twined together, producing a uniquely vigorous and, in part, messianic temperament. He was courageous, obdurately persistent, impatient with fools, and sometimes an arrogant prig. A twentieth-century American, but with the bark still on him. He could change his opinions but was incapable of compromise. A wide Puritan streak in him combined with a deep sense of the erotic, which he expressed in his photographs of Georgia O'Keeffe with breathtaking frankness. He was formed in the mold of American Transcendentalism, of Thoreau especially, but without the sense of God's presence in nature that infused the nineteenth century: nature itself was enough for Stieglitz. "Standing up here on the hill," he wrote to a friend in 1920,

away from all humans—seeing these Wonders taking place before one's eyes—so silently—it is queer to feel that beyond the hills there are Humans astir—& just the reverse of what one feels in watching the silence of Nature. —No school—no church—is as good a teacher as the eye understandingly seeing what's before it—I believe this more firmly than ever.

212. Morgan Russell, *Synchromy in Orange: To Form,*
1913–14. Oil on canvas, 135 × 121½″ (342.9 × 308.6 cm).
Albright-Knox Art Gallery, Buffalo, New York; gift of
Seymour H. Knox, 1958.

Stieglitz cared passionately about the visual arts, not as decor or confirmation of received ideas, but as "the very breath of life"—the means whereby the health of a society could be assessed. No ringmaster ever fought harder for "his" artists. If you believed in renewal, you had to believe in modernism; and without renewal, what could America claim for itself? For an artist, the burden of Stieglitz's belief could be heavy indeed. The messiah did not have a light hand with his apostles. He knew; others must understand.

That Stieglitz was "agin the system," and in particular against the Academy—meaning not just the National Academy in America but academic thinking in general—goes almost without saying. He regarded academic rules and prescriptions as effete, as a way of playing it safe with arts that should be conduits of vitality. In particular he rebelled against the academic assumption that photography, though useful to the artist, was inferior to painting.

The idea of art merely for art's sake, with all that it implied—a certain languor, a decorative bonelessness, and a *gratin* audience—repelled Stieglitz as much as any academic formulae. "My whole life in this country," he wrote to a friend in 1914, "has really been devoted to fighting the terrible poison which has been undermining the American nation. As an American I resented the hypocrisy, the short-sightedness, the lack of construction, the actual stupidity in control everywhere." He did not want an "activist" art, preaching political slogans; but, somewhat in the spirit of William Morris, he despised any art that was not engaged with the conditions of life, that would not challenge and refresh its viewers' responses to the world. To Stieglitz, the moral passion of the artist was therapeutic and could not be feigned in the work; art's meaning could only work its way outward from the maker's own moral core. In part, it expressed itself in fine craftsmanship, a dedication to the difficult nuances of the work, in painting and sculpture no less than in photography. Stieglitz loathed whatever was botched or skimped, a fact that shows itself everywhere in his own photography. But in larger part, it showed itself in what Stieglitz—a devotee of Bergson—believed was the recognizable *élan vital* of the work, its power to communicate the purity, freshness, and honesty that lay in the artist's own character. This is why Stieglitz expected so much from "his" artists, and it explains the sometimes bruising rejections and quarrels that arose in his various relationships with them.

Even to discuss the value of the creative impulse in such terms strikes today's postmodernist as hopelessly naïve. When the "self" is a mere "construction," sincerity deflates; when all reality is "mediated," none dare speak of freshness; and when the art world is a sanctimonious commercial mill, its inhabitants shrink from words like "purity," except as sales talk. But Stieglitz believed otherwise, and it is unlikely that modernism would have found its foothold in America in the way that it did—as a model of authentic experience in the arts, as against whatever was stale, rhetorical, and unfelt—if he had not.

There were many other ways in which Stieglitz's convictions would have clashed with the assumptions of our own day. One was his fierce belief in the autonomy of the arts, and the unique character and needs of each medium. "The arts . . . have distinct departments, and unless photography has its own possibilities of expression, separate from those of the other arts, it is merely a process, not an art." Not for him the arbitrary mix-and-match from the image-haze of postmodernist sensibility, or the assumption that photography could be used merely as "information" or "process" without regard to its intrinsic qualities. For the idea of the intrinsic, coupled with "the spirit of the thing," was the cornerstone of his esthetic. It meant respect for each medium on its own terms, and Stieglitz refused to accept the hierarchies of his day by which painting and sculpture stood at the top and photography and crafts in a vague netherworld. To the extent that photography imitated painting, it condemned itself. And if painting imitated photography, its fate was the same. Only by robust equality could the Great Concert be played: otherwise, "as they are all placed in their separate cells," he wrote, imagining the arts as different species in Noah's Ark, "they grow so self-conscious that finally, if one were to take them out and put them together they would all fall upon one another and kill each other."

Stieglitz never bothered to paper over the changes in his thinking. The man who led the charge for the autonomous value of photography in America began in the 1890s as a "Pictorialist"—one who strove to give his photographs ("pic-

213. Alfred Stieglitz, *The Terminal,* 1892. Photogravure, 4³/₄ × 6¹/₄″ (12 × 15.8 cm). International Center of Photography, New York.

tures," the public invariably called them) a resemblance to painting. There were two branches of Pictorialism, soft and hard; the soft was very soft indeed, seeking Barbizon-style blurs, romantic murk, and often cloying sentimentality, with much manipulation of focus, negative, and print. Stieglitz preferred the hard, in the sense that although he wanted the unfussed photographic character of the print to predominate, he allowed his images to evoke the character of paintings. Thus *The Terminal,* 1892 (Figure 213), with its draft horses steaming in the cold wet, is straight out of the New York of the Ashcan School. But all is relative: Stieglitz's photographs, compared to most other Pictorialist ones, were—a word he valued—"straight." Most of the time, when he spoke of pictorial photography, he meant photographs that stand on their own with value as works of art—not ones that aped oil painting, watercolor, or etching in their effects.

In 1902, with his younger friend the photographer Edward Steichen (1879–1973), he started the "Photo-Secession" group and appointed himself its leader. The record of its ideas was a handsomely produced quarterly magazine, *Camera Work,* which began publication in 1903. The meaning of "Photo-Secession" was nebulous then and remains so still; it was cribbed from the Viennese and Munich *Sezessionist* art movements, which were for the new and against the academic. What Stieglitz's secessionists were seceding from was what they considered poor photography. The group included such photographers as Gertrude Käsebier, F. Holland Day, and Clarence White. Presently the Photo-Secession installed itself in a small permanent gallery at 291 Fifth Avenue; and after 1909, as Stieglitz began to lose interest in current photography and his attention shifted to painting and sculpture, this gallery, "the biggest small room in the world," became New York's epicenter for the artistic avant-garde—the Ellis Island, as conservatives darkly thought, of bad foreign art.

The 291 Gallery, or simply 291 for short, had an amazing track record. Its 1905–7 seasons showed only photography, but its first show of drawings, which opened in January 1908, was by Auguste Rodin. Henri Matisse exhibited at 291 three months later. And from then on some of the major figures of European modernism were shown at 291: Picasso, Cézanne, Toulouse-Lautrec, Picabia, Gino Severini. Constantin Brancusi's display of eight sculptures there in March 1914 was his first one-man show anywhere, not just in America. True to his convictions, Stieglitz gave his band of American artists equal prominence. The first one to have his first painting show at 291 was John Marin (in 1910), and he was followed by Alfred Maurer, Marsden Hartley, Arthur Dove, Max Weber, Arthur Carles, Abraham Walkowitz, and, in 1916, an unknown young woman named Georgia O'Keeffe.

"No ideas but in things," the poet William Carlos Williams wrote. This statement of a very American pragmatism, which reaches back to the Puritans in the seventeenth century, was central to Stieglitz's beliefs as a photographer, and to the

art that he supported. In the 1920s the educational reformer John Dewey un-packed Williams's koan. "All concepts, theories, general ideas are thin and inef-fectual," he wrote, unless they are grounded in the concrete reality of "things which specifically enter into our lives and which we steadily deal with." This had been the spirit of Copley's American portraits in the eighteenth century, and of Eakins and Homer in the nineteenth. It was true of photography; and most of the artists in Stieglitz's circle believed in it too. They tended to reject theory in favor of direct experience; they were not interested in symbolism or woozy "poesy"; though very different as artists, Marin and Dove, Hartley and O'Keeffe wanted to see the thing-in-itself, full and apprehensible, laconic, and as honest as an apple on a plate. As would the "Precisionists" later—Demuth, Sheeler, and their colleagues in the 1920s; and the photographers of the f/64 group, led by Paul Strand. But the event that transformed the small modern art environment in which they moved until 1913 had little to do with these empirical qualities, and Stieglitz had no direct role in organizing it; it was too big a project to suit his ex-clusivist temperament. This was the Armory Show.

The idea was to give modern art a splashy debut before an ignorant New York public. It succeeded beyond its organizers' dreams. In 1910 a group of artists led by the members of the Eight—Henri and his realist friends, along with some of Henri's brighter students—had held a show of "Independents" in opposition to the National Academy's spring exhibition. It caused a sensation: on the first day, the riot police had to be called in to discipline a rowdy fifteen hundred people. In 1911, hoping to repeat the Independents' *éclat,* the Association of American Painters and Sculptors was formed, with a view to holding a big invitational show that included Europe. None of its members were firebrand modernists; most were distinctly conservative. And in truth, none of them knew much about what had been happening in Europe, beyond the names of obvious if still dis-puted masters like Cézanne and Gauguin. But the Association's control fell into the hands of two open-minded men: the realist painter Walt Kuhn (1880–1949) and his friend the New York symbolist artist Arthur B. Davies (1862–1928).

They looked around for a better model than the provincial "Independents" show, and found it in one of the first European exhibitions ever to attempt to chart the early course of international modernism: the Sonderbund exhibition, held in 1912 in Cologne. It was the precursor of the Biennales and Dokumentas of our own day, and Kuhn, hurrying across the Atlantic, just caught it as it was closing. There followed a quick, crowded trip to Munich and Berlin, and then on to Paris with Davies to make contacts with artists, dealers, and collectors. Then Kuhn and Davies went to London to get the episcopal blessing of the art critic Roger Fry, whose show of Post-Impressionism (a term he coined) at the Grafton

Gallery had set the English art world on its ear and was another model for their coming show.

Walt Kuhn had a talent for promotion, but Davies became the prime mover of the Armory Show. His tastes were classical and formal; he disliked both realism and Expressionism because he disliked disclosure of any kind. Outwardly mild, affable, and sociable, good at moving between art-world factions and hence an ideal organizer for such a project, he was, deeper down, an archconcealer who lived between hermetic compartments. From 1905, for twenty-five years, he managed to keep two households, one with his wife and children, the other with his mistress and children, both in New York and each in complete ignorance of the other. How he managed this feat, those of a more unruly emotional economy can hardly begin to guess. Such arrangements demand an iron vigilance against emotional leakage, and Davies's paintings are by a man who refused to let drop any clues from his life into his art. He was the antitype of the Ashcan painters. Not a breath of the street, or of modern life in any form, intrudes into his frieze-like idylls, where slender nymphs minister to white unicorns (Figure 214) by an emblematic sea. His predilection for the romantic and the decorative was formed in Europe, where he absorbed the work of Whistler (for the muted nuance), Arnold Böcklin (for the slightly morbid romanticism), Puvis de Chavannes—whose abstract designs and pale etiolated figures of nymphs and poor fishermen, like low-protein Poussin, had great appeal for younger artists of the fin de siècle, including Picasso—and such Venetian masters as Giorgione. He also admired the Pre-Raphaelites, for the tension between their often morbid sensuality and their high Victorian idealism.

Such an American, one might think, would not like modern art. In fact, Davies loved it, provided that it offered sensuous fulfillment, a distance from the world of politics, narrative, and struggle—Matisse's idea of an armchair for the tired businessman, or perhaps the entrance to a secret Eden that he had managed to re-create in his own life through bigamy. Perhaps it was really Davies who, refracting his unique temperament through the Armory Show, set in train an American preference for "pastoral" as against "engaged" modernism that would continue through much of the twentieth century, in the taste of collectors like Duncan Phillips and critics like Clement Greenberg. The Armory Show was violently attacked, as we will see, on political grounds. It was made into a metaphor of stress in American life. Many artists were eager to claim political metaphors (radical confrontation, revolution) for the new art. And yet hardly a work in the Armory had any political aspect at all.

The committee wanted to put the show in Madison Square Garden. But that was too expensive, and so they chose instead the Armory—hence the name—of the "Fighting Irish," the New York Sixty-ninth Regiment, on Lexington Avenue between Twenty-fourth and Twenty-fifth streets.

The Armory was a vast, high-ceilinged space, a roofed parade ground without internal walls that paintings could be hung on. So the organizers used screens covered in fireproof burlap, dividing the floor into eighteen octagonal rooms—a maze inside the cavernous hall. These were decorated with cut sprays of pine branches, with live, potted pine trees set here and there. The pine tree had been a symbol of Liberty in Massachusetts during the American Revolution. It proclaimed both freedom from the past *and* a continuing American tradition. The trees may have given visitors the impression that they stood on the disputed, unconquered frontier of art. At least they smelled fresh.

The show itself was a hotchpotch of style, period, and place, representing more than three hundred artists, living and dead. Its catalog listed over a thousand works, but the real total was closer to thirteen hundred. About one-third were by American artists, the rest by Europeans, mainly French. The earliest pieces were two drawings by Ingres (d. 1867), a Delacroix (d. 1863), and a small Goya (d. 1828). Work by the main Impressionist artists was on view, though there was nothing of importance by Manet or Courbet. The main body of European work on view was shaped by Arthur Davies's taste: it strongly favored French Symbolist artists, starting with Puvis de Chavannes and the visionary painter Odilon Redon, who was represented by no less than thirty-two oils, the most of any artist in the Armory Show.

From there the line went to the so-called Nabis or "Prophets" of the 1880s and 1890s (Bonnard, Vuillard, Maurice Denis, Ker-Xavier Roussel, and Félix Vallotton), thence to the French Fauves: Derain, Manguin, Dufy, and Matisse, who was well represented with thirteen works, including *The Red Studio*, painted two years before. Georges Seurat and Paul Signac appeared, as did other neo-Impressionists and *pointillistes*. The core of the modern French section of the

214. Arthur Bowen Davies, *Unicorns (Legend—Sea Calm),*
c. 1906. Oil on canvas, 18¼ × 40¼″ (46.4 × 102.2 cm). The
Metropolitan Museum of Art, New York; bequest of Lizzie
P. Bliss, 1931.

show consisted of van Gogh (seventeen paintings), Gauguin (eight), and Cézanne (fifteen). Then there was Cubism: Picasso, Braque, Léger, Picabia, and, a name soon to be raised to infamy, Marcel Duchamp.

Other important Europeans were left out of the Armory. The early teens had seen the rise of German Expressionism, but this important movement was represented by just one Kirchner, and a landscape at that, not one of his superbly edgy figure paintings. Davies regarded German Expressionism as a Nordic offshoot of French Fauvism, and in terms of color he was right—but not right enough. There was nothing from the "Bridge" and "Blue Rider" artists, those mystic-expressionist Germans, except for one painting by their leader Wassily Kandinsky. Italian Futurism was completely absent, though the press took to calling everything "Futurist." Sculpture was spottily chosen: the show had Rodin, Maillol, Brancusi's *Madame Pogany,* and one of Lehmbruck's spindle-shanked women, but little else of interest.

So to say that the Armory Show gave a coherent account of modernism, as it had developed in Europe from 1860 to 1913, is to exaggerate. But that wasn't the point: rather, it presented a challenging *sample* of modernist effort, embedded in a lot of semiconservative or secondary work, to an audience which was about as ignorant of current European culture as any audience could be. If the European material was patchy, some of it was excellent. The same was true, at a lower level of achievement, of the American work on view. Most of the painters one now thinks of as keys to the early American avant-garde were present: Hartley and John Marin, Charles Sheeler and Joseph Stella, Stanton MacDonald-Wright and Morgan Russell. Alas for the American balance, Max Weber took umbrage at having only been asked for two pictures and pulled out altogether. Members of the Ashcan School, such as Bellows, Henri, Glackens, and John Sloane (whose politics by 1913 were far more radical than his paintings), were well represented, but they looked provincial and old-fashioned beside the Europeans.

No exhibition had ever had such a media blitz. For once, here was an art event that had the crunch of real news, the latest murder or the newest political scandal. It provoked a torrent of satires, cartoons, and hostile reviews. The French artists, in particular Matisse and the Cubists, bore the brunt of it. How could such ugliness, such fragmentation, such denial of all pictorial common sense, go under the name of Art? Madness was loose in the Armory, and New Yorkers, on reading the papers, flocked to see it. "What drew crowds," fumed an editorial in *The Century* magazine,

> were certain widely talked of eccentricities, whimsicalities, distortions, crudities, puerilities and madness, by which, though a few were nonplussed, most of the spectators were vastly amused. . . . The exploitation of a theory of discords, puzzles, ug-

liness, and clinical details, is to art what anarchy is to society, and the practitioners need not so much a critic as an alienist.

By the end of its run—it traveled to Chicago, where art students burned Matisse and Brancusi in effigy, and then to Boston—about three hundred thousand Americans had bought tickets to see the International Exhibition of Modern Art. Unquestionably, many who came to scoff stayed to wonder and went home to think. But since America is the country where enough bad reviews almost equal good ones, as long as they create a critical mass of celebrity for their subject, one artist in particular benefited from the Armory Show. This was Marcel Duchamp, and on the basis of one picture: *Nude Descending a Staircase, No. 2*, 1912 (Figure 215). It became the star freak of the Armory Show—its bearded lady, its dog-faced boy. People compared it to an explosion in a shingle factory, an earthquake on the subway; Theodore Roosevelt, a shade more benignly, likened it to a

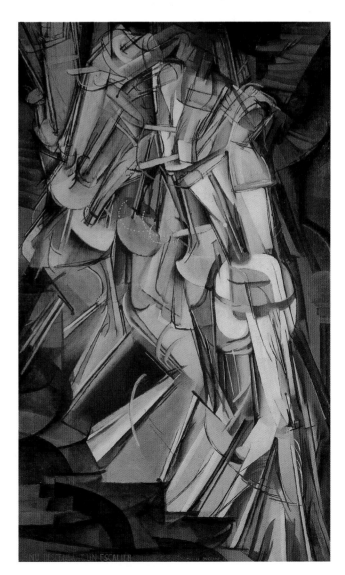

Navajo blanket, which it did not resemble in the least. A dull-brown painting in a Cubist idiom, its overlapping planes were partly derived from the sequential images of the French photographer who analyzed motion, Étienne Jules Marey. Its very title was ironic, almost insupportable. Nudes, in art, were not expected to move, let alone walk downstairs. They were meant to stand or lie still, to imitate the chaste condition of statues. It suggested decorum fractured almost to the verge of pornography, even though this nude had no detectable sexual characteristics—not that the public didn't try to find them.

As a picture, *Nude Descending a Staircase* is neither poor nor great; it hardly compares with the best Analytical Cubist paintings of Picasso or Braque. Its fame today is the fossil of the huge notoriety it acquired as a puzzle picture in 1913. It is, quite literally, famous for being famous—an icon of a now desiccated scandal. It is lodged in history because it embodied

215. Marcel Duchamp, *Nude Descending a Staircase, No. 2*, 1912. Oil on canvas, 58 × 35″ (147.3 × 88.9 cm). Philadelphia Museum of Art; Louise and Walter Arensberg Collection.

the belief that the new work of art, the revolutionary work of art, has to be scorned and stoned like a prophet by the uncomprehending crowd. Because Americans actually love the new and embrace it quicker than anyone else, they are especially fond of this myth and have built cathedrals to it, known as museums of modern art. In their cult of the problematic, as distinct from the enjoyable, Marcel Duchamp is a saint, and this is one of his prime relics.

If the artists who organized the Armory Show wanted to conflate its radicality with politics, so did the patrons and new collectors who supported it. Mabel Dodge, for instance, the manic-impressive heiress whose generosity and relentless narcissism made her the Miss Piggy of the early American avant-garde, got on the Armory committee. She boasted that "I felt as though the Exhibition were mine. . . . It became, overnight, my own little Revolution. *I* would upset America; *I* was going to dynamite New York and nothing would stop me." Her salon, whose regular evenings began in 1913, became a switchboard dating service and wrangling-place for New York's Left intelligentsia. One of the pleasures of New York in 1913 was that radical ideas in all fields moved in a continuum, from labor organizers to journalists, from feminists to artists: it was a smaller and much less subdivided place than it is today. Everyone, as it were, knew everybody. Thus Dodge was not only on the Armory committee, as a rich woman today might be a trustee of the Whitney Museum; she also helped (with John Reed, Walter Lippmann, and John Sloan) to organize a huge pageant of striking textile workers from Paterson, New Jersey, at Madison Square Garden in 1913. There was no doubt in such people's minds that the Left was where the talent and the cultural action were—and in this, they were largely correct.

My enemy's friend is my enemy. These linkages across the politico-cultural left made the Armory Show a doubly inviting target for conservative critics, and they help explain why paintings like Henri Matisse's, which now strike us as invocations of an Edenic order, were accused of "anarchism"—along with all the Cubist works in the show. The anarchist—so often depicted in cartoons as a Middle European Mephistopheles, with cloak and round bomb—obeyed an imported creed. He was, by very definition, un-American. Except that he *was* American—anarchist ideas had helped inspire the American Left through nearly thirty years of class war between workers and bosses, a war whose battlegrounds bore the names of the great industrial strikes of 1886–1913: Haymarket, Homestead, Pullman, Coeur d'Alene, Lawrence, Paterson. It was, however, a fact that some anarchist leaders had foreign names—August Spies, for instance, who was hanged in 1887 for helping organize in Chicago's Haymarket Square a rally of forty thousand workers for an eight-hour day, put down by the guns of the police. So the idea of "anarchy in art" meant something graver than mere esthetic disorder to a newspaper reader in 1913. It suggested deliberate subversion, coming across the Atlantic to derange its cultural polity and making monsters or fools of real American artists.

Fear of "anarchism" fitted into the general matrix of suspicion of the foreign immigrant. This ran strong and hot in 1910s America, toward the end of its first age of mass immigration. Cartoons played variations on a theme—Uncle Sam / American doughboy / fresh young Aryan couple standing on the ramparts or the coastal rocks while crowds, whole seas, of *Untermenschen* came sweeping in: grinning Chinese, shifty-eyed Italians, Rasputin-like Russians, greasy-locked Jews, moronic Poles. Often immigrants were depicted as rats, microbes, or cockroaches. Ten years after the Armory Show, the conservative critic Royal Cortissoz combined most of these tropes in a bugle blast against modernism in the arts:

> The United States is invaded by aliens, thousands of whom constitute so many acute perils to the health of the body politic. Modernism is of precisely the same heterogeneous alien origin and is imperilling the republic of art in the same way. . . . By the time the cubists came along there was an extensive body of flabby-mindedness ready. . . . These movements have been promoted by types not yet fitted for the first papers in aesthetic naturalization—the makers of true Ellis Island art.

No doubt many people outside the New York art world—and not a few academic painters within it—agreed with this *Invasion of the Body Snatchers* scenario. It would recur, in changing forms, throughout the twentieth century in America: dim-witted chairs of Senate committees in the 1950s denouncing abstract art as un-American, or, when the foreigner-at-the-gates had shifted into the fairy-at-the-bottom-of-the-garden as a figure of paranoia, the lunatic fuss over Robert Mapplethorpe's homoerotic photos in the 1980s.

Attached to the idea that modern art was foreign was the further notion that it was influenced by blacks and thus uncivilized. Cortissoz related it to "a world full of jazz"—sexual, convulsive, primitive. Since "primitivism" had been and still was a great issue in the European avant-garde, through early Cubism and Expressionism, Cortissoz's observation was not altogether wrong; only his hostility was. Whereas most white Americans around 1910–20 thought of cakewalk, ragtime, and jazz as mere jungle music, French composers since the 1890s had taken it with the utmost seriousness, recognizing it for what it was: the great, indigenous American musical form. Darius Milhaud, Maurice Ravel, and Claude Debussy all embraced it and were influenced by it, and for Igor Stravinsky jazz meant "a wholly new sound in my music . . . my final break with the Russian orchestral school in which I had been fostered." Jazz was in fact the only product of American culture that Parisians admired without reservation: certainly they would have turned up their noses at the kind of genteel academic painting and fourth-string, late Impressionism that the attackers of the Armory Show regarded as *le beau et le bien* in American art.

The main living beneficiaries of the Armory Show were the European artists: Picasso, Matisse, Brancusi, and of course Duchamp, that singular and wily dandy

who went on to parlay a small body of work into a towering reputation as ironist, sage, and seer, while living mostly off art dealing and the gratitude of rich ladies. The show also marked the beginning of modern art collecting in America. It highlighted a small group of American collectors who liked risky new art—John Quinn, Walter Arensberg, and Agnes Meyer. It thus prepared the way, though few at the time could have foreseen it, for America's massive institutionalization of modern art after 1950.

Other than Marcel Duchamp, the big Dada winner at the Armory was another foreigner, Francis Picabia (1879–1953), whose large Cubist paintings such as *Dances at the Spring*, 1912, had been received hardly less noisily than Duchamp's *Nude*. Picabia knew exactly how to tickle and flatter the press; his come-on in America was an adroit mix of prophecy, mystification, and flattery. After the Armory Show he had gone back to Paris for a couple of years, but he reappeared in New York in 1915, prophesying that New York would soon become the center of modernist effort because its reality had already made it into the modernist site to beat all others. France was *vieux jeu,* suffocating under the crust of the past; "Your New York is the cubist, the futurist city. It expresses modern thinking in its architecture, its life, its spirit. You have passed through the old schools, and are futurists in word and deed and thought. I see much, much more, perhaps, than you who are used to it see." His audience liked this, much as Monsieur Jourdain in Molière's *Bourgeois Gentilhomme* reveled in the discovery that, without knowing it, he had been speaking prose all his life. Endowed with a passion for fast cars and the money from Cuban sugar to support it, Picabia saw machinery as the prime metaphor of modern society and, particularly, of love. Machine people and machine pleasures for a machine age. His most telling machine images were about sex. They were based on the familiar trope of a woman, typically a prostitute, as *une machine à plaisir.* They present the act of love as a ballet of soulless machines, pistons inside cylinders, valves opening and closing, cogs driving other cogs. Though parts of his erotic gizmos are identifiable, their functions, beyond pushing, sliding, turning, and transmitting fluids, are not. Had he lived long enough, Picabia would have adored the android bimbos in Japanese animated movies and the notion of "virtual sex" through computers—clean, perfect whoring, the expulsion of all sentiment by technology. In *Universal Prostitution*, 1916–17 (Figure 216), an upright male machine whose "head" vaguely resembles a dynamo shoots out a string of abrupt words (*Convier . . . ignorer . . . corps humain*—"To get together . . . to ignore . . . human body") while feeding electrical energy into a crouching female machine labeled *Sexe féminin idéologique,* which translates, colloquially, as "Ideological pussy." It, or she, has a traveling bag slung below, to indicate that she is on the move, or perhaps that her thoughts are elsewhere.

But such Picabias were made after the Armory Show, which actually contained

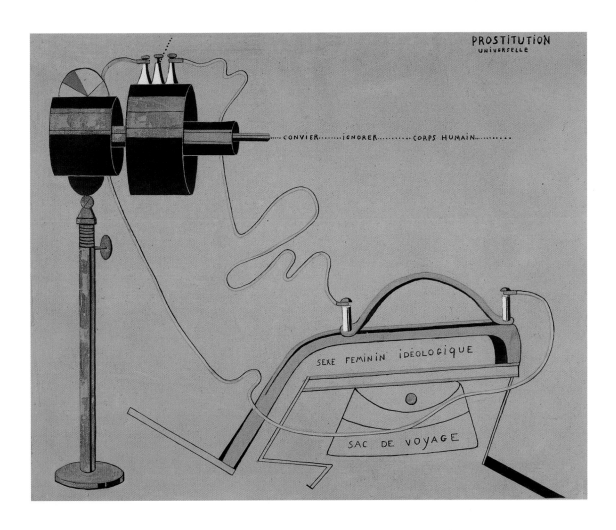

Text within image: PROSTITUTION UNIVERSELLE · CONVIER · IGNORER · CORPS HUMAIN · SEXE FEMININ IDÉOLOGIQUE · SAC DE VOYAGE

216. Francis Picabia, *Universal Prostitution,* 1916–17. Black ink, tempera, and metallic paint on cardboard, 29⁵/₁₆ × 37¹/₈″ (74.5 × 94.2 cm). Yale University Art Gallery, New Haven; gift of Collection Société Anonyme.

217. Morton Schamberg, *God,* c. 1918. Miter box and cast-iron plumbing trap, height: 10¹/₂″ (26.7 cm). Philadelphia Museum of Art; Louise and Walter Arensberg Collection.

very little of a sexual or blasphemous nature. New York Dada as it developed later was mostly high jinks and amiable fluff, except for Picabia and Duchamp, although it did create one of the few exceptional images of blasphemy in American art—as startling, in its way, as Duchamp's *L.H.O.O.Q.*, the mustache on the Mona Lisa. It is usually attributed to Morton Schamberg, a machine-painting follower of Picabia whose promising career was cut off at thirty-two by the great influenza epidemic of 1918. Its resonant title is *God,* c. 1918 (Figure 217)—a cast-iron plumbing trap turned upside down and affixed to a wooden miter box. Recent research suggests that Schamberg may only have photographed it, and that its real author was Schamberg's friend, a bizarre denizen of Greenwich Village bohemia, Baroness Elsa von Freytag-Loringhoven. The Baroness, *née* Elsa Plötz in Germany in 1874, had reached New York in 1913 and married a minor German noble who soon afterward committed suicide. Slender, long-backed, penniless, and as mad as a March hare, she survived as an artist's model. She would be seen at soirées at the Arensbergs or stalking through the Village with black lipstick and postage stamps stuck to her cheeks, with her head shaven bald and painted reddish purple with potassium permanganate, with dozens of lead soldiers and metal toys sewn to her skirts, or wearing a hat trimmed with vegetables and parsley. She was America's first punk, and when roused in pursuit of a man she could be a very strange sight—one acquaintance recalled how, on being given a news clipping about Marcel Duchamp's *Nude Descending a Staircase,* she proceeded to rub it all over her body, chanting "Marcel, Marcel, I love you like hell, Marcel." If there was anyone in New York likely to exhibit a grease trap as God, that person was probably the Baroness.

For American artists, however, the Armory Show did little. In fact, it was more a disaster than a triumph. They were eclipsed by the School of Paris, left looking more provincial than ever. Marginal to begin with, they now looked marginal within modernism itself: there was no way that their talents, by and large, could be seen as the equal of Matisse's or Picasso's. Nor did they reap much from the whirlwind of publicity.

Its one American star, but a fading one, was the painter Albert Pinkham Ryder (1847–1917), old and infirm by then; he would die four years later. The show's organizers were determined to enshrine him as the first authentic American modernist.

Ryder was an erratic painter, and his reputation rests on perhaps a dozen works, most of which are his famous "marines"—dark, concentrated images of boats, the fishing smacks of his New England youth, pitted against wind and wave under the centered, tide-dragging eye of the moon. Images like *Moonlight Marine* (Figure 218) are diminutive in size but large in scale. They concentrate the Romantic terrors of seascape; in them Ryder showed that he was the Samuel Palmer of Ishmael's "watery part of the world." Thick darkness and eerie light

turn in the sky; the turgid sea heaves, scattered with moon flakes and endowed with a Courbet-like solidity by Ryder's constant overpainting. "My soul, like to a ship in a black storm, / Is driven I know not whither"—Vittoria's dying words in John Webster's Jacobean tragedy *The White Devil* seem to fit this recurrent and obsessive vision of human fate, the boat scudding in the maw of the waves or becalmed, like a floating coffin, on the expectant water.

The strong tonal structure of the marine paintings, with their big masses, holds them together despite their rapid degeneration over time. For Ryder was an appallingly bad technician. In pursuit of jewel-like light effects and a deep layering of color, he would paint "lean over fat" so that slower-drying strata of paint below pulled the quicker-drying surface apart. He would slosh messes of varnish on the surface, and pile up the pigment by incessant retouching until the images became pitch lakes. Then there was the dirt. "It's appalling, this craze for clean-looking pictures," Ryder once complained. "Nature isn't clean." Neither was his pack rat's nest of a New York studio, where he slept on a rolled-up carpet. Preserving Ryders has long been a conservator's nightmare—and a losing battle as well. The glow and atmospheric subtlety that early American moderns praised in

218. Albert Pinkham Ryder, *Moonlight Marine,* 1870s or 1880s. Oil and possibly wax on wood, 11½ × 12″ (29.2 × 30.5 cm). The Metropolitan Museum of Art, New York; Samuel D. Lee Fund, 1934.

Ryder's work eighty years ago have to be taken on faith today; they are almost gone.

Though his color was rich, he drew feebly. The convention is to treat this as Ryder's good luck, as though it permitted his native, visionary qualities to prosper, unsullied by academic convention. But the truth is that his figures and animals never benefited from his awkwardness. Ill-schooled in anatomy, he spent no time looking at bodies and analyzing their structure. His men and women looked like slugs. He was very far from the great American empiricists, Thomas Eakins and Winslow Homer. Instead he generalized. He was like Edgar Allan Poe—so overwrought, and yet so influential. Though he was never (in his own view) a modernist, a succession of American artists from Marsden Hartley to Jackson Pollock and beyond would look up to him as an emblem of esthetic purity, a holy sage, and the native prophet who linked tradition to modernism.

As the saint of Greenwich Village he attracted acolytes, who tended to be artists of a religious bent who felt the pangs of spiritual inadequacy and were looking for father figures. One such man was Kenneth Hayes Miller (1876–1952), in his youth a symbolist whose wistful, indeterminate figures owed much to Ryder. It seems that Ryder reminded Miller of his father, an elder in one of the odd mystical sects that flourished in America—the Oneida community in upstate New York. Miller left Oneida to study art in New York; in doing so he took on a load of apostasy-guilt which he could only assuage by convincing himself of a duty to minister to the peevish and aging Ryder, his second father. (He also had the bad luck to marry a young Oneida woman who, after the wedding, announced that she was renouncing sex as a drag on her spiritual growth.) Small wonder that, when Ryder died, Miller declared that "I have never enjoyed New York so much, nor sensed it as richly as I do now." Relieved, he embraced the world and its pomps by painting groups of buxom women shoppers in cinquecento poses, trying on clothes in department store changerooms. This peculiar form of social realism had a great effect on his students Reginald Marsh and Isabel Bishop.

The idea of Ryder as secular saint was scripted into the very fabric of the Armory Show by Walt Kuhn and Arthur Davies. For Kuhn, there was "only Ryder in American painting." Davies had long concurred: his paintings faithfully echoed Ryder's storybook fantasies, with their enchanted groves and maidens and Siegfrieds. Ryder was the sole painter who, in their view, could make up for the dispiriting absence of a great national school of American art in the early twentieth century. Others, including some conservatives, also agreed: the critic Frank Jewett Mather, for instance, considered that Ryder and the tragic nineteenth-century romantic Ralph Blakelock were "the most American artists we have. Neither their minds nor their methods betray any alien tinge." If Ryder was truly a *naïf*, a visionary, then there had to be some original current in America to

which he had connected: a natural and instinctive vision, a sort of cultural bird-song, not imported from Europe. There were problems with this, since Ryder's own pictorial god was the French landscapist Jean-Baptiste-Camille Corot, and his themes (except for the "marines") were all drawn out of transatlantic literary and musical sources. Still, needing a sign of American parity, Davies made sure that Ryder was the only American to share the central space of the display with the European masters: Matisse, Cézanne, Gauguin, van Gogh. This endorsement (which no curator, one suspects, would make today) had something messianic and hopeful about it, but it also signaled a grave underlying pessimism. Dozens of American protomodernists after 1900 had been imitating Ryder's moons and seas and forests. But did that make them truly "American," whatever that word, in the context of a modernist idiom, meant?

The painter on whom Ryder's work had the most direct and cathartic effect was Marsden Hartley (1877–1943), a diffident, gangling Down Easter from Lewiston, Maine, and the greatest of early American modernists. His devotion began in 1909 with a Pauline burst of revelation, on seeing *Moonlight Marine* in a New York gallery. "Just some sea," he wrote, "some clouds, and a sail boat on the tossing waters,"

> and when I learned he was from New England the same feeling came over me . . . as came out of Emerson's Essays when they were first given to me—I felt as if I had read a page of the Bible. All my essential Yankee qualities were brought forth out of this picture. . . . [I]t had in it the stupendous solemnity of a Blake. . . . I was a convert to the field of imagination into which I was born.

This sense of homecoming—Ryder the patriarch welcoming the prodigal son—had intense emotional meaning for Hartley, because he already felt like an exile in his own culture. An early orphan; a homosexual in a fiercely prejudiced society, where even fellow artists (who were apt to stress their orthodox masculinity to rebut philistine jeers) deprecated the "pansy" and the "nancy-boy"; an Emersonian mystic seeking transcendental wholeness in a fractured, materialistic America; a plain speaker who couldn't bear cultural pretension; a political fleabrain—nothing was easy for Hartley. He was afflicted throughout his life by feelings of disconnection from others: as he wrote to Mabel Dodge after she ejected him from her house in Taos for insulting the other guests, "I must never do more, at most, than walk in as graciously as possible, sit a little and pass out again for there is always the quality of wonder in being really not quite anywhere at all." The sense of estrangement, of pure depressive "otherness," came to Hartley almost with his birth, and his growth as an artist was a long struggle to keep it at bay and to work against it. This, once rightly seen, deserves the overused word "heroic."

Hartley was a writer as well as a painter—in some respects the most rewarding writer on art, others' as well as his own, that America produced in the 1920s or 1930s—but he had no more than a grammar school education. As a painter, he trained in New York with William Merritt Chase and at the National Academy. The great early influence on his imaginative life, though, was the poet Walt Whitman; through Whitman's work he learned that his turbulent homoerotic feelings did not set him apart from others—"Ah lover and perfect equal, / I meant that you should discover me so by faint indirections." In gratitude, he used Walt Whitman's pictorially unpromising house in Brooklyn as the subject of one of his earliest paintings.

The mystical bent of Hartley's work began to emerge after 1906, in Maine, where he painted a number of images of its brooding hills—his "efforts at rendering the God-spirit in the mountains," as he wrote to his friend Horace Traubel, Whitman's literary executor. Soon after, Traubel persuaded him to join a community devoted to Eastern religion near Eliot, Maine, and there his color reached a new intensity in a series of mountain paintings, rendered in a pelt of divisionist, cross-stitch strokes like "fine old tapestries—Paisley shawls and Persian rugs," under the influence of the Italian artist Giovanni Segantini, whose mountain images he knew only from reproduction. In New York he showed them to Stieglitz, and in 1909 a show at 291 followed. It failed to sell, and the collapse of Hartley's manic hopes into what was, according to Stieglitz, a suicidal depression is recorded in a series of "dark landscapes" painted later in 1909. Their background is always a tall, bare black hill, filling four-fifths of the canvas—a wall of despair, topped by a narrow band of oppressive Ryderesque clouds. In the foreground are rocks and trees, but the trees are bare and their branches hang at dejected, broken angles.

Stieglitz decided to get Hartley out of America. Over the next three years, one sees the young artist reacting to his first sight of Cézanne, Matisse, and the massive, bulging forms of 1909 Picasso; he was primed to go to Paris, and in 1912, funded by Stieglitz's friends, he left.

In Paris he was welcomed into the circle of the Steins. He disliked the glib theorizing of the French artists he met, admired Matisse from a distance, was further moved by Picasso to paint some rather indecisive Cubist exercises. But the great impact on him came from Wassily Kandinsky, the Russian painter-mystic who had recently published *Über das Geistige in der Kunst* (*Concerning the Spiritual in Art*), whose very title aroused in him the mystical yearnings that lay beyond the range of Cubism. Kandinsky's ideas—which he was able to decipher with the help of some German friends—chimed with his reading of Bergson and the sixteenth-century mystic Jakob Böhme, and reawoke in him the longing for transcendental experience which, as he so often said, had been implanted in his American youth by Emerson.

The second thing that happened to Hartley in Paris was equally important. He was in a cosmopolitan wonderland, with a strong gay subculture in which his sexuality, driven underground in Maine, could now disport itself. And in the process he met two young German officers: a sculptor named Arnold Rönnebeck, and his cousin Karl von Freyburg, with whom Hartley began to fall deeply and sentimentally in love. It was the need for von Freyburg, quite apart from artistic considerations, that took him to Berlin.

The Berlin to which Hartley came in 1913 offered him a spectacle he had never imagined before: a city with the strongest homosexual subculture in Europe, linked to flamboyant rituals of military display. The "sweets," the "warm brothers," were everywhere, and Berlin's gay nightlife was less available than inescapable. Homosexual acts were still proscribed as crimes under Article 175 of German law, but a more powerful and open movement of intellectuals and writers than anywhere else in Europe was protesting against them: among these were Martin Buber, Herman Hesse, Karl Jaspers, Thomas Mann, and Rainer Maria Rilke. Hartley wrote back to America that he had "every sense of being at home" in Berlin, a considerable understatement. He loved the public rituals of masculine supremacy, order, and strength. The imperial dragoons parading in formation down the boulevards, with their flashing breastplates and plumed helmets, their skintight white leather breeches and their regimental insignia glittering in the sun, excited him to dithyrambs:

> It was of course the age of iron—of blood and iron. Every backbone in Germany was made of it—or had new iron poured into it—the whole scene was fairly bursting with organized energy and the tension was terrific and somehow most voluptuous in its feeling of power—a sexual immensity even in it—when passion rises to the full and something must happen to quiet it.

He first tried to convey this bombardment of the senses—in etherealized form—in *The Warriors*, 1913, a mystico-military vision filled, as in the eyepiece of a kaleidoscope, with dozens of white cavalrymen on white horses, stacked up like the angelic choir in a late Gothic image of heaven.

Von Freyburg was the first great love of Hartley's life. Nothing much is known of him except that Hartley was ecstatically happy with him and idealized him without restraint. Nothing is known, either, of the sexual side of their relationship, and no photo of von Freyburg has survived. Hartley remembered him as a "Man in perfect bloom / of six foot splendor / lusty manhood time—all made of youthful fire / and simplest desire." He first appears in *Berlin Ante-War*, 1914 (Figure 219), painted in the months just before Sarajevo: a schematic figure in white uniform and white feathered helmet, riding on a blue charger. Votive clouds swirl around him, and there is a mandala containing a white horse kneel-

219. Marsden Hartley, *Berlin Ante-War,* 1914. Oil on canvas with painted wood frame, 41¾ × 34½″ (106 × 87.6 cm). Columbus Museum of Art, Columbus, Ohio; gift of Ferdinand Howald.

ing on the ground as though in adoration of a cross. Below are small emblematic scenes done in the manner of the primitive landscapes in Bavarian folk painters' ex-votos: houses and hills, a blue sea at sunset, and in the center a shrine whose entrance curtains are drawn to show a checkered floor, a cross, and what may be either a Eucharist or a sun—all betokening the idealized peace of the German *Heimat,* the homeland over which his White Knight stands guard.

This idyll was not to last. The First World War, the apocalyptic conflict that was to end the nineteenth century and plunge Europe into the era of total war and mass death, broke out in August 1914. At first, with a naïveté that now seems barely credible, Hartley welcomed it. Like some Italian Futurist, but more like the young German militarists he hung out with in Berlin, he proclaimed it "the only modern religious ecstasy," and was completely on the Kaiser's side. (Anti-Americanism was not an issue, however; the United States did not enter the war for another three years.) He imagined a chivalric conflict between young knights. But very soon the reality burst in on him, for two months later Karl von Freyburg was killed. Hartley was inconsolable. He wrote of his "eternal grief" and "unendurable agony," and we can be sure that he was not exaggerating. But his mourning and loss cracked him open, and from them—based on strict and strong formal principles, and a powerful capacity for sublimating pain while remembering its symbols—he constructed the finest paintings of his early career, of which *Portrait of a German Officer,* 1914 (Figure 220), was the first. From it, the slightly diffuse mysticism of the earlier Berlin paintings is banished; he achieves focus, and makes anguish palpable.

In *Portrait of a German Officer,* Hartley assembles the "things that were," the symbols and emblems worn by von Freyburg or marking his chivalric role. An Iron Cross on a green ground, within a triangle which symbolizes the friendship between three men: Hartley, von Freyburg, and Rönnebeck. (Von Freyburg had

220. Marsden Hartley, *Portrait of a German Officer,* 1914. Oil on canvas, 68¼ × 41⅜″ (173.3 × 105.1 cm). The Metropolitan Museum of Art, New York; Alfred Stieglitz Collection, 1949.

369

received the Iron Cross for gallantry the day before he was killed.) A scrolled red letter on a yellow ground, *E,* probably stands for Edmund, Hartley's unused first name. The numbered tabards indicate his lover's regiment; the red-white-and-black banner is that of imperial Germany; there are silver tassels and lance points, and von Freyburg's initials, K v.F, appear on a red patch at the lower left.

It is a funerary memorial; that is implied by the black background. Being a portrait, it is also a "submerged" representation, which can be made out as a vertical, totemic figure composed of the emblems of von Freyberg's military profession: the triangle that bears the Iron Cross can be read as a head, for instance, and the twin waving black-and-white banners on either side as shoulders. One thinks of a mummy prepared for burial, wrapped not in linen but in flags and tabards. Perhaps some distant memory of Arcimboldesque portraits, those Mannerist images in which the head of Autumn was made of vegetables, or a carpenter's figure of tools, played its part here. But more important than this is the solidity of the image. It is Cubist in structure—perhaps the most sophisticated Cubist painting made, up to then, by an American—but it shows none of the fragmentation and translucency employed by the Analytical Cubism Hartley would have seen in Paris. The pigment is dense, each edge defined, the overlaps explicit—you could almost pick it up and turn it around. Hartley in his grief is re-creating the absent body, the physical presence torn from him by war.

Numerous other mourning pictures followed, all featuring the same elements—the cavalry uniforms, flags, crosses, ciphers, letters, and von Freyburg's initials. War had hurt him into poetic utterance, but it would do him no good in America. In 1915 Hartley had to come home. He thought of it not as home but as a second exile, which it was: the temper of New York had changed, for since the torpedoing of the *Lusitania* (a British liner, on which 128 Americans died) the United States had been cranking itself up into a hatred of all things German. At a time when performances of Mozart and Beethoven were banned and indignant citizens were stomping dachshunds to death on the pavements of Fifth Avenue, there was not going to be much chance for Cubist paintings with recognizable Iron Crosses and other signs of the Kaiser's presence in them.

The idea that New York—the city itself—should be the prime subject of a New York artist seeking to connect his work to modernity was neither new in itself nor the invention of any one person. But it took some time for painters and photographers to grasp its possibilities. John Sloan, for instance, painted the Flatiron Building and the trestles and flying roadbed of the elevated railway in flurries of paint and atmosphere, making them look romantic, as if they were part of nature. Alfred Stieglitz in 1903 took his famous photograph of the Flatiron Building in a snowfall (Figure 221), and later said that "it appeared to be moving

toward me like the bow of a monster steamer—a picture of a new America still in the making." But the soft gray silhouette, gridded with window openings but blurred in a near-Whistlerian way by the blowing snow, doesn't look at all harsh; indeed it is naturalized by the tree trunk on the right, with a half-moon of snow (of the same tonal value as the Flatiron) couched in its crotch—a Japanese touch that, with the tiny scale-giving figure of the man on the bench, suggests a photographic Hokusai. It is a natural tendency among artists, when confronted with "unpoetic" subjects, to poeticize them, to slide them into the file of "artistic" themes by giving them a romantic treatment—a strategy that offered a defense against the subject as well. But the stronger option was to depict them head-on, with a detached eye (behind which a deeper romanticism could still beat, concealed) in all their flatness, hardness, and apparent banality. Dadaist machine-and-sex metaphors did not supply the main poetic vein of New York artists' relation to modernity, and especially the modern city, in the teens. For that, one must look to the remarkable explosion of imagery about New York itself, the "shock city," condenser of crowds and creator of unique impaction. And its origins lie with Walt Whitman, just as they did for the Ashcan School. Whitman is the ecumenical genius whose poetic vision marked fifty years of attempts to figure New York. It is the desire to see the city as a totality, a sum of energies,

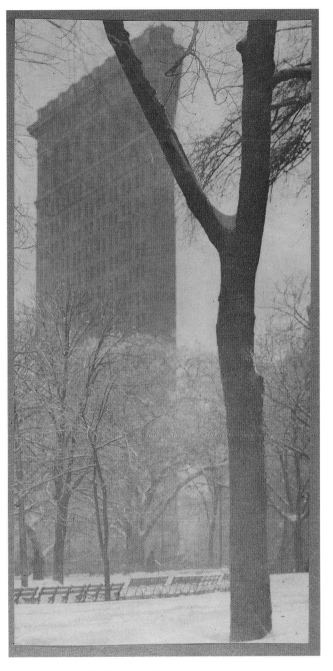

221. Alfred Stieglitz, *The "Flat-iron,"* 1903. Photogravure, 6⅝ × 3¼" (16.8 × 8.2 cm). International Center of Photography, New York.

that links the New Yorks of Whitman and of the early American avant-gardists—
John Marin, Joseph Stella, and, a little later, Charles Sheeler.

One catches the authentic Whitman note in a catalog statement Marin wrote
for his show at 291 in January 1913, later published in *Camera Work:*

> Shall we consider the life of a great city as confined simply to the people and an-
> imals on its streets and in its buildings? Are the buildings themselves dead? . . . You
> cannot create a work of art unless the things you behold respond to something
> within you. . . . Thus the whole city is alive.

Such a vision of the city as a mighty organism was not only Whitman's, of
course; Dickens had imagined London in such powerful terms, and Balzac Paris.
But Whitman had opened New York to it. Marin shifts the idea into terms of the
visual, the stress and reaction of formal elements that seem to cast a shadow of
social conflict:

> I see great forces at work; great movements; the large and the small buildings, the
> warring of the great and small; influences of one mass on another greater or smaller
> mass. . . . [These arouse] the desire to express the reaction of these "pull forces,"
> those influences which play with one another . . . each subject in some degree to the
> other's power. . . .
> While these powers are at work pushing, pulling, sideways, downwards, up-
> wards, I can hear the sound of their strife and there is great music being played.
> And so I try to express graphically what a great city is doing.

Marin's preferred medium for this was watercolor. Its mobility, quickness, and
transparency made it an ideal means of catching the fugitive energies he sought:
sticky oil might have slowed them. The watercolors of Cézanne, which he had
seen at 291 and also during a sojourn in Paris, influenced him strongly: the use
of inflected dabs and broken washes of color to set up a discontinuous structure,
through which the white of the paper burns as light. This atomization of once
continuous form had opened the way to Fauvism, and to Cubism. Marin, com-
ing somewhat late to the French avant-garde as Americans were fated to do, was
not temperamentally attuned to the rigors of Analytical Cubism. He seems to
have found it too hard and dry. Robert Delaunay's paintings of the Eiffel Tower
from around 1910, in which the four-legged colossus is imagined as though danc-
ing in light amid puffballs of cloud, pulling the nearer buildings into the twisting
rhythm of its movement, was a much more vital influence on Marin's New York
paintings than any particular Picasso. And there was something else: Chinese
landscape. Marin liked wet painting and atmospheric lushness. He wanted color
to bleed into the white; he sought to combine a wide variety of strokes, marks
that had a self-delighting and calligraphic quality, with a certain sparseness of

means. He had certainly had ample opportunity to study the Sung landscape scrolls in the collection of the Met, and his friend Marsden Hartley saw in his watercolors "the same sense of surety of observation and of surety of brush-stroke" that animated the work of the Sung masters—the presence, though he did not use the word, of *ch'i*, the vital anima or energy whose release was the goal of Chinese brush painting. In 1910 he painted the Brooklyn Bridge as a Gothic nave gone wild in the sky, the cable-hung roadway bucketing in the flux of brushstrokes as though about to pull apart (Figure 204, page 336). *Movement, Fifth Avenue*, 1912 (Figure 222), suggests how intuition reigned over programmed structure in

222. John Marin, *Movement, Fifth Avenue*, 1912. Watercolor, 17 × 13¾″ (43.3 × 35cm). The Art Institute of Chicago; Alfred Stieglitz Collection.

Marin's work—as it seldom did in the more phlegmatic Delaunay's. The street heaves, the buildings lean in a jubilant flurry of spots, washes, and broken cranky outlines that never establish a closed or certain form; even the street clock is cartoonishly drunk. Thus Marin conveys the raw anarchic energy of Manhattan, its all-against-all competition, its abandonment to improvised struggle—social, political, economic. When he painted the Woolworth Building, the first American structure to push higher than the Eiffel Tower, giddily atilt in the air, its architect, Cass Gilbert, saw the watercolor and is said to have been infuriated at the libel: it looked so unstable.

There was a distinct similarity between Marin's pictorial ideas and those of the Italian Futurists, whose work he knew slightly. Certainly he had read a Futurist statement that was translated into English for an exhibition in London in 1912, which said, in part, that "every object influences its neighbor . . . by a real competition of lines and by real conflicts of planes. . . . It is these *force-lines* that we must draw in order to lead back the work of art to true painting. . . . [T]here is with us not merely variety, but chaos and clashing of rhythms, totally opposed to one another, which we nevertheless assemble into a new harmony." Other Americans were influenced by Futurism too. Max Weber, in 1915, used a specifically Cubo-Futurist idiom to paint the very scene that cartoonists had guyed Marcel Duchamp's *Nude* for allegedly representing: rush hour in Manhattan, its frenetic energies conveyed by speedlines, overlaps, sawtooth triangles in the manner of the Italian Luigi Russolo. But the definitive Futurist response to New York came from an Italian immigrant: Joseph Stella.

Giuseppe Michele Stella (1877–1946) was born in Italy's *mezzogiorno,* in a village southwest of Naples; and although his family was better off than most Italian immigrants, he too came through Ellis Island, in 1896. In 1898 he began studying under William Merritt Chase at the New York School of Art. And gradually, over the next decade, he was drawn into social reportage through magazine illustration. This phase of his early career culminated in his work for *The Pittsburgh Survey,* a report (funded by a liberal foundation and inspired by the crusading journalism of Jacob Riis and Lincoln Steffens) on working-class life in that industrial capital of Pennsylvania. To Stella, whose prose ran to the dramatic, Pittsburgh appeared as the adamantine city of Dis:

> Often shrouded in fog and smoke, her black mysterious mass—cut in the middle by the fantastic, tortuous Allegheny River and like a battlefield, ever pulsating, throbbing with the innumerable explosions of its steel mills—was like the stunning realization of some of the most stirring infernal regions sung by Dante.

What he drew, however, was not the mills, but charcoal portraits of their workers. Pittsburgh traumatized Stella. Such scenes of industrial grandeur and misery

lay outside his experience—they existed nowhere in the undeveloped south of Italy from which he had come. Before long he yearned to get back to Italy, writing of his life in America as "an enforced stay among enemies, in a black funereal land over which weighed . . . the curse of a merciless climate." And in 1909 he sailed for Naples. In Italy, for two years, he studied the techniques of the Venetian masters, but by 1911 he had begun to feel that this preoccupation with the Renaissance was turning into a trap, denying him a genuine language of his own. And so he moved to Paris.

The atmosphere of Paris in 1911 overwhelmed Stella. "Fauvism, Cubism and Futurism were in full swing. There was in the air the glamour of a battle, the holy battle raging for the assertion of a new truth. My youth plunged full in it." In fact, his Parisian pictures were fairly tame, but he had the immense advantage over most other American artists of having seen a plethora of avant-garde works at first hand. He had also befriended a fellow Italian, the Futurist Gino Severini, whose brilliantly frenetic cabaret image *Dynamic Hieroglyphic of the Bal Tabarin*, 1912, would influence his own art to the core. Here, especially in Futurism, lay a language that could be applied to American experience, to encompass the discontinuity, scary dynamism, and prodigious scale of the New. Through it, could something be saved from the terrible inequalities he had seen in America? Stella thought so. He returned to New York in 1912 and was welcomed into Stieglitz's circle at 291. He found his essential subject the next year, on a bus ride to Coney Island for the Mardi Gras festivities. He saw the light—or lights.

In the thirty-three years since Thomas Edison invented the filament bulb, electric light had become one of the wonders of American cities. It was still new to many people, but it had already developed a complex rhetoric of visual pleasure, and nowhere was it used to such anarchic, congested, delirious effect as in the great amusement park at Coney Island. Its strings and wheels of light, like perpetually exploding fireworks, had an abstract ebullience that dazzled the crowds surging along its walkways. Its "Tower of Lights," an electric colossus, could be seen at night from thirty miles away. Stella associated the scene with the fireworks and candles of the religious *feste* of his childhood in Calabria; it had a character of ritual that lifted it above ordinary entertainment, into the realm of the emblematic. It also connected to the very center of Futurist fantasy as described by Umberto Boccioni in 1911:

> Night life, with its women and men marvellously bent on forgetting their daytime life . . . the geometrical city landscapes enamelled with gemstones, mirrors, lights; all of this creates around us an unexplored atmosphere that fascinates us, and into it we fling ourselves to conquer the future!

Stella's response to all this was *Battle of Lights, Coney Island, Mardi Gras,* 1913–14 (Figure 223). He had brought Paris's fascination with things American back to America with him, and released it in a starburst of a painting which visually fulfilled, as Picabia himself could not, everything Picabia had been saying about the uniqueness of the American city. *Battle of Lights* is conceived as a vortex, or rather a series of vortices spinning off one another and swarming with microforms, signs, and fragments. One can pick out the Tower of Lights rising in the center, the humps of switchback trolley rides, whirling spiders, spoked tornadoes, the Ferris wheel. But all such details are subsumed in the strobing of acid, lemon-yellow light, a glare and wild glitter, that is the true matrix of the image. In his rendering of restless energy through arrays of small, swift forms, Stella out-Futurized Futurism; *Battle of Lights* makes Severini's *Dynamic Hieroglyphic* look almost staid by comparison. "I built the most intense dynamic arabesque that I could imagine," Stella would reminisce,

> in order to convey in a hectic mood the surging crowd and the revolving machines generating for the first time, not anguish and pain, but violent dangerous pleasures.

223. Joseph Stella, *Battle of Lights, Coney Island, Mardi Gras,* 1913–14. Oil on canvas, 76 × 85″ (195.2 × 215 cm). Yale University Art Gallery; bequest of Dorothea Dreier to the Collection Société Anonyme.

Thus the American machine-as-Moloch, represented for Stella by Pittsburgh, is redeemed on Coney Island and becomes a sort of pleasure-turbine, a machine for overstimulation, scary but liberating.

If there was a religious aspect to Stella's vision of the Electrical City in Coney Island, that sense of the sacred became the main theme of his paintings of the Brooklyn Bridge. By 1917 the circle around Stieglitz was feeling badly pinched: the prospect of American entry into the war was closing in, bringing with it, in Stella's words, "a sense of awe, of terror weighing on everything—obscuring people and objects alike." The market for avantgarde American art, never abundant, now dried up. Stieglitz brought out the last issue of *Camera Work* and closed 291 down. With no chance of income from his art, Joseph Stella found a job teaching Italian in a seminary in Williamsburg, the industrial quarter of Brooklyn close by the towering anchorage of the Brooklyn Bridge. The view down that span from Brooklyn to New York, with the sky-

scrapers of Wall Street framed in the bridge's structure, is more impressive than the view from Manhattan to Brooklyn, and it began to obsess Stella. He saw it through Walt Whitman's images too, mingled (in Stella's imagination) with the dark romanticism of Edgar Allan Poe—although Poe died more than forty years before the bridge was built. The bridge stood for the conjunction of old (Gothic stone mass) and new (steel cable); it collapsed the sacred into the secular by architectural quotation; it spoke of American unity, and still, thirty years after it was finished, it remained the most vivid and durable emblem of American technological aspiration. Stella resolved to paint this "metallic weird Apparition under a steely sky . . . as the shrine containing all the efforts of the new civilization of AMERICA—the eloquent meeting of all the forces arising in a superb assertion of their powers, in APOTHEOSIS."

224. Joseph Stella, *The Voice of the City of New York Interpreted: The Bridge,* 1920–22. Oil and tempera on canvas, 88¼ × 54″ (224.1 × 137.2 cm). The Newark Museum; purchase, 1937, Felix Fuld Bequest Fund.

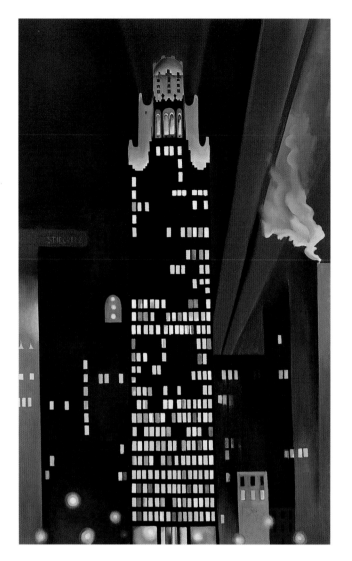

Stella's idea of the bridge-as-shrine was not just a conceit—it had already been built into the fabric of the great structure by its designers, the Roeblings, who treated the openings in its towers as double Gothic arches, framing the view at either end. In *The Bridge* (Figure 224), the fifth and last panel of his polyptych *The Voice of the City of New York Interpreted*, 1920–22, he makes these Gothic forms into dark frames around a silvery vision of skyscrapers beyond—in effect, the New Jerusalem, backlit and shining in a modernist stained-glass window. The three pairs of catenary suspension cables soar upward, hosannas in steel.

"Monstrous dream, chimeric reality, Oriental delight, Shakespearean nightmare"—the tone of Stella's inflamed apostrophes to New York was more extreme than any other American artist's. But the city still wound its way into their work. It is there in Georgia O'Keeffe's paintings done in the 1920s, before she departed for New Mexico. In her strongest treatment of it, *The Radiator Building— Night, New York, 1927*, 1927 (Figure 225), she rendered the shaft of Raymond Hood's almost new structure—it had been built three years before, on Fortieth Street—as a black and frontal facade punctuated by brightly lit windows, dense below and sparser above, culminating in the building's lit-up crown, whose shape Hood had designed to evoke the fins on the American Radiator Company's products. Brownstones huddle at its base, the sky is split by searchlights, her husband Alfred Stieglitz's name appears in a red neon bar to the left, and the whole image projects a cool, sophisticated romanticism. This is very far from Stella. But it partakes of the spirit of a movement in American art which, by the late 1920s, was well under way: Precisionism, whose two leading painters were Charles Demuth and Charles Sheeler.

225. Georgia O'Keeffe, *The Radiator Building—Night, New York, 1927*, 1927. Oil on canvas, 48 × 30″ (121.9 × 76.2 cm). Fisk University Galleries of Fine Arts, Nashville, Tennessee; Alfred Stieglitz Collection.

Luckily or not, Charles Demuth (1883–1935) painted one picture so famous that practically every American who looks at art knows it. *The Figure 5 in Gold*, 1928 (Figure 226), is a prediction of Pop art, based on an Imagist poem, "The Great Figure," by his friend William Carlos Williams:

> Among the rain
> and lights
> I saw the figure 5
> in gold
> on a red
> firetruck
> moving
> tense
> unheeded
> to gong clangs
> siren howls
> and wheels rumbling
> through the dark city.

"Imagist" because each line, a snap unit of meaning, is meant by its isolation to be perfectly clear, a pulse in itself, without narrative—suspended for contemplation, like elements in a painting. Obviously Demuth's rendering has something in common with Hartley's arrays of banners, numbers, and emblems, and in fact Williams later recalled that he had seen and heard the firetruck in question from the window of Marsden Hartley's studio on Fifteenth Street. Here are the streetlights, the red back of the truck and the engine company number 5, that gloss-enamel heroic heraldry of the New York Fire Department, interspersed with lettered apostrophes to Williams: "BILL," "CARLO[S]," and, at the bottom left, "W.C.W." next to his own initials, "C.D."

The Figure 5 in Gold is deservedly one of the icons of American modernism, but it came almost at the end of Demuth's life and its author has always seemed a little elusive beside the heavier reputations of his contemporaries—Georgia O'Keeffe, Marsden Hartley, Arthur Dove, Charles Sheeler. Of them all, he was the most unabashed esthete. And the wittiest too: it's hard to imagine any of his colleagues painting a factory chimney paired with a round silo and calling it, in reference to star-crossed lovers in a French medieval romance, *Aucassin and Nicolette*.

Blessed with a private income from his parents in Lancaster, Pennsylvania, coddled in childhood, lame, diabetic, vain, insecure, and brilliantly talented, Demuth lacked neither admirers nor colleagues. He was well read (and had a small talent as a writer, in the Symbolist vein) and his tastes were formed by Pater, Huysmans,

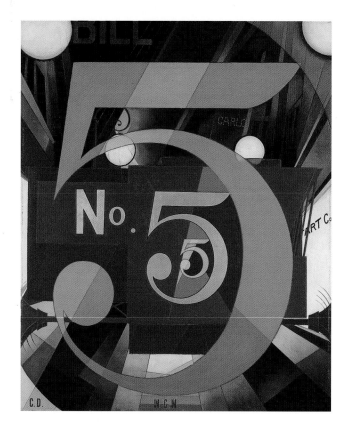

Maeterlinck, and *The Yellow Book;* he gravitated to Greenwich Village as a Café Royal dandy-in-embryo. Free of market worries, he did a lot of work that was private in nature, for the amusement and stimulation of himself and his gay friends, and much of it was unexhibitable—at least until the 1980s.

Demuth was not a flaming queen, in fact he was rather a discreet gay, but if he could not place his deepest sexual predilections in the open, he could still make art from them. Seen from our distance, that of a pornocratic culture so drenched in genital imagery that sly hints about forbidden sex hardly compel attention, the skill with which he did this might seem almost quaint. But in the teens and twenties the public atmosphere was of course very different, and Demuth, like other artists in the avant-garde circle that formed around the collectors Louise and Walter Arensberg—especially Marcel Duchamp, whose recondite sexual allegory *The Bride Stripped Bare by Her Bachelors, Even* Demuth called "the greatest picture of our time"—took a special delight in sowing his work with sexual hints. To create a secret subject matter, to disport oneself with codes, was to enjoy one's distance from (and rise above) "straight" life. The handlebar of a vaudeville trick-rider's bicycle turns into a penis, aimed at his crotch; sailors dance with girls in a cabaret but ogle one another.

If these scenes of Greenwich Village bohemia were all that Demuth did, he would be remembered as a minor American esthete, somewhere between Aubrey Beardsley and Jules Pascin. But Demuth was an exceptional watercolorist and his still-lifes and figure paintings, with their wiry contours and exquisite sense of color, the tones discreetly manipulated by blotting, are among the best things done in that medium by an American. They quickly rise above the anecdotal and the "amusing."

Around 1920 Demuth began with increasing confidence to explore what would become the major theme of his career: the face of industrial America. It may seem odd that Demuth, yearning for Paris, should have become obsessed with grain elevators, water towers, and factory chimneys. But as he wrote to Stieglitz in 1927: "America doesn't really care—still, if one is really an artist and

226. Charles Demuth, *The Figure 5 in Gold,* 1928. Oil on composition board, 36 × 29¾" (91.4 × 75.6 cm). The Metropolitan Museum of Art, New York; Alfred Stieglitz Collection, 1949.

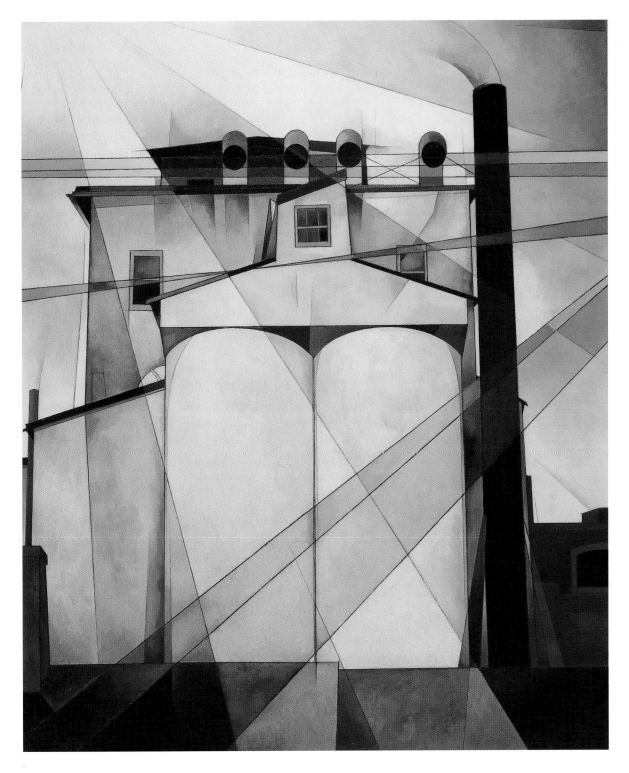

227. Charles Demuth, *My Egypt,* 1927. Oil on composition
board, 35¾ × 30″ (90.8 × 76.2 cm). Whitney Museum of
American Art, New York; purchase, with funds from
Gertrude Vanderbilt Whitney.

at the same time an American, just this not caring, even though it drives one mad, can be artistic material." Precisionism was by no means just a provincial-American response to the European avant-garde—the splintering of planes from French Cubism, the machine ethos from Italian Futurism. Sheeler and Demuth were painting a functional American landscape refracted through a deadpan "modernist" lingo that, in Demuth's case, picked up bits of Robert Delaunay and Lyonel Feininger while anticipating some of the essential subjects of Pop art. The machine emblems of this American landscape had fascinated some of the best minds in Europe (Picabia, Duchamp, Le Corbusier), who saw them either as exotic whiffs of the Future or as instruments of irony. Being American, Demuth took the silos and bridges rather more literally. Out of this came his Precisionist masterpiece, *My Egypt,* 1927 (Figure 227). It is a face-on view of a grain elevator in Lancaster, Pennsylvania, Demuth's hometown, painted with such careful suppression of gesture that hardly a brushstroke can be seen. Demuth's title whimsically refers to the mania for Egyptology planted in American popular culture in 1922, when Howard Carter discovered Tutankhamen's tomb. The visual weight of those twin pale silo shafts and their pedimental cap does indeed suggest Karnak.

But Demuth may have had a deeper level of intent. His title connects to the story of Exodus. Egypt was the symbol of the Jews' oppression; it was also the starting point for their collective journey toward the land of Canaan, the forging of themselves as a collective and distinct people. An invalid in later life, Demuth was "exiled" in Lancaster, bedridden in his parents' house, cut off from the intellectual ferment of Paris and the sexual-esthetic comradeship of New York. All these were Canaan; home was Egypt. Yet he was poignantly aware that the industrial America which gave him a *rentier*'s income had also given him a great subject which would define him as a painter. From that tension, his finest work was born.

The ungainly name "Precisionism" was coined by the painter-photographer Charles Sheeler (1883–1965), mainly to denote what he himself did. It indicated both style and subject. In fact, the subject *was* the style: exact, hard, flat, big, industrial, and full of exchanges with photography. Photography fed into painting and vice versa. No expressive strokes of paint. Anything live or organic, like trees or people, was kept out. There was no such thing as a Precisionist pussycat. Sheeler's work records the displacement of the Natural Sublime by the Industrial Sublime, but his real subject was the Managerial Sublime, a thoroughly American notion. And though Precisionism broadened into an American movement in the late twenties and early thirties, Sheeler's work defined its essential scope and meaning.

The son of a steamer-line executive in Philadelphia, Sheeler took his first art classes under William Merritt Chase at the Pennsylvania Academy in 1903; and,

in the now familiar pattern of other American modernists-to-be, he experienced his conversion to Cézanne, Picasso, Braque, and Matisse during a trip to Paris in 1908. Back in Philadelphia he took up commercial photography to support his painting. He worked with Morton Schamberg until the latter's early death in 1918. Sheeler's talent for high-definition photography, with stark, plain, and well-judged masses of tone, shied away from human documentary: he avoided figures in favor of near-abstract subjects, images of anonymous architecture, such as the sides of barns in Bucks County, Pennsylvania—plain American vernacular. This preference would inform his later work. Sheeler's interest in old structures and tools wasn't antiquarian. It came from his belief that a common line of empirical functionalism was the "unseen soul" of American tradition, linking the old barn to the new industrial plant.

In 1920 he and the photographer Paul Strand made a short experimental film together—one of the first American "art" films. It was meant as a portrait of the city, and its title (as well as its silent-movie captions) was quoted from Walt Whitman.

Despite the lines from Whitman's poems, *Manhatta* is not really Whitmanesque in feeling, because it either omits the people of New York or sees them as molecules in a crowd, abstract parts of "one-million-footed Manhattan, unpent," but with none of the social richness that stirred Whitman's soul. Strand and Sheeler's Manhattan is a hard, clear, abstract place: not always as grim in its alienation as Strand's 1915 photo of businessmen trailing long black chains of morning shadows as they scurry to work past the blank, tomblike windows of the Morgan Guaranty Trust Building, but depopulated enough to act as a series of signs only for itself.

The film bred paintings, as Sheeler's still photographs would continue to do through the 1920s and 1930s. One shot in *Manhatta* looked down at a train on the Church Street elevated railway sliding into view (Figure 228); *Church Street El*, 1920 (Figure 229), takes this image, colors it and cleans it up, abstracts it, but leaves it essentially recognizable. His vision was dour and romantic at the same time. You often feel, in Sheeler, the presence of an artist who wanted to submit himself to structures and ideologies larger than himself, as though—whatever doubts he might have had about them—they promised security. And the ideology of American managerial industrialism underwrote that promise. So he set out to become its artist laureate.

It is difficult, today, to imagine the enthusiasm with which Americans (and especially American managers) in the 1920s embraced the idea of the machine as a model and regulator of working life. It grew out of Henry Ford's use of the production line in mass car manufacture. Ford declared in 1909 that he was going to democratize the auto, that "when I'm through everybody will be able to afford one, and about everyone will have one." He produced millions of identical cars

228. (above) Charles Sheeler and Paul Strand, frame from the film *Manhatta,* 1920.
229. (below) Charles Sheeler, *Church Street El,* 1920. Oil on canvas, 16 × 19⅛″ (40.6 × 48.5 cm). The Cleveland Museum of Art; Mr. and Mrs. William H. Marlatt Fund.

in exactly the same way, by breaking down each stage of their making into small repetitive units of work, each of which could be performed, hundreds of times a day, not by a craftsman but by an ordinary worker in charge of a single, specialized machine. These work-molecules flowed into the river of the production line, watched over by a hierarchy of managers. In 1914, the year full production-line assembly began at the Ford plant in Detroit, the basic black Model T cost $490— a quarter of what the cheaper sort of American car had cost ten years before— and 248,000 Fords were sold; by 1924 the car was down to $290, and in 1929, on the eve of the Wall Street crash, American automakers produced 4.8 million units. The sales graph had gone almost vertical.

Ford, omnipotent crank that he was, believed he had invented something like a new religion, based on industry. It would lead to a United States of the World, with himself—the complete antihumanist, serene and objective in his understanding of process, the literal *deus ex machina*—as its messiah. "The man who builds a factory builds a temple. The man who works there, worships there." Even the defective human body, a meat machine, would in time be fixed with interchangeable parts. History, he famously pronounced, was bunk, and "machinery is accomplishing in the world what man has failed to do by preaching propaganda or the written word." And doubters were to Ford—as skeptics about one-world "interactivity" are to Internet votaries today—contemptible Luddites, dust beneath the pneumatic tires of the certain future.

In 1927 the Ford Motor Company hired Charles Sheeler to spend six weeks in its River Rouge plant, taking photographs. Sheeler was so deeply impressed that he would echo Ford's bizarre pieties about industrial religion: "Our factories," wrote the artist, "are our substitute for religious expression." And so, in Sheeler's photographs of River Rouge, they became. The interiors of the mighty factory buildings are high, clean, invested with a numinous light, and free of all human presences except when they are needed to give scale. His image of a stamping press expresses the fantasy of the machine as cult object, with no hint of the often boring, dehumanizing, and dangerous character of factory work: impassive and objective, the godlike engine is served by its tiny acolyte. And in 1929, not long after he made his photograph of crisscrossing conveyors at the Ford plant (Figure 230), he took a similar one of a much earlier form: the flying buttresses at the crossing of Chartres Cathedral (Figure 231).

But the painting that most succinctly expressed his feelings about big industry is *American Landscape*, 1930 (Figure 232). It holds no nature at all, except for the sky (into which a plume of effluents rises from a tall smokestack) and the water of a dead canal. Whatever can be seen is man-made, and the view has a curious and embalmed serenity, produced by the regular cylinders of silos and smokestack and the dark authoritarian arms of the loading machinery to the right. The sphere, the cube, and the cylinder are no longer things to be sought in

nature, as Cézanne had once recommended: in the mighty abstraction of process and product, they have replaced nature altogether. The ancient tension between nature and culture is over. Culture has won. It has colonized all the space in the American imagination that nature once claimed. The world of Thomas Cole is finally, irreparably, concreted over. One human figure remains, and you can hardly see him, or it, at first: a tiny, scurrying ant, on the tracks by the canal, between the uncoupled boxcars.

But did Sheeler's work mean that nature had in fact drained out of the vision of other American artists under the stress of modernist consciousness? Of course not. As the desire for mechanized, impersonal, and abstractly urban images developed in the 1920s, so did its opposite: an interest in what was primal, "primitive," mythic, and linked to the natural world. Where could you go in America to feel such vibrations? The answer lay in the Southwest, and particularly in New Mexico, around Albuquerque, Santa Fe, and Taos. Though Alfred Stieglitz himself could hardly be persuaded to cross the Hudson, most of the artists in his circle—and other early American modernists too—rode the Atchison, Topeka & Santa Fe Railway to the desert after World War I: Marsden Hartley, John Marin, and, most famously, Georgia O'Keeffe all went there.

 The Taos of 1920 was not the Taos we have today. It had not yet become a high-sierra New Age theme park full of channelers, holistic healers, wanna-be witches, ethnic kitsch dealers, and matched blond lesbians in Jeep Cherokees. But

230. (left) Charles Sheeler, *Criss-Crossed Conveyors—Ford Plant*, 1927. Gelatin silver print, 10 × 8″ (25.4 × 20.32 cm). Museum of Fine Arts, Boston; The Lane Collection.

231. (right) Charles Sheeler, *Chartres—Flying Buttresses, East End, with Chapel Roof*, 1929. Photograph. Museum of Fine Arts, Boston; The Lane Collection.

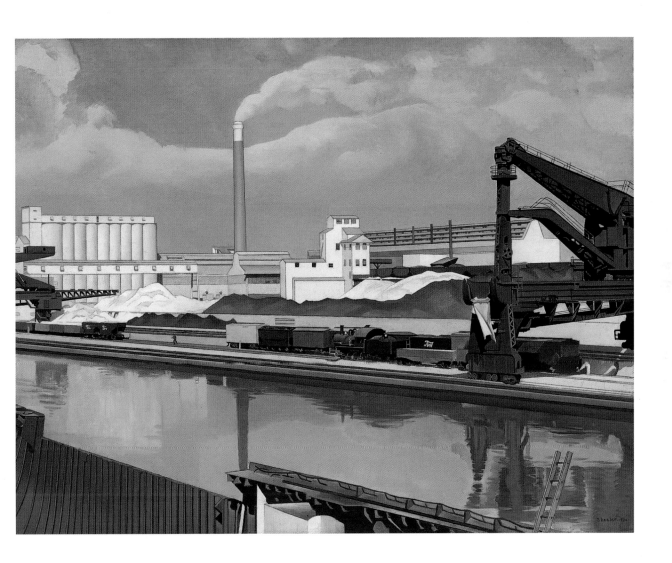

232. Charles Sheeler, *American Landscape,* 1930. Oil on
canvas, 24 × 31″ (61 × 78.8 cm). The Museum of Modern
Art, New York; gift of Abby Aldrich Rockefeller.

the construction of the Southwest as the home of mythic American primitivism was already under way. Santa Fe and Taos were becoming America's internal Tahiti, thanks to the growth of cultural tourism, which was fueled by an increasing desire among Anglos from the East to experience something of Indian Pueblo culture—along with some of the most beautiful landscape on earth. Taos, in particular, had been an art colony for years before any modernists got there; since 1900 minor academic painters like Ernest Blumenschein had gone there to paint the Pueblo Indians, the adobe churches, and the bewitching high-mountain landscape. By 1915 organized tourism had begun to convert the whole area; railroad posters from the 1920s showed young white couples gazing from the gondola car at Pueblo Indians dancing by the tracks, and an inspired promoter named Fred Harvey invented what he called "Detourism" in New Mexico, Nevada, and Arizona. Chauffeured cars would pick up train passengers in Las Vegas and take them through the desert to Santa Fe and Albuquerque before rejoining the railroad; guides explained "the lure of the Southwest that lies beyond the pinched horizons of your train window." A network of Harvey Houses, staffed by Harvey girls and Courier guides, sprang up, along with station shops and exhibition rooms, all stocked with authentic Pueblo Indian rugs, baskets, silver, turquoise, and pottery. At the El Tovar Hotel on the edge of the Grand Canyon was a "Hopi House," full of such handwork and exhibiting, the brochure promised in 1904, "a small band of Hopis. Without exception these are the most primitive Indians in our country." In a 1909 brochure the Hopis were still there, "smoking corn-cob pipes, building sacred altars, mending moccasins—doing a hundred un-American things." A gifted architect named Mary Colter, whose name deserves some permanent place among the pioneers of the American theme-park mentality, constructed ancient kivas and "prehistoric" watchtowers with still "older" ruins on the south rim of the Canyon, with a close eye for archaeological accuracy:

> The RUINS built to the west of the Watchtower are supposed to be the remains of an abandoned older structure built by earlier dwellers on Desert View Point. . . . It was impractical to design the Watchtower in as ruinous a condition as usually prevails and the adjacent broken down walls to the west add to the desired atmosphere.

By 1919 the mythic Southwest was as mediated a place as any in America—though not, of course, to the degree that it is today. And the priestess of cultural renewal in New Mexico—at least in her own view—was Mabel Dodge. Her salon in New York had wound down after 1915, when she went to live with the firebrand Left journalist John Reed in a house on Croton-on-Hudson; but when she ditched Reed and (temporarily) married the artist Maurice Sterne, she moved to Taos. Having disposed of Sterne, she found the love of her life in her chauf-

feur, an imposing Tiwa Indian of the Taos Pueblo named Antonio Lujan, whose name she took but anglicized to Luhan. The future Mabel Dodge Luhan had had an epiphany while watching a Pueblo dance in 1917. Her mission, she now realized, would be to throw a bridge between two forms of consciousness: the ancient, collective blood-knowledge, as she called it, of the Indians, and the inventive mind-set of Western modernism. Put them together and Taos would be a city on the hill, paradise regained, the center of a new American civilization. Accordingly, she built a large, rambling house in the Pueblo manner outside Taos, named it Los Gallos, and settled in to change the course of American civilization.

Mabel Dodge Luhan was a mystagogue and an egotist, a sexual imperialist and much of the time an intolerable bitch as well, but there was something undeniably impressive about her and she fought hard and valiantly for the cause of Indian rights, which few Anglos in the twenties were prepared to do. In her role as talent collector, she made sure that no visiting artist—not Marsden Hartley, not John Marin, not Georgia O'Keeffe—could escape her relentless hospitality; and when D. H. Lawrence and his wife, Frieda, came to Taos, it was here that they stayed. The prudish author of *Lady Chatterley's Lover* was so alarmed by the sight of Mabel cavorting naked in her bathroom that he obscured its windows with painted totemic designs (very much in the manner of Marsden Hartley), which still survive. But his response to the New Mexican landscape fairly represents the sense of discovery that most incoming artists felt there, whether they stayed or not: "The moment I saw the brilliant, proud morning shine high up over Santa Fe, something stood still in my soul, and I started to attend. . . . In the magnificent fierce morning of New Mexico one sprang awake, a new part of the soul woke up suddenly, and the old world gave way to a new." Out of such deserts, modernists felt, prophecy might come.

Despondent and emotionally drained after the loss of von Freyburg, Hartley himself had gone to New Mexico for a year in 1919, with inconclusive results for his painting. At first he stayed with the Lujans in Taos, but then, hating the milieu—"the stupidest place I ever fell into"—lit out for Santa Fe. He loved the New Mexican landscape as much as he disliked its Anglo inhabitants. "I am an American discovering America," he wrote. "Any one of these beautiful canyons is a living example of the splendour of the ages, and I am bewitched by their magnificence and austerity. It is the only place in America where true color exists. It is not a country of light *on things*—it is a country of things *in light*."

Hartley's New Mexican landscapes did not measure up to his enthusiasm for their scenes. But his pictures were selling at last, and he set out on more than ten years of wandering. In 1927 he left for Berlin, where boys were marching again—this time in brown shirts. Though an aging queen like himself would not have lasted a week in the New Germany that was coming, he got a crush on Adolf Hitler: here was the man who would restore the clean, vigorous, masculine Ger-

many of his lost love. Of Hitler's genetic programs, he remarked that "it is really an all right idea abstractly. There is no use in having defectives to support." Later he was in Paris, Aix-en-Provence, Mexico, Bermuda, Dogtown on the coast of Massachusetts, and Nova Scotia. In Nova Scotia he suffered a nearly exact repeat of his loss of von Freyburg: living with a fisher family in the coastal village of Eastern Points, he fell for one of their handsome sons, Alty Mason, about whose conversion to male love he fantasized hotly and incessantly, veering (as was his way) into lofty idealizations. Nothing happened. And then, in 1936, both the Mason boys were drowned when their boat foundered in a night storm. Once more, inconsolable loss; once more, the effort to stabilize and make sense of it by painting. Hartley's series of "Elegies" to the drowned youths are perhaps the finest works of his late career, in structure, concision, and somber beauty of color. Some of them carry fantasy over the top—in particular a Pietà of a drowned green Christ supported by a whole crew of half-naked maritime hunks in blue jeans, which looks like the aftermath of a heart attack in a gay bar. However, the memorial seascapes are the best. In *Northern Seascape, Off the Banks*, 1936–37 (Figure 233), the first of his elegies to Alty and Donny Mason, Hartley brought strongly together two of the abiding influences of his life, Ryder and Winslow Homer. Light-rimmed clouds—oblongs, triangles—turn mournfully in the sky above the dark horizon, on which two ships (Donny and Alty's souls) are scudding; in the foreground, Homeric rocks, a long jaw of black teeth with the foam bursting over them.

After so many wanderings, Hartley was determined to return home to his original landscape of nurture, Maine. In a catalog essay in 1937, he invoked "the quality of nativeness": it was, he said, "built of such primitive things, and whatever is one's nativeness, one holds and never loses no matter how far afield the traveling may be." He would paint dead birds and flotsam thrown on the beach, rope ends and shells,

> the marine vistas to express the seas of the north, the objects at my feet everywhere which the tides washed representing the visible life of place, such as the fragments of rope thrown overboard out on the Grand Banks by the fishermen, or shells and other crustacea driven in from their moorings among the matted seaweed and the rocks, given up even as the lost at sea are sometimes given up. . . . I wish to declare myself the painter from Maine.

Here the strands come together: the dead things and discarded fragments, emblems of memory, of the harsh sunderings and disappointments of Hartley's life; the living crustacea driven helplessly from their small moorings, like Hartley himself; the dead lovers, "lost at sea," "given up." Six years later, this greatest and most conflicted of early American modernists died in a small Maine hospital, to

which he had been taken unwillingly, wishing only to go in his rented upstairs room surrounded by his few "things."

The artist who was bound to New Mexico, as Hartley was to Maine, was Georgia O'Keeffe (1887–1986), and she became an emblem and finally an icon of Southwestern modernism. She first saw New Mexico's Sangre de Cristo Range from a train in 1917—"from then on I was always on my way back." She spent part of each year painting in New Mexico, usually at the Ghost Ranch outside Taos, until in 1945 she bought a ruined adobe on a mesa at Abiquiu, New Mexico, and fixed it up with the help of her friend Maria Chabot. There she lived until her death. It remains a site of incessant pilgrimage, a shrine in fact, art's analogue to the shrine at Chimayo, where thousands go to eat the miraculous earth from the crypt. She remains the most famous woman artist America ever produced, eclipsing even Mary Cassatt. In the quarter century before her death, and the ten years since, she also became such an icon of feminism that her work acquired a peculiar immunity from any sort of critical demurral. O'Keeffe was O'Keeffe, the diva of independence; everything she made was by self-definition extraordinary, and God help the male chauvinist pig who suggested that there might have been some slight variation of quality in her work between, let's say, the manifestly

233. Marsden Hartley, *Northern Seascape, Off the Banks,*
1936–37. Oil on cardboard, 18³/₁₆ × 24″ (46.2 × 61 cm).
Milwaukee Art Museum; bequest of Max E. Friedman.

transcendent and the merely wonderful. A further complication arises from her long and intense relationship with Stieglitz; they became lovers, and married in 1924, and there can be no question that Stieglitz was telling the truth about their life together when, early on, he confessed that "we have talked over everything. Into one week, we have compressed years—I don't think there is anything to equal it."

O'Keeffe was born near Madison, Wisconsin, the daughter of farmers. Later the family moved to Virginia and, feeling a strong vocation as a painter, she went to study at the Art Institute of Chicago in 1905–6. But her inspirational training came from a brief stint at New York's Columbia University in 1912, under an innovative teacher named Arthur Dow, a devotee of Pont-Aven painting (emphasizing the flat abstract arrangement of color and bounding line) and of Japanese art, from whose own flatness the ideas of the Nabis had sprung. This was radical then, and it laid the basis of her style.

O'Keeffe had no contact with Stieglitz or 291 until 1915, when a batch of her abstract charcoal drawings, sent to a friend in New York, came under his eye. He enthused over them: though nonrepresentational, they suggested large landscape space—an American space. Their author was teaching art in a school in Texas, and Stieglitz, without asking her permission, put them straight up on the walls of 291. This irked O'Keeffe, but not for long. The reception they got, in the tiny 291 circle, was too positive. In 1917 she had her first one-woman show there, and a career was launched. The works in it arose from the Texas landscape: horizon, sun, clouds, and a sense of sparseness and extreme luminosity. *Light Coming on the Plains III*, 1917 (Figure 234), arouses the now familiar sense of the American sublime with its solemn arch of green-blue sky, distinguished from the earth by the thinnest of unpainted horizon lines: it conveys the anticipation one feels before dawn, waiting for the sun's rim, and suggests a space both infinite and womblike. At the same time it seems almost styleless—you can't tell what other pictures she had been looking at. This sense of stylistic transparency was one of

234. Georgia O'Keeffe, *Light Coming on the Plains III*, 1917. Oil on canvas, 11⅛ × 8⅞″ (30.2 × 22.5 cm). Amon Carter Museum, Fort Worth, Texas.

the aspects of her work that most excited Stieglitz and other 291 artists. O'Keeffe was a "natural": not a naïve or primitive painter by any means, but one who seemed to be instinctively in touch with the vibrations of the cosmos. As Charles Demuth put it, "Each color almost regains the fun it must have felt within itself on forming the first rainbow." In paintings like *Blue and Green Music*, 1919 (Figure 235), with its ripples, blue-black rays, and green-white flame shapes (which could also be highly abstracted plants bending in a wind, but are probably best imagined as synesthetic forms representing musical chords), one heard America singing—in O'Keeffe's distinct voice.

This character of Americanness mattered immensely to Stieglitz, Paul Strand, and her other admirers. Ever since the Armory Show, the American avant-garde had resented the dominance of Europe, the feeling of inferiority— whether the new heroes like Picasso and Matisse were exerting their magnetism from Paris or, like Marcel Duchamp, basking at ease in the heart of the New York art world. Beyond them, there wasn't a fourth-rate École de Paris painter that the new modernist collectors didn't snobbishly prefer to an American one, however good. Everything came with French sauce on it, usually canned. Bad days for the natives. But with O'Keeffe, it seemed, this impasse was broken. A remarkably original spirit could show itself anywhere. It didn't have to come from Europe. It could appear in all its purity in America, and in a woman too—best of all, a woman who had never been to Europe, and didn't *want* to go. When her admirers like Marsden Hartley praised O'Keeffe's "purity," they were not talking morals; purity, said Hartley, was "the quality of a thing or a thought when it has been released from all irrelevant influences." To Strand, this implied "vast new horizons in the evolution of painting as incarnation of the human spirit."

Moreover, it was apparent that O'Keeffe's paintings were not only "intrinsically" American but very clearly the products of a female sensibility. Not "female" in the sense of "feminine," meaning weak or derivative: her laconic toughness was clear to all who met her early on. Rather, in their use of cloud forms, cave forms, inward-moving eddies, and soft profiles, they suggested a

235. Georgia O'Keeffe, *Blue and Green Music,* 1919. Oil on canvas, 23 × 19″ (58.4 × 48.3 cm). The Art Institute of Chicago; Alfred Stieglitz Collection; gift of Georgia O'Keeffe, 1969.835.

sense of the body externalized on canvas that could not have been a man's. Much ink has been spilled on the topic of whether O'Keeffe ever set out to use specifically genital images; she herself indignantly denied it, and especially refused to countenance any sexual interpretation of the large close-ups of flowers she painted in the twenties—the blossom seen as if from the eyeline, and body size, of a questing bee. This must have been overreaction against what O'Keeffe felt was prurient criticism of her work. To deny the sexuality of a painting like *Black Iris III*, 1926 (Figure 236), is absurd; it amounts to not seeing the work. O'Keeffe was, after all, the collaborator in Stieglitz's photographs of her, the most

236. Georgia O'Keeffe, *Black Iris III*, 1926. Oil on canvas, 36 × 29⅞″ (91.4 × 75.9 cm). The Metropolitan Museum of Art, New York; Alfred Stieglitz Collection, 1969.

daring and complete hymn to the erotic ever created by a photographer. O'Keeffe's denials can only have been a way of fending off the prurience of those philistines—which meant, in guilt-crippled America, most Americans—who could make no distinction between the erotic and the pornographic. To Stieglitz and those closest to him, Eros was the breath of existence, the precondition of esthetic insight; and O'Keeffe was closest to him of all.

O'Keeffe's weaknesses were mainly of drawing. When doing architectural form—the kind of anonymous barns and sheds that Sheeler also liked—the line could not resist irrelevant crotchets, and her paintings of the Church of San Francisco de Assis at Taos so exaggerate the organic curves of its adobe shapes that they look boneless and woozy. Most of the time O'Keeffe's draftsmanship was serviceable, no more. It provided enough scaffolding to carry her delicate elaborations of color: those nuances of pink, white, and green which, unexpectedly tightened by a mass of black or Prussian blue, still carry a lyrical charge that no amount of reproduction can quite dim. But there was no sense in which she could be called a major formal artist. Rather, her art lived through its moments of visionary insight, when a memorable *image* clicked into place: the bare skull of a ram against far-off red hills (even though many of her bone paintings look as sentimental as kitsch surrealism), the eroded gulleys of a mesa clutching the earth like old lions' paws, a slowly whirling abstract mass whose sawbacked profile might be the earth's rim—or a silhouetted cross of the Penitente sect on a mesa, all black arms and space-filling mass, which seems to be preaching to the prostrate hills below.

The greatest nature-modernist in America, however, was not a painter but an architect: Frank Lloyd Wright, for whom the word "genius"—which should be sparingly used—is not too strong. Wright (1867–1959) was born in the age of the horse-and-buggy and died in that of the Boeing and the hydrogen bomb; his career forms a mighty arch over the history of American architecture, and its intricacies and sheer variety cannot be sketched here. The salient points of his early life are these.

He was born in Wisconsin, the son of a clergyman who loved to play the piano; the sense of musical structure and interval, which the child grasped early, interacted with the Froebel blocks (an educational construction set of modular wooden elements) which his mother, a schoolteacher, insisted he play with. Meter, ratio, and interval, he realized, belonged in three dimensions no less than in the abstract time flow of music. Thus, as he later declared, "*form* became *feeling*."

Landscapes mark children, moreover, and so it was with Wright. The landscape of his childhood was a remarkable one: the so-called Driftless Area of Wis-

consin, a region of sandbars enclosed by rock bluffs, layered of sandstone and limestone, which eroded at different rates and had produced fantastic, tree-crowned buttresses and scooped horizontal slabs of stone—the archetypes, without doubt, of his later Prairie Houses.

By the time he was eighteen, Wright had read Ruskin's *Seven Lamps of Architecture* and *The Stones of Venice*. A career beckoned, and his mother encouraged him. First he apprenticed himself to a minor architect named Silsbee; and then, in 1888, he had the luck to find a post as a draftsman with the firm of Adler & Sullivan in Chicago, whose chief partner was that prophet of American modernist building, Louis Sullivan. In Sullivan, Wright found his mentor: an inspirational idealist with a great talent for detail, Beaux Arts trained but standing well outside the Beaux Arts style as practiced by Hunt or McKim, Mead & White. Gradually, Wright became committed to an idea he first encountered in Victor Hugo's *Notre-Dame de Paris:* that technological progress would inevitably destroy traditional handcraft. This melancholy thought was working on the minds of others, unknown to him: the furniture designer Gustav Stickley, along with all the others in the burgeoning Arts and Crafts movement. Wright was determined to resist this. He worked for Adler & Sullivan for six years, and then went into practice on his own, designing houses in what he termed (out of memories of the Western flatlands) the Prairie Style.

None of the houses Wright built in the Prairie Style actually stood on a prairie, though the drawings in the 1910 Wasmuth edition of his works, which made his name famous among German architects, show them in the vast spaces of an imaginary Wild West. Thus Walter Gropius and others could never quite shake the idea of a Wright house with Nez Percés and Buffalo Bill lurking somewhere over the next hillock. The Prairie Houses were all suburban, and mostly built on the outskirts of Chicago on sites that were not and never had been prairie grassland. Which hardly mattered: "prairie" was Wright's metaphor, not a location. It stood for a relation between architecture on the one hand, and American expanse and flatness on the other, interwoven with nostalgia for the lost frontier past. None of Wright's work shows it better than the Robie House of 1909, built on a busy street corner of inner Chicago on the edge of the Midway (Figure 237).

Today—largely thanks to the immense influence of Wright, diffused through ranch-style suburban housing—we do think of houses as horizontal. It was less normal in the 1900s. The idea of "prestige" housing implied verticality, detachment from the raw line of earth. Upper Americans felt their homes should affirm the reign of culture over nature, looking like Greek temples or rising Gothic boxes. Certainly not like this ground-hugger with its wide, strong eaves and balconies, every line betokening kinship with the flat, flat earth of the Midwest. Fred Robie, the client, was an ideal one for Wright: a manufacturer of bicycle and auto supplies, who wanted the most modern and laborsaving house possible, free of

"curvatures and doodads," as he put it, and rooms "without interruption." Wright gave him all that, and even supplied a built-in vacuum-cleaning system, which worked fitfully. The skeleton of the Robie House is not "organic" in the sense of being made of natural materials. Its long cantilevers, reaching fore and aft as though trying to grasp the space beyond the site, are carried on a complex steel grid; it uses glass, tile, concrete. And yet you cannot perambulate its rooms, or see its overhangs from the street, without being reminded of the ur-form of American building, the log cabin, with its horizontal bands of tree trunks. This, one may be sure, was quite conscious on Wright's part, even though it had nothing to do with the real houses that once dotted the prairie, the mean earth huts and lean-tos of the sodbusters on a treeless plain.

Inside, you are reminded of the great influence on his work, which he did not see firsthand until he began work on the Imperial Hotel in Tokyo in 1916—Japanese building. Wright was a connoisseur of Japanese prints. They were about the only kind of two-dimensional art that interested him, and he made extra money dealing in them. He had studied Japanese farmhouse and classic palace architecture, such as the imperial villas at Katsura, in reproduction. One of the hallmarks of its planning was its lack of rigidity: space was more permeable and fluid than in the West, lightly divided by sliding partitions, *shōji*, and movable folding screens, *byōbu*, while even the demarcation between inside and outside was less absolute. In Japan you didn't step over a threshold like crossing a small Rubicon, from one world into another. Culture flowed outward into nature, nature into culture. Reflecting on this, Wright came to dislike dividing a house into separate cubicles and permanent rooms. On the main floor of the Robie House,

space flows continually, parted (and anchored) by the massive stone fireplace, which recalls the social anchorage of the Japanese farm-hearth. Wright's adaptive genius as a planner was the capacious aqueduct through which the lessons of Japanese design flowed into the American mainstream. They also flowed outward to Europe, for the ideas of planning represented in the Robie House were to become the foundation of the "open plan" of the Bauhaus and of international modernism generally. Wright considered the Robie House one of his three favorite buildings, along with the Unity Temple in Oak Park, Illinois, and the Imperial Hotel in Tokyo, which almost alone withstood the Great Earthquake of 1923. He displayed his maddening egotism, neither for the first nor for the last time, when he called the Robie House "the cornerstone of modern architecture." But he was right.

The house that most fully shows the lyric and complicated relation Wright sought between culture and nature is several hundred miles from Chicago, in the woods of Pennsylvania. He built it, between 1936 and 1939, for a young Pittsburgh department store heir named Edgar Kaufmann, who owned sixty acres of virgin mountainside forest a couple of hours south of Pittsburgh. Through it cascaded a stream called Bear Run, between dramatic slabs of gray stone. Kaufmann approached Wright, who came to study the spot. They picked for the house a large hanging boulder, over which the stream poured in a waterfall. What Wright raised on it—or rather, out of it and above it—remains one of the most astonishing tours de force in all modern architecture. He named it Fallingwater (Figure 238).

You do not see it at first, from the winding approach paths in the spring woods. It does not announce itself like a mansion standing up on its green plinth of lawn

in a park. Instead, through gaps in the green, you get partial views, tantalizing glimpses, like those of a Japanese teahouse. Your expectation rises; and then, from a small bluff looking upstream, bingo!—the whole thing, on the far bank.

The house is cantilevered out over Bear Run on concrete supports, and its three terraces—concrete trays, in effect—seem to float in the air. Their apparent lightness is increased by the low parapets, which Wright designed to his own short stature, not for taller inhabitants. They are supported on a tall stone core wrapped around the kitchen, with bedrooms above (again, the Wrightian theme of the hearth or kitchen as focus of the house). As all the supports, which he called "bolsters," are anchored in solid rock and can only be seen from the back, the effect of levitation is magical at first view. The south walls, looking over and down the stream, are glass. The west and east walls are fieldstone, and seem to grow up out of the rock. Wright used color subtly, neither camouflaging the house nor making it stark. The terraces are a warm, light peach tint, and the metal window framing is a sharp earth-red, which, when seen against the winter snows, has the same visual snap as the bare red branches of a *Cornus elegantissima* poking through the whiteness. In sum, this is a wonderful set of variations on themes: the liquid water surface and the hard skin of glass; the cut fieldstone masonry and the raw rock ledges; the sense that the bulk of the building is cradled in the rock while the balconies fly out into the air, working against gravity and the assuring grasp of the earth. All the opposites, held in a poetic synthesis. They make you forget—until you go inside—the perversity of Wright's idea of building a house over a waterfall that can't be seen from inside it, but only heard: a dull, continuous roar that, in spring-melt time, must have rendered life in Fallingwater nearly insufferable.

Starting with the 1904 Larkin Building in Buffalo, New York, the headquarters of a mail-order business, Wright in the course of his long life designed a number of public and corporate structures. The best known of them today is in New York, the only thing he ever built there: the Solomon R. Guggenheim Museum. Like many geniuses, Wright was capable of quite breathtaking arrogance, which did not diminish with age. When he came to do the Guggenheim it was in full flood, and the result was both a masterpiece of space formation and a perpetual headache as a museum, a place to show works of art in (Figure 239).

Its origins lay with the copper magnate Solomon Guggenheim (1861–1949) and his deeply eccentric, pushy, and autocratic German mistress, the Baroness Hildegard Rebay von Ehrenweisen, Hilla Rebay for short. Guggenheim, who had never given much thought to modern art, had a collection of Old Masters, but then Rebay got to work on him. She was one of those mystical-minded creatures who believed, as a result of her acquaintance with Kandinsky and other Russian and German artists in the circle of the Bauhaus, that the coming spiritual Utopia would be contingent on the worldwide acceptance of nonobjective painting: not

238. Frank Lloyd Wright, Fallingwater, 1936–39.
Pennsylvania.

"abstraction," which was deduced from the things of this world, but art consisting only of pure Platonic forms and equivalents of spiritual auras, and thus containing no objects at all.

She persuaded her elderly protector to buy a collection of Cubist, Expressionist, and nonobjective art, which is still the core of the museum's collection, and included Klee, Moholy-Nagy, Robert Delaunay, Chagall, Arp, and a large group of works by Kandinsky. Her favorite painter, in the personal sense, was her other lover, an odious and exploitive semi-Nazi named Rudolf Bauer, scores of whose frigid, candy-colored abstractions, derivative of Kandinsky, were acquired by the love-smitten Guggenheim. Hilla Rebay then proposed that he should set up a museum for them. Its first form in 1939 was a converted auto showroom on Fifty-fourth Street, which the Baroness hung with gray flannel; such few visitors as went were regaled with piped-in fugal music, mostly Bach, while they looked at the nonobjective pictures, and Rebay told staff members to listen to their comments and write them down, while she sat behind the scenes devouring movie magazines. The place was farcical, though much of the art in it was not, and Rebay had bigger plans. In 1943 she and Guggenheim approached Wright about building them a museum in New York City. Between the difficulties of finding a site, the arguments over design, and the construction delays, the Solomon R. Guggenheim Museum did not open to the public until 1956. By then its patron was dead.

Wright conceived it from the start as a continuous spiral, a single ribbon floor with no breaks anywhere—a ziggurat. Then he thought of inverting it, so that the spiral form flared toward the top, thus—since the sweep of its helix got larger as it rose—giving expanded views of all levels from any point in the interior. The inverted ziggurat appealed greatly to Rebay, whose theosophical notions led her to think that spirals, the line of plant growth and upward aspiration, had cosmic meaning and were right for the display of nonobjective art. Whether Wright believed this superstitious farrago is uncertain; more likely, the spiral aroused his enthusiasm on other grounds. It was daring, it was a spectacular "signature"— nothing else built in New York even faintly resembled it—and its design enabled him to direct, with a despot's hand, the pattern of movement of visitors through the space. No museum in the world enforces a more linear progress along its exhibitions (and hence through a narrative of art history) than the main drum of the Guggenheim. It is, literally, one continuous path a quarter of a mile long. Its slope discourages you from doubling back. There are no corners to turn, no sense of the labyrinth, which is one of the pleasures of other museum spaces. But Wright didn't care about the requirements of museum design; he bluffed about them, and collapsed all the problems of showing easel pictures or sculpture into the single model of displaying the art he did know about—Japanese prints. He therefore came up with a series of bays of inflexible size, lit from above by the

band of clerestory windows, with the wall sloping backward. Add to that the slope of the floor, which makes large paintings look crookedly hung, and it is hard to imagine a more cramped and awkward environment for paintings—while vertical sculptures have to lean against the pitch of the ramp like guardsmen in a gale. There was every reason to think that Wright designed the Guggenheim as a gesture of contempt for all arts other than his own, the supreme Mother Art, architecture. And yet, and yet. Perhaps the lesson of this powerful building is its autonomy. Wright, the supreme egoist, saw nothing wrong with this—in fact it was a precondition of his work. To enter the Guggenheim today is to enter a space to which the mere art contents seem nearly irrelevant. As the spiral ramp draws you up toward the climax of the flat dome, which sheds its pure and even radiance across all parts of the drum, the whole space seems beatific and yet as natural as the unfolding of a primal organic form, nautilus, whelk, or cone shell: the esthetic experience of the museum, tied into metaphors of nature which are treated with such authority, purity, and restraint, signals that there's little chance of seeing a work of art inside it that will create the transcendence that the building does. Such was Wright's revenge on art in America.

239. Frank Lloyd Wright, Solomon R. Guggenheim
Museum, open to the public 1956. New York City.

7

STREAMLINES AND BREADLINES

In the mid- to late 1920s New York, along with the rest of America, was in full economic boom. With only 4 percent unemployment and all markets careening upward, there seemed to be no end to it. Hadn't big business solved most of America's social problems? Hadn't regulatory reform damped the workers' anger? Postwar patriotic fervor and the Red scare of the twenties had worked. The radicals were in disarray and retreat. "The business of America," Calvin Coolidge had said in the one famous utterance of his presidency, "is business." "We in America today," his successor Herbert Hoover told the American people as he accepted the Republican nomination for president in 1928, "are nearer to the final triumph over poverty than ever before in the history of any land. We shall soon . . . be in sight of the day when poverty will be banished from this nation." Into the White House he went. Eleven months later, on Black Monday, October 24, 1929, the earth opened and the American economy fell into it.

America had never suffered anything like the Great Depression. There had been recessions and slumps before, some severe, as in 1893. But American business, blindly believing in perpetual expansion, overinvested so heavily in capital equipment and development projects that it did not see the signs of market saturation. In the real estate and share markets, speculative greed created huge surpluses of office space in the cities, threw off irrational property bubbles (as in Florida), and drove share prices through the roof by allowing investors to buy on margin. Nothing could support this house of cards. Now the Depression knocked away the props on which America's collective self-image had been raised:

> Once I built a tower to the sun,
> Brick and rivet and lime,
> Once I built a tower, now it's done,
> Brother, can you spare a dime?

240. Jacob Lawrence, *The Migration Series, Panel No. 57:* *"The female worker was also one of the last groups to leave the South,"* 1940–41 (text and title revised by the artist, 1993). Tempera on masonite, 18 × 12" (45.7 × 30.5 cm). The Phillips Collection, Washington, D.C.

The chasm had no visible bottom. In the first two months after Black Monday, the number of unemployed went from less than half a million to over four million, and by 1933, the nadir of the Depression, almost one out of three wage earners, fifteen million Americans, had no work. The value of all stocks traded on the Big Board in Wall Street plummeted from $87 billion in 1929 to $18 billion in 1933, and in the same four years America's gross national product—the sum value of all goods and services produced in the country—slid by 29 percent.

These indices of hubris, a boom mentality followed by epic failure, had their cultural results too—how could they not? The most visible of them was the supreme architectural symbol of boom: the New York skyscraper. The new towers of Manhattan were spikes on a fever chart: densely clustered, beginning around the year 1927, rising to a peak in 1929, and then coming down in a different world. To the foreigner, the out-of-towner, and above all to New Yorkers themselves, they represented Manhattan. New York's shifting, rising skyline was like nothing Europeans had ever seen. It was a graph of cultural and economic impaction, the condensation of lives, work, and fantasies onto a mere pocket handkerchief of land, bought from Indians with trinkets and glass beads.

There was a reason for skyscrapers, and it grew out of the tight space of Manhattan Island. When land is scarce it makes sense to multiply the site; to squeeze it upward, so to speak, like toothpaste out of a tube. The Manhattan skyscraper seemed heroic because it replayed the myth of frontier expansion. Not horizontal expansion, with the wagons rolling westward. But vertical expansion, a land grab in the sky, the creation of wealth out of empty air. Thus Manhattan got both airier and denser, and even more of a hive of competing fantasies. People watched the phallic progress of rival skyscrapers with the enthusiasm once reserved for baseball games; the very word "erection" took on new architectural meaning. Their construction was a romance, and girl dancers were hired to perform on their bare girders, hundreds of feet up in the dizzying air, for the avid media. Some of the finest photographs of Lewis Hine, the recording angel of American labor in the 1920s and 1930s, were taken to document the construction of the Empire State Building, and one in particular became an icon: the rangy young man in overalls swinging on the hook of a crane, a thousand feet above Manhattan's sidewalks, like some Icarus of skill and risk (Figure 241). The world wondered at how Americans could turn a patch of property into an abstract, universal sign of thrust and power and go-getting. Americans, too, were dazed by the force of their new imagery. "What figure the poet might employ to describe the skyscraper," wrote an enthusiastic architectural critic, Sheldon Cheney, in 1930,

> dwarfing the church, outpointing the cathedral spire, I do not know. There is an epic implication in man's defiance of the laws of gravity, and beauty in the naked uplift of steel and concrete. . . . Perhaps Commercialism is a new God, only too powerful and too appealing, to whom men are now building their highest and most laudatory structures.

A dearth of office space in New York in the early 1920s (the war had halted construction and inflated its costs) meant that, by 1925, only 5.5 percent of the available space in Manhattan was vacant. Between 1925 and the Crash, the city's office space nearly doubled, increasing by 92 percent—and buildings finished on the other side of Black Monday added another 56 percent to that. Between 1927 and 1933 New York went skyscraper-crazy and produced some of the most daring, exuberant, and flat-out original buildings in the history of architecture, led by the Chrysler and Empire State buildings, and by Rockefeller Center. These were powerful cultural icons of their time—more so, to the general public, than any painting or sculpture made in America in the 1930s.

Their style was modernist, but it bore little or no relation to the kind of minimal, functionalist, austere architectural modernism represented by Le Corbusier in France or Walter Gropius and his colleagues at the Bauhaus in Germany. The

241. Lewis Hine, *Construction Worker on the Empire State Building*, c. 1930. Photograph. Arnold Hine Collection, Drawings and Archives Department, Avery Architectural and Fine Arts Library, Columbia University, New York.

dictum that "form follows function" made little or no sense to William Van Alen, designer of the Chrysler Building, or to other skyscraper maestri like Raymond Hood or Ely Jacques Kahn. To them, there was no single definition of "function" and no obvious way in which function inexorably dictated a single typology of form. And weren't the display of economic power and the excitement of fantasy real "functions" too? Try telling Bernini that they weren't.

Nevertheless, there is a peculiarly distorted idea about how the 1930s skyscraper style came about—floated in the 1970s by Tom Wolfe, in his silly book *From Bauhaus to Our House*. Once, by this version, there had been a truly *American* skyscraper architecture, exuberant, loaded with detail, finials, statuary, frills—in effect, the decorated Tower of Joy, whose origins lay with structures like Cass Gilbert's 1913 Woolworth Building and whose full flowering was reached with Rockefeller Center and the Chrysler Building some twenty years later. It was invented in America, it expressed America, there was nothing "foreign" about it. But then, at the end of the 1930s, under the malign influence of the International Style and its prophets at the Museum of Modern Art, Philip Johnson and Henry-Russell Hitchcock, puritanism came to Manhattan. The foreign influence of Mies van der Rohe and the Bauhaus now reigned, popular among fashion-victim American intellectuals just because it was European. The full-blooded native style gave way to the stripped, dour import: the universal, pseudo-Utopian glass box. American capitalism lost its voice; architectural Marxism now prevailed.

In fact, what happened was the very opposite of this farrago. The ideas of the Bauhaus were deeply influenced by, even based on, American prototypes, such as the explicitly functional forms of American bridges, factories, and silos. The very idea of the "open plan" came to Europe, as we saw in the last chapter, from Frank Lloyd Wright. By the late 1920s most American architects (except for Beaux Arts fossils, of which there were still a few) wanted to express a modernist esthetic in their work, not because they wanted to copy Europe, but because they wanted to be American. But then came a further twist: the Art Deco "look" so characteristic of the New York skyline by the mid-1930s was actually an import. For Art Deco was the world's last universal decorative style. It spread worldwide at lightning speed, from Rio to Sydney. Its main root was in France, as its name proclaimed: "Deco" was short for the name of the pivotal exhibition in which it burst upon the world, the 1925 Exposition des Arts Décoratifs in Paris. New York architects like William Van Alen saw it in Paris, brought it back, and morphed it into something American: an apotheosis, in the form of the decorated skyscraper. The combination of decor and the skyscraper was what was new. Paris had no skyscrapers. London had spires, but no super-tall functional buildings. Only in New York, Le Corbusier's "tragic hedgehog," bristling with towers extruded sky-high to multiply the profit of small sites, could such an idiom come to pass. The New York architectural, decorating, and marketing elite of the late

1920s was deeply Francophile. French Art Deco gave its American cousin an instant grammar of ornament—chevrons, sprays of flowers, sunbursts, lightning bolts, arcs, all-purpose maidens, and the ubiquitous *biche*, or doe, replicated in scores by sculptors like Paul Manship.

What most shaped the new buildings, however, was not decor but a city zoning ordinance passed in 1916, whose aim was to prevent the streets and avenues of New York from turning into mere sunless canyons, overwhelmed by vertical blocks. The law (its complications need not detain us here) enjoined architects and developers to step their buildings back as they went up, thus creating a "slope" that let more sun into the street below. This encouraged a more sculptural approach to mass and, by leading the street-level eye up the diminishing façades, gave importance to the top of the building, its crown or finial, on which architects lavished much fantasy and ingenuity.

Moreover, the setback ordinances brought in another style, still imported but from closer to home. This was ancient Mayan architecture, which rapidly twined into the lingo of Art Deco and spread, from New York, to more remote parts of the world. The form of the Mayan step pyramid, especially the steep structures of Tikal, hovers behind the stepped New York skyscraper without being specifically quoted; it made them imperial, "Pan-American," if not North American.

But although the shape and detail mattered, the key element of the New York skyscraper was always its gratuitous height—overlaid (or not) with a perfunctory rhetoric of function.

The race for the sky began in 1926 with a project never built, the Larkin Tower, meant to top out at 1,028 feet, or 500 feet higher than the Woolworth Building. By 1928 it had settled into a race between William Van Alen's Chrysler Building at Lexington Avenue and Forty-second Street, and Craig Severance's Bank of the Manhattan Company at 40 Wall Street. Van Alen and Severance had been in partnership but fallen out, and the competition between their skyscrapers was a fierce grudge match. At one point it looked as though Van Alen was going to lose, because Walter Chrysler ordered him to trim the building by ten floors. But this was rescinded, and the skyscrapers went up neck and neck until Van Alen managed to bluff Severance into thinking the Chrysler would top out at 925 feet. So Severance finished his tower at 927 feet. Then Van Alen pulled the spike out of the hat. He had designed and, inside the fire shaft, secretly assembled a 185-foot steel spire. The press was primed, film crews stood ready, and Van Alen's "vertex" was hoisted into place in ninety minutes, emerging through the top of the pinnacle like a wasp's sting. At over a thousand feet, victory was his.

The Chrysler Building outdid its rival in height, but even more in design. Van Alen—who was memorably photographed at an architects' ball costumed as his own creation (Figure 242), and looking like Flash Gordon's opponent Ming the Merciless—had a showman's flair and flamboyance. In 1908 he had carried off

the design prize at the École des Beaux-Arts; he had been to the 1925 Exposition in Paris. "No old stuff for me!" he exclaimed, his enthusiasm making up, in some degree, for his terrible spelling. "No more bestial copyings of arches, and colyums, and cornishes! Me, I'm new! *Avanti!*" The signature of the Chrysler Building was, of course, its fantastically inventive finial (Figure 243)—a stack of seven groined vaults, one atop the other, tapering to the sky, each of the twenty-eight outfacing arches (thinning from semicircular at the bottom to parabolic at the top) pierced by triangular windows that suggest the spokes of a wheel. These were not the only references embedded in the Chrysler Building to the cars that had made its owner rich. Van Alen designed, at the thirtieth floor, a frieze of Chrysler hubcaps running round the building; at each corner there were enormous "gargoyles," sculpted out of welded stainless-steel sheet, in the form of eagles—the Chrysler radiator cap. In sum, Van Alen's masterpiece remains America's most successful example of building-as-corporate-logo. Nor was it just a billboard: Van Alen went to immense trouble (and expense) with the internal detailing, from the strange coffin shape of the black marble entranceways, to the ocherous glow of russet and yellow marble sheathing the lobby; from a now badly faded ceiling fresco full of aircraft, workmen building the tower, and a portrait of the tower itself, to the brilliant marquetry elevator cabs, each a one-off design in brass inlay and a dozen kinds of exotic veneer.

242. "The New York Skyline" at the Bal des Beaux Arts, 1932. Kilham Collection, Drawings and Archives Department, Avery Architectural and Fine Arts Library, Columbia University, New York.

243. William Van Alen, Chrysler Building. New York City.

The Chrysler Building was not just Van Alen's best work; it was, effectively, his last, for by its completion in 1930 the real estate market was dead and the construction industry too. In less than a year it would be outtopped by an even taller tower, the Empire State Building (Figure 244), by the architects Shreve, Lamb & Harmon. It occupied the site of the old Waldorf Hotel, which had gone broke under the impact of Prohibition. Demolition of the Waldorf started less than four weeks before the 1929 Crash, and the construction of the Empire State took less than two years; at one point the behemoth's frame rose fourteen floors in a mere ten days. This miracle of process and teamwork left behind it a building that was stupendous rather than beautiful. You look *at* the Chrysler, but by Manhattan tradition you look *from* the Empire State. It is, of course, impossible to imagine Manhattan without the presence, symbolic and physical, of this mighty trunk of Indiana limestone and nickel-chromium steel, rising in its succession of powerful massed blocks. It epitomizes what one writer called "the monstrous blast of energy which is congealed into the skyscraper." It is completely devoid of the symbolism that enriches the Chrysler Building, at least until you reach the top. There, the owners insisted on an observation tower that would double as a mooring mast for airships. This conceit of bringing a flying machine to the tower was always part of Manhattan's tower-fantasies—one developer proposed a 1,600-foot skyscraper downtown on whose roof biplanes could land—but it never came to anything, at least until the time of the corporate helicopter, which was not yet at hand. But, except for a couple of brief and precarious blimp dockings, the Empire State's spike was never used.

It remained for Rockefeller Center (Figure 245) to carry the Babylonian grandeur of the skyscraper idea—a culture of smooth-flowing con-

244. (left) The Empire State Building. New York City.
245. (right) Rockefeller Center. New York City.

gestion—to its limit. Not a tower within a city, but a city within a city. It took ten years from groundbreaking to the last rivet, 1929 to 1939, and cost about a quarter of a billion dollars; once the money was in place, the Depression helped its construction by lowering the cost of labor and materials. It remains the greatest self-sufficient urban complex—office space, entertainment, shops, restaurants, gardens, plaza—that ever has been, or probably ever will be, built in an American city.

Its origins were smaller. The germ of Rockefeller Center was a scheme to create a new Metropolitan Opera House, rivaling Covent Garden, La Scala, or the Paris Opéra. New York had a Metropolitan Opera House at Broadway and Thirty-ninth Street, dating from 1883. But the center of town had been inexorably moving north since then, and Thirty-ninth Street was no longer a prestige site for the rituals of wealth and social display. Scouting around, the promoters of the Metropolitan Opera found an ideal one, owned by Columbia University, bounded on the west and east by Sixth and Fifth avenues, and north and south by Forty-eighth and Forty-ninth streets.

To make the Opera pay for itself, it ought to lease space all around it for shops, hotels, and businesses. But when the Depression struck, John D. Rockefeller was persuaded to come in to salvage the value of the assembled land, the Metropolitan Opera Company (for reasons too intricate to go into here) pulled out, and Rockefeller and his advisers started developing the form it has today. It was an inordinately long and tortuous design project, and so many architects were involved in it that no one of them can claim complete credit for the results. One name, however, stands out: that of Raymond Hood, the man chiefly responsible for the central poetic effect of Rockefeller Center—the sunken public plaza, which over the years has spontaneously become the core of midtown New York City, and the soaring slab of the RCA Building.

Hood was a virtuoso, the "brilliant bad boy" of architecture, as a 1931 article in the New York called him:

> There is conflict in whatever he does, an intense emotion sweeping first over him, then over his spectators. . . . [I]t is impossible for him to run with the pack. He can't even run with himself.

Before Rockefeller Center Hood had designed several of the showpieces of the skyscraper boom: the Daily News Building, the American Radiator Building (1923–24) with its black brick walls and gold-painted finial meant to symbolize the company's products, and the blue-green-banded McGraw-Hill Building (1930–31), whose use of glazed terra-cotta and glass as a membrane hung on a steel frame clearly points away from the solid-shaft skyscraper and toward the International Style. All along the way, he had been increasingly fascinated by the

unique nature of Manhattan: "Congestion is good, it's the best thing we have in New York. The glory of the skyscraper is that we have provided for it so well." In Rockefeller Center he had the chance to help create an ultimate form of congestive architecture, a kind of megamountain, and impose a poetic nature on it through theatrical contrivances. The RCA Building replaced the lost "high-culture" core of the Center, the Metropolitan Opera House, with a vertiginous giant dedicated to the intersection of popular and high culture: radio, which beamed everything from kids' serials and horse races to Toscanini into American homes. The high-culture excuse for Rockefeller Center, opera, had been snuffed out by the weight of the commercial superimpositions which had been meant to make it pay. When the mighty Radio Corporation of America was persuaded to take its headquarters to Rockefeller Center, Hood had to shift the focus, from a traditional monument to a celebration of a worldwide technology which could bring "culture," in the widest sense, to everyone. For that, you didn't need a theater—you needed a completely memorable form, which Hood found in the thin freestanding slab with setbacks, mounting up like a tapering blade, so different from the usual extruded box. As an example of coordinated, monumental place-making, Rockefeller Center stands nearly alone in New York (its only competitor being the complex of Columbia University). Even after sixty years, it can still elate the visitor with the close harmony between the RCA tower and the twelve subsidiary buildings that surround and defer to it, all grouped around the scintillating open focus of the plaza, which, summer and winter, provides a constant open-air theater. It refutes the jeremiads that Frank Lloyd Wright, through the twenties and the thirties, kept issuing against the skyscraper and the idea of the tower city—mainly, in fact, because he was furious at not getting to build any himself:

> They are monotonous. They no longer startle or amuse. Verticality is already stale; vertigo has given way to nausea; perpendicularity is changed by corrugations of various sorts, some wholly crosswise, some crosswise at the sides with perpendicularity at the center, yet all remaining "envelopes." The types of envelope wearily reiterate the artificial setback, or are forced back for effect, with now and then a flight that has no meaning.

The architects—and the Rockefellers—wanted to fill the complex with art, from Paul Manship's gilded *Prometheus* in the plaza to the murals in the RCA Building. But for most visitors the "cultural" focus of the vast complex is its main theater, a cocoon of illusion and an imperishable period piece whose shows are usually forgotten as soon as they are done: Radio City Music Hall. This temple of choreographed pleasure was the creation of Samuel Lionel Rothafel, whose nickname, "Roxy," later found itself on scores of lesser theaters and movie

houses, just as the name of the hotelier César Ritz entered the language of luxury. Roxy was a celebrity, the most famous vaudeville impresario in New York. His Music Hall, designed by Wallace Harrison, would be the theater to end them all, with more than six thousand seats, or a thousand more than were planned for the Metropolitan Opera. Being inside its auditorium was like sitting in a vast gold egg, laid by the goose of Capitalism. Its arched vault enclosed you; it drew the audience together, without splitting it into balconies and loges, for, as Roxy put it in words that could hardly have been improved on by Albert Speer, "there is mass thought, emotion and confidence when the crowd is in a huddle." The gilded semicircular vault of the ceiling, defining the sixty-foot-high proscenium, suggested the view from an ocean liner of the sun rising and setting over the ocean (Figure 246). Why a liner motif? Because those floating palaces were the arch-symbols of escape and luxury: floating islands that could carry you away (along with Ginger Rogers and Fred Astaire) from the dreary anxiety of the Depression. Morning in America, at least for a couple of hours.

The interiors of Radio City were by Donald Deskey, New York's preeminent Moderne designer of the day. He left his uniquely stylish imprint throughout, from the lavatories to the theater and foyers. Not a handrail or a light fixture in the theater failed to get the maximum treatment: you went first-class when you entered Roxy's dreams. Deskey promised that Radio City would be "completely

246. Wallace Harrison, auditorium of Radio City Music Hall. New York City.

and uncompromisingly contemporary in effect, as modern in its design of furniture, wallpapers and murals as it will be in technical devices for stage presentations." For the men's smoking lounge, for instance, he commissioned a large mural, *Men Without Women*, from Stuart Davis (Figure 261, page 436), and set it against an aluminum-foil wallpaper of his own design printed in Havana brown with a "nicotine" pattern. Not all the art in Radio City was equally successful, and Roxy himself had some of it removed as being, to his censorious eye, sexually suggestive. The most elegant and stylistically unified part of Radio City was not open to the public: it was Roxy's own apartment at the top of the building, Deskey's masterpiece, as good as anything by the leading Paris *ensembliers* (Figure 247)—soaring flat walls and flush doors veneered in cherrywood, consoles and tables in lacquer, bronze, and rare woods, creating a sense of luxury through severe restraint that Mies van der Rohe might have envied.

If the building was a triumph, its opening night at Radio City Music Hall was a disaster. It happened in 1932, the bleakest year of the Depression, and only de-

247. Donald Deskey, Samuel L. (Roxy) Rothafel apartment at Radio City Music Hall. Cooper-Hewitt National Design Museum, Smithsonian Institution, New York; Donald Deskey Collection.

pressed the audience more. The place was so big that vaudeville acts onstage looked like a puppet show from anywhere but the front seats. Scarcely edited, the show dragged on from 8:15 p.m. to 2:30 a.m., and most of the audience had fled long before. The fiasco broke Roxy's heart, and his health. The columnist Walter Lippmann, who had sat through the whole mess, perciently remarked that "for such a theater it would be necessary to create some radically new kind of spectacle, some sort of show in which the individual performer was disregarded, because few in the audience can really establish any relationship with him." Roxy took notice—and developed Radio City's signature act, a piece of dancing architecture in its own right: the Roxyettes, a name later streamlined to the Rockettes. This was a chorus line of sixty-four dancers, as like one another as peas in a pod, all between five feet four inches and five feet seven inches tall, identically costumed. Robotic, high-kicking, bleakly smiling, flawlessly on the beat, the Rockettes crystallized the fantasies of the abstraction of the human body that had been afloat in the culture. Their movements had no content but they were the *summa* of Art Deco choreography in America, along with Busby Berkeley's abstract mass dances on film. They were to the mechanization of pleasure what the Nuremberg rallies—another extreme of Art Deco choreography—were to the mechanization of aggression and obedience. That the same type of show should have been dreamed up by a New York Jew and Adolf Hitler at the same time only shows the utter pervasiveness of the Art Deco style.

New York's architecture of joy also had its sinister side: delight and oppression were, so to speak, only inches apart. The authoritarian nature of the energies the proud towers symbolized would glare through, providing its own spectacle, which became more vivid as the Depression lengthened. There is no better example of this than the foyer of the Daily News Building at 220 East Forty-second Street, designed by Raymond Hood and built in 1929–31, exactly straddling the Crash.

It resembles an energized mausoleum: a round room sheathed in black marble, the ceiling black and twinkling with electric lights that look like stars in remote space, and at the center a circular pit in which a ten-foot-diameter blue globe of the world slowly rotates on a hidden axis (Figure 248). Hood got the idea from Napoleon's tomb in the Invalides in Paris, and it is an intense metaphor for American belief in the power of the press—instead of the sarcophagus of a dead emperor, here is a captive world in the inquisitorial chamber of the Media. Inscribed on the granite rim of the pit are the names of the world's principal cities, with directional lines that show their bearing and distance from the Daily News Building. This, Hood in effect says, is the omphalos, the center of the world. At one point Captain Joseph Patterson, the paper's publisher, wished to ratchet up the lugubriousness of this space by placing a "murder chart" around its walls—"some kind of map of the metropolitan area where the latest crimes could be

chalked up." But he was dissuaded, and weather charts in glass cases were put up instead. Today, the lobby induces acute nostalgia: it speaks, uneasily, of the days when Clark Kent was a boy, and the newsrooms of America were full of Jimmy Cagneys in fedoras, belting out stories on three-carbon copy paper on their Underwoods.

By 1931 the shift from the Tower of Joy to the Tower of Doom was complete—at least in popular imagery. Manhattan, it seemed, was fast catching up with the dystopic vision of the future set forth in Fritz Lang's *Metropolis* (1926): the soulless city, buzzing with mechanical activity, autogiros fluttering between the towers while hordes of human drones passed robotically below. One of New York's archetypal images, ramified through a thousand cartoons and illustrations, now became the millionaire, diving to his death from his own building: the skyscraper as personal scaffold or funerary mastaba. The technocratic, clean tower-city replaced the dirty old Victorian one—"Hell is a city very much like London—/ A populous and smoky city"—as an image of social dread.

The architect whose work captured this was Hugh Ferriss (1889–1962). Perhaps it is misleading to call him an architect, though he was trained as one, since

248. Raymond Hood, lobby of the Daily News Building,
1929–31. New York City.

417

249. Hugh Ferriss, *Study for Maximum Mass Permitted by the 1916 New York Zoning Law, Stage 3,* 1922. Black crayon, stumped, brush and black ink, over photostat, varnish, on illustration board, $26^1/_2 \times 20^5/_{16}$" ($66.8 \times 50.9$ cm). Cooper-Hewitt National Design Museum, Smithsonian Institution, New York; gift of Mrs. Hugh Ferriss, 1969.

he never put up a single building. Instead, he went straight into doing renderings and presentation drawings, working first for Cass Gilbert until 1915, and freelancing thereafter. Ferriss was by far the most sought-after and influential architectural delineator of the 1920s and 1930s, doing presentation drawings for Hood, Ely Jacques Kahn, Van Alen; nobody did more to deliver the mood and message of unbuilt buildings. Among his most powerful images were the imaginary "zoning envelope studies" done in 1922, which explored the possible results of the setback formula for high buildings prescribed by the 1916 New York Zoning Law (Figures 249 and 250).

Ferriss was, in fact, the Piranesi of the skyscraper, and many of the illustrations in his influential book *The Metropolis of Tomorrow,* 1929, are modern equivalents to Piranesi's visionary series of "Imaginary Prisons"—giant tomblike structures, prismatic and towering, filled with a sculptural density that excludes the fuss of surface detail. His favorite medium was charcoal; he went in for broad planar effects and deep chiaroscuro, and his favorite stylistic device of making the towers darker at the top than at the bottom lent them all an ominous air. His renderings were really dreamings: "As one contemplates these shapes," he wrote, "images may begin to form in the mind of novel types of building which are no longer a compilation of items of familiar styles but are, simply, the subtilizing of these crude masses." And still today, walking in Manhattan, one can find oneself glancing up at one of its towers—the Chrysler, the McGraw-Hill Building, the Empire State, or the shaft of the RCA—and seeing, not a real building, but an oneiric presence: a Ferriss.

No American painting or sculpture between World Wars I and II was able to accumulate, at least in the ordinary public's eye, the kind of cultural power that skyscrapers had. Nor, indeed, could it have done so—most Americans didn't care about art, especially modern art, and the institutions that could have displayed new work were either so conservative that they ignored it or else so new themselves (like the Whitney Museum, which began in a brownstone in 1931, and the Museum of Modern Art, founded in 1929) that they had, as yet, little public clout. Big buildings were always before you; mere paintings were not.

250. Hugh Ferriss, *Study for Maximum Mass Permitted by the 1916 New York Zoning Law, Stage 4,* 1922. Black crayon, stumped, brush and black ink, over photostat, varnish, on illustration board, 26³/₁₆ × 20″ (66.5 × 50.8 cm). Cooper-Hewitt National Design Museum, Smithsonian Institution, New York; gift of Mrs. Hugh Ferriss, 1969.

After the shock of the Armory Show, experimental painting in America lost much of its impetus. The Depression confirmed this by turning American eyes inward, on themselves, their ills and troubles, and their national character—which, more and more, was held by artists and pundits to be quite different from anything you could find in Europe. A mood of cultural xenophobia spread, along with a strong hankering for didactic and legible public art, supported by the New Deal government of Franklin Roosevelt under the Public Works of Art Project (PWAP) and the Federal Art Project (FAP). Naturally, since avant-gardism was both obscure and dependent on European models, this was bad news for the avant-garde. The most influential foreign artists in the 1930s were not Picasso or Matisse: they were the Mexican muralists Diego Rivera, José Clemente Orozco, and David Alfaro Siqueiros—and, for abstract painters, Piet Mondrian.

By the early thirties American art—very broadly speaking—had split into three camps: abstract artists, Social Realists, and Regionalists. The smallest one, mostly in New York, was the abstractionists. Little attention was paid to them. In the main they turned out derivative forms of geometric, Utopian abstraction based on Mondrian and de Stijl, or else on the pedantic "universalism" of the Abstraction-Creation group in Paris. Among them were Fritz Glarner, Ilya Bolotowsky, Burgoyne Diller, Carl Holty, and Charmion von Wiegand.

Far and away the most interesting American abstract artist whose work reached maturity in the 1930s was a sculptor and partial expatriate, Alexander Calder (1898–1976), pioneer of kinetic art and inventor of the "mobile." In his later years, Calder was to produce quantities of oversized, uninteresting, and corporate-flavored work, whether in the form of "stabiles"—large painted sheet-metal sculptures—or hypertrophied mobiles the size of DC-3s, of which a particularly stolid example hangs from the ceiling of the east wing of the National Gallery in Washington, so large that its own inertia all but prevents it from budging (Figure 251). But in the early 1930s he was a genuinely inspired artist, one who came to suffer a common fate of innovators—people got so used to his work

that they took it for granted, and ceased to appreciate what a graceful leap in sculptural syntax it once had been.

The son and grandson of sculptors, Calder may not have meant to become one. He studied mechanical engineering, and as a young man worked at many trades, from ship's fireman to draftsman, from logger to illustrator. By 1926, convinced of his vocation as an artist, he was in Paris, where he took a small studio and began work on *The Circus*, a collection of toy figures made of wood, wire, and rags—dancers, acrobats, a lion, trapeze artists, musicians, an elephant—which he played with and manipulated, giving performances in a miniature ring, for invited guests. Before long the roster of visitors included some of the best-known artists and writers in Paris: Jean Cocteau, Tristan Tzara, Fernand Léger, Hans Arp, Marcel Duchamp, the Delaunays. A reputation was launched. Then, one night, a friend brought Piet Mondrian along, and Mondrian invited Calder to come and see his work. From that studio visit in 1930, Calder's career as a "serious" artist began. It was, he said, "the shock that started things":

> Though I had heard the word "modern" before, I did not consciously know or feel the term "abstract." So, now, at thirty-two, I wanted to work in the abstract.

In the late twenties Calder had been making brilliant and witty wire figures—caricatures, in essence, done with a single length of bent wire extended in space. Thinking about Mondrian's planes of primary color—and about Hans Arp's kidney and "Shmoo" shapes, and the abstractions of Miró, too, with their flat biomorphic forms afloat on monochrome grounds—Calder decided to see if he could transfer them into materials that he could "twist or tear or bend." A thought, he recalled, passed through his mind in Mondrian's studio: "How fine it would be if everything moved!"

Now Calder could use his training as an engineer. He began to make his "mobiles"—the word was an invention of Duchamp's—out of wire, wood, and tin: mere lines in the air with colored vanes or balls on their ends, linked to one another by rings, swinging in delicate equilibrium, responding to the least current of air in the room. Some forms moved in slow, deliberate arcs, like the arms of an orrery, suggesting planetary motion and the music of the spheres. Others trembled like aspen leaves, or wiggled and danced, or quivered with a delicious solemnity. Because they were not driven by motors (as some Russian Constructivist sculptures had been, earlier), the movement of these mobiles was random and could not be programmed. Hence, Calder was the first artist to introduce chance as well as movement into art, thus opening a trail down which many others would go—though none with the same funny, lyrical, mysterious, and capricious results.

The other two camps duked it out under the label of "American Scene" paint-

251. Alexander Calder, *Untitled*, 1976. Aluminum and steel, 358½ × 912" (9.103 × 23.155 m). National Gallery of Art, Washington, D. C.; gift of the Collectors Committee.

ing. On one side—the left—were the Social Realists: Ben Shahn, Jack Levine, Philip Evergood, and a clutter of very minor figures, all of a humanitarian-Marxist persuasion. On the right were the Regionalists: Thomas Hart Benton, Grant Wood, John Steuart Curry, and their imitators. But the two outstanding American painters of the time were essentially apolitical. These were Stuart Davis and Edward Hopper.

Edward Hopper was the quintessential realist painter of twentieth-century America. His images have become part of the very grain and texture of American experience, and even today, thirty years after his death, it is all but impossible to see America without some refraction through them. This can be true even if you have never seen a Hopper, because his paintings so affected popular culture. His isolated Victorian houses, with their porches and pediments and staring windows, were recycled by a host of illustrators and filmmakers: the house the comically sinister Addams family lived in is a Hopper house, and so is the mansion alone on the Texas prairie in *Giant,* and the house in Hitchcock's *Psycho*—as have been innumerable stage sets and film sequences, particularly in noir movies, for the last fifty years. Hopper affected the look of American film even more widely than artists like Lyonel Feininger affected German Expressionist film in the 1920s.

The "Hopper effect" is particularly strong in New York, where Hoppers are everywhere: in a man staring out of a window, in the sunlight on a cornice, in the lobby of an old third-class hotel. There hasn't been a painter in the twentieth century who became more identified with the look and feel of a certain kind of America, an experience which has nothing to do with the rhetoric of patriotism, but goes much deeper. Earlier artists had painted the frontier. But it was Hopper, a man of extreme inhibitions who had no interest in communicating with the world at large except through his art, and then only obliquely, who saw that the old frontier had moved inward and now lay within the self, so that the man of action, extroverted and self-naming, was replaced by the solitary watcher.

He was an artist of extreme plainness, straightforwardness, and tact of feeling. His work always seems candid, but is what you see what you get? Not necessarily: the candor is mysterious, and you acknowledge this even as you trust his responses, though at the same time knowing that they come from a depressive mind.

The son of a dry-goods merchant in Nyack, New Jersey, Hopper spent almost all his life in America except for a period of study (1906–7) in Paris and two short visits to Europe in 1909 and 1910. In Paris he was impressed, most of all, by Manet—the strong tonal structure, the swift eye for the rituals of amusement and social transaction—and by the overtly caricatural work of such artists as Daumier and Steinlen. He had no contact with or interest in Cubism, and found

Cézanne's paintings flimsy beside those of Courbet, whose weight and materiality of paint appealed to him "tremendously." He was a diffident outsider to Paris bohemia, but he sketched it incessantly, like a man looking into a forbidden world—the various grades of prostitute, the drinkers in bars, the clowns at street carnivals, police fishing a suicide from the Seine. This combination of distance and fascination would stay with him, and characterize his mature work. One of his few public utterances—in 1927, to the effect that "now or in the near future, American art should be weaned from its French mother"—used to be taken by American cultural nationalists as a manifesto of secession from wicked Europe, but it wasn't. Hopper was in no doubt about his affiliation with France, or how much confidence it had given him. He knew that real originality is made, not born; that it does not appear in spasms and tics, but rather through a long digestive absorption, sometimes interrupted (in his case) by anxiety. He was a ruminator, placid on the surface, but capable of incalculably deep feeling. He strenuously objected to efforts to cast him with the "American Scene" painters of the 1930s, like Thomas Hart Benton and Grant Wood. That made him "so mad," he said—"I never tried to do the American Scene. . . . I think the American Scene painters caricatured America. I always wanted to do myself." Along with Jackson Pollock, his polar opposite in every way, Hopper was probably the most original American painter of the twentieth century.

Hopper's realism had nothing to do with the prevalent realisms of the thirties and forties. That is to say, it had no persuasive content; it was free from ideology, either left or right. No hints of class conflict intrude on Hopper's vision of American society, which he painted one isolated person at a time. There are no noble peasants, striving workers, moneybags plutocrats, or town meetings to be seen— no sense of collectivity. Though he had studied painting in New York under Robert Henri, no trace of the romantic anarchism with which Henri imbued many of his students rubbed off on Hopper. The only painting in his oeuvre that could even be guessed to show an industrial worker is *Pennsylvania Coal Town*, 1947; and its figure of a bald man is posed like Millet's peasant with a hoe, raking grass outside his house in the sunlight, not hewing at the coalface in darkness. His own politics, which you would not guess from his paintings, were those of a conservative Wendell Willkie Republican, who loathed the New Deal and believed that Franklin D. Roosevelt was trying to become an American dictator.

Henri had encouraged Hopper to go often to the theater, where, he thought, his student would be drawn into the vortex of ebullience the Ashcan artists so enjoyed: city life, fleshy and energetic. The opposite happened. Hopper responded intensely to the theater—but as a spectacle of withdrawal and transparency, not of human closeness. An imaginary proscenium would frame almost everything he did from then on. A great Hopper always emits one moment of frozen time, literally a tableau, as though the curtain had just gone up but the narrative hadn't

begun. It gives images of quite ordinary things—and everything, in Hopper, is on the face of it ordinary—their mystery and power. It may be that one of his more famous images, *Early Sunday Morning*, 1930 (Figure 252), was actually derived from a stage backcloth. Certainly it looks like one: a frontal view of a row of stumpy red brownstones somewhere in New York, too early for people to be up or traffic to be moving. The façades are ordinary and poker-faced, with their empty but never standardized windows, and the fire hydrant and the barber's pole. Hopper pays so much attention to the exact play of light across the band of red brick that your eye is drawn into the detail and dragged (as it were) across the canvas by the long blue streaks of raking shadow on the pavement. You know that this is a slice of life, that the buildings go on beyond the frame, that he has slipped a sense of time into his space without alerting you or implying any sort of narrative. The effect is not portentous, as the "metaphysical" cityscapes of Giorgio De Chirico intentionally were. You are in the real world, but it's a stranger world than you imagined. The screwdriver slips under the lid of reality and lifts it a crack, no more. What's inside? Ask early Auden:

> "The glacier knocks in the cupboard,
> The desert sighs in the bed,
> And the crack in the tea-cup opens
> A lane to the land of the dead.

> "O look, look in the mirror,
> O look in your distress;
> Life remains a blessing
> Although you cannot bless.

252. Edward Hopper, *Early Sunday Morning,* 1930. Oil on canvas, 35 × 60″ (88.9 × 152.4 cm). Whitney Museum of American Art, New York; purchase, with funds from Gertrude Vanderbilt Whitney.

253. Edward Hopper, *Room in New York,* 1932. Oil on
canvas, 29 × 36″ (73.7 × 91.4 cm). Sheldon Memorial Art
Gallery, University of Nebraska, Lincoln; F. M. Hall Collec-
tion, 1936.

He excelled at painting, discreetly and from without, people who are outsiders to one another. You imagine him staring from the Second Avenue El as it rattled past the lit brownstone windows, storing the enigmatic, mentally framed snapshots of home and business life for later use. These are all constructed scenes which give the illusion of sudden emotion recollected in tranquillity. In *Room in New York*, 1932 (Figure 253), it is night; a man reads a paper at a round table, a woman turns away in her own absorption and boredom, touching the piano keyboard softly with one finger: an exquisitely telling gesture. They are out of sync, and their emotional distance from each other is figured in the simple act of a woman with a shadowed face sounding a note (or perhaps only thinking about sounding it) to which there will be no response.

Perhaps Hopper glimpsed something like this, yet not very like it. The space would not have been measured by his three exact and consciously placed patches of red: the armchair, the woman's dress, the lampshade. The figures would have been remote, whereas in the painting they are large and we are close to them, outside their window. You don't for a moment imagine Hopper on a scaffold outside, or spying on the couple through binoculars. To suppose that he was literally a peeper would be as absurd as to imagine that Watteau lugged his easel out on the grass to paint an actual *fête champêtre*. And yet the painting does evoke the pleasure, common to bird- and people-watchers, of seeing from cover, unnoticed; it does put your eye close to that window several floors up; and this contributes a dreamlike tone to the image, as though you were levitating while the man and the woman remain bound by gravity in their chairs. This is not realistic, but the scene is intensely "real," a vignette framed in the dark proscenium of the window.

In Ashcan School painting, New York City was lush and solid; in Hopper it is much more abstract, the walls and windows sometimes being so schematic that they look paper-thin—just enclosures, boxes, space-frames. Abstraction is a sign for the emotional state of deracination, of not-belonging. In *Nighthawks*, 1942 (Figure 254), the classic film noir Hopper, this reaches an extreme: it is a sort of geometrical aquarium with four inscrutable fish in it. Nothing can be told about the lives of the people at the counter, or the diner employee serving them: each person is locked within the self, and held like a specimen in the firm grip of Hopper's receding space, with its greenish light cast on the pavement and the ivory blaze of the inner wall.

It is the spaces between people that Hopper painted so well. Distance is seen as the concomitant of the act of love. In *Summer in the City*, 1932, we see a woman in a thin shift sitting on the edge of a bed on which a naked man lies, facedown. One feels the heat of the room from the trapezoids of light and shade the slanting sun, through the big bare window, makes on the walls and floor. Has she put on her clothes after sex? Or has he taken his off to mitigate the New York heat? Is it the aftermath of a passionate but casual encounter, a moment in a bored marriage, or what? We don't know, and aren't meant to know. Hopper's peculiar mix of voyeurism—putting our gaze in the room—and discretion—not revealing what the people are doing or thinking—is the hook in the painting. He offers slices of an insoluble life, moments in a narrative that can have no closure.

Now and then a female figure will erupt into his paintings with blazing, full-out sexuality, like the stripper in *Girlie Show*, 1941, her jutting breasts, red trap of a mouth, and finely turned legs—big solid legs, like those of Reginald Marsh's Coney Island floozies or Robert Crumb's dream girls—reminiscent of the dancers, *grisettes,* and whores that he drew in Paris thirty years before, seen on the other side of an uncrossable space of desire and curiosity. There is an ironic memory of Botticelli in the way she holds her veil. But at such moments Hopper is more like a demotic Watteau, tracing an American *commedia dell'arte* with great respect for its players, not as "stars" but as workers in the mine of illusion. Hopper liked painting seediness and abandonment. He saw it for what it was: a particularly American condition. He spoke of capturing

the look of an asphalt road as it lies in the broiling sun at noon, cars and locomotives lying in Godforsaken railway yards, the steaming summer rain that can fill us with such hopeless boredom, the blank concrete walls and steel constructions of modern industry, midsummer streets with the acrid green of close-cut lawns, the dusty Fords and gilded movies . . . all the sweltering, tawdry life of the American small town, this sad desolation of our suburban landscape.

254. Edward Hopper, *Nighthawks*, 1942. Oil on canvas,
33⅛ × 60″ (84.1 × 152.4 cm). The Art Institute of Chicago;
Friends of American Art Collection.

Nevertheless, the boredom and solitude that afflicted Hopper sometimes transcends itself when it is projected through the human image. It can even lead to a sense of epiphany, as when the blond woman in the open blue robe, her fine breasts taking the morning light like the touch of another hand above her own, appears in the dark doorway of *High Noon,* 1949 (Figure 255), like some secular Madonna drawn from sleep by a distant angelic voice.

Hopper's usual model, however, was his wife Jo Nivinson, a painter herself (though a mediocre one) and a notoriously "difficult" woman, trapped between the role of supportive wife and her own creative ambitions. They fought incessantly for more than thirty years; now and then a sign of this creeps into Hopper's paintings, as in *Four Lane Road,* 1956 (Figure 256), a scene of a rural gas station—bypassed, presumably, by a newer highway—whose owner sits patiently in a folding chair waiting for nonexistent traffic to turn in, while his wife leans from the window hectoring his back. (Are they Hopper and Jo? Did Hopper feel "bypassed" by art history at the end of his life?) Jo Hopper may have been an untamed shrew, and sexually parsimonious, but her husband loved to paint her—with distance observed. Like Bonnard painting his neurasthenic Marthe in the bath, he returns to her again and again, clothed or naked, and most memorably the latter. She is always much the same age. When Hopper painted her in *A Woman in the Sun,* 1961 (Figure 257), Jo was actually seventy, but her body

255. Edward Hopper, *High Noon,* 1949. Oil on canvas, 27½ × 39½" (69.6 × 100.3 cm). The Dayton Art Institute, Dayton, Ohio; gift of Mr. and Mrs. Anthony Haswell, 1971.

256. (above) Edward Hopper, *Four Lane Road*, 1956. Oil on canvas, 27½ × 41½″ (69.9 × 105.4 cm). Private collection.

257. (below) Edward Hopper, *A Woman in the Sun*, 1961. Oil on canvas, 40 × 60″ (101.6 × 152.4 cm). Whitney Museum of American Art, New York; fiftieth anniversary gift of Mr. and Mrs. Albert Hackett in honor of Edith and Lloyd Goodrich.

is that of a lean-shanked fifty-year-old—facing the morning light in their house at Truro, Massachusetts, she reminds you of any number of Renaissance Annunciations, and her shadow seems printed on the floor by a blinding shaft of revelation.

The other outstanding American painter of the 1930s—and after—was Hopper's opposite in almost every way: extroverted, loquacious, witty, and optimistic, with a strong bent toward pictorial journalese that got subsumed under the influence of Cubism. This was Stuart Davis (1894–1964). All the two men had in common was the same early art education in New York, under Robert Henri. Whereas Hopper's parents had no interest in the visual arts, so that he had to make his way against indifference from the start, Davis's father and mother were both artists. His father was art editor of a Philadelphia newspaper and often gave work to members of the Ashcan School early in their careers—Shinn, Sloan, Glackens, and Luks. After the family moved to Newark, near New York, he encouraged his son (then fifteen) to enroll in Henri's school.

What Henri gave young Davis, apart from solid training in drawing and painting, was a taste for the demotic. In Davis's case it stuck, as it did not in Hopper's. Later the artist-journalist's son would describe himself as "a cool Spectator-Reporter at an Arena of Hot Events." He believed art ought to be socially oriented, and with John Sloan's encouragement he drew illustrations for *The Masses*. With other Henri students, he tramped the downtown sidewalks of the Lower East Side and Chinatown, and spent nights in Manhattan and Newark saloons that catered to blacks, thus picking up an early passion for jazz that would be one of the shaping forces in his mature art. "I [was] particularly hep to the jive, for that period, and spent much time listening to the Negro piano players," he would recall.

> About the only thing then available on phonograph records was the Anvil Chorus. Our musical souls craved something a bit more on the solid side and it was necessary to go to the source to dig it. These saloons catered to the poorest Negroes, and outside of beer, a favorite drink was a glass of gin with a cherry in it, which sold for five cents. The pianists were unpaid, playing for love of art alone. In one place the piano was covered on top and sides with barbed wire to discourage lounging or leaning on it. . . . But the big point with us was that in all of these places you could hear the blues, or tin-pan alley tunes turned into real music, for the cost of a five cent beer.
>
> It seems fantastic to think that today I can sit in my centrally-located and centrally-heated studio and hear this kind of music [on the radio] without taking a bus to Newark or Harlem.

At a time when, as we have seen, most white Americans thought jazz was mere jungle music, Stuart Davis, the admirer of such musical greats as Earl Hines and James P. Johnson, saw them as cultural heroes: "At one time or another, in darker mood, I have questioned the possibility of cultural advance in the United States, but on the evidence here presented I guess I must have been wrong."

His first exposure to the European avant-garde came with the Armory Show in 1913, whose impact he compared to that of Henri's teaching: "Both were revolutionary in character, and stood in direct opposition to traditional and academic concepts of art." It was an opposition that Davis would always keep up. He responded particularly to Gauguin, van Gogh, and Matisse: their "objective order" gave him "the same kind of excitement I got from the numerical precisions of the Negro piano players . . . and I resolved that I would quite definitely have to become a 'modern' artist."

The Armory Show made a painter out of the illustrator. Davis's early paintings were imitative, of course; but even when trying on the various jackets of style, he comes across as a virile, decisive young talent; there was nothing hesitant about the broad, sour-colored patterning of clouds and their reflections on shallow water in *Ebb Tide—Provincetown,* 1913. He had gone to Provincetown to paint, supported by illustration work; then, in 1914, he settled in Gloucester, Massachusetts, an old whaling and fishing port which was still full of working schooners. He would spend a good part of every year there until 1934, and his work—through its increasing abstraction—would be suffused with its images: docks and bollards and ships' masts, cranes and loading gear, signal lamps, the big declarative lettering on the side of warehouses, striped buoys, cordage, autos, traffic lights, and gas pumps.

"A work of art," Davis wrote in his notebook in 1922, "should have the following qualities."

It should first of all be impersonal in execution . . . not a seismographic chart of the nervous system at the time of execution. It may be as simple as you please but the elements that go to make it up must be positive and direct. This is the very essence of art that the elements of the medium in which the work is executed have a simple sense-perceptual relationship. The work must be well built, in other words. The subject may be what you please. It may express any of the qualities that man is capable of perceiving or inventing. It can be a statement of character or a statement of pure abstract qualities but in all cases the medium itself must have its own logic.

This is the pure voice of American empirical vision. You can imagine a Philadelphia joiner in 1760 saying much the same thing; or Copley in 1770, talking about his "liny style," with its factual directness and lack of fuss; or Audubon

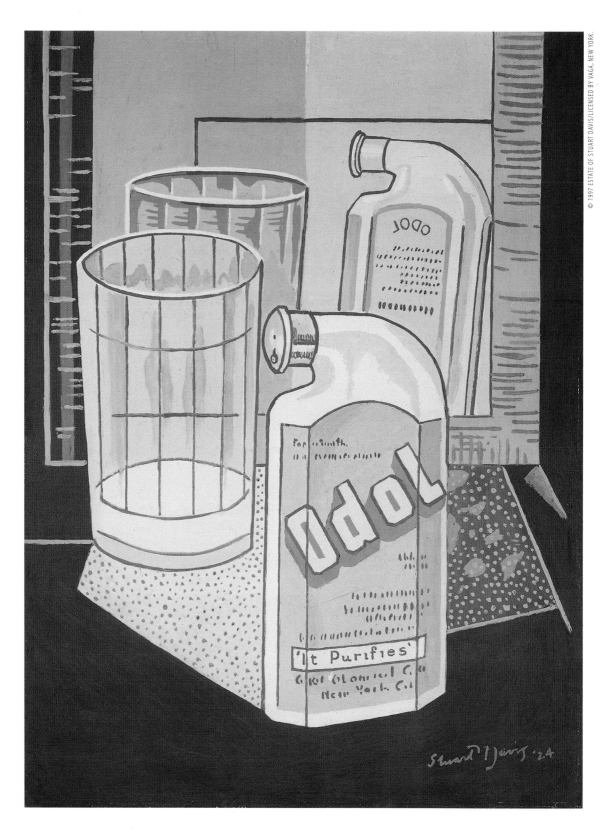

258. Stuart Davis, *Odol*, 1924. Oil on cardboard, 24⁷/₁₆ ×
17⁵/₈″ (62 × 44.7 cm). Cincinnati Art Museum; The Edwin
and Virginia Irwin Memorial.

speaking of how to draw a bird; or Thomas Eakins reflecting on how to get a rower's body rightly situated in a shell moving away, with all the reflections in place.

The difference, however, was that Davis wanted to make this desire work in the context of what he called "abstraction"—not pure abstraction, but a highly formalized approach based on Synthetic Cubism, as he understood it from reproductions and from the works of Fernand Léger he had seen in the Armory Show. Léger and other Cubists had used lettering—bits of newspaper, fragments of signs—in their paintings and collages, but Davis brought to this an especially American brashness, reflecting the landscape of signs that was all around him, and especially packaging; indeed, he was the first American artist since Peto to be aware of the omnipresence of packaging. Packing protects, packaging sells. "Don't emotionalize," Davis told himself. "Copy the nature of the present—photography and advertisements, tobacco cans and bags and tomato labels." Thus *Lucky Strike,* 1921, is a hand-painted (not collaged) version of a tobacco package, opened and flattened out, with all its texts. One of the classics of this phase of Davis's work is *Odol,* 1924 (Figure 258). It is a bottle of mouthwash, frontal though slightly skewed, paired with a faceted glass and reflected in a bathroom mirror. Its slogan, "It Purifies," is as legible as the lettering in a Cubist collage, while the rhyme between the faceted bottle and the fluted glass suggests classicism. In its deadpan factuality, it is the ancestor of all Pop art, done at a time when the Pop artists themselves were not yet born. It also bears an obvious similarity to the cool, impersonal pictures which that gifted dilettante expatriate Gerald Murphy, the original of Dick Diver in F. Scott Fitzgerald's *Tender Is the Night,* was making in France in the 1920s. Murphy's *Razor,* 1924 (Figure 259), is very close to Davis in its direct presentation of the matchbox logo and the Léger-like stylization of the pen and razor crossed, like the bones of a Jolly Roger, underneath; but this can only have been the result of a common admiration for Léger, since Davis and Murphy never met and it is most unlikely that either knew the other's work.

In 1927 Davis started his most radically abstract series of paintings.

259. Gerald Murphy, *Razor,* 1924. Oil on canvas, 32⅝ × 36½" (82.9 × 92.7 cm). Dallas Museum of Art; Foundation for the Arts Collection; gift of the artist.

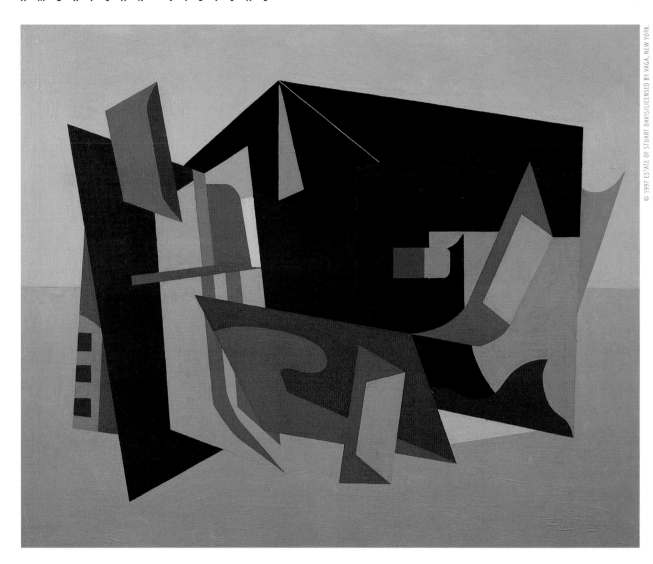

He nailed an eggbeater, a rubber glove, and an electric fan to a table in his studio and painted this still-life arrangement for a year, stripping it down to "an invented series of planes which was interesting." And yet the results were not entirely nonfigurative, though they certainly looked it if one didn't know their origins (Figure 260). Traces of the still-life remain: the fingers of the glove, the cranked handle of the eggbeater, a vertical line that hooks and reminds one of the curved wire on the beater's end. Davis's "eggbeater" paintings have an affinity with the earlier machine pictures of Morton Schamberg and the Dada productions of Marcel Duchamp and Francis Picabia, but the irony and sexual punning

260. Stuart Davis, *Egg Beater No. 1*, 1927. Oil on canvas, 29⅛ × 36″ (74 × 91.4 cm). Whitney Museum of American Art, New York; gift of Gertrude Vanderbilt Whitney.

of the latter is quite absent from them. "My aim," he later remarked in an interview, "was not to establish a self-sufficient [i.e., wholly abstract] system to take the place of the immediate and accidental, but to . . . strip a subject down to the real physical source of its stimulus. So you may say that everything I have done since has been based on that eggbeater idea."

He would do nothing so radical for some years. In 1928 Davis was able to make his one and only trip to Paris. It lasted nine months, and although he luxuriated in the tolerance that modern artists enjoyed in France—so different from the reflexive suspicion shown them in America: even the French customs officials, he discovered, seemed to know what Cubism was—he felt no impulse to "go French" or to stay. In fact, the trip only convinced him of the essential vitality of American subject matter, whose character he would praise in a torrent of images reminiscent of his poetic hero, Walt Whitman, impacting the relatively old and the brashly new:

American wood and iron work of the past; Civil War and skyscraper architecture; the brilliant colors on gasoline stations, chain-store fronts, and taxi-cabs; the music of Bach; synthetic chemistry; the poetry of Rimbaud; fast travel by train, auto and aeroplane which brought new and multiple perspectives; electric signs; the landscape and boats of Gloucester, Mass.; 5 & 10 cent store kitchen utensils; movies and radio; Earl Hines hot piano and Negro jazz music in general. . . . The quality of these things plays a role in determining the character of my paintings. Not in the sense of describing them in graphic images, but by predetermining an analogous dynamics in the design, which becomes a new part of the American environment. Paris School, Abstraction, Escapism? Nope, just Color-Space compositions celebrating the resolution in art of stresses set up by some aspects of the American scene.

He was particularly irked by the continuous complaint, from academic conservatives, "American Scene" artists, and left-wing Social Realists as well, that there was something impure and un-American about the modernist embrace of European styles. America was a melting pot, a nation of immigrants; why shouldn't its art be? "I am as American as any other American painter," he memorably protested. "Over here we are racially English-American, Irish-American, Russian- or Jewish-American—and artistically we are Rembrandt-American and Picasso-American. But since we all live and paint here we are, first of all, American."

Everything about Davis's work—its clarity of form and of ideas, its high spirits and legibility—invited mural scale. But he did not get to paint a mural until 1932, when the designer Donald Deskey asked him to produce one for the men's smoking room at Radio City Music Hall (Figure 261). It is a yo-ho-ho masculine image, appropriately enough; many of its elements (the sea with a yacht on it, the

gas pump on the left, the ship's bell, and the barber's pole) are familiar from his Gloucester dockscapes. It also has a large pack of cigarettes, and a zeppelin-size Havana cigar, the largest in Western art. It was originally called *Men Without Women,* a title with several layers, taken from Ernest Hemingway's 1927 collection of short stories. But then, the smoking room was a threatened all-male precinct too; Davis joked that "the flappers had taken over. Only McSorley's Ale House was left. But they couldn't get into the Men's Room to see my mural."

The most powerful of Davis's surviving murals is *Swing Landscape,* 1938 (Figure 262), done under the auspices of the Works Progress Administration's Federal Art Project for a public housing development in Williamsburg, Brooklyn. Not incidentally, it illustrates the difference between Davis's idea of public art and those of ideologues both on the right and the left in the 1930s. The abstract artist Burgoyne Diller (1906–1965), a young purist follower of Mondrian, was in charge of the FAP and he was determined to give young abstractionists the same access to government commissions that narrative painters had. He reasoned that since many of the dwellers in the Williamsburg project worked in factories anyway, they would not want to come home to a mural of muscular workers

261. Stuart Davis, *Men Without Women,* 1932. Mural in the men's lounge of Radio City Music Hall, New York. Oil on canvas, 128⅞ × 203⅞" (327.2 × 518 cm). The Museum of Modern Art, New York; gift of Radio City Music Hall Corporation.

brandishing monkey wrenches: "Abstract patterns painted in strong vibrant colors would add to the enjoyment of residents." Davis supplied them. *Swing Landscape* is a riotous, almost chaotic frieze in which his passion for finding visual analogues to jazz syncopation gets full play. "It don't mean a thing if it ain't got that swing," he was fond of quoting from Duke Ellington, and here Davis's signs for bridge, cable, girder, funnel, ladder, and buoy jive and flicker in a matrix of all-out color dominated by cobalts and ultramarines, against which his lemon yellows and fuchsias pulse. *Swing Landscape* is a triptych of the port of New York, visible from Williamsburg, thematically related to the site. But it was never installed there, so the workers' reactions to it will never be known.

The creation of the movement known as "Regionalism" was the first full-scale American art-world hype. Its instigator was Maynard Walker, a journalist from Kansas turned art dealer in New York. In 1933 Walker put on a show at the Kansas City Art Institute, some thirty-five paintings under the vague and generic title "American Painting Since Whistler." It contained work by a number of figurative painters who are now all but forgotten—and by three others: Thomas Hart Benton, John Steuart Curry, and Grant Wood. This trio—which had not been thought of as such until then—already had their modest reputations; Benton was well known in New York, Wood had won a large art prize with *Ameri-*

262. Stuart Davis, *Swing Landscape*, 1938. Oil on canvas, 86¾ × 172⅛″ (220.3 × 437.2 cm). Indiana University Art Museum, Bloomington.

can Gothic, and some of Curry's work had been nationally reproduced and purchased by the Whitney Museum. The three men hardly knew one another, and certainly did not, at that time, think of themselves as a "movement." But a statement Walker gave to the magazine *Art Digest* took care of that. Here, Walker announced, was "real American art . . . which really springs from American soil and seeks to interpret American life." If collectors and museums supported it, America would soon have "an indigenous art expression." The Depression had opened people's eyes to the phoniness of the foreign art that collectors had been buying: it was a symptom of the malaise that had laid American prosperity low:

> The complexity and ultra-sophistication of the era just preceding the crash led many to seek only the bizarre and the sensational in art. Unless some absolutely incomprehensible creation was put forth, it failed to be noticed. If in addition the painting was the work of a madman or a drug addict or a carpenter, and could therefore be tagged with the alluring term "naive," it had all the possibilities of success.
>
> But with the crash of 1929 everyone began to look around to see if there were any realities left in the world. The shiploads of rubbish that had just been imported from the School of Paris were found to be just rubbish. The freaks and the interesting boys . . . have lost caste. . . . People have begun to look at pictures with their eyes instead of their ears.

This appeal to bedrock American "values," to xenophobia and Depression anxiety and to the wallets of potential Midwestern collectors, might not have resonated far beyond Kansas City if Walker's catalog introduction had not been picked up by one of *Time* magazine's Midwestern stringers and forwarded to its head office in New York. As it happened, Henry Luce, the founder of *Time,* was interested in art—in a spotty and episodic way. But what particularly interested him was the care and feeding of his favorite journalistic construct: the idea of "The American Century." So when the notion that a whole new nativist art movement was brewing between the Alleghenies and the Rockies was laid before him by a senior editor, his eyebrows—those bushy and much-feared antennae tuned to the *Zeitgeist*—began ominously to waggle. Christmas was coming up, and *Time* liked patriotic or religious subjects for its Christmas covers. Moreover, it had recently got the technical capacity to print four-color inserts. A reporter was dispatched to interview Walker in his lair on Fifty-seventh Street. And so it came to pass that the December 24, 1934, issue of *Time* carried a self-portrait by Thomas Hart Benton on its cover, with a portfolio inside—the first color reproductions of paintings *Time* ever ran—featuring his work, along with paintings by Curry, Wood, Charles Burchfield, and, as a healthy city cousin to these robust sons of the prairie soil, Reginald Marsh. These "earthy Midwesterners," wrote the anonymous *Time*scribe, were restoring American values through their art, in

the face of the "outlandish" foreign import, modernism. Pages of effusive praise, particularly of Benton ("none represents the objectivity and purpose of their school more clearly"), then followed; the presses rolled, and out the glad news went to nearly half a million subscribers. In years to come, the Luce magazines would have fitful, but sometimes considerable, impact on the art world and its market. An article in *Life* would create Jackson Pollock's public reputation overnight. But this was the only time that *Time* ever created an art movement out of more or less thin air. Suddenly, the front page of American visual culture was taken over by Regionalism.

As movements go, it was a disjointed affair. Benton and Wood had never actually met, and Wood was the only one of these stalwart Regionalists who actually lived in the Midwest; Curry lived in a Connecticut artists' colony, and Benton had his studio in New York.

But once the fantasy got going, it took on its own life. It would have had none except for the Depression. The Regionalists' vision of a rural Eden in America had two things in common with all other Edens. It attracted a lot of people, and it didn't exist. It was the kind of image one looks back on with the nostalgia and yearning that, in times of stress, become confused with a sense of history—rather as the wholesome, unconflicted image of America generated by network TV in the 1950s became a "real" but lost America for right-wing fantasists like Newt Gingrich in the mid-1990s. In fact, the Depression devastated rural as well as city life in the 1930s; there were no areas of exemption, as other artists, like John Steinbeck or the photographer Margaret Bourke-White, knew only too well. But the America of *The Grapes of Wrath* or of WPA photodocumentation had very little in common with the Regionalists'. One looked to art for escape; the myth of a lost Eden was an anodyne for people who were dazed and battered by having fallen out of prosperity, or at least comfort, with no safety net.

As Benton himself admitted some years later, "A play was written and a stage erected for us. Grant Wood became the typical Iowa small-towner, John Curry the typical Kansas farmer, and I just an Ozark hillbilly. We accepted our roles."

The one whose role fit him most ambiguously was Grant Wood (1892–1941). Iowa-born, he lived most of his life in his home state.

However, far from being a sturdy son of the soil, Wood was a timid and deeply closeted homosexual. From time to time he would don a pair of denim overalls and lean against a tree for a visiting photographer, but the two main influences on his work had nothing to do with American nationalism. The first was a set of Chinese willow-pattern plates, which his mother had on display in the house in Anamosa, Iowa, where he grew up. Wood never forgot their design—those neatly rounded hills, those clumps of formalized trees and little figures. It permeated his later work, with its child's-world make-believe landscapes, so formal, distanced, and "quaint," as in *Stone City, Iowa,* 1930, a dollhouse view of a tiny village a

few miles from Anamosa (Figure 263), where Wood was presently to set up an artists' commune. In his portrait of three vinegary and implacable Midwestern ladies, *The Daughters of the American Revolution,* one of these provincial Fates is actually holding a willow-pattern teacup in her chicken-claw hand and thus, presumably, standing in for Wood's mother.

The second, which bore on him in adult life—he studied at the Art Institute of Chicago, taught art for a while, and during the 1920s made four trips to Europe—was sixteenth-century Flemish painting, with its meticulous realism, bright palette, and careful suppression of surface texture. He aspired to be the Jan van Eyck of Iowa. Or, rather, that was one of his aims. Wood's idea of the artist's métier was a late-nineteenth-century one, a hangover from the idea of the painter as Renaissance man that had inspired the big names of the Gilded Age and still enjoyed a currency in the American heartland, or provinces, whichever term one preferred: an artist should be able to turn his hand to anything. So he did murals of cornfields for hotels in Cedar Rapids, and stained-glass lunettes for doorways, and Art Nouveau panels, and Adam-style cartouches, and allegories of Freemasonry for the local lodge, and straightforward descriptive portraits of Iowa notables. And then, in the midst of this slow stream of diligent and painstaking craftwork, he stumbled into a sort of immortality.

The most famous house in America, next to the White House itself, is in Eldon, a tiny community of about two thousand people in southern Iowa. It is a smallish wooden-frame affair, carpenter-built without help from an architect in the

263. Grant Wood, *Stone City, Iowa,* 1930. Oil on wood panel, 30¼ × 40″ (76.8 × 101.6 cm). Joslyn Art Museum, Omaha, Nebraska.

early 1880s. It has vertical wooden siding, a projecting veranda, and a simple Gothic window in the gable. Nobody of any distinction, notoriety, or power has ever lived in it, or ever will, since it is now a tourist shrine. There is even a replica of it near Stone City, which saves visitors the trouble of going as far as Eldon. Its fame is owed entirely to Grant Wood, who used it in the background of his painting *American Gothic*, 1930 (Figure 264).

American Gothic, along with the Mona Lisa and Whistler's Mother, is one of the three paintings that every American knows, in reproduction if not in the original. One index of its fame is the number of variations run on it by cartoonists, illustrators, and advertisers over the last forty years. The couple in front of the house have become preppies, yuppies, hippies, Weathermen, pot growers, Ku Kluxers, jocks, operagoers, the Johnsons, the Reagans, the Carters, the Fords, the Nixons, the Clintons, and George Wallace with an elderly black lady: strangely, the only couple who never seem to have been imported into Wood's image for satirical purposes are John and Jackie Kennedy, presumably because their glamour would not fit the hick context. It has been used to advertise a staggering range of products and services, from air freight to whiskey to electronics.

Wood did not imagine that this could happen to his image; who could? What he had meant to make was a version of one of the tintypes from his family album—an icon of Iowan ancestry. He got his sister Nan to pose as the woman, and recruited one B. H. McKeeby, a dentist from Cedar Rapids, as the man. He put each of them in period dress of the 1890s: she with an apron over a black dress with a white collar and a cameo brooch at her neck—the head on the brooch, a goddess's, contrasting sharply with her own plain and worried look; he in stud-fastened collarless shirt, overalls, and black jacket, holding a pitchfork. He is the father defending the virtue of his not very alluring daughter against all comers. The pitchfork, Satan's archetypal tool for tossing souls into eternal fire, becomes the weapon against Satan. It rhymes neatly with the carpenter-Gothic window mullions above, which make the home the church of Virtue. It is also echoed in the seams of his blue overall front—no longer shining, menacing, and phallic, but worn and soft with age.

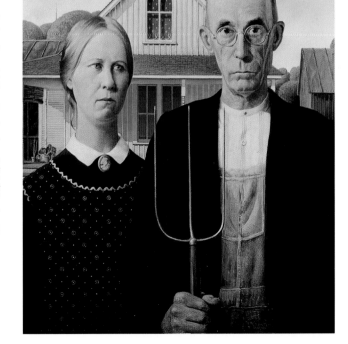

264. Grant Wood, *American Gothic*, 1930. Oil on beaverboard, 29¼ × 24½″ (74.3 × 62.4 cm). The Art Institute of Chicago; Friends of American Art Collection, 1930.

No more consciously constructed picture was ever painted by an American, though this is not a judgment on the esthetic merits of *American Gothic*. Today, one is inclined to see it, like so much of Wood's other work, as an exercise in sly camp, the expression of a gay sensibility so cautious that it can hardly bring itself to mock its objects openly. Was Wood poking a quarter of an inch of fun at the denizens of Iowa and their fetishized values of sobriety, moral vigilance, patriarchy, and the rest? Or was he, as millions of Americans have thought since the painting won a prize in Chicago in 1930 and was catapulted into national fame, actually praising those virtues? The answer, in a sense, is both: a mass audience was intrigued by the image because it couldn't quite decide, just as Grant Wood couldn't quite decide either. Generally, the assumption that *American Gothic* was a satire tends to increase in direct proportion to one's distance eastward from Cedar Rapids. But *ogni dipintore dipinge se*, as Leonardo once remarked: every painter paints himself. Of none is this truer than Grant Wood, who has had *American Gothic* hung around his neck ever since, as Leonardo had the Mona Lisa.

The work of John Steuart Curry (1897–1946) the second of the triad, need not detain us here. Kansas-born and trained under a Russian academic émigré named Basil Schoukaieff in Paris—whose influence would seem to have turned him into an American imitator of the Russian realists of the late nineteenth century led by

265. John Steuart Curry, *Baptism in Kansas*, 1928. Oil on canvas, 40 × 50″ (101.6 × 127 cm). Whitney Museum of American Art, New York; gift of Gertrude Vanderbilt Whitney.

Boris Repin—he was a semicompetent illustrator but an inept and formally incoherent painter, whose attempts at "heroic" art were travesty. Curry is remembered mainly for his scenes of prairie life threatened by disaster—twisters, floods, droughts, mass hysteria—and for one painting especially, *Baptism in Kansas,* 1928 (Figure 265), a scene of Baptist fundamentalists chanting and hollering while a young girl receives total immersion in a trough.

The top dog of Regionalism was, of course, Thomas Hart Benton (1889–1975). No American artist until Andy Warhol understood the art of publicity better: a cantankerous loudmouth brimful of vitality, Benton had an unerring eye for the jugular of the media. He was a dreadful artist most of the time. His work was genuinely popular, in part because of his ability to attract controversy, but mainly because it was bad in the way that popular art can sometimes be: not vulgar in the tasteful, closeted, Puritan-wistful way of an Andrew Wyeth, but "life-enhancing." It was flat-out, lapel-grabbing vulgar, unable to touch a pictorial sensation without pumping it up.

And yet Benton's is a curious case, because despite the energies he invested in attacking modernism as decadent, he actually began as a modernist painter. Born in Neosho, Missouri, to a political family—his father was a U.S. congressman and his granduncle a senator—he studied painting at the Chicago Art Institute and in 1908 left for Paris, where he spent three years. There he fell under the spell, first of Cézanne, and then of the American expatriate painter Stanton Mac-Donald-Wright. Back in New York, he struck up a peripheral relationship with Stieglitz's circle of modernists, though he was never invited to show at 291 and would later bitterly denounce Stieglitz himself as "no intellectual [and] thoroughly ignorant." Since Benton destroyed most of the abstract paintings that he did in imitation of MacDonald-Wright's Synchromism—"to get," he said, "all that modernist dirt out of my system"—they are hard to assess, but the survivors, like *Bubbles,* 1914–17 (Figure 266), leave the impression of an artist doing illustrations of abstraction rather than abstraction itself—a pastiche of MacDonald-Wright's own versions of Robert Delaunay's disks. However, the basic attraction of MacDonald-Wright's work was the hidden figure it often contained—usually a version of a design or sculpture by Michelangelo. What captured Benton's interest, he later wrote,

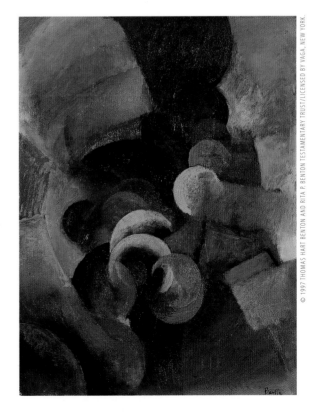

266. Thomas Hart Benton, *Bubbles,* 1914–17. Oil on canvas, 22 × 16½″ (55.9 × 41.9 cm). The Baltimore Museum of Art; gift of H. L. Mencken, Baltimore.

was the Synchromists' use of Baroque rhythms, derived not from Cézanne's work, as was the case with most of the Parisian painters who had experimented with such rhythms, but from the more basic source of Michelangelo's sculpture.

Benton rarely painted without a sculptural basis. Some early Constructivist abstractions he painted in New York around 1917–18 were based on paper, wire, and wood constructions in the round.

Thereafter, while rejecting abstraction, Benton would stress the abstract basis of his compositions, often too much. The scheme of his bulging figures—usually worked out in advance through three-dimensional clay models—was based on the *linea serpentinata*, the twisting line, of sixteenth-century Mannerism. From Michelangelo, and from other Mannerist sources like Luca Cambiaso's block figures and El Greco's posturing saints, Benton assembled a kind of "kinetic" composition in which nothing is at rest, everything strains and heaves against everything else. This incessant surge and flow would have large effects on his pupil, Jackson Pollock, but in Benton's own paintings it mainly produced rhetoric. His ideas about "bulge and hollow," the rhythmical distortion of bone and muscular structure, made his human figures look strangely overdetermined,

like lanky dummies with cartoon faces. Benton's trains lean forward like Walt Disney's as they steam along; the very clouds in his landscapes flex their biceps.

There is a certain irony in the fact that Regionalism, which was promoted as the very expression of American democracy, was the kissing cousin of both the official art of 1930s Russia and that of 1930s Germany. If both Stalinist and National Socialist Realism meant images of rural production, green acres, new tractors, straw-haired children, and sinewy farmers breaking the sod of the homeland, so did the Populist/Capitalist Realism set forth by Benton and other Regionalists. All were arts of idealization and propaganda. In esthetic terms, little that Benton painted in the 1930s (or after) would have seemed out of place in the Moscow subway.

When Benton saw himself on the cover of *Time* at the end of 1934, he realized that he was truly famous. And to clinch his celebrity, he decided to punish New York for not having appreciated him enough. He would leave, and with the loudest possible hullabaloo. It took the form of an attack on the New York scene as a conspiracy of homosexuals. There had been, he wrote in in 1935, a "concentrated flow of aesthetic-minded homosexuals into the various fields of artistic practice." Limp but implacable wrists were everywhere, and they ran everything:

> Far be it from me to raise my hands in any moral horror over the ways and taste of individuals. . . . But it is not all right when, by ingratiation or subtle connivance, precious fairies get into positions of power and judge, buy, and exhibit American pictures on a base of nervous whim and under the sway of those overdelicate refinements of taste characteristic of their kind.

None of this could happen in the Midwest, whose citizens were "highly intolerant of aberration," subjecting the devious queer to "the scrutiny of strong prejudice." So back to Kansas the Michelangelo of Neosho would go, shaking the dust of Sodom from his feet. New York had had it, anyway: the big cities were dead. Only in the heartland could a real and virile American culture arise. And so on, and so forth.

In fact, Benton was not to find the paradise of absolute heterosexuality that he had hoped for in the Midwest. Kansas City's newly founded Nelson-Atkins Museum of Art had just hired as its first director one Paul Gardner, a former dancer in Anna Pavlova's corps de ballet, who loathed Regionalist painting. Perhaps there were as many fairies per capita in Kansas as anywhere else. Was he, like Dorothy, not in Kansas anymore? But he was to turn from such somber reflections to an enormous mural commission, which he began in 1935. It is only one of his mural projects that survives undamaged in its original place.

This was the decoration of the House Lounge in the state capitol of Missouri, in Jefferson City (Figure 267). Its theme was the social history of the state, from

267. Thomas Hart Benton, *Social History of Missouri*, 1935. Mural #1 of the series in the Members' Lounge of the Missouri House of Representatives, Capitol Building, Jefferson City, Missouri.

pioneer times to the present, the whole narrative spreading across four large walls and linked by the image of the Missouri River winding down through space and time. On getting the commission, he went at it with his usual thoroughness, reading voraciously about Missouri history, making innumerable sketches, building a clay model with relief figures twenty inches high and fifteen feet long, having it photographed and then checking the progress of the painting against the photos.

Nowhere else can you get a better sense of the man: his enormous rhetorical energy and equally enormous vulgarity, his worship of the late Renaissance and his cornball humor, his self-confidence and the anxiety that's written all over these huge posturing figures in their buckling space. Once Benton was done, this was no longer a lounge; as one aggrieved legislator complained, you couldn't settle down to a quiet game of cards with Jesse James about to jump off the wall onto your back. The Renaissance fresco the work most resembles—though this can only have been an accident—is Giulio Romano's room with *The Fall of the Giants* in the Palazzo del Té in Mantua; Benton's figures induce the same feeling of ill ease, through their instability. Some Missourians objected to its images, such as a homestead wife wiping her baby's butt with a pad of wool—not the right thing for the high deliberations of government. But they liked his vernacular and the big cast of characters: Huck Finn and his black friend Jim, Davy Crockett, and even Frankie shooting Johnny for doing her wrong. A curiosity of this passage is that Frankie is firing her .44 right up Johnny's backside, as he sprawls in terror over the barroom table. Perhaps only a man who hated gays with Benton's consuming and pathological intensity could have produced such a remarkable image of anal rape, without knowing it.

The color of the murals is tawdrily emphatic, as Benton's usually was, and they show no sense of surface—paint is dry stuff for conveying the message. The rhythmical distortion of bone and muscular structure, transcribed from the clay model, makes his human figures weirdly overdeveloped. Here, in a parody of Michelangelo and El Greco, are the twisting, bulging, overstressed forms of his mature work, mannerisms which would so influence his pupil, Jackson Pollock.

By the mid-thirties the quarrels between Social Realists and Regionalists had come to a full boil. In some respects, the two factions were similar: both rejected European modernism, both claimed to tell the truth about "the people," and both often painted the same subjects. However, their political differences soon became irreconcilable as Communist influence penetrated the art schools, the art clubs, the Artists Union, and the cultural magazines. Doctrinaire Stalinists kept pressuring painters to toe the party line, and after the formation of the Popular Front at the Seventh Congress of the Communist International in 1934, this pressure only increased. The Popular Front called for a general alliance—cultural as well as political—between the USSR and all "progressive" Western democracies

against Fascism. In New York it was easy for leftists to paint Benton and the Regionalists as "Fascist," which they were not—although Benton's attachment to soil and race rather than class, his strident nationalism, and his bullying ways could certainly be painted as "fascistic," and were. And finally, most of the better Social Realist painters were Jews: Jack Levine, Ben Shahn, the brothers Moses and Raphael Soyer. They were only too well aware of Hitler's racial policies, and saw threatening parallels between American Regionalist and Nazi German cultural nationalism. "Yes, paint America, but with your eyes open," Moses Soyer warned his fellow artists:

> Do not glorify Main Street. Paint it as it is—mean, dirty, avaricious. Self glorification is artistic suicide. Witness Nazi Germany.

Perhaps because it was largely the creation of Jews with family histories of oppression and discrimination behind them, and the Depression all around, American Social Realism had almost none of the forced optimism of its Russian relative. It went to the other extreme. It was dyspeptic. It stressed pathos. It showed underdogs and victims. A beaten striker was more pictorial than a winning one, although the twenties and thirties in America saw many a victory for organized labor. Shahn painted the American working class as a bunch of unhappy yeshiva students in blue collars. His workers looked as if three of them together couldn't have lifted one of the sledgehammers that Benton's eupeptic Kansas railroad mechanics tossed around like jackstraws.

As one might expect, the best painters of the time kept their art away from ideology: Edward Hopper because he was a shy conservative who acknowledged no connection between art and politics, and Stuart Davis because he was too smart. "There's nothing like a good solid ivory tower for the production of art," he remarked in 1940. But Davis hadn't always believed this: earlier in his career he was a passionate Marxist, and a supporter of Stalin's policies up to the time of the Hitler-Stalin pact in 1939; he even signed a group declaration of support for the iniquitous Moscow show trials. Nevertheless, Davis rejected Stalinist Socialist Realism, and the wispier American kind too, as "false social content in art." His particular quarrel, though, was with the Regionalists, especially Benton, whom he denounced as a racist for his Negro stereotypes and a proto-Fascist for his animus against "progressive" ideas: "Benton," he scoffed, "should have no trouble in selling his wares to any Fascist or semi-Fascist type of government that might set itself up." And as for the idea that the heartland would become America's cultural center, Davis wrote that "I, too, think great art will come out of the Middle West" (did he really?), "but certainly not on the basis of Benton's presumptions. . . . Regional jingoism and racial chauvinism will not have a place in the great art of the future."

The socially committed left artists who had the most influence in the United States were not American but Mexican: Diego Rivera and, to a lesser extent, David Alfaro Siqueiros and José Clemente Orozco. They led and epitomized a Mexican "national school" which had been called into being after 1920 by an act of government patronage: the socialist president, Alvaro Obregón, had turned endless walls of public buildings over to them, giving them free rein to express the ideals of the Mexican socialist revolution and the events of Mexican history, back to Mayan and Aztec times. In the view of many North Americans, they had created the greatest school of mural painting since the Italian Renaissance, in a country whose art had only been provincial up to then. This seemed a cultural miracle, one that could perhaps be repeated in the United States.

Rivera was by far the most gifted of the three, and in his role as the pictorial voice of the Mexican revolution he was strongly supported by gringo capitalists. In 1930, when he did his fresco cycle of Mexican history in the Palacio de Cortés in Cuernavaca—a work which made no bones about his Communist sympathies—his $12,000 fee was paid by Dwight Morrow, the U.S. Ambassador to Mexico and Charles Lindbergh's father-in-law. In 1931 Abby Aldrich Rockefeller, one of the founders of the Museum of Modern Art and the wife of the man who was synonymous with American capitalism, John D. Rockefeller, Jr., bought Rivera's sketchbook of the 1928 May Day parade in Moscow. In 1932 Edsel Ford, inheritor of the vast River Rouge auto plant in Detroit, commissioned a cycle of Rivera frescoes for the garden court of the Detroit Institute of Arts, which are Rivera's principal surviving work on North American soil. And then, in 1933, he began work on what would have been his largest job of all in the United States: a three-wall fresco covering some 1,100 square feet of the lobby of the RCA Building, in New York's Rockefeller Center, the most conspicuous throne and emblem of capitalist power in all America. It was commissioned by the Rockefeller family: the young Nelson Rockefeller dealt directly with Rivera, on behalf of the rest of the clan; and the person who chose Rivera for the task was Abby Aldrich Rockefeller, with the enthusiastic encouragement of Alfred Barr, the director of "her" new Museum of Modern Art. The title of the work—the kind of title that nobody today could affix with a straight face to any work of art—was *Man at the Crossroads Looking with Hope and High Vision to the Choosing of a Better Future.*

It was meant to be one of three major murals by foreign artists in the hall. The other two—the Rockefellers hoped—would be by Matisse and Picasso. But Matisse was not interested (he didn't want his work shown in the bustle of an office building entrance, however large, where people would not be in a calm and reflective state of mind) and the architect Raymond Hood, dispatched to Paris, reported crestfallen that Picasso was simply unfindable. Just as well, perhaps: it is hard to imagine how the cocreator of Cubism would have dealt with the subject

the Rockefeller Center committee wanted him to tackle: "Man's Ultimate Destiny Depends on His Acceptance of Lessons Taught Him Close on Two Thousand Years Ago." So instead the commissions went to the ultrafashionable Catalan muralist José María Sert and to the English artist Frank Brangwyn—and to Rivera, who was expected to produce a monumental image reconciling Capital and Labor in this time of economic misery, industrial unrest, and Red scares. The sight of the world's richest oil family hiring one of the world's most famous Trotskyites to paint for them would, at the very least, act as a sign of good intentions. But since neither Rivera nor the Rockefellers were apt to do anything in a small way, it produced the stormiest and most grotesque fiasco in the history of American patronage.

Rivera described his iconographic plan for the mural in a statement to the committee in charge of Rockefeller Center's decorative program:

> At the center, Man is expressed in his triple aspect—the Peasant who develops from the Earth the products which are the origin and base of all the riches of mankind, the Worker of the cities who transforms and distributes the raw materials given by the Earth, and the Soldier who, under the Ethical Force that produces martyrs in religions and wars, represents Sacrifice. Man, represented by these three figures, looks with uncertainty and hope towards a future more complete balance between the Technical and Ethical Development of Mankind necessary to a New, more Humane and Logical Order.

Nobody could have detected the germs of controversy in this flurry of vague generalizations and symbolic abstractions, and the scheme was passed. No one asked whether Rivera's frequently avowed Marxism might affect the look or content of the fresco. Mrs. Rockefeller was interested in art, not politics, and nobody was going to gainsay her personal interest in the great Mexican. Up went the scaffolding, and Rivera went to work with his assistants in March 1933.

Before long it became apparent to the suits at Rockefeller Center that something odd was happening in the lobby. Sandwiched in between the massive forms of a dynamo and a pair of cosmographical ellipses full of stars and planets were some distinctly capital-unfriendly images: poison-gas warfare, mounted cops glaring suspiciously at marching workers, gaudy bourgeois women playing cards in a nightclub, the walls of the Kremlin, Lenin's tomb. And then, shortly before the grand unveiling of the mural scheduled for May 1, 1933, the unmistakable cannonball head and ace-of-spades beard of Vladimir Ilyich Lenin appeared on the right (Figure 268).

Nelson Rockefeller took (one surmises) a deep breath and dictated a diplomatic letter to his wayward artist. "Viewing the progress of your thrilling mural," it read,

I noticed that in the most recent portion of the painting you had included a portrait of Lenin.

This piece is beautifully painted, but it seems to me that his portrait appearing in this mural might very easily offend a great many people. . . . As much as I dislike to do so I am afraid we must ask you to substitute the face of some man where Lenin's head now appears.

This mild response (imagine, by contrast, the reaction of a seventeenth-century cardinal to some painter's inclusion of Luther among the saints in heaven—racks, pincers, excommunication, anathema) was countered by Rivera. Lenin must stay, but he would replace the card-playing women with a set of American heroes and heroines: Abraham Lincoln, Nat Turner, Harriet Beecher Stowe.

The Rockefellers would not accept this. They feared that if Lenin stayed on the wall, their partners in the financial structure of Rockefeller Center might pull out in a huff—and the whole Rockefeller Center project would collapse. Rivera had no room to maneuver either. Behind him now stood a crowd of left-wing artists and ideologues of all stripes, egging him on to defy the Moloch of capital—while

orthodox Stalinists attacked him on the flank for pandering to Rockefeller in the first place.

Something had to give. It was the wall. Two weeks after Nelson Rockefeller's letter, police sealed off the lobby of the RCA Building. Rivera was brought down from the scaffold, given a check for the full amount of his commission, and escorted from the building. Apart from some mural panels in the Communist-run New Workers' School in New York, this was the last effort he would make to bring a socialist vision to the *norteamericanos*. Six months later, amid much protest and resentment, Nelson Rockefeller ordered in the masons to hammer the plaster and the incomplete fresco from the walls of the RCA lobby, an act of vandalism to which, probably, there was no alternative.

During the Depression the American art market, modest as it was for living

268. Diego Rivera, head of Lenin from the Rockefeller Center mural, later destroyed.

artists, collapsed; some painters, like Edward Hopper, continued to make a living, but even for them things were precarious. No areas of culture were immune to the slump. As well as artists, tens of thousands of writers, actors, and musicians were thrown out of work. Franklin Roosevelt's New Deal had committed itself to creating relief work programs for all kinds of American workers. American history had no precedent for this, and it was bitterly criticized by the right. Now the architects of the New Deal did something that struck conservatives as even more bizarre, verging on frivolity. They decided to treat members of the creative professions as workers, and create relief systems for them. No presidency had ever accorded the artist or the writer the simple dignity of being classed as a productive worker, someone with an actual and worthwhile role in society. None would again.

The idea came from a friend of Franklin Roosevelt's, George Biddle, who wrote to the President in May 1933 urging government support for public mural painting. Biddle dilated on the success of the Mexicans, working "at plumber's wages" to create an epic national style, and added that

> the younger artists of America are conscious as they have never been of the social revolution that our country and civilization are going through; and they would be eager to express those ideals in a permanent art form if they were given the government's cooperation. They would be contributing to and expressing in living monuments the social ideals that you are struggling to achieve. And I am convinced that our mural art with a little impetus can soon result, for the first time in our history, in a vital national expression.

Seduced by this promise of "living monuments" to his own policies, Roosevelt laid on that "little impetus." It took the form of a six-month program called the Public Works of Art Project (PWAP); 3,750 artists were funded to create 15,660 works, 700 of which were murals. This was nothing if not democratic, and the Democrats—Republicans were more skeptical—judged the PWAP a complete success. And so a newer and larger project succeeded it. The new branch of the Works Progress Administration known as Federal Project Number One was set up in 1935 and lasted until 1943. It had four divisions, each with its own director: music under Nikolai Sokoloff; the Federal Theatre Project under Hallie Flanagan; the Federal Writers' Project led by a former journalist, Henry Alsberg; and the Federal Art Project (FAP) run by Holger Cahill. They distributed workfare, not welfare. Thus one of the enduring results of the Federal Writers' Project was a series of guidebooks to America, state by state, bringing together historians, cartographers, archaeologists, photographers, and writers of all kinds; the ones that were finished, like the WPA Guides to New York and to Illinois, remain unsurpassed sixty years later. The Federal Art Project was not a relief project but

a system of government commissioning: no artists were paid until their designs were accepted. It was therefore quite unlike today's National Endowment for the Arts, which gives grants to artists and groups to encourage the creation of works which the federal government does not then own. In the eight years of its existence, the FAP employed some five thousand artists, who created 108,000 easel paintings, 18,000 pieces of sculpture, 11,300 original prints, and 2,500 murals for offices, schools, libraries, and other government buildings. In the easel painting division, once a painter had shown an examining board he was competent and in need of support, he was put on a salary of twenty-three dollars a week—"plumber's wages"—and turned loose to paint whatever he wanted, however he chose, in his own studio, turning in new work every four to eight weeks. It would then be taken for public exhibition and the decoration of public buildings. The mural division was more closely controlled: the artist had to satisfy a committee on matters of style and content, submitting sketches every step of the way.

How can one make any assessment of the success of the FAP? At the very least it gave a lot of artists work, food, and a degree of freedom and dignity within the imploded work ethic of Depression America. Some of those artists—Jackson Pol-

269. James Brooks, *History of Flight,* c. 1935. Marine Air Terminal, La Guardia Airport, New York City.

lock, Philip Guston, Arshile Gorky—were to be of great significance to American art in the years ahead, and some of their careers could have been lost without the FAP's spartan encouragement. It helped—somewhat, and unevenly—to bring about some understanding between artists and people in other jobs, métiers, and walks of life. It promoted solidarity among the artists themselves, or at least within groups of artists; but it did nothing to tone down the often rancorous dislike between Social Realists, Regionalists, and "abstractionists." On the debit side was the large, unwieldy cultural bureaucracy it created, and the abysmal quality of most of the thousands of works of art it sponsored.

This was, in part, built into the numbers: neither in the 1930s nor at any time before or since have there been five thousand artists in America worth encouraging. It also resulted from the worthily democratic but esthetically unproductive desire to use regional artists in their own regions, which all but guaranteed deserts of mediocrity. But most of all, bias was inherent in the system: the FAP was loaded toward Regionalism, and against any kind of abstraction, however mild. That greater abstraction, the American public, was assumed to want recognizable images of its own place, history, and folkways. As Holger Cahill, the Federal Art Project's national director, put it, Regionalism

brought the artist closer to the interests of a public which needs him, and which is now learning to understand him. And it has made the artist more responsive to the inspiration of the country, and through this the artist is bringing every aspect of American life into the currency of art.

Yet there were areas of exemption from this—mainly in New York, which during the thirties maintained its position as the center of American art, whatever the pictorial cornhuskers might say. There, the regional director of the Federal Art Project was an abstract artist, Burgoyne Diller, who based his work on Constructivism and had been a student of Hans Hofmann's at the Art Students League. For the Williamsburg housing project in Brooklyn, Diller commissioned murals, reliefs, and freestanding pieces not only by Stuart Davis (see Figure 262, page 437) but by such abstract or semiabstract artists as Ilya Bolotowsky, Willem de Kooning, Byron Browne, and Balcomb Greene. Arshile Gorky got to do a large mural for Newark Airport, *Aviation: Evolution of Forms under Aerodynamic Limitations*, long since destroyed. One work sponsored by Diller that has survived is in the circular hall of the Marine Air Terminal at La Guardia Airport: James Brooks's *History of Flight*, a cyclorama tracing man's efforts to fly from Daedalus and Icarus, through Leonardo, and so on to the Wright Brothers, its scenes interspersed with abstracted images of propellers, instruments, and engine cowlings (Figure 269). Almost unbelievably, it became the subject of an *enquête* by witch-hunting politicians in the early 1950s; these Republican extremists be-

lieved they had found evidence of Marxist sympathies in it, and the whole mural was effaced with white paint. Fortunately, this coating was removed thirty-five years later, leaving the design no worse for wear.

Many of the WPA murals have decayed, been demolished, or got lost; and of the survivors, few are of much esthetic (as distinct from historical) interest. Indeed, it may be that the most powerful American work of art produced under the auspices of social commitment in the 1930s and 1940s was not a mural at all, but a narrative series of sixty small paintings, done on store-bought panels through 1941 by an African-American artist, Jacob Lawrence (b. 1917). At twenty-three, he was too young for the WPA, "too young," in his later words, "for a wall." His work was called the *The Migration of the Negro,* later retitled *The Migration Series.*

Its subject was huge, and probably only a black artist could have handled it with the depth of feeling it required. The migration of blacks from the rural South to the industrial North of America in the first decades of the twentieth century was the biggest internal migration in American history and, in the words of Henry Louis Gates, Jr., "the largest movement of black bodies since slavery." It involved at least a million people—due to defects in the records, the number will never be known. It went largely uncommemorated, except by historians and sociologists. No novel, in or out of the African-American tradition, has handled it on the scale it deserved—it provoked no black equivalent, for instance, of *The Grapes of Wrath,* and although Richard Wright's *Native Son* dealt with a part of its aftermath in Chicago, there was no fictional work to match the drama of the migration itself. No monuments commemorate it, no documentary films were made about it. Lawrence simply picked up the subject and made it his own.

The Great Migration had an epic character—a collective Odyssey to match the Iliad of the Civil War. It was forced by the merciless Southern white reaction that came in the wake of Reconstruction, plunging the black population of the Southern states—all poor, and nearly all rural workers—into a purgatory of abrogated rights. In the South, the years 1900–25 brought the high tide of Jim Crow laws, of lynchings, and the unrestrained terrorism of the Ku Klux Klan. Moreover, most of the work available to "free" blacks depended on the cotton industry; and the invention of cotton-picking machines knocked the bottom out of their labor market. Deprived of work, unable to vote, and powerless to change their political status, Southern blacks voted with their feet and started flocking to the Midatlantic, Northeastern, and Midwestern cities, repeating en masse the old perilous journey on the abolitionists' Underground Railroad, north out of bondage in the nineteenth century. They were looking for a better America than they had known—not a hard one to find, one might have thought; except that racism and unemployment were also endemic in Chicago, Boston, and New York. Those who imagined they were heading for the Promised Land were

sharply disappointed, especially after 1929, when they arrived in a North economically devastated by the Depression, with little work and less chance of finding any. In "Po' Boy Blues," 1932, the black poet Langston Hughes put words in the mouth of the migrants caught between two worlds:

> When I was home de
> Sunshine seemed like gold.
> When I was home de
> Sunshine seemed like gold.
> Since I come up North de
> Whole damn world's turned cold.

But there was no way back. Thus the South was drained of its black proletariat, while the North acquired a new one, out of which grew a radically altered conception of black culture in America: distinctively urban, but still Southern in its origins and collective memory. This was the culture whose synthesis, in New York, produced the Harlem Renaissance; and through it, American blacks reinvented themselves.

Lawrence was one of them. Born in Atlantic City, he spent part of his childhood in Pennsylvania and then, after his parents split up in 1924, he went with his mother and siblings to New York, settling in Harlem. When years later he told an interviewer that "I am the black community," he was neither boasting nor kidding. He had none of the alienation from Harlem that was felt by some other black artists of the 1930s, like the expatriate William Johnson.

He trained as a painter at the Harlem Art Workshop, inside the New York Public Library's 135th Street branch. Younger than the artists and writers who took part in the Harlem Renaissance of the 1920s, Lawrence was also at an angle to them: he was not interested in the kind of idealized, fake-primitive images of blacks—the Noble Negroes in Art Deco guise—that tended to be produced as an antidote to the toxic racist stereotypes with which white popular culture had flooded America since Reconstruction. Nevertheless, he gained self-confidence from the Harlem cultural milieu—in particular, from the art critic Alain Locke, a Harvard-trained esthete (and America's first black Rhodes scholar) who believed strongly in the possibility of an art created by blacks which could speak explicitly to African-Americans and still embody the values, and self-critical powers, of modernism. Or, in Locke's own words, "There is in truly great art no essential conflict between racial or national traits and universal human values." This would not sit well with today's American cultural separatists who trumpet about the incompatibility of American experiences—"It's a black thing, you wouldn't understand"—but it was vital to Lawrence's own growth as an artist. Locke perceived the importance of the Great Migration, not just as an economic event but

as a cultural one, in which countless blacks took over the control of their own lives, which had been denied them in the South:

> With each successive wave of it, the movement of the Negro migrant becomes more and more like that of the European waves at their crests, a mass movement towards the larger and more democratic chance—in the Negro's case a deliberate flight not only from countryside to city, *but from mediaeval America to modern.*

To narrate it, then, would require a modern language, a deep immersion in the experience, and an awareness of the harsh toll that contact with American modernity exacted on the blacks. From childhood, Lawrence had been steeped in family and community stories of the Migration, and when—encouraged by Locke—he decided to paint it, he worked hard to get the historical background right. Months of painstaking research in the Schomburg Collection of the Public Library, New York's chief archive on African-American life and history, followed—even though the finished paintings rarely allude to specific historical events. He took on the task with a youthful earnestness that remains one of the most touching aspects of the final work, and goes beyond mere self-expression. As a result, you sense that something is speaking *through* Lawrence—a collectivity.

The series is notable for the language it does *not* use. Lawrence was not a propagandist. He eschewed the caricatural apparatus of Popular Front Social Realism, then at its high tide in America. Considering the violence and pathos of so much of his subject matter—prisons, deserted villages, city slums, race riots, labor camps—his images are restrained, and all the more piercing for their lack of bombast. When he painted a lynching, for instance, he left out the dangling body and the jeering crowd: there is only bare earth, a branch, an empty noose, and the huddled lump of a grieving woman. He set aside the influence of Rivera and the Mexican muralists, which lay so heavily on other artists; he wasn't painting murals, but images closer in size to single pages, no more than eighteen inches by twelve. Nevertheless, he imagined the paintings as integrally connected—a single work of art, no less unified than a mural, but portable. *Migration* is a visual ballad, each image a stanza—compressed, like the blues, to the minimum needs of narration. Number 10, *"They were very poor"* (Figure 270), pares the elements of a black sharecropper's life down to the least common denominator: a man and a woman staring at empty bowls on a bare brown plane, an empty basket hung on the wall by an enormous nail—the sort of nail you imagine in a crucifixion. There isn't a trace of the sentimentality that coats Picasso's Blue Period, or the work of most American Social Realists.

Lawrence called his style "dynamic cubism," though it wasn't notably dynamic, except when he used flamelike forms and pushy oppositions of structure;

270. Jacob Lawrence, *The Migration Series*, Panel No. 10: *"They were very poor,"* 1940–41 (text and title revised by the artist, 1993). Tempera on gesso on composition board, 12 × 18″ (30.5 × 45.7 cm). The Museum of Modern Art, New York; gift of Mrs. David M. Levy.

generally the paintings tend to an Egyptian stillness, friezelike even when you know the subject was moving. His debts to Cubism and to Matisse are obvious: the flat, sharp overlaps of form, the reliance on silhouette, and a high degree of abstraction in the color. But there is something more demotic behind those colors. They came, as Lawrence acknowledged, more from his experience in Harlem than from other art:

> In order to add something to their lives, [black families] decorated their tenements and their homes in all of these colors. I've been asked, is anyone in my family artistically inclined? I've always felt ashamed of my response and I always said no, not realizing that my artistic sensibility came from this ambiance. . . . It's only in retrospect that I realized I was surrounded by art. You'd walk Seventh Avenue and look in the windows and you'd see all these colors in the depths of the depression. All these colors.

The memory of them is plain in Number 57, *"The female worker was also one of the last groups to leave the South"* (Figure 240, page 402), with its single figure of a laundress in a white smock, stirring a vat of fabrics—blue, black, yellow, pink—with her pole: a dense and well-locked composition, suggesting the permanence and resistance which is one of the underlying themes of Lawrence's series.

. . .

However, neither painting nor sculpture supplied America with what one now thinks of as the typical form of the Depression era. Industrial designers did, and it was the "streamlined" shape. Streamlining was loaded with symbolism; it promised an end to friction, social as well as mechanical. Amid the miseries of the Depression—the sense of being stuck in a hopeless economic jam, of tension, friction, social overheating, collision—the streamlined object displayed an iconography of effortlessness and control. The desire for this lay deep in the psyches of the designers, one of whom, Walter Teague, remarked that "it is not surprising that we all came to approximately the same conclusions, adopted the same methods; because those who did not, simply did not last." Raymond Loewy found the American environment a continuous irritation: he felt harassed by ugly things, from vibrating machines to leaky ballpoint pens; America gave an impression of "massiveness and coarseness." The emblematic form of the teardrop was a "magic bullet" that could kill the amorphous beast of economic and spiritual stagnation. Raymond Loewy's chrome teardrop pencil sharpener, though screwed down to the desk, looked ready to blast off through the window at 600 mph, like Buck Rogers's spaceship. It said: Escape with me to Utopia! The motto of the 1933 Chicago Century of Progress Exposition was "See America Streamlined!" affirming what everyone desired—that America would get on the move again, going faster than ever. "Speed," wrote the designer Norman Bel Geddes in 1932, "is the cry of our era, and greater speed one of the goals of tomorrow." This, in design, translated into virtual speed, not actual miles per hour.

When times are bad, some Americans idealize the past—as fans of Regionalist painting did. But more Americans were idealizing the future, through the medium of hopeful packaging based on streamlines. Yet the streamlined object was Janus-faced. It declared the phallic yearning for a thrust into the future. But the teardrop and the pod were also womb symbols; their promise of enclosure, their denial of friction, expressed a wish for protection and stasis, for a managed society—the "womb with a view" which, Cyril Connolly wrote, was modern man's desire.

The imagery of streamlining may seem a little naïve to us today, but it was enormously powerful and persuasive. Never before had American consumer objects been so swathed and caressed by a general styling envelope. It was the creation of designers, not painters.

These product designers were the most influential visual arts practitioners of the time. In the thirties American designers as a group began to be treated as stars: they created the need for themselves, convincing industrial management that goods could not move without new packages and envelopes keyed to an overarching esthetic, a "total look" which promised relief from the dispiriting present in the Future. As one publicist put it in 1931, "To put up a well-designed

271. Gordon Buehrig for the Auburn Automobile Company, 1936 Cord 810 Westchester Sedan, conceived and introduced autumn 1935. Auburn Cord Duesenberg Museum, Auburn, Indiana.

front is to put up a brave front and is . . . one of the ways to beat Old Man Depression." The rise of the industrial designer paralleled that of the advertising agency; the work of both went hand in hand, for the same purposes. The aim was to create products that were self-advertising, and struck an eloquent balance between function and fantasy. Fantasy *became* function, and vice versa.

The chief constellation of designers was Norman Bel Geddes, Walter Teague, Raymond Loewy, and Henry Dreyfus: all exceptionally gifted men, and some with the attributes of genius, who created the industrial, mass-market, American form of Art Deco. They were the American equivalent of the French *ensembliers* of the 1920s, but with important differences. To begin with, none of the Americans had come out of a craft tradition. They emerged from either advertising or theater set design, or a mix of both. Bel Geddes and Dreyfus began as theater designers; Teague and Loewy, as advertising illustrators. Illusion and spectacle, and the creation of mass desire, were wired into them and affected all they did.

French Art Deco was a luxury style, intensely elitist both in its market and its materials, the product of exacting handwork. Its materials were macassar wood and palisander, gilded bronze, sharkskin, ivory, crystal, and rare types of stone. Its imagery tended to be timeless and pastoral, or else hieratic. Its aim was sumptuousness, and in this it was not so different from the work of the great *ébénistes* of the eighteenth century, men like Roentgen or Riesener.

American Art Deco, by contrast, was industrial and based on the mass-produced unit. It was made of chrome, stainless steel, Monel Metal and injection-molded plastics. It promised efficiency rather than luxury, and it was geared to the primacy of the machine as generator of esthetic form. This did not mean that the objects looked like familiar machines. On the contrary; the aim was to disguise the distinct complexity of parts, hood them, enclose them in fairings and pods. Machine Deco favored the teardrop, the long hard edge and the sheer surface, and it took its metaphors from aviation.

A quintessential example was Gordon Buehrig's design for the 1936 Cord 810 Westchester Sedan (Figure 271), still one of the most beautiful cars ever to hit the

road. Instead of the conventional radiator grille, which suggested a static flat façade (that of the Rolls-Royce, the polar opposite of the Cord, was actually based on the front of a Greek temple), the Cord had wraparound louvers that faired the nose effortlessly into the body. Its pop-up headlamps were based on the retractable landing lights of aircraft. Every part of the body shell was designed for maximum flow. It is doubtful whether, at the Cord's top speed of 100 mph or so, the streamlining made the least difference in its performance or fuel consumption. But it was immensely sexy in its own right, and made the driver feel like a pilot. A less successful, cheaper attempt at the same effect was the 1934 Chrysler Airflow, whose body—in profile—was like a thick airfoil, with a curv-

272. "Double Zephyr" streamlined trains.

ing grille and flush headlights. "The automobile world learns from aviation," declared Chrysler's ad copy. But the Airflow never took off: it looked clunky and turtlelike rather than birdlike, and sold poorly.

The streamlined form that everyone knew, at first, was the Goodyear blimp, serenely drifting overhead, aloof from earthly concerns. Perhaps that very aloofness deprived it of immediacy for the American public; in any case, the machine that really introduced streamlining and made it popular was the train. Railroads were badly hit by the Depression, and by 1930 three-quarters of passenger traffic between American cities was going by car, with another 5 percent by bus. How to recapture the once powerful mystique of the passenger train? The answer lay in the "streamliner," locomotives and carriages of such aggressive modernity that they would provoke wonder and curiosity (Figure 272).

The biggest presentation of industrial design as total social styling was the 1939 World's Fair in New York. It was the realization of Franklin D. Roosevelt's prophecy that "in the future we are going to think less about the producer and more about the consumer"—but it was staged, of course, by the producers themselves, and became a solemn High Mass of American corporate industry, at which General Motors officiated. From a stinking morass on the edge of Flushing Bay, the Future arose at the behest of New York's megaplanner, Robert Moses: six million cubic yards of ash and treated garbage became fill for the largest land-reclamation project ever tried on the Eastern Seaboard of America, and on it was built the cathedral of consumer engineering, a fantasy world whose motto was "Tomorrow, now!"

The Fair's logo complex, its "theme center," was the Trylon and Perisphere, designed by Wallace Harrison (Figure 273). The Trylon was an obelisk, triangular in cross section, rising seven hundred feet into the air; the Perisphere, a globe two hundred feet in diameter floating over a pool, was linked to it by a sweeping spiral ramp, the Helicline. The Trylon symbolized flight into the Future, the Perisphere benign social control—the big womb—and both were white. Inside the Perisphere, one looked down from

273. Wallace Harrison, Trylon and Perisphere, New York World's Fair, 1939. Museum of the City of New York.

one of two platforms rotating in opposite directions on rings around the "equa-tor" of the globe, and saw below you the Fair's chief theme: Democracity, a huge model of an ideal future metropolis designed by Henry Dreyfus. Sired by Le Cor-busier's *ville radieuse* on Ebenezer Howard's theory of the "Garden City," and of course designed without reference to any existing community, Democracity of-fered an abstract and authoritarian scheme of a frictionless society, closed to growth or change, in which all places were assigned.

So they were, too, in the Fair itself; the designers strove to eliminate random crowd movement by means of moving platforms, conveyors, and ramps; you did not "explore" the exhibits, you were carried past them, "following the line of least resistance just as water does," Teague wrote. The Fair was the largest essay in crowd control and the processing of real-time response to images as yet car-ried out in America, and in due course it would become the prototype for later, larger, and even more authoritarian sites like Disneyland—a factory for the man-ufacture of one-level meaning and the repression of imagination.

The single biggest hit of the 1939 World's Fair was, however, Futurama: the General Motors exhibit, built at a cost of $8 million to the design of Norman Bel Geddes. So obvious was its people-processing role that one architecture critic compared its "strange power" to "some vast carburetor, sucking in the crowd by fascination into its feeding tubes, carrying the people through the prescribed route, and finally whirling them out"—a striking image of subjugation to the Machine.

The theme of Futurama was America in 1960. Ensconced in twenty-four-seat rubber-tired trains, visitors were carried on a 1,600-foot ride, simulating an air-plane flight across a miniature America seen below through a glass wall. The dio-ramas included a million trees, half a million buildings, and fifty thousand streamlined cars—all future GM models, of course, with ten thousand of them moving on the highways. After this "flight," they moved past two larger-scale simulations: a City of Tomorrow, with high-rise glass towers and greenspace and all Corbusian mod. cons., and a large-scale ten-lane superhighway system, promising "safety . . . with speed!" with the model cars whizzing between up-curved barrier walls, safe distance maintained by automatic radio systems. Ged-des's obsessive emphasis on flow and predetermined safety enraptured its visitors: here, at last, was the safety net that benign megaplanning and the hand of Big Business would rig beneath a Depression-battered society.

It was only a metaphor, of course. Geddes hoped that his Utopian dreams might be extended into real city and highway construction, but they never were. What was good for General Motors might be good for America, but GM was in the business of making and selling cars, not reconstructing the environment in which they were piling up.

The ideal of "total design" could no more outlast the Depression than the at-

tractions of Roosevelt's New Deal itself. As soon as American business and real estate development recovered, they reasserted their competitive babel, the war of all against all, under whose sign all notions of general planning for a common good dreamed up by designers became meaningless. The utter unreality of the World's Fair, staged at the very moment that Europe was plunging into the most destructive war in human history—a war which, two years later, America would enter—was summed up in the earnest vaporings of Grover Whalen, the World's Fair president, in the official guidebook to the Fair. It proved, he wrote,

> the immediate necessity of enlightened and harmonious cooperation to preserve and save the best of our modern civilization. We seek to achieve orderly progress in a world of peace; and towards this end many competent critics have already achieved marked progress.

Admiral Yamamoto, leading the attack on Pearl Harbor in 1941, saved America from the Depression and made it rich again by bringing it into the war. For every shell Krupp and Mitsubishi fired, General Motors fired twenty back. Meanwhile, the idea of a planned society was not looking so good to Americans, with the frightful Utopian planning of Nazism before them. Better the chaos of democracy than the streamlined order of the Nuremberg rallies. No more Futuramas, therefore; Levittown would be next, and the suburbs, and the sprawl. Instead of teardrop cars, American designers would be doing Jeeps and situation maps for the warroom. American artists—for whom no role had ever been reserved in the drama of megaplanning—came into the 1940s more isolated, more alienated, than they had ever been. But this disconnection was also the background to the birth of the New York School, in which American art, for the first time, would achieve full imperial status.

8

THE EMPIRE OF SIGNS

America went into World War II late, as one power among several. It came out of it, in 1945, as a superpower, the good half of a Manichaean universe whose evil half was Soviet Russia. And from then on it accumulated the greatest arsenal the world had ever seen, an ever-expanding mass of hardware whose growth was driven by the Cold War. Part of it sits on a square of flat desert outside Phoenix, Arizona, six miles on a side, fenced off, guarded, and closed to the public. The place is known as AMARC, an acronym for American Military Aircraft Recycling Center. It is a colossal dump into which billions upon billions of tax money have been poured. Thousands of obsolete aircraft stretch on all sides in rows, as far as the eye can see, reminding you of the myriads of mummified ibises that were buried with Egyptian pharaohs, as the Cold War itself has now been buried: F-111s, F-15s, helicopters, transports, and all of the Strategic Air Command's B-52 fleet.

The B-52s are parked in rows, their drooping wingtips supported by rough wooden trestles. The huge bomb-bay doors gape; instead of H-bombs, desert doves nest in them and fly whirring out in flocks as you approach. At specified intervals, in accordance with a treaty with the Russians, a jib crane will roll up to one of these aircraft and raise a three-ton guillotine blade. It is dropped, chopping the B-52 up as a butcher cuts up a chicken. The dismemberment is watched by a geosynchronous Russian satellite, far above.

This graveyard is one of the archaeological sites of a culture of grandeur, self-confidence, and almost unbelievable abundance, but also of self-doubt and paranoia: a culture that turned imperial. The sense of empire extended to everything, including American culture, which circled the world. In the 1950s and 1960s Americans came to believe in the supremacy of their art. By the seventies it was taken for granted that New York was the center of the art world, as Paris had

274. Robert Rauschenberg, *Estate,* 1963. Oil and
silkscreened ink on canvas, 96 × 70″ (243.8 × 177.8 cm).
Philadelphia Museum of Art; given by the Friends of the
Philadelphia Museum of Art.

been in the nineteenth century and Rome in the seventeenth. Today, we're not so sure. But we were then.

Europeans knew American power very well by the late 1940s; but how did they see American culture? It was comic books and Cadillacs, bubble gum, Spam, Hollywood movies, and the mushroom cloud. Jazz, of course, and some American writers were admired: Faulkner, Hemingway. But American painting, sculpture, theater, dance, orchestral music? America looked naïve, swollen with production and pleasure, in contrast to the pinched and traumatized life of a Europe flattened by bombs, a Europe which (counting Russia) had lost forty million people, mostly civilians, in less than ten years. America had lost nobody except soldiers, sailors, and airmen. No bomb had ever fallen on its mainland. It was a fictive paradise full of lies about how consumption produced social happiness. America was the place an artist escaped *from,* in order to mature in Europe.

Not surprisingly, most American intellectuals also took this view. The real artist was the one who worked against the grain of American vulgarity, who aspired to a European complexity and subtlety and felt alienated at home. To feel thoroughly at home, easy in one's skin (rarely possible for an artist anyway), was to surrender to a mass cult, to an empire of commercial signs and thoughtless patriotism. If Americans were happy wallowing in that, they were culturally deluded. This scheme of total alienation within America was summed up by the art critic Clement Greenberg in 1947:

> Our difficulty in acknowledging and stating the dull horror of our lives has helped prevent the proper and energetic development of American art [since 1925]. . . . Apart from Jackson Pollock, nothing has really been accomplished as yet. . . . [For serious American artists] their isolation is inconceivable, crushing, unbroken, damning. That anyone can produce art on a respectable level . . . is highly improbable. What can fifty do against 140,000,000?

There you had it: the American artist under the heel of all other Americans, locked in weak but noble opposition to a country which attached no value, monetary or spiritual, to his work. The heroism of failure.

In fact, Abstract Expressionism encountered no more public indifference and ridicule than early American modernism had after the Armory Show, and its acceptance time was much shorter. There was initial resistance to the work of the artists Greenberg had in mind: Jackson Pollock, Willem de Kooning, Mark Rothko, and others. But by the end of the 1950s it was recognized as the dominant force in American painting, and encouraged as such by the American government as a symbol of American cultural freedom, in contrast to the state-repressed artistic speech of Soviet Russia. By the early 1960s the Abstract Ex-

pressionists were Exhibit A in the display of American cultural prestige, the ornaments of an American modernist establishment that had gone global.

"It is disastrous to name ourselves," said Willem de Kooning, and he was right. There is no clumsier label in art history than "Abstract Expressionist," and yet, for want of a better one, it has stuck. Few of the artists involved made abstract paintings or sculptures in any pure sense: images kept rising up through the paint, especially in their early work, and sometimes right through their careers (Pollock, de Kooning). You can't look at Rothko or Still without thinking of landscape, and Motherwell's work was one long invocation of imagery—the black of death, the blue of the sea off Provincetown, unbidden monsters delivering themselves from his subconscious. Far from being nonreferential artists, the Abstract Expressionists were obsessed with the search for subject matter, the more exalted the better. "Tragic and timeless" themes, said Rothko, were his grail. Abstract Expressionism was not a movement but a loose confederation of very different painters who had some things in common. It had no manifesto. Nor was there a core style: nothing could look less like the tangled, gestural skeins of Jackson Pollock's paint, for instance, than the calm, luminous, thinly painted blurs of Mark Rothko.

In maturity, the painters diverged, as artists must as their individual visions define themselves. But the early paintings explain the later ones; they have more shared content. The main key to this content was primitivist myth. Diverse as artists, Pollock, Rothko, Motherwell, William Baziotes, Barnett Newman—all of them, in fact, except for Willem de Kooning—valued the primordial, the "spiritual," the "primitive," and the archetypal as sources of inspiration.

There were several reasons for this. The first was a recoil from "socially grounded" activist art—the work of the thirties Social Realists, now seen as fatally contaminated by the clichés (and worse) of the Stalinist Popular Front. "Poor art for poor people," sniffed the painter Arshile Gorky. Like Regionalism, this seemed provincial and irrelevant. The artists wanted to dive deeper. "Our aspirations," wrote the painter Adolph Gottlieb in 1947, "have been reduced to a desperate attempt to escape from evil. . . . [O]ur obsessive, subterranean and pictographic images are the expression of a neurosis which is our reality."

Second, there was the influence of Surrealism, with its stress on the power of the unconscious as the most fertile ground of imagery—and on "psychic automatism" as the artist's best way of accessing those images. Surrealist automatism revealed the action of the dreaming mind in paint. It valued the accidental, the involuntary. It welcomed the blot, the stain, the unsought shape, the image that rose unbidden from a chaos of marks. It also intersected with New York's expanding culture of psychoanalysis.

The war had sealed Europe off from America. But it also gave America a bequest of talent, as European artists, writers, intellectuals, and scientists fled across the Atlantic to safety, just ahead of the Wehrmacht and the Gestapo. Among them were some of the French Surrealists, with their leader the poet André Breton: Max Ernst, André Masson, Yves Tanguy, Salvador Dalí, Kurt Seligmann. Their chances of survival in a Paris ruled by Nazis were small. Their contact with American artists was limited by language; none except Max Ernst spoke English, while the Americans—even Robert Motherwell, the most sophisticated of them—had little or no French.

But the Surrealists' very presence was a tonic. The young Americans felt marginal, ignored by other Americans, provincial with respect to Paris. The Surrealist émigrés had brought the center with them. Their sense of mission, their belief that art and life were inseparable, heartened American artists who wished, above all, to believe in the value of an avant-garde.

The third main influence on the early work of the Abstract Expressionists was "primitive" art. Embracing it was a way of cultural escape. They eagerly looked at tribal artifacts in the American Museum of Natural History uptown. The Museum of Modern Art, in the 1930s and 1940s, regularly included "primitive" art in its exhibition program from 1933 onward, in the belief that it was disclosing one of the main buried roots of modernism: Aztec, Mayan, Incan, African, American Indian, and even, in 1937, a show of large facsimiles of "Prehistoric Rock Pictures in Europe and America." In cave paintings and petroglyphs one saw an apparent lack of interest in composition, with the sacred totemic signs overlaid across unconfined surfaces, not constricted by a framing edge: this influenced Pollock's work, and others' as well, such as Baziotes's and

275. Adolph Gottlieb, *Pictograph No. 4*, 1943. Oil on canvas, 35¼ × 22⅞" (89.5 × 58.1 cm). Private collection.

Rothko's. The scale of cave paintings mattered too. They were very big, and encouraged their American admirers to paint big—confirming a hankering for size born of the Federal Art Project mural projects.

In particular the Americans were intrigued by American Indian art. Pollock's technique of dripping and pouring paint from above, on a canvas laid flat on the floor, was in part suggested by Navajo sand painting, in which colored dusts were poured and sifted to make a design on the earth. After visiting some prehistoric Indian mounds in Ohio, Barnett Newman in 1949 wrote that

> here are the greatest works of art on the American continent, before which the Mexican and Northwest Coast totem poles are hysterical, overemphasized monsters . . . perhaps the greatest art monuments in the world, for somehow the Egyptian pyramid by comparison is nothing but an ornament. . . . Here is the self-evident nature of the artistic act, its utter simplicity.

This is Newman at his most bombastic, but also his most sincere: the mud mounds of Ohio confirmed, for him, the minimalist experience of his own paintings.

Adolph Gottlieb's pictures, with their totemic signs—fish, eye, profile, hand, zigzag—enclosed in a grid of "windows" (Figure 275), relate strongly to Indian pictographs. The difference was that the pictographs had specific meanings for their Indian makers, whereas Gottlieb's signs did not. He deliberately wanted to keep them vague, in the hope that their associative aura would go beyond interpretation and thus give both him and the viewer access to the internal world of the unconscious.

The modern artists who most influenced them were the ones who believed in the same things: Miró and Kandinsky in particular, but Surrealism in general as well. Two émigrés living in New York in the thirties also helped to incubate Abstract Expressionism. They were John Graham and Arshile Gorky.

Graham was a charismatic poseur riddled with delusions of grandeur. Born Ivan Dombrowski in Poland somewhere around 1886–87, he turned himself into a White Russian on coming to the United States late in 1920. In one of his more manic-impressive moments he declared that there had only ever been six "universal men"—Pythagoras, Plato, Leonardo da Vinci, Pico della Mirandola, Madame Blavatsky, and himself. He said he was an expert on everything from occultism to artillery warfare, that he spoke nine languages, that he had beheaded Jews with his saber during pogroms, and that "I am an expert on Prehistoric, African, Oceanic, Mexican-Precolumbian, and North American Indian, as well as Modern and Antique art in general." The last, at least, was true (Graham had a most discerning eye), and it helped make him a mentor to some of the future Abstract Expressionists—in particular, Jackson Pollock.

Graham's thinking was a compost of occultism, Symbolism, and Theosophy, infused with readings from Buddhist and cabalistic texts, and tamped down with copious borrowings from Jung. It suited the vanguard art world perfectly, given the rise of interest in what "primitivism" might hold for modern artists in the hypermodernist capital. In 1938 Robert Goldwater published his classic *Primitivism in Modern Art,* and the year before, Graham had written an article called "Primitive Art and Picasso." In it, he argued that children, naïfs, and "primitive" peoples had fuller access to the collective unconscious, to a wisdom of inherited images from which art accumulated its power: "The unconscious mind is the creative factor and the source and the storehouse of power and knowledge, past and future. The conscious mind is but a critical factor and a clearinghouse." The "primitive" was the royal road to the unconscious.

Graham introduced Jackson Pollock to the ideas of Carl Jung. And though never an Abstract Expressionist himself—his forte was symbolic figure paintings and portraits with a highly mannered sense of contour, derived from Ingres (Figure 276)—Graham certainly laid out the tone of early Abstract Expressionism with his passionate belief that the time was ripe for a second modernist "revolution," "like before Cézanne, van Gogh and Gauguin, like before Matisse and Picasso," conducted by social exiles dredging truths from unplumbed wells.

Arshile Gorky (1904–1948), the larger influence on de Kooning's work and on Abstract Expressionism generally, was born Vosdanig Adoian in Khorkom, Armenia. His parents were upper-middle-class Armenians of Christian faith, and the family was uprooted and partly destroyed in the Turkish genocide of Armenians. His mother died of starvation on a forced march of deportees. His father had escaped to America. His son and sisters followed him there in 1920. The boy took the name of Arshile Gorky—literally, "Achilles the Bitter One."

As an artist, Gorky was self-taught, assimilating what he needed by copying and absorbing the styles of modernism, starting with Cézanne and continuing through Picasso, Kandinsky, and Miró. His eclecticism was conscientious and troubled. "I . . . am changing my painting style," he wrote at one point. "There-

276. John Graham, *Marya,* 1944. Oil on canvas, 48 × 48″ (121.9 × 121.9 cm).

fore, this gives me extreme mental anguish. I am not satisfied. . . . I desire to create deeper and purer work."

Gorky had great natural talent as a draftsman, and honed it to exquisiteness. His sense of drawing was bound up in the "speed" of a line, its whip and springiness, its ability to define an edge and suggest the volume behind the edge. It would enable him to draw the most minute distinctions of form; even when Gorky was at his most abstract, you are aware of this variety and restless sensitivity, this ability to change the frequency of his signal, as it were, from one part of a painting to the next. His drawing was always governed by a sense of tradition, the continuity about which he wrote so movingly to his sisters, in 1947:

> The tradition of art is the grand group dance of beauty and pathos in which the many individual centuries join in the effort and thereby communicate their particular contributions to the whole event just as in our dances of Van. . . . For this reason I feel that tradition . . . is so important for art. The soloist can emerge only after having participated in the group dance.

The way to "deeper and purer work" lay through form, but also through content. Memory infused Gorky's art. He kept meditating on paradises of childhood joy and nurture: one image of these, on which he worked intermittently for ten years, was based on a photograph of himself as an eight-year-old boy with his lost mother. It is suggestive even to a stranger, and to Gorky it must have been unbearably poignant. In the painting *The Artist and His Mother,* c. 1926–36 (Figure 277), these details are suppressed for the sake of broad effects—the flat shapes of sleeve and bib, the blurred hands, and a rhythmically inflected boundary line that reminds one how carefully Gorky had been studying Ingres and Paolo Uccello, as well as his modernist heroes. Through Miró, and his contacts with the Chilean Surrealist painter Roberto Matta Echaurren, Gorky became obsessed (the word is hardly too strong) with the Surrealist promise of renewed content in art. But he never believed that art could come from unconstrained free association: "unrelenting spontaneity," he wrote, "is chaos."

277. Arshile Gorky, *The Artist and His Mother,* c. 1926–36. Oil on canvas, 60 × 50" (152.4 × 127 cm). Whitney Museum of American Art, New York; gift of Julien Levy for Maro and Natasha Gorky in memory of their father.

The complex balance Gorky sought between governing form and free-running imagery began to settle in such paintings as *Garden in Sochi,* c. 1943 (Figure 278). It emerges from childhood memories of his parents' garden in Armenia, "our beautiful Armenia which we lost and which I will repossess in my art," where, he wrote in a poetic effusion to accompany the picture,

> often I had seen my mother and other village women opening their bosoms and taking their soft and dependent breasts in their hands to rub them on the rock. Above all this stood an enormous tree all bleached under the sun, the rain, the cold, and deprived of flowers. This was the Holy Tree. . . . [P]eople . . . would tear voluntarily a strip of their clothes and attach this to the tree.

The "figure" in the upper left of *Garden in Sochi,* with its flapping breasts and its flowering head on a single stalk of line, is to be read as one of those village women—perhaps Gorky's mother; the Holy Tree with its fluttering strips of cloth for leaves balances it on the right.

To bloom, memory had to be set against present experience. Gorky's maturity as an artist came after his marriage in 1941; his wife's family owned a farm in Virginia, where he spent more and more time drawing and painting. It became the successor to the lost Armenian garden, the site of Time Regained. In the early 1940s Gorky's art gained immeasurably in expansiveness and precision. He was

278. Arshile Gorky, *Garden in Sochi,* c. 1943. Oil on canvas, 31 × 39″ (78.7 × 99 cm). The Museum of Modern Art, New York; acquired through the Lillie P. Bliss Bequest.

inspired by Kandinsky as well as Miró, and the flowing landscape forms of Kandinsky's *Improvisations* found an echo in his work—as did the Russian's way of inserting passages of black drawing in the midst of a generally warm and high-keyed color scheme, to regulate its sensuousness. Gorky's best paintings of the 1940s embody a close-up look at natural forms, the eye down deep in the grasses and near the plants, combining the shapes of seedpod, bract, stamen, and insect wing with larger metaphors for the sexual human body.

For Gorky, this world, boundlessly suggestive, was drenched in fertility. In 1942 he wrote of "the heat, the tenderness, the edible, the lusciousness, the song of a single person. I like the wheat fields, the plough, the apricots, the shape of apricots, those flirts of the sun." Sexuality and enraptured memory were his great themes: the apricot, that fruit with the warm, slightly fuzzy skin and the buttock-like division, becomes erotic in itself; the paintings swarm with vulvas, cocks, viscera, and organs of all sorts, rubbing against one another, given a sweet glow by Gorky's color. It's a pantheism of the gut and the mucous membranes. It also has an anxious, even ominous, side, as in *The Liver Is the Cock's Comb*, 1944 (Figure 279), with its rising plumes of hot, rich color—a landscape of orifices and talons, prehensile, grappling, and intensely pansexual. By his early forties Gorky

279. Arshile Gorky, *The Liver Is the Cock's Comb,* 1944. Oil on canvas, 73¼ × 98″ (186 × 248.9 cm). Albright-Knox Art Gallery, Buffalo, New York; gift of Seymour H. Knox, 1956.

the former eclectic was painting some of the most voluptuous and original images ever produced in America. But this was not to last. Gorky succumbed to cancer of the throat; then his neck was broken and his painting arm paralyzed in an auto crash; then his wife left him, taking the children. Sunk in terminal depression and only forty-four, he hanged himself in his studio barn in Connecticut, after chalking a single phrase on a wooden crate: *Goodbye My Beloveds*.

Not long after Gorky's death, Willem de Kooning (b. 1904) wrote a letter to *ARTnews* about his Armenian mentor. "I come from 36 Union Square"—the address of Gorky's studio. "I am glad that it is about impossible to get away from his powerful influence. As long as I keep it with myself I'll be doing all right. Sweet Arshile, bless your dear heart."

De Kooning's filial relation to Gorky resembled an earlier one, played out exactly a century before: Frederic Church's to Thomas Cole. (Cole died in 1848, Gorky in 1948.) Like Church, de Kooning never dissembled about his mentor's influence—he was proud of it, and grateful for it. He took over the style: it is impossible to look at the drawing in early de Kooning without thinking of Gorky's sinuous, taut line, describing edge and implying volume in a single gesture; the two men even used the same sort of brush, a thin housepainter's flitch, to draw with. Like Church in the 1860s, de Kooning in the 1960s also went on to become an institution, the most famous living American painter—Jackson Pollock having died in 1956. At this writing (mid-1996) de Kooning is still alive, but too far gone with Alzheimer's disease ever to paint again; the work of his last fifteen years will remain controversial, regarded by some as the products of a Great Late Style and by others as a sad, ghostly diminuendo.

De Kooning was born and raised in Rotterdam, where his father, Leendert de Kooning, was a liquor dis-

280. Willem de Kooning, *Seated Figure (Classic Male)*, 1940. Oil and charcoal on plywood, 54⅜ × 36″ (138.1 × 91.5 cm). Private collection.

tributor, and his mother, Cornelia Nobel—reputedly a woman of fearsome toughness—ran a sailor's bar on the waterfront. In the 1920s he went to study art at the Rotterdam Academy of Fine Arts, an undistinguished school. His main interest, as a youth, was in commercial art, shopwindow design and illustration; these skills, rather than a classical "fine arts" training, were what he got at the Academy. The idea that de Kooning had a rigorous education as a formal draftsman comparable, say, to Mondrian's is a myth. His ambition was to do the kind of illustrations he had seen in American magazines, but "I had no talent for it." This early background helps explain the irrepressible fondness for popular culture—cigarette ads, Marilyns, and so forth—that kept surfacing in his work in the 1950s, to the annoyance of some American critics: de Kooning was never a pure "high" artist, partly because he was not trained to be one. And in any case, the one thing he wanted was to get to America, the cornucopia of dreams across the sea from Rotterdam.

He did so in 1926, by working his way on a steamer and then jumping ship into America without papers. He settled in New York, an illegal immigrant. Gradually he made friends with artists, including Gorky and Graham. They influenced the look of de Kooning's early figure paintings, by turning his attention to Ingres. De Kooning's first series of paintings, the figures of clothed men—single or in pairs—that he did in the late 1930s, are an amalgam of Picasso and Ingres as transmitted through Gorky and Graham. Their main source is Gorky's *The Artist and His Mother.* De Kooning's men, however, are less confidently painted. These dejected and wistful-looking creatures stand in an indeterminate brownish space, from which they are distinguished mainly by Ingresque shadings of charcoal. They have the *misérabiliste* look of Depression-era workers. Sometimes he tried to imitate Ingres's glassy surface by sandpapering the pigment. *Seated Figure (Classic Male),* 1940 (Figure 280), reflects Ingres as filtered through Graham's own curiously mannerist treatment of the human head; it also derives from Picasso's Rose Period circus strongmen.

De Kooning's abstract impulses appeared quite early. They grew out of the biomorphic abstraction of form that Gorky was working toward, derived from early 1930s Picasso (especially *Girl Before a Mirror,* in the Museum of Modern Art), and from Miró's free-floating shapes—"even abstract shapes must have a likeness," de Kooning felt. The result, which first began to appear around 1944–45, is a de-composed figure, whose parts and limbs are scattered around and then tied together by de Kooning's looping line—stronger and more autonomous as drawing now—against a background whose rectilinear elements remind you of a Cubist grid. The color gets pungent and sweet: hot oranges and pinks, candied greens, aquamarine, white. Or it disappears altogether, as in the more severe black-and-white paintings that first made him a reputation when he had his first one-man show, at the age of forty-four, in 1948.

281. Willem de Kooning, *Excavation,* 1950. Oil on canvas,
81⅛ × 101¼" (206.2 × 257.3 cm). The Art Institute of
Chicago; gift of Mr. and Mrs. Noah Goldowsky and Edgar
Kaufmann, Jr.; Mr. and Mrs. Frank C. Logan Purchase Prize.

If one had to pick the best single picture de Kooning ever painted, it would probably have to be *Excavation,* 1950 (Figure 281): that tangled, not-quite-monochrome, dirty-cream image of—what? Bodies, is the short answer: every one of the countless forms that seem embedded in the paint, sometimes even pressed into it as though by some process of collage, jostling and slipping against one another in a tempo that seems to get faster toward the edges and corners, can be read as an elbow, a thigh, a buttock, or the fold of a groin, though never quite literally. There is even a set of floating teeth—the dentures that the *Women* would soon be sporting. De Kooning's characteristically hooked, recurved line takes on an invigorating speed, charging and skidding through the dense pigment. The space of *Excavation* is not deep, as its title suggests, but shallow, more like a bas-relief. Slits offer a promise of spatial depth behind the wall of paint, only to shut again. The sole contrast to the close churning of body forms is a curious "window" in the middle of the painting, red, white, and blue, that looks like a blurred American flag. You keep expecting the image to fly apart into formal incoherence, but despite its overload it never does.

Part of its genesis is said to have been a film de Kooning saw: *Bitter Rice,* 1949, starring Silvana Mangano as a rice gatherer in the paddies of the Po valley; evidently de Kooning liked a sequence showing this sexy actress mud-wrestling in the rice fields. Fragments of pop culture—movies, ads, the immense bric-a-brac of the American desire industry—were always sailing into his pictures and sticking there, like bugs on a windshield. De Kooning, the "slipping glimpser" as he called himself, open to a constant stream of momentary impressions, loved contradictory vernaculars. Smiles from Camel ads, shoulders from Ingres; pinups and Raphael; high and low, everywhere. It was his mode of reception, never intellectualized but often funny, and always sensuous. He is probably the most libidinal painter America has ever produced. One sees him as the consummate anti-Duchamp, a permanent relief from overtheorized art and from excess of self-conscious irony, a man exhilaratingly in touch with the body of paint and the body of the world. This kind of sensory intelligence has always been rare in American art.

Some critics, including Clement Greenberg, felt that after 1950 de Kooning's work declined. The rot is supposed to have set in immediately after *Excavation,* when the artist started on another run of figure paintings—the *Woman* series. Greenberg is said to have told de Kooning that at this point in history (meaning forty-five years ago) you couldn't paint a human face. Sure, said the artist, and you can't *not* paint one either—meaning, by this laconic koan, that no matter how abstract your painting gets, people will always read images into it, like seeing faces in the fire. So why not come right out with the figure? Even more than Pollock, de Kooning was fated to disappoint those who wanted him to be purer than he was. Just as Pollock's "all-over" paintings would be less intense if they

weren't landscapes too, so the ghosts of Dutch and Flemish baroque figure paint-
ing kept jolting de Kooning's elbow.

 "I wanted them to be funny," de Kooning recalled in 1964, "so I made them
look satiric and monstrous, like sibyls." And again: "I find I can paint pretty
young girls, yet when it is finished I always find they are not there, only their
mothers." More likely, his own mother, Cornelia, that coarse sibyl of Rotterdam
dockland. One of the sources of the vitality of the *Woman* series was, one can
only surmise, the simultaneous desire for and fear of women implanted by

Mama. Its icon is the first of the paintings, *Woman I,* 1950–52 (Figure 282). Middle-aged and blocky, fixed in a domineering squat, she glares at you with enormous eyes like a pair of black headlamps: no escape from her for little Willem. She has the worst overbite in all Western art. She is a bad dream of nurture denied, rendered with immense pictorial verve—imposing and commonplace and full of a power which flows from the slashing brushstrokes into the body. When upholders of "pure" abstraction felt that de Kooning, by painting such a creature, was backsliding into "conservatism," they did not grasp the greater psychic daring that *Woman I* embodied then for him and still may for us. What seemed, at the time, particularly disturbing about the *Women* was their balance between atavism and kitsch. On one hand, they invoked a long string of archaic goddesses, harpies, and dominatrixes, from the Venus of Willendorf to Ernst Ludwig Kirchner's Berlin streetwalkers. But on the other, their origins were American: the smile on the face of de Kooning's women had begun in advertising, when he cut out a picture of the "T-Zone"—the mouth and throat of a happy model—from an ad for Camel cigarettes and pasted it into a drawing. The cute red fifties mouth became the eye of a hurricane of anxiety, figured in paint.

By the late 1950s de Kooning was surrounded by imitators. There was a gestural de Kooning "look," easily reduced to parody. The rising stars of the next generation, Jasper Johns and Robert Rauschenberg, reacted against him—sons against the father. But with Rauschenberg, especially, it was impossible to disentangle revolt from homage. The paint in his combine-pictures of the 1950s came straight out of the older Dutch master, drips, clots, and all. In painting *Factum I* and *Factum II,* 1957, two virtually identical pictures with virtually identical "random" drips and splatters, Rauschenberg was performing a much-needed deflation of the idea that accident + vehemence = authenticity; any painting, he was saying, is a fiction, something constructed, not an involuntary sign of the True Self. Rauschenberg asked de Kooning for a drawing, which he then erased. You could take this as a young man's aggression against the older painter. Or you can see it as an excessively patient act of devotion, Rauschenberg laboriously unmaking the drawing (it took weeks) like a monk un-illuminating a manuscript. Either way, the power de Kooning had over younger American artists is clear enough.

But by the late 1950s, de Kooning was easing himself out of Manhattan. He bought a house in Springs, on the south fork of Long Island. The flat potato fields, beaches, and glittering air of that tongue of land must have reminded him of the Dutch seacoast, but what mattered most in his paintings at the time was the experience of getting there and back, being driven along Route 495: fast movement through unscrolling American space. Hence the highway images of 1957–58, in which the full-reach, broad-brush speed of the paint becomes a headlong road movie, analogous to Jack Kerouac's writing or the photographs of

282. Willem de Kooning, *Woman I,* 1950-52. Oil on canvas, 75⅞ × 58″ (192.7 × 147.3 cm). The Museum of Modern Art, New York; purchase.

de Kooning's friend Robert Frank. See America now! And you do—in abstraction; you feel its rush and tonic vitality in the toppling blue and sea-green strokes of *Ruth's Zowie,* 1957, which echo the big-girder structures of Franz Kline but move them into a pastoral context.

What he found at the end of Route 495, however, when he moved permanently to eastern Long Island in 1963, was mostly suds and mayonnaise. The long series of squidgy pictures— landscapes, nudes splayed like frogs, and female clam diggers whose body silhouettes waver as though reflected in disturbed jelly—that issued from his studio over the next fifteen years was lush but trivial. De Kooning's once terse and wristy drawing got submerged in weak, declamatory brushmarks; the color, mostly pink, seemed bright and tedious. He tried sculpture, too, in 1973–74: a mistake. He worked the clay and plaster into a haptic frenzy of surface that didn't convey any energy as form; the results, cast in bronze, were like giant nose-pickings.

Presumably de Kooning's alcoholism was a factor in the decline of his work, but it wasn't a steady drop: the movement of his talent, in advancing age, was less on-off than ebb-and-flow. He came back in the late 1970s with some big, rapturously congested landscape images with real intensity to them, held together by a deeper tonal structure than the preceding ice-cream work. And even in old age he could produce thin, lyrical paintings like *Pirate (Untitled II),* 1981 (Figure 283), which spin away the congestion altogether and recapitulate some of the graphic intensity of his work in the late 1940s in the colors of famille rose porcelain. *Pirate* was de Kooning's last tribute to Arshile Gorky, and the most explicit of them all: the forms traced by the turning, almost negligent movement of the flitch are so like the Armenian's work that you could almost take them for a copyist's. De Kooning's hand did not altogether lose its cunning in old age. His mind, however, did, and the very last paintings of 1983–86 are dispirited and dispiriting stuff, with their thin ribbons of paint and their spectral air, like seeing an old man's veins through the skin: the remains of a style, no more.

283. Willem de Kooning, *Pirate (Untitled II),* 1981. Oil on canvas, 88 × 76¾″ (223.4 × 194.4 cm). The Museum of Modern Art, New York; Sidney and Harriet Janis Collection Fund.

. . .

Thanks to the critic Harold Rosenberg and his term "action painting," which expanded from de Kooning's work to encompass all of AbEx, the idea arose that de Kooning was an "existential" artist. Sartre, Heidegger, Nietzsche, and Dostoyevsky, among others, were freely invoked by the art-critical rhetoric of the late 1940s and early 1950s to present the Abstract Expressionist as a man creating his identity from moment to moment in the act of painting, staking everything on the risky outcome of a series of unmediated gestures. A picture was not a picture but an act—a notion which ignored the fact that acts, once finished, have a way of turning into pictures. Each artist, wrote Rosenberg in 1947, "is fatally aware that only what he constructs himself will ever be real to him." But the course of de Kooning's work, entwined as it was with Gorky's, would seem to refute this; and so does the work of the man who became de Kooning's closest artist friend after Gorky's death, Franz Kline (1910–1962).

Kline is best known for his black-and-white paintings of the early to mid-1950s. Rightly so; later he used color, but without success—he couldn't integrate it into the structure of the work. In monochrome, however, he could be superb. And though much rhetoric about the Unique Existential Act was ladled onto such works, they came from premeditation and an acute sense of style. One of their roots was black-and-white cartoons: Kline began as an illustrator. Another was de Kooning's black-and-white paintings of the late 1940s.

But Kline's work had nothing to do with what was often supposed to be its main source: Zen calligraphy, with all its implications of spontaneity and speed. There was a superficial resemblance between Kline's structures of black on a white ground and ideograms brushed on paper, but the things themselves are very different. "People sometimes think I take a white canvas and paint a black sign on it," Kline complained, "but this is not true. I paint the white as well as the black, and the white is just as important." The black masses and bars are not just gestures but forms; the white is not an absence but a color. Sometimes the speed of the brush matters, as in Oriental ideographs, but not always. Kline was such a deliberate artist

284. Franz Kline, *White Forms,* 1955. Oil on canvas, 74⅜ × 50¼″ (188.9 × 127.6 cm). The Museum of Modern Art, New York; gift of Philip Johnson.

that he took to making small gestural drawings which he would then transfer to the large canvas with an opaque projector, quite like a nineteenth-century painter "squaring up" a sketch. These studies dispose of the idea of Kline as a wholly spontaneous painter who staked everything on a one-shot gesture. The title of *White Forms*, 1955 (Figure 284), draws attention to the spaces between the black forms; the balance between the rushing black and the captured density of the static white seems exact, yet imperiled by the energy of movement. Such structures aren't metaphors for New York skyscraper grids, but they had much to do with Kline's childhood memories of industrial sights in Pennsylvania, and with the way New York was described by his friend Robert Frank's high-contrast photography. In Manhattan, Kline saw hieroglyphs of power, and they entered his work.

The artist who really seemed to fulfill the "existential" model of the day was Jackson Pollock, in life and in death, and through the processes of his art. He painted riskily, just on the edge of control. He butted and shoved his way through blocks and indecision, without any protection. He drank like a fish, couldn't contain his internal violence and sexual insecurities, and died in 1956 at the age of forty-four like a puffy, mean James Dean, in a big American car with two girls in it, neither of them his long-suffering wife, the painter Lee Krasner.

In 1949 Clement Greenberg had pronounced him to be the best living American artist, and this was taken up by the then enormously influential *Life* magazine, which splashed him and his paintings across several pages: this transformed his career and life even more than the cover of *Time* had altered the career of Thomas Hart Benton, who happened to have been Pollock's teacher. It was the first time that the American mass media had latched onto an abstract painter, and his celebrity was instantaneous. After his death, "Jack the Dripper" became one of the legends of modern art, and American culture never got over its surprise at producing him. This, it seemed, was the man who finally freed American painting from the grip of its own deference to Europe. He was, in de Kooning's generous words, the guy who "broke the ice." He set a canon of intensity for generations to come. His work was mined and sifted by later artists as though he were a lesser Picasso. The basic *données* of color-field abstraction, which treated the canvas like an enormous watercolor dyed with thin matte pigment, were deduced by Helen Frankenthaler, Morris Louis, and Kenneth Noland from the soakings and splatterings of Pollock's work. Along with that went the "theological" view of Pollock as an ideal abstractionist obsessed by flatness, which conveniently ignored the fact that there were only four years of his life (1947–51) when he was not making symbolic paintings based on the totemic animal, the Jungian archetype, and the human figure.

If Claes Oldenburg dribbled sticky floods of enamel over his hamburgers and plaster cakes in the sixties, he did so partly in homage to Pollock. If Richard Serra made sculpture by splashing molten lead in a corner, Pollock lay somewhere be-

hind that gesture too. Traces of Pollock lie like genes in art-world careers that, one might have thought, had nothing to do with his. And if the work was so influential, so was the image of the man himself. Pollock had been more photographed (by Rudy Burckhardt, Hans Namuth, and Arnold Newman, among others) than any artist in American history except Georgia O'Keeffe by Alfred Steiglitz. These photos, Namuth's especially, depicted not his art but the "mythic" process of making it: a man dancing around the borders of a canvas, an "arena" laid flat on the floor, spattering it with gouts and sprays of paint. Pollock as seen by Namuth's lens, half athlete and half priest, seemed to confirm Harold Rosenberg's existential notion of Abstract Expressionism as not painting at all, but a series of exemplary "acts." The very photos of Pollock would have their effect on the esthetic of "happenings" in the 1960s and avant-garde dance in the 1970s.

Perhaps inevitably, he also has a shrine: the modest house and studio used by him and Lee Krasner in the village of Springs, on Long Island. It is maintained by a private foundation and contains none of his actual paintings. Instead are relics: the Holy Coffee Can with a bunch of the Miraculous Brushes sitting in it; the Sanctified Shoes, crusted in paint. And there, in the sanctum sanctorum of the studio, is the Floor, bearing the surplus drips of the Master, the sacramental ichor that went off the edges of *Lavender Mist, Blue Poles, Autumn Rhythm,* and the rest.

"The source of my painting is the unconscious," Pollock declared; and there was no Abstract Expressionist of whom this was more clearly true. His emotions and conflicts had always been raw and close to the surface, ever since his boyhood—he was born in Wyoming in 1912, though his parents later moved with him to California—and by the early 1930s, when he enrolled at the Art Students League in New York, he was addicted to alcohol. By 1937 one of his brothers, Sanford Pollock, was writing to his other brother Charles that "Jack has been having a very difficult time. . . . [I]t was obvious that the man needed help. He was mentally sick." Jackson Pollock sought this help in psychoanalysis, which intertwined with his art. He had read John Graham's 1937 article "Primitive Art and Picasso"; he wrote to Graham, and the two men became friends. Graham persuaded the twenty-five-year-old Pollock to enter Jungian analysis, which might not only help his alcoholism and depression but also benefit his art by letting him access his unconscious more freely, discovering archetypal forms and myths. Just how deep Pollock went into Jungian theory is unclear; but he strongly believed in the validity of psychoanalysis and accepted as a working principle that improvisation and "automatism" could lead to deep meaning in imagery.

And so, through the late 1930s and early 1940s, one sees the work change radically. Pollock had studied under Benton at the Art Students League, and stayed friends with him for years thereafter. Benton's sculptural, buckling rhythms were

imitated by the student; there would always be, in Pollock's work, a violently energetic, twisting movement of masses, derived from Benton's version of Mannerist *contrapposto*. He fused this with his admiration for Ryder, Miró, Orozco, Picasso, and (later) Kandinsky, but it was Picasso who predominated at first, except that Picasso's relatively stable forms were decomposed by turbulent rhythms and overwritten by inscrutable signs. Pollock was in search of mythic, totemic images with universal meaning, and his titles in the 1940s reflect this: *The She-Wolf, Pasiphaë, Guardians of the Secret, Male and Female, Moon Woman Cuts the Circle*. He didn't so much illustrate myth as invoke its presence, to give the painting resonance. So with *Pasiphaë*, 1943 (Figure 285). Disconcertingly, its original title was *Moby Dick*, and the change from white whale to Cretan queen happened after a friend told Pollock about the Greek myth of the wife of King Minos, who disguised herself as a cow to slake her unappeasable sexual desires with a bull and later produced the Minotaur. Three figures can be made out: two standing totems or sentinels, left and right, and between them a body lying down, whose three-lobed breastlike forms (like the dugs of a wolf) suggest that it is female; at a stretch, since it is very unlike a whale, one might read it as Pasiphae giving birth to the Minotaur. But what counts more than any specific reading is the choked, blurting urgency with which the painting itself is delivered. Every inch of it pullulates with signs and gestures, scrawled in a thick impasto. They abolish spatial recession and press the whole image against the picture plane.

285. Jackson Pollock, *Pasiphaë*, 1943. Oil on canvas, 56⅛ × 96″ (142.6 × 243.8 cm). The Metropolitan Museum of Art, New York; purchase, Rogers, Fletcher and Harris Brisbane Dick Funds and Joseph Pulitzer Bequest, 1982.

286. Jackson Pollock, *Mural*, 1943. Oil on canvas, 97 × 238″ (247.6 × 604.5 cm). The University of Iowa Museum of Art; gift of Peggy Guggenheim.

Among them one can discern eyes, hands, zigzags, commas, vortices. The energy is relentless. The skin of signs predicts Pollock's "all-over" paintings five years later.

However, the picture in which Pollock moved to a fully gestural style was also done that year: *Mural*, 1943 (Figure 286), commissioned by Peggy Guggenheim for the hall of her New York duplex. No doubt Pollock's enthusiasm for Mexican mural painting of the 1930s, which he often talked about, emboldened him to try this enormous canvas, twenty feet wide and eight feet high. But whatever its antecedents, this was the first painting by an American abstract artist to be so enveloping in its scale—meaning not raw size but its relation to your body and to the building it was in. You are surrounded, from the center to the periphery of your vision, by a frieze of writhing forms to which suggestions of the human figure are bonded: a bacchic dance in which the totems of Pollock's earlier work are set in motion. Their movement is entirely given by gestures of the brush. Traces of Benton remain in the opposing curves and loops of the design, and its profusion of hooks and comma forms, but these are teased out into pure brush movement and not sculpturally rendered. *Mural* doesn't have a center or a cumulative structure: it unfolds across the wide canvas, making every part of its rough surface as interesting as the next. And yet you sense its strong visual control. Moreover, it was painted on the floor of the apartment, so that Pollock worked around and "in" the painting. *Mural* prepared the way for what would be Pollock's most radical achievement: the drip paintings of 1947–51.

Pollock didn't "invent" the drip. Surrealists like André Masson and Max Ernst had used free dripping as a way of putting chance in their paintings. Hans Hofmann's paintings of the early 1940s were full of drips and splotches of paint. But Pollock gave the drip a unique esthetic character. Holding the brush or stick a foot or so off the canvas, he threw lines of paint in the air whose grace, when they landed, transcended the clumsiness of his fist as an orthodox draftsman. The painting grew from his control of the gesture. He described his own way of work-

ing as though he were a medium, in words that recall Picasso's confession that "painting is stronger than I am: it makes me do what it wants":

> On the floor I am more at ease. I feel nearer, more a part of the painting, since this way I can walk around it, work from all four sides and literally be *in* the painting. This is akin to the Indian sand painters of the West. I continue to get further away from the usual painters' tools. . . . I prefer sticks, trowels, knives, and dripping fluid paint. . . . When I am *in* my painting, I'm not aware of what I'm doing. It is only after a sort of "get acquainted" period that I see what I have been about. . . . [T]he painting has a life of its own. I try to let it come through.

In speaking of his work in terms of "acquaintance" with the image, letting it "come through," almost of deference to another life outside his own, Pollock wasn't exaggerating: the violence and anal aggression of his early pictures began to dissipate, disclosing the work of an esthete tuned to the passing nuance. The struggle for autobiography through Jungian images ends, and though the work is deeply expressive, it is beyond Expressionism. Many of the passages in his all-over works remind one of Monet. (In fact, it was Pollock's work that helped reawaken an enthusiasm for the late, "all-over" Monets among Americans, back in the sixties.) The title of his most ravishingly atmospheric painting, *Number 1, 1950 (Lavender Mist),* 1950 (Figure 287), sums this up. It has no compositional climax; it is a broad swatch of small incidents which melt into one another, the overlaid filaments of paint sometimes suggesting deep space only to deny it again. But this swarming gives it a delicacy that no reproduction can capture. He used the patterns caused by the separation and streaking of one enamel wet in another, tiny black striations in the dusty pink and blue, to produce an infinity of tones. This is what imitators could never do, and why imitating Pollock was pointless. Did Nature disappear from such work? On the contrary; Pollock said that he wanted to "be nature," not just paint it, an aspiration similar to Kandinsky's. The mark of his greatest all-over canvases, like *Lavender Mist* or *Autumn Rhythm,* 1950 (Figure 288), was their balance—between, on the one hand, the web of shallow space, so transparent to the eye and nuanced in its energy, and on the other the surface, with its puddles and blots and crusts of pigment. There is more than a mere memory in them of the epic space which nineteenth-century artists had found in American landscape: they are expansive, full of wind and weather, shifts of light, and ceaseless mutation. The life with which they are imbued is that of Nature, near and far.

This phase of Pollock's work did not last long. If the all-over paintings were the most abstract of his career, they only continued for four years; after that, Pollock's interest in totems, eyes, and faces rose again, and perhaps if he had lived to seventy, dying (say) in the early 1980s, he would now be seen as a basically

287. (above) Jackson Pollock, *Number 1, 1950 (Lavender Mist),* 1950. Oil, enamel, and aluminum on canvas, 87 × 118″ (221 × 299.7 cm). National Gallery of Art, Washington, D.C.; Ailsa Mellon Bruce Fund.

288. (below) Jackson Pollock, *Autumn Rhythm,* 1950. Oil on canvas, 105 × 207″ (266.7 × 525.8 cm). The Metropolitan Museum of Art, New York; George A. Hearn Fund, 1957.

imagistic artist who had one abstract phase in his early middle age. But this is un-knowable, because alcohol addiction and depression pulled him under. By 1954 he had almost ceased to paint, and in 1956 he crashed and died not far from his Long Island studio.

Early in *Moby-Dick,* Ishmael arrives at the Spouter-Inn and sees a large picture in the gloom. Peering, he can just make out

> a long, limber, portentous, black mass of something hovering in the centre of the pic-ture over three blue, dim, perpendicular lines floating in a nameless yeast. A boggy, soggy, squitchy picture truly, enough to drive a nervous man distracted. Yet was there a sort of indefinite, half-attained, unimaginable sublimity about it that fairly froze you to it, till you involuntarily took an oath with yourself to find out what that marvellous painting meant.

So Mark Rothko, Barnett Newman, and Clyfford Still had got to the Spouter-Inn before Ishmael and Queequeg. These three formed another wing of Abstract Expressionism, loosely called the "field" as distinct from the "gestural" painters, and on their work was posited the belief in a revival of the Sublime.

Mark Rothko (1903–1970) was born Marcus Rothkowitz in Dvinsk, Lithua-nia. He received a Talmudic education as a boy, and his early childhood was scarred by memories of mob violence against Jews. Persecution forced his mother to immigrate with her children to America, where they settled in Portland, Ore-gon. Rothko grew into a touchy, academically gifted scholarship boy, fiercely at-tached to radical causes; right up to 1970, the last year of his life, he would maintain that he was still an anarchist. In 1921 he went to Yale, but left in his second year and fetched up in New York, studying painting with Max Weber. He met artists and forged strong bonds with some of them.

One was Milton Avery, whose broad, simplified areas of glowing color were the root of Rothko's mature style. Avery's pictorial construction was achieved al-most entirely through color: the weight of a red, the brooding distension of a pur-plish sea against a blue headland, thinly and dryly painted in flat silhouettes with little internal texture and almost no modeling. Avery was one of the first Ameri-can painters, perhaps *the* first, to insist that a painting should be flat and on one plane, without "photographic" depth: the idea of a painting as a field of color starts with him (Figure 289), and Rothko's later work was faithful to his exam-ple. (In the 1940s Alfred Barr, director of the Museum of Modern Art, asked Rothko who he thought was the greatest American painter: Rothko said Avery was, and Barr laughed out loud.) Avery learned from Matisse's abutments of pure color planes, but he was without Matisse's power and grace of draftsmanship; he

289. Milton Avery, *Red Rock Falls,* 1947. Oil on canvas, 33⅞ × 43⅞" (86 × 111.4 cm). Milwaukee Art Museum; gift of Mrs. Harry Lynde Bradley.

drew clumsily and scraggily, and lacked the ability to translate the presence of the physical object, especially the human body, into abbreviated signs without sensuous loss. But Rothko was not a gifted draftsman either, and it was Avery's color, rich, subtle, and distinctive, that inspired not only Rothko but American color-field painting as a whole—an achievement that went unrecognized by dogmatic believers in pure abstraction like Clement Greenberg, because they found Avery's commitment to figure and landscape "retrograde."

Another artist who deeply affected Rothko's growth was Adolph Gottlieb, with whom he came to share the Jungian hope that painting might extract from cultural memory archetypal and mythic symbols with a relevance to the present day. "The known myths of antiquity," Rothko declared in the early 1940s,

> are the eternal symbols on which we must fall back to express basic psychological ideas. They are the symbols of man's primitive fears and motivations . . . changing only in detail but never in substance, be they Greek, Aztec, Icelandic, or Egyptian. And our modern psychology finds them persisting still in our dreams, our vernacular, and our art, for all the changes in the outward conditions of life. The myth holds us . . . because it expresses to us something real and existing in ourselves.

What fascinated Rothko, then, was not the formal language of classical Greek art, which he felt was dead, but the inner core of truths about human character and fate which, expressed as myth, was common to Greek drama and epic as well. In an effort to evoke it, he resorted to forms vaguely recognizable as totemic

figures, enacting rituals in a hazy landscape setting, like *Baptismal Scene*, 1945 (Figure 290). He derived them from birds and fish, from plant forms, and even from scientific illustrations of protozoa. Under the influence of Avery's work, he simplified his compositions until, at the end of the 1940s, he arrived at the essential Rothko form: a series of stratified blocks—or, rather, oblong blurs—of color, some deep and others thin bars, stacked up on the canvas. With these, he hoped to express the sense of awe and numinous presence which had once been associated with the depiction of gods in art—but do it without the human figure. He was an esthete to the fingertips, and wanted to employ the vocabulary of Symbolism—the presence of Mallarmé's "negated object," the indeterminate space, the refined and sensuous color—to render the patriarchal despair and elevation of the Old Testament. That Rothko had a religious vision of some kind is not in doubt. There was a deeply rabbinical streak in his character. But he was struggling, as a Jew, to do what only Christian iconography could achieve, and the vital relationships between myth, dogma, symbol, and personal inspiration that had carried religious art from Cimabue to William Blake were denied him by the reductive trajectory of modernism itself. His mature paintings could be ravishingly beautiful, in their depth and relationships of color, in their trust that Rothko's own abandonment to feeling could evoke an equal letting-go in the viewer, in their sensitivity to the feathered and frayed edges of big shapes, and in the solemn light that they emanate (Figure 291). Their emotional range is wide, from foreboding and sadness to an exquisite and joyous luminosity. But was this enough to constitute a major *religious* utterance? One can only answer, without skepticism, that it was

290. Mark Rothko, *Baptismal Scene,* 1945. Watercolor on paper, 19⅞ × 14″ (50.5 × 35.6 cm) sight. Whitney Museum of American Art, New York; purchase.

not. The evidence is in the Rothko Chapel in Houston, commissioned by the de Menil family in 1964, finished in 1967, but not installed until 1971, a year after Rothko's suicide. These gloomy black-and-dark-red canvases, inscrutable and immobile, seek to extend the viewer's response time; the eye searches for the form (a near-black rectangle on a purplish red ground) and then, in the diminished light of the chapel—muted daylight being part of the theatrical effect—seeks its nuances. But the expected epiphany does not come.

Rothko's work could not, in the end, support the weight of meaning he wanted it to have. He and other "field" painters—Clyfford Still, Barnett Newman—were given to describe their ambitions in terms of the "Sublime," as set forth by Edmund Burke in 1757. What, Burke enquired, produced that sense of overwhelming awe that characterized "sublime" emotion in the face of Nature and Art alike? Unity, vast size, bound-

lessness, emptiness, and darkness; in the presence of these, "the mind is so entirely filled with its object that it cannot entertain any other," and the work of art becomes self-sufficient. Rothko believed in the possibility of such painting but often doubted that he had realized it. But Clyfford Still (1904–1980) and Barnett Newman seem to have had no doubts that they had.

Having found his basic style in the mid-1940s, Still produced a stream of enormous, visually aggressive, and somewhat monotonous paintings which, allowing for variations of color and form, tend to look pretty much the same. His tone was a constant fortissimo. He described his own career to a friendly critic thus:

291. Mark Rothko, *Ochre and Red on Red,* 1954. Oil on canvas, 92⅝ × 63¾″ (235.3 × 161.9 cm). The Phillips Collection, Washington, D.C.

It is one of the great stories of all time, far more meaningful and infinitely more in-
tense and enduring than the wars of the bullring and the battlefield—or of diplo-
mats, laboratories or commerce. For in two [museums] some thirteen years
ago . . . was shown one of the few truly liberating concepts man has ever known.
There I had made it clear that a single stroke of paint, backed by work and a mind
that understood its potency and implications, could restore to man the freedom lost
in twenty centuries of apology and devices for subjugation.

Some brushstroke, that. Still was an American nativist, born in North Dakota,
who spent the first forty-five years of his life on the prairies of Alberta, Canada,
and later in Spokane, Washington, where the nobility and grandeur of the land-
scapes indelibly impressed him. He wanted to reconstitute in his art a heroic and
entirely American conception of space: that of nineteenth-century Big Sky land-
scape, Church and Bierstadt brought forward into a modernist idiom. True to na-
tivist type, he was a visionary loner, a sort of Albert Ryder with ten-foot, not
ten-inch, canvases. He believed that all the problems of modern American art
could be traced back to the Armory Show, which had "dumped upon us the com-
bined and sterile conclusions of Western European decadence." Still, of course,
emphatically denied that he was a landscape painter at all, or that his work had
any relation to landscape. But it did—big cliff-like forms split by glissades of
light, flame shapes flickering in the sky, the whole effect unearthly and intense
and, in his best work, undeniably impressive. Its ruggedness continues in the
paint surface, crusty and disagreeable—like Still himself. No other abstract paint-
ing of the 1940s and 1950s looks like his; the only earlier American works that
resemble it in any way are the softer and more nuanced "cosmic" abstractions
done in the 1920s by the still largely overlooked painter Augustus Vincent Tack,
though it is not clear whether Still knew Tack's work; if he had, he would cer-
tainly have denied it anyway. Every artist has a right to his own clichés, but long
before he died this gifted man had painted himself into a corner, running varia-
tions on his basic format. All dialogue with other art, indeed all exchange with
the culture around him, had stopped long before, and he was frozen by his own
sense of grandiose outsidership in an art world whose corruptions he loudly de-
spised—but which he skillfully manipulated himself, managing to install perma-
nent groups of his paintings in selected museums where they could be seen as in
a chapel, without distraction from other artists whose work he loathed.

One of these was Barnett Newman (1905–1970). The two had been friends,
but they fell out in a quarrel over the invention of what Newman called his
"Zip," the vertical stripe bisecting the canvas which was the basis of Newman's
mature style. The unwitting culprit was Robert Motherwell, who, reminiscing
about the origins of the New York School in 1967, recalled that whereas he,
Baziotes, and Pollock all had some degree of figuration in their work up to 1943,

Still had none: "His canvases were large ones in earth colors They mainly had a kind of jagged streak down the center, in a way like a present-day Newman if it were much more freehanded, that is, if the line were jagged, like lightning." This imputation of (how to put it?) modified originality sent Newman into a petulant fury and destroyed his relationship with Motherwell as well as Still. Newman, along with his chief exegetes and critical supporters Thomas Hess and Harold Rosenberg, set enormous store by his Zip. It first appeared in 1948 in a small canvas, *Onement I* (Figure 292). Before, Newman had been painting bent or crooked vertical lines which might indeed have been influenced by Still's work of 1945. But the "invention" of the *straight* Zip struck him and his many admirers as an epochal event in modern painting, clearing the way for direct apprehension of the Sublime. No matter that virtually identical proto-Zips had been used back in the 1920s by Russian Constructivist artists—they had not interpreted it in terms of Spinoza, the Cabala, Adam and Eve in Genesis, Giacometti's thin, tragic figures, and all the other heavy baggage Newman's Zip was supposed to lift. In fact, there is nothing in the paintings to justify the depths attributed to them; but so fixed has the belief in Newman's profundity become that in some quarters the merest doubt is taken almost for anti-Semitism. Hess, Rosenberg, and others may have used their overinterpretations of Newman to reconnect to their own Jewishness, but that doesn't make the Zip any deeper. Still, the rhetoric around Newman's work—his own and others'—became an intimidating force field which zapped all who doubted the Zip. Harold Rosenberg said the Zip "stood for [Newman] as his transcendental self. . . . [T]he divided rectangle took on the multiplicity of an actual existence—and a heroic one." If Newman declared that "the self, terrible and constant, is for me the subject matter of painting," who could question his implied claim to Michelangelo's *terribilita*? He even told an interviewer in 1962 that

292. Barnett Newman, *Onement I,* 1948. Oil on canvas, 27¼ × 16¼" (69.2 × 41.2 cm). The Museum of Modern Art, New York; gift of Annalee Newman.

almost fifteen years ago Harold Rosenberg challenged me to explain what one of my paintings could possibly mean to the world. My answer was that if he and others could read it properly it would mean the end of all state capitalism and totalitarianism. That answer still goes.

Such utterances are the very definition of bullshit: empty depth. You only need to compare Newman's or Still's claims with what you know of the resistant world to sense their absurdity. But they lent their authors a vatic air, particularly Newman, and so in the midst of an all-too-willing suspension of art-world disbelief a major reputation sprouted from a minuscule base. Though Newman went on at length about the importance drawing had to him, there is no evidence that he was even a minimally competent draftsman: his surviving drawings from the 1940s are feeble biomorphic doodles. He had one formula, and one alone. The Zip was all he could do, and he did it over and over again, on big fields of assertive, saturated color, with titles attached to them that left no doubt as to the epic sublimity of their intended aura—*Vir Heroicus Sublimis*, *Adam*, *Covenant*, and the like. The gap between aura and meaning, however, could be acute, as in his series of fourteen *Stations of the Cross*, 1958, which have their own room in the National Gallery of Art in Washington. They have a certain interest as talismans of early Minimalism, but as a narrative of the passion and sacrifice of Christ they are utterly vacuous. At one point Newman said, with a straight face, "I thought our quarrel was with Michelangelo." It was not a quarrel anyone could win with a stripe.

The belief in the production of sublime awe that puffed up so much of the writing about Abstract Expressionism was part of a period style. It was the intellectuals' version of American gigantism. It encouraged a phony grandiloquence, a confusion of pretentious size with scale, that has plagued American painting ever since, down to the efforts of Julian Schnabel and others in the 1980s.

After such bombast, it is a relief to turn to the youngest, most intelligent, and most cultivated of the Abstract Expressionists, Robert Motherwell (1915–1991). These very attributes, of course, were once thought to work against him, and for some they still do. Unlike his colleagues, he was held to be rich; in the 1940s he received an unprincely fifty dollars a week from a trust fund set up by his father, a San Francisco bank president who was disappointed that his son hadn't the sense to be a banker or a broker. Family money gave him a broad education: a B.A. in philosophy at Stanford, a prewar tour of Europe, and Ph.D. studies in philosophy at Harvard, abandoned in 1940 in favor of an art history course at Columbia given by the art historian Meyer Schapiro. It was Schapiro, a political radical with the finest of antennae, who persuaded Motherwell to stop doing art history and become a painter. But he never ceased to write, lecture, and edit: his *Documents of Modern Art* series in the 1940s was the first to provide translations of crucial texts of European modernism to an American audience. He was,

in short, a rare type in America: the painter as intellectual. And as such, he was suspected of being "too French." Motherwell read French and spoke some, and he soon became conversant with the exiled Surrealists in New York. They clicked, at first because Motherwell had common ground with them: his *literary* culture, based on an enthusiasm for French Romantic and Symbolist poetry, from Baudelaire to Mallarmé and beyond to Paul Éluard. The Symbolist idea of direct correspondences between sound, color, sensation, and ideated memory struck Motherwell as one of the supreme achievements of Western culture and the key to modernist painting. He had never agreed, and never would, that painting could feed only on theory or Utopian fancy. It had to be located in the world of feeling, of feeling *about* the world. "A weakness of modernist painting," he wrote in 1950, "especially prevalent in the 'constructivist' tradition, is inherent in taking over or inventing 'abstract' forms insufficiently rooted in the concrete, in the world of feeling where art originates, and of which modern French poetry is an expression. Modernist painting has not evolved merely in relation to the internal structure of painting."

New York in the early 1940s was full of talent; what it lacked, Motherwell thought, was "an original creative principle . . . that was not a style, not stylistic, not an imposed esthetic," that could lift it above a too passive imitation of European avant-gardism. New York was swimming in styles, and there were more modernist masterpieces (Picasso, Matisse, Kandinsky, Miró) to be seen in it, in the wartime years, than in any city in Europe. That was part of the problem. No help was going to come from Surrealist painting, but Surrealist ideas were a different matter, and in particular the idea of "psychic automatism" or free association: doodling, dreaming, letting the unconscious well up. As in *Elegy to the Spanish Republic LXX*, this way the self came through, "one's own being is revealed, willingly or not, which is precisely originality, that burden of modernist individualism."

The series for which Motherwell is best known—though, in fact, it makes up only a small fraction of his output—is the *Spanish Elegies*. They completely represent what Motherwell had in mind when he thought about "the subjects of the artist." At the time he began them he had never been to Spain, but there were several reasons that this subject bore in on him. The first was a general and political one: that the fate of Spain, in losing democracy to the dictator Franco, was an emblem of a larger European struggle for freedom. The second was that Motherwell wanted to generalize from the historical event: to paint a meditation on death, loss, and sexuality. And third, he needed a constant theme and a general format in which he could test himself, see the way his automatism worked. The *Spanish Elegies* provided that. Their color, for the most part, is restricted to white and black—a peculiarly dense and velvety black, *el negro motherwell*, as the poet Rafael Alberti would call it, as distinctive as Georges Braque's slaty blues or Pierre Bonnard's high-keyed oranges. Occasionally there is a patch of ocher or a

flare of crimson and yellow (the colors of the Falangist flag but also, more anciently, those of the Catalan resistance), but these are basically monochrome paintings, their absent color an undisguised homage to the journalistic black-and-white of Picasso's *Guernica* and the tragic tonal intensity of Goya's *Caprichos* and *Desastres de la guerra*. In the same way, the forms remain constant. Thick descending bands, rounded at the bottom, alternate with black ovoids against a white ground. The effect, in the best of the *Elegies,* is extraordinarily evocative. Their images work on several levels at once, evoking Spanish light in their vehement contrasts of white glare and shadow, suggesting a variety of Spanish motifs—bull's testicles, the patent-leather hats of the Guardia Civil—and presenting the sharpest of contrasts: vitality (white) against death (black), living forms (the ovoids) imprisoned or crushed between the black bands. The first painting to summon up these forms was *At Five in the Afternoon,* 1949—the hypnotic refrain from Federico García Lorca's elegy for the great Andalusian bullfighter Ignacio Sánchez Mejías, gored to death in the ring; but as the forms develop they take on a grand funereal amplitude, as in *Elegy to the Spanish Republic LXX,* c. 1961 (Figure 293).

But Motherwell's work ranged wider than the elegiac mode. Though he once declared that "I belong . . . to a family of 'black' painters and earth-color painters in masses, which would include Manet and Goya and Matisse," there is a sensuous and hedonistic aspect to his work. It showed in the *Open* paintings, which relate not to an imagined Spain but to the Atlantic coast at Province-

town—where Motherwell spent his summers—overlaid with memories of the Mediterranean. These broad fields of color are marked by an incomplete rectangle or trapezoid, formed by three or four lines of charcoal or black paint. The lines seem to open up a field behind the field with the impression of an architectural form—a window or a door. The passages of tone in the paint, the variations of blue or ocher depth, drench the eye in light without offering a glimpse of horizon; it's as though a part of nature had been taken down to its bare essence and then contrasted with an equally reduced emblem of culture—the ghost of a building, humanizing the "landscape" in which it is embedded.

Motherwell's collages most clearly represent the "French" side of his work. He was the only artist since Matisse in the 1950s to significantly alter the language of this medium. In Motherwell's work, drawing is tearing, and the implied violence and unpredictability of the torn edge (so different from Braque's clean edges of newsprint or Matisse's scissor-cut paper) embodies chance: it is the equivalent of the unforeseen spatters in his paintings. No one can tell how a piece of paper will go when it is torn. It is Surrealist automatism: chance, fixed. This mix of violence and elegance, along with the large size of the images, was Motherwell's addition to the art of collage. It is epitomized in pieces like *Unglueckliche Liebe* (Unhappy Love), 1975 (Figure 294), with its soaring white bird form contrasting with the fragment of sheet music whose words apostrophize the miseries of passion: "Begone, begone, ye children of Melancholy!"

Surrealism continued to linger in American art after the 1940s, but not the same strand that had affected the Abstract Expressionists. It was more theatrical, and its given form was the box with found objects assembled in it—the box as miniature stage. One sculptor who explored its possibilities to dramatic effect was Louise Nevelson (1899–1988). Nevelson's work belonged to a broader current of junk-assemblage sculpture, by artists like John Chamberlain, who used crushed auto bodies, Richard Stankiewicz, and Mark di Suvero, but she did not use steel.

293. Robert Motherwell, *Elegy to the Spanish Republic LXX,* c. 1961. Oil on canvas, 69 × 114″ (175.3 × 289.6 cm). The Metropolitan Museum of Art, New York; anonymous gift, 1965.

294. Robert Motherwell, *Unglueckliche Liebe,* 1975. Acrylic and collage on canvas board, 48 × 36″ (121.9 × 91.4 cm). Private collection.

Her material was wood—stray bits and pieces from the street, from junkyards, from antiques shops: scroll-sawed offcuts, bits of molding, battered planks, balusters, toilet seats, gunstocks, dowels, finials—anything that seemed to have some character. She would then arrange these abstract forms in shallow trays or boxes, which by the early 1950s she was stacking up into enviromental walls, sprayed flat black. She took the box's power as theater and subjected it to a constructivist rigor of formal layout (Figure 295). The flatness of the screens seemed pictorial—she had studied with Hans Hofmann, who always kept on at his students about the importance of the picture plane. The shallow space became a dark reef of nuances, shadow vanishing into deeper shadow. In her romanticism, Nevelson's was perhaps the nearest sensibility in American art to Martha Graham's in dance.

Without much question, however, the finest American heir to this side of Surrealism was Joseph Cornell (1903–1973). There were no large Cornells. His tiny images, however, opened onto vast tracts of the imagination. He spent most of his life in a frame house on Utopia Parkway in Queens, New York, with his mother and his crippled brother, Robert. From there this reclusive, gray, long-

295. Louise Nevelson, *Sky Cathedral,* 1958. Assemblage: wood construction, painted black, 135½ × 120¼ × 18″ (344.2 × 305.4 × 45.7 cm). The Museum of Modern Art, New York; gift of Mr. and Mrs. Ben Mildwoff.

beaked man would sally forth on small voyages of discovery, scavenging for relics of the past in New York junk shops and flea markets. To others these deposits might be refuse, but to Cornell they were the strata of repressed memory, a jumble of elements waiting to be grafted and mated to one another.

In the studio he would sort his finds into their eccentric categories—"Spiders," "Moons," and so forth—and file them with boxes of his own mementos, like love letters to Jennifer Jones and other movie stars or ballet dancers he'd never met; and from them he made boxes. He would tinker with them for years. *Object (Roses des Vents)* (Figure 296) was begun in 1942

and not finished until 1953. It is full of emblems of voyages Cornell never took, a little box of mummified waves and shrunken exotic coasts, peninsulas, planets, things set in compartments, with a drop-in panel containing twenty-one compasses, each with its needle pointing insouciantly in a different direction from that of its neighbor. Even the map on the inside of the lid, cut from some nineteenth-century German chart book, depicts an excessively remote coastline: that of the Great Australian Bight. The earth is presented not as our daily habitat but as one strange planet among others, which to Cornell it was.

Some of his beginnings in the 1930s lay in Surrealism: Cornell was particularly affected by the collages of Victorian steel engravings in Max Ernst's series *La Femme 100 têtes.* Yet nowhere in Surrealism is there an imagery quite like his. Cornell distinguished between what he called "the Max Ernst white magic side" of Surrealism and its darker, more violent aspects. He embraced the first but shied away from the second. He didn't share the revolutionary fantasies of the Surrealists or their erotic obsessions. There isn't a sexual image, let alone a trace of *amour fou,* in his entire output. The most he would permit himself was a gentle fetishism. If, as some have thought, Cornell's imagery had to do with childhood, then it was one which no child has ever known, an infancy without rage or desire. Sometimes he would crack the glass pane that protected the contents of the box, but that is all he allowed in the way of violence—it suggests that the sanctuary of imagination has been attacked. That glass, the "fourth wall" of his miniature theater, is also the diaphragm between two contrasting worlds. Out-

296. Joseph Cornell, *Object (Roses des vents),* 1942–53. Wooden box with twenty-one compasses set into a wooden tray resting on Plexiglas-topped and -partitioned section, divided into seventeen compartments containing small miscellaneous objects, and three-part hinged lid covered inside with parts of maps of New Guinea and Australia, 2⅝ × 21¼ × 10⅜″ (6.7 × 53.7 × 26.2 cm). The Museum of Modern Art, New York; Mr. and Mrs. Gerald Murphy Fund.

297. Joseph Cornell, *The Hotel Eden*, 1945. Assemblage
with music box, 15¼ × 15⅝ × 4¾″ (38.3 × 39.7 ×
12.1 cm). National Gallery of Canada, Ottawa.

side, chaos, accident, and libido, the stuff of unprotected life; inside, sublimation, memory, and peace, one of whose chief emblems was the caged bird, the innocent resident of *The Hotel Eden*, 1945 (Figure 297).

At times, though not often, Cornell's imagination looks fey or precious. There is a treacherous line between sentiment and sentimentality, particularly in his evocations of his own Edwardian environment as a child. Yet his gothic fantasies and fussily reverential evocations of dead Victorian ballerinas—Marie Taglioni being a special favorite—are usually drawn back from the edge by Cornell's rigor as a formal artist. Not for nothing did he call himself a "constructivist." Cornell was intensely Francophile, though he had never been to France—witness his many references to French provincial hotels, and even by the worn, comfy French colors of his box interiors, the ivory whites and pinks and faded blue-grays. But he was, just as intensely, an *American* artist, with his asexual Puritan imagination and his belief in unsullied purity, expressed in the strict architecture within his boxes: white compartments and pigeonholes, sometimes—as in his series of "Dovecotes"—without anything else in them. It is an imagery of New England spareness, suggesting clapboard meetinghouses, plain fences, and rectitude above all.

During his life, which ended in his fifty-ninth year when his pickup truck skidded off a country road in Vermont, David Smith (1906–1965) was the most inventive sculptor America had. Thirty years later, he still is. He worked in iron, and he explored its possibilities more fully than any artist before or since—more, even, than Picasso or Julio Gonzalez, the Spaniards who were the first modern artists to make welded sculpture. Iron didn't have a history, like bronze or marble. It was industrial, it spoke of the machine age, its direct power, structure, mobility, brutality, eroticism. All of that was in Smith's work. "What are your influences?" he was repeatedly asked, and some time in the fifties he came up with a rambling free-verse answer that ran, in part:

> From the way booms sling
> From the ropes and pegs of tent tabernacles
> and side shows at county fairs in Ohio
> from the bare footed memory of unit relationships
> on locomotives sidling
> through Indiana,
> from hopping freights, from putting them together
> and
> working on their parts in Schenectady
> from everything that happens to circles
> and from the cultured forms of women and the free
> growth
> of mountain flowers . . .

Such lines are not, of course, a description of Smith's own sculpture. But they poignantly evoke the spirit of his work, rooted in a broad recapitulation of memory, physical feeling, and hard manual work with resistant materials. Iron was in Smith's name, of course, and in his family history and social environment as well. He was born in Decatur, Indiana, the descendant of a nineteenth-century blacksmith, and his sculptural language flowed naturally out of a childhood in the part-mechanized heart of America, the country of railroads and manufacture and invention. "We used to play on trains and around factories," he recalled. "I played there just like I played in nature, on hills and creeks." Huck Finn, with nuts and bolts. But art grows out of other art, and what opened the sluices and let Smith's abundant childhood associations flow into a career as a sculptor was seeing photographs (not the originals, which were unknown in New York) of the metal sculpture of Picasso and Julio Gonzalez in an art magazine published in the early thirties. Smith had wanted to be a painter; he now began to realize that iron could be handled as directly as paint. But his work reminds one that the history of twentieth-century iron and steel sculpture, sometimes treated as continuous, is actually branched. On one side, there was the artisan-based, forged-iron tradition that came out of Catalunya, where Gonzalez had worked, and continues to this day in such artists as Eduardo Chillida. Because it entailed forging shapes from blocks of metal, it was closer to the traditional monolith of sculpture. And then there was the industrial strain, based on welding together plates, rods, and bars—the main line of Constructivism, originating with Picasso's celebrated sheet-metal Cubist *Guitar* of 1912–13. Smith was a welder, not a forger.

He was also a *bricoleur* of gargantuan appetite, a user-up and redeemer of discarded things, a collagist in three dimensions. His work as it developed touched base with the fundamental modernist movements, seizing and transforming something from each of them. From Cubism and Constructivism came the planar organization of forms and the abstract language; from Surrealism, the sense of encounter with a "personage" latent in some of the sculpture, as basic to his work as it was to Miró's. Given enough found metal, he could launch into runs of profuse and astonishing inventiveness: in the last thirteen years of his life Smith completed more than four hundred works, in different series, varying widely in their formal concepts and approach to material—some painted (the *Zigs* of 1961–64), some left rust-raw (the *Voltris* and *Voltri-Boltons*), and others done in polished stainless steel (the *Cubis* of 1963–65). The most notable of these outbursts came in 1962, when he was invited to make a sculpture for the Spoleto Festival in Italy. On going there he found, in the nearby town of Voltri, five deserted steel mills littered with offcuts, sheets, bars, and, best of all, tons of abandoned tools and equipment, from calipers and wry-necked tongs to the ponderous, archaic-looking iron wagons and barrows used to run hot forgings from one part of the work floor to another. From these he made twenty-seven

298. David Smith, *Voltri VII*, 1962. Iron, 85 × 122⅞ × 43½″ (216 × 312 × 110.5 cm). National Gallery of Art, Washington, D.C.; Ailsa Mellon Bruce Fund, 1977.

sculptures in a single month, then had the leftovers shipped back to his studio at Bolton Landing, New York, to complete the *Voltri-Bolton* series.

In a work like *Voltri VII*, 1962 (Figure 298), one sees the power that Smith could develop from the collision of the archaeology of the new (abandoned steel) and that of the old (the Italian environment, as mythic to him as to countless other artists). Its image is that of a chariot—a thin bar of forged steel supported at one end by a prop and at the other by two spoked wheels on a U-shaped axle. One thinks of Etruscan chariot images, or, closer in time, Roman funerary biers used to parade sarcophagi. Welded to the bar are five roughly S-shaped vertical elements, bar forgings Smith found in one of the Voltri mills. Although Smith said "they are not personages," they do read as such, solemnly bowing on the sculpture's spine. It is a work of remarkable richness and dignity, but although ten feet long and seven high, it is not "monumental" in the expected sense. Like almost all his pieces, it is made to the scale of one man, for human scale was of immense

importance to Smith and accounts for the alertness with which his work addresses the spectator. It called, he said, for "response in close proximity and the human ratio." By such means he wanted to focus the image, make it speak to one pair of eyes, one mind at a time, as precisely and earnestly as possible. Many of Smith's sculptures are "totems" which suggest a figure and accordingly evoke responses from one's own body. They convey forceful impressions of posture and gesture. Smith was not in the business of making large iron dolls, and it may be, as various critics have pointed out, that the usual verticality of his sculptures encourages one to read them too readily as effigies of the figure. But in the end, the body messages of his sculpture don't depend on whether the pieces have "heads" or "legs," as quite a few do. They flow from the internal relations of the forms and from the metaphorical suggestions of tension, spring, alertness, and so forth that their "drawing in space" sets up.

Often Smith painted his work in polychrome, a habit of which Clement Greenberg apparently disapproved, since after Smith's death he had the paint stripped from a number of the sculptures at Bolton Landing—an extraordinary violation of an artist's posthumous rights in the name of a critic's opinion. The high colors and splashy textures with which Smith painted the steel were certainly meant to be seen against the colors of tree, snow, and autumn grass.

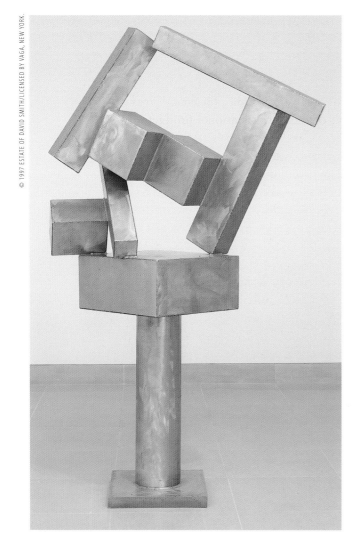

Placing sculpture outdoors, in natural light, came to matter greatly to Smith by 1957, when he embarked on a sequence of pieces in stainless steel: first the *Sentinel*s, and then his last series, the *Cubi*s. At first he had divided feelings about outdoor siting, since he felt it was "historic or royal and has nothing to do with the contemporary concept": landscape all around seemed to diminish the work; "far away it makes less demand on the viewer." But then he realized that, especially with the highly reflective material of stainless steel, one could bring sunlight and color into the work to develop the illusion of surface and

299. David Smith, *Cubi XVII*, 1963. Polished stainless steel, 107³/₄ × 64³/₈ × 38¹/₈" (273.7 × 163.5 × 96.8 cm). Dallas Museum of Art; The Eugene and Margaret McDermott Art Fund, Inc.

depth. "There is a sort of golden color reflected by the late afternoon sun in the winter, and [the sculpture] reflects a rather golden color; and when the sky is blue, there is a blue cast to it. It does have a semi-mirror reflection, and I like [stainless steel] . . . because no other material in sculpture can do that." From it he wanted to make "a structure that can face the sun and hold its own against the blaze and power." The silvery planes of the *Cubis*, scribbled with stuttery, glittering lines by the rapid "drawing" of a power grinder—a freehand texture over the architectonic blocks of form—respond better to sunlight or starshine than to the static lighting of a museum. They create a grand architectural presence, with overtones of portals and sacrificial altars or even, as in *Cubi XVII*, 1963 (Figure 299), something on a more intimate scale written large—a still-life table, the *guéridon* of Cubism, with canted corner-welded blocks flying above it. Such a range of expression, culminating in the *Cubis*, had never been seen in American sculpture before and has not reappeared since. Smith was to the twentieth century what Augustus Saint-Gaudens had been to the nineteenth. "Oh, David," wrote his best friend Robert Motherwell, in one of the most moving valedictions ever offered to a dead American artist by a live one, "you were as delicate as Vivaldi and as strong as a Mack truck." And so he was.

For most Americans, though, the most eloquent sculptural object in their lives wasn't something that recalled the world of blacksmiths and railroads. It was a car. In the 1950s Americans put 20 percent of their gross national product into cars, and they owned three out of every four cars in the world. And the finny dreamboats were the ideal. They were designed and marketed as fantasies: as works of art, in fact, in their own right. They were unveiled, like public sculptures, on rotating plinths, under spotlights. Their makers in Detroit rejected the dicta of Puritan heritage behind the early Fordian idea of a black box on four wheels. The fifties car was a rocket, onto which a heavy layer of symbolism and body metaphors was packed. It had things ostentatiously both ways, as both womb and phallus. The dreamboat had the tail of a rocket and the chrome breasts of Jayne Mansfield—a design feature that the designers, in homage to a now forgotten Scandinavian sex bomb of fifties TV, called a "Dagmar." When you hit the brakes, the whole rear end lit up red, like a robot animal in heat. Ultramatic ride, Dynaflow penetration. Triumph, lust, aggression, and plenty of room for the whole family: the siren song of imperial America. Nothing like them will ever be made again. They're the rolling baroque public sculpture of a culture that has gone forever.

What counted was image, which Detroit was happy to supply, and dreams, which it was expert at provoking. Image also meant enhanced turnover. Changes of "features," of styling, shifted into what the business language of the day called

"dynamic obsolescence." It meant raising desire by changing style every year. The '55s would keep rolling for a few years yet; only their image rusted out fast and needed total replacement by the '56s, an idea which would have struck Henry Ford as blasphemous, if not mad. The image-saturated dreamboat obeyed the same laws of gratuitous change as would come to govern the American art market through the myth of the avant-garde.

If the dreamboat was mass luxury and fantasy, so were other consumables. The war was long past, and rationing (never severe in America anyway) just a memory. Now the cornucopia of American industry tooled up, tipped, and released a cataract of styling: fridges, toasters, Formica countertops, juicers, microwaves—gaudy, lush, avocado-colored and hot pink, chrome everything, and big. These were the rudiments of capitalist paradise, and they carried a strong political message. It became explicit at a trade fair in Moscow in 1959, to which America sent an ideal modern kitchen with ideal air-hostess girls in crisp aprons to demonstrate it. This techno-Arcadian domestic scene became the site of the "Kitchen Debate," when Richard Nixon (then Dwight Eisenhower's Vice President) escorted the Soviet leader Nikita Khrushchev through it. Look, said Nixon, this is what the American housewife has. And Khrushchev lost his temper, shouting "These things are gadgets! Mere gadgets! They don't count!" But of course they did count, deeply—although many of the American intelligentsia at the time would have agreed with Khrushchev.

The problem was that in the postwar years American artists and intellectuals did want to be part of America. The old Abstract Expressionist stance of negation and alienation could not hold. Somehow, an artist or a writer had to enter the stream of common American life without giving up his outsidership, his cherished tradition of critical nonconformity. But that stream was now controlled, directed, and sustained by an ever-expanding mass culture, whose sheer weight and power consigned the "high" artist, if not to irrelevance, then to the social margin: a spectator, outside looking in. The anguish of this situation prompted Clement Greenberg to write his well-known essay "Avant-Garde and Kitsch," in 1939; the problem would be endlessly debated after the war, and into the 1950s.

America was consolidating very fast. It was homogenized by the spread of new highway systems that made national distribution of uniform goods easier than ever before; by the growth of airlines and of fast, easy travel in general; by the replication of identical supermarkets, retailing chains, and franchises that slowly drove out the idiosyncrasies of the village market and the corner store. Tectonic shifts took place in housing, first in a postwar flight to the suburb (that *locus classicus* of social conformity) and then in a drive to renew faltering city centers, often at the expense of their surviving historical fabric, which most visibly defined one city's difference from another. The sub-Bauhaus, corporate glass box made them all look the same.

But the greatest change in the American pattern was not in bricks and mortar but in media. Through the 1950s television—once a little glowing screen the size of a dinner plate with flickering gray images on it—took over the life of Americans. It rearranged their domestic habits, it filled up their waking hours, it administrated their dreams and taught them their desires. It was the most powerful means of advertising that had ever been devised, and very soon the tiny group of meganetworks that controlled it realized that the best way to make it profitable was to turn all its content into a mere carrier for ads. The entire content of television was thus shaped by the imperatives of the market. Since the 1950s and 1960s also brought new and infinitely more sophisticated techniques of market research and audience-sampling than had ever existed before, this guaranteed that all TV would be aimed at the Great Middle; and by a kind of cybernetic feedback, the desires of the Middle, once shaped by TV's power, were easily sounded out and became the pretext for further Middling. The rapid expansion of an American mass culture meant that more Americans were required—by their peers, their authorities, their media—to hold the same values and symbols in common and not deviate from them.

The result was unification: an enormously enhanced belief in *an* American culture, arising from the pervasiveness of American *mass* culture. The phrase "the American way of life," as though there was only one, had never been heard so often as in the 1950s—it would have meant very little to most Americans in the eighteenth or even the nineteenth century, who still tended to regard America as the great open field on which different ways of life could rub along freely, side by side, in friction and tolerance. But there was something distinctly coercive about the idea of "*the* American way of life."

As television's power eclipsed radio's, it weakened American regionalism by giving all Americans the same images of desire through ads and the same fantasy images through narrative. In short, a huge administrated monoculture began to grow, and it started to blot out the earlier ideas of a Texan, a Virginian, a Californian, or a New York cultural ethos. It worked in the same way as the death of the frontier had, sixty years before. Just as the vanishing of the mythic West only made its fictive images vastly more popular, so the massing and incorporation of American culture produced intense nostalgia for "old" and "real" America, its folkways and idiosyncrasies, its threatened values. Naturally, television and other media then fed off this, recycling folk stuff and small-town imagery in an endless loop into the national monoculture and dramatizing "difference" with shows like "The Beverly Hillbillies." The analogue of this process, in art, was the popularity of certain painters whose work evoked lost or fading Americas of one kind or another. There was Anna Mary Robertson Moses (1860–1961), Grandma Moses, the folk-primitive painter from Eagle Bridge, New York, with her copious and ever-charming vignettes of rural America. There was Andrew Wyeth

(b. 1917), whose austerely dun-and-gray realist pictures of reclusive New Englanders, bleached frame houses, and open windows with lace curtains blowing a little spookily in the wind provided images of hardscrabble Puritan rectitude, tinged with close-lipped sentimentality: to this day, *Christina's World,* 1948 (Figure 300), his subtly ominous painting of a polio-crippled girl gazing at a distant house and apparently crawling toward it (according to Wyeth, though, she was picking berries) vies with *American Gothic* in popularity.

But most of all, there was Norman Rockwell. Grandma Moses and Wyeth had owed much to mass reproduction of their work, but Rockwell's fame was inseparable from it. From the day in 1916 the *Saturday Evening Post* hired him as an illustrator, he was greeted by nothing but recognition. Large-scale magazine color illustration was the TV of preelectronic America; by 1925 Rockwell was a national name, and by the end of the Depression he was an institution. In the 1950s he shared with Walt Disney the astonishing distinction of being one of the two American visual artists familiar to nearly everyone in the United States, rich or poor, black or white, illiterate or Ph.D. To most of them, Rockwell was a master: sane (unlike van Gogh), comprehensible (unlike Picasso), and perfectly attuned to what they wanted in a picture.

A *picture,* not a painting. Practically none of his audience ever saw an original Rockwell. His work addressed its vast audience through reproduction alone. Its images had no surface. Its minute verisimilitude—as well as the exaggeration of

300. Andrew Wyeth, *Christina's World,* 1948. Tempera on gessoed panel, 32¼ × 47¾″ (81.9 × 121.3 cm). The Museum of Modern Art, New York; purchase.

every wink, scowl, grin, and pout on its characters' faces—had the depthless narrative clarity of TV. It offered Arcadia. In Rockwell's America, old folk were not thrust like palsied, incontinent vegetables into nursing homes by their offspring; they stayed basking in respect on the porch, apple-cheeked and immortally spry. Kids did not take Ecstasy and get pregnant; they stole apples but said grace before meals. The great social fact was family continuity. It was a world unmarked by doubt, violence, or greed. The mountainous Thanksgiving turkey that appears in *Freedom from Want*, 1943 (Figure 301), is a symbol of virtuous abundance rather than extravagance, a Puritan tone confirmed by the glasses of plain water on the table.

Norman Rockwell was homelier than apple pie, more American than the flag, gentler and more affirmative than Dad, and that was what the American public in the early 1950s wanted.

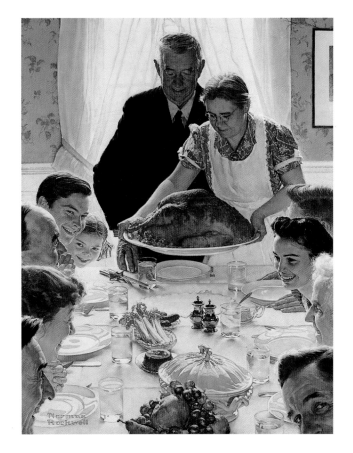

What could younger artists do with the enormous, bland, and yet imperially demanding constructions of Middle American mass culture? They were right in the midst of them, affected, even formed by them. Some were fascinated by its icons but wary of their implications. They felt a compulsion to analyze and to reflect this new Americanism without being overwhelmed by it.

The solution was irony—not a tool in the older Abstract Expressionist kit. One sees it beginning to peep through in a painting from 1953, by the young artist Larry Rivers: *Washington Crossing the Delaware* (Figure 302). Its title came from one of the best-known American history paintings of the nineteenth century, by Emanuel Leutze, reproductions of which hung in half the classrooms of America: the *pater patriae* forging to victory across the frozen river at the prow of his boat. Rivers's painting, by contrast, is fuzzy and indecisive-looking. Washington is a blurred figure standing alone in a dinghy. His head, Rivers later pointed out, was based on a drawing by Leonardo da Vinci, *An Old Man in Hell*. Uncertain figures appear at various distances from him. The American flag, which centered Leutze's composition with its blazing promise, is not there. The inhabitants of this history painting might as well be digging clams for all the des-

301. Norman Rockwell, *Freedom from Want,* 1943. Oil on canvas, 45¾ × 35½″ (116.2 × 90.2 cm). Permanent Collection, Norman Rockwell Museum, Stockbridge, Massachusetts.

tiny they radiate. So it is not a painting to inspire the patriot. But then, Rivers (who had been reading *War and Peace*) was thinking more about Napoleon's retreat than Washington's advance. Above all, he wanted to offend the New York art world's own taste, which found the very idea of history painting anathema, and figuration itself not much better. "I wanted," he recalled, "to do something the New York art world would consider disgusting, dead and absurd. I was branded a rebel against the rebellious abstract expressionists, which made me a reactionary." Other painters, as yet unheard of, got the message: an art teacher in Ohio named Roy Lichtenstein laid aside the orthodox abstract paintings he was doing and, rather tentatively, began one of cowboys and Indians. Two years later, Jasper Johns painted a flag.

By then, in America, to be a patriot was not enough. Victory in World War II, possession of the Bomb, and a stupendous global economic expansion had all combined to confirm the long-standing belief in exceptionalism—that Americans were a unique and anointed people, enacting a sacred history on earth—which

302. Larry Rivers, *Washington Crossing the Delaware*, 1953. Oil, graphite, and charcoal on linen, 83⅝ × 111⅝" (212.4 × 283.5 cm). The Museum of Modern Art, New York; given anonymously.

had been one of the motifs of American culture since the Puritans arrived with it in the seventeenth century. But this confidence was both sustained and imperiled by the Cold War. Exceptionalism required constant fueling by paranoia to keep it at boiling point. Hence the apocalyptic anti-Communism of politics in a country which, having defined its ideology of "Americanism" in terms of individualism and private enterprise, saw its polar opposite in Soviet Russia. The sense of apocalypse was popular. It afforded a frame in which Americans could see themselves. They did not need a government to create it for them: the frenzy of the anti-Red witch-hunts came, not from the White House, but from either bureaucrats like J. Edgar Hoover or from squalid and opportunistic "primitives" (Dean Acheson's phrase) like Senator Joseph McCarthy, whose denunciations and tribunals struck terror into American cultural and political life for four years without unmasking one certifiable Red spy.

The atmosphere of superpatriotism and fear of "the enemy within" dumped an extraordinary excess of meaning into American public icons, most obviously the flag. Americans had always revered the Stars and Stripes as their prime symbol of national identity, but now they began to worship it rather as Catholics do the consecrated Host. No other nation treats its flag the way Americans do theirs. It is a peculiarly sacred object. You must handle it with care, fold it in a ritually specified way, salute it, and never allow it to touch the ground. To burn or deface it is a supercharged political act, and right-wingers are always trying to create a constitutional amendment to punish such indignities. But on the other hand, Americans make jeans, T-shirts, and underwear out of it, and use it to advertise everything from gas stations to hot-dog stands. And some, intrigued by the penumbra of irony about this symbol, made paintings of (or from) it.

The best-known and most influential of these was to be a young artist, originally from South Carolina, who had moved to New York in 1952: Jasper Johns (b. 1930). One night in 1955, by his own account, he had a dream of painting a large American flag, and the following morning he got up and began to do so. He would play with the flag motif for several decades more, rendering the Stars and Stripes in wax encaustic paint on newspaper collage, in oil on canvas, in bronze, pencil, lithography, and Sculpmetal. Johns's fascination with the flag came, in part, from his very nuanced and ironic feelings about the function of art, particularly in America and most especially after Abstract Expressionism. American abstract painting had been full of displays of transcendentalist ambition, not tied in any clear way to the specifics of contemporary American culture; its "field" painters in particular shunned any embrace of what could be recognizably American. It had also, in its followers, created an academy of "authenticity," sign of the hot, tragic and inventive sensibility. Johns wished to work with something that was *not* invented, something so well known, as he put it, that it was not well seen. Hence the flag. In real life, after Johns, the flag continued to be the com-

munal property of all Americans, the climax of their stock of public symbols. But in the art world it belonged almost entirely to Johns; it became his sign. Other artists would include flags in their work in a spirit of protest and provocation. Johns never did; his flags had a beautiful and troubling muteness. They were cooler than the culture wanted them to be, in the midst of the Cold War.

The American flag is an abstraction—the most recognized abstraction in the world. Americans still argue about what it means, what social values it symbolizes, but they all know what it is. So is a *painting* of an abstraction a representation? Is Johns's *Flag*, 1954–55 (Figure 303), a flag or a painting? The question runs back to René Magritte's ancient brainteaser about representation, a picture of a pipe with *Ceci n'est pas une pipe* (of course not: it's a picture) written above it.

Flag resembles a flag in its design, forty-eight stars and thirteen stripes, and in the cloth it is painted on. But it is actually made, not of cloth, but of paint, and it does not "fly"—it is static, stretched, rigid, and completely iconic. You are also meant to pay attention to its surface, which never happens with a real flag. This surface is beautifully articulated, in an impasto of encaustic pigment over a ground of glued-on newspaper, some of whose print (its words meaningless to the image, as they were not in Cubist collage) shows through.

Yet the very finesse of the surface detracts from the flag's political meanings,

303. Jasper Johns, *Flag*, 1954–55. Encaustic, oil, and collage on fabric mounted on plywood, 42¼ × 60⅝" (107.3 × 153.8 cm). The Museum of Modern Art, New York; gift of Philip Johnson in honor of Alfred H. Barr, Jr.

makes it more autonomous as a painting. This was part of Johns's game. He altered the image of the flag to suit the distancing imperatives of style. It could become a ghost of itself, as in *White Flag*, 1955 (Figure 304), where the patriotic design recedes into an underlying fossil beneath the surface, which is mostly what counts: that pale, perfect skin of white encaustic, exquisitely nuanced. Or the flag, abandoning all trace of its softness, could become a rigid metal plaque; or be half lost in the silvery shadings of a pencil rendering. Sometimes the stripes are longer than they should be, or there are more stars. All these willful changes produce a double reaction. On the one hand, Johns seemed devoted to the flag—but his devotion was esthetic, not patriotic. On the other, by treating its sacred form as mutable, he undermined it as a conventional symbol. But since he did so without any visible aggression or skepticism, you could not tell where he stood in the American patriotic frame. A flag, after all, produced automatic reactions, and Johns's project as a painter was to confuse such responses. This very ambiguity, set in such a frame, set up a whisper of disturbance: though it was never publicly attacked, Alfred Barr after some hesitation decided not to buy a Johns flag for the Museum of Modern Art in 1958, in case it raised patriotic hackles.

Much the same thing happened with Johns's less obviously charged target paintings in the 1950s. On one level, the target—a configuration which, like the

304. Jasper Johns, *White Flag,* 1955. Encaustic and collage on canvas, 78⁵/₁₆ × 120³/₄″ (200.5 × 306.7 cm). Collection of the artist.

flag, everyone knows from childhood—is completely unambiguous, a test pattern of skill for marksmen. Concentric rings; either you hit the bull's-eye or you don't. But beneath their muteness, targets are supercharged with imagery of aggression. A target always implies a weapon. But what about a target that disappears in its own painterly aura, without clearly marked rings, as in *Green Target, 1955*? Can a target be vague, camouflaged in paint, and yet remain what we call a target? Does it *want* to shrink from the marksman's gaze, and disappear?

Probably. The submerged text in Johns's target paintings connects to the stresses of Cold War America. To begin with, the whole nation felt it was a target. Magazines, newspapers, television, and politicians' speeches repeated this theme unceasingly, pounding it into the collective imagination like a ten-inch spike. There, over in Russia, were countless ICBMs in their silos, pointing their nuclear tips at you, and you, and you. Since the patriotism of World War II, no collective emotion in America had exceeded—or perhaps ever will exceed—the mingling of fear and denial at the unimaginable prospect of all-out thermonuclear war between the United States and the USSR. The diffused sense of being a

target in mutual apocalypse is the inescapable background to Johns's targets. In 1958, the year in which his show at the Leo Castelli Gallery made him famous, he told an interviewer from *Newsweek* that "I have no ideas about what the paintings imply about the world. I don't think that's a painter's business. He just paints paintings without a conscious reason." One need not believe this mask. There is no more self-conscious American artist than Johns.

But then, there was a second and more personal level of "targeting," expressed in Johns's *Target with Four Faces, 1955* (Figure 305), and *Target with Plaster Casts, 1955*. Through the 1950s, and especially in the McCarthy years, American hatred of homosexuals ran particularly hot. The idea that homosexuality was not only unnatural and repulsive in itself, but that (in officials and bureaucrats) it constituted a security risk to the American

305. Jasper Johns, *Target with Four Faces,* 1955. Assemblage: encaustic and collage on canvas with objects, 26 × 26″ (66 × 66 cm) surmounted by four tinted plaster faces in wood box with hinged front. Box, closed, 3³/₄ × 26 × 3¹/₂″ (9.5 × 66 × 8.9 cm). Overall dimensions with box open, 33⁵/₈ × 26 × 3″ (85.3 × 66 × 7.6 cm). The Museum of Modern Art, New York; gift of Mr. and Mrs. Robert C. Scull.

state, and that it had secret affinities with Communism, went virtually unquestioned. Indeed, if you did question it, that said something about you. Jasper Johns was a reserved, closeted gay. *Target with Four Faces* is all about threat and concealment; its impassive, identical plaster casts of faces are contained in boxes with hinged doors, small "closets" in a row above the ominous target. Your gaze, in looking at the target, is assimilated to the eye of the inquisitor, hunting out what is concealed. It is a pessimistic and, above all, defensive work.

Because of their early friendship, and because both men emerged as stars at the same time, Robert Rauschenberg (b. 1925) is habitually bracketed with Johns. But in fact, they had very little in common as artists beyond a love of popular culture, an intense interest in the iconography of America. Johns was elusive, cool, withdrawn; his work declined to give anything away. Rauschenberg was effusive, hot, and generous; he had difficulty holding anything in reserve. Rauschenberg breathed out, Johns breathed in. Johns was a masterly curator of his own reputation, partly because the linguistic conundrums embedded in his work were catnip to the higher 1960s criticism. But Rauschenberg had a much more direct effect on other artists. It was largely to his prancing, careless, and fecund talent that America in the 1960s and 1970s owed a basic cultural assumption that a work of art could exist for any length of time, in any material (from paint to silk to a stuffed goat to a patch of earth to a live human body), anywhere (onstage, on a video screen, on the surface of the moon, underwater, or in a sealed envelope), for any purpose (invocation, threat, amusement, contemplation, or sexual turn-on) and find any destination it chooses, from the museum to the trashcan. In those years Rauschenberg was a protean genius who showed Americans that all of life could be open to art. Since his work went against all the prevailing assumptions of American formalism, he was much detested. Rauschenberg didn't give a fig for consistency, or curating his reputation; his taste was always facile, omnivorous, and hit-or-miss, yet he had a bigness of soul and a richness of temperament that recalled Walt Whitman.

Milton, later Robert, Rauschenberg was born in 1925 in Port Arthur, Texas, a shabby, humid oil-refinery town on the Gulf of Mexico. He was part German and part Cherokee Indian. The closest thing to art he saw as a child were the cheap religious chromolitho cards pinned up in the family living room: the memory of these would later surface in his work in the 1950s. His education was haphazard, his grades poor. He enlisted in the U.S. Navy and spent the last years of World War II as a mental-hospital nurse. Discharged in 1945, he decided to study art, and set off—where else?—for Paris. It was a mistake; he spoke no French and felt queasy and disoriented, surrounded by an already academized modernist tradition that he could not grasp.

Back in America by 1948, he enrolled at Black Mountain College in North Carolina, where the painter Josef Albers—a veteran of the Bauhaus, held in awe as a theorist and disciplinarian—ran the art department. Albers despised Rauschenberg's efforts (years later, when his ex-pupil was famous, the old maestro of the painted square pretended not to remember him at all), but Rauschenberg got two essential things from him. The first was a sense of discipline, or at least the need for it. The second was Albers's habit of sending the students out to find "interesting" objects, anything from an old tin can to a stone, and bring them into class as examples of accidental esthetic form. This laid the ground for Rauschenberg's later scavenging.

Moreover, Albers was not the only charismatic figure at Black Mountain. The composer John Cage and his friend the dancer-choreographer Merce Cunningham were living there too, and if advanced American art through the 1950s and early 1960s had one single native guru, that man was Cage, the Marcel Duchamp of music, who erected combinations of silence and random sound into esthetic strategies. It was Cage's example that prompted Rauschenberg to make his much-quoted remark that "painting relates to both art and life. . . . I try to work in the gap between the two." And when he moved back to New York in the fall of 1949, the first sense he had of a community of artists came, not so much from painters, as from the group of dancers and musicians gathered around Cunningham, Cage, and the composer Morton Feldman: as set designer and occasional participant onstage, Rauschenberg was to have an effect on avant-garde American dance.

In New York he was in the midst of a junk-crammed environment. An afternoon's stroll gave him a complete "palette of objects," as he called it, to make art

with: cardboard cartons, striped police barriers, sea tar, a stuffed eagle, a broken umbrella, grimy postcards. These relics were sorted out in his studio, glued to surfaces, punctuated with slathers of paint. They emerged as large-scale collages, which he called "combines." Of course, their roots are fixed in the history of Dada and Surrealist collage, and particularly in the work of Kurt Schwitters. He was particularly influenced by the way Schwitters composed on a horizontal-vertical grid, a vestige of Cubism. That effect shows in early Rauschenbergs like *Rebus*, 1955 (Figure 306), a curiously fugitive image despite its size, full of airy space and emblems of flight: the Winds from Botticelli's *Birth of Venus*, photographs of a bee, a dragonfly, a mosquito, and a fly's eye. The collage bits were veiled in dark washes and white scumbles of paint, as the images in Rauschenberg's *Hoarfrosts*, some twenty years later, would be veiled by translucent panels of silk. A rebus, Latin for "with things," is a picture puzzle in which images stand for pronounced words. Sometimes Rauschenberg chose not to build up his implied narratives in this indirect way: he went straight for a single memorable and sometimes shocking image. Thus *Bed*, 1955, is an early American quilt so slathered in red paint that it might have been the site of an ax murder, the crusty pigment a manifesto of impurity and violence. Like his friend and mentor Marcel Duchamp, he was also given to embedding a kind of ironic lechery in his combines—the best example being *Monogram*, 1955–59 (Figure 307). *Monogram* remains the most notorious of Rauschenberg's combines: a stuffed Angora goat (glimpsed and then bought for thirty-five dollars in a failing office-supply store

306. Robert Rauschenberg, *Rebus,* 1955. Oil, graphite, and collage on canvas, 96 × 131″ (243.8 × 332.7 cm). Private collection.

307. Robert Rauschenberg, *Monogram,* 1955–59. Combine: oil and collage on canvas with objects, 42 × 63¼ × 64½″ (106.7 × 160.6 × 163.8 cm). Moderna Museet, Stockholm.

on Eighth Avenue), girdled with a tire. The title is self-fulfilling: it is Rauschenberg's monogram, the sign by which he is most known. But if one asks why it became so famous, the answer can only lie in its power—funny but unsettling too, especially thirty years ago—as a sexual fetish. The lust of the goat, as William Blake remarked, is the glory of God; and this one, halfway through the tire, is an image of anal sex, the satyr in the sphincter.

In 1962–65 Rauschenberg stopped making combines and worked with enlarged photographic images, silk-screened onto canvas and then tuned or part obliterated with swipes and scrubs of paint. It was the same sensibility, but in two dimensions, and it gave him a bigger range, encompassing anything printed: a brilliantly heightened documentary flavor. The canvas trapped and accumulated images like flypaper, and one was reminded of the shuttle and flicker of a TV set in channel-surfing: rocket, eagle, Kennedy, dancer, oranges, box, street signs, buildings, all swiftly registered with the peacock-hued, aniline-sharp intensity of electronic color. He was as much a poet of information overload as he had been of material surplus. The masterpiece of this phase of his work was *Barge*, a huge (thirty-two-foot wide) black-white-and-gray canvas done under pressure during the filming of a Mike Wallace documentary in 1962–63. The title and the horizontal format refer to transportation, both of cargo and information—things being moved across America (a superhighway cloverleaf), and images of space exploration and electronic communications. It is a freely improvised riff on the sense of living in a country that was both more chaotic and more connected than ever before (Figure 308, detail).

Other silk-screen paintings include more immediately legible American icons. *Retroactive*, 1964, was made after John Kennedy's assassination, but the silk screens themselves were done before it: rather than throw away the big image of Kennedy with the pointing finger, Rauschenberg turned it into an elegy, reinforced by an image at lower right, actually a strobe photo of moving naked bodies, which irresistibly recalls Masaccio's figures in the Carmine of Adam and Eve expelled from Paradise—the loss of American happiness. Such direct political imagery, though, was rare in Rauschenberg's work. What counted more in the silk

screens was the atmosphere that evoked the culture around him—urban, electronic, and harsh: the rush and chaos of Manhattan in the choppy images of *Estate*, 1963 (Figure 274, page 464), the turmoil of sensation, the overarching sense of congestion and distraction in the glimpses of buildings, signs, and primary colors.

If Rauschenberg in the sixties was the laureate of downtown New York, Romare Bearden (1912–1988) was the narrator of a very different city-within-the-city: Harlem. In the wake of America's greatest internal moral struggle of the 1960s, the civil rights movement, various black writers had risen to national and then international fame: James Baldwin, for instance, Ralph Ellison, and Richard Wright. And yet the visual arts were curiously silent about the experience of African-Americans, because an overwhelmingly white art world, critics, dealers, museum staff, good liberals all, tended to regard blacks as a social abstraction. It was Bearden, more than anyone else except Jacob Lawrence, who set out to change this. "I felt," he once explained,

> that the Negro was becoming too much of an abstraction, rather than the reality that art can give a subject. What I'd attempted to do is establish a world through art in which the validity of my Negro experience could live and make its own logic.

His chosen vehicle for this was collage, the most eloquent medium for capturing the disjunction and impaction of city life. On the way to it, he traversed a lot of ground and did not find his style early. The son of intellectual New Yorkers, themselves deeply involved in the Harlem Renaissance of the 1920s, Bearden also spent long stretches of his boyhood and youth in the rural South and industrial Pittsburgh. The range of his acquaintance, from field-pickers, ironworkers, and Storeyville pimps to such heroes of black culture as Duke Ellington, was large; wide enough to make a novelist—or, in Bearden's case, to give a young artist—an abiding love of actuality and pictorial anecdote that abstract art could not possibly satisfy.

He had the luck to study with the German expatriate George Grosz at the Art Students League in New York in the late 1930s, and Grosz's fiercely satirical drawings from Weimar Germany gave him a model for social narrative. The urge to tell a story was always uppermost in Bearden's mind, and it came to full flower in the 1960s, forced (in part) by the need for declared identity that the civil rights movement had brought with it. In 1963 a group of African-American composers, painters, and writers formed a group called "Spiral," to figure out how their work might contribute to the movement; Bearden was one of them. He was interested, not in making propaganda, but in declaring the nature of his own experience as a black American—which, he knew, was extraordinarily remote from white reality:

308. Robert Rauschenberg, *Barge* (detail), 1962–63. Oil and silkscreen ink on canvas, 79⁷/₈ × 368″ (202.9 × 934.7 cm). Collection of the artist.

As a Negro, I do not need to go looking for "happenings," the absurd, or the surreal, because I have seen things that neither Dalí, Beckett, Ionesco, nor any of the others could have thought possible; and to see these things I did not need to do more than look out of my studio window above the Apollo Theater on 125th Street. So you see this experience allows me to represent, in the means of today, another view of this world.

It was large-scale collage that supplied a frame for this "view" from the early 1960s on. Since the work of Dada artists like Max Ernst, John Heartfield, and Hanne Hoch in the 1920s, collage had always been small—keyed to the actual size of reproduced images in print, which the artist cut up and combined. The other form of collage, which did not use print images and so was not limited by their size, had been brought to its grandest and most lyrical form in the early 1950s by Henri Matisse's *découpages*—sheets of paper painted in pure colors, cut or torn into shapes, and pasted down. Bearden developed an approach that combined both. He made his faces, for instance, from photo elements ("parts of African masks, animal eyes, marbles, mossy vegetation, etc.") and then had the small original photographically enlarged, recutting it to go in the final composition, with sudden abutments, breaks, and repetitions that worked, for him, as a visual equivalent to the jazz music he loved. Having moved from the miniaturism of collage to a larger scale, he could use paint more freely and combine his effects with the "pure" *découpage* of cut colored papers that his idol Matisse had used. It was his city collages, based on Harlem life, that carried the most punch. In *The Dove*, a ghetto street scene from 1964 (Figure 309), the emptiness of the foreground band of asphalt only accentuates the congestion of faces and bodies on

the pavement. It is crammed with faces and eyes. Faces peer from doors, windows, stoops, even a coalhole; the people in the street are as recognizable as the "types" of Victorian Londoner in the Cruikshank illustrations that Bearden also liked, from the courting couple by the lamppost on the left to the young dandy in the flat cap leaning on the fire hydrant with an enormous cigarette, to the "conjur woman," or neighborhood witch-healer, on the right, her arm extended, holding a staff of entwined serpents. One sees a city run-down but bursting with life, and this sense of vitality grows straight out of Bearden's formal system, with its sudden breaks of scale—heads too large for bodies, an enormous hand with its fingernails over the sill of an upper window—and wrenching fragmentation, stabilized just on the edge of chaos by the Cubist-derived space around them.

Bearden's work held no trace of black cultural separatism: he abhorred the very idea. He felt free to draw on the whole range of European art history, from the Sienese trecento to Matisse. But he insisted on his right to treat Afro-Caribbean culture as an equal source of inspiration, and to discover in collage a way of making visual equivalents of the greatest of black American art forms: jazz and the blues. No artist except Stuart Davis had achieved such a synthesis before, but Davis did it from outside blackness, and Bearden, more richly, from within.

In the mid-sixties, however, the eyes of the American art audience were not on Bearden (or any other black visual artist). They were fixed on more glittering things: Pop art, and the changed art world into which it sprang.

In 1964, a time when the Venice Biennale still really mattered as a sign of priorities in world art, Robert Rauschenberg was given its grand prize for his silkscreen paintings. This set off dark rumors of conspiracy, accusations that his dealer Leo Castelli had somehow fixed the prize jury, and a severe case of esthetic heartburn among Italian and French critics, particularly those on the left. It was American imperialism erupting, symbolically, into the field of culture. But in fact, Rauschenberg's victory only confirmed what the art world already knew: that, like it or not, in terms of collecting power, museum clout, promotional and dealing skills, and, not least, the amount of talent stacked up in it, New York had become the imperial center of Western contemporary art, as Rome had been in the seventeenth century and Paris in the nineteenth and early twentieth. An artist's success in Paris, London, or Milan, however gratifying, was now to be seen as only a step on the way to the final certification granted by criticism, museums, and the market in New York.

The art institutions of America were also in flux. It affected the public perception of both old art and new. The wider culture of middle-brow spectacle was encircling the museum.

309. Romare Bearden, *The Dove,* 1964. Cut-and-pasted
paper, gouache, pencil, and colored pencil on cardboard,
13³/₈ × 18³/₄" (33.8 × 47.5 cm). The Museum of Modern
Art, New York; Blanchette Rockefeller Fund.

In 1963–64 two curious events, now all but forgotten, predicted the coming future of the American museum. The first was the arrival of the Mona Lisa at the National Gallery of Art in Washington, D.C., and the Metropolitan Museum of Art in New York. The idea of bringing the world's most famous painting across the Atlantic and showing it, without any scholarly purpose or historical context whatsoever, simply as a public curiosity and a diplomatic trophy, began in 1962 with a conversation between Jacqueline Kennedy and the French minister of culture, André Malraux, during a tour of the National Gallery. President Kennedy wasn't much interested in the fine arts, though his wife was; and apart from flicking some of their stardust in their general direction, the Kennedys did nothing for the arts in America. Still, they wanted to promote themselves as Medicean idols; though the President could not actually commission the Greatest Painting in the World, he could at least show it to a grateful people and bask in the radiance of its myth. It would be a brilliant PR stroke to have Jackie and Mona, the world's two most famous babes, in the same room at the same time.

The French government's stake in the affair was just as obvious: Kennedy and de Gaulle were at loggerheads over NATO and the Common Market, and the ballyhoo over the loan of the Mona Lisa might temper American public opinion of France.

Conservators on both sides of the Atlantic protested against the "irresponsibility" of sending Leonardo's fragile limewood panel to America like a Hallmark card, but they were ignored, and Malraux declared with magnificent irrelevance that "when the American boys landed in Normandy during World War II, there was risk too." And indeed, the arrival of La Gioconda in America set off an explosion of press coverage comparable to that of D-day seventeen years before. Carried across the Atlantic on the SS *France*, in a crate strapped down to a double bed in a double stateroom, the Mona Lisa arrived in New York and was handed over, in a giant press ceremony involving many speeches and a replica cake of mille-feuille pastry and whipped cream, to the director of the National Gallery. On the President's orders, the Lincoln Tunnel was closed for "her" motorcade, which sped south to Washington at sixty miles an hour. And on January 8, 1962 (the day the new Congress opened), to even more hoopla and hullabaloo, "she" received a private viewing by two thousand dignitaries. The next day, in went the public, to view Leonardo's green ghost hung on a burgundy velvet backdrop known to the curatorial staff as "Mona's kimono," flanked by armed, full-dress Marine guards. In the first two hours of the first day, 5,500 people had shuffled past the Mona Lisa, yielding an average viewing time of 1.3 seconds per person. The National Gallery then dropped the pious fiction of the verb "to see" from its press releases, citing instead the number who had "passed in front of" the picture. In less than a month, 518,535 people did so, at an average rate of one every 1.95 seconds.

Then "she" went north to New York, to be greeted by an even greater media frenzy and a flood of advertising tie-ins. In four weeks, "she" was viewed by 1,077,521 visitors, yielding an average of 0.79 seconds per person. Never in history had so many people come to an American museum to see anything. The Metropolitan Museum had the public advance ten abreast toward the thick pane of armor-plated glass that protected "her," so that each person actually got just under eight seconds' visual contact before being chivvied on to the exit—better than Washington, but not much. The original Gioconda, throughout, was more remote and indistinct than its myriad clones in the museum shop. When Andy Warhol heard the Mona Lisa was coming, he remarked, "Gee, why don't they just send a reproduction? Nobody would know the difference." And nobody did.

The lessons of the Mona Lisa and of crowd control were applied in the second emblematic event which took place the following year, at the 1964 New York World's Fair. To it the Vatican, not to be outdone by de Gaulle, sent Michelangelo's *Pietà* as the centerpiece of its pavilion. Rather than have people lingering in front of it, the Vatican installed a moving walkway, traveling at 2.8 miles per hour. It carried you past a proscenium, and in it was the *Pietà,* looking just like a full-size reproduction of itself carved from Ivory soap. Behind it rose a ten-foot black cross with a purple penitential drape—not part of Michelangelo's intent, but an improvement by a Broadway set designer. On either side were guards, armed to the teeth. The whole spectacle took fifteen seconds. Once out and blinking in the daylight, one realized that this bizarre experience had something crucial to say about the future of the American museum.

As indeed it did. For the 1960s ushered in the age of the blockbuster exhibition, the idea of the museum as the home of the gee-whiz, populist, spectacular event, whose first Barnum was a new director at the Metropolitan, Thomas Hoving. The devising of blockbusters would not develop full momentum for another eight or ten years, but it deeply changed what the public expected from museums and, in the end, the mentality of museums themselves. It would shift the museum's emphasis away from the permanent collection and toward the temporary show, and implant a "Masterpiece-and-Treasure" mind-set. The difference between Masterpieces and Treasures was plain: Treasures had gold in them, whereas Masterpieces did not. The ur-version was Hoving's "Treasures of Tutankhamen" at the Met in 1972, but from then on the marvels proliferated to the point where almost anything from a rusty medieval helmet to a Fabergé egg could be a Masterpiece, a Treasure, or at least a Splendor. And there was a distinctly imperial subtext to this. True, America could no longer repeat the enormous scale of acquisition of old European art that had created the museums of the Gilded Age, back in the 1880s. But the Masterpiece-and-Treasure syndrome held memories of older ceremonies involving art as booty: Napoleon, for instance, parading the treasures of a conquered Italy through Paris, consciously repeating the

triumphal parade of the statues of the gods of fallen Greece through the streets of imperial Rome.

The major American museums could get such loans because they were the richest in the world, and (though not directly subsidized by government) were backed with enormous political clout through their boards of trustees, who tended more and more to be selected on the basis of their wealth and influence rather than for any particular expertise in the visual arts. (To this day, it is extremely rare for a scholar or an art historian, and all but unheard of for an artist, however eminent, to be invited to join the board of an American museum.) The fallout from this would not be seen until the 1980s, and must wait for the next chapter.

However, in the 1960s American museums also looked as never before to the present as well as the past: they began to sprout departments of contemporary art and to thicken their links to a burgeoning market in new art. Now it was important for a museum to shed whatever associations it might have had with the tomb or the temple, lest it lose its audience. Thus began the institutionalization of the American avant-garde, and the loss of its oppositional character. Once the tensions between new art and its public were defused, "advanced" art could become popular and chic—which it forthwith did. The Museum of Modern Art, incomparably the most powerful instrument for educating a broad American public about modernism, had long promoted a picture of modern art as a succession of "movements," successive attack waves going up against entrenched taste—Post-Impressionism followed by Fauvism, Fauvism by Cubism, and so on down to the Abstract Expressionists and beyond. This scheme had its merits (it was memorable and had some truth to it) but grave defects as well, being grievously unfair to individual artists who couldn't be slotted into "movements." The main trouble, however, was the expectation it created of continuous art-historical renewal through an inexhaustible supply of the Next Thing, the New Movement, the Cutting Edge. Somewhere out there, more likely in America than Europe, the next form of art's inevitable future was always welling up, and God help the collector or curator who failed to spot it early. Because it fell into an American mindset deeply conditioned by the view of the future represented, in industry, by Detroit's system of dynamic obsolescence, this expectation was a boon to the market and an immense bane to judgment.

Such was the new, eager, promotional context into which Pop art was delivered in the early 1960s. Pop, as its most famous exponent Andy Warhol said, was "about liking things." Instead of recoiling from the commonplace and commercial, the new generation of painters embraced both, in a spirit of cool and rather detached irony. There was no point in fighting Gargantua, the vast desire industry of advertising and promotion and mass production. Gargantua *was* American culture now. The once jealously guarded barrier between high and low collapsed like an undermined wall, and its sentries were left in disarray. Out came

a number of young artists who had little in common beyond their curiosity about the hitherto disparaged sea of mass media and commercial persuasion, the images on which Americans fed 95 percent of their waking lives: ads, billboards, newsprint, TV montage, and all kinds of kitsch. Forty years earlier, Dadaists and Surrealists had been fascinated by this too, but Pop art dived into it with a kind of wallowing abandon. The term itself originated in London—its very first visual use was in a 1956 collage by the British artist Richard Hamilton, *Just What Is It That Makes Today's Homes So Different, So Appealing?*, in which a muscular hunk is holding a phallic sucker labeled "Pop," and a blown-up frame from a romance comic—a prediction of the as yet uncreated work of Roy Lichtenstein—hangs on the wall.

Pop art caught on fast. It started in the studios in 1959–60; by 1961 most of the artists involved—Andy Warhol, Roy Lichtenstein, James Rosenquist, Tom Wesselmann, and others—had met one another for the first time; big and successful one-man shows followed the next year, for the market was there, like magic, driven by new-rich collectors who had missed out on Abstract Expressionism and wanted to certify their social arrival in booming New York. In Pop, they found everything easy and accessible. You made money from soap flakes and bought art based on soap-flake ads. There were no problems about difficult art anymore, and no lag between appearance and acceptance: in the early sixties the promotional machinery that would turn the late seventies and eighties into a *Walpurgisnacht* of frantic speculation in a manipulated art market was being assembled.

This instant success was much resented, but resentment couldn't stop the wagon. Pop art was the first accessible style of international modernism; it was art about consumption that sat up and begged to be consumed. It also fed back, with incredible speed, into the domain of popular culture—because it was so easily, and at times misleadingly, reproducible.

The most popular of the Pop artists was, and still is, Roy Lichtenstein (b. 1923). His images, coming originally out of mass reproduction, slide back into it with the utmost ease, filling memory with tiny Lichtenstein clones. And then you have to reckon with their effect on advertisements, on packaging, on T-shirts, posters, show-window design, on the whole reappropriation party—amusing and even joyous at first, and then, like most parties, a drag—that the American commercial world threw to welcome back the images and techniques that Lichtenstein took from it and put into an artier form, ripe for reuse as "quality" stuff. There was nothing quality-ridden about the artist's original sources—a smudgy one-column figure of a girl with a beach ball advertising a resort in the Poconos, a moony frame from a romance comic. But by the time such things had been run through the loop from ad to art and back to ad again, they had become as invested with glamor as a *Vogue* photo by Richard Avedon. The sheer omnipres-

ence of Lichtenstein's style rivals and perhaps exceeds that of Warhol's, even though, unlike Warhol, he kept his own distance from the mass-media ad industry and never offered himself to it as a celebrity.

Tragic elevation—or at least the version of it promoted by the rhetoric of late AbEx—was exactly what Lichtenstein reacted against when he started out in the early 1960s. Was "real American" art loaded with signs of commitment and authenticity—the "Tenth Street touch" of thick, frayed brushstrokes, hortatory pigment, drips à la Pollock, swipes à la de Kooning, inherited by a second generation of AbEx wannabes? Then Lichtenstein would go the opposite way and paint thin, programmed pictures, enlarged copies of the least arty things within reach: romance and adventure comic strips.

He found beauty and a sort of wry pathos in these crude and (in most eyes) culturally negligible designs, along with a disregarded but distinct sense of style. Lichtenstein wasn't the first artist to react to American comic strips. But apart from Stuart Davis, he was the first *American* artist to do so, because American artists had always been rather ashamed of their own vernacular, the way kids on the way up can be embarrassed by an old relative who never learned to speak right.

Like the *Iliad,* Lichtenstein's early strip-based paintings come in two basic subjects: girls and war; sometimes, as in *The Kiss,* 1961 (Figure 310), both together. Inside the comic frame, Lichtenstein could unlock his nostalgia for experiences

he was old enough to have had but didn't: he went into a pilot-training program in Mississippi in 1944 but never flew combat. He might have been that pink boy embracing his sweetheart in front of the bomber. His girls are the nymphs of a lost Arcadia of American gush, as remote from us now as Gibson girls were from the early 1960s. Their innocence is counterpointed by the naïveté with which they're painted. Lichtenstein re-alized that the half-tone dots of a printed comic strip could be enlarged along with the image, but at that stage he didn't know how to do it evenly: he used stencils, which smudged, so that the big areas of neck and cheek came out with a random sort of acne. They now look touchingly formal and handmade.

By 1965 he had stopped using comics. Instead, he turned to incon-gruous subjects that didn't fit his achieved style: blowups of AbEx brushstrokes, perversely rendered in flat color and Benday dots; or, most successfully, mirrors. The *Mirror* paintings of 1969–72 remain entranc-ing because, of all Lichtenstein's later work, they are the only ones in which his now cleaned-up techniques al-lowed for a degree of mystery and am-biguity: they are perfect and icy, and reflect nothing but themselves—a pro-leptic comment on his own future work.

Then he started doing other picto-rial styles as subjects of his own. He parodied everything from WPA Art Deco to Synthetic Cubism, from Franz Marc's horses to Picasso's women, from Matisse to Max Beckmann; he even parodied parodies, like the hole-in-the-blob kitsch modernism as imag-ined by cartoonists. The trouble with

310. Roy Lichtenstein, *The Kiss*, 1961. Oil on canvas, 80 × 67¾" (203.2 × 172.1 cm). The Paul G. Allen Collection.

311. Roy Lichtenstein, *Mural with Blue Brushstroke*, 1984–86. Oil and magna on canvas, 68 × 32' (20.72 × 9.75 m). Equitable Life Assurance Society Building, New York.

527

these versions of modernist classics-'n'-clinkers is their sameness. After a while it isn't particularly interesting to know that just about anything can be turned into a Lichtenstein, congealed in his cryogenic style.

Lichtenstein, in fact, has become the academician of Pop—the equivalent of English Royal Academicians a century ago, like Sir Edward Poynter or Sir Laurence Alma-Tadema, but far more monotonous. Witty and skillful, his pastiches represent the triumph of industry over inspiration. Thus his pseudo-Deco mural (Figure 311) in the Equitable Building in New York gives an insurance company the glamorous aura of artistic fame. It advertises patronage, and has no point beyond that. It is empty, pharaonic postmodernism. "What do you know about my Image Duplicator?" snarled a mad scientist in one of Lichtenstein's early paintings. Lichtenstein's own Image Duplicator hums along, stuck in automatic mode.

The aspects of Pop which lasted best are the very ones its bright hardheadedness was supposed to have expelled—namely, mystery and metaphor. Here, the outstanding figure was Claes Oldenburg, whose work (now coauthored by his wife, Coosje van Bruggen) continues with unabated vigor thirty years later, in the form of monuments.

"Everything I do is completely original," Oldenburg claimed in 1966. "I made it up when I was a little kid." It was true, in a way. Oldenburg (b. 1929) was the elder of two sons of a Swedish diplomat, born in Stockholm but raised, since the age of seven, in Chicago. Together, the Oldenburg boys invented a fantasy island named "Neubern," creating maps, histories, and a whole body of descriptive lore for it, in high detail. This desire to invent a parallel world and fill it with every sort of utensil, food, and amenity would carry over into his mature art. When Oldenburg arrived in New York in 1956, after studying at Yale and the Art Institute of Chicago, he sought out Allan Kaprow, an artist who had created a hybrid form of performance art called "happenings"—informal, artist-made stage events, with props and spontaneous utterances, that he had developed out of the ideas of Dada theater mixed with Rauschenberg's esthetic of urban junk art. "Not satisfied with the *suggestion* through paint of our other senses," Kaprow had written in an article on Jackson Pollock's legacy,

> we shall utilize the specific substances of sight, sound, movements, people, odors, touch. Objects of every sort are materials for the new art: paint, chairs, food, electric and neon lights, smoke, water, old socks, a dog, movies, a thousand other things. . . .

This struck an immediate chord with Oldenburg, and his art was to develop out of the impure, hybrid, city-fixated field of experience that Kaprow and other artists like Red Grooms and George Segal wanted to explore. Later, in one of his Whitmanesque and incantatory lists, Oldenburg would declaim that

I am for an art of things lost or thrown away. . . . I am for the art of teddy-bears and guns and decapitated rabbits, exploded umbrellas, raped beds. . . .

I am for the art of abandoned boxes, tied like pharaohs. . . .

I am for Kool-Art, 7-Up art, Pepsi-art, Sunshine art. . . . I am for U.S. Government Inspected Art, Grade A art, Regular Price art, Yellow Ripe art, Extra Fancy art, Ready-to-Eat art. . . .

He was also, he said, "for an art that is political-erotical-mystical, that does something other than sit on its ass in a museum. . . . I am for an art that embroils itself with everyday crap and still comes out on top." In due course the museums drew Oldenburg in, and hundreds of his works are sitting on their asses in them now, doing nothing else. But in the early 1960s it was otherwise. Oldenburg's first serious—or seriously playful—work belonged to the area staked out, in France, by Jean Dubuffet: a fascination with the discarded, the improvised, the dirty, and the ignoble, a desire to get behind the screens of "high" culture and see what they concealed. What he found in junk, and then reelaborated in junky objects like his series of phallic ray guns or the grungy environment of *The Street*, an installation from 1960, was himself, peering from behind an integument of crud. For *The Store*, 1961, Oldenburg rented an actual store on Second Street, on New York's Lower East Side, surrounded by shops that sold every kind of discount garment and textile, cheek by jowl with fast food counters and delis— a bustling souk of cheap stuff. To match it, Oldenburg made his own stock. The Store was a parody of an art gallery, too—a low shop with low art in it. Out of canvas and plaster, resin and rags and papier-mâché, all covered with shiny house enamel, he made burgers and slices of pie, a sewing machine, stockings, knickers, shirts, and shoes—all unwearable, all absurd, plaques of rough papier-mâché whose ragged edges suggested that they had been ripped from their context in life.

Inside the lowness, Oldenburg stressed the formal significance of his images. He liked

the forms that have a kind of architecture. . . . The pie for example with its layers, the ice-cream with its cone. They're geometrical forms, architectural forms, and they're found in very simplified fast food. The hamburger is a perfectly structural piece of food and I think I'd almost rather look at it than eat it. It's got three circles—top half of the bun, patty and bottom half; and if you put an onion slice on it you have even more variation. A pickle is very geometrical too.

But then he changed the scale and material. Hard things went soft; soft ones, hard. Objects swelled up to Brobdingnagian size: a cloth burger or a baked potato the size of a couch, a three-way electric plug monopolizing the corner of

a room. Central to Oldenburg's restless, inventive fantasy was the idea that non-human things could yield metaphors for the human body; this first emerged in his soft sculptures, which developed out of props that he and his wife, Patty, made for performances in the Store. The softness of the objects, their malleability, re-call the soft toys of childhood and their promise of infantile comfort in contact with another body. They emit Oldenburg's desire to touch and be touched: "Each thing," he said, "is an instrument of sensuous communication." They recall Baudelaire's remark that talent "is nothing more nor less than childhood redis-covered at will—a childhood now equipped for self-expression, with manhood's capacities and a power of analysis which enables it to order the mass of raw ma-terial which it has involuntarily accumulated." You immediately connect the soft sculptures to the diffuse image of the body. A huge electric light switch sags de-spondently, its twin switch levers like pendulous breasts. A fireplug mimics a torso. Such objects, all "surrendering"—to gravity, to the rearranging push of the hand—are weirdly, passively sexual. "Any art that is successful in projecting pos-itive feelings about life," Oldenburg thought, "has got to be heavily erotic." His soft sculpture was a testament to polymorphous perversity. Vinyl played a large part: "Vinyl has this look of metal and yet it's soft at the same time. To make something hard out of vinyl was to transform it and make it seem to be melting." Hard things like toilets and typewriters acquire a helpless, dysfunctional air; they are just this side of losing structure altogether, becoming a puddle. They are American cousins to Dalí's soft watch in *The Persistence of Memory.*

From the late 1960s on, Oldenburg turned his attention to monumental pub-lic sculpture. This coincided with what some people felt was the last gasp of the monument in Western art. There was plenty of "monumental" sculpture around—but the word by now just meant "very big." The traditional language of monuments was heroic and commemorative—Verrocchio's statue of Bar-tolommeo Colleoni, for instance, raking his bronze eyes across a conquered horizon from his striding horse. The monumental hero is, actually and metaphorically, bigger than life. But to make one, there must be some belief in heroes, and there must be something commonly agreed to be worth celebrating.

People still build monuments, but the art died when the celebration stopped, when artists began thinking of themselves as critics, not upholders, of the estab-lished order. In any case, the fate of monuments in an age of mass communica-tion, when we come to know the public person through the fragmented, pseudo-intimate eye of television, is a queasy one. One way of thinking about Oldenburg's monuments—most of them unbuilt, and existing only as drawings—is to see them as monstrous parodies of that situation, betokening (and inducing) anxiety. In 1965 he dreamed up a monument for upper Central Park in the form of a giant teddy bear; partly inspired by the balloon animals in the Macy's Pa-rade, this woebegone and helpless image was, for Oldenburg,

an incarnation of white conscience; as such, it fixes white New Yorkers with an accusing glance from Harlem but also one glassy-eyed with desperation. . . . I chose a toy with the "amputated" effect of teddy paws—handlessness signifies society's frustrating lack of tools.

Unsurprisingly, it was never built. Neither was a giant pair of scissors meant to replace the Washington Monument, whose blades would ponderously open and close, reminding visitors of the divisions in American society. Nor was a prodigious windshield wiper for Grant Park in Chicago, slapping back and forth between two long rectangular pools: these would be swimming pools for the city's children, who would nonetheless have to watch the descending blade and get out of the water before they were hit. "The Wiper," said Oldenburg, deadpan, "makes the sky tangible in that it treats the sky as if it were glass. Making the intangible tangible has always been one of my fascinations. But 'wipe out' is slang for 'kill,' isn't it?"

In 1969 Oldenburg for the first time got close to building a monument when a group of graduate students approached him to make one for his old alma mater, Yale. They were fascinated by the aggressive, subversive character of his monument projects, and by the response to them of Herbert Marcuse, hero of the sixties' student left:

> If . . . at the end of Park Avenue there would be a huge Good Humor ice cream bar and in the middle of Times Square a huge banana, I would say . . . this society had come to an end. Because then people cannot take anything seriously: neither their President, nor their Cabinet. . . . There is a way in which this kind of satire, of humor, can indeed kill.

It was not one of the guru's more successful prophecies, but somewhat in that spirit Oldenburg went ahead with his *Lipstick*—a gift to the college. From a tank-like base with caterpillar tracks, an enormous red lipstick was meant to rise, alternately stiffening and softening. (It stayed soft, because there wasn't the money to buy a good air pump.) Since sculpture was banned from the Yale campus, the thing was built in a Connecticut factory and brought secretly at night to Beinecke Plaza, the heart of the Yale campus. The students loved this absurd and polemical ultraweapon, the collapsed red phallus of American power atop its rolling base (which didn't actually roll, because its track plates were plywood): cosmetic, rocket carrier, and drooping antihero, all in one. It was, however, soon banished from the campus and languished (along with Marcuse and the yippies' fantasies of instant revolution) in storage, until it was rebuilt in the early 1970s, brought back to Yale, and installed at Morse College, the lipstick now and evermore in full fiberglass erection.

The first permanent Oldenburg monument in America was installed in Philadelphia in 1976: the *Clothespin* (Figure 312). It is forty-five feet high, and at first you read it as a colossus on two legs. It shows the various, even contradictory, meanings Oldenburg could pack into a single image. Being made of steel, and held together by a tension spring, you may at first read it as a stiff authority figure. But it also alludes to another sculpture in the Philadelphia Museum of Art, not far away: Brancusi's *Kiss*, with its pair of blockish troglodytic lovers bound together in each other's arms, as the spring holds the two halves of the clothespin together. So it has a sensuous and intimate undercurrent, not just a "heroic" one. Meanwhile, the shape of the spring combines the numbers "7" and "6," evoking 1776, the year of the American Revolution, in which Philadelphia played such a part.

Some figurative artists of the period, though they appear in every book on Pop art, no longer fit its contours very well. George Segal (b. 1924) was one. His spectral figures in white plaster (Figure 313), cast from the bodies of friends and acquaintances and then put in constructed urban settings—a bus seat, a diner table—are far closer to the melancholy and withdrawn world of Edward Hopper than to the bright outwardness one associates with Pop. Edward Kienholz, as we shall see in the next chapter, was another. And then there was Wayne Thiebaud (b. 1920), whose main subject overlapped with Claes Oldenburg's, but who dealt with it in a quite different spirit.

This was mass-production American food. In the 1950s and 1960s uniform food was one of America's cultural binders. It was the same everywhere, without regional variations—the reverse of food in France or Spain. The hamburger with fries, the hot dog with its mustard and ketchup, the club sandwich: their sameness made you feel (notionally) at home anywhere. So did their look. You did not have to be a Pop artist to be intrigued by Pop food as a subject.

312. Claes Oldenburg, *Clothespin*, 1976. Cor-ten and stainless steel, 540 × 75¾ × 48″ (1372 × 192 × 122 cm). Centre Square, Philadelphia.

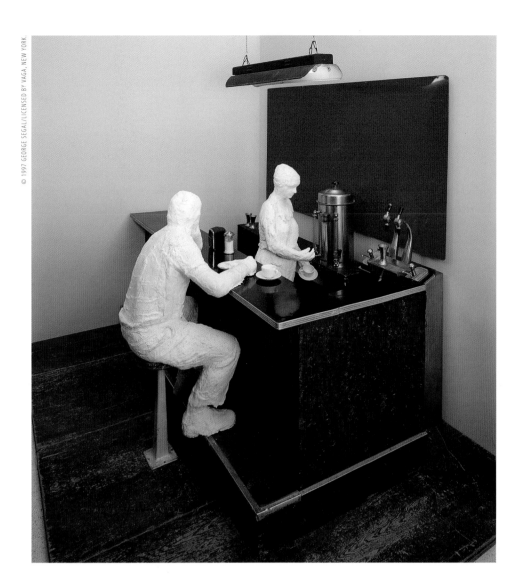

Thiebaud wasn't remotely interested in stylistic irony, or in sign systems. He saw himself as a realist painter, in a European-American tradition that wound back from Edward Hopper to Édouard Manet, and thence to the *bodegones* of Velázquez and the intensely rendered still-lives of Zurbarán and Sánchez Cotán. The fact that his still-life subjects were American-demotic did not alter that. As a boy in southern California, he had worked in restaurants, and he remembered "seeing rows of pies, or a tin of pie with a piece cut out of it and one piece sitting beside it. These little *vedute* in fragmented circumstances were always poetic to me."

He loved the look of the icing, its thickness—an impasto of lavish but artificial goo, pistachio, chocolate, orange, or the white fluff of coconut—and the standardization of the cakes, within which innumerable nuances of shape and color lay. Twinkies and lollipops were part of the culture, as solidly fixed in it as cop-

313. George Segal, *The Diner,* 1964–66. Plaster, wood, chrome, laminated plastic, masonite, and fluorescent lamp, 93³/₄ × 144¹/₄ × 96″ (238.1 × 366.4 × 243.8 cm). Walker Art Center, Minneapolis; gift of the T. B. Walker Foundation, 1966.

per pots and dead game had been in Chardin's in the eighteenth century. Thiebaud saw no reason to ironize about this. The extraordinary colors of truck-stop and deli food, and its highly codified shapes, were at least as interesting a field for the realist as the forms of croissants or brioches. Instead of the flat, detached surface of Lichtenstein or Warhol, he loaded his images of cakes and pies with paint as thick and luscious as icing, as visibly glutinous as cornstarch-thickened syrup (Figure 314). If Warhol silk-screened rows of Coke bottles, he was stressing the sameness of the product. But when Thiebaud set forth twenty slices of pie on a table, he scrupulously attended to the small visual differences between one slice and another which rise from scrutiny and are part of the realist's perception. He found in junk food an almost Egyptian solidity and nobility of abstract form: prisms and wedges, disks and cylinders.

But some forms were indissolubly part and parcel of Pop sensibility, and the main one was advertising. Americans were the first people to completely adapt to mass advertisement. It bombarded them with thousands of messages a day. It shaped their dreams, it interrupted their landscapes, and it helped to form their cities. The monumental form of the ad was the billboard, and one artist in particular got his training by painting them, high above Times Square in Manhattan. This was James Rosenquist (b. 1933), and the peculiar specialized skills his job required—such as visualizing the whole field of an enormous image when he was up on the scaffolding, too close to see it as a whole—flowed directly into his work in the studio:

> I'd paint a 60-foot glass of beer beautifully, with bubbles and the right yellow and everything, and the salesman would come along and say "James, that beer doesn't have enough hops in it. Make it a little lighter." So I did it one-thousandth degree lighter, the whole damn thing. It passes. The next day I painted an Arrow shirt, twenty feet high. "James, the collar looks dirty. You gotta change the collar."

So I had all this color. I had Ford Seafoam green. I had dirty beer color, wrong hops. I had dirty Arrow shirt color. I took that paint home and made abstract paintings—and only I knew this was the wrong color. These colors were specific, but they were wrong. Then it dawned on me. Why don't I try to make a mysterious painting by doing enlarged fragments as best I can, so that the largest fragment would be the hardest to see and therefore be mysterious.

Early Rosenquists like *I Love You with My Ford*, 1961 (Figure 315), are thinly painted: nothing insists, as AbEx always did, that paint surface and stroke are interesting in themselves. But the plainness of the rendering accentuates the "mysterious" quality Rosenquist was after. It makes the images imposing but not tactile, big but oddly weightless, like things seen in a dream: they could not be more familiar-looking, but their cropping makes them irreal. Three zones: below, a woman's dreaming face (it is actually a face whispering in a man's ear, but turned horizontal); above that, an orange field of Franco-American spaghetti, squirming like a parody of Pollock done in pasta; on top, the chrome radiator grille of a (now long obsolete) Ford. Counterposed, deadpan, these unrelated images have a surrealist charge to them.

314. Wayne Thiebaud, *Lunch Table,* 1964. Oil on canvas, 35⅞ × 59¾″ (91.1 × 146.8 cm). Stanford University Museum of Art, Stanford, California; Committee for Art Acquisitions Fund.

315. James Rosenquist, *I Love You with My Ford,* 1961. Oil on canvas, 82¾ × 93½″ (210.2 × 237.5 cm). Moderna Museet, Stockholm.

316. James Rosenquist, *F-111,* 1964–65. Oil on canvas
with aluminum; overall, $10 \times 86'$ (3.048×26.213 m).
Museum of Modern Art, New York; purchase.

Rosenquist in the 1960s was never a "political" artist as such, and yet a political current did from time to time rise in his work—how could it not, with an artist who wanted to represent common life, in however allusive a way, in that supercharged decade? "Life enters naturally into one's work," said Rosenquist, "so what do you do? Do you use the energy to throw it out, or leave the energy and keep it in and just incorporate it, instead of working hard to stay away from everything?" This inclusiveness produced one masterpiece, *F-111*, 1964–65 (Figure 316), an enormous multipanel painting eighty-six feet long, which caused a hullabaloo when the Metropolitan Museum of Art first put it on view in the sixties. Rosenquist had always shared the American dread of nuclear catastrophe. Sometimes, high on a billboard above Times Square in 1957 or 1958, he would have exposure fantasies about an atomic airburst behind his back over Manhattan, printing his shade on the surface he was painting: "I kept thinking of myself being whited out right on the signboard, or becoming part of the signboard for a millisecond, when the atomic bomb burst in Times Square." *F-111* belongs to this eschatology of the nuclear age. Its title is the name of a fighter-bomber the Americans were using in Vietnam, then the newest and most publicized of weapons.

> I thought of this new war device that's a defense economy item, supporting aircraft workers, each with two-and-a-half statistical children in Texas or New England or wherever. And I thought that being an artist was insignificant. How insignificant it is to be an artist in this day and age when all that power is zipping by for defense.
>
> I thought I'd make a painting that surrounds a whole room, covers all the walls. A rather airless, evil-looking room that has metaphors for nothingness, total destruction.

Rosenquist swears he wasn't thinking of the nineteenth-century tradition of American dioramas. He did have vaguely in mind the effect of Monet's *Waterlilies* in the Jeu de Paume, hung in a circle around the room so that "in the center, your peripheral vision filled with color." The colors of this painting are painful: Day-Glo reds and oranges, dark blue, mirror aluminum sheet. The fuselage of an F-111, sleek as a shark, glittering, is the armature of the painting, skewering it from left to right. The tail, silhouetted in aluminum foil, has a pattern over it made with an Italian wallpaper roller: to Rosenquist, this "was like radioactivity coming down on everybody." The plane flies through a storm of images, "a contemporary modern-day flak of household things," all of which have an unstable, equivocal life as metaphors. The angel-food ring cake is also a missile silo. The tire with the deep-cut, aggressive tread pattern on it suggests "a king's crown or a powerful piece of industry." A little blond moppet of a girl is

under a hair dryer, whose gleaming cone recalls a pilot's combat helmet or the nose cone of an ICBM. Beyond a beach umbrella we see, in red monochrome, the roiling burst of a nuclear explosion (the phrase "nuclear umbrella" was much used thirty years ago), and further along a bubble of air from a scuba diver's regulator repeats that archetypal mushroom cloud.

Nothing under the umbrella of Pop sensibility could have been less like the free-associating, lyric character of Rosenquist's imagination than the work of Andy Warhol (1928–1987). For it was Warhol who, more than any other Pop artist, took on the sheer mind-numbing overload of American mass culture and allowed himself (selectively, but very effectively indeed) to become an apparently passive conduit for it. He was not exaggerating when, in 1980, he described his way of working as a form of self-cancellation:

> The music blasting cleared my head out and left me working on instinct alone. In fact, it wasn't only rock and roll that I used that way—I'd also have the radio blasting opera, and the TV picture on (but not the sound)—and if all that didn't clear enough out of my mind, I'd open a magazine, put it beside me, and half read an article while I painted.

Warhol began as a commercial illustrator, and a very successful one, doing jobs like shoe ads for I. Miller in a stylish blotty line that derived from Ben Shahn. He first exhibited in an art gallery in 1962, when the Ferus Gallery in Los Angeles showed his *32 Campbell's Soup Cans, 1961–62*. From then on, most of Warhol's best work was done over a span of about six years, finishing in 1968, when he was shot. And it all flowed from one central insight: that in a culture glutted with information, where most people experience most things at second or third hand through TV and print, through images that become banal and disassociated by being repeated again and again and again, there is a role for affectless art. You no longer need to be hot and full of feeling. You can be supercool, like a slightly frosted mirror. Not that Warhol worked this out; he didn't have to. He felt it and embodied it. He was a conduit for a sort of collective American state of mind in which celebrity—the famous image of a person, the famous brand name—had completely replaced both sacredness and solidity. Earlier artists, like Monet, had painted the same motif in series in order to display minute discriminations of perception, the shift of light and color from hour to hour on a haystack, and how these could be recorded by the subtlety of eye and hand. Warhol's thirty-two soup cans are about nothing of the kind. They are about sameness (though with different labels): same brand, same size, same paint surface, same fame as product. They mimic the condition of mass advertising, out of which his sensibility had grown. They are much more deadpan than the object which may have partly inspired them, Jasper Johns's pair of bronze Ballantine ale cans. This affectlessness,

this fascinated and yet indifferent take on the famous object, became the key to Warhol's work; it is there in the repetition of stars' faces (Liz, Jackie, Marilyn, Marlon, and the rest), and as a record of the condition of being an uninvolved spectator it speaks eloquently about the condition of image overload in a media-saturated culture. Warhol extended it by using silk screen, and not bothering to clean up the imperfections of the print: those slips of the screen, uneven inkings of the roller, and general graininess. What they suggested was not the humanizing touch of the hand but the pervasiveness of routine error and of entropy. Warhol once remarked that "everything I do is connected with death," and indeed his most memorable images—apart from the soup cans—were all Thanatos and no Eros, like the *Electric Chairs,* those dark and awful versions of a photo of America's then favorite tool of legal execution, standing unoccupied in its chamber with a notice on the wall enjoining SILENCE.

In one of his bizarre noninterviews on film, one sees an eager questioner asking Warhol about the meaning of his electric chair paintings, why he did them, and getting stonewalled every time with "Uh . . . I dunno." But he did know, of course, and so does anyone who sees these stark, mute images: the dark side of

Warhol was the most interesting one, perhaps the only interesting one. He was truly mesmerized by death, American death, whether inflicted by the state or simply by accident. Gazing at the death of others was his ultimate form of voyeurism, more interesting than sex or even money. Over and over again, he silk-screened photos of it, culled from police files: a suicide's body crashed on the roof of a car, so caught up in the baroque swirls of black and white in the crumpled metal as to be hardly distinguishable as a corpse; a single foot sticking out from under the tire of a truck, an awful image that reminds one of the grinding mills of God; a car burning in suburbia (Figure 317), with its driver—you hardly notice his limp vertical body at first—hanging from the side of a telegraph pole.

Warhol wasn't Goya, not by a million miles, but in these early paintings he was true to his experience and to his

317. Andy Warhol, *White Burning Car III,* 1963. Synthetic polymer paint and silkscreen ink on canvas, 100½ × 78¾″ (255.3 × 200 cm).

voyeuristic nature, and that gave them a res-
onance that his more frivolous and routine
output, now that he too is dead, no longer
has. And that was true of his gold Marilyn
Monroe as well (Figure 318): suicide, drag
queen, Madonna, her silk-screened and cru-
elly colored effigy painted like a whore or a
corpse and enshrined in a wide, slightly tacky
field of gold paint, borne up as an icon.
Warhol was a Polish Catholic, devout by na-
ture, however much his devotion got skewed
toward the secular sainthood of celebrity. It is
a curious fact that America, even though it is
one of the most religious countries on earth,
has produced very little in the way of original
religious art. Warhol's Marilyn is close to
that condition, in its distanced and sleazy
epiphany. You could imagine the whole ca-
reer of the as yet unborn pop star Madonna
being deduced from this Evita-Marilyn-
Madonna. This brazen image reminds you
that, somewhere near the heart of Pop, mori-
bundity lurked. The artists, for the most part (Rosenquist and Oldenburg ex-
cepted), were dealing with a vanished world, one closer to their youth than to
their maturity. What they along with all other Americans had in the present, by
the end of the 1960s, was different and more troubled. American self-confidence
was in poor shape. Not even the amazing feat of putting Americans on the moon
could convince other Americans that all was well on earth. The space program,
that vast symbol of American power, was returning little or nothing to the pub-
lic that paid for it. John Kennedy, Martin Luther King, Jr., and Bobby Kennedy
were all dead, assassinated. The war in Vietnam was stalled, perhaps un-
winnable. Huge splits of race and gender, class and belief were opening in the
American polity, and the clamp of the Cold War could no longer hold them to-
gether. Perhaps it had never been as easy to be an American as many Americans
thought. But now it was especially difficult; and this would apply to artists, too,
in a new age of anxiety.

318. Andy Warhol, *Gold Marilyn Monroe,* 1962. Synthetic
polymer paint, silkscreened, and oil on canvas, 83¼ × 57″
(211.4 × 144.7 cm). The Museum of Modern Art, New York;
gift of Philip Johnson.

9

THE AGE OF ANXIETY

America entered the 1960s as a great and secure nation, reasonably certain—despite the paranoia of the Cold War—that its culture and moral framework were unique in the world; its destiny was virtuous, its prosperity immense, and even its huge internal problems of inequality and racism could eventually be fixed by good laws written by good men. Nothing could resist American know-how and American can-do. There was a New Frontier, on which, in that phrase of the time, a Great Society would be raised. Scores of millions of Americans watched John Fitzgerald Kennedy's January 1961 inaugural speech on TV and thrilled to his words:

> I do not believe that any of us would exchange places with any other people or any other generation. The energy, the faith, the devotion which we bring to this endeavor will light our country and all who serve it—and the glow from that fire will truly light the world.

But then this world of promise began to unravel, its fabric pierced by Kennedy's assassination in 1963 and then torn asunder by the foreign policy his presidency had set in train. America's troubles lay in a tiny and remote Asian country called Vietnam, a former colony of France in which Americans had never had the smallest strategic, economic, or cultural stake. But it was in a state of growing civil war, between the government of Ngo Dinh Diem in Saigon and the Communist insurgents who, led by Ho Chi Minh in the north, had driven out the French in 1954. Kennedy, Lyndon Johnson, and their advisers had convinced themselves that Vietnam was being taken over by an expansionist China (though China had been regarded by the Vietnamese as their principal enemy for a thousand years). In one of the most tragic foreign policy mistakes in American history,

319. Mark Tansey, *Triumph of the New York School,* 1984. Oil on canvas, 74 × 120″ (188 × 304.8 cm). Whitney Museum of American Art, New York; promised gift of Robert M. Kaye.

they went to war to support the satellite regime in Saigon, supposing that if Vietnam went Communist, so would the rest of Southeast Asia, country by country.

In 1965 nine out of ten Americans couldn't have spelled Vietnam's name or found it on a map; but by 1968 Vietnam was a national obsession, and it split American society apart in what proved to be the most divisive and culturally ruinous conflict since the Civil War a century earlier. In the end, which came in 1975, after more tonnage of explosives had been dropped on Vietnam than on all Europe in the Second World War, fifty-eight thousand young Americans and countless Vietnamese were killed in a war that America lost. And such was the internal dissension over Vietnam—the riots and demonstrations, the furies unleashed by the rebellion of the young against their elders, the sense of a polity spinning off its axis and out of control—that America has not in any full sense recovered from it, thirty years later.

The *annus horribilis* was 1968, the year in which hope for a civil society seemed most imperiled: the assassinations of Martin Luther King, Jr., and Robert Kennedy, the bloody police action against demonstrators in Chicago at the Democratic Convention, the riots of blacks in burning ghettos across America, from Watts to Detroit, seemed not only fearful in themselves but portents of worse to come. In many respects, however, 1968 now seems a time of relative sanity and security compared to the present. Campus bombings, for instance, were small and, in human cost, relatively harmless affairs beside the destruction of 168 lives by the truck bomb in Oklahoma City in 1995; the actual threat posed to civil society by the Black Panthers and other radical left outfits was slight compared to the proliferation of paranoid, armed, far-right militias today; and there was still a general belief in the capabilities of formal politics to deal with social problems, which seems to be dwindling, if not altogether dead, in the America of 1997.

Still, it was in the sixties that the consensus that had held America together for a hundred years came spectacularly unstuck. Because they are all, ultimately, immigrants, and so different in their origins from one another, Americans had always been quick to disagree but good at creating consensus. But they became less good at it after Vietnam, and the results are still with us: in mistrust of government, in the collapse of the Great Society programs, in the so-called culture wars between the politically and the patriotically correct, and in America's disillusionment with its power to fulfill its own idealist promises. The cowboys were no longer the good guys. The Indians were no longer the savages. The nightmare of Vietnam cast America into an age of anxiety from which it has not yet emerged.

The sense of American crisis in the 1960s and early 1970s left its marks all over the culture: in writing, theater, film. And yet, if one looked at American art—at least the art which was (as it were) official, the painting and sculpture which flowed in the "mainstream" from the studio to the dealer and thence to the museum collections of modern art—there was very little sign of it. As the 1960s

turned the corner into the 1970s, America had plenty of activist art, most of which, though not all, was utterly mediocre. Some artists imagined (wrongly) that they had influence by virtue of being artists. Thus the Minimalist-Conceptualist sculptor Robert Morris, in 1970, closed down his show of logs and boxes at the Whitney Museum in protest against the bombing of Cambodia, as though Nixon and Kissinger would have been sufficiently impressed by the disappointment of the museum trustees (rich white males, and therefore coconspirators in the military-industrial complex) to ground the B-52s. Lesser-known radical artists threatened "art strikes," but the prospect of being deprived of so marginal a product as vanguard art somehow failed to impress an "establishment" which had scarcely heard of them anyway. But "mainstream" art, the stuff that enjoyed the Mandate of MoMA, the large works designed for the museum and therefore for History as their natural home, remained totally indifferent to politics. The locomotive of crisis did not pull these carriages. Not even Pop art had much political content, except for isolated works like Rosenquist's *F-111;* though Minimalist artists sometimes expressed political opinions, their work did no such thing. And "post-painterly" abstraction, or "color-field" painting, the museum style par excellence, totally excluded all social reference of any kind from its lofty Apollonianism. Its dominant position was largely due to the influence of one critic: Clement Greenberg.

In 1984 Mark Tansey (b. 1949) painted *Triumph of the New York School* (Figure 319, page 542). The title was ironically drawn from that of a distinguished history by Irving Sandler. It is a mock-history painting. It depicts the mythic event we saw in the last chapter: the capitulation of Paris, as world art center, to New York. There they are, in military uniform on a devastated battlefield, the grand old *poilus* of the School of Paris: Picasso, Braque, Matisse, Léger, and the rest. And there on the right are the representatives of the victorious army: Pollock, de Kooning, Still, Motherwell, and the rest. But it is a critic, in his role as the General MacArthur of modernist formalism, who receives the surrender.

No modern critic—perhaps none since the death of Roger Fry, and certainly none alive today—has ever been as influential as Clement Greenberg, in all his dogmatism and formidable *certezza*. In championing the Abstract Expressionists, especially Pollock, he had won a reputation for near infallibility. But a reputation is one thing, and power another; real power over taste, in the end, is granted to a critic by institutions and the market. Some critics want this, others don't, and Greenberg did. More than anyone else, Greenberg was responsible for the fiction that American art only came of age, achieved international quality, with Abstract Expressionism. The true lineage of future American art, therefore, *had* to start with AbEx and proceed by deduction from there.

Greenberg's formalist line had a hypnotic power over some parts of the art world and defined, for a while, the official relationship to new art of American

museums. Of course, its sway wasn't complete, but those who believed in it saw the painters it favored as the sole hope of Western art in an age of trivial "novelty."

Greenberg was able to find a little grudging praise for Johns, but for Rauschenberg he had no time at all, and he dismissed Pop art as a whole just as harshly as, fifteen years earlier, he had brushed Dada and Surrealism aside. It, like Minimalism, was mere "novelty art," without historical resonance—the result of a desperate desire for the Next Thing.

The only Next Thing that interested Greenberg was what he called "postpainterly abstraction." In 1962 his essay "After Abstract Expressionism" passed the palm from Pollock to Newman, Rothko, and Still, who were pushing their color away from its "localizing or denotative function," so that it "speaks for itself by dissolving all definiteness of shape and distance." Space had to be indefinite and open, pigment thin, colors few, and canvases big: "Size guarantees the purity as well as the intensity needed to suggest indeterminate space: more blue being simply bluer than less blue." In meeting these criteria, Newman, Rothko, and Still represented "the only way to high pictorial art in the near future." "The ultimate source of value or quality in art" had nothing to do with skill or training but with "conception alone." The real "triumph" was to suppress the evidence of skill.

320. Morris Louis, *Where,* 1960. Magna on canvas, 99³/₈ × 142½″ (252.3 × 361.9 cm). Hirshhorn Museum and Sculpture Garden, Smithsonian Institution, Washington, D.C.; gift of Joseph H. Hirshhorn, 1966.

The Historical Imperative that was chivvying art toward openness, indeterminacy, thinness, and bigness produced its characteristic painters. Their stains, veils, and disembodied stripes of pure untextured pigment, soaked into the weave of unprimed canvas like enormous watercolors, represented the final triumph of the "high" decorative art he had been calling for all along—its elevation to a historical principle. "It's Athene whom we want," Greenberg wrote, "formal culture with its infinity of aspects, its luxuriance, its large comprehension." But where, in anxious modernism, was Athene to be found? In Europe, he argued, that question had been partly answered by Henri Matisse, in his august pursuit of pleasure, and

partly by Cubism. Cubism fulfilled what Cézanne had started (a dubious idea); Cubist collage embodied "the contempt for nature" Greenberg felt was necessary to "the great and absent art of our age" (though if any artist had more *reverence* for nature than Cézanne, one would like to know his name). All other kinds of collage—Russian Constructivist, Dada, Surrealist—he despised as mere literature, and in his recoil from content of any kind he even managed to read the lyric and scatologically obsessed Joan Miró as a sort of late Cubist. Any kind of modern art that wasn't abstract or materialist, or (sin of sins) leaned toward mysticism, got short shrift from Greenberg and his circle. Their allegiance went to the lavish stained canvases of Helen Frankenthaler, the glowing veils of Morris Louis (Figure 320), Kenneth Noland's circles (Figure 321), and the peach-bloom surfaces of Jules Olitski. This, formalist criticism kept saying in the 1960s, was the *only* way painting could go: it was the inevitable future. "Only an art of constant formal self-criticism," wrote the critic Michael Fried in a preface to a Noland museum retrospective in 1965, "can bear or embody or communicate more than trivial meaning."

Noland's circle paintings, in particular, seemed to expel everything "inessential" to painting. No representation—it mattered that they weren't *targets*, like Jasper Johns's, but abstract *circles*. No drawing. A blazing sensuousness of color carried them, intensified by the circular format; since the circles were centered in square canvases, their form seemed gravity-free, not to be read as solid substance.

321. Kenneth Noland, *Whirl*, 1960. 70¾ × 69½" (178.4 × 176.5 cm). Des Moines Art Center; purchased with funds from the Coffin Fine Arts Trust, Nathan Emory Coffin Collection of the Des Moines Art Center, 1974.

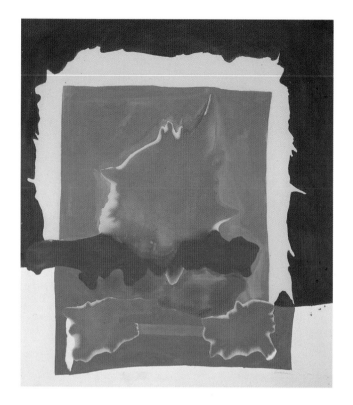

The color seemed to come out of the weave of the canvas, as though dyed into it; Noland used Magna, a synthetic pigment which gave a more even and intense wash than dilute oils. "I wanted to have color be the origin of the painting," Noland said in 1969. "I was trying to neutralize the layout, the shape, the composition in order to get away from the color. Pollock had indicated getting away from drawing."

Pollock had done so in his "all-over" paintings, by suppressing the large unitary shape with outlines and turning line, almost, into a function of atmosphere, a kind of subtle shading. The Pollock follower who picked up on this earliest was Helen Frankenthaler (b. 1928), in 1952, with a precocious picture called *Mountains and Sea*. An amalgam of Hans Hofmann (with whom she briefly studied), Kandinsky, and Gorky, this landscape set the tone of her later work by conspicuously dissociating "painterliness" from heavy, impasted paint. From then on she worked with extremely dilute pigment, floated, washed, and puddled on the absorbent ground. The results, like *Interior Landscape*, 1964 (Figure 322), had at their best a burning immediacy of color all of whose elements hit the eye purely and straight off, with one hedonistic jolt.

By the early 1960s Greenberg was writing less often and seemed more concerned with laying down the law than arguing positions in detail. But as for influencing museum policy and the taste of collectors, he didn't need to—an oracle was enough. In the 1960s and early 1970s, more museum time and space was devoted to color-field painting than to any other American art movement or style.

Those who saw the Museum of Modern Art's Morris Louis retrospective in 1986 and remembered what had once been written about these sumptuously hedonistic paintings must have felt a bump of transition. Did anyone still feel, as Michael Fried had felt when writing about Louis, that "nothing less than the continued existence of painting as a high art" depended on him? Could you see those lavish flowerings and cascades of paint, controlled in their spread by the most individually cunning of dyer's hands, as fulfilling the "impersonality" Greenberg had called for? Louis was the exemplary "Greenbergian" painter, not only because his painting seemed to embody the critic's sense of historical necessity, but

322. Helen Frankenthaler, *Interior Landscape*, 1964. Acrylic on canvas, 104⅞ × 92⅝" (266.4 × 253.3 cm). San Francisco Museum of Modern Art; gift of the Women's Board.

because he depended on Greenberg's advice (and let him edit his output). But after him, color-field painting became more and more a matter of cuisine, and timid cuisine at that. Declining into mannerism, it had taken belief in abstraction with it; American abstract art was now in the unenviably depleted condition of most Italian painting after the death of Titian. "What abstraction promised in the sixties, it did not deliver in the seventies," as Frank Stella argued in his 1983 Charles Eliot Norton Lectures at Harvard. In these, he argued for the need to reconnect abstract art to the deep dramatic spatial energies of Caravaggio or Rubens. "The biggest problem for abstraction is not its flatness, articulated by brittle, dull, bent acrylic edges and exuding a debilitating sense of sameness, unbearably thin and shallow. . . . Even more discouraging is the illustrational, easily read quality of its pictorial effects." As a result, he thought, abstract painting "has rendered itself space-blind in order to assure its visibility to an audience that can only read." He did not need to say what that audience had been reading.

Greenberg's version of modernism has long since had its day. Not only because of the victories of what he dismissed as "novelty art"—Pop, Minimalism, and media-based imagery of all kinds—but, more important, because of the limitations of his positivist worldview, based on a truculent antispiritual materialism which also rejected nature, "there is nothing left in nature for plastic art to explore."

This proscription had never been true, and never will be; and it certainly wasn't true in American art in the 1960s and 1970s. It was just that artists who did feel nature was worth exploring were sidelined by the institutional and critical clout of purist abstraction. This happened both to realist painters and to artists who tried to keep a fluid balance in their work between abstraction and deliberate references to nature. At least one of the latter seems, in hindsight, to have achieved more than any of the "post-painterly" Greenberg-approved artists who were thought to constitute the "mainstream." This was Richard Diebenkorn (1922–1993). Living in the Bay Area of California in the 1950s, Diebenkorn at first had made abstract pictures with strong emphases on landscape imagery, their directional brushstrokes and swelling forms a homage to de Kooning, as was their high palette of pinks, yellows, ochers, and blues. But by 1957–58 he had begun a sequence of brusquely rendered figure paintings, generally of women seated in transparent interiors, looking out on a landscape through an architectural grid. The prototype for these was Henri Matisse, to whom Diebenkorn felt a strong filiation. *Woman in Profile,* 1958 (Figure 323), is one of his tributes to Matisse's *Studio, Quai Saint-Michel,* 1916, which he had studied in the Phillips Collection in Washington. In these interiors with figures, translated into the high light of California, a tough formality reigns: the black window posts splitting the

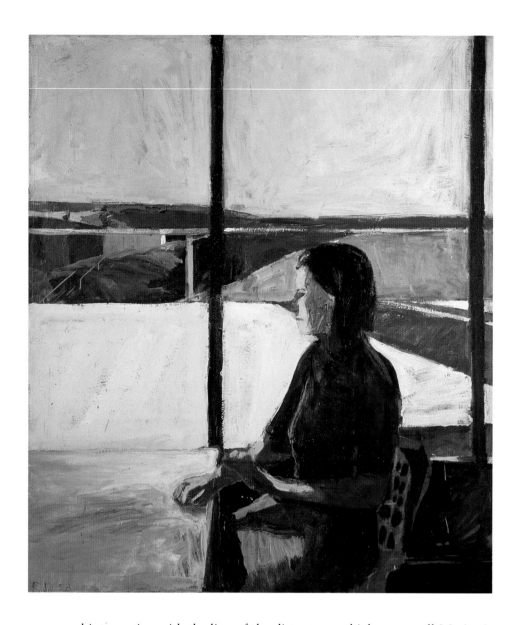

scene and intersecting with the line of the distant superhighway recall Matisse's studio window; the abutment of the roughly brushed plane of the table on which the woman's hand rests is a Matissean device as well. The other influence on Diebenkorn was Edward Hopper, whose traces lie not only in the woman's abstracted reverie but also in the diagonal cuts of highway berms in the background; Diebenkorn loved Hopper's diagonals, and they would become a steady element in his mature series of paintings, the *Ocean Parks* (Figure 324), which he began in 1967 and named after the beachside section of Santa Monica, California, where he lived. These large, clear paintings are essentially abstract, and yet you cannot walk the Santa Monica esplanade without recognizing their elements in the real landscape. Diebenkorn tended to keep the "action," the polyphony

323. Richard Diebenkorn, *Woman in Profile*, 1958. Oil on canvas, 68 × 58¾" (172.7 × 149.3 cm). San Francisco Museum of Modern Art; bequest of Howard E. Johnson.

324. Richard Diebenkorn, *Ocean Park #105*, 1978. Oil and charcoal on canvas, 100 × 93" (254 × 236.2 cm). Modern Art Museum of Fort Worth; museum purchase, Sid W. Richardson Endowment Fund and The Burnett Foundation.

and intercutting of small forms, at the verges of the canvas, reserving the center for large areas of pale, silky cobalt and green, which recall the stretch of the Pacific seen from above and Santa Monica's tracts of municipal grass; sometimes the blue is vaporous and foggy with gray scumbling, tuned by cuts of line. The subsidiary forms suggest others present in the landscape: cuts of gable, white posts by the sea, sudden drop-offs of hill or throughway. There is a kind of light on Diebenkorn's coastline—mild, high, and (when smog doesn't descend) ineffably clear, dropping like a benediction on the slopes overbuilt with ticky-tacky just as the sun drops into the Pacific—that is all but unique in North America, and Diebenkorn's *Ocean Park*s always seem to recall it. It is part of their signature, no matter how abstract they get.

It took time—too much time—for the magnitude of Diebenkorn's achievement to be fully recognized in New York. For entirely figurative artists, of course, it was harder still. They were reluctantly granted a niche at the side of the "mainstream," but not much more. Few people in the 1970s would have taken the view that, for all the difficulty of comparing apples and oranges, the calm and time-

lessly ordered still-lives of William Bailey (b. 1930) were at least as full of pictorial intelligence and visual subtlety as anything in color-field painting, although it was obvious that they belonged to a different order of pictorial ambition from that of most American realism at the time, which tended to be anecdotal and nostalgic. There was nothing nostalgic or narrative about Bailey's work (Figure 325). Its calm arrays of pots, jugs, eggs, and bowls make up an ideal form-world, Platonic in its removal from "the itch of desire." Nothing spills out, thrusts forward, or wants to be touched or possessed—the traditional solicitations of still-life painting, most materialistic of arts. They are as removed from touch (and as grandly articulate in their scale) as the façade of a fine quattrocento building, seen from the other side of the piazza: it is no accident that Bailey should have had a profound attraction to Italy, or that he spent summers in Monterchi, where Piero della Francesca's *Madonna del Parto* presides in the local cemetery. They are less domestic and tactile than Chardin and more precise (and, crucially, less modest) than Morandi. Distance envelops them; they are, as his friend the poet Mark Strand put it, "realizations of an idea," in which all the groping *toward* the idea has been submerged—an extreme opposite to the American taste for works of art which bear the signs of their struggle, unedited, in their final form.

The painter who bore much of the brunt of sustaining the essential seriousness of realist painting in a time of abstraction was Philip Pearlstein (b. 1924). Pearl-

325. William Bailey, *Hotel Raphael,* 1985. Oil on canvas, 40 × 50″ (101.6 × 127 cm). Collection of the Equitable Life Assurance Society of the U.S.

stein's work affords an interesting example of how artists, seeming so utterly different, can yet have things in common. Nothing, you would think, could be further from the austerities of Minimalist art than someone who painted nudes in the studio. And yet in Pearlstein's work there was (and is) a feeling typical of other areas of 1960s art, including Minimalism: a distanced, sharp, hard, clear factuality. He had begun painting under the spell of Abstract Expressionism, his surfaces as roiled and heavy as any young abstract painter's in the 1950s; but step by step, in a spirit of systematic rebellion, he set himself against the assumptions of the New York School. Why *should* it be assumed that painting naked bodies, specifically rendered in one-point perspective in precise and closed forms, was "dead" and "academic," whereas doing indeterminate patches of evocative color in an open-ended, unfinished manner was not? Might it not be a valuably aggressive, even a cathartic gesture to go against the central tenet of New York modernism and turn the sacred "picture plane" and its holy flatness into a window again, making a spatial illusion? Pearlstein didn't want to throw out everything he had discerned in the language of abstract art. As he later put it,

> The prime technical idea I took was that large forms deployed across the canvas produce axial movements that clash and define fields of energy forces, and that the realistic depiction of forms . . . in nature is as capable of creating these axial movements and fields of energy forces as are the forms of abstract art.

"Our prime qualification was sharp-focus," Pearlstein added, speaking not only of himself but of other New York painters like Alfred Leslie, who had undergone a similar conversion from AbEx to large realistic images. "Aggressiveness was the key note." Pearlstein wanted to start all over again from Courbet, painting naked people—*not* idealized "nudes"—in a spirit of detached documentation, "specific, measurable, matter-of-fact, female and male, all parts rendered with uniform focus," under electric lights whose illumination, unlike the sun's, did not vary. He wanted his work to look "strongly conditioned by procedures," and thus it came to be aligned with "systematic" art and even with Minimalism. A painting like *Standing Female Model and Mirror,* 1973 (Figure 326), does not suggest that you have walked into a room and come across someone standing there. The framing and angles are too conscious for that. The top of the canvas slices off the model's head. The play between axes—the strong, angular thrust of the thighs, the sharp jut of the bent arm, the X of the reflected canvas stretcher, the ceiling bars crossing the mirror—is intensely conscious, and beautifully relieved by the serpentine curve of the mirror's wooden frame. Inanimate objects—the baseboard molding, for instance—are given exactly the same attention as the model's sallow flesh. The artist's own brow, appearing in the mirror, matters no more and no less than the woman's pubic triangle. One's eye sorts

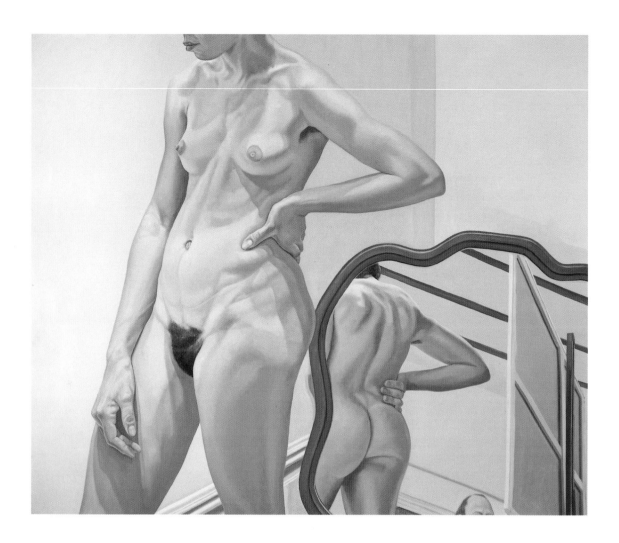

through these rhymes and fragments, reassembling the scene against the resistance of the pattern. Antisentimental, antihumanist, antierotic, hostile to uncertainty, indifferent to the "psychology" of Expressionist figure painting and the existentialist doubt of AbEx: Pearlstein's work is unlike anything seen in American realism since Thomas Eakins.

Neil Welliver (b. 1929) is another realist artist who came out of Abstract Expressionism, seeking to escape an exhausted style in order to reengage the physical world and recomplicate the game; but in his work the original genetic code shows clearly. His large paintings of the Maine woods—usually shown in winter or the early thaws of spring, in the clarity of cold light and with a brusque directness, stroke for form—could only have matured in the last thirty years A.P. (after Pollock). "With my work," Welliver remarked, "there is always the resistance of the surface of the painting. The fact of the painting is always in the way."

What detains the eye in a Welliver like *Shadow,* 1977 (Figure 327), is, in part, his assertion of "abstract" readings within a very forthright and realistic tran-

326. Philip Pearlstein, *Standing Female Model and Mirror,*
1973. Oil on canvas, 60 × 72″ (152.4 × 182.9 cm).
Collection Edmund P. Pillsbury, Fort Worth.

scription of raw nature. Typically, his spaces are shallow and entangled—if Pollocks can look like brambles, brambles reserve the right to look like Pollocks. No horizon line offers visual release. The surface isn't oppressively congested, but it puzzles the eye. You can feel the twigs plucking at your coat.

Such landscapes are "all-over" paintings, slices taken from a boundless field of pictorial incident. They pay homage to the materialism of Courbet, and to large-scale nineteenth-century American landscape, and to Abstract Expressionism, all at once. But as Welliver put it,

> Courbet looked very hard and had a method. Bierstadt did not look very hard and had a method, and de Kooning makes it up as he goes along. . . . I look very hard, and then make it up as I go along.

327. Neil Welliver, *Shadow,* 1977. Oil on canvas, 8 × 8′ (243.8 × 243.8 cm). The Museum of Modern Art, New York; gift of Katherine Lustman-Findling, Jeffrey Lustman, Susan Lustman Katz, and William Ritman in memory of Dr. Seymour Lustman.

"Making it up" on a canvas eight feet square could not be done outdoors. Laden with a seventy-pound pack of easel, paints, canvas, and gear, Welliver would trudge out in winter to find a scene and make an oil sketch; the large version was always a studio painting, and its fictions of spontaneity—of rapid-fire correspondence between the eye scanning the motif and the hand making its marks—might take a month or more to achieve. The result, sometimes, is an emotional intensity that goes beyond the ordinary limits of realism. *Shadow* shows a stand of birches in snow, a strong blue sky peeping through their pale trunks, and more blue scattered in the dark clefts of the snow. Just above the middle of the image, the shadow line of a ridge falls across the trees and the ground. The hill behind you becomes a presence: a sign of what the Middle Ages called *natura naturans*—nature going silently about its business of being.

An older artist than either Pearlstein or Welliver, Fairfield Porter (1907–1975) was a more reticent realist, and with no link to Abstract Expressionism. He was largely self-taught. From the mid-1950s on he stayed away from Manhattan, preferring to paint on Long Island and on Great Spruce Head Island in Maine, which his family owned. This didn't put him out of touch with "the scene"—Porter was a gifted and lucid art critic as well as a painter—but he needed to be in constant touch with his motifs, especially American light and the still expanses of coastal field and sea. Porter rejected the piety that the empirically painted figure or landscape was dead. It simply didn't accord with his deepest convictions about how art relates to experience and conveys its "density"—a favorite word of his.

Porter's was very much a modernist vision, but classically so. Its main source was the work of Bonnard and Vuillard. In Vuillard's scenes of bourgeois life, he remarked, "what he's doing seems ordinary, but the extraordinary is everywhere." It was "concrete in detail and abstract as a whole," and therefore "just the opposite of Cubism," whose influence, he thought, overintellectualized American art at the expense of its sensuous qualities. Aspects of the work of older American artists also appear: Marsden Hartley's love of bony mass, Edward Hopper's treatment of light. But Porter was a more nuanced and daring colorist than Hartley, and his world was untouched by Hopper's melancholy and more generalized in treatment. In a large painting, *Island Farmhouse*, 1969, the white weatherboard asserts itself in a blast of light like a Doric temple; the lines of shadow are a burning visionary yellow; everything, from the angular dog in the shade to the ragged trees, is seen in sharp patches, and yet one's eye seems bathed in atmosphere, all the way out to the blue island on the remote horizon. Artists who were in other ways close to Porter, like Alex Katz, never quite equaled his ability to suggest the air around things by the use of color alone. And for Porter, classicism counted deeply. In his best paintings you sense a whole culture at work, easily accessible through long absorption but never invoked in a facile spirit. *The Mirror*, 1966 (Figure 328), quotes from Velázquez's *Meninas* with a

328. Fairfield Porter, *The Mirror*, 1966. Oil on canvas, 72¾ × 60¼″ (184.8 × 154.3 cm). The Nelson-Atkins Museum of Art, Kansas City, Missouri; gift of the Enid and Crosby Kemper Foundation.

sort of discreet frankness, but it isn't touched by pastiche, and what you are most aware of is the subtlety of the color, the direct gaze of the artist's daughter at her father (who stands reflected in the mirror), and the perfect registration of tonal levels, from the white blaze of the window on down the scale.

There was always an awkwardness to Porter's treatment of the human body—a Yankee stiffness, the opposite of Bonnard's sensuous fluency. The figures in his paintings are never *not* in the right place, but his work didn't show much feel for the movement or the solid presence of the body, and it always preferred sociability to any hint of sensuality—a trait also shared by Katz. He never painted a nude. What he connected to best was landscape, houses, interiors. There, the reticence he brought to the scrutiny of other people melted away. Not that the land-

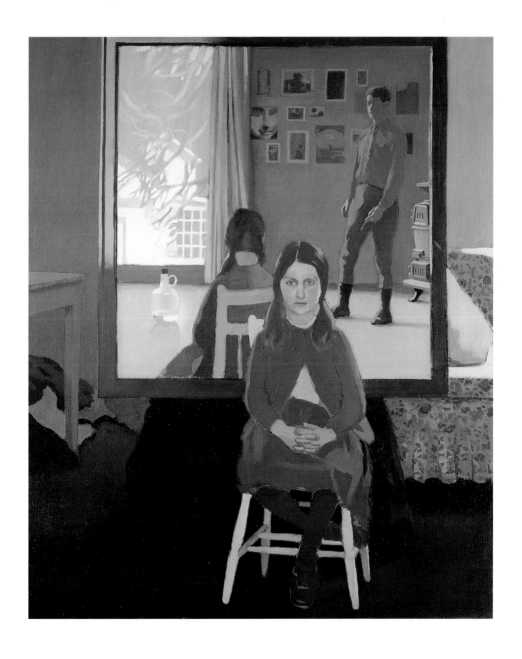

scapes are more "expressive"; they just radiate more freedom, and a fuller sense of Porter's desire to find concrete shapes that spoke on their own: presences. "The presence in a painting," he once wrote,

> is like the presence a child feels and recognizes in things and the way they relate, like a doorknob, the slant of a roof or its flatness, or the personality of a tool. Art does not succeed by compelling you to like it, but by making you feel this presence in it. Is someone there? This someone can be impersonal.

In 1970, the year I moved to New York, impersonality reigned so widely that all forms of figure painting (the art world agreed) were marginal. Where, to judge from the art magazines and museum schedules, was the action? Mainly in Minimalism and its offshoots, enacted against the background of what vanguard opinion believed was the Death of Painting. Downtown Manhattan, south of Houston and not called "SoHo," where only two galleries and two bars existed in that far-off year, looked like the art that was made there—as places come to do. You might be walking along the bank of the Seine in Paris on a fine spring day and think: I'm in the middle of an Impressionist painting. The sight of downtown New York from my loft roof takes me back in the same way, to the landscape out of which Minimalism came, the industrial metaphor: tar and steel plates and bundled rags, offcuts and Dumpsters on the pavements, the smells and sounds of small, dying, blue-collar businesses that were here long before the boutiques and galleries took over. With the water tanks on the roofs like tribal huts, and the World Trade Center presiding over it all, huge and stark and rather dumb-looking, the chamfers on its corners looking—when the evening light was right—like Barnett Newman's Zips.

Minimalism expressed America's Puritan tradition: a rejection of everything that was sensuous in abstraction. You might say it began with the Shakers, or indeed with the famous all-black page expressing melancholy in Laurence Sterne's novel *Tristram Shandy* (in 1759–67 two centuries before!), but the modern artist who engendered it was Ad Reinhardt. Gadfly, fanatic, and dandy, Reinhardt (1913–1967) belonged to the same generation as the Abstract Expressionists but had nothing in common with their spirit. He was an aphoristic preacher and a deadly parodist. His satires drew blood from the thin skins of his contemporaries.

Reinhardt loathed the mysticism that clung to interpretations of the New York School in the fifties: the cult of the expressive personality, the artist as existentialist. He was an extreme reducer, always looking for the edge where art ceases to be art, because only there, he thought, could one find what art is. How much can I jettison? This desire to strip art down to its barest nature and test the com-

329. Ad Reinhardt, *Red Painting,* 1952. Oil on canvas, 78 × 144" (198.1 × 365.8 cm). The Metropolitan Museum of Art, New York; Arthur Hoppock Hearn Fund, 1968.

municative power of austerity began with Mondrian's grids and Malevich's black square; it shed its mysticism in America and reemerged as factual, what-you-see-is-what-you-get Minimalism. Reinhardt's work in the 1950s cleared the ground for Minimalism without sharing its factuality. Impatient with the spiritual claims made for, and by, painters like Newman and Rothko, he hated being classed with them—not because he shunned the spiritual dimension of art, but because he thought their version of it bogus. "What's wrong with the art world," he wrote with characteristic asperity, "is not Andy Warhol or Andy Wyeth but Mark Rothko. The corruption of the best is the worst."

Reinhardt was never a figurative painter; all his surviving work is abstract, Cubist-based at first with overtones of Stuart Davis. Davis left a lasting stamp less on Reinhardt's art than on his pungent way of writing.

In the 1940s he passed through a phase of all-over painting, influenced not by Jackson Pollock but rather by the white writing of Mark Tobey, whose calligraphic impulses were linked to his main enthusiasm: classical Chinese brush painting. Eventually he settled on a steady format: a symmetrical, plainly painted array of blocks of one highly saturated color varying slightly in tone, first red—as in *Red Painting,* 1952 (Figure 329)—then blue, and finally black; just the single, hieratic array, motionless and ineloquent.

The black paintings in their final form after 1960 were all square, five feet by five, and with the same design: a cross which divided the surface into nine equal squares. So close were their values that you needed to gaze at the canvas for some time before your eyes, as though adjusting to a dark room, could make this out at all. If you kept looking, you would then see an extremely faint color inside the black, a disappearing aura of red or bronze, a nuance so faint and fugitive that

you might be wishing it into existence. Perception, illusion, a trick of sensory deprivation? You didn't know, but this almost subliminal trace of light asked for a discipline of looking. (The cross had no symbolic meaning. Raised as a Lutheran, Reinhardt was far more interested in Buddhism and Islam than in any Christian religion.) Reinhardt's black paintings are among the few works of art that are *entirely* meaningless when reproduced. They are a vindication of art's right to be experienced at first hand, because at second hand there is nothing to experience.

The only place for such pure stelae of darkness, Reinhardt wrote, was "a tomb": the museum. No American artist has ever put the claims of what he called "art-as-art," free from any social or therapeutic agenda, more categorically than Reinhardt. "The more uses, relations and 'additions' a painting has, the less pure it is," he wrote in 1957. "The more stuff in it, the busier the work of art, the worse it is. 'More is less.' " He offended true avant-garde believers by advocating a "true modern academy" that would purify the art world, shaming artists into being less eager "to accommodate their behavior to the undignified and standard forms in fashion, such as artist as entertainer, parasite, sufferer, actionist, cry-baby, primitive." The academy would train artists and free them from the now growing pressures of the art market, which Reinhardt viewed with disgust. There was little prospect of turning New York artists into Buddhist monk-painters, but that was his ideal. About the survival of high art in America's mass society, he was rightly pessimistic. His intransigeance made Reinhardt a saint in the eyes of a coming generation of artists at the beginning of the 1960s, who could have taken their motto straight from another of Reinhardt's canons: "The laying bare of oneself, autobiographically or socially, is obscene."

The artist who launched Minimalism was Frank Stella (b. 1936), who was still a student at Princeton when he saw Jasper Johns's 1958 show at the Leo Castelli Gallery. He liked the repetition of the flags, so many stars, so many stripes: their eschewal of "invention." He was also intrigued by the way Johns's image was co-extensive with the shape of the canvas, without space around it—just the image in itself, presented flat and raw. "The balance factor isn't important—we aren't trying to jockey everything around," remarked Stella, and his words could have stood for all subsequent Minimalism, which aimed for an all-at-once take: a work of art which could be taken in at a single look, in which nuance didn't matter—direct, macho, and very "American."

Stella was an idea cruncher, and he set out to isolate each element in Johns that could be pushed a bit further. To stress the canvas as object rather than illusion, he shaped it with cuts and notches. To get rid of color-generated space, he used monochrome: first black, then copper, then aluminum paint. He used the framing edge of the canvas to dictate every form inside it. The painting was generated almost automatically. The results (Figure 330) were about as close to flatness as Western painting had ever gone: those imposing, lugubrious structures of equal

330. Frank Stella, *Die Fahne Hoch*, 1959. Black enamel on canvas, 121½ × 73″ (308.6 × 185.4 cm). Whitney Museum of American Art, New York; gift of Mr. and Mrs. Eugene M. Schwartz, and purchase, with funds from the John I. H. Baur Purchase Fund; the Charles and Anita Blatt Fund; Peter M. Brant; B. H. Friedman; the Gilman Foundation,

bands of black with no depth and no feeling of pictorial light, bearing their peculiarly and sometimes gratuitously emotional titles which sometimes came from Nazi imagery—*Die Fahne Hoch* (*Raise the Banner High*) from the Horst Wessel song, or *Arbeit Macht Frei* from the iron letters over the gate of Auschwitz. All the content had migrated to the title (and still you didn't know why it was there), leaving the painting itself open to no interpretation, only formal description. "My painting," said Stella in an interview, "is based on the fact that only what can be seen there *is* there. It really is an object. . . . All I want anyone to get out of my paintings, and all I ever get out of them, is the fact that you can see the whole idea without any confusion. . . . What you see is what you see." The single-glance clarity of Stella's formats was at a far remove from the way Reinhardt's subtle relations of deep, near-black tone demanded time to become even faintly apparent.

Stella's art was polemical, argumentative. It helped set a tone for other artists. Minimalism was very dogmatic. Leading Minimalists believed they were riding the train of History itself, and said so with unabashed truculence, like Donald Judd in a 1962 article on Stella, whose works, he wrote, "show the extent of what can be done now."

The further coherence supersedes older forms. It is not only new but better . . . on the scale . . . of development. The absence of illusionistic space in Stella, for example, makes abstract expressionism now look like an inadequate style, makes it appear a compromise with representational art and its meaning.

Out with the old, in with the new. Such ideological certainties were politics transferred, with a strong Jacobin undercurrent. Nor were they confirmed by

Inc.; Susan Morse Hilles; The Lauder Foundation; Frances and Sydney Lewis; the Albert A. List Fund; Philip Morris, Inc.; Sandra Payson; Mr. and Mrs. Albrecht Saalfield; Mrs. Percy Uris; Warner Communications, Inc.; and the National Endowment for the Arts.

later developments in Stella's work, which in the 1970s and 1980s got increasingly baroque, warped, giddily overloaded with color, graffiti scrawls, and glitter, and full of spatial fictions (Figure 331)—because Stella himself got tired of polemical purity and wanted to reach for the embodiment of feelings in spatial experience that had characterized the works of seventeenth-century artists like Caravaggio, Rubens, or Bernini. But in the 1960s the idea that any of the Minimalists would end up talking in such terms would have seemed as unlikely as the fall of that largest of all Minimalist public sculptures, the Berlin Wall.

Dan Flavin with his arrays of fluorescent tubes, Carl Andre with his Brancusi-inspired stacks of wood baulks and (most notoriously) his rows of bricks on the museum floor (Figure 332), Robert Morris with his mazes and piles of cloth waste: to such artists, all humanistic content in art was mushy and to be avoided.

331. Frank Stella, *La Vecchia dell'Orto, 3x,* 1986. Mixed media on etched magnesium, aluminum, and fiberglass, 127 × 152¾ × 42¼″ (322.6 × 388 × 107.3 cm). Musée National d'Art Moderne, Centre Pompidou, Paris.

Only the object counted: an uncommonly mute object, a thing among other things in the world, which distinguished itself as art to the extent that, as Donald Judd put it, it was "interesting"—that is, presented some sort of challenge to taste. Not that being "interesting" implied any exoticism. Rather, Judd pointed to the vapidity of the things Americans surrounded themselves with as a source of inspiration: "most modern commercial buildings, new Colonial stores, lobbies, most houses, most clothing, sheet aluminum." In short, there was something in common between Minimalism and Pop art: a coldness, an attachment to the novel and the technical no matter what form the results might take. The Pop artist closest to the Minimalist sensibility was Andy Warhol, with his admission that he'd like to be a machine, his pseudo-industrial way of producing pictures in series by silk screen, and his belief that "during the sixties . . . people forgot what emotions were supposed to be. . . . I never thought in terms of 'love' again."

In rejecting imagery, Minimalist art rejected nature, and yet it could sometimes play very well against a landscape as its mysterious other—something that might have been left by extraterrestrials, without a user's manual (except, of course, for the precepts of American critics of the 1960s, sternly enjoining the art audience to accept the "bracing" esthetic of boredom). From this point of view, the ultimate Minimalist work appeared on film and not in real life: it was the black slab interred on the moon by long-departed aliens in Stanley Kubrick's *2001: A Space Odyssey*. But the later works of Donald Judd (1928–94) ran a close second.

Judd was the doyen of "high" Minimalism: inorganic materials (steel, tin, colored plastic, aluminum), blatantly artificial colors (Harley-Davidson red lacquer

332. Carl Andre, *Equivalent VIII*, 1966. Firebricks, 5 × 27 × 90¼" (12.7 × 68.6 × 229.2 cm). Tate Gallery, London.

was a particular favorite), geometric rigidity (but without the Utopian overtones of earlier geometric abstraction), industrial process, and, in its refusal of touch, an address to the eye alone. Lavishly underwritten by the Dia Foundation, Judd in the last twenty years of his life acquired some thirty-two buildings on Fort Russell, an abandoned military site near Marfa, a cattle town in southwest Texas. The main ones were two artillery sheds, in which he set up a series of boxes, a hundred per shed, each three feet by four by six, each with a different internal structure, and all factory-made of polished three-eighths-inch aluminum sheet which reflects (through the glass walls) the big sky, the flat landscape, and the changing light outside, as well as the softly gleaming surfaces of their neighbors (Figure 333).

This temple of esthetic fanaticism epitomizes Judd. His work was hard to like because the reduction he sought was of a kind that most people don't want in sculpture. No figure, no parts. No relationships, except the accidental ones produced, at Marfa, by mutual reflection of light. No movements, no metaphors, no secrets: just the thing in itself, and a completely inexpressive thing at that. None of which excluded the fact that the work could be beautiful, in an anxious, muffled-Utopian way. It is in the world but it tells us nothing about the world. But its

333. Donald Judd, *Untitled*, 1982–86. Permanent installation of one hundred works in mill aluminum. The Chinati Foundation, Marfa, Texas.

denial of the sensuous is deeply American. You think of the purity of Shaker furniture, the spareness of Puritan meetinghouses—boxes with God's word in them. Except that Judd's work, in its utter secularity, represents only the husk of the beliefs behind such earlier American creations.

Some American abstract painting was cognate with Minimalism without actually sharing its assumptions. Ellsworth Kelly (b. 1923) created an art of spare, authoritative, and infinitely refined forms (Figure 334), Matissean in their intelligent joy of color, on the basis of constant drawing from the observed world, the profiles of leaves, the heads of friends, the reflected arch of a bridge. He wanted to

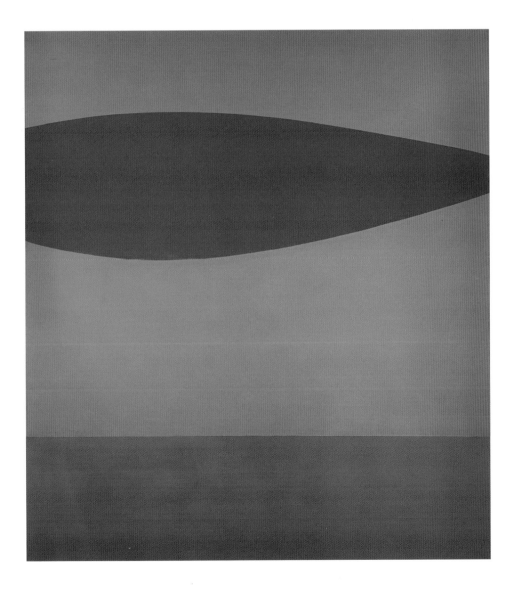

334. Ellsworth Kelly, *Blue, Red, Green,* 1962–63. Oil on canvas, 91 × 82" (231.1 × 208.3 cm). The Metropolitan Museum of Art, New York; Arthur Hoppock Hearn Fund, 1963.

335. (above) Brice Marden, *Cold Mountain 1 (Path)*, 1988–89. Oil on linen, 108 × 144″ (274.3 × 365.8 cm).

336. (below) Brice Marden, *Green (Earth)*, 1983–84. Oil on canvas triptych, 84 × 109″ (213.4 × 276.9 cm).

imbue his art with an "object quality," neither abstract nor figurative, the thing in itself. On his first sojourn in Paris in 1948, he found that, as he later put it,

> all art since the Renaissance seemed too man-oriented. . . . An Egyptian pyramid, a Sung vase, a Romanesque church appealed to me. The forms found in the vaulting of a cathedral or even the splatter of tar on the road seemed more valid and instructive and a more voluptuous experience than either geometric or action painting. Instead of making a picture that was an interpretation of a thing seen, or a picture of invented content, I found an object and "presented" it as itself alone.

Kelly's entire work is an argument for subtlety and beauty, qualities that Minimalism was hardly interested in. So, too, are the paintings of Brice Marden (b. 1938), perhaps the finest American abstract painter of his generation. In the 1970s Marden worked in a very controlled format of blocks of subdued color butted up against one another: the image "built" from monochrome canvases. The quality of the color and the proportional relations of the canvases were both crucial (Figures 335 and 336). He liked his paintings to be the size of a person—not the extravagantly large fields common in American abstract art—so that one would be induced, without being quite aware of it, to experience them as standing figures, other "presences" in the room, rather than as spectacles. He admired Jasper Johns, and like him worked in a mixture of oil paint and wax, a false encaustic that gave his surfaces both substance and an inner glow, like light working its way through layers of slightly dusty translucency. You thought of the surface as skin. Marden was a brilliant colorist, in a very toned-down way. His warm grays and brick reds, his low, thick salty blues and blocks of terre verte, betokened nature, suggesting planes of light on sky, sea, old stone, and vegetation: frequent visits to the Aegean contributed to this. This was Minimalism humanized, an activity that engaged other Americans too.

The most powerful body of work made by an American sculptor in direct answer to Minimalism came from Richard Serra (b. 1939). He wanted to find a way past Minimalist purity by invoking the human body and its anxieties in weight, mass, and hard work with heavy materials. "I thought," Serra recalls,

> that with my own hands I could involve myself in a process of making that could confront Minimalism and open up the field. So basically I started writing down a verb list and enacting physical processes in relation to the material I had at hand.

To roll, to crease, to fold, to bend, to crumple, to shave, to cut, to sever, to drop, to remove, to simplify. And so on. "High" Minimalism could be ordered, and often was, from a factory by phone. Not Serra's work. He was a manual worker, intimately involved with the process of making and the logic of materi-

als, such as the propensity of steel to rust and produce surfaces whose markings, seen in isolation, can be argued to be as beautiful as those of travertine or bronze. He lifted stiff sheets of industrial rubber and let them slump. He dumped arrays of metal on the floor. He propped steel plates together. He spattered molten lead into corners, producing heavy molds of a part of the room. The act of throwing lead seems cognate with Jackson Pollock's practice of throwing skeins of liquid paint, but Serra denies that he had Pollock in mind.

What did concern him was the weight of sculpture, its presence in the world—something to set against the abstraction of ideas, and even against the idea of "style." He wanted to make large sculpture that would be explicitly itself, with none of the character of either "failed architecture [or] three-dimensional painting." (Even earthworks, Serra felt, tended to be viewed "pictorially": "It is no coincidence that most . . . are photographed from the air.") Architecture was stable, constructed; Serra would make large sculpture with no connectors, not welded or bolted but held together by gravity, the elements leaning or stacked—in a word, rigged, not built. In 1969, in a California steelyard, he made the extraordinary *Skullcracker* series: great irregular slabs of "crop," the waste steel off a hot-roll mill, stacked perilously one atop the other by a magnetic crane (Figure 337) to make "dense, loose and balanced" towers, two hundred tons of metal twenty feet high. These introduced the main character of Serra's work thereafter: its scariness. You are never allowed to forget the weight of Serra's metal. The possibility of being crushed by it is part of its sculptural effect. It addresses the body through anxiety, and this is a thoroughly legitimate though long-repressed function of sculpture at its most archaic level. You skirt his steel walls and walk through the curving spaces they define with a degree of dread (Figure 338).

However, in America at least, this raised problems for Serra in the domain of public sculpture. Hence the controversy over his *Tilted Arc,* which for a time became the most famous nonexistent sculpture in the country. Commissioned by

337. Richard Serra, *Stacked Steel Slabs (Skullcracker Series),* 1969. Hot rolled steel, 240 × 96 × 120″ (609.6 × 243.8 × 304.8 cm). Temporary installation: Kaiser Steel, Fontana, California (work destroyed).

the General Services Administration, a branch of the federal government, it was installed in 1981 on the plaza of a federal building in downtown Manhattan. The GSA cannot have been under any illusion about what kind of sculpture Serra made, how confrontational it was. It wasn't expecting a nice bronze of Peter Pan. But it was not prepared for anyone to actually *object* to this 124-foot, curved, tilting wall of steel plate. Provoked by vehement objections from federal workers in the building, who thought *Tilted Arc* menacing and couldn't see why their already ugly plaza should be made worse by a steel wall that cut it in half, public hearings were held. At them, Serra testified with equal passion that the work could not be removed because it was "site-specific," designed for a given spot. Remove it, he said, and you would utterly destroy it—reducing it to the meaningless array of rusty metal its opponents said it already was.

In fact, the world's museums are full of formerly "site-specific" art, from the Elgin Marbles to any number of displaced frescoes, tombs, and statues, which were diminished but did not die when moved. However, the matter is now moot: *Tilted Arc* was dismantled and moved to storage, where it remains. Serra's supporters compared this to Hitler's book burning, called it an act of censorship, and predicted that it would start an iconoclastic stampede against public art in Amer-

338. Richard Serra, *Intersection II*, 1992. Cor-ten steel, four plates, each 157$\frac{1}{2}$ × 669$\frac{1}{4}$ × 2″ (400 × 1700 × 5 cm).

ica. And indeed, as we will see, there was such an attack—wide-ranging, vehemently moralizing, and deadly effective—against publicly *funded* art some ten years later, but the fate of *Tilted Arc* had nothing to do with it. In the meantime, it exemplified the fact that a sculpture may have genuine and even deep merit as a work of art, and yet fail in the public realm.

Despite Serra's misfortunes as a public sculptor in America, a work that derives from his became the most successful, beloved, and often visited monument built in the nation's capital in half a century. It was designed by an unknown twenty-one-year-old artist, Maya Lin, and it commemorates the fifty-eight thousand American dead of the Vietnam War. She had no consensus to work with, as the designers of war memorials in the 1920s did. Half of America believed the war had been a moral tragedy, and all America knew it had been lost. But even those who had opposed the war felt that the soldiers were not to be blamed for it, while the vets themselves were angry at the raw deal American civilians had given them. Maya Lin was faced, as she put it, with the problem of designing a memorial that would not "tell you what to think" about Vietnam. She came up with a design that would not try to resolve conflicting emotions over the war—which for most historically conscious people may never be resolved—but would reawaken the intensity of each buddy's or brother's or parent's feelings through a single memorial device: the names of the dead on the black walls, in whose polished surfaces the living see themselves visually united with the dead. They take rubbings; they leave flowers; they kiss the names of those they have lost.

One of the old themes of American art that got a new lease on life in the later 1960s and 1970s was the apprehension of nature's sublimity. It reappeared, in a secular form, in the Earth Art movement. Perhaps it was inevitable that younger artists, having been raised on the rhetoric of fictive sublimity that surrounded Abstract Expressionism, should have tried going out into the vast and actual spaces of America to test themselves against them.

More people "knew" the results through reproduction than ever got to see them. One was Walter De Maria's *Lightning Field* (Figure 339), completed in 1977 in a spectacular mountain-rimmed valley in New Mexico, two hundred miles southwest of Albuquerque. It consists of four hundred glittering stainless-steel spikes, their needle tips forming a level square like a fakir's bed of nails one mile long and one kilometer wide. The metal poles invite lightning strikes, which rarely happen, but their shimmer in morning sunlight and their virtual disappearance under other conditions of weather are enough to establish a gratuitous and intensely poetic presence.

De Maria's most visited piece is in downtown New York, on the second floor of a loft building in SoHo. There, also in 1977, he filled the entire space with 125

tons of rich, chocolate-brown soil, covering 3,600 square feet of prime real estate, in perpetuity, to a depth of 22 inches. The *Earth Room* is still there, sedulously maintained and viewed by perhaps fifty people a week. It is said that reproduction does not do it justice, but perhaps neither does an actual visit. This odd conceptual icon enshrines a moment when Minimalist and Conceptualist artists alike were hoping to contradict the art market, which they tended to view as inherently wicked; certainly it's hard to imagine all that soil being trucked up to Sotheby's, and presumably all offers from indoor marijuana growers will continue to be refused.

The image of the sublime West would always be attached to American earthworks, because it was their necessary site. They needed a tabula rasa, but one with deep cultural associations. Michael Heizer (b. 1944), who came from a family of geologists and archaeologists, was fascinated by mysterious sites, places that retained the marks of inscrutable ancient technology such as the moving of great blocks of stone. In homage to these mighty "primitive" efforts, Heizer carved out *Double Negative,* 1969–70, a straight trench thirty feet wide, fifty feet deep, and a third of a mile long cut with bulldozers across the Virgin River mesa in Nevada, removing some quarter of a million tons of sandstone. The most striking example of Heizer's efforts to create a lost-civilization effect stands in a stretch of desert near Hiko, Nevada: *Complex One,* 1972, a prismatic hill of rammed earth between two end triangles of reinforced concrete, inflected by large concrete beams, the whole thing being 140 feet long and 110 feet wide, thus recalling, in its massive presence, the enigmatic structures left behind by America's various nuclear and space programs, which by the 1970s were already beginning to seem an archaeology of the Age of Paranoia.

339. Walter De Maria, *The Lightning Field,* 1977. Four hundred stainless-steel poles with solid, pointed tips, situated in a rectangular grid array, 1 mile × 1 kilometer. Catron County, New Mexico; commissioned and maintained by the Dia Center for the Arts.

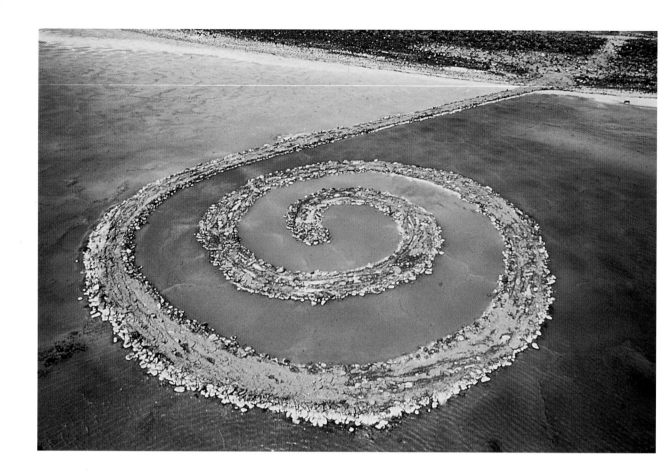

The best-known work of earth art has already disappeared. It was created by Robert Smithson (1938–1973), in the shallows of the Great Salt Lake in Utah. Up to the time he began work on it, in 1969, Smithson had been preoccupied with entropy: "evolution in reverse," the decline of systems, enforced by the second law of thermodynamics, under which energy dissipates and all distinct form blurs and disintegrates across the span of geologic time. He made rather opaque and theoretical indoor works to illustrate this point, but his great success was a work which virtually no one in the art world ever saw except in the art magazines. This was the *Spiral Jetty* (Figure 340). In 1969 Smithson took out a twenty-year lease on an abandoned lakeside industrial site. The water was red from saline algae and fouled with chemicals and tailings; the shore, littered with obsolete machinery. The whole place looked like a ruined moonscape, which suited him perfectly, since Smithson's imagination had a strong component of the higher sort of science fiction, such as the apocalyptic, time-drenched landscapes of J. G. Ballard, whom the artist read avidly and admired.

Into the water Smithson dumped some seven thousand tons of rock, to make his *Spiral Jetty:* a counterclockwise coil fifteen hundred feet long and fifteen wide, built with aged Caterpillars and dump trucks. The spiral form, of course, was so

340. Robert Smithson, *Spiral Jetty,* 1970. Rock, earth, and salt crystals, coil 1,500 × 15′ (457.2 × 3.81 m). Now submerged (Great Salt Lake, Utah).

organic and archaic that it could have been associated with almost anything, and was: from viruses and spiral salt-crystal deposits, to legends about mysterious whirlpools forming and vanishing in the Great Salt Lake, to archetypal serpents and snail shells, scrolls and—seen from the air—nebulae in outer space. That it could attract such a traffic jam of symbolic references was, of course, part of Smithson's design. The *Spiral Jetty* remained visible for two years, until the waters of the lake rose and covered it. It is still there, under the reddish muck.

The earth sculpture that will probably be remembered as the most impressive of the whole genre is not yet finished. It is in Arizona, on the edge of the Painted Desert: the work of James Turrell (b. 1943).

Turrell's earlier work consisted of almost nothing: bare walls, some tungsten and filament lamps, natural daylight, and the reactions between them. But the effect could be extraordinarily compelling. One sees, for instance, what appears to be a big flat rectangle pasted to a white wall, dark gray in color with perhaps a greenish cast: undifferentiated, banal late Minimalism. But as you approach, corners appear within its surface, as though reflecting the gallery in which you stand. Perhaps this "thing" is a dark, smoky sheet of mirror? But no; it is only a hole in the wall, giving onto another room, which seems to be filled with a gray-green mist. The surprise of this dissolution of substance into absence is so intense, and yet so subtly realized, that it becomes magical.

The problems of illusion are obviously central to art. How does one conjure up the presence of something that isn't there? And once that is done, how do we recognize the limits of image and reality? Can one make art by just having light?

Turrell tried to. His *Second Meeting*, in Los Angeles, is a square pavilion with a clean-cut square opening in the roof. It contains nothing but air, and from it you watch the sky. As the sun sets, the changing contrast between the artificial light inside and the natural light of the sky makes that square almost palpable. "I put you in a situation," says Turrell,

> where you feel the physicality of light. This is an art that people try to touch—but there's nothing to touch. There is, first of all, no object; there is no image, nor any place of focus. What are you then looking at? Well, I'm hoping that you then have the self-reflexive act of looking at your looking, so that you're actually seeing yourself see to some degree, so that it actually does reveal something about *your* seeing as opposed to being a journal of *my* seeing.

The medium of Turrell's work is perception itself; his art happens behind your eyes, not in front of them.

Since 1979 Turrell's consuming project has been to turn an extinct volcanic crater north of Flagstaff, Arizona, into a work of art: not painting the Western landscape but subtly transforming a part of it. He found the Roden Crater in the

course of a seven-month search, piloting his own plane around the West, sleeping under the wing at night; and in the end "I had to buy a ranch to get a volcano." The Roden Crater is a stepped cone which, from one angle of view, looks like an immense pair of lips on the horizon. Inside it, looking upward from its basin, Turrell plans tunnels, viewing chambers, and pools acting as lenses of water that will enable the visitor to experience the light of the sun, the moon, and the stars in isolated, concentrated ways: an instrument that will "engage celestial events in light, so as to play the music of the spheres in light" (Figure 341). Its first stage, the shaping of the crater rim, is now complete. It entailed bulldozing off some 200,000 cubic yards of earth, "so as to shape the sky." Which it does: when one lies down on the ground and looks at the upside-down firmament framed in the smooth arc of the rim, it becomes a blue dome, all-embracing, transparent, and yet somehow solid: the "luminous eyeball" Emerson wrote of in the nineteenth century, a huge emblem of peaceful and oceanic consciousness.

The settlement of northeastern America in the seventeenth century was done by iconoclasts: radical Puritans bearing an already old and fanatical tradition of English hostility to the graven and colored image. To them, as we have seen, the Word was law and the Image a delusion and a snare, except in the "shades" of family portraiture. Once implanted, the idea that virtue may lie in the breaking (or at least the rejection) of idols, the scorning of the visual and the sensuous, is not easily shaken off. It has been fixed in the American genome for three hundred years and is apt to show itself in moments of political or moral anxiety.

Its residue impelled not only Minimalism in the 1960s, but conceptual art in the early 1970s as well. Radical artists disparaged the "commodification" of art—not that there had ever been an earlier age in which art was *not* a commodity. The aim was to get rid of the object, turn it into pure text, volatilize it. What was free? Words, actions, propositions, ideas, gestures—all of which would acquire some kind of special aura by being made and recorded by an artist, and placed in the frame of a gallery. In 1971 Lawrence Weiner exhibited the following artwork, consisting in its sublime entirety of words on the gallery wall:

341. James Turrell, *Roden Crater Bowl, Finished Contours,*
1990. Photo emulsion, wax pastel, acrylic and ink on Mylar
and vellum paper, 36¼ × 36¼" (92.1 × 92.1 cm).

AFFECTED AS TO PRESSURE AND/OR PULL
EFFECTED AS TO PRESSURE AND/OR PULL

AFFECTED AS TO HEAT AND/OR COLD
EFFECTED AS TO HEAT AND/OR COLD

AFFECTED AS TO EXPLOSION AND/OR IMPLOSION
EFFECTED AS TO EXPLOSION AND/OR IMPLOSION

AFFECTED AS TO CORROSION AND/OR VACUUM
EFFECTED AS TO CORROSION AND/OR VACUUM

AFFECTED AS TO NOISE AND/OR SILENCE
EFFECTED AS TO NOISE AND/OR SILENCE

Not very heady stuff, but at least you couldn't accuse it of bourgeois lushness. Artists locked themselves in steel cabinets, crucified themselves on Volkswagens, had their friends shoot them at close range with low-caliber pistols. They sat autistically in corners in front of TV cameras, or rolled about on the studio floor uttering low grunts. They compiled long lists of meaningless measurements, or wrote stacks of numbers over and over again. They typed out certificates promising to take photographs of everyone in the world. They exposed themselves to third-degree sunburn. They sent daily postcards recording the time they got up. And some really thought they were doing something radical. "It is an astonishing but inescapable conclusion that we have reached," a group of Conceptualists declared in their magazine, *Art-Language*, in 1970,

> namely, that the seemingly erudite, scholastic, neutral, logical, austere, even incestuous, movement of conceptual art is, in fact, a naked bid for power at the very highest level—the wresting from the groups at present at the top of our social structure, of control over the symbols of society.

Fat chance.

The most influential artist to come out of the unwieldy, hard-to-categorize mix of conceptual art, "process" art, and performance art by the end of the 1970s was Bruce Nauman (b. 1941). Most of the idioms preferred by younger artists at the end of the 1980s, from video to body pieces to language games of various sorts, were affected by Nauman. There is no mystery as to why. What Nauman mainly practiced was a form of psychic primitivism, or atavism if you prefer. His art is chiefly about two states: compulsion and regression. When you see a videotape of him smearing himself with black paint, you aren't sure whether he's dis-

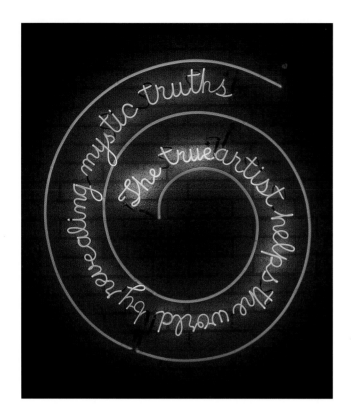

guising himself or simulating the fecal games of a backward child. Autism is the governing metaphor of his work's "look"—the long-winded rituals of trivial movement, the ejaculatory phrases, the bouts of ungovernable rage. He is therefore a guru to artists who value the regressive, seek gnomic "enactments" of pain, are obsessed by splits between public and private identity—including their own feelings of victimization—and treat the body as canvas. The artist as hero is long gone from American culture, but Nauman has cut himself a different niche: the artist as nuisance.

Nauman's art has no interest in pleasure, and this suits a museum culture that would rather have art "problematic" than enjoyable. He exploits whatever can turn you off: aggro, solipsism, tension, repetition, torpor, and bad jokes. He is good at a particular sort of put-on, a sour clownishness so dumb that you can't guess whether its dumbness is real or feigned. Thus with his spiral neon piece, inspired by a beer ad in a bar window, reading "The true artist helps the world by revealing mystic truths" (Figure 342). You assume it's irony, the corpse of "inspirational" American romanticism. Then you reflect that maybe that's what Nauman once really thought, and that he'd still like it to be true. But the sign can't deliver on its promise in any case, and this frustration—you assume—is part of the piece.

Yet there is a peculiar grip to some of Nauman's work. An example is *Shit in Your Hat—Head on a Chair,* 1990, a video piece: the projected image of a mime, with a chair suspended from the ceiling in front of it, and a green wax head on the chair. A disembodied voice, calm and in control—the Outer Parent—issues a string of orders which get more and more humiliating ("Shit in your hat. Show me your hat. Put your hat on your head") as the poor mime obeys them all. The most sinister Nauman to date, however, is *Carousel,* 1988 (Figure 343). Four motor-driven arms swing on a pivot. From each hangs what appears to be the flayed carcass of a deer or wolf. (They are, in fact, hard plastic foam molds, originally used by taxidermists.) These casually suspended mock-bodies are covered in graphite paint, and they drag on the floor, producing an irksome scraping noise and leaving a silvery snail trail behind them. You shudder at the gratuitousness

342. Bruce Nauman, *The True Artist Helps the World by Revealing Mystic Truths,* 1967. Window or wall sign, neon 23¼ × 21¾" (59 × 55.1 cm). Kröller-Müller Museum, Otterlo, the Netherlands.

of their posthumous torment, and its parody of that source of childhood pleasure, the fairground carousel with its friendly animals. It is a glimpse of Hell.

The artist who did most to humanize Minimalism without sentimentalizing it was Eva Hesse (1936–1970). Dying of brain cancer at thirty-four, an age at which most artists' careers are barely under way, she left a truncated body of work but one of remarkable power: an instrument of feeling that spoke of an inner life, sometimes fraught with anxiety.

Hesse's *Accession II,* 1969 (Figure 344), is a gray cube of metal mesh, thirty inches on a side, sitting on the museum floor, at a quick distant glance just like a Donald Judd. But on a second look, how different! Every pair of holes in the mesh has a strand of gray plastic tubing threaded through it, the ends pointing inward. The whole inside of the cube is lined with these large glossy hairs. You can't not see it as organic: a sea anemone, a vagina. Its obvious predecessor is that Surrealist icon of oral eroticism in the Museum of Modern Art, Meret Oppenheim's fur cup and spoon. The hands-off character of Minimalism has vanished

343. Bruce Nauman, *Carousel,* 1988. Steel and aluminum, 84 × 216¾″ (213.4 × 550.5 cm). Stedelijk Museum, Amsterdam; on loan from Haags Gemeente Museum, The Hague. (Seen here in a gallery installation with two other works.)

in a tough, unappealing image that oscillates between fear and desire, irony and alarm.

Spurred by the examples of Joseph Beuys, Claes Oldenburg, and Jean Dubuffet, Hesse grew more and more interested in what didn't usually pertain to sculpture. Backing away from its "male" rigidity, which included the high-style rhetoric of Minimalism, she allowed her fascination with the "female" and the inward, including what was grotesque and pathetic, to enlarge. The phallic mockery in Hesse's work can be comically obscene: black salamis wound with string, slumping cylinders of fiberglass. Even when it looks entirely abstract, her work refers to bodily functions. *Hang-Up,* 1965–66 (Figure 345), looks at first like a query about illusion and reality—the big rectangular frame hanging on the wall with no picture in it, but with a loop of steel tube spilling onto the gallery floor and connecting the frame's top left to its bottom right corner. But again, there's a fleshy metaphor. Both tube and frame are wrapped in cloth, like bandaged parts of a patient, and the tube might be circulating some kind of fluid. Blood? Lymph? Fantasies? Even in absence, the body is somehow there, as an ironically suffering presence; the title phrase, "Hang-Up," means both what you do to pictures and (in sixties' slang) a mental block, a neurosis.

However, Hesse wasn't an art martyr and her images are very much more than mere enactments of illness or oppression. They reflect on identity, sometimes with wry wit or an angry fatalism; but to see Hesse as a precursor of "victim art" does

344. (above) Eva Hesse, *Accession II,* 1969. Galvanized steel and plastic tubing, 30¾ × 30¾ × 30¾" (78.1 × 78.1 × 78.1 cm). The Detroit Institute of Arts.

345. (below) Eva Hesse, *Hang-Up,* 1965–66. Acrylic on cloth over wood and steel, 72 × 84 × 78" (182.9 × 213.4 × 198.1 cm). Art Institute of Chicago; through prior gift of Arthur Keating and Mr. and Mrs. Edward Morris.

her a disservice. She never wanted to see her work snugly categorized as "women's art." Quite the contrary; Hesse wanted it to join the general discourse of modern images, uncramped by niches of gender or race. "The best way to beat discrimination in art is by art," she brusquely replied to a list of questions a journalist sent her. "Excellence has no sex." Very old-fashioned of her, by today's standards of cultural complaint.

Nancy Graves (1940–1994) was Hesse's contemporary and a friend of Smithson and Serra as well. Her ideas about sculpture arose from anatomy, archaeology, and anthropology; she was less interested in the inner body than in its often bizarre outward forms. Living in Italy in 1965, Graves became fascinated by the life-size wax écorché figures of the eighteenth century sculptor Clemente Susini, preserved in La Specola, Florence's museum of natural history. From her visits came the desire to make, of all things, camels. She constructed them life-size on wooden armatures and lumps of plastic foam, covered with the skins of sheep and goats (though never real camel skin). Seen in the gallery, these intrusive beasts confound our distinctions between effigy and sculpture (Figure 346). They are not found objects but made ones, and yet they seem hard to define clearly as either art or nonart. In querying their own status, they border on conceptual art. It's their strangeness that counts, and by the 1980s Graves was making sculpture by putting contradictory objects together with an élan and freedom worthy of any Surrealist in the 1920s.

346. Nancy Graves, *Camel VI,* 1968–69. Wood, steel, burlap, polyurethane, animal skin, wax, and oil paint, approximately 90 × 144 × 48″ (228.6 × 365.8 × 121.9 cm). National Gallery of Canada, Ottawa.

Her work spread a wider fan of poetic association than any other sculptor's of her generation. Graves was alert to any stimulus, and never too bothered with purity. She wanted to refresh a word much overworked in modern art: metamorphosis. She did it by casting soft or perishable things—fruit, rope, leaves, paper, vegetables—in bronze, and then assembling them into colored sculpture.

To see this at work, consider one piece in detail: *Hay Fervor,* 1985 (Figure 347). Its main part, the "spine," is the bar of a brush cutter Graves found rusting on a New York farm. Its teeth read as vertebrae. It rises from a base made partly of frills (cut-up lampshades stuck together with wax, then cast in bronze) and partly from a curl of three-inch marine hawser, bronze-cast and then colored blue, green, and white. Being solid metal, this base is far heavier than it looks: the eye can't guess the weight of the elements, and there is an irrational play-off between apparent and actual weight. It balances the sculpture's topknot, a row of huge leaves held in a yellow wriggle of bronze rope that shoots into space with oratorical confidence. Gradually *Hay Fervor* begins to look distantly but distinctly like a head with hair. Surfaces tend to the matte and the coralline; colors, to the exotic brightness of photos of a barrier reef.

This is Constructivism gone haywire, weirdly mutating. It is focused on structure, not mass. It is open, not solid. It emphasizes welding and connecting, not casting (though its parts are cast). Its bits and pieces don't match; they argue for the world's heterogeneity, instead of creating metaphors of seamless unity, as bronze and marble traditionally do. One sees that despite the vegetable and animal shapes, Graves's work carried on the tradition whose great American bearer was David Smith. Her trial-and-error improvisation reflected the mix of Surrealist and Constructivist impulses in Smith's work. Graves found fresh terms on which to enter art's long discourse on nature, which in America in the 1970s and 1980s seemed to be flagging badly. Her sculpture immobilized the exotic forms of nature, presenting a dry curl of pig gut or a stalk of brussels sprouts with the same sense of discovery that once greeted the use of newsprint in collage. In the spirit of her modernist ancestors, but with organic and perishable things, Graves celebrated nature's vast power of mass production, along with its alienness and reconciling beauty.

The sculpture of Martin Puryear (b. 1941) achieves a deeply organic charac-

347. Nancy Graves, *Hay Fervor,* 1985. Bronze and steel with polychrome patina, baked enamel, and polyurethane paint, 93¾ × 87 × 38¼" (238.1 × 221 × 97.1 cm). Private collection.

ter through other means. Puryear works directly in wood, though mud, wire, and tar also figure in his repertory. His cultural memory bank is filled with images from wood cultures: canoes and framed tents, ceremonial staves and coffins, Mongolian yurts, tribal Indian sweat lodges, trestle framing and basketry. In particular, having spent two years in the 1960s teaching for the Peace Corps in a remote village in Sierra Leone, he was influenced by the work of West African carpenters. And an important part of his esthetic education came from meeting the great Seattle-born cabinetmaker James Krenov in Stockholm in 1966. "He opened my eyes," says Puryear, "to an entirely new degree of commitment and sensitivity to materials." And when this new appreciation of material intersected with the primary Minimalist forms Puryear had taken in, his real line of development began.

The work of Minimalists like Judd and Serra had an industrial metaphor at its heart; Puryear preferred *earlier* industrial forms, those of the wooden pattern-maker, the wheelwright, the cooper. He was a maker, not a manufacturer, absorbed by crafts that had been pushed out of their older role in industrial society. He wanted to rescue hand techniques for sculpture, using them to realize in organic materials, mainly wood, large mysterious forms that bordered on nature and drew poetic strength from its limitless variety. Other artists of Puryear's generation, like Joel Shapiro, Jackie Windsor, Nancy Graves, and Eva Hesse, were into the same idea, though by different means. Puryear turned out to be the most craftsmanly of them all; his work has the strong American-grain character—if not the episodic fussiness—of that earlier virtuoso of dovetail and lamination, H. C. Westermann. The joint, said the American architect Louis Kahn, was the beginning of all ornament. Puryear's work accepts and celebrates this. Behind the work one also sees the influence of Constantin Brancusi, who did more than any other twentieth-century sculptor to combine a reductive, purist sensibility with the language and techniques of vernacular carpentry. Puryear's forms recall boxes, pods, coffins, and tents; one piece, *For Beckwourth,* 1980, resembles a solid wooden hogan with a top plastered in cracked mud, recalling both the primitive hut and the origins of the dome. In *Old Mole,* 1985 (Figure 348), the

348. Martin Puryear, *Old Mole,* 1985. Red cedar, 61 × 61 × 34" (154.9 × 154.9 × 86.4 cm). Philadelphia Museum of Art; purchased with gifts (by exchange) of Samuel S. White 3rd and Vera White, and Mr. and Mrs. Charles C. G. Chaplin and with funds contributed by Marion Boulton Stroud, Mr. and Mrs. Robert Kardon, Mr. and Mrs. Dennis Alter, and Mrs. H. Gates Lloyd.

overlapping strips of red cedar produce a strangely ambiguous effect: on the one hand, the logic of the thing's making is obvious, a kind of free-form basketry in wood, but on the other the mole-like shape with its pointy "nose" suggests that something else is hidden under the cedar, muffled and swaddled in it, mysteriously lurking.

In American painting in the 1970s, one figure stands out above all others in terms of intensity and influence. He was Philip Guston (1913–1980). His work over that decade redefined the terms of painting for a whole generation of Americans. But it was also Guston's misfortune that the existential courage of his leap back into figure painting from "high" abstraction was embraced by many an artist whose work, had he lived to see it, would have bored or repelled him. Misunderstandings about it gave courage to a number of uncouth duds whose work filled up the horizon in the early 1980s, with their arbitrary clichés, their affectless rummaging in the bin of past styles and images, their inept drawing, and their high-flown bombast. But Guston's own relation to past art was deep, reverent, and specific. It had none of the opportunist and weightless character of postmodernism. His immersion in the past was the necessary precondition of work in the present, not just another function of cultural overload. The antique fragments he saw in Rome in the late 1940s enabled him to start painting figures again in the late 1960s. Battle sarcophagi, and the triumphal stone processions on the Arch of Titus and Trajan's Column, wound into his friezes of bugs and legs in the 1970s. As far as Guston was concerned, Piero della Francesca never died, and he spent his life intermittently wrestling with him (and with Goya too, and Piranesi, and Velázquez, De Chirico, and Picasso) like Jacob with the angel. But he would never pull an image out of art history into his own painting without some deep personal reason for it. For instance, the naked lightbulb that recurs in his mature work has a clear descent from the lantern in Goya's *Third of May,* which became Picasso's electric light in *Guernica.* But it also helps to know that as a boy Guston used to draw in the only "studio" he could get in his parents' mean house in Los Angeles, a closet lit by a single bare bulb, whose unshaded glare became associated, for him, with the very process of work: the emblem of the cave of making. Likewise, his Russian-Jewish-Canadian father, Louis Goldstein, an inveterate failure in a town where Jews were supposed to make it, worked mainly as a junkman; and this would set up a long train of echoes in the piles of discarded boots and other claustrophobic rubbish that would fill his son's paintings, though we also know that the boot soles were meant to recall the horse's hooves in Paolo Uccello's *Battle of San Romano.*

And he wrestled with abstraction too. Guston began as a figurative painter in the 1930s, in Los Angeles, where he grew up and went to art school. One of his

349. Philip Guston, *Painting,* 1954. Oil on canvas, 63¼ × 60⅛″ (160.6 × 152.7 cm). The Museum of Modern Art, New York; Philip Johnson Fund.

fellow pupils was Jackson Pollock. He yearned to paint grandly constructed, di-
dactic murals; the Mexican muralists (Rivera, Orozco, and Siqueiros) were the
living proof that this could be done. He met Orozco in Los Angeles and in 1934
worked as his assistant in Mexico. In 1935, at Pollock's urging, he moved to New
York and began doing mural work for the Federal Art Project, all of which has
since been destroyed. Over the next fifteen years, by a process too winding to be
summarized here, he became an abstract painter, one of the little group that also
included Pollock, Rothko, de Kooning, Kline, and the rest. His work had its dis-
tinct edge of originality. It didn't look or feel like anyone else's in the New York
School. What it did share with Pollock, to some degree, was an all-over web. But
with Guston that image is suspended, like an indistinct veil, before your eyes (Fig-
ure 349)—a fog, a palpitation of color. Go in closer, and it is not a fog at all, but
a mass of little incidents, microforms made by the crossing and recrossing of
brushstrokes. They are diffused in light but they never lose their character as sep-
arate strokes. This Monet-like effect was why critics called his work of the early

1950s "Abstract Impressionism." But it doesn't fit, because the pictures actually have more to do with Mondrian than with Monet—specifically, the seascapes Mondrian painted on the coast of Scheveningen in 1912–15, in which he resolved the movement of waves and light into a pattern of crosses. This field of twinkling intersections became Mondrian's sign for all substance, and from it his grid would eventually come. In rather the same way, the membrane of Guston's paintings of the early 1950s is a matrix for diffused presences which would finally push their way to the surface.

These paintings were very influential. After de Kooning and Pollock, Guston was probably more imitated by second-string painters in the early 1950s than any other Abstract Expressionist. But he was a man without a program. The work gave him access to deeper levels of the self, and at those levels the currents carried him where they wanted. "There is something ridiculous and miserly," he remarked in 1960,

> in the myth that we inherit from abstract art—that painting is autonomous, pure and for itself, therefore we habitually analyze its ingredients and define its limits. But painting is *impure*. It is the adjustment of impurities which forces its continuity.

An arch-worrier and naysayer, Guston knew that almost everything that moved him most as a painter, from Velázquez and Goya to early Mondrian and Pollock, was rich in images of a psychic and social world that couldn't be dispelled as the imperfect, coarse stuff that art was supposed to transcend in the name of disinterested pleasure. In the 1950s we hear him muttering about it: "I do not see why the loss of faith in the known image and symbol in our time should be celebrated as a freedom. It is a loss from which we suffer, and this pathos activates modern painting and poetry at its heart."

But recovering the "known image" was hard for Guston, because he did not know where it was. In the late 1950s you sense in his paintings the pressure of something trying to come through the beautiful surface, a lump in the mind. By 1964 it has become a squarish black blob that might be the back of a head. But it wasn't named yet. In the early 1960s things *were* being named in American art, but in the wrong way for Guston—by Pop. His obstinate Jewish-modernist nature made him leery of its bright explicitness and enjoyable ironies. He distrusted its promise of an American consumer Eden. He didn't like the way Pop art resisted internalization. And yet his inherent cussedness made him leery of simply *evading* Pop by appealing to high art. Popular culture was woven into his imagination. He was acutely aware of the ancient relations between high art and cartooning, from Goya's *Caprichos* to Daumier's caricatures. He loved Robert Crumb's "Zap Comix," and as a boy he had copied George Herriman's great strip "Krazy Kat." Its highly stylized comic violence would surface in the lump-

ish pathos of his mature paintings, and its staged landscape would be echoed in them too. So instead of rejecting the Low, Guston began to draw things—at an elementary level, a way of naming. A boot. A clock. A book. A hairy paw of a hand, itself drawing a single dumb line. "These fragments have I shored against my ruins." And finally, in 1970, he started painting Ku Klux Klansmen, as he had back in the thirties.

The Klan was obsolete in 1970, politically spent. As an image of evil, it had been replaced by newer ones, principally the Vietnam War. In hindsight, one realizes that Guston's Klan paintings were forced into existence by a political environment they don't specify. Or so Guston would claim:

> When the middle 60s came along, I was feeling split and schizophrenic. The [Vietnam] war, what was happening to America, the brutality of the world. What kind of man am I, sitting at home, reading magazines, going into frustrated fury about everything—and then going into my studio to adjust a red to a blue?

Guston didn't fool himself for a moment into believing that his art, successful or not, could have the smallest effect on American politics. It was just that without speaking up, he would have felt like a hypocrite in the curiously affectless world of late modernist formalism.

Here was American society tearing itself apart, and there was American art maintaining its calm refusal of the world, its pretense that content was irrelevant. So he broke with the formalist consensus: not for others, just for him.

His Klansmen, shown to general critical disapproval in 1970, were both ludicrous and menacing. Red of neck and white of sheet, they ride around in jalopies, up to no good, with blood streaked on their robes. The Klansmen Guston painted in the 1930s (a posse of whom actually destroyed one of his paintings) had been impersonal figures of menace, but now Guston began to identify with them (Figure 350). He depicted them as painters in the studio, smoking and drinking and painting monochrome

350. Philip Guston, *The Studio,* 1969. Oil on canvas, 48 × 42″ (121.9 × 106.7 cm). Private collection.

red canvases—"seeing red." The cartoony style of these paintings is like a loose sheet thrown over a dense pack of ambivalences, tensions, and painful memories, a mask behind which the artist can see without being seen.

In the early 1970s the mask comes off the Klansman, and the painter, Guston's alter ego, is revealed in the full squalor of work. Guston's actual studio in Woodstock was a fairly organized place, but he thought of it as a messy hole, akin to the cave of the one-eyed ogre Polyphemus in the *Odyssey*. *Painting, Smoking, Eating*, 1973 (Figure 351), is a self-portrait as Cyclops. ("Only an eye," it was said of Monet, "but what an eye!") The sense of being thrust into a scurfy internalized world is almost unbearable. Guston may have been the first painter to paint that frame of mind so well known to artists and writers: slothful regression. You pee in the sink. You put out your cigarette in the coffee cup. The bloodshot Cyclops eye is the abstracted gaze of a whole succession of literary heroes who can't move, from Laurence Sterne's father through Bartleby and Oblomov to Samuel Beckett's paralyzed loners. Time moves very slowly in this congealed place, and paranoia reigns.

Outside the studio lies a wider and blacker world, full of death and grotesquerie. A battle piece of knobbly legs and arms holding garbage-can lids for shields pays homage to Paolo Uccello's *Battle of San Romano*, whose fixity Guston loved—the sense that the killing unfolds in silence and slow time. In a sardonic pendant to Kafka's *Metamorphosis*, a door opens and in marches not one bug but a procession of them, clicking and scurrying through another swarm of

351. Philip Guston, *Painting, Smoking, Eating*, 1973. Oil on canvas, 77½ × 103½″ (196.8 × 262.9 cm). Stedelijk Museum, Amsterdam.

legs—a bad dream of domestic invasion. A mass grave with its pathetic boots, a TV set showing fire falling on a red sea, and more fires rising from the distant stony horizon is called, simply, *Pit*, 1976 (Figure 352). Guston's modernism, as Dore Ashton has eloquently written, was of a classic and stonily integrated kind. Its domain of imagery was charted by T. S. Eliot—not the later critic, whose bouts of Anglo-Catholic scolding would be sheet music to American neoconservatives in the 1980s, but the earlier poet of *The Waste Land* and "The Hollow Men." Guston's paintings in the 1970s give form to much the same sense of alienation, traumatized emptiness, grim resistant humor, and lyric glimpses of a saving order that Eliot made visible in the 1920s. His landscape of detritus, the grunge of civilization evoked in "Gerontion"—"The goat coughs at night in the field overhead; / Rocks, moss, stonecrop, iron, merds"—was Guston's too, and so was his sense of living underneath the monuments, the great signs of a cracked-up culture on the horizon, at the rim of the dried plain, visible but out of touch. All rose quite naturally from Guston's paintings, through his appeal to a common culture whose preservation was one of the deepest objects of his anxiety.

 Guston's legacy didn't take the form of direct imitation by other artists. Rather, his "dumb" figuration and above all his sense of the raw pathos of the human body opened choices for them. A good case in point is the work of Susan Rothenberg (b. 1945). Rothenberg first got noticed in New York in the mid-1970s, with

352. Philip Guston, *Pit,* 1976. Oil on canvas, 75 × 116″
(190.5 × 294.6 cm). National Gallery of Australia,
Canberra.

paintings of horses. Despite her other merits, Rothenberg was no George Stubbs, but she wasn't particularly interested in equine anatomy as such. Her nags were generic, crude silhouettes with some texture and internal patterning but no modeling, with heads like wombats and hooves of clay. Her sense of herself as an artist, up to then, had unfolded within the New York ethos of late, "humanized" Minimalism, not only the sculpture of Eva Hesse and Richard Serra but also the work of performance artists and dancers like Yvonne Rainer. If her horses look clunky, it was because they were also, in a way, human—disguised self-portraits, or at the least "presences" that stood in for human presence. Partly they did so in response to performance art, which had sheltered the body images abstraction had expelled from painting; Rothenberg had been trained as a dancer, and she tried performance herself in the early 1970s. Partly it was just out of instinctive need—the need to reconnect with the world, through self-description that didn't exclude pathos.

Her horse images were embedded in a lush, forceful, and nuanced paint surface which—as in *Cabin Fever,* 1976 (Figure 353)—retained traces of Minimalist signs. Though the vertical split-line that bisects *Cabin Fever* might be read as the finish post at the end of a race, it's more likely a relic of Barnett Newman's Zip. The opposites didn't amalgamate well; as Rothenberg said later, "My formalist side was denying my content side." And so "I began tearing [the horse] apart to find out what it meant."

Tearing, literally; Rothenberg's paintings over the next few years were all about dismemberment, blockage, and fright. She started butchering her horse image into haunches, fetlocks, and heads scattered on the ground of the canvas, with no gore but a lot of implied anxiety. Most of them started from small, envelope-size doodles, and the large paintings retained the cryptic and improvised look of drawings. Her larger charcoal drawings, done with a fiercely scrubbed, hairy line that broadens out into areas of velvety black, are often of real intensity and beauty.

From 1979 on, glimpses of the human face and body started appearing in her work. These are bluntly autobiographical, "miserable" figuration, piercing in its plainness. Some depict vomiting heads, which, as Rothenberg put it in an interview, were "divorce images," conveying "a sense of something threatening, like a stick in the throat . . . the whole choked-up mess of separating from someone you care for and a child being involved." Her combined face-hand images were particularly strong, perhaps because they so vividly fused a sign for openness and invitation (the human countenance) with one for rejection or warding-off (the closed fist, or an open palm shoving one's gaze away).

Her work became more atmospheric in the 1980s. In its cold, flickering, indistinct light, there were images of dancers (including one of her esthetic heroes, Piet Mondrian, solemnly doing the fox-trot with a Rothenberg-like partner); the style

353. (above) Susan Rothenberg, *Cabin Fever,* 1976. Acrylic and tempera on canvas, 67 × 84″ (170.2 × 213.4 cm). Collection of the Modern Art Museum of Fort Worth; museum purchase, Sid W. Richardson.

354. (below) Susan Rothenberg, *Blue U-Turn,* 1989. Oil on canvas, 91 × 112″ (231.1 × 284.5 cm). The Anderson Collection.

contained long-distance echoes of Impressionism and also of the multiple-position photographs of Marey, Muybridge, and others, once copied by the Italian Futurists. In these, as in the accompanying drawings, form was extremely provisional: the shape of a rider teetering on a bicycle, for instance, swam up out of a fog of approximate lines which poignantly suggested the mutability of perception. But Rothenberg's gift for mulling over diffuse impressions and suddenly pulling them together in one hieroglyphic image, startling and weird, remained. In *Blue U-Turn*, 1989 (Figure 354), an androgynous body, huge and bent into an arch, vibrant with sparkles of cobalt and ultramarine, seems to be swimming in deep marine space. It looks powerful and benign, free from the anxiety of her earlier work. It has the directness of a grotesque from a twelfth-century cloister capital.

The demotic influence of Guston went other ways too. For instance, it helped liberate the work of Elizabeth Murray (b. 1940), in its very personal blend of biomorphic abstraction and references to still-life and the figure. Murray's work is sensuous, only nominally abstract, and—until one gets used to the shaping and layering of canvas planes—a bit hard to read; but its appeal to the eye is almost profligate. The chrome greens and purples, cobalts, reds, and pinks that proliferate in her work are the signs of a colorist without inhibitions. There is a curious tension between the enormous size of Murray's work and the domestic and maternal emblems that often form its subject matter, as in *More Than You Know*, 1983, a goofily Cubist interior with yellow walls, a big green splayed table with the image of a head and a letter embedded in it, and the red back of a Windsor chair:

> The room . . . reminds me of the place where I often sat with my mother when she was ill. . . . I was thinking of van Gogh, of *memento mori* subject matter, and the paintings by Vermeer of women reading letters which express simultaneously such serenity and anxiety. I wanted to paint the chair very realistically; at the same time, it's like a big heart.

All Murray's early ideas about art came, she once said, from comic books, and the shapes in her mature paintings retain a cartoony flavor—speedlines and zap zigzags, and speech balloons too; one of her favorite forms, a swollen lobe pinched at the ends, looks like Popeye's bicep ready to take on the world after the transforming gulp of spinach; others resemble Tweety Bird, Pillsbury Doughboys, and the ears of Bugs Bunny. But these are not quoted directly, in the manner of Pop art. She transforms them; her art is about dreaming and free association, the peculiar insecurity of familiar objects that sidle through the filter of a tactile sensibility and peek out, transformed, on the other side, though retaining a diagrammatic air. The results go beyond pat categories of "abstract"

and "figurative," and give her work a sweet, rambunctious, and very American life.

The 1980s utterly transformed the American art world; it became the beneficiary—and, ultimately, the victim—of speculative mania. Ronald Reagan, like most American presidents, including John Kennedy, had no particular interest in the visual arts—beyond film, of course. Yet his presidency had enormous indirect effects on the art world, more than any, perhaps, since Franklin Roosevelt.

Why? Because in the course of quadrupling America's national deficit to a trillion dollars and filling the country with oceans of borrowed money, his financial policies helped create the art-market boom of the 1980s. This bubble burst in 1990, never to reinflate, but it had a blinding iridescence while it lasted. And every new investor knew that if you bought new art, you'd come up smelling like Lorenzo de' Medici's aftershave. Indeed, it was the art market itself—rather than any individual work of art—that became the chief cultural artifact of the 1980s. The figures were astonishing, and need only be briefly recalled here. At the opening of the decade in 1980, the three most expensive paintings ever sold at public auction were Turner's *Juliet and Her Nurse* ($6.4 million), Velázquez's *Portrait of Juan de Pareja* ($5.4 million), and van Gogh's *Poet's Garden* ($5.2 million). These prices seemed scandalous at the time—headline stuff. Eight years later, they would scarcely have been thought worth reporting. Pumped by its own fetishism, by billionaires competing in the auction room like mountain goats clashing horns over possession of a crag or a mate, and—to no small degree—by the entry of private and corporate Japanese collectors for whom low or medium price was a kind of disgrace, the market went off the chart and then off the wall. In 1986 van Gogh's *Sunflowers* sold to a Japanese insurance company for $35 million. *Yo Picasso*, a small early self-portrait of no special importance, which sold for some $5 million in the mid-eighties, reached $47 million in 1989. Even a work by a living artist, Jasper Johns's *False Start*, made $17.7 million on the block. In 1990 a Japanese wood-pulp baron named Ryoei Saito paid $82.5 million for van Gogh's portrait of his physician, Dr. Gachet, and, two nights after that, $78.1 million for Renoir's *Au Moulin de la Galette*. That one man could spend over $160 million (roughly the entire annual budget of America's National Endowment for the Arts) on a brace of paintings sent the top end of the art market from obscenity into farce. Museums were hamstrung by the market, unable to compete; they took to selling, not buying.

These new price levels were propelled by ever more aggressive marketing policies at the auction houses. The leader of the change was Sotheby's, which was taken over by an American shopping-mall magnate, A. Alfred Taubman. "Selling art has much in common with selling root beer," Taubman declared. "People

don't need root beer and they don't need to buy a painting, either—we provide them with a sense that it will give them a happier experience." He was determined to beat the private art dealers at their own game; in effect, to cut them out as middlemen. He did this by hardball promotion, which was quickly imitated by the staider Christie's. ("The Museum Where the Art Is for Sale," ran the headline on one glossy Christie's ad, and both companies strove to create the illusion that the métier of auctioneering, dependent as it is on illusion, snobbery, death, and divorce, was actually a noble and disinterested business akin to the teaching of art history and the running of museums: almost a public service, if you thought about it.)

Sotheby's next went into the moneylending business, offering discreet loans to clients to buy important works, like a casino giving credit to big players. This backfired dramatically when, in November 1987, van Gogh's *Irises* came on the block and was bought for $53.9 million—or so everyone supposed—by an Australian investor, Alan Bond.

No sale had taken place, and the art market was looking wobbly after Black Monday, the Wall Street crash three weeks earlier in which the Dow lost 590 points in one day. Sotheby's needed a record price and, well aware that the antipodean shark had been the underbidder on *Sunflowers* in 1986, they secretly guaranteed Bond an open-ended loan of half *Irises'* hammer price, whatever it went to—some $27 million, as it turned out. But, as every Australian banker and financial journalist at the time knew, Bond was on the edge of bankruptcy, struggling to shift around $9 billion in debts on an asset base of $4 billion, with little cash flow.

Thus both buyer and seller were hoist with their own petards. Bond couldn't pay, and Sotheby's couldn't admit that they had not been paid. Sotheby's rolled the debt over for another year, but by the end of 1988 Bond still couldn't find the money. Sotheby's could have repossessed *Irises* and put it back on the block, but it was compromised now, and probably could not have passed $30 million—and the results for the art market if the World's Most Expensive Picture were seen to lose a third of its value in a year hardly bore thinking on. Problem: how to maintain the public impression of a completed transaction? The stopgap answer was to say that though Bond "owned" the painting, Sotheby's "had control" of it. They could not let it out of America because if *Irises* entered Australian jurisdiction, they might have had great legal difficulty extraditing it. But then, early in 1989, it transpired that Bond had already arranged for the painting (along with five minor-to-mediocre Impressionist pictures he owned) to tour the Australian state museums, announced as "*Irises* and Five Impressionist Paintings from the Alan Bond Collection."

In 1989 the show went on. Australians flocked to see *Irises*, protected from close inspection by a velvet keep-away rope and a large double-glazed frame. It

was, Bond crowed, "the greatest painting in the whole bloody world." All went swimmingly until it arrived at the Art Gallery of Western Australia, in Bond's home city of Perth. The museum's chairman, Robert Holmes à Court, was one of Bond's more dedicated enemies, and he decided to run a check on the ownership and insurance status of *Irises*. It revealed that Sotheby's appeared to half-own it, along with Dallhold (a Bond company) and two unidentified Hong Kong corporations; and that although the frame was insured for $50,000, its contents carried no insurance at all. What the Australian public had been lining up to see, the senior staff of the Perth museum ruefully concluded (joined in their opinion, later, by other Australian museum directors), was a copy. The museum docents were then advised to enthuse no further about the fine condition of *Irises*, and how van Gogh's paint looked as fresh as if it had been put on yesterday, and the show finished its run without a word leaking to the press.

After much negotiation, the real *Irises* was finally sold by Sotheby's to the Getty Museum in Malibu for an undisclosed sum, probably in the region of $35 million.

Though the saga of *Irises* was uncommon, indeed unique, it epitomized the sense of unreality that the art market generated in the 1980s.

The net effect of the inflation, especially of Impressionist prices, on the public perception of art in America during the 1980s was disastrous. It turned works of the human imagination, sometimes very beautiful ones, into mere counters in a fiscal game: objects of spectacle whose grotesquely alienated status mocked as a sentimental fiction the idea that great works of art (and some not so great) were, or ought to be, in some sense the common property of mankind. The effulgence of record prices tended to strike people blind. And inevitably—to exhume the phrase much loved in the 1980s by supply-side economists—it had a trickle-down effect. If the best fate of an old work of art was to create a record price, then all works of art had to be expensive to show their worth. Old pictures by dead artists were rare in themselves: no more were being made, except by forgers. But new pictures by young artists were not rare, and their supply was copious, especially since the more than fifteen hundred art schools of America were turning out close to thirty-five thousand graduates a year, or, every two years, as many painters, potters, sculptors, art historians, and other VARPs (vaguely art-related persons) as there had been *people* in Florence at the end of the fifteenth century. Did this mean America had a new Renaissance? Hardly; due to the lackadaisical conditions of 1970s art education, it meant America had a figurative revival spearheaded by the worst generation of draftsmen in the history of its art. An overcrowded art world meant intense competition, and it gave the dealing system a large proletariat of artists from which trends (like graffiti, briefly the hot thing of the early 80s) could be condensed at will, before they were thrown on the discard pile. It also meant a severe unemployment problem in the lower three-

quarters of the artist population and an exaggerated star system at the top, while the anxiety of the consumers (will this work last? will it be curated into history? will it rise in price and repay my investment in it?) precipitated in ways that made the art world, now converted into the American art industry, more vulnerable to passing fads and fashions than ever before. America by the end of the 1980s had about 1.5 million millionaires, all seeking badges of distinction. The large house in the Hamptons or the sixty-foot offshore cruiser would no longer do; everyone had those. Accordingly, one collected art. But in order to keep the signs of status legible, one had to collect the same art as the next millionaire. Hence the remarkable, indeed near-industrial, uniformity of new money's taste. The American audience for art in general, especially contemporary art, had grown beyond recognition, as had its support system. In 1967 American corporations spent $22 million a year on cultural disbursements; by 1988 the figure was $698 million, and in the same year 500 million visits were made to American museums. "Art is now upon the town," remarked James Whistler in London a hundred years before, "and may be chucked under the chin by any passing gallant." Luckily, perhaps, he was not vouchsafed a glimpse of SoHo and the East Village in the late 1980s, with their four hundred or so galleries, between which great herds of VARPs drifted in limos or on tasseled loafers, ruminating on that Saturday's claimants to a position on the Cutting Edge.

Never before had star artists been so bathed in adulation. In the 1970s it had been movie actors, in the 1990s it would be supermodels, but in the 1980s it was hot young postmodernists and their dealers. The doings of collectors, the gyrations of the market, the increasingly passive promotional role of museums, the whole social circus attached to the art world, supplied limitless fodder for breathless journalists. Art magazines devolved into sycophantic praise-bulletins. Since the magazines depended on advertising revenue from dealers, who were not averse to applying pressure, 95 percent of the writing published in them was the merest puffery, garnished with opaque Derridian and Lacanian jargon. For new talent and old alike, there was no such thing as a bad review. Even the dealers came to be known by the ghastly neologism "gallerists," since this suggested that they were in some way above the crass concerns of trade. The golden legend of a rejected avant-garde triumphing over retrograde taste was used to ram home the lesson that nothing, however trivial or ephemeral, could be rejected. The longing for all-American cultural eagles degenerated into a game of throwing eggs into the air while extolling the arc of their brief flight. The "art world," in its older form, had now become Artworld, a theme park you could visit, full of temporarily interesting rides.

The patron saint of this malign situation was, of course, Andy Warhol. He died in 1987. By then his achievements as a painter in the 1960s had been completely volatilized in celebrity; it had been years since he had produced anything of real

significance, although etiquette usually restrained the voices of Artworld from saying so. A 1976 series of large paintings of skulls retained some of the awful frisson of his early Disaster and Electric Chair paintings; but in general, Warhol had been content to crank out very routine silk-screen portraits of celebrities and wannabes based on Polaroid photographs, which made even the dullest of Sargent's social "paughtraits" of the 1900s seem positively inspired by comparison. There were, of course, true believers who continued to feel that depths lay within the Warholian shallows; as late as 1996, Julian Schnabel opened wide his mouth on PBS and thrust his foot into it by informing a startled Charlie Rose that "Andy [Warhol] is one of the most misunderstood people since Hitler." In his last years, Warhol was reduced to witless pseudo-Dada stunts like pissing—or having assistants with more capacious bladders piss—on canvases to make abstract patterns, thus spoofing Jackson Pollock. The machine he had announced that he wanted had to be kept running: he did pictures of Mercedes-Benz autos, and boys with big cocks, and a portfolio of *Ten Portraits of Jews of the Twentieth Century*, and versions of Leonardo's *Last Supper*, and Rorschach blots, and reruns of his old tabloid front-page images of the early 1960s, all equally null.

After his death, he got his own museum in Pittsburgh, his birthplace: an elegant tomb, full of the paintings and prints that remained unsold, and boxes of the stuff he couldn't bear to throw away, now reclassified as time capsules. Doubtless he would have preferred it to be in New York.

Did he "deserve" his museum, anywhere? Absolutely, if you measure worth by influence. Warhol had demystified the art world by calling it by its real name: a business, a promotional system. An art gallery, in the end, is just a specialty shop selling expensive luxury goods. After Warhol you could no longer be under any illusions about this. He matched the 1980s, and was in perfect sync with their greed, their puffery, their rampant pursuit of status through art. As Sir Thomas Beecham said when the elephant crapped on the stage during rehearsals for *Aida*: what a critic!

The 1980s were constantly spoken of as a decade of hype. Hype may be defined as the management of disproportion: it enters the gap between esthetic achievement and cultural fantasy, and inflates the former by appeal to the latter. Hype is what happens when a living artist in his twenties or thirties gets a "retrospective" at a major museum, as though he or she were already part of art history. Hype occurs when a dealer persuades the eager client to buy as-yet-unpainted works by Genius X, because all the painted ones have gone to other clients more agile, or more in favor with the dealer, than he or she. Hype is the ability to keep the journalistic pot briskly boiling with stories and rumors of escalating prices. Hype keeps scratching the central terror of the up-to-date collector of the contemporary—the fear that the A-train will leave without him, bound for history. Hype was the midwife of many of the typical reputations of the

1980s: Schnabel, Salle, Koons, Basquiat, and so on. And yet the masterpiece of art-world hype in the 1980s had nothing to do with such younger artists, or even with Andy Warhol. It centered on American art's other Andy, Wyeth, and it concerned some paintings of a middle-aged blonde named Helga.

On August 6, 1986, *The New York Times* ran a front-page story by its art reporter Douglas McGill. It announced that a hitherto unheard-of Pennsylvania collector named Leonard Andrews had bought, for an undisclosed sum in "the multi-millions of dollars," 240 hitherto "unknown" works by Andrew Wyeth. There were four tempera paintings, sixty-seven watercolors, and many drawings, made over a period of fifteen years between 1970 and 1985. All except one depicted a woman named Helga, no surname, clothed and nude. Wyeth had kept them in a mill on his property in Chadds Ford, Pennsylvania. His wife, Betsy Wyeth, had not known of their existence until 1985. In an earlier interview with *Art & Antiques* magazine, Wyeth had hinted at a "secret" cache to its editor, but, he said, "I don't want them to be seen. There's an emotion in them that I feel very strongly about." Now Mrs. Wyeth, asked what she thought the Helgas were about, paused significantly and uttered the magic monosyllable, "Love."

This was enough to throw my colleagues at *Time* into a state of advanced rapture. The secret hoard, the unknown collector, the presumed affair between America's champion pictorial puritan and a mystery blonde, the unknowing wife—the lot. Phone calls and telexes started flying to Chadds Ford to secure transparencies of the Helgas. Meanwhile, the same was happening at *Newsweek,* which resolved to put Helga on its cover. So *Time* upped Helga to a cover story too; never before had one artist, not even Picasso, made the covers of both magazines in the same week.

Soon the story was all over network television and the tabloids, nationwide. The back roads, diners, and Kmarts of rural Pennsylvania were clogged by intrepid reporters looking for Helga, as though she were Patty Hearst or the Lindbergh baby. And presently she was found: Mrs. Helga Testorf, a German émigrée aged fifty-four, who refused to say anything at all, but disappeared behind an irate husband, several hostile kids, and a pair of Doberman pinschers.

Reportedly, Wyeth had been able to paint her without his wife knowing because she worked as a housekeeper for Wyeth's sister Carolyn, who also lived at Chadds Ford. Did the creative trysts take place there? Probably not, because according to reliable witnesses, Carolyn Wyeth was "eccentric." Her neighbors called her the Wolf Lady; she kept a dozen or so large hounds which allegedly loped baying around the house while she herself made loud howling noises at passersby from the porch. Could Wyeth and his model have got on with the creative act—or any other—with this sibling vociferating in the next room? When

asked, the sister pithily dismissed the Wyeth-Helga romance story as "a bunch of crap."

It was all beginning to look discouragingly thin, and haggard *Time* staffers were heard invoking the Lord to send a nice little war in the Middle East to bump Helga off the cover. But this was August, a month when nothing ever happens, so the two weekly dreadnoughts of news and opinion continued to steam toward each other on their collision course, each with Mrs. Testorf, the Simonetta Vespucci of Chadds Ford, affixed like a figurehead in full color to its prow. Too late to turn the wheel, and neither captain would blink.

Meanwhile, it developed that, far from knowing nothing about the Helga paintings, Mrs. Wyeth had learned about them from her husband and owned several of them, including a Helga entitled *Lovers*, herself. And far from being "hidden," several had been very widely exhibited and published over the preceding six years. To make things more suspicious still, the "collector" Leonard Andrews had nothing else in his collection: he was simply an investor who published newsletters with titles like the *Swine Flu Litigation Reporter* and the *National Bankruptcy Report*. He also manufactured greeting cards, and he had negotiated his block purchase of Helgas so that he got all reproduction rights to the pictures and drawings.

Now the penny dropped: this was merely a publishing deal, which portended much cloning of Helga. Meanwhile, back at the newsweeklies, the story was sinking fast. Neither could take it off the cover, but it unraveled as fast as it was put together. There *was* no story to "Wyeth's Stunning Secret" (*Time*) or the more juicy "Wyeth's Secret Obsession" (*Newsweek*). At least, with a desperate wriggle, *Time* managed to jettison the love angle. "So dismissive are [the Wyeth neighbors] of any charge of infidelity," the story ran, "that they are willing to entertain . . . the possibility of a Wyeth scam."

Possibility.

Everyone had been royally had, in a classic *folie à deux,* joined by the rest of the media. *Time* made *Newsweek* do it and *Newsweek* made *Time* do it, and neither could let go. And, of course, the publicity ensured that special exhibitions of the Helga paintings would be mounted, with great pomp, at the National Gallery of Art in Washington before touring the rest of America. But on a deeper level, the Great Helga Hype was the natural outcome of fantasies about art and artists that had been brewing in American culture for years, spurred on by museums, the market, and the blockbuster mentality with its overheated imagery of secret troves, Unknown Treasures, Hidden Masterpieces, Gold of the Gorgonzolas, and the rest. By the mid-1980s this had transferred itself even—or perhaps one should say, especially—to contemporary art, where the equivalent of the Unknown Treasure was the Hot Young New Artist.

By now the myth of the avant-garde was dead: not stinking, but simply desic-

cated. How could its bones live? There could be no avant-garde in the original sense of the word, no group of artists out laying the rudiments of the Future against the entrenched opposition of the Academy, when most of the institutional culture of America was based on encouragement and acceptance of the new. The older model of thesis and antithesis collapsed; what the 1980s brought to American art instead was the fulfillment of a process that had begun in the 1960s, the relaxation of a tense, linear idea of modernist progress into a swarming of recycled styles in a field that included everything and its opposite. The big difference between this and older patterns of "innovation" was that now artists couldn't get into trouble with anyone else in the art world for doing anything. Taste presented no resistance. Indeed, the idea of "taste" seemed distinctly old-fashioned in the 1980s, and was to become odious and politically offensive in the 1990s, since it carried with it the idea of "discrimination," which, as everyone came to know, was hegemonic, elitist, and close to racism and sexism. The man of taste, in its old sense, was replaced by the person of openness. Progress, in art, had never existed anyway—certainly not in the terms in which the late twentieth century understood it. Art was not like science in that respect. Every third-year medical student in 1985 knew more about the fabric of the human body than the greatest doctor in eighteenth-century Bologna. But no artist alive in 1985 could draw as well as Goya or Tiepolo. Under the stress of the market, the idea of "progress" in art now devolved into something much more American: stylistic turnover. Since terms like avant-garde or "vanguard art" could hardly be uttered, even by dealers, without a twinge of embarrassment, the replacement term became "cutting edge," which conveyed a warmly positivist idea of new stuff slicing through the mass of old stuff, coming to the fore, without suggesting what was being cut or to what purpose.

All the new money that was swashing around in the system had to go somewhere, and produce more money. During the last big art-buying boom in America, at the end of the nineteenth century, collectors anxious to improve their social standing had lashed out unheard-of sums on a few American artists, like Bierstadt and Church. Some, as we have seen, plunged heavily on Old Masters, to the subsequent glory of American museums. A few, with good advice from figures like Mary Cassatt, bought Impressionists; their more conservative brethren, Corot. But not until the 1980s was there such a market for purely contemporary Americans, the younger the better, and it was based almost entirely on speculation with the hope of rapid turnover. Crucial to this was the notion of "important" new art. Only inflated notions of "importance" could justify the inflated prices of contemporary art, which by the end of the decade were getting truly crazy: at one point someone paid $1 million for an Eric Fischl. Their continuous rise induced a pervasive mood of greed and sanctimony, a very American combination, notably among dealers. Thus one found the dealer Arnold Glimcher, di-

rector of the PaceWildenstein gallery, telling a TV camera, with keen self-satisfaction, "It sounds terribly arrogant, but it's true; anyone who gets one of these paintings" (gestures around the office) "is receiving a prize." The prize, when it came to 1980s art, was not infrequently a booby prize.

What did "importance" mean? Generally, size and pretension. The archetypal "important" art of the early 1980s was produced by Julian Schnabel (b. 1951), a roundly self-admiring painter who once compared himself to Duccio, Giotto, and van Gogh. Not very close, and no cigar. Schnabel was a perfect painter for a culture of replays. He fitted the emergent postmodernist mold. Postmodernism— that weasel term which, current for nearly two decades now, has still not settled into any agreed meaning—was old-fashioned eclecticism overlaid with affectless postures: a constant recycling of past styles and motifs, without any of the deep and organic relation to the past that marks an artist willing to learn from it and build on it. Quote here, quote there. Quote the broken-tile collage done by Gaudí and Jujol on the chimneys of the Güell Palace and the benches of the Güell Park in Barcelona, translating it into an aggressive texture of broken plates overlaid with messy paint; then claim profundity for this heavy mannerism by implying a connection to the broken glass of Jews' windows on *Kristallnacht*. Quote, in *Exile*, 1980, a figure from Caravaggio, the boy holding a basket of fruit, but drawn with paint-by-numbers ineptitude. Quote big names in big clumsy lettering (e.g., SPINOZA). Above all, quote the vulgarly romanticized stereotype of the tragic AbEx artist, rerunning it as careerism for an audience which, understandably bored with the spartan diet of words on walls and sticks on floors the art system had given it in the 1970s, yearned for the hot and the heavy. Perhaps no painter ever got more mileage out of the supposition that bad drawing plus thick, roiled paint equals passionate feeling. In fact, it turned out to be a code like any other. It was the sensibility of a disgruntled but hardworking teenager: theatrical, maundering, and immovably convinced of its own boyish genius.

"Importance" could also come from inscrutability. This turned out to be the reason for the rise of David Salle (b. 1952): nobody, and probably least of all the collectors who bought them, could figure out just what his pictures meant. But they gave off a consistent mood of media-induced alienation, and that was enough. Their origins lay in James Rosenquist (for the collision of unrelated images, culled from consumer iconography) and in Francis Picabia's late, "low" overlays of transparent images, as adapted by Salle's slightly older German contemporary Sigmar Polke. Salle had worked in the art department of a publisher of romance and porno magazines, and on leaving he took with him a stack of their sentimental and erotic photos, which served as an image bank for his later paintings, combined with movie stills, fragments of advertising, and snippets from higher art (Géricault, Courbet, Freud). In its curiously congealed raciness, shot through with an eroticism that was only the derisive quotation of excite-

ment, Salle's work did tell a small truth about the image-glutted conditions of seeing in the mid-1980s: it was nasty, knowing, hip, and at least more stylish (within the limits of its drawing, done by assistants who had to learn to draw as feebly as Salle himself) than Schnabel's heroic-artist posturings.

The suburban landscape of America stretches all the way from Long Island to Anaheim; from TV sitcoms and movies, it has become as familiar as the mythic West—and, of course, many more people live in it. In the 1980s its inhabitants got their own painter laureate: Eric Fischl (b. 1948), probably the most talented of the "new" 1980s artists. From the moment that he exhibited *Sleepwalker*, 1979 (Figure 355), his image of a lanky teenage boy resentfully masturbating in a suburban wading pool, Fischl zeroed in on the discontents of his own middle-class background: unreachable kids, grotesque parents, small convulsions of voyeurism, and barely concealed incestuous longing. "From the beginning," says Fischl,

I think my paintings were generated by a lot of anger, focussed on the place I came from, the suburbs. . . . In the environment I grew up in there was no ability to acknowledge what the reality was. Everything was confined to a set of acceptable images, and they didn't often conform to what was really happening.

355. Eric Fischl, *Sleepwalker*, 1979. Oil on canvas, 72 × 108″ (182.8 × 274.3 cm). Private collection.

Memories of Edward Hopper underlie his work, but Fischl didn't have the benefit of Hopper's intensive training. He had the misfortune to go to art school at the California Institute for the Arts in Los Angeles in the early 1970s—just at the height of the belief, then widespread in American art circles, that Painting was Dead. Cal Arts epitomized the frivolity of late modernist art teaching, Fischl would recall. The only serious life classes were reserved for the animation department of the film school, because if a student wanted to follow in the footsteps of great cartoon animators like Chuck Jones, creator of Bugs Bunny and Wile E. Coyote, he needed, at least, to draw competently. No such restrictions applied to would-be painters. Art education that has repealed its own standards can destroy a tradition in a generation or two by not teaching its skills, and that was what happened to figure painting in the United States between 1960 and 1980. Fischl was badly hampered by it, and although he aspired to a way of drawing that was tense, dramatic and full of body, he only achieved it episodically. He wanted an overall look that was not too finished, consistently "imperfect," with an air of unconcern for its own pictorial mechanisms. But this required a mastery over the detail and frequency of brushstrokes, and a certainty about the drawing embedded in them, which he cannot consistently manage—though when he does, the results can be very seductive. Thus the formal means of Fischl's work fall below its interesting symbolic and narrative purposes. His response to Max Beckmann, in particular, was deep and visceral, and he aspired to create a symbolic theater of American anguish and desire parallel to the German master's.

The only thing the art market liked better than a hot young artist was a dead hot young artist, and it got one in Jean-Michel Basquiat (1960–1988), whose working life of about nine years was truncated by a heroin overdose at the age of twenty-seven. His career, both actual and posthumous, appealed to a cluster of toxic vulgarities. First, the racist idea of the black as *naïf* or rhythmic innocent, and of the black artist as "instinctual," someone outside "mainstream" culture and therefore not to be rated in its terms: a wild pet for the recently cultivated collector. Second, a fetish about the freshness of youth, blooming among the discos of the East Side scene. Third, guilt and political correctness, which made curators and collectors nervous about judging the work of any black artist who could be presented as a "victim." Fourth, art-investment mania. And last, the audience's goggling appetite for self-destructive talent: Pollock, Montgomery Clift. All this gunk rolled into a sticky ball around Basquiat's tiny talent and produced a reputation.

Basquiat's career was incubated by the short-lived graffiti movement, which started on the streets and subway cars in the early 1970s, peaked, fell out of view, began all over again in the 1980s, peaked again, and finally receded, leaving Basquiat and the amusingly facile Keith Haring (1958–1990) as its only memorable exponents. Unlike Haring, however, Basquiat never tagged the subways.

The son of middle-class Brooklyn parents, he had a precocious success with his paintings from the start. The key was not that they were "primitive," but that they were so arty. Stylistically, they were pastiches of older artists he admired: Cy Twombly, Jean Dubuffet. Having no art training, he never tried to deal with the real world through drawing; he could only scribble and jot, rehearsing his own stereotypes, his pictorial nouns for "face" or "body," over and over again. Consequently, though Basquiat's images look quite vivid and sharp at first sight, and though from time to time he could bring off an intriguing passage of spiky marks or a brisk clash of blaring color, the work quickly settles into the visual monotony of arid overstyling. Its relentless fortissimo is wearisome. Critics made much of Basquiat's use of sources: vagrant code-symbols, quotes from Leonardo or *Gray's Anatomy*, African bushman art or Egyptian murals. But these were so scattered, so lacking in plastic force or conceptual interest, that they seem mere browsing—homeless representation.

The claims made for Basquiat were absurd and already seem like period pieces. "Since slavery and oppression under white supremacy are visible subtexts in Basquiat's work," intoned one essayist in the catalog to his posthumous retrospective at the Whitney Museum, "he is as close to a Goya as American painting has ever produced." Another extolled his "punishing regime of self-abuse" as part of "the disciplines imposed by the principle of inverse asceticism to which he was so resolutely committed." Inverse asceticism, apparently, is PC-speak for addiction. There was much more in, so to speak, this vein. But the effort to promote Basquiat into an all-purpose inflatable martyr-figure, the Little Black Rimbaud of American painting, remains unconvincing.

Basquiat's death more or less took American neo-expressionism with it. By 1987 the favored minimovement was called, for want of a better term, "Neo-Geo"—though its products were neither particularly new nor, except for Peter Halley's paintings, noticeably geometric. Halley specialized in large abstract paintings, rectangles and tabs done in shrieking Day-Glo colors (Miami lime, Pepto-Bismol pink) with an inertly textured surface reminiscent of the plaster on motel ceilings. Between these "cells" ran lines or "conduits" illustrating the "circulation" of information or power (Figure 356). The diagram or model of social reality, we are to understand, has wholly supplanted the real thing. In a similar vein, Haim Steinbach stacked up brand-new saucepans, lava lamps, and electric clocks on neat Formica shelves to simulate the production of desire by marketing—basically a variant, twenty years late, on Warhol's Brillo boxes; while Ashley Bickerton made objects covered with designer logos and brand names. The staleness of such gestures was alleviated, at least for some, by a garnish of deliciously opaque theory in the French taste, of which the following passage from a lecture by two curator/critics, Tricia Collins and Richard Milazzo, is a fair sample:

356. Peter Halley, *Nirvana*, 1992. Day-Glo acrylic, acrylic, Roll-a-tex on canvas, 95⁵/₁₆ × 85¹⁵/₁₆" (242 × 218.3 cm). Private collection, Italy.

If placing a frame around culture, if "framing" the media, properly describes the mechanism of appropriation, then the mere consciousness of the frame bracketing or framing the frame or the framer, and the hybridization of this regression and instrumentalization, both captures the legacy of appropriation and projects its demise in the hyperframe.

No meaning could be extracted from such gibberish, but it had its uses as incantation, hypnotizing the collector with a sense of intellectual mystery that the bland and shallow objects themselves did not possess.

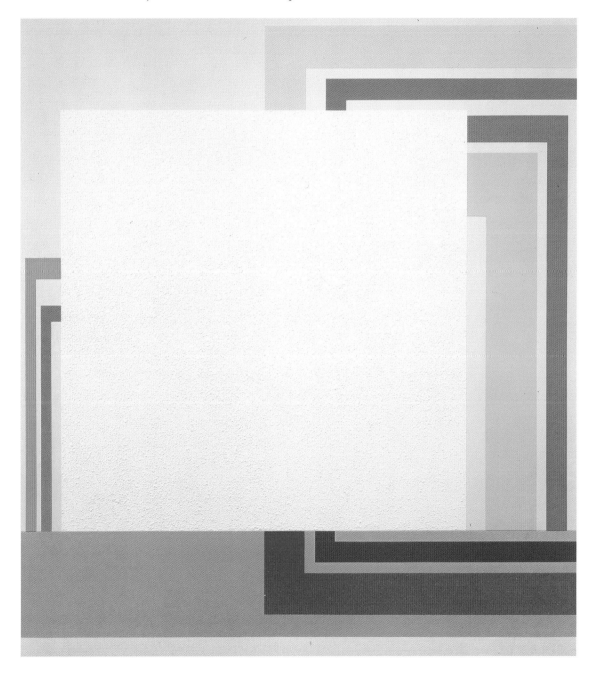

The main text-source for Neo-Geo was a French philosophe, Jean Baudrillard, whose endgame vaporings about the disappearance of reality into simulation made him a talisman for artists and critics in the 1980s who could not imagine transcending the banal discourse of mass media. Baudrillard's central insight about America, if you could call it that, was that the whole place was fake and only Disneyland, that Delphi or Shangri-la of the visiting French *intello*, was real:

> Disneyland is there to conceal the fact that it is the "real" country, all of "real" America, which *is* Disneyland. . . . Disneyland is presented as imaginary in order to make us believe that the rest is real, when in fact all of Los Angeles and the America surrounding it is no longer real. . . .

In the late 1980s such twaddle made Baudrillard an Artworld cult-figure. He offered a cure for old-fashioned anxiety about the market and its bad effects. The art object, he claimed, could save its radicality from corruption as merchandise by becoming *absurdly* expensive:

> It must go further into alienation. . . . Through reinforcing the formal and fetishized abstraction of merchandise, becoming more mercantile than merchandise itself. . . .

Thus, it seemed, ludicrously high art prices became subversive, which offered Artworld a way of having its cake and eating it too. The attempt to collapse all cultural meaning into mere simulacra lent credibility to the axiom of the eighties market: that art no longer had any purpose beyond its own promotion.

Neo-Geo described itself as a "simulationist" movement, and with reason: it was in every way an artificial business, a pseudo-cooling of the pseudo-heat of early 1980s neo-expressionism. Its artists were absolved from any worries about authenticity; they could make art in the belief that since all signs are autonomous and refer only to one another, no image is "truer" or "deeper" than the next.

Most transgressive of all, it seemed, was the last art star to be cranked out by the Manhattan mechanism: Jeff Koons (b. 1955), the starry-eyed opportunist par excellence, a former commodities trader. Koons's work is a late footnote to Pop art which relies on one obsessive device: the exaggeration of the aura of consumer objects, a single-minded devotion to gloss and glitz. He put brand-new vacuum cleaners in highly lit Plexiglas cases, forever virginal and unused, to reflect the buyer's desire for goods; he set up aquarium tanks in which baseballs floated, weighed down by a solution of Epsom salts to neutralize their buoyancy; he cast souvenir whiskey bottles and kitsch statuary in stainless steel. Once in a while Koons could contrive an image of peculiar intensity, such as *Rabbit*, 1986, a stainless-steel cast of an inflatable plastic toy bunny, once pneumatic, now rigid

357. Jeff Koons, *Michael Jackson and Bubbles*, 1988.
Ceramic, 42 × 70½ × 32½" (106.7 × 179.1 × 82.5 cm).

and manically shiny, which parodied Brancusi's polished *Birds* and possessed some of the virtues of Claes Oldenburg's work twenty years earlier.

The surprising thing was that Koons's main message, that—as he told an Italian art magazine—a person finds "confidence in his position by virtue of the objects with which he surrounds himself," should have been thought at all new or even interesting; it is one of the hoariest truisms imaginable, except, apparently, to collectors who wanted to display confidence in *their* position by surrounding themselves with Koonses. Nothing was more delicious to "advanced" taste than an enhanced sense of its own tolerance, and Koons supplied this in abundance after 1988 with his large polychrome statues. His picture of Michael Jackson with Bubbles the chimp (Figure 357), like his version of Leonardo's Saint John clutching a winsome piglet, are so syrupy, gross, and numbing that collectors felt "challenged" by them; they repeat the debased baroque of kitsch religious sculpture in an inflated, condescending way. Koons's way of looking "radical" is to play a tease. Don't you really prefer silly knickknacks to Poussins? Don't you long for the paradise of childhood, before discrimination began? "Don't divorce yourself from your true being," he wrote in one of his catalogs, in the accents of some quack therapist. "Embrace it. That's the only way you can move on to become a new upper class." There is something nauseating about such unctuous calls to regression from an artist so transparently on the make; even more so, perhaps, than his bizarre claim—apropos of Koons's gaudy images in photography, carved wood, and blown glass of him and his former wife, the Italian porn star Cicciolina, having sex—that "when somebody sees my work, the only thing that they see is the Sacred Heart of Jesus." From this enervated claptrap, one might suppose Koons had psyched himself into thinking he was a latter-day Bernini. Or was it a pose? By now it hardly matters.

Après lui, le déluge. The market for "important" contemporary art, which had risen in the financial euphoria of 1982 and crested in late 1989, vanished into the sand in 1990. Scared by the descent of the Nikkei index that fall, the Japanese—who in 1988 accounted for more than half the total recorded sales volume of all art bought at auction worldwide—sat on their hands. Impressionist prices collapsed and those of every hot young artist, from Schnabel to Fischl, went south too. By now even the greenest newcomer to collecting was aware that he was being taken for a ride in a shamelessly manipulated market. All the practices the auction houses had used to pump the market, from "chandelier" bidding to the continuous inflation of estimates, now rebounded upon them, and Sotheby's stock, which had been trading at $37 in the fall of 1989, went down to $10. One could hardly view the ensuing dismay without schadenfreude, unless one was the sort of collector who, a year before, had laid out $231,000 for a Keith Haring.

Now, after carnival, came the hangover. All of a sudden Important Pictures didn't seem quite so important, with the price tags fallen off. A battered Artworld now shifted its attention, as a form of penitence, to social issues: racism and other inequalities, AIDS, and identity art about power, gender, and sexuality. Mainly this expressed itself in various kinds of recycled conceptual art, presented in a carapace of virtually impenetrable theory, spun off Derrida and Foucault. Every kind of colonial mentality was denounced, except the colonization of American academe by French poststructuralist writers.

It wasn't as though American artists suddenly discovered there was such a thing as politics and injustice. Political art had been made in America ever since the 1930s, and reached a peak of indignation during and immediately after the Vietnam War. The problem was that little of it had much weight, though all of it was vehement. Most of it was content to project Manichaean ideological stereotypes onto schematically experienced realities. When so much bad art was busy defending the wretched of the earth, did it make one a fascist, a sexist, or a racist to speak of taste? There were, however, certain political artists of unquestionable power.

In the 1960s, as the quagmire of Vietnam deepened and American society was increasingly riven by protest against the war—protests which, because they originated among the young in academic centers like Berkeley, California, soon took on the rhetorical character of class war based on age, between the young and the old—it became difficult for some artists to remain "above" the political. The results, in terms of art, were uneven and often incoherent, but some of the best work that was done came out of the West Coast rather than the East: the savagely mutated ceramic busts of the sculptor Robert Arneson, for instance, or the work of the man who did much to create an artistic identity for the centerless sprawl of Los Angeles in the 1960s, Ed Kienholz (1927–1994).

Kienholz's last work was his burial, which took place outside his hunting cabin

on a mountaintop in Hope, Idaho. A heart attack felled him at age sixty-seven, and now his corpulent, embalmed body was wedged into the front seat of a brown 1940 Packard coupe. There was a dollar and a deck of cards in his pocket, a bottle of 1931 Chianti beside him, and the ashes of his dog Smash in the trunk. He was set for the Afterlife. To the whine of bagpipes the Packard, steered by his widow Nancy Reddin Kienholz, rolled like a funeral barge into the big hole: the most Egyptian funeral ever held in the American West, a fitting exequy for this profuse, energetic, sometimes brilliant, and sometimes hopelessly vulgar artist.

Kienholz didn't believe in refinement. What he believed in was a mixture of technical know-how, moral anger, and all-American barbaric yawp. As an artist, Kienholz was self-taught, and his early work in the 1950s was mostly rubbish— Beat coffee-shop art writ large. What enabled him to achieve originality in the 1960s was junk, scraps, the offcuts and excreta of America, which he combined first into small hybrid pieces and then into whole rooms and environments.

The assembly of junk into metaphoric objects went back forty years, to Surrealism and German Dada. Joseph Cornell in the 1940s was the first American to base a whole oeuvre on it; Robert Rauschenberg in the 1950s picked up on Cornell, and Kienholz, in the 1960s, on Rauschenberg. But whereas Cornell was butterfly-gentle and Rauschenberg effusively open, Kienholz was a raging satirist, attached to the view from over-the-top. Show him any kind of establishment and he loathed it. Almost from the start, his work was about social pain, madness, and estrangement. He disliked all cant, including the art world's.

As Kienholz himself said, writers "always have difficulty finding a box to put me in." Sometimes he would be classified with the American Pop artists, but he didn't fit: his angry earnestness threw out everything Pop saw as benign in mass culture. To Kienholz, the TV set was both America's anus and its oracle. He was a history artist, but more explicitly so than Rauschenberg, combining the bile of twentieth-century political expressionism (George Grosz or Otto Dix) with the nineteenth-century public scale of Emanuel Leutze, in a real-things-in-the-real-world vernacular which was, by turns, scabrous, brazenly rhetorical, and morally obsessed. Compared to the thin, overconceptualized gruel that most "political" art in postmodern America would become, Kienholz was red meat all the way.

His best tableaux, most of which belong to the 1960s, remind you of what a long shadow Edward Hopper cast on American art, reaching sometimes into unexpected places. (It is a fair bet, though, that Hopper would have found Kienholz's raucousness and sexual satire detestable.) *The Beanery,* 1965, his reconstruction of a grungy West Hollywood bar—a little slice of Hell, in fact, full of endless chatter, where all the drinkers' heads are clocks whose hands have stopped for eternity at 10 p.m.—has its affinities with Hopper's *Nighthawks.* Was this where George Lucas got the idea for the bar scene full of mutants in *Star Wars?* Even the silver GIs in his great antimilitarist piece *The Portable War*

Memorial, 1968 (Figure 358), have a spectral Hopperish sadness as they raise the Iwo Jima flag on a patio table. To the left, the patriotic singer Kate Smith, represented as a trash can on legs with a head sticking out the top, emits a continuously taped rendition of the unofficial national anthem, Irving Berlin's "God Bless America." The GIs are faceless—mere units in the military machine—and behind them is the most famous of all American recruiting posters, James Montgomery Flagg's World War I Uncle Sam with his bony finger pointing at you. To the right is a blackboard, a sort of funerary stela on which are scrawled the names of 475 nations that no longer exist because of wars. But beyond that, a couple eat their hot dogs at a fast food counter, beside a Coke machine. Their bulldog's a killer, but they don't even notice the GIs. Kienholz is saying that America is so tied into a war mentality, a vast militarist economy—as indeed it was, as never before in its history—that it seems quite ordinary by 1968, in the twentieth year of the Cold War, with Vietnam raging. It's just business as usual, taken for granted, as addiction becomes "normality" to the junkie.

Kienholz excelled at pathos. He made it fierce. For a short while he had worked in a California madhouse. Through the door of the *State Hospital,* 1966 (Figure 359), you peer into a charnel house of the soul, in which an emaciated naked body lies on the lower bunk of a two-tiered unit while his doppelgänger, in the same pose, lies on the upper one, encircled by a red neon thought-balloon. He is the "real" patient's dream; there is no escape from the hell of confinement and lunacy; one fortifies the other. Such tableaux, breaking through the crust of American denial and euphemism about old age, madness, and death, packed a wallop thirty years ago and still do today. It's not surprising that Kienholz's work was more popular and respected in Europe, particularly Germany, than in his native America; Americans have never had much appreciation of satire in the visual arts. Even today, Kienholz's more politically conservative detractors think he was

358. Edward Kienholz, *The Portable War Memorial,* 1968.
Mixed media, 112¼ × 94½ × 374″ (285 × 240 × 950 cm).
Museum Ludwig, Cologne, Germany.

x

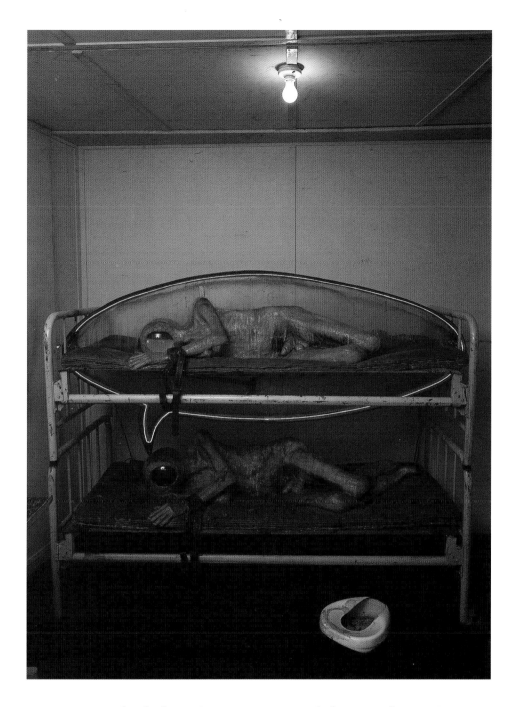

practicing some kind of anti-Americanism. In truth, he was at least as American as his critics—a compulsive Puritan who realized that the City on a Hill had been built in a mud-slide area. The very thought of this moved him to gusts of bitter laughter, and these still blow from his work. Did he exaggerate? Of course; that's what large-hearted moralists do. Some truths speak only from the well of exaggeration.

359. Edward Kienholz, *State Hospital* (interior), 1966.
Mixed media, 96 × 144 × 115¾" (244 × 366 × 294) cm.
Moderna Museet, Stockholm.

Another political artist of interest was Leon Golub (b. 1922). Until the early 1980s, when he had his first New York show in twenty years, Golub was conventionally seen as a "Chicago artist," living in New York but tucked away on his own atoll of social irritability, far from the "mainstream," best known for his activism in the Vietnam years and for his earlier paintings of thick, eroded, archaeological figures like mutilated Hellenistic statues in wounded repose or lumbering combat. But his 1980s canvases were much more documentary. They were about power and torture on the fringes of the American imperium, in hellholes like El Salvador: "White Squad" killers, interrogators, mercenaries, the seedy and pitiless emissaries of order.

The paintings were huge, with some figures nearly twice life-size. Tacked unstretched to the wall like tapestries or (as Golub preferred to think of them) like stretched hides, they resembled in their stark silhouetting and red-earth backgrounds Roman frescoes whose colors had been corrupted by the blackening breath of the late twentieth century.

Their paint was like no one else's. Coat after coat was laboriously scraped back with the edge of a meat cleaver and then scumbled again until it looked weirdly provisional, a thin caking of color in the pores of the canvas. The images were gripping yet strangely distant, scratchily insistent but short on virtuoso rhetoric, and their scale was convincing. Though there was no lack of "big" American painters who confuse eloquence with elephantiasis, the size of Golub's figures seemed justified and even necessary. Only by monumentalizing their documentary content could he give it the fixity and silence it needed, and only in that way could he strike his peculiar balance between the sacrificial and the banal and so get rid of the suspicion of pornography that attends images of extreme violence.

For Golub, as for others, the difficulty of being an "engaged" painter in America came down to the dominance of other media. How can painting operate in the realm of ideas about violence and power when its audience's sense of the terrible has been preempted by photography, film, and TV? This was not a problem for earlier painters of the human clay in extremis, like Goya. It became so for Picasso with *Guernica,* working in an age of mass media to set forth contemporary carnage in terms of a fierce rehash of classical rhetoric: broken sword, dying horse, weeping Niobe. Picasso thus "universalized" his image in a way that neither realism nor photography could, while sowing the enormous canvas with black-and-white references to modern media, including newsprint and the flashbulb.

Golub was likewise doubly haunted by classical diction and mass imagery. His early paintings quoted freely from antique prototypes like the Capitoline *Dying Gaul.* He especially liked the swollen, corroded forms of late Roman official art. The idea of power revealing itself in a "fuzzy or paradoxically discernible way"

360. Leon Golub, *Mercenaries I*, 1979. Acrylic on unstretched linen, 120 × 166″ (304.8 × 421.6 cm). Collection Lannan Foundation.

at the edges of empire interested him a lot, and from it eventually came his 1980s paintings of mercenaries and interrogators.

The presence behind them is not Picasso but Caravaggio, with his groups of massive figures in bare underground rooms, theatrical and claustrophobic at once, and linked implicitly to martyrdom. Golub took Caravaggio's anticlassical poses and fused them with the random positions of photography. No one in his scenes stands like a Renaissance figure. Their postures, whether of infliction or submission, are mobile, awkward, and "modern," the stances and gestures of men at work with clubs, Uzis, and M-16s.

But this threatening lightness is frozen by their exaggerated size, and the result is a degraded monumentality more subtle than the literal references to monuments in Golub's earlier work. He had an eagle eye for banality. The good-ol'-boy smirk on the face of the soldier of fortune in *Mercenaries I,* 1979 (Figure 360), greeting you like a buddy as his other buddies show off their guns, sets your teeth on edge because he is including you, the viewer, in a circle of dirty-secret complicity that you don't want to be part of. In the end, there are perhaps some tasks that painting can do and photography cannot, even when the painting is partly based on photography.

The new American political art that rose in the 1990s had practically none of Kienholz's or Golub's robustness. Most of it was thin, overconceptualized stuff, offering little esthetic presence and rudimentary ideas. Its line of descent was from the art manifestos of the 1970s, like this one from GAAG, the Guerilla Art Action Group, which in its heyday had shown its disapproval of the Establishment by such gestures as dumping a box of live cockroaches on the boardroom table during a trustees' meeting at the Metropolitan Museum of Art:

> Poverty, exploitation, discrimination, racism and war, are all direct consequences of the concept of business. Art and business should be at war with one another—not allies! The artist is as guilty as the businessman. The artist himself has become a businessman. The collector is the stock speculator. The art magazines are the trade journals. Yes, the artist is as guilty of murder as the businessman. Action can force the elitists to relinquish their death-grip on art. . . .

What lay behind this rhetoric, apart from the usual apocalyptic late Marxist habit of pretending that America had a monopoly on wickedness, was a deep anxiety about the future of supposedly radical art. In the 1990s the politically inclined artist shifted his or her focus from the diffuse target of Capitalism itself to its supposed offshoots (which, of course, have always flourished just as vigorously under socialist governments as well): racism, sexism, homophobia, species-ism and the rest, the obsessive concerns with groups and minorities and subsets that were boiling up in the general culture and, especially, in American academe.

Identity politics have made for narrow, preachy, single-issue art, in which victim credentials come first and esthetic achievement a very late second—all posited on an unrealistically schematic division of the world into oppressors and victims. Its mood is didactic, sometimes irritably so, but it teaches little. Who needs art to tell them that racism and child abuse are wrong? Fewer, in this media-saturated day and place, than needed art to tell them Louis XIV was a god. Most people who are at all likely to enter the sleek white space of a SoHo

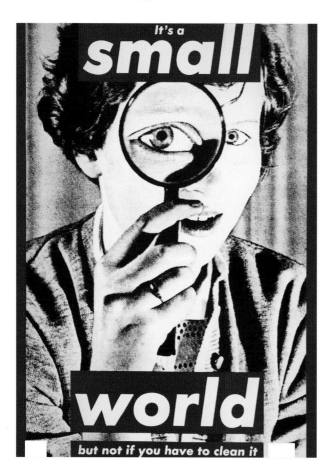

361. Barbara Kruger, *Untitled (It's a small world but not if you have to clean it)*, 1990. Photographic silkscreen on vinyl, 143 × 103″ (363.2 × 261.6 cm).

gallery and there contemplate one of Barbara Kruger's snazzy reruns of John Heartfield's Dada collages and 1920s Russian Constructivist posters (Figure 361), announcing "It's a small world but not if you have to clean it," are apt to be perfectly in sync and sympathy with the aims of feminism.

Such work is one long exercise in preaching to the choir. It affords the pleasure of striking more or less radical attitudes without the risk entailed in radical belief. This is so because it falls into Artworld, which makes no critique of its criticism. It is striking, for instance, that an artist like Jenny Holzer could have built a reputation on the basis of her *Truisms*, replicated in posters and light-emitting diodes—or, for the Venice Biennale, carved in stone at a cost of some $800,000. For these phrases—one hesitates to call them epigrams, Holzer being no Oscar Wilde—had no claim to wit or indeed to any literary status. No doubt ABUSE OF POWER COMES AS NO SURPRISE and MONEY CREATES TASTE; one may even entertain the notion that LACK OF CHARISMA CAN BE FATAL, though in America it's usually too much charisma that is. Such flaccid utterances are no worse, no better, and certainly no closer to serious art or writing than the improving precepts that earlier American women used to stitch on samplers. Today's political art trades on its marginality to an absurd degree, knowing that its audience—its only possible audience—lies within Artworld, but at the same time indulging in ritual denunciations of "elitism."

Art, even mediocre art, tends to shape discussion to its own ends. Ever since Clement Greenberg's objurgations on pictorial skill, which he regarded as a snare and a delusion—a claim to importance by "minor" artists—there had been a strengthening current of opinion against displays of "mere" technique in American art. It began as a conviction that skill was deception, mind-fooling if not eye-fooling. Too much language was a bad sign. This was strengthened by a somewhat sentimental love of the "primitive," the unmediated utterance, which revealed what was sincere and authentic in the artist. (To this we owe the present market vogue for what is conventionally called "Outsider Art," for the productions of the innocent madman, the religious crank, the Sunday painter, and the stitching granny are "pure" in a way that "gallery art" is not, even if the artist in question now has a dealer.) But by the 1990s it was so far internalized that it became simply a rationale for having little or no technique; and at this point it acquired political virtue by a semantic trick: the disparaging use of the word "mastery." The politically correct view of painting, in some quarters, was that it was *in itself* a congealed form of white male domination, a vehicle of "mastery," the artist as Simon Legree pushing his flake white and cadmium yellow around like slaves; the best way to "subvert" it was not to be much good at it. Thus, in the 1993 Whitney Biennial, what might have struck the unprepared visitor as mere ineptitude in the work of Sue Williams (scratchy drawings and a now famous puddle of plastic vomit on the floor), Raymond Pettibon (maundering lit-

tle vignettes done in a vaguely comic-strippish manner), or Mike Kelley (likewise, but with stuffed toys) became a sign of alertness and compassion. Such work, the catalog said, "deliberately renounces success and power in favor of the degraded and the dysfunctional, transforming deficiencies into something positive in true Warholian fashion."

Actually, the presiding spirit wasn't Andy Warhol's but Oprah Winfrey's. One saw it alighting on such art like a portly Tinker Bell, waving the wand of reclamation: I'm OK, you're OK. Presumably, if such artists hadn't been so strict with themselves in renouncing "success and power" (though not to the point of actually withdrawing from the Whitney Biennial), they ran the risk of becoming teensy Titians, engorged with "mastery." No sodden cant, no cliché of American therapeutics, need be rejected, and any attempt at esthetic discrimination can be read as blaming the victim. It's the lesson of performances by such as Karen Finley, smearing her skin with chocolate and pushing yams into herself to illustrate the degradation of women in American society. *Hey, look, those are my guts on the floor. You don't like my guts? You and Jesse Helms, fella.* The idea that one could actually be against oppression while rejecting such lumpen therapeutics seemed a tad too nuanced for the early 1990s art world to grasp. Modern museums led by postmodernists played their part, with their cult of the "problematic" and the "confrontational" and their rejection of the idea that one of the primary aims of art had always been to afford its public pleasure, complex pleasure sometimes but pleasure all the same. It was more improving to be preached at. It also tended to bore and alienate the public, since the content of the sermon turned out, more often than not, to be quite banal. To have recycled conceptual art

362. Cindy Sherman, *Untitled,* 1987. Color photograph,
47½ × 71½" (120.6 × 181.6 cm).

614

mounting largely theoretical barricades is a pretty thin pleasure, compared to looking, say, at Goya's *Third of May* or a drawing of a hanging judge by James Gillray.

Identity art did yield some images of real intensity, such as Cindy Sherman's often ferociously ironic photographs starring herself in different roles. Sherman (b. 1954) began with small black-and-white prints in the late 1970s, showing herself in fifties outfits, enacting fragments of an otherwise indecipherable narrative as housewife or glamor girl, modeled on film stills of Marilyn Monroe and Sophia Loren, and exploring the various stereotypes of women. These had a quiet, ironic grip on the theme of identity-as-construct, the sense that when a person's costumes and props are taken away, there is (as Gertrude Stein famously said of Oakland, California, where she grew up) no *there* there. Later in the 1980s, Sherman's work expanded into the baroque horrors of the *vanitas* (Figure 362). She made huge Cibachrome prints in which, grotesquely made up and extravagantly costumed, she parodied images from art history. An element of sexual terror entered some of these. In a related way, Kiki Smith (b. 1954) made figure sculptures in wax, plaster, or papier-mâché that looked like George Segals subjected to torment or humiliation, hangdog images of the put-upon, suffering, or menstruating female body (Figure 363).

But the mother of American feminist identity art had already been working for decades. She was Louise Bourgeois (b. 1911), who had married the art historian Robert Goldwater and moved from Paris to New York in 1938. Until the late 1960s her work was completely obscure, and even by 1982 she was probably the least-known artist ever given a retrospective at the Museum of Modern Art. But since then Bourgeois's influence on younger artists has been enormous, almost comparable to Jasper Johns's on the generation behind his. Her work asked questions by rummaging, painfully, in her own psyche. What images can art find for depicting femaleness from within, as distinct from the familiar male conventions of looking at it from the outside, from the eyeline of another gender? What can sculpture say about inwardness, fecundity, vulnerability, repression, and resentment? How can it propagate different meanings for the body?

363. Kiki Smith, *Lilith*, 1994. Bronze with glass eyes, h. 31½″ (80 cm); cast 1 of 3. The Metropolitan Museum of Art, New York; purchase, Roy R. and Marie S. Neuberger gift, 1996.

"For me," said Bourgeois, "sculpture is the body; the body is the sculpture." The defining experience of her early work was Surrealism, still very much an active movement in the France of her youth. Surrealist fascination with the female body becomes, so to speak, turned inside out, rendered as an imagery of weak threats, defenses, lairs, wombs, and almost inchoate groupings of form. The sense of touch is vital to Bourgeois's sculpture, some of which is made of rubber; it embodies both intimacy and repulsion at the same time, along with a sardonic humor—*Fillette,* which means "little girl" in French, is actually a shrouded bronze penis complete with two massive testicles. Her images oscillate between a

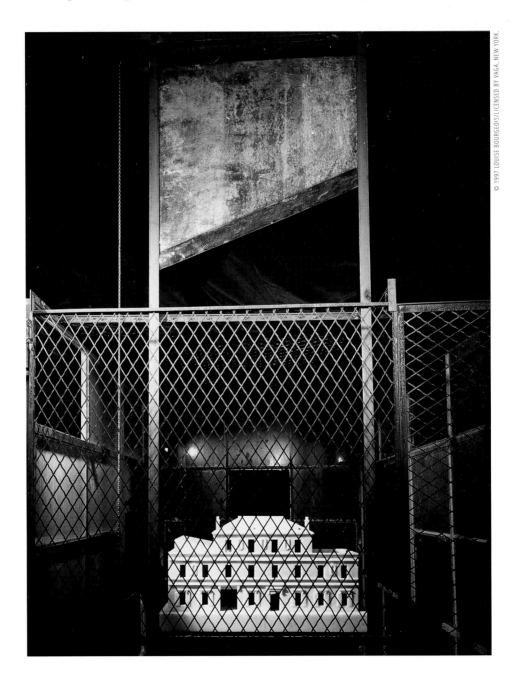

fanatical aggression and a neurotic tenderness; they are suffused with childhood memory and fantasies of dismemberment, and one of her installation pieces, *The Destruction of the Father,* 1974, a red-lit grotto full of lumpy, pendulous stalactites and objects like joints of meat, looks like a cannibal's cave. "It is a very murderous piece," remarked Bourgeois, with some understatement; "an impulse that comes when one is under too much stress, and one turns against those one loves the most."

Memories of childhood are woven into much of her work, and often form the subject of her "Cells"—environments the size of small rooms, full of bottles, dummies, writings, stuffed dresses. *Cell (Choisy),* 1990–93 (Figure 364) commemorates the house outside Paris where her parents ran a business in the restoration of Gobelin tapestries. Inside an iron-mesh enclosure, untouchable, is an effigy of the house done in pale pink marble, spectral but with the enticing glow of a Magritte villa in the dusk. But above the door to the cage, ready to be tripped, is a raised guillotine blade. You can't go home again.

Identity is one main channel of American cultural anxiety today. (The other is a sense of mediocrity, which "anti-elitist" postures will not alleviate.) Nobody can live in America without getting a gutful of identity—if not your own, then mine, or his, or hers. And all the extremes of the permutations, from Louis Farrakhan to the members of the local white supremacist militia; and all sorts of Americans in between, who are neither fanatics nor fools, but who tend to accept the sectarian division of "culture" almost to the point where they feel that one person's desires may constitute some sort of "culture" in themselves.

If you have a tribe, so must I. It is a very short step from the 1960s idea that the personal is political to the 1990s belief that the personal should be submerged in the tribal. Identity does not mean individuality; it is a means of framing public conformity and proclaiming what the writer Leon Wieseltier called a foolish worship of origins:

> If the differences between individuals and groups were as thick as multiculturalists think, then not even multiculturalism would be possible. Everyone would be shut up in subjectivity. There would only be total silence or total war.

Every assertion of identity is also an exclusion of others. Yet this may not be the best thing for an artist or a writer to feel. The desires that go into the making of a work of art can be very complex and conflicted, and may have nothing to do with "belonging." (Much of the story of modernism is one of exile and deracination.) One makes art to allow the unknown self—unknown to others, but also to the artist—to speak; the work gropes its way to the light of such a resolution,

364. Louise Bourgeois, *Cell (Choisy),* 1990–93. Marble, metal, and glass, 120½ × 67 × 95″ (306.1 × 170.2 × 241.3 cm). Ydessa Hendeles Art Foundation, Toronto.

and identity slogans may trip it up. Identity says nothing about deep esthetic ordering; such ordering is conscious and existential, and identity is an accident. The multicultural society is certainly an end in itself, in terms of ethical tolerance for others. However, multiculti guarantees absolutely nothing about the merits—the quality, to use a much-disparaged word—of the writing, painting, music, and architecture made in it. What counts in art is the multicultural *person*, the individual who is more complex than his or her origins, and who can speak to the complexities of others.

Ask not what art has done for identity politics in America, which is not much, since art has little if any direct political effect; ask rather what identity politics has done to art, which has been troubling when not actually ruinous. For example, factionalism has made any but the blandest public art impossible. When people can't agree on what is worth commemorating, and go into complaint-overdrive at the sight of another group's images, the sense of common ground goes and the etiquette of civic space is lost. The 1990s brought a spate of this, in all areas of the arts, as factions poured out the vials of their resentment.

If there is one idea that tribalists and fundamentalists of all stripes agree on, it

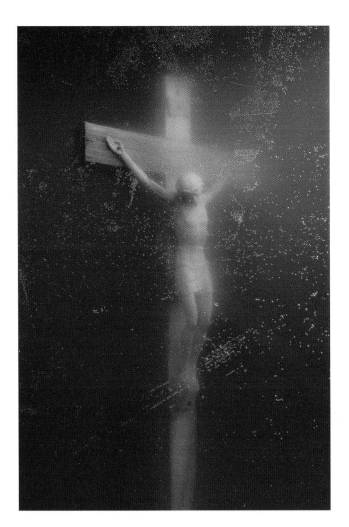

is that art is mainly instrumental. Images are things, words are deeds. Monkey see, monkey do. They credit art with a power it does not have (but which the political "vanguard" nostalgically wishes it had): that of literally changing behavior and reality. Show people the wrong photo by Robert Mapplethorpe and suddenly America will be full of millions of priapic fists seeking the wrong orifices. In Washington in 1995, Congress voted by 229 to 195 to cancel all funding for the National Endowment for the Arts within two years, as a blow against what its more enthusiastic members called a "cultural elite" (names unspecified) which, six years before, had indirectly funded a grant to the artist Andres Serrano for a body of work that included the now legendary *Piss Christ*, 1987 (Figure 365)—a photo of a cheap plastic crucifix immersed in a jar of the artist's own urine. Since it

365. Andres Serrano, *Piss Christ,* 1987. Cibachrome, silicone, Plexiglas, wood frame, 60 × 40″ (152.4 × 101.6 cm); edition of 4.

was founded in 1965, the NEA had distributed tens of thousands of grants, of which perhaps twenty caused some controversy; but now it was better that the American government should assign no funding to the arts, or to the humanities either, or to public broadcasting for that matter; better that it should have no state-sponsored public culture at all than that it should risk offending the inflamed identity of the Christian right. For conservatives, too, had brilliantly appropriated the trick of identity politics, which is to pose as a historically demeaned and violated group, a "culture" in itself. The surrounding fray between the politically and the patriotically correct—the latter much more powerful than the former—brings to mind the bleak words of the painter John Trumbull in 1793, lamenting that "the whole American people" had become "violent partisans":

> The whole country seemed changed into one vast arena . . . on which the two parties, forgetting their national character, were wasting their time, their thoughts, their energy. . . . In such a state of things, what room remained for the arts? None.

America's present "culture wars" do not exist in liberal democracies on the other sides of the Pacific or the Atlantic. Their intolerance is aggravated by the deep anguish that descended on America after it won the Cold War—and found itself no better off without Communism. For forty years Americans had been living in a Manichaean universe, divided between right (them) and wrong (Russia). Now this scenario, so frightening and yet so consoling, dissolved. But the mindset it fostered remains, particularly since America is the only country in the developed Western world with a strong current of fundamentalist, apocalyptic religion. With the death of Communism new Antichrists and minor demons have to be found inside America. The two PCs—patriotic correctness on the right, political correctness on the left—have mutually fostered this search, creating an atmosphere of inflamed accusation in which all moderation is lost; scholarship and the arts then become scapegoats, grotesquely politicized stereotypes in our "culture wars."

Art is rarely, in the end, untouched by the deep currents moving in the society around it. American art in the twentieth century could not expect to be—and was not. A central myth, not only of American art but of America itself, was that of newness: the perpetual renovation which, from the moment of Puritan arrival in the seventeenth century, stood as the promise of God's contract with a chosen people in the New World. At the end of the eighteenth century, this was transposed into political renewal by the world's first great democratic revolution. By the 1830s the sense of renewal and discovery had been re-projected on the exploration and internal colonization of America, producing, among a host of other results, its first significant and original landscape art. By 1900 the myth of

newness, of perpetual progress, had been vastly fortified and confirmed by technology: Americans could make anything, solve any problem, produce a Niagara of inventions, and lead the world while doing so. So it was hardly surprising that soon after modern art arrived in America, the idea of the avant-garde, representing progress in the imaginative sphere, should have been welcomed, seized on, and eventually institutionalized to a degree unheard of in Europe. Americans, more than any other people, learned to believe that art progresses: that its value to human consciousness lay in renovation, seen as therapeutic in itself.

In the arts at the end of the twentieth century, as in other fields of social life, this cherished belief is now falling apart. To promise American renewal is a fixed ingredient of American politics, from Ronald Reagan's belief that "today is better than yesterday, and tomorrow will be better than today," right down the line to William Jefferson Clinton's incessantly repeated bromide about "building a bridge to the twenty-first century." Look forward, don't look back: history is not a nightmare from which Americans cannot wake (as in Europe) but something to be selectively transcended.

This mantra of debased optimism no longer rings culturally true, because America is not new but old. It has the world's oldest democracy (and Boston is an older city than St. Petersburg); it has been riven by inequality and social tension to the point of fatigue, resentment, and fanaticism; and for the first time in its history, the future looks worse than the past to a large and growing number of its citizens. With the millennium at hand, in a society founded on messianic optimism, more imps and goblins will appear than ever before; the sleep of reason will produce its monsters. But there is little reason to expect that it will also bring forth a Goya to record them.

For the smaller sphere of the visual arts is equally fatigued, and its model of progress—the vanguard myth—seems played out, hardly even a shell or a parody of its former self. This, however, only seems unnatural or disappointing to those whose expectations have been formed by vanguardism. Cultures do decay; and the visual culture of American modernism, once so strong, buoyant, and inventive, and now so harrassed by its own sense of defeated expectations, may be no exception to that fact. One thinks, with regret, of W. B. Yeats's lines: "The best lack all conviction, while the worst / Are full of passionate intensity." But on the other hand, in the equally durable words of Scarlett O'Hara, tomorrow is another day.

INDEX

Reproduction of 1971 Laurence Weiner exhibition © 1997 Laurence Weiner/Artists Rights Society (ARS), New York.

Grateful acknowledgment is made to the following for permission to reprint previously published material:

FABER AND FABER LIMITED: Excerpt from "Gerontion" from *Collected Poems 1909–1962* by T. S. Eliot. Reprinted by permission of Faber and Faber Limited, London.

HARCOURT BRACE & COMPANY and FABER AND FABER LIMITED: Excerpt from "The Waste Land" from *Collected Poems 1909–1962* by T. S. Eliot, copyright © 1936 by Harcourt Brace & Company, copyright © 1963, 1964 by T. S. Eliot. Rights outside the United States administered by Faber and Faber Limited, London. Reprinted by permission of Harcourt Brace & Company and Faber and Faber Limited.

ALFRED A. KNOPF, INC., and HAROLD OBER ASSOCIATES INCORPORATED: Excerpt from "Po' Boy Blues" from *Collected Poems* by Langston Hughes, copyright © 1994 by the Estate of Langston Hughes. Reprinted by permission of Alfred A. Knopf, Inc., and Harold Ober Associates Incorporated.

NEW DIRECTIONS PUBLISHING CORP. and CARCANET PRESS LIMITED: "The Great Figure" from *Collected Poems: 1909–1939, Volume I* by William Carlos Williams, copyright © 1938 by New Directions Publishing Corp. Rights in the United Kingdom administered by Carcanet Press Limited, Manchester, England. Reprinted by permission of New Directions Publishing Corp. and Carcanet Press Limited.

RANDOM HOUSE, INC., and FABER AND FABER LIMITED: Excerpt from "As I Walked Out One Evening" from *W. H. Auden: Collected Poems* by W. H. Auden, edited by Edward Mendelson, copyright © 1940, copyright renewed 1968 by W. H. Auden. Rights in the United Kingdom administered by Faber and Faber Limited, London. Reprinted by permission of Random House, Inc., and Faber and Faber Limited.

SIMON & SCHUSTER and A. P. WATT LTD.: Excerpt from "Ancestral Houses" from *The Collected Works of W. B. Yeats, Volume I: The Poems*, revised and edited by Richard J. Finneran, copyright © 1928 by Macmillan Publishing Company, copyright renewed 1956 by Georgie Yeats; excerpt from "The Second Coming" from *The Collected Works of W. B. Yeats, Volume I: The Poems*, revised and edited by Richard J. Finneran (New York: Macmillan, 1989). Rights outside the United States administered by A. P. Watt Ltd., London. Reprinted by permission of Simon & Schuster and A. P. Watt Ltd. on behalf of Michael Yeats.

THE SONGWRITERS GUILD OF AMERICA: Excerpt from "Brother, Can You Spare a Dime?" by E. Y. Harburg and Jay Gorney. Reprinted by permission of The Songwriters Guild of America on behalf of Gorney Music Publishers and Glocca Morra Music.

A NOTE ABOUT THE TYPE

The text of this book was set in Sabon, a typeface designed by Jan Tschichold (1902–1974), the well-known German typographer. Based loosely on the original designs by Claude Garamond (c. 1480–1561), Sabon is unique in that it was explicitly designed for hot-metal composition on both the Monotype and Linotype machines as well as for filmsetting. Designed in 1966 in Frankfurt, Sabon was named for the famous Lyons punch cutter Jacques Sabon, who is thought to have brought some of Garamond's matrices to Frankfurt.

Composition by North Market Street Graphics, Lancaster, Pennsylvania
Color separations and film preparation by Pro Graphics, Rockford, Illinois
Printed and bound by Tien Wah Press, Singapore
Designed by Peter A. Andersen and Arlene Lee